THE

FIRST

MODERNS

William R. Everdell

THE FIRST MODERNS

PROFILES IN

THE ORIGINS OF

TWENTIETH-CENTURY

THOUGHT

THE UNIVERSITY OF CHICAGO PRESS

CHICAGO AND LONDON

WILLIAM R. EVERDELL is Dean of Humanities at Saint Ann's School in Brooklyn.

The University of Chicago Press, Chicago 60637
The University of Chicago Press, Ltd., London
© 1997 by William Everdell
All rights reserved. Published 1997
Printed in the United States of America
06 05 04 03 02 01 00 99 98 97 1 2 3 4 5

ISBN: 0-226-22480-5 (cloth)

Library of Congress Cataloging-in-Publication Data

Everdell, William R.
 The first moderns : profiles in the origins of twentieth-century
thought / William R. Everdell.
 p. cm.
 Includes bibliographical references and index.
 ISBN 0-226-22480-5 (cloth : alk. paper)
 1. Thought and thinking—History—20th century. 2. Modernism
(Aesthetics) 3. Intellectual life—History—20th century.
4. Science—History—20th century. I. Title.
B804.E84 1997
190'.9'04—dc21 96-44334
 CIP

For Ellie and Bill
Barbara and Chris
Lynn and Josh
and Ellen

◆

This all happened
before you were born.

CONTENTS

ACKNOWLEDGMENTS

Among the many people who inadvertently precip-
itated this book is an eighth-grade teacher named Alexander Lehman,
who assigned his students in 1954 to create a genuine Pablo Fiasco. This
caused a few of us to realize that we were members of the last generation
of students for whom "Modern" art could be a learned experience, and
brought at least one of us to consider trying to tell others what that expe-
rience had been like. Others answerable include C. P. Snow, who pub-
lished *The Two Cultures* in 1959, and lamented in a lecture at Princeton
that year that humanistically trained scholars had no idea what the Sec-
ond Law of Thermodynamics was. Perhaps the most important was the
incomparable André Jacq, who taught French at St. Paul's School in such
a way as to ignore the bulkheads separating national cultures and aca-
demic fields from each other, to mix poetry and mathematics, and to
make it seem the most natural thing in the world that Baudelaire should
have learned from Poe or Paul Valéry from Henri Poincaré and Zeno of
Elea. André Jacq was neither the first nor the last of the great teachers it
has been my luck to run across, among them Edward Sullivan, Joseph
Strayer, James Billington, and Frank Manuel. Two still live, historians,
who take the long view of our closing century and advancing age.

But books don't exist without readers—a truth that predates decon-
struction. For this writer at least, it is the reader who makes everything
possible, and I am glad to be able to thank so many: those who volun-
teered to read what I had written when it was very far from being print-
able, and those who listened to the stories before they got onto paper at
all. Students who have helped include Sebastian Keneas, Karen Bloom,
Katherine Healy, Jendi Reiter, Julia Holderness, Mollie MacDonald (who
translated Bohr), Abi Basch, Adam Stofsky, Jamie Hood, Max Gross,
Lisa Schneider, Sam Shiffman-Ackerman, and all the students, both high

schoolers and adults, who questioned their way through my Twentieth-Century Ideas courses at Saint Ann's between 1992 and 1996.

My colleagues in the Saint Ann's history department have also helped immeasurably. Roger Westerman, Roger Frie, Victor Marchioro, Ruth Chapman, and David Johnson in particular have read chapters and commented in the uninhibited way that is the custom here. And a multidisciplinary book like this one could not have been done without enthusiastic testing by members of other departments, including Doctor Ted Kaufman; chemist Paul Siegel; literature maven Patrick O'Connor; biologist Dana Solecki; philosopher Stanley Bosworth; poets Carol Rawlings, Jane Avrich, and Nancy White; physicists Sam Keany, Mike McGarry, and John Gulla; artists Charles Luce, Peter Leventhal, and Marsha Liberty; composer John Elliott; St. Louisan Nancy Melnick; and Lena Tengberg, the Strindberg buff who heads the sports program. Nancy Garrett's opera, *Dora*, gave me better evidence of Freud's effect than any history; Deborah Dobski, A.I.V.F., launched me in the study of film, and mathematician Richard Mann has taken me through the Dedekind Cut more than once with unfailing verve and patience. Four of the most helpful of my colleagues were once my students: musician Erika Nickrenz; theatre director Sharon Lamazor; Latinist Emily Stone; and writer Beth Bosworth, whose own book of stories is called fiction.

I am also indebted to learned friends like European historian George Herland; art historian Ken Rush; Austrian historian Andy Whiteside; American historian Jon-Christian Suggs; composer and musicologist Julian Goodwin; poet Laura Kennelly; Dan Poag, who knows the jazz history of Memphis; and Gordon Schochet, who has helped pull historians of ideas together. Peter Herbert and Jay Kramer, whose considerable expertise lies in the area of authorial contracts, were generous in sharing their knowledge with me.

I owe much to squadrons of nearby librarians, in particular those of New York University's Bobst and Princeton's Firestone libraries. The American Institute of Physics librarians were helpful even after the library itself had left New York. When the only edition of Mendel and Correns available in New York turned out to be at the Bronx High School of Science, Saint Ann's Anne Bosworth requisitioned it for me. At their Book Den East, Cynthia and Ivo Meisner, booksellers not librarians, seemed able to find whatever the southern Massachusetts libraries no longer possessed. Nineteenth- and early twentieth-century scholarly books, printed in small editions on acid paper and now rapidly disintegrating, have so often been the primary sources for this study that I am grateful, too, to publishers like Dover, Ox Bow Press, Chelsea, Open Court, and 10/18, who have taken on the mission of reprinting them in new editions, sometimes even in paperback.

I owe no less to translators. Since my Russian does not exist, I have

offered the reader D. M. Thomas's English *Akhmatova* and J.-C. Marcade's French version of *Victory Over the Sun*. Since my Swedish is rudimentary, I am grateful to Strindberg's translators, who have served him well in every other Western language. My philosophical German often feels shaky (I am not alone in this) and I have used translations uninhibitedly as checks on my work. It is said that the first step for Germans assigned to read Kant is to secure an English translation, and I too am especially indebted to an English translation, J. English's lucid rendering of Husserl's *Philosophie der Arithmetik* into French. One English translation I am grateful for permission to reprint: Louise Varese's translation of "Motion" by Arthur Rimbaud, in *Illuminations* (New York: New Directions Publishing Corp., 1957), 116–19. Copyright 1957 by New Directions Publishing Corp.

I have many scholars to thank whom I have met only in that new gazette of the republic of letters, the Internet; but their help, though faceless, has been both personal and selfless. The members of the electronic bulletin boards RUSSELL-L, HOPOS-L, H-IDEAS, NIETZSCH, RUSSTHEA, PEIRCE-L, and C18-L have provided some of the details in this book and given some of its ideas a workout. Historian of philosophy Jan Dejnozka and filmmaker Eric Breitbart helped with sources. The newly formed Society for Literature and Science and its journal, *Configurations,* were a source of much optimism, since they have been able to practice an interdisciplinary history of ideas that largely avoids the confusion of levels that often besets it. I owe still more to my editor, David Brent, to scholars like Jacques Barzun, Peter Bondanella, and Joseph Dauben, who encouraged my project, and especially to Stephen Brush, who read the manuscript and tried to set some of it straight. If errors remain, it's not their fault.

As a practical matter, books require some capital investment. This one has twice been given grants by American taxpayers via the now-beleaguered National Endowment for the Humanities. I hope those responsible for the author's Summer Study grant and his Wallace Foundation Teacher-Scholar grant will find the game has been worth the candle, for these have been for many years the only research fellowships available to noncollege teachers in America. I would guess, however, that the largest capital investment in this project has been made by the author's own family. Barbara, Josh, and Chris Everdell have been an indulgent crew, but one with an excellent sense of humor—both useful when you live with someone who is possessed by a book.

1 INTRODUCTION

WHAT MODERNISM IS AND WHAT IT
PROBABLY ISN'T

The century is ending. The Western world is in what might be called a *fin-de-siècle* mood. What sense can we make of this long era? What legacy has it left? Every day we hear more talk about how the century began, with the simultaneous invention of movies, automobiles, skyscrapers, and abstract art. The high culture we have called Modernism has now been with us for most of this century and part of the previous one, longer than any other cultural *-ism* since the French began naming them back in the eighteenth century. This book is an attempt to tie down Modernism's beginnings and to begin to write its history.

The result you have before you is a narrative history of ideas, a thing that has become rare. Narrative, some now say, is obsolete, to which accusation the many have replied by building our time's demand for meaningful story—indeed, for any kind of story—to something like a fever pitch.[1] History too is now accused of obsolescence, and "theory" contends it is impossible to adopt a point of view and interpret the past from it. But it is extraordinarily hard to avoid doing that, and there are many reasons why one ought not to try. Some accuse ideas themselves of being obsolete, since all ideas are artifacts of subjectivity and cannot be passed on without intersubjectivity. This book, then, takes an old-fashioned position—that individuals can think new thoughts and communicate them. In fact, it is the collective history of a small group of people who did just that.

They are all of them individuals, and all of them are, in their way, geniuses. A genius I take to be a person who does something no one else can do until enough time has passed for a lot of other people to learn how to do it too. One can be a genius without being a hero; Valeriano Weyler in chapter 8 was, at least in my view, a classic villain. All are presented here, in a nod to a form of history as old as Plutarch, as profiles

in genius, notables of their intellectual specialties, from mathematics to painting. On the other hand, they ought not to be thought of as acting alone, like the mythic American frontiersman. Some, indeed, are women. They learned from each other, something that is harder to do in the more advanced state of intellectual specialization typical of our own times. The intellectual and cultural environment in which the first Moderns found themselves as the twentieth century began was rich and complicated, composed of every sort of social relationship in Western culture, including academic disciplines, family, nation, class, and language, habitual cafés and cabarets in particular cities, and of course circles of correspondents, blessed by the historian because they leave such good evidence behind. Ideas may well occur to people who have no relationships, but they are not ideas history can find out about.

Writing about Niels Bohr, the genius who came up with Modernism's epistemology of science, a historian asserted:

> The creative individual is, in a sense, complementary to the society in which he lives, rather as a soloist in a concerto. Both the basic ideas of science and the key inventions of mankind have generally been conceived in the minds of individuals, while the effort to gain the data on which the ideas and inventions have been based, and the subsequent effort to turn them to good account, have required the contributions of many besides the inventor and originator of ideas. So the individual and the community are necessary to one another. . . .[2]

For these individuals the necessary community, in many cases, was the entire Western world, at least insofar as it communicated with itself in the major Western languages. The great cities of 1900 where the first Modernists found themselves were already very populous, and usually multicultural. The nineteenth century had accomplished that. Communication was extremely swift, whether by postal correspondence (five deliveries a day in Munich), by publication (one month plus one week from contract to presentation copy for Kafka's first book of fiction), or by telephone and telegraph. It was possible for the poet Jules Laforgue to be born in Uruguay, educated at one of the best provincial secondary schools in France, employed as a reader by the Dowager Empress of Germany, and commissioned to translate the American works of Walt Whitman. James Joyce could write a novel meticulously set in the Dublin of 1904 while he was teaching English to Italians in the main seaport of the Austro-Hungarian Empire. In this sort of world an aristocratic Russian like Igor Stravinsky could change the course of Western music with a ballet score written in Switzerland and performed in Paris. Niels Bohr could write his classic paper on the atom in English while teaching in his native Denmark, publishing it in the journal of the British Royal Society under the guidance of a New Zealander who had made his scientific repu-

tation in Ontario, Canada, by extending the work of a Polish woman living in Paris. This kind of "hopscotching the world," as early film news-reels called it, suggests an absence of system, certainly to those who prized nineteenth-century distinctions based on ethnicity and language. But the system was there, and it was itself transnational. In fact, the insistence on a supra-ethnic community of thought and of art is one of the positions now often defined as Modernism.[3]

Are we in the wrong intellectual climate for a narrative history of Modernism? For a while now we have been in what is called the post-modern era. Restless academics and other employees of the culture factory who launched "Structuralism" in the 1960s tried out a new term in the 1970s, "Post-Modernism," hoping to apply it to the last fifty years or so of Western culture (with a nod or two further back at Nietzsche). Debate has been fierce about what postmodernism might mean, and before the word even lost its hyphen there were nay-sayers claiming there was no such thing. The word "Post-Modern," with hyphens and capitals, has been around at least since Irving Howe and Harry Levin used it in the 1950s, but it was Robert Venturi's 1972 *Learning from Las Vegas,* an architect's manifesto, that became postmodernism's charter in the United States.[4] By 1977, only five years later, Venturi's colleague Charles Jencks was writing that Modern architecture had "expired finally and completely."[5] There ensued something of a rush among intellectuals to be the first with a general definition of postmodernism.[6]

Historian of literature Charles Newman and historian of science Stephen Toulmin dubbed literature and science "postmodern." Dance, critics archly assumed, was also postmodern, though not so often.[7] According to Andrew Ross, who taught "Postmodernism: Theory and Practice" in the Princeton English department, postmodernism was an "emerging concept . . . a contemporary response to the modernist division of high culture from mass culture." Not so, countered Claude Rawson, whose field is eighteenth-century studies:

> the massive works of what are called postmodern novelists are . . . in their difficulty, allusive density, and simpering air of in-group donnishness . . . in their bulky appearance and learned showmanship, reminiscent of dissertations. . . . The trend was already potential in an earlier modernism, with its delight in esoteric allusion and its self-conscious (part satirical, part participatory) obsession with pedantry.[8]

Ada Louise Huxtable didn't like postmodernism either, but hers was different. It was "the renunciation and devaluation of everything the modernists believed in and built," and embodied "something somewhat nastier—a parvenu, old-tie, anti-liberal snobbism of the new, and young, far Right."[9] (Huxtable had probably been reading *The New Criterion,* which had become, under Hilton Kramer's editorship, the U. S. voice of

those whose only quarrel with Modernism was that it had been too uto-pian or too austere, not to mention anticapitalist, and never too demo-cratic.)

According to Mark Stephens in 1985, "One of the great achieve-ments of modernism was to stress the value of art as art, free from its encumbering baggage,—the overstuffed rooms, the money, the snob-bery." On the other hand, a "concern with glitter, opulence and spectacle . . . ersatz theatricality and devotion to stylishness . . . eclectic taste and reverence for the past are all typical of postmodernism."[10] If he was right, we might seem to be going backwards.

What are these good people talking about? Bruce Handy at *Spy* mag-azine wondered too, and must have begun filling a file on postmodernism at about the same time I did. His 1988 article noted, among other loony delights, *Elle* magazine's "The Postmodern parka? Après-ski gone party with semiprecious metallic parkas for p.m." from 1986, and the *Village Voice*'s "Postmod Sex" from 1987.[11] By 1992 the abbreviation "pomo" had appeared in print in a magazine addressed to struggling humanities scholars.[12] As Margaret Atwood summed up the situation, "post this, post that. Everything is post these days, as if we're all just a footnote to something earlier that was real enough to have a name of its own."[13] Perhaps in reaction to this sort of glitz, Kirk Varnedoe of MOMA read the word out of his vocabulary in 1990. "I don't believe that there is such a thing as Postmodernism," Varnedoe said flatly. Instead he saw "a continuity of what began as a revolution from around 1880 to 1920. It opened up a new set of languages and questions and options. I don't believe those options are over. There has been no comparable watershed since."[14] This was five years after Paul Goldberger, on page 1 of the Arts and Leisure section of the *New York Times,* had invented postmod-ernism's successor, "Neo-modernism."[15] So far, it doesn't seem to have caught on.

"Post-Modernism" may still have a future; after all, we have been calling ourselves "modern" in the West at least since the sixteenth cen-tury. In a more than graceful gesture to our own past, we began a hundred years ago to term "modern" everything that had happened to us since the fourteenth century. By extension we later began to call "modern" everything that happened to any other culture after it had built its first railroad or printed an edition of Marx. With a capital letter, Modern, like postmodern, becomes a term applying mostly to high, or intellectual, culture; but whatever postmodernism may mean—a furious eclecticism, "decentering" of "discourse," abandonment of self and "other," or "high" and "low," confusion of periods, bricolage, formalism, a brittle insistence on the decomposability of a work of art, or the replacement of the Chevrolet Impala by the Apple Macintosh—it seems, at the very least, that we should be cagy about calling our culture "postmodern" until we

know what "Modernism" means. If John Barth was right in 1980 that discussions of postmodernism must "either presume that modernism . . . needs no definition . . . or else must attempt after all to define [it]," then Maurice Beebe was wrong to assert in 1974 that "we can now define Modernism with confidence."[16] Perhaps we could, but we haven't. Isn't it about time? After all, it has been at least fifty years since Modernism became known as a settled phenomenon.[17]

The educated reader uses the term "Modernism" all the time, possessed of certain spreadeagled definitions learned, perhaps, in courses in art history or twentieth-century fiction and reinforced by daily trips through the glass canyons of downtown; but in fact we know less about it than we do about any other -ism—very little indeed. Communism or liberalism, even classicism or romanticism, would be less of a problem for us, if only because they are not so general. Unlike Modernism, none of these others requires us to understand a bit of everything and to indulge in the wholesale crossing of what we have come, in the twentieth century, to call "disciplinary barriers."

There is classical music, classic art, and classical physics, to be sure, and there may even be classical mathematics, but the disciplines have charge of them and they do not all belong to the same period. Were we to define a Classical period, extending from about 1620 to 1780, and call it, as historians do, the Ages of Reason and Enlightenment, we would still confront fewer creators working in fewer and far less well-marked-off "disciplines." With some ease we could put them together, as we put Locke, Newton, Voltaire, and Bach together, on the basis of style, attitude, or preconceptions. By contrast, Modernism requires uncomfortable leaps. What kind of biology, for example, is Modernist (if any)? What kind of problems does a Modern mathematician solve? Is there a Modern style in sociology—or is it simply Modern to be a sociologist? And Immodern to be a ballet dancer? Most important, do the biologists and the ballet dancers ever affect each other, and in what sense may they be said to be contributors to a common culture?

If Modernism may be too broad a term to be meaningful, it may also be too long. What is the duration of an -ism? The first to name itself was romanticism (classicism is retroactively applied), and it lasted little more than a generation, though much later and even now, thinkers will be called "romantic" if the old ingredients are there.[18] Realism in the later nineteenth century has the same sort of history, though it seemed to last longer. By the 1880s -isms had begun to succeed each other at roughly five-year intervals. Five years, in the age before international telephoning, was barely enough time for bright members of a generation to find each other. Now, with postmodernism we have -isms that cover more than a generation and have little coherence. Perhaps because the bright young people in a generation don't cohere, or because there are too many of

them, or because we are now in the habit of -ism-ing and can't find an alternative, critics and commentators have taken over, and instead of making terms that refer to new ideas and those who come up with them, they make terms that refer to themselves.

So what is Modernism? One premise of this book is that we had better define Modernism soon or we will lose the use of the term as soon as the last generation of Modernists follows the first to its centenary, putting an end to what may be the longest-lived cultural movement our civilization has ever experienced. It has been a long time since the first Moderns.[19] James Joyce was born in 1883 when Freud and Strindberg were twenty-four; Anton Webern and Niels Bohr were born in 1885 when Bertrand Russell was thirteen and Kandinsky going on twenty. Isadora Duncan, Ludwig Boltzmann, Georg Cantor, and Stéphane Mallarmé all died before their work could be fully understood. Stravinsky and Picasso lived long, but not forever. Oskar Kokoschka was still alive when this book was planned, but he did not reach one hundred. The last of the quantum physicists, Paul Dirac, died in 1985 at eighty. Martha Graham survived until 1991, but modern dance is older than her company.

Another premise of this book is that history can still be written: history being defined in that rudimentarily whiggish way as the story of how we got the things we value, the things that are currently important to us. But how is that value decided? Because of what Modernism has achieved we can no longer be blithe in defining or deciding the importance of things. Nevertheless, impossible though it may be to back it up philosophically, it is still possible to make such a claim and to hope for the best. And why not be bold? What we value may well be the discovery of new truth and new beauty. This book, at any rate, is a collection of such discoveries. If it must therefore read as an elegy for Modernism, there is no one to blame except perhaps Minerva's famous owl of wisdom who, according to one downcast historian, took flight only at dusk when the day's chaos was over and understanding could at last begin.

In consequence, yet another premise of this book is that we really can define Modernism, and that in fact we can define it a good deal less loosely than we can something like liberalism. To make that definition, we will have to cut Modernism loose from a populous entourage. Modernism is not, to take a few examples: industrialism, capitalism, Marxism, or the Enlightenment. All but one of those is from the nineteenth century (one is from the eighteenth), and they all make hash of the painstaking task of periodization. What Cyril Black and the economic historians have called "modernization" is not the same as Modernism, and their use of "modern," almost the equivalent of "industrialized," refers to the results of a process that began in England at the end of the eighteenth century.[20] It is a usage closely related to the phrase "Modern History,"

the historian's term of art for what begins with the rebirth of cities in the fourteenth century and continues today. Many German culture critics, following Jürgen Habermas, insist on a "modern" era that begins with the Age of Enlightenment, but this too is a confusing retronym that probably better represents the stumbling blocks of German historiography than a stage in Western culture.

Some time after her bones were found in the cave of Cro-Magnon in 1879, *Homo sapiens sapiens* came to be called "Modern Man," but this is yet another meaning of the word. Cro-Magnon is the type specimen for us only because our species has shown no biologically definable change since the Upper Paleolithic. Embedded in this usage is the idea that the word "modern" must never refer to things that are no longer with us. The tendency to insist on this meaning is what makes the term "postmodern" so jokily contentious. Similarly, the use of the word "Modernism" to refer to an episode in cultural history implies the assumption of up-to-dateness. In fact, it should not have to. If the changes in the way we think and in the ways we make science, philosophies, and art should come to be seen as fundamental, we should be ready to name a new -ism and relegate Modernism, as some already have, to a dead and superseded past.

For such an enterprise we need our history, for how can we assess any change as fundamental without comparisons? What then does Modernism mean in this century and in cultural terms? Why does "Modernism" not mean, for example, the movement in the Catholic Church condemned by Pope Pius X in 1907? Because that "Modernism" attempted to revise theology with nineteenth-century science. Why does "Modernism" not mean a school of Spanish poets and critics called "Modernismo" in the 1880s, or one that German and Scandinavian speakers called "Modernismus" only slightly later? The reason must be that the international "Modernism," when it appeared, had a considerably different content. The "Modernismo" of José Martí, Rubén Darío, and their group would have been called by the French "Parnassian," a decidedly pre-Modernist style, or "symbolist," which chronologically just precedes Modernism and is often opposed to it. The most Modernist thing about "Modernismo" may be the fact that it originated not in Spain but in the Americas, and that Martí, a Cuban, and Darío, a Nicaraguan, had both learned some prosody from Walt Whitman.[21] The "Modernisme" popular among writers in Spain's step-province of Catalonia from about 1890 to 1910 was also under some influence from Whitman, though it took most of its cues from Wagnerites and francophone symbolists.[22] The German term "Modernismus," on the other hand, was first applied in the 1880s mainly to plays, the prose "problem" plays of Ibsen and of successors like August Strindberg, Gerhart Hauptmann, Léon Hennique, and Frank Wedekind.[23] Here modernism meant roughly the same thing as

"naturalism"—that is, theatrical or slice-of-life realism, rough surfaces, sexual indiscretion, and true crime. As an aesthetic in theater and fiction it fit in well with the nineteenth century's new allegiance to science and technology, and it certainly fits with the economist's "modernization," but this puts it in the old century rather than this one.[24] Symbolism better accords with the Modernism we have come to mean, for symbolism was characterized by an idealist reaction against naturalism and a parallel reaction against science. The reaction was so strong in France that the first name applied to the group was *Décadence*.

Symbolism is also a more useful term than most for the cultural historian, since it was adopted not only by playwrights and novelists but also by poets and painters; but it is fundamentally an aesthetic, too narrow to provide a core for Modernism. Unless it is stretched to include some Freudian psychologists, it describes no scientists at all. Such deepening divisions between the "disciplines"have made it difficult for academics in one of them to feel competent to write about others; as a result, a full history of Modernism, including all the arts and sciences, has never before been written.[25] Successors of Louis Untermeyer's old biographical dictionary exist, but they all use the order we call alphabetical.[26] What seems to be needed is a set of centrally located ideas, informing more than one discipline, that can together be termed Modernist retroactively if necessary but without serious anachronism.

Ideas like this are usually philosophical, and indeed, in the history of culture it is philosophy that is usually first to arrive in new intellectual worlds. Historians of philosophy, however, have not yet agreed on what is Modernist, nor do they seem at all anxious to do so. In general, Pragmatism, Phenomenology, and Logical Positivism are all Modern, but Monism, Materialism, and Idealism are not. Positivism may be, depending on whether we believe its early nineteenth-century inventor, Auguste Comte, or its last great practitioners, Ernst Mach and his disciples.

For similar reasons, other terms fail to satisfy the requirements of comprehensiveness. Because Modernism has been so long-lasting it makes no sense to identify it with the *fin-de-siècle*. Because it has been international, it makes no sense to identify it with what are in essence reactions to it, like Ezra Pound's fascism. Because it has been so multidisciplinary, calling it *Jugendstil* or art nouveau or Bauhaus is merely identifying a part with the whole.

Modernism is, moreover, not merely what the architects say it is, pointing to the likes of Louis Sullivan, Mies van der Rohe, and the International Style. If primacy of function over decoration (or worse, the prevalence of reinforced concrete) is to be its essence, then we can do nothing with the word in literature or even painting. The literary equivalent of unadorned functionalism would have to be "naturalism," but naturalism's unadorned description, based on purely empirical theories of

knowledge, disappeared from literature with Zola and Conrad long before the Bauhaus came to our house, and even before it came to Dessau.

Architectural Modernism has been defined, almost from the first, by its relation to the industrial modernization of materials and the economic modernization of production. This is not confusing to begin with, because so much in the word "modern" has its origins in the heroic materialism of the late nineteenth century. Modernism, however, is something different. Except in architecture, Modernists got started precisely by rejecting that heroic materialism of the nineteenth century and much more, including positivism, scientific determinism, the idea of progress, and the moral faith that went with it. From an aesthetic (as opposed to a historical) point of view, modern architecture may have just begun.[27]

History, however, must deal with temporal coincidence, even if it makes other things a little messy. The influence of structural steel on Sullivan, like that of standard time on Joyce, of the telephone on Proust, of the bicycle on Boccioni, or of electric streetlights on Delaunay, is real and not to be denied. The powered safety elevator, first presented to the public at the New York Crystal Palace Exhibition in 1854, suggested the thought experiment that led Einstein to rewrite Newton's laws. It is hard to explain how Einstein could have imagined the equivalence of gravity and inertia in 1907 and come up with the general theory of relativity without an elevator to imagine himself in. As for the special theory of relativity, it was an answer to a question raised by the creation of standard time in the 1880s, and by the wireless telegraph of 1900. The telephone, a gadget first shown off at the 1876 Philadelphia Centennial, changed the idea of dialogue for Twain and Strindberg, and possibly for Joyce. Generalized "modernity" is not the subject of this book. In fact there is good reason to wonder if "modernity" means anything at all beyond a change in the pace of change. But there can be no question that there are changes in the way people think and in the way their cultures work that can be considered one by one, that many of the changes depend on each other, and that many of them together can be called "Modernism."

Where Modernism began may have more to do, as we shall see, with a couple of mathematicians in Germany and a cabaret in Paris than with novels and buildings. Its intellectual origins lie in an often profound rethinking of the whole mind set of the nineteenth century, the world view that originally gave rise to speed, industry, world markets, and the newly aggressive tone of the word "modern." The nineteenth century's collection of assumptions fit so smoothly together that even now there are many who cannot see how to insert a blade between them.

Smoothness, in fact, was one of the ruling metaphors of the age. Nineteenth-century minds disagreed about almost everything except how much they disliked hard edges. Between one thing and another, whether

on the canvas of an academic painter or in the natural and social worlds, there was always a *sfumato,* a transition. Marx, Hegel, and Darwin agreed that change was, if not regular, at least smooth. The tidal wave of dialectic, the *Aufhebung* (elevation) of Being, the evolutionary origin of a species, was a spectacular show, but it was neither catastrophic nor unpredictable. It was more like the forbiddingly complex but entirely harmonic development of a Brahms symphony. And its tempo, like that of a classical ballet, was *legato.* The reader of novels, mimicking the omniscient narrator, could assess something called "development of character" over hundreds of pages that mimicked real time. Even in physics it began to seem, especially after the full influence of James Clerk Maxwell was felt toward the end of the century, that there were no particles in the world, only waves and fields, that everything shaded into everything else. An observer, that "objective observer" with whom so many nineteenth-century thinkers were so intimately acquainted, could watch such phenomena unfold, with an Olympian assurance that they would not overwhelm him.

This set of assumptions about continuous change was unaffected by politics or religion. It was neither right nor left, neither French nor German, neither Christian nor unchristian. It said nothing about what changes might occur—only about the shape of the transition. It legitimized a vocabulary used by nearly every thinker, comprising words like "stasis," "development," "*Auf-* and *Erhebung,*" "transition," "*Entwicklung,*" "evolution" (suitably less staccato than "revolution"), "*Untergang,*" and decay. The assumption of continuity was what philosophers call ontological, a decision about the nature of being that goes beyond (or below) any particular thing. And ontological continuity was so strikingly characteristic of the thought of the nineteenth century in the West that even now it is hard to find an exception. As Charles Sanders Peirce, one of the true founders of Modernist thought, noticed in 1894, "If we survey the work of the nineteenth century, it is surprising to find to what extent its successes have been due to the recognition of the idea of Continuity, and its failures to the want of such recognition."[28]

We shall begin with the few areas in the thought of the nineteenth century where the recognition of continuity was wanting, and show how they began to relate to each other in the later and newer corners of the late nineteenth-century intellectual world. The earliest atoms in common thought were the atoms of the chemical elements, proposed by John Dalton in 1808 to help explain why the weights of substances in chemical combination tended to be in simple whole-number ratios. We shall see, first, how the atomism of chemistry came to find echoes in other sciences, in the arts, and in philosophy. We shall see how the atomic assumption in mechanics drove first scientists and then all sorts of thinkers to the conclusion that statistical and probabilistic descriptions of reality were

truer than the old deterministic dynamics. We shall see how, beginning not in science but in literature and painting, Modern thought gave up the stubborn old belief that things could be seen "steadily and whole" from some privileged viewpoint at a particular moment—or, in other words, why it is that Cézanne painted Mont Sainte-Victoire from nearly every available perspective except its summit. We shall see also how, at the same time, the belief in objectivity crumbled so that phenomenology and solipsism began to take over not only philosophy, but literature, politics, psychology, and at last even physics. Finally, we shall see, I hope, how looking at oneself not only produces the sensation of consciousness, but sets an axe to the roots of formal logic and ends by making it impossible to know even the simplest things that the nineteenth century took for granted. Each of these—statistics, multiple perspective, subjectivity, and self-reference—alone and together can be shown to have devolved from the collapse of ontological continuity.[29] Severally, they lead to the nonlogical, nonobjective, and essentially causeless mental universe in which (with the exception of a few historians) we all now live.

One might expect an academic to do things of that sort on a high level of abstraction, but my academy is a secondary school. The reader will recognize no sense of obligation here to narrow the field of research or to restrict what is written about Modernists to things that have never been published before. The usual academic taboos against supplying a lay reader with a general history are not in effect, and this book uses biographical and chronicle forms, rather than those ritually adopted for launching a new salvo in one or another specialists' debate. These biographical profiles of the great first Modernists are focused on their most ground-breaking works, linked and arranged so that those works appear in chronological order. In this way there can always be one or more stories to tell: the story of how a particular poem or theorem was made, the story of one individual life or another, and the story of early Modernism as a whole.

Telling stories is not only, I hope, the more appealing way of arguing a case, but also by far the most Modern. Philosophers of the most contemporary dash now argue that there is no theory by which to judge truth—only more or less plausible stories. Given a collage of remarkable events, chronologically arranged, the reader will hopefully not mind the narrator's occasional insistence on consequence and coincidence among them, his assumption of near-omniscience, or his observance of the tradition that there be always one damned thing after another.[30] The French critic Remy de Gourmont already understood this attitude a year before the twentieth century began, when he wrote that "ideas, like the atoms of Epicurus, hook up to each other as best they can, whatever the risk of confrontations, shocks and accidents."[31] The story of Modernism begins with German mathematicians and moves on to physicists in Vienna, Ber-

lin, Bern, and Copenhagen; a French painter; French and American poets; a histologist and a politician from Spain; a Viennese psychologist; a Dutch biologist; English, German, and Italian logicians; a New York filmmaker; a Parisian painter from Spain; a Swedish playwright; musicians from Vienna, New Orleans, and St. Petersburg (Russia); a novelist from Dublin; and a Muscovite painter in Munich. In addition to these central characters there were architects from Glasgow and Vienna, dancers from California and New Jersey, African nationalists from Georgia and the Caribbean, and writers of fiction from a dozen countries, including New Zealand and Norway. Finding each other was not hard for them, in the age of the telephone and the railroad and the heyday of the World's Fair. This book tries to bring them together by pausing occasionally for a sudden confluence of minds in Vienna, Paris, or St. Louis, Missouri. Sometimes, as at the Upton Inn in *Tom Jones,* everyone was in the same place without ever meeting each other at all, while the emerging professions and disciplines ignored their cross-talk and fervently organized and subdivided themselves. More often, however, these geniuses did meet, conveniently or incongruously, deliberately or by the remotest chance, in person or in the educated minds of our own late twentieth-century culture. As the French say, "les grands esprits se rencontrent"; but if great minds have met in this century, it is because they have had no choice.

2 THE CENTURY ENDS IN VIENNA

MODERNISM'S TIME LOST

1899

My watch is turned backward
Never is what's past over for me
And I stand differently in time.
Whatever future I may reach
And whatever I grasp for the first time
Becomes for me the past.

—Karl Kraus, "Turn Back in Time"

Time was on the move. People not yet born in those
days will find it hard to believe, but even then time was
racing along like a cavalry camel, just like today. But
nobody knew where time was headed. And it was not
always clear what was up or down, what was going
forward or backward.

—Robert Musil, *The Man without Qualities*

In 1857, in Vienna, the headquarters city of the old world of Central Europe, the ancient walls that had kept out the Turks for so many centuries were ordered demolished and replaced by a great circular boulevard. Under the benign sponsorship of Franz Josef, who had been Emperor of Austria since 1848, feverish construction began that would in thirty-five years line the newly created Ringstrasse with a tiara of new public buildings flaunting every architectural style inherited from the glory days of Western civilization, from classical to Gothic to Flemish and Italian Renaissance. Nothing new of course, or Modern, for Vienna had never been the sort of city that looked to the future. In the 1890s it was the capital of the most Catholic country east of Spain, where once a year on Corpus Christi Day the Emperor appeared on foot leading the other classes, in order of rank, in procession to the cathedral. It was the capital of an empire of peasants where in some provinces thirty-three percent of the land might be owned by one or two percent of the population. It was the city of waltzes and whipped cream ("schlock," as they called it in dialect), where Metternich was still remembered fondly for having turned back the clock after Napoleon. When Baron Franz von Uchatius invented a motion picture projector in the 1850s, he used it to

teach ballistics and sold it to a local stage magician. When Siegfried Marcus drove Vienna's first automobile down the street in 1875, he got not a single order. When Viennese founded the world's first organized aviation institute in 1880, no one noticed; twenty years later, when Wilhelm Kress tried to fly a gasoline-powered airplane two years before Kitty Hawk, he crashed and was forgotten. Still later, Hermann Oberth's dissertation on space rockets was rejected by the city's university. As for Vienna's Emperor Franz Josef, he remained skeptical of telegraphs, telephones, typewriters, electric lights, and elevators well into the 1890s, and didn't ride in an automobile until England's Edward VII shamed him into it in 1908, his sixtieth year on the throne. Early in his reign, even railroads had been banned because they might bring on revolution, and his daughter-in-law Princess Stephanie had had to pay to have bathrooms constructed in his palace. The situation had not much changed for Austria since Napoleon had taken the title of Holy Roman Emperor away from Franz Josef's grandfather, prompting the latter to call his kingdom "a worm-eaten house. Take away part of it, and the rest might collapse."[1]

In such a city Modernism would find it impossible to thrive; but Vienna was indeed the kind of city where it could be born. Most of the preconditions were in place. Vienna was big, and getting bigger almost as fast as Chicago. Immigrants quadrupled its population between 1857 and 1910. Also like the other great cities where Modernism began— Paris, New York, London, Prague, Munich, Chicago, and Saint Petersburg—Vienna was rich, polyglot, and protean. Where Vienna differed from New York and Paris, however, was in its inability to rejoice in the new. What Ezra Pound (and Hugh Kenner) called "vortices" were always about to coalesce there, but Vienna foiled them all. The city was jammed with original minds, young men and women whose fathers had come from the empire's distant provinces to make their fortunes; but originality was never at home there. One by one all of the great Viennese Modernists ran into trouble in Vienna, from Sigmund Freud and Ludwig Boltzmann to Arnold Schoenberg, Arthur Schnitzler, Adolf Loos, Oskar Kokoschka, Erwin Schrödinger, and Ludwig Wittgenstein. Eventually almost all of them left. As one of them summed it up, "This Vienna possesses, in addition to other significant qualities, the extraordinary gift of banishing its most worthwhile talents, or of humiliating them."[2]

Immigrants did not stay. In time an Austrian provincial who had lived six years of his life as an artist in Vienna, surrounded by these founders of twentieth-century culture, would devote his life to wiping out everything they stood for.[3] And Hitler is only the deadliest example of the way, in Vienna, nineteenth-century culture kept muffling and misunderstanding twentieth-century ideas. Modernism was always there in Vienna, struggling to be born; but to find out what Modernism was not,

to understand what it replaced or reacted against, Vienna is the place to look.

In Vienna, even the Enlightenment was new. The orthodoxy of the nineteenth century, still fresh in old Vienna, was called Positivism. Some called it "modern," but it had been invented in the eighteenth century, and had already passed its prime in England, France, and northern Germany. Positivism, sometimes called "scientism," was a philosophical program, drawn up in the belief that the problems of philosophy were all soluble if only people could resist the temptation to be mystical. Ontology (what exists, if anything, and how?), epistemology (how do we know it?), and ethics (what should we do?) must all be predicated on "positive" knowledge of phenomena (mostly scientific) and keeping the ghosts out of one's machines. For positivists matter was what primarily existed, and only matter was capable of making or affecting mind. Positivists dismissed Immanuel Kant (who had thought there were things unknowable) and the romantics (who had thought they knew those things) as good minds sadly misled by enthusiasm. If the French inventor of positivism, Auguste Comte, had had an embarrassing decline into religious faith, and American positivists seemed strangely willing to think of religion as a measurable phenomenon, Austrian and German positivists felt an even greater obligation to keep their religions, if any, closeted away from thought. The best positivist thinker was a thrifty one. He or she would junk any concept that smelled of metaphysics, and any general term that was more than an appropriate name for a collection of measurable facts. As for facts, they could not be measurable unless they themselves were names of material things or things that happened to material things. Concepts were only conveniences, not real; and the positivist must be ready to dispense with any idea that proved ill-fitted to the ways of matter—even if there were no new idea available to fill the breach.

At the University of Vienna sat the dean of Europe's philosophical positivists, professor of philosophy and history of science, Ernst Mach. In 1895, to set a seal on his positivism at the height of a twenty-year career, Mach had been called from Prague University to Vienna to replace Franz Brentano, who had insisted so long and so unfashionably that human perception was purposeful, and who was now retiring to Italy. Mach had taken his doctorate in mathematical physics in Vienna in 1861, but his only real excursion into ordinary physics was in 1872 when he perfected a stop-motion camera with which he photographed bullets in flight and discovered the supersonic shock wave. Shock waves are still measured by the so-called Mach Numbers he came up with in 1884; but Mach's original idea had been to measure not the flight of the bullet, but the bang, and he filed his most celebrated experiment not under avionics but acoustics. He wanted to know how the senses worked and how they in-

formed the mind. Time and space themselves, he thought, might be no more than mental events. His defining moment of revelation had been the spectacle of a canted world from the window of a railroad car as it rounded a steeply banked curve. In 1864, as a new professor at Graz, he had begun his lifetime scientific program of reducing psychology to measurable and understandable behaviors by applying physics to it, and a year later was publishing his analysis of color vision. As a professor at Prague in the 1870s, he had spent some time spinning in the dark in a seat he had designed that could rotate on three axes while suspended inside a box, and he later became known for blindfolding acquaintances and swinging them in the cars of Vienna's huge Prater ferris wheel to investigate the human sense of balance. In 1874 he submitted a paper to a Vienna medical journal on how the semicircular canals of the inner ear could tell people whether they were right side up or not, beating the fashionable Viennese G. P., Josef Breuer, to the discovery by only eight days. By 1875, Mach had decided that all psychological events were behaviors that could be broken down into irreducible bits or "atoms" of action. In 1886 he wrote that there was no such thing as an ego or a consciousness, only a flow of sensations. Perhaps his greatest work, published when he was still at Prague in 1883, was a book called *The Science of Mechanics,* in which he had tried to prove that physics was less a description of reality than a convenience, a quick and efficient way for humans to store useful knowledge about how material nature usually behaved. Proudly he announced that he could dispense entirely with several old physics terms, including "ether" and "atom," and could prove that the rest of them were not really a part of nature. Even numbers like 1, 2, and 3, he suggested, were non-Platonic products of practical solutions arrived at by thousands of human beings over centuries of evolution. This was positivism in spades; but in fact most people didn't quite get it, because if you truly grasped what Mach was saying, you would have to throw out the atoms of good old-fashioned materialism as adolescent fancy, and reduce the cold, hard facts so beloved of positivists to the bare sensations of warmth, pressure, time, and space.[4]

Thinking Vienna thought of Mach as forbidding but salutary. You need to read him, Michele Besso told his friend Einstein, who was going for his degree at the Polytechnic in Zurich. In Vienna, Mach's questioning of the autonomous, conscious self moved Richard Wahle to write *On the Mechanism of Mental Life,* and Mach's public lectures in 1897 on bullet photography attracted dreamers like the poet Hugo von Hofmannsthal, anxious for edification and shaken by rumors that this sort of science might dissolve the poets' world. But Mach's reign in the capital was brief. In 1898 the investigator of the sense of motion was felled by a stroke in a railway car, and three years later, his right side incurably paralyzed, he resigned. He lived until 1916, railing in painful retirement against those

benighted physicists, among them Ludwig Boltzmann, the new occupant of his chair of Philosophy in Vienna, who continued to maintain that atoms were real. If Mach had been able to understand his own influence, the pain might well have been greater, because in case after case, what was truly Modern in his Central European successors began in their encounters with his reductionism and their attempts to embrace it or shake it off. It happened to writers like Hofmannsthal and his friend Hermann Bahr, to philosophers of knowledge Alexius Meinong and Christian von Ehrenfels, to philosophers of language Fritz Mauthner, Wahle, and Otto Stöhr, and to Vladimir Ulyanov, better known as Lenin. It even happened to some extent to thinkers of Mach's own generation like Ludwig Boltzmann and the Americans, Charles Sanders Peirce and William James. As we shall see, it happened to Einstein, Husserl, Musil, Heisenberg, and Wittgenstein. It was as if Mach had laid out a positivism so critically sharp that it was able to make one doubt the existence of phenomena, and thus cut to pieces its own foundations.

But Ernst Mach was only the most sophisticated Viennese positivist, and perhaps the most prominent. There were many others left over outside Vienna in the rest of Central Europe, including the polymathic Hermann von Helmholtz, who had first asserted that the amount of energy in the universe could never be increased or decreased; Emil DuBois-Reymond, who had said in 1872 that there were only four questions humans would not eventually be able to answer; or Ernst Haeckel. Haeckel, Darwin's German bulldog, thought DuBois-Reymond was a pessimist and that evolution would prove a one-time materialist answer to the entire *World-Riddle*, as his 1899 best seller was called.[5]

In Vienna's academies, the positivists controlled the board. In the Law School of Vienna University, Austrian Supreme Court Justice Hans Kelsen was laying the foundations of legal positivism, teaching law not as it should be but as it was, consistent in its own logic and free of history, politics, sociology, or ideas of right and wrong. On the economics faculty there was a whole school of positivists who took philosophy too much for granted to write about it and instead spent their days providing proofs that economics was either a real science or else not worth studying. More scientific than Marx, in time Carl Menger, Friedrich von Wieser, Eugen von Böhm-Bawerk, Joseph Schumpeter, Ludwig von Mises, Friedrich von Hayek, and even Otto Bauer the socialist would come to be called the "Vienna School." (Today their intellectual descendants are called the "Chicago School.") The Vienna School had done much more than argue the value of free markets. Economics was in the area Comte had called "social science," where positivism dictated that if any generalizations were to be found at all, they would have to be strictly descriptive, rather than metaphysical or ethical. Thus it was Menger who announced, in 1871, the bemusing discovery that any value a commodity had was not

put into it by producers, but put onto it by demanders. This meant that since your demand for the last unit of a good you acquired was less than your demand for the first unit, the value of the last unit must be smaller; for example, that your first glass of water had more value—or utility—than your last. This was *Grenznutz,* marginal utility, the first of the many marginal concepts that now define microeconomics. Menger's successor, von Wieser, gave it its name, and pointed out how markets in mixed economies might improve the distribution of the total utility. He also invented "opportunity cost," or the value of roads not taken. Von Wieser's brother-in-law, Böhm-Bawerk, and his student, Schumpeter, never noticed that units of "utility" were not exactly positive knowledge, but they did discover many of the ways by which markets call forth goods. Only William Jevons in England and Léon Walras in Switzerland had the same kind of formative effect on what is today taught as the foundations of microeconomics.

In the University of Vienna's Medical School, which many said was the best in the world, medical positivism took the form of "therapeutic nihilism." Exemplified by Joseph Skoda, therapeutic nihilism was the belief that cures were so hard to explain materially that getting a diagnosis correct, or corrected, was often more important than saving the patient. Professor-Doktor Carl von Rokitansky had become famous at the Medical School for performing some 85,000 autopsies. Theodor Meynert, professor of mental diseases, spent his time trying to localize psychological functions in the continuous network of which, he taught, the brain was constituted. Though his book was called *Psychiatrie,* he spent very little time with actual lunatics because he didn't think any therapy would work. Richard von Krafft-Ebing, who would eventually fill Meynert's chair, was only a bit more concerned about treatment. He had begun assembling his definitive catalogues of mental disease in 1879, seven years before his famous tome on sexual deviations, *Psychopathia Sexualis.* Professor Josef Hirschl had proved in 1895 that the lunacy and degenerated brain tissue of some older patients like Hans Makart, Vienna's favorite painter (and Nietzsche too, raving and still alive) was the result of the tertiary action of the syphilis infection, but here especially there was not much one could do. Professor Moriz Kaposi, one of those who had made Vienna the world center of dermatology,[6] had given his name to a skin cancer with no cure. Johann Schnitzler was an up-and-coming laryngologist who could tell you anything you wanted to know about your throat except, often, how to make it better. Hermann Nothnagel did like to visit patients, but often what he did for them was decide what was wrong with them based on their blood pressure. Of almost godlike stature was Ernst Wilhelm von Brücke, who had learned materialism in Berlin as a friend and fellow-student of Helmholtz himself. DuBois-Reymond, another friend, remembered that, as young students, he and

Brücke had "pledged a solemn oath to put in power this truth: No other forces than the common physical chemical ones are active within the organism."[7]

Brücke had dominated the Medical School since the 1850s with his insistence that all disease was physico-chemical, and that even psychiatry was an extension of his specialty, physiology. In spare moments Brücke painted, so he wrote two books to show that art, too, was entirely explicable through material science. He did do cures occasionally, as did the surgeon Theodor Billroth, who wrote about music and was among the first to resection a stomach or remove a larynx. When the professors themselves wanted cures, they often went to a man who wasn't on the faculty at all—Brücke's old student, Josef Breuer, who could treat anyone from Brahms to Brentano. Meanwhile, ambitious young medical students flocked to their lectures and laboratories, among them Doctor Schnitzler's charming son Arthur, an amateur author, and Sigmund Freud, a bright young man out of rural Moravia who aspired to become a research biologist.

In the Physics department of the University of Vienna, other young scientists had wholeheartedly adopted positivism because it reinforced materialism, and materialism promised to physics precisely the exalted status that in idealist societies had historically been held by religion. In their laboratories Josef Stefan, Josef Loschmidt, and Ludwig Boltzmann worked to pin down an airtight mathematical description of the cosmos the ancient atheists had reduced to atoms and movement in the void. Their heroes were Ludwig Büchner, who had written one of their bibles, *Kraft und Stoff* (Energy and matter) in the 1850s; and Karl Vogt, who had announced in a debate with a Christian physiologist that "all is matter and nothing but matter."

Stefan had long been professor of physics at the University when in 1865 Loschmidt, then a Vienna secondary school teacher, found Loschmidt's Number (non-Viennese call it Avogadro's Number), 2.7×10^{19}, for the number of atoms or molecules in a cubic centimeter of gas. The next year Stefan gave Loschmidt a university appointment and brought him into the laboratory. In 1867 Stefan brought in Boltzmann, and together they all worked on the mathematics of these colossal assemblages of randomly active particles. Their constant motion was no less than the energy of the universe, which, as Helmholtz had said, could neither be created nor destroyed. In 1893 Loschmidt retired and Stefan died, leaving Viennese physics to Boltzmann; and when Loschmidt, too, died in 1895, it was Boltzmann who immortalized his old lab partner with the words: "Now Loschmidt's body is disintegrated into atoms. Just how many we can calculate on the basis of principles established by him. I have the number written on the blackboard." It was 10^{25}, one followed by twenty-five zeros.[8] In their universe, there was nothing but matter in motion.

Of course, the most radical materialists were Marxists, but Marxists thought positivists had missed the point, which was to change the world rather than to understand it. Karl Marx himself had died in exile in 1883, but Engels was still around in the 1890s, editing his old friend's books and writing against positivists like Eugen Dühring, polemics that would have a considerable effect on Lenin. There were indeed a few Marxists in Austria, including the great labor-socialist leader Viktor Adler; but in the 1880s and 1890s most of them were also Wagnerians. Viennese partisans of Richard Wagner, composer of the opera tetralogy *The Ring of the Nibelungs,* met in the Café Griensteidl, on the Michaelerplatz not far from Franz Josef's Hofburg Palace. That Austrians could comfortably combine Marx and Wagner, the tone-deaf materialist and the musical genius of romantic idealism, the internationalist who claimed the worker had no country and the anti-Semite who asserted the Germanness of art, is one measure of how far they still were from Modernism.

It was indeed startling how romantic and dated the celebrities of Austrian culture were in the 1890s. Most of Vienna's many theaters played nothing but operetta. The Court Opera produced bonbons. The Court Theater would play nothing that mentioned revolution. Army officers in Napoleonic-era uniforms strutted in the streets. All but a handful of the aristocracy took their cues from Franz Josef and the court. In 1900, when Prince Franz Ferdinand was unconventional enough to marry a commoner named Sophie Chotek, the Emperor forbade their children to inherit. Prince Otto was openly critical of his brother's marriage, though he was not entirely conventional himself. Otto wore a leather nose to hide what syphilis had done to the original, and he had more than once appeared wearing nothing but a sword and an officer's cap in the lobby of the posh Hotel Sacher. Vienna's favorite painter was Hans Makart, who designed the city's costume parades and whose paintings were the canvas equivalent of Court Opera and the Hotel Sacher's famous torte. Vienna's favorite "new" composer was Anton Bruckner, who would rather rewrite a symphony than offend an audience. When Gustav Mahler took over as conductor of the Court Opera in 1897, Viennese were willing—barely— to countenance a tightening of standards in the orchestra and the introduction of Wagner into the repertory, but they would not sit still for the mighty symphonies Mahler composed on his summer vacations. These works had a thoroughly nineteenth-century coherence, but too much dissonance—even irony—to be premiered in Vienna.

It was the same with poetry. The roses that Stefan George had had delivered to Hugo von Hofmannsthal in his Vienna high school classroom announced a great poet, but not, as yet, a modern one. Hofmannsthal's verse was delicate and lyrical, fitted beautifully to meter and rhyme, and perfectly adapted to the anti-positivist mood that was roiling in Vienna's literature in the 1890s. For Hofmannsthal, the prospect of discontinuity

was fearful and depressing, especially discontinuity in the self. In 1897, Hofmannsthal had attended Mach's lectures. Five years later, in the persona of the Elizabethan nobleman Lord Chandos, Hofmannsthal would write a letter to Francis Bacon complaining that his ego, his soul, was flying to pieces under the impact of positivist analysis.[9] To Hofmannsthal, Bacon stood for Mach and all the other Baconians in the modern world, rational analysts and dissectors of experience. Hofmannsthal was afraid they would make poetry impossible, and so was his fellow author, Hermann Bahr.[10]

Hermann Bahr (1863–1934), "The Man of the Day After Tomorrow," was the critic and local impresario of the new literature. Like Bruckner and Hitler, Bahr was from the provincial town of Linz. After a beginning as one of Vienna's Wagnerites, he had gone to Paris, returning to Vienna in 1889 with news of Oscar Wilde, the new "naturalist" theater, Mallarmé, and the symbolist movement. By 1891, at the Café Griensteidl, Bahr had found his new generation and dubbed it *Jungwien* (young Vienna). Hofmannsthal, the high-school genius, was a charter member. The others included a sketch-writer with wooden shoes and no fixed address who called himself Peter Altenberg; Schnitzler, now a young dermatologist with comedies in his pocket; Felix Salten, not yet the author of *Bambi;* and another aspiring novelist named Richard Beer-Hofmann. Later Stefan Zweig became a regular. Snorting in the wings was Karl Kraus, the great satirist, who renamed the Griensteidl the Café Megalomania, and memorialized it in the unforgettable essay, "Literature Demolished," when it was torn down in 1896. The Viennese are snoring, not sleeping, Bahr told the journalist Bertha Zuckerkandl, and "I am going to wake them up."[11] Despite his optimism, they continued to sleep, accepting from *Jungwien* only what it offered in schlock and sentimentalism while judiciously ignoring its experiments with epistemology and tone, which would eventually lead to the first stream-of-consciousness narrative, the first underminings of meaning, and the first ironic deconstructions of "reality" in the German language.

In art, positivism seemed to correspond to realism, and in German, realism meant Modernism. Realism was in fact the first artistic trend to be given the name of *Modernismus.*[12] The goal proclaimed by *Modernismus* was to present life as it was, low life as well as high, sexual as well as romantic. This worked better in fiction than it did in painting, and best of all in theater, the era's most public art. Here again, Vienna was late and half-hearted. The age of Ibsen had begun in the 1880s, and Gerhart Hauptmann had already bid to become the Ibsen of Germany by putting a birth on the stage in *Before Sunrise* in 1889, but Hauptmann's plays were banned in Vienna as immoral. In Vienna there was not only no realism, there were practically no straight plays. Half a dozen theaters founded to produce them ended up putting on operettas by Strauss,

Suppé, and Franz Léhar. The state Burgtheater thought it a step forward when they added "well-made plays" by Scribe and Sardou to the repertory. In 1891 there had been an Ibsen week in Vienna's theaters, but it had had no sequel. After years of application by successful but not very Modernist playwrights Arthur Schnitzler and Hugo von Hofmannsthal, the Burgtheater agreed to put on a month's run of several of their plays in 1899; but that was all, and the Burgtheater never produced Hofmannsthal again. Vienna waited until 1905 for Strindberg, when the Lustspieltheater gave his play *Comrades* its world premiere in October, but *Comrades* is Strindberg at his least Modern. If anything smelling of *Modernismus* got onto an Austrian stage, Austria would soon squeeze it off. The plays Arthur Schnitzler managed to have produced where he lived were the ones that could get past the censors in the guise of sentimental comedies.

The source of much that was new in theater in the twentieth century was late nineteenth-century cabaret, where the dream play, the chamber drama, audience participation, discontinuity of scenes, and separation of dramatic elements were pioneered. The new ironic monologue in poetry, stream-of-consciousness in fiction, *Sprechstimme* (speak-singing) in music—even some ideas of modern art, architecture, and film—can be traced back to the avant-garde vaudeville that flourished despite censorship in places like the Chat Noir in Paris; but Vienna was a city of cafés like the Griensteidl and the Central. It had no Black Cats, no cabarets as yet.[13] Peter Altenberg had to cast his monologues as columns or *feuilletons* in the Vienna press, and Karl Kraus, after a brief career on the stage, was left to found his own newsletter and print his own satires. To the north, in Munich, the playwright Frank Wedekind would help found a cabaret called the Elf Scharfrichter (Eleven executioners), and other Modernists founded the Überbrettl in Berlin; but that was not until the new century, 1901. Vienna's first cabaret, the Nachtlicht, did not open until 1906, and the Fledermaus, its most celebrated, not until 1907.

Modernismus in painting was also banned in Vienna. In the most famous case in 1901, Gustav Klimt's allegories of Medicine and Justice were rejected by their intended patron, the University of Vienna, on the grounds that, seen from below, pale, bony, expiative nudes, flaunting buttocks and pubic hair as they floated in allegorical space, did not properly reflect the work of the medical faculty or the law school. Klimt and some of his fellow artists had earlier dropped out of the Vienna Academy of Fine Arts and set up their own exhibition society, the Sezession. But this artists' rebellion was years behind the ones in Paris, and was late even in the German world. Sezession in Vienna had come five years after the first Sezessions of German-speaking artists in Munich and Berlin. Young Berlin artists had invited the pioneer expressionist painter Edvard Munch to put on a one-man show in 1892, and had started the Berlin Sezession

when their shocked seniors had gone back on the deal. When the same thing had happened to a Munch show in Vienna in 1889, no Sezession had resulted. In France, where rebellion was an old story, rebels rarely flagged; but Klimt, the leader of Vienna's rebel artists, seemed to have shot his bolt in the University panels, and would confine himself for the rest of his life to mosaic-like portraits and nudes that were less challenging, lusher, and more romantic. He could paint, using flat Modernist color planes, something we might call modern feeling or sensibility, but never again would he paint "modern life" the way he had in 1901. That was left to his protégés: Oskar Kokoschka, a fearsome young man whose work, signed "O. K.," was thrown out of the Sezession exhibit itself for what amounts to sexual frankness; and Egon Schiele, who was later jailed for the same offense. In 1907, Kokoschka would pause in his painting career to write a one-act play that has become one of the two founding works of Modernist theater, but when it was finally produced at the Vienna Art Show in 1909, the police had to be called to contain the disturbance and would have stopped the performance if it had not been over before they could act.

Austria's incipient Moderns were sunk even more completely by neglect than they were by hostility. Stefan Zweig's memoir describes how Vienna's middle- and upper-class women were shoehorned into clothing whose complexity only advertised their vulnerability and helplessness.[14] Vienna, like other great and soon to be Modernist cities, had a smart and vocal women's movement. Adelheid Popp led the first women's strike there. Bertha Pappenheim ("Anna O."), once she had recovered from Breuer's psychoanalysis, became one of the pioneers of social work. Rosa Mayreder and Auguste Fickert founded the Austrian Women's Union (Allgemeiner österreichischer Frauenverein) in 1893, but they made little headway, and were all but forgotten a century later. Austria simply could not decide, as northern Europe sometimes did, how to deal publicly with sex and gender. Then there was that extraordinary baroness, Bertha von Suttner, whose campaign for the elimination of war first gained notoriety in 1889 with the publication of her autobiographical novel, *Die Waffen Nieder! Eine Lebensgeschichte* (Lay down your arms: A life story). She had gone on to found the Austrian Peace Society and to edit and publish an antiwar periodical, where she predicted in 1899 what we now call total war. Von Suttner was awarded the fifth Nobel Peace Prize in 1905, becoming the second woman (after Marie Curie) to win a Nobel; but the journal had folded six years before, and the Austrian reaction to her prize seems to have been embarrassment. Von Suttner died on June 21, 1914, one week after the Austrian Archduke Franz Ferdinand was assassinated at Sarajevo.

In 1891, von Suttner's husband, the Baron, had founded the Vienna branch of the *Verein zur Abwehr des Antisemitismus* (Union for defense

against anti-Semitism), which included Johann Strauss; but there was no way for the Baron or his Union to alter the ugly truth that anti-Semitism was becoming mainstream in Austria, and perhaps even the wave of the future. The word itself had been coined there in 1880 by a right-wing writer named Wilhelm Marr, who was looking for a way to distinguish the new biological and cultural separatism from the old religious variety. Three years later a professor at the Austrian university of Graz, Ludwig Gumplowicz, had a book in print called *The Race War,* whose arguments for the inevitability of ethnic separatism would be carried on by Gumplowicz's disciple, Gustav Ratzenhofer.[15] By 1894, Modernism's Viennese champion, Hermann Bahr, had published the first international inquiry about anti-Semitism, and his fellow journalist, Theodor Herzl, had founded Zionism, anti-Semitism's antithesis, after trying and failing to assimilate as a citizen of Vienna. Vienna's favorite politician, "Handsome Karl" Lueger, would eventually win eight elections for mayor on the Christian Social Party platform, composed of roughly equal parts anti-Semitism and municipal socialism. (Franz Josef, who approved of neither -ism, would refuse to allow Lueger to take office until after his fifth election.) A Viennese industrialist's son who led the German Nationalist Party, Georg von Schönerer, would be banned from his seat in the imperial Parliament for repeatedly urging his followers to violence and destruction of property. A proper English racist, Houston Stewart Chamberlain would make his home in Vienna for twenty years and would publish his magnum opus there in German. The Viennese disciple "Jörg" Lanz "von Liebenfels" of a Viennese crank named Guido von List would recast cultural Germanness as a racist ideology, turning the Aryan language family into a race and resurrecting the swastika. The twentieth century owes these things to Vienna.

Yet anti-Semitism and the nationalism of "blood and soil" were neither Modernist nor modern. In effect they were a resurgence of the romanticism of the earliest decades of the nineteenth century—perhaps an example of what Freud was later to call a "return of the repressed." The free-form romantic nostalgia that found poetic expression in Hofmannsthal and drew him later into the movement to found the Salzburg Festival found political expression in Theodor Herzl, as it did no less in Marr, Liebenfels, and Schönerer. In his now celebrated book on *Fin-De-Siècle Vienna,* the historian Carl Schorske noticed that "all three"—Lueger of the Christian Socials, Schönerer of the Nationalists, and Theodor Herzl of the Zionists—"connected 'forward' and 'backward,' memory and hope, in their ideologies. . . ."[16] What they were seeking was a way to combat the growing discontinuity in art, the fragmentation of professions and of knowledge itself, a subrational continuity that could overcome the ethical effects of competitive capitalism and liberal individualism. What they came up with was ethnic solidarity and separatism, of which the

opposition to Modernism has made use throughout the twentieth century and turned into a new form of discontinuity.

Perhaps Austria was destined to be the cradle of this sort of anti-Modernism because it was so unusually vulnerable to it. It was a decrepit multicultural empire, economically only a little more modernized than its neighbors Russia and Turkey. Politically it was balkanized, deliberately divided ethnically so as to be easier to rule from the center; indeed the Balkans themselves were part of it, balkanized centuries ago by the Turkish Empire and further divided by the Austrian. The reactionary nationalism of the Empire's Serbs, Croats, Muslims, and Slovenes was responsible no less than imperialism for starting the century's first Great War. The reactionary nationalism of its Italians, and the nationalist reaction of its Germans, had a lot to do with bringing on the Second. As we look back on it with embarrassment from the end of the twentieth century, the Austro-Hungarian Empire's domestic politics look like little more than a series of unsuccessful attempts to shake it apart from within, its foreign policy little more than an extended effort to keep other nations from pulling it apart from without. The 1867 constitution essentially gave the Hungarian minority parity with Austro-Germans; but as soon as the novelty wore off, it was attacked on all sides by every other nationality in the Empire. It survived into the twentieth century only because "all nations in the empire hate the government—but they all hate each other, too, and with devoted and enthusiastic bitterness" even more than the Hungarians and the Germans.[17]

And so it was that as roads and railroads were built in Austria-Hungary all through the modernizing, industrializing, increasingly democratic nineteenth century, people cared not nearly so much about the roads as they did about what language the government would write the road signs in.

The issues came to a head spectacularly in 1897, the year of the artists' Sezession and Freud's most critical dreams, when the Emperor signed an act of the Austro-Hungarian parliament. This act guaranteed for the first time the right of all men, rich and poor, to vote, and set aside seats for working-class representatives in both the parliament and the Vienna city council. Its author was Franz Josef's new prime minister, a Polish count named Kasimir Badeni. Elections held in March under the new franchise yielded a chamber with more than twenty-five different parties, most of them ethnic, the rest ideological, and a majority in Vienna for Karl Lueger's Christian Social Party. Badeni proceeded to patch together a coalition, decreeing in April that all government employees in what is now the Czech Republic be required to speak and write in Czech as well as they did in German and that all lawsuits there be tried in the plaintiff's language. The result was pandemonium. Indignant Austro-Germans called for demonstrations all over the Empire, and so did the defensive

but jubilant Czechs. By autumn, several other minorities had mounted pro-Badeni demonstrations, while Austro-German nationalists had raised the German flag in western Bohemia and killed a man in Graz. The chief of the Pan-German Party had wounded Badeni in a duel. It had been under these circumstances that Franz Josef finally agreed to let Karl Lueger take office as mayor of Vienna. Later in November, when crowds poured into the streets of the capital, Lueger thanked his emperor by calling on him to fire Badeni. The emperor did so, but not before some of the most memorable filibusters in the history of parliamentary government had convulsed the new parliament house on the Ringstrasse. There was a twelve-hour speech, and legislators shouted, whistled, blew a fireman's trumpet, and even threw inkstands at each other. Georg von Schönerer's party of German nationalists had forced the parliament to suspend its sessions for months by picking up their parliamentary chairs and throwing them at the multiculturalists. Mark Twain, who was in Vienna to give lecture readings, described as many of these absurdities as he could, deadpan, from a perch in the visitors' gallery; but when at last the chairman had been driven to order the arrest and expulsion of members, Twain's sense of the ridiculous left him. "And now," he wrote, "we see what history will be talking of five centuries hence: a uniformed and helmeted battalion of bronzed and stalwart men marching in double file down the floor of the house—a free parliament profaned by an invasion of brute force. . . . I think that in my lifetime I have not twice seen abiding history made before my eyes, but I know that I have seen it once."[18]

Hitler was eight years old in 1897. When he got to Vienna "Handsome Karl" Lueger, reelected in 1903 and 1909, was still mayor, and Hitler learned the practice of politics from him. He learned the tactics of street violence from Schönerer, and ideology and swastika-symbolism from List and Liebenfels. But Hitler was still in high school in Linz when the very first "National-Socialist German Workers Party" was founded in the Sudetenland by German-speaking wage-workers yearning for ethnic solidarity in a sea of Bohemian Czechs.

Nevertheless, for a few years on either side of 1900, when Hitler was only a student artist, and no masses had ever been told of Nietzsche, Vienna teetered on the edge, full of not-yet-discouraged youth and hope. The young composers who would shape twentieth-century music—Arnold Schoenberg, Anton Webern, and Alban Berg—were living and working in Vienna, and the man who held court at the Court Opera, Gustav Mahler, could reach out to encourage them. Young Franz Kafka could encounter Brentano's ideas and German Modernist theater in his native Prague and visit Vienna for more. Rainer Maria Rilke, perhaps the greatest of all twentieth-century poets in the German language, could leave his Prague childhood behind, meet Hofmannsthal in Vienna and launch a new life. Architect Otto Wagner, who had designed his first

Modernist building in 1882, could be commissioned by Karl Lueger's city government to design street railway stations more Modernist than anything in Louis Sullivan's Chicago. Wagner wrote that nothing could be beautiful that was not practical.[19] His disciple, Adolf Loos, who proclaimed that ornament was crime, could build a house opposite the site of the demolished Café Griensteidl with nothing on its façade but holes for the windows.

Edmund Husserl, born like Freud in rural Moravia, could come from the University of Berlin to the University of Vienna to learn philosophical psychology from Brentano (who believed that perceptions came into the mind through intention) and his successor Mach (who did not), thereby founding a new philosophical field: phenomenology. Other new philosophers conjuring the twentieth century out of Brentano and Mach included Alexius Meinong and Christian von Ehrenfels. Meinong thought intention could give a new reality to mental events, and founded the first experimental psychology laboratory in Austria. Ehrenfels was recoining the word *Gestalt* to refer to the formal bundles by which the mind receives perceptions. Sigmund Freud, also a former student of Brentano's psychology, was joining a medical specialty—psychiatry—full of Austrian pioneers, including Moritz Benedikt, Obersteiner, Krafft-Ebing, and Julius Wagner-Jauregg. Young physicists strolled the Ringstrasse, too, brought to the University of Vienna by the work of Mach and Ludwig Boltzmann: Paul Ehrenfest, who would codify the consequences of turning matter into molecular statistics; Erwin Schrödinger, who would discover the quantum wave equation for subatomic particles; and Lise Meitner, Boltzmann's last student, who would in her Berlin laboratory in 1938 become the first to realize that the nucleus of the uranium atom had been split.

When Ludwig Boltzmann briefly took over as Mach's successor in the philosophy chair and delivered a blast against the meaningless romantic abstractions of Schopenhauer, he was being more than a positivist. The new drive to set limits to discourse and restrict words to what they could truthfully say had begun with Viennese writers like Fritz Mauthner and Otto Stöhr. When the sharpest of all Viennese satirists, Karl Kraus, began editing *Die Fackel* (The torch) on April Fool's Day 1899, the assault on schlock and obfuscation in language began in earnest. In time Kraus made Vienna so synonymous with pretense that the world would forget that the attack on Viennese hypocrisy had been led by Viennese. Ludwig Wittgenstein did not forget, however, writing in the first of his great philosophy texts in 1915 that when we get to things we cannot talk about, we must learn to stop talking. In 1904, at the Linz scientific high school, a fifteen-year-old Wittgenstein was studying hard and looking forward to learning honest subjects like physics and engineering with Boltzmann and Mach. Young Robert Musil, the Proust of Austria, had nursed the same

ambitions at the Vienna Military Science high school and the Brunn Technical Institute not long before. (So had Einstein in Zurich, though he was no Viennese.) In 1904 Musil was planning his first novel and a doctoral thesis on Mach. In 1904 Mauthner had just published the last volume of his masterwork on honest language. And in 1904 one of Wittgenstein's classmates in the Linz high school—Adolf Hitler—flunked out.

Hitler was a misfit, but he was also a romantic, and romanticism was worse than outdated; it could survive only by overcoming the new. Romantics who idealized social solidarity could not be reconciled to the temporal, spatial, and social fragmentation of urban communities. Romantics like Hofmannsthal and his friends, who idealized the self in its wholeness and singleness and power, knew that positivists like Mach were irresistibly dismantling it. Romantic lovers of nature had found their love undermined by the realist and naturalist demand for faithful and scientific reproduction of nature. Decadents had tried, unsuccessfully, to contradict nature, and symbolists had tried to break through to an ultimate reality by a method of ellipsis. But there was no going back on the positivist demand for analysis. When Modernism emerges it is seen to be a culture of analysis, a culture at home with bits and pieces and proud of contradictions. What Modernists have not accepted is the nineteenth-century assumption that we can analyze nature, whether it be physical, biological, or human, without analyzing the means we use to become aware of it: language, symbols, and what we persist in calling "mind." For Modernists the constant dialogue between perceiver and perceived has no predictable outcome and may alter either or both of them beyond recognition. This is because both sides of the dialogue have parts, irreducible, separable parts with nothing in between, for which many different configurations may be possible.

It is on this point that what we might call the mind of Vienna refused to be changed, and that young Viennese Modernists like Loos, Kokoschka, Wittgenstein, and Schoenberg eventually felt obliged to leave. In this distempered part, one may also argue, Vienna's twentieth-century political tragedy originated. Hermann Bahr, for example, stayed in Vienna but he changed to fit it, circling back from the incipient Modernism of his Young Vienna group to positivism and romantic pan-Germanism, and ending his life as a Catholic monarchist, author of guides to Old Salzburg and biographies of its bishop.

Vienna had insisted on continuity for a very long time. Bernard Bolzano, the first mathematician to try to define the meaning of discontinuous curves and functions, had been underestimated by Vienna way back in the 1820s, and there were others. A promising physics student, who had dropped out of the University of Olmütz to become an Augustinian monk in the 1840s, reenrolled at the University of Vienna a decade later. There, in May, 1856, he failed his teacher qualification exam for the sec-

ond time and went home to the Bohemian provincial city of Brno (Brünn) to serve the rest of his monastic life as a substitute high school science teacher and amateur botanist. The exam he failed had come after several years of study at the University of Vienna in physics and philosophy, including Professor Andreas von Ettingshausen's course in the new science of statistics. Ten years after his failed exam, the monk, Gregor Mendel, published the results of a seven-year botanical experiment on garden peas, in which he proved that traits like wrinkled seed-coats are not inherited in any continuous way, but either all at once, or not at all. Applying the methods of statistics, he had found simple whole-number ratios among the offspring bearing the traits—the telltale signature of the atoms of heredity that would later be called the genes. Mendel sent the publication out to every major botanist in the German-speaking world. Only one replied, advising him to try a different plant the next time. In this, the first appearance of modern "digital" thinking in biology, Austrian culture had blinked again.

> "We have as much talent as other nations," [said an Austrian citizen to Mark Twain] resignedly, and without bitterness, "but for the sake of the general good of the country we are discouraged from making it overconspicuous; and not only discouraged, but tactfully and skillfully prevented from doing it. . . . Consequently we have no renowned men. . . . We can say today what no other nation of first importance in the family of Christian civilizations can say: that there exists no Austrian who has made an enduring name for himself which is familiar all around the globe." [20]

Such Austrians did indeed exist in 1897, like Freud, who went to see Twain perform; but the world, like Twain, did not know their names yet. As Austrian Modernists achieved renown, more and more simply ceased to be Austrian. The war came, and Austria-Hungary itself simply ceased to exist, falling into ethnic pieces. Few cities have this option, and so, instead of falling apart, Vienna shrank in 1918 like a pricked balloon.

3 GEORG CANTOR, RICHARD DEDEKIND, AND GOTTLOB FREGE

WHAT IS A NUMBER

1872–1883

> I will not go so far as to say that to construct a history of thought without profound study of the mathematical ideas of successive epochs is like omitting Hamlet from the play that is named after him. That would be claiming too much. But it is certainly analogous to cutting out the part of Ophelia. The simile is singularly exact. For Ophelia is quite essential to the play, she is charming—and a little mad.
>
> —Alfred North Whitehead, "Mathematics as an Element in the History of Thought"

> The question "What is a number?" is one which has been often asked, but has only been correctly answered in our own time. The answer was given by Frege in 1884, in his *Grundlagen der Arithmetik.*
>
> —Bertrand Russell, *Introduction to Mathematical Philosophy*

According to one of the great mathematicians of the early twentieth century, "The 'real' mathematics of the 'real' mathematicians . . . is almost wholly 'useless.'"[1] In fact, it only seems useless to those who, like Hardy, allowed themselves to be convinced that the paradigm of usefulness is the broad back, the cancer cure, or the machine. Gottlob Frege, Georg Cantor, and Richard Dedekind were pure mathematicians who built no machines; but they did provide a means, laying the foundations of a new way of thinking in the West. If there is any utility to Modernism, Dedekind did something profoundly useful. The great event of his quiet life came in the year he wrote his first letter to a fellow mathematician named George Cantor, and soon after published a mathematical definition of irrational numbers now known as the "Dedekind Cut." Separating forever the digital from the continuous, at least in arithmetic, Dedekind became the West's first Modernist in 1872.

Everyone who has heard of Modernism has heard of Picasso. Most
have heard of Joyce. But who has heard of Dedekind? Only mathemati-

cians, the least likely-looking of those who aspire to change the world by using their minds. The public doesn't know what mathematicians are doing, and mathematicians are just as happy it doesn't, for they are as genuinely unworldly as artists claim to be. To find an ivory tower in the late 1860s one would not have to go much further than the mathematics faculty in one of the bucolic university towns of central Germany—Heidelberg, Halle, Jena, or tiny Göttingen—a world limited to mathematicians, their spouses, students, and a few professors of the sciences, lubricated by rustic vacations and lager beer. At the height of this age of steam, other professors could be known beyond the town, some to all Germany. Chemists were respected as the makers of explosives. A steely aristocracy of engineers was sallying forth from the new "Polytechnics" of the Western world to build Suez Canals and Brooklyn Bridges. Economists and even historians had found the ears of the powerful. At one time philosophers, especially German philosophers, had been thought to be more unworldly even than mathematicians; but after the Prussians crushed the Austrians in the Seven Weeks War in 1866, Europe had begun to take a different view of the colleagues of Nietzsche and Schopenhauer.

But mathematicians? Even the waving flags and marching legions of Bismarck's Second Reich had left them out. Their problems were abstract—so ethereal and remote that the practical bourgeois of the Victorian period dismissed them as useless. Everyone knew, in a vague sort of way, that mathematics was essential to engineers, but this did not make a bridge-builder like John Roebling seem any less godlike or independent, nor did it help explain to ordinary educated people why the taciturn son of a bricklayer, Karl Friedrich Gauss, was somehow so important that his small university town of Göttingen had become the world capital of mathematics. Actually this question rarely came up, because only real mathematicians knew about Gauss and Göttingen. It could hardly be relevant to a conversation about building railroads or empires in Africa that there were now three different plane geometries or that the fundamental theorem of calculus remained without an airtight proof. Mathematicians did not invent. Instead, they insisted, they discovered things as Plato had—searching in a complicated alternate universe for elegant and beautiful relationships among objects that could not be said to exist outside the mind.

Without their knowledge, however, the mathematicians of 1870s Germany were about to change the world. As a clutch of Victorian professors, avuncular, ascetic, and a little disheveled, they were gathering unawares around the cradle of an infant Briar Rose that would one day be christened Modernism. It is true they would build no bombs or skyscrapers, but as they focused in on an ancient and exasperating problem of pure mathematics, they would become the first creative thinkers in any field to look at the world in a fully twentieth-century manner.

In a way it was simply the nature of the problem. In part it was the nature of the mathematicians. The problem had been posed in terms that the solution itself would blow away, the terms of nineteenth-century positivism, which in mathematics had been taken to mean "rigor". Positivists were suspicious of mathematics because the objects of mathematical study were not material. If mathematicians were to legitimate themselves, they would have to define without a loophole, prove beyond a shadow of a doubt, and consider only objects that were reducible, ultimately to number.

But they were at least as creative as artists. The first one off the mark, Georg Cantor of Halle, was the sort of person who could run with anything. The son of immigrants (by no means poor ones) from St. Petersburg, Russia, Cantor was energetic, bearded, and forbidding. He was known to lose all decorum in claiming he had been cut out of a professorship in the capital, Berlin, because of the envy and censoriousness of the German mathematical establishment. That did not prevent him from taking a leading role in the founding of the Deutsche Mathematiker-Vereinigung, the first German professional mathematicians' association, and the organizing of the first international mathematical congresses in 1897 and 1900. In 1884 came the first of his descents into manic-depressive psychosis. A switch to philosophy made it easier for Cantor to get published but did nothing for his therapy, and in 1918 he died in an asylum, the Nervenklinik in the university town of Halle where he had lived his entire professional life.

Cantor's fellow explorer, the bespectacled and goateed Herr Professor Richard Dedekind (he had shortened it from Julius Wilhelm Richard Dedekind), was older and more proper, very much in the German academic tradition that made an associate professor in a university bureaucratically equal to a colonel in the Prussian army, and hard not to salute. He had been born in 1831, and arrived at Göttingen in time to become one of old Gauss's last students and a pallbearer at his funeral. Dedekind then taught for a while in Switzerland, returned to his home town, and, unmarried, spent the rest of his life teaching in the college in Brunswick where both his father and his grandfather had been professors. Until 1872, the year he contacted Cantor, Dedekind's scholarly career had largely consisted of reconstructing and publishing the legacy of his other great teacher, Robert Lejeune-Dirichlet (he had by then reached Supplements 10 and 11) on differentiable functions and trigonometric series. To this he had allowed himself to add some original work of his own, often in the form of notes and prefaces. In fact the most original idea Dedekind had had so far had been rattling around in his head, unpublished, for nearly fourteen years. It had struck him when he was twenty-seven years old, on November 24, 1858, a month or two into teaching the required

introductory calculus course he had been assigned at one of the great new European engineering schools, the Technische Hochschule of Zurich.

In 1872 the forty-one-year-old Dedekind finally published his idea in a pamphlet called *Stetigkeit und irrationale Zahlen* (Continuity and irrational numbers). It didn't look like much, twenty-odd pages of good German prose, containing a minimum of equations and the simplest of proofs. Today it is universally admitted to be the closest that exact thinking has come to defining something mathematicians call the "numerical continuum." It was based, Dedekind wrote, on an idea so simple that "my readers will be very much disappointed in learning that by this commonplace remark the secret of continuity is to be revealed."

The modern reader, especially one untrained in mathematics, will not find the idea so simple. To understand it she will have to back up a bit, to the ancient Greeks in fact, for the problem of continuity is one of the oldest in mathematics, a sort of figured bass that can be heard beneath the work of all the great Western mathematicians from Pythagoras to Isaac Newton. And perhaps it is fitting that cultural Modernism should begin with a revival of the oldest conundrum in mathematics.

Continuity becomes a problem when you try to figure out what it means to be "between." In the sixth century B.C., Pythagoras already knew that the whole numbers (1,2,3, . . .) were not all there was. Like any American fifth- or sixth-grader, he knew that fractions—one whole number divided by another—lay between them. Fractions were a little messy, but they were quite real and reasonable; and for a long time Pythagoras believed that every conceivable quantity could be expressed as a ratio (*ratio* in Latin is reason) of two of the available infinity of whole numbers—as for example 3/5 is the ratio of three and five or 119/120 is the ratio of one hundred and nineteen and one hundred and twenty. Then one day, one of Pythagoras's disciples pointed out to him that the diagonal of a square whose side was one unit could not be expressed that way. The two whole numbers needed to give the diagonal as their ratio simply did not exist; it was true and could be proved. Instead, one had to use the square root of 2, which is in this sense irrational and never "comes out even." Since they were all on a boat at the time, Pythagoras threw his student overboard and swore everyone else in his class to secrecy.

The truth, however, did not drown, and Greek mathematics was brought face to face with a brand new question. If it were true that irrational numbers lay hidden between the whole numbers and the rational fractions, how many parts did a line have? How often could one subdivide a line, and how many numbers were there really between zero and one?

A later Greek, Zeno of Elea, and his school promptly turned the new knowledge into a series of paradoxes which even today lie at the root of

physics. The most famous still comes up in school. Called "Achilles and the Tortoise," it goes like this: if the tortoise gets a head start on Achilles, Achilles can never catch him because first he will have to halve the distance between himself and the tortoise, then halve what remains, and so on. Since there is no mathematical end to these halvings, Achilles will never come to the end of his task. Soon after pointing this out, Zeno was answered by Leucippus and Democritos, who said in effect that Achilles would catch the tortoise because one cannot subdivide something forever, certainly not something material like a race course. After a certain amount of subdividing, said Democritos, one reaches the "indivisibles" for which he used the Greek word *atomoi* "atoms." Epicurus, who came later, even seems to have made the startling suggestion that time itself has atoms of this sort. In other words, Achilles can catch the tortoise because during his atoms of time he can do more than halve the distance while the tortoise can do much less than double it.

Aristotle tried to sum up and settle the debate in Book 6 of his *Physics,* but neither he nor the legions of his commentators during the Middle Ages could find their way out of the paradoxes.[2] Continuous things, like motion, would seem to require an infinity of parts, but how can an infinity of parts make up a finite whole? What is an "instant" of time, or an "atom" of matter, if it is not nothing? Is the universe continuous or not? Is a line continuous? Is a trajectory? An interval? If it is, how can you count the parts? If parts have no size, how can even an infinity of them make a whole? By the time the seventeenth century rolled around, Newton and Leibniz had created a whole new branch of mathematics to deal with the problems of continuity. It was called the calculus.

The calculus Newton devised in the seventeenth century came in handy in deriving Kepler's three laws of planetary motion from Newton's own law of gravitation, and vice versa. The physical problem that founded calculus was how to find a speed when the speed keeps changing. Speeds are given in miles per hour, meters per second, or any distance divided by a time interval. We say somewhat blithely that the speed is such and such at a particular time, but in fact we cannot really find such an "instantaneous" velocity unless we can find a way to divide by zero, since zero is what an "instantaneous" time interval is. Newton and his rival Leibniz had to assume the existence of "infinitesimal" instants and intervals, marvelous creatures that manage in some way to exist though they have no duration and no length. For their "infinitesimal calculus" to work there had to be an infinite number of these infinitesimals; but if instants have some duration, however small, and intervals some minimum length—that is, if they are atoms—then lining up an infinite number of them creates an infinite sum—eternal times or endless lengths. If, on the other hand, these instants and intervals don't exist—if they are true zeros—then no matter how many of them you may assemble, finite or

infinite, they still add up to nothing. Then the time is zero, and zero is what you must divide your distance by; but if you do it, the speed you get will be infinite. The philosopher Berkeley wrote that Newton's "fluxions" and Leibniz's "differentials" had to be either religious or ridiculous.

Calculus obviously raises the same dilemma Zeno had proposed, once you look beyond the veil of dazzling mathematical algorithms. Accept continuity and you get infinities; reject infinities and you are left with discontinuity. The reaction? It is part of the lore of mathematics that everyone ignored the impossibilities, and that this enabled the mathematical giants of the eighteenth and early nineteenth centuries—D'Alembert, Euler, Laplace, Lagrange, Lacroix, Fourier, and Monge—to be so prodigiously creative. Lovely theorems proliferated, sometimes without any proofs at all. In 1781 the philosopher Immanuel Kant decided, in his *Critique of Pure Reason,* that mathematics was essentially intuitive, or a priori, a science that came not from the structure of the world but from the way humans think. This view, in turn, was embraced by even the least mathematical of the romantic generation of the early 1800s.

The infinitesimal tangle would have been ignored even longer, but attitudes changed in the century of rails and heavy machinery. The new wave was the metaphor of evolution and development, and the new hardnosed attitude toward truth was called "positivism." For its inventor, Auguste Comte, and his followers in the 1850s, experimental science became the model for the acquisition of all knowledge. Positivists saw the experimenter, or observer, as "objective"—separate from the material reality he or she observed. Any knowledge you had that looked as if it did not depend on material reality was suspect as "theological" or "metaphysical" until you could show that relationship with matter. All the sciences, furthermore, were related up and down a ladder of increasing rigor. The simplest and most objective was the "mechanics of a material point" (that is, physics), and this lay at the root of all the others. Such talk brought back materialism, the ancient Epicurean philosophy that asserts there is nothing in the world but atoms of matter and motion.

Most science did well under positivism. Biology thrived on this attitude. Anthropology stood theology on its head and took the occasion to be born. Even psychology moved smoothly into the new era by setting aside its lovely general theories of consciousness, admitting that the mind was made of matter, and experimenting with how the senses worked. But mathematics could not entirely respond to the positivist program. When Comte himself had called mathematics the first science and a model of the method to be used in all the others, he neglected to point out the material reality it investigated. Only nonmathematicians could maintain that Euclidean geometry was derived from or confirmed by experiments on the real world. Perhaps if one thought of it as a branch of psychology, a byproduct of perception implied by the shape of the cornea or the abil-

ity to distinguish one note from another . . . but mathematicians, idealists since Plato, bridled at this.

Instead the mathematicians responded to positivism by looking carefully at their two methods of establishing truth: intuition and proof. Intuition could not be "positivized," except perhaps through psychology, but surely proof could. It would therefore be necessary to set the most rigorous standards for proof, and indeed to expel from mathematics everything that had not been positively proved, from Fermat's famous "last theorem" to the fundamental postulates of calculus. In the words of Newton (who by now had been somewhat ironically adopted by positivism as a saint), "Hypotheses non fingo" [I feign no hypotheses]. Moreover, if this were to be the program, then the leading scandal (as they called it) in mathematics was clearly the basic concept of the calculus: the derivative, or quotient of infinitesimals (dy/dx). No one at the beginning of the nineteenth century knew positively what the derivative was. It was not going to be easy to find out, either, especially in a period Hegel, Darwin, Marx, Maxwell, and even Tolstoy were to make into the triumphal era of continuous fields, continuous energy, continuous change, evolution, and development.

Much of nineteenth-century mathematics, then, took the form of a Victorian-sounding search for "rigor," particularly in that branch of mathematics called "analysis," or the study of the behavior of functions at its most general—what the calculus was now called after its centuries of imperial expansion. (An early attempt to pin down the philosophical work of our own twentieth century was a book called *The Age of Analysis,* meaning by "analysis" nothing more mathematical than the intellectual tendency to break things down into finite constituent parts; but the mathematical meaning of "analysis," and its effect on twentieth-century thought, makes for a truer title.)[3] At the frontiers of analysis, the continual discovery of bizarre, ambiguous, and even "pathological" functions was making Newton's elegant but intuitive calculus look more and more primitive. How, asked the Austrian Bernhard Bolzano (1781–1848) as early as 1834, could one differentiate (find a tangent or derivative to) a curve with a number of sharp bends, something like /\/\/\/\/\/\? How could one integrate (find the area under) a function where, for any value of the argument, X, the function, Y, was always either $+1$ or -1, but never the same for any two consecutive Xs? How could one be sure of what Fourier had asserted around 1811, that a function was completely represented by an infinite trigonometric series—or that it was represented by only one such series?

Answers eventually came from Augustin Cauchy, a contemporary of Comte's in France, and from Karl Weierstrass in Berlin. Weierstrass moved to the city's university from a high school faculty in 1858 when he was forty-three and became a name to be conjured with among

nineteenth-century mathematicians. He and his colleagues, Leopold Kronecker and Ernst Kummer, were credited with corralling the calculus after a century of creative abandon. The leader of a "Berlin School" that demanded absolute rigor in the definitions used in analysis, branded the so-called "infinitesimal" quantities unscientific and occult, and insisted (like Comte himself) that all of mathematics could be boiled down to arithmetic, Weierstrass became the saint of positivism in mathematics. Unable to claim the same "objectivity" as other scientists, the mathematical positivists at Berlin satisfied themselves by making their definitions and proofs as airtight as possible and by reducing the number of ideal (or undefined) objects needed to a minimum: whole numbers, for instance. In Kronecker's words: "God made the integers. All else is the work of man." In 1861 Weierstrass went Bolzano one better by finding a function with an infinite number of sharp bends that had no derivative at any point, but was continuous at every point.[4] In lectures given in the mid-1860s, Weierstrass claimed success in arithmetizing the concept of limit. It was not a value that a function "approached" as its variable(s) changed; it was a neighborhood of values whose difference from the value of the function remained smaller than an arbitrarily small number. At last, he thought, there was an answer to the question of what the derivative was. If he was right, he had made rigorous not only the analysis of trigonometric and other functions, but also its ancestor, the calculus. All around the Western world, from Baltimore to Turin, a phalanx of young professors of calculus began to close in on what they thought would be the mopping-up operations after a successful campaign.

Dedekind, you will recall, taught calculus. His 1858 idea, the Dedekind Cut, simply defines a continuous function or number field as one that can be "cut" by choosing one point or number anywhere such that all remaining points or numbers are either greater or smaller than it is. This idea, as Dedekind knew, was simple only in form, but in its consequences exceedingly deep—what mathematicians call "elegant."[5] With the Cut it was no longer necessary to examine numbers themselves to find out if they were "between" or "next to" other numbers.

Dedekind knew that ordinary numbers ("real numbers" to mathematicians) come in at least three varieties: whole or natural (2, 3, 119, etc.), rational (2/3, 118/119, etc.), and irrational, like $\sqrt{2}$. Irrationals were like droplets of fog among the numbers; seemingly everywhere but impossible to distinguish properly. Integers like 1 or 2 were consecutive all right, but their sequence wasn't continuous. There were rational fractions like 5/3 between them. Rational fractions were not continuous either; between any two of them, no matter how nearly equal, there were more numbers. These were, in fact, the irrationals. The irrationals might not even be consecutive. How many irrationals between 5/3 and 2? There seemed to be no limit. In fact there seemed to be no fewer real numbers between 1

and 2 than there were between 1 and 1,000. On a line, as the geometers define it, one could more easily understand why there should be no gaps and that point must succeed point without any "space" between. By extension, there ought to be no gaps among the real numbers.

It was Dedekind's insight that this difficulty by itself amounted to a definition of that grail of nineteenth-century metaphor, smooth change, which in mathematics was called "continuity." So, he wrote, if one could choose one and only one number, a, which divided all the others in the interval into two classes, A and B, such that all numbers in A were less than a, all in B were greater than a, while a itself could be assigned to either class, then the interval was continuous by definition. And A might have no maximum and B no minimum, in which case a would be an irrational number like $\sqrt{2}$. You didn't have to specify the number a to have a definition, either. In our example, as long as there are always one or more numbers between any two other numbers in the interval, then the interval (in our example, the interval between 1 and 2) is "continuous." As Aristotle had put it in yet another of his deceptively dull definitions, "That which a changing thing, if it changes continuously in a natural manner, naturally reaches before it reaches that to which it changes last, is 'between.'"[6] The real numbers are "continuous" because, given any two, regardless of how small the difference between them, there is always another "between." Dedekind had defined the numerical meaning not only of continuity but of the very concept of between.

The Dedekind Cut solved a host of problems and seemed vastly to advance the positivist program in the area of number theory; but new and even deeper problems arose from it almost immediately, and before long Dedekind himself was trying to solve them. Weierstrass had based calculus on number and Dedekind had discovered what numerical continuity meant. But what was a number anyway? Besides, if the class of all whole numbers was infinite, how could one be sure of the characteristics of "all" of them? And even if you grant that any number can be generated by arithmetical operations, or that most arithmetical operations can be reduced to some kind of addition, just what in the world is addition? These questions that only a mathematician might ask were the ultimate challenge to the positivist attitude. Consistent answers could banish metaphysics and Kantian intuition from the very groundwork of mathematics and, a fortiori, of science itself. This, in fact, is the enterprise in which Dedekind was joined by Cantor.

Georg Ferdinand Ludwig Philipp Cantor, born in 1845, was a member of the most materialist generation Europe had yet seen. Nevertheless, he turned out to be a poor positivist who believed not only in intuition but in God. A devout Lutheran, Cantor became convinced when he discovered infinite cardinal numbers that God had revealed them to him. Like Nietzsche he eventually went mad, but between 1872 and 1897 he

almost singlehandedly created the theory of sets and the arithmetic of infinite numbers, cabalistic giants of the mathematical imagination to which Cantor gave names based on the first letter, *aleph,* of the Hebrew alphabet. Cantor's first paper of 1872 reached Dedekind on March 20, as he was sending the last parts of *Stetigkeit und irrationale Zahlen* to the printer. "I find," he wrote, "on a hasty perusal, the axioms given in Section II of that paper, aside from the form of the presentation, agrees with what I designate in [my] section III as the essence of continuity."[7]

Cantor had been a student of Karl Weierstrass in Berlin until 1866. From him he had learned the "arithmetization of analysis," the centrality of number, and the rigorous requirements of proof that constituted Berlin mathematical positivism. Cantor never lost the contempt for infinitesimals he had learned in Berlin, calling them "nonsense . . . a cholera bacillus in mathematics"[8] long after he had discovered something far stranger—the "transfinite" numbers and the arithmetic of the infinitely large. Weierstrass had eliminated the "infinitesimal" changes and unspecifiable functional values on which calculus depended by defining them as restricted to an "interval" of real numbers (or a "domain" of points) whose bounds were "arbitrarily small". It was this new doctrine (since Weierstrass published very little) that Cantor explained to his colleague Heine, who then drew on it for his own paper, "The Elements of Function Theory."[9] Since the world of mathematics was (and still is) small, we are not surprised to find Dedekind "confirmed" in his decision to publish his *Continuity* by the appearance of Heine's paper.

The relationship of Cantor and Dedekind, begun in 1872, would end only with the death of Dedekind many years later. In the summer of 1874 they finally met, in Interlaken, Switzerland, where Cantor had gone on his honeymoon. To the Cantors, who were eventually to have four daughters and two sons, Dedekind remained a bachelor uncle, "taken care of" by his sister Julie, a novelist, in a then unremarkable Victorian arrangement. In 1899, Teubner's *Calendar for Mathematicians* reported that Dedekind had died on September 4. Dedekind responded by writing to the editors that they must have been exaggerating, that he had been having lunch that day with his "honored friend" Cantor and talking shop.[10] In fact Dedekind did not die until 1916, and Cantor a year later. In the course of their long friendship, their work was to convulse mathematics and even revolutionize philosophy.

The paper Cantor sent to Dedekind, titled "On the Consequences of a Theorem in the Theory of Trigonometric Series," did not seem that consequential. It set forth a way to relate the infinite trigonometric series for which Cantor had, in 1870, found a uniqueness theorem, to irrational numbers and to the totality of points in one of those Weierstrass intervals. It seemed to Cantor that there was not just one infinite set or space of points (*Punktmenge* or *Punktmannigfaltigkeit*) within which solutions

condensed, but several; indeed a hierarchy of ever greater infinities. More-over, each of them might be derived by the operation of a short algorithm from the one before, by simply constructing the set of all its (infinite) subsets. "Über die Ausdehnung eines Satzes der Lehre den trigono-metrischen Reihen" was published in 1872.[11] The vision of a ladder of infinities that produced this early paper guided almost all of Cantor's work until he died, and placed him at the center of the gathering storm of debate on the consistency of mathematics—a storm that is by no means over.

Dedekind had proved that irrationals existed, and he had shown how to find them in a dense set, like numbers or points on a line. Cantor went a lot further and discovered how to make sense of the idea of "set." Within a few years, Cantor's work had made the simple word "set" (sometimes "aggregate" or "collection" in English; *Menge, Mannigfaltig-keit, Vielheit,* or *Verbindung* in German; *ensemble* or *groupe* in French; and *aggregato* or *gruppo* in Italian) into the most advanced term in both mathematics and philosophy. The first step, in 1873, was the discovery that he could compare sets that were infinitely large. In fact, as Cantor explained in his November 29 letter to Dedekind, there was a reliable way to do this by actually counting the elements. On January 5, 1874, Cantor wrote that he had found a way to define "counting" rigorously, something the positivists had long hoped for, since, if their program were correct, the process of counting and a definition of the integers should be all that was needed to lay a rock solid foundation for all mathematics. The method, as published in *Crelle's Journal* no. 77, was absurdly simple, involving no more than repeatedly placing the elements in one set into "one-to-one correspondence" with those of another. In the case of the integers, it showed that each integer $(1, 2, 3, \ldots, n)$ could be paired with an even integer $(2, 4, 6, \ldots, n_1)$, thus proving that the set of all integers was equal in number to the set of all even numbers.

The next step took even Cantor and Dedekind by surprise. Amaz-ingly, it turned out that some infinite sets were larger than others. The infinite set of all real numbers in an interval was greater than the infinite set of all integers. Again the method was one-to-one correspondence, with the added trick (now called the "diagonal proof") of showing how new endless decimals could always be generated from the already infinite array of such decimals set up for correspondence. Now Cantor had two different "transfinite" cardinal numbers, and he proceeded to name them cabalistically, using the first letter of the Hebrew alphabet, *aleph,* with the subscript zero (or aleph-null) for the set of integers, and C for the set of all real numbers or points on a continuum. At this point he conceived the hope that haunted him all his life: that C would prove to be the "next larger" transfinite and identical to aleph-sub-one. This, however, was not to be. Instead, in 1877 came an unexpected and much more startling

result—Cantor's proof that the infinite number of points on a line segment is equal to the infinite number of points in a plane figure. "I see it, but I don't believe it!" he wrote to Dedekind on June 29; but it was true all the same.[12] Mathematical novices still feel this way about set theory.

As Cantor pursued and tried to domesticate his transfinite sets after 1872, mathematicians everywhere began to see that everything from functional analysis to the theory of real number limits depended on the protean notion of number itself, and that the idea of number might depend on the foundations of logic. Cantor's set theory seemed the only available tool for advancing the inquiry. Hermann Grassmann, Julius Baumann, Hermann Hankel, Eduard Heine, and H. C. R. Méray, who had touched on these ideas in publications before Cantor, were joined in the 1870s by Johannes Thomae, Oskar Schlömilch, Rudolf Lipschitz, the forgotten founder of German mathematical logic Ernst Schröder, and even Marx's foe, the philosopher Eugen Dühring.[13]

In the 1880s a flood began. Cantor's former professor, Leopold Kronecker, leader with Weierstrass of the Berlin school of numerical rigor, weighed in with a denunciation of most of the newer work. The great physicist Hermann von Helmholtz (also, it should be added, a leading experimental psychologist) contributed "Counting and Measuring" to the same 1887 volume in which Kronecker's summation appeared.[14] Among the younger mathematicians publishing on these issues were the Germans Freyer, Harnack, Pasch, Paul DuBois-Reymond, and Otto Stolz, the Frenchman Jules Tannery, the Italians Bettazzi, Pincherle, and Peano, the singular American genius Charles Sanders Peirce, and the mathematical historians H. Cohen, Paul Tannery, Julius Baumann, R. Reiff, and Joseph Bertrand.[15] By 1886, even Friedrich Nietzsche had heard the news, and characteristically made of it an argument for seeing the whole of logic and mathematics as a constricting fiction.

> [W]ithout accepting the fictions of logic, without measuring reality against the purely invented world of the unconditional and self-identical, without a constant falsification of the world by means of numbers, man could not live.[16]

And so the investigation of continuity pioneered by Cantor and Dedekind had brought mathematics in the 1880s face to face with the first and most fundamental of all its problems. A problem far older than continuity, but laid aside for centuries as either trivial or axiomatic, this was nothing more (or less) than the question of what numbers are. If it was true that one could rely on number to banish the paradoxes of continuity from analysis, then no one could postpone much longer this question of the nature of number, or those fundamental questions of logic that related to it. What was "counting," and was it really as simple as Cantor's 1874 paper had said it was? What was really meant by the tricky idea of "or-

dering" on which counting by one-to-one correspondence seemed to rely? Was it really as easy as Cantor had said to define or discover the cardinal number of an infinite set? With the implicit promise that whoever solved these problems would be instantly acknowledged as the greatest mathematician of the age, it is easy to understand why so many found the area suddenly irresistible.[17]

Dedekind went into it immediately. With some help from Cantor, he tackled the whole array of questions and was "able in the years 1872 to 1878 to commit to paper a first rough draft" of his second classic essay, *Was sind und was sollen die Zahlen* (The nature and meaning of numbers), finished in 1887.[18] It was nothing less than a proof of arithmetic derived from set theory. The truth of ordinary addition was proven in Paragraph 136, by the 105th Theorem, after preliminaries involving the definition of sets, of proper subsets, of set inclusion, of functions (which Dedekind called "transformations"), of "chains" [*Ketten*] (transformations that made elements of a set into other elements of the same set), of induction, and of the infinite. When it was published in 1888, mathematicians hailed it. Though long and difficult, it was a rigorous and seemingly successful attempt to prove that basic operations with numbers constituted positive knowledge in the mathematical sense—in other words, that third grade arithmetic set out from a complete collection of axioms and led to conclusions that could be proved and would not contradict each other.

By publishing in 1888, however, Dedekind missed his prize. Two other mathematicians had worked out better solutions. One was Gottlob Frege, who taught in an obscurity even greater than Dedekind's at Jena, upriver from Cantor's Halle, and had already published twice, in 1879 and 1884. The other was an Italian, Giuseppe Peano, who would publish later that same year (1888), and again in 1889.

Both began with logic itself, the purest and simplest rules of inference, on the grounds that if the foundation of all mathematics lay in arithmetic then the foundation of arithmetic must lie in logic. Of the two, Frege's was not only by far the earliest, but also the most elegant and the most obscure. He invented a logical notation for the *Begriffschrift* of 1879 that had never been used before; and no one but Frege ever used it again. It was so baffling that nearly everyone who ever learned from his work had to apologize somewhere for not having understood it sooner.

If Frege's work was difficult, Peano's was transparent. He had been born in 1858 during Italian unification, and as Professor of Mathematics in the royal capital of Turin, he was in the habit of reading everything remotely related to his field in six European languages and writing in four. He would spend the last twenty years of his life developing and promoting an Esperanto-like language he had invented himself. His biographer credits him personally with bringing down most of the old barriers

between Italian mathematics and the English-French-German mainstream. It is no wonder that Peano's books should sum up and simplify previous contributions by an American (Peirce), two Germans (Ernst Schröder and Hermann Grassmann), and three Englishmen (George Boole, William Jevons, and Hugh MacColl), or that his logical language should have prevailed in a world whose commonest symbol is still the word.[19]

Peano also went further, separating logic from arithmetic as Frege had done, while reducing his axioms to nine. The first two, by way of example, were: "One is a number" and "A = A if A is a number." In this way addition became a consequence of the definition of the "successor" of a number (that number plus one—in nonrigorous language). The continuum of real numbers came only nine sections later—a major abbreviation of Dedekind. Infinite classes Peano put at the very end, for he remained as wary as he was enthusiastic about Cantor's infinite sets. Like Cantor, he had come to the foundations of arithmetic via the arithmetization of analysis. He was another of those professors of calculus who had wondered about infinitesimals, limits, and continuity; and he knew how counterintuitive those infinite point-sets could be. Indeed, in 1890 he gave an equation for the first fractal, a curve or continuous line that filled a two-dimensional space, thus giving eye-rubbing evidence for Cantor's 1878 theorem of the equivalence of points on a line with points on a plane.[20] And in 1897, one of Peano's legion of brilliant students, Cesare Burali-Forti, discovered the first of the strange contradictions buried under Cantor's elegant set theory by asking how the "largest set" could be (as Cantor had conjectured) the "set of all sets." Such a set would be even larger if it included itself, but how could it include itself?

By common consent of mathematicians, historians, and even philosophers, however, Gottlob Frege has the honor of being the true begetter of modern mathematical logic. It is not so much that he was the first to answer in print the basic question of number raised by Cantor's discoveries; but that his answer proved in time to be the best. It was clear, it seemed quite unambiguous, it disposed of all its rivals, and it was deeply positivist in the precise sense that positivism had by then acquired in mathematics. In fact, Frege's logic, like Einstein's physics, could well be called the positivists' last throw—a final and heroic effort to establish the objectivity of the world and of the logic and mathematics we use to think about it. As Frege himself wrote in 1884:

> I understand objective to mean what is independent of our sensation, intuition and imagination, and of all construction of mental pictures out of memories of earlier sensations, but not what is independent of the reason, for what is independent of the reason? To answer that would be as much as . . . to wash the fur without wetting it.[21]

Frege had been born in 1848, four years after Cantor, and was, like him, a trained mathematician. His first and most fundamental work, the *Begriffschrift* of 1879, began, he said, with an effort to see "how far one could proceed in arithmetic by means of inferences alone [preventing] anything intuitive from penetrating . . . unnoticed." First came "an attempt to reduce the concept of ordering in a sequence to that of logical consequence so as to proceed from there to the concept of number" [22]— in other words, to found number on the underlying concepts of order and succession just as Dedekind and Peano would.

This Frege did by inventing the now standard function-argument form for logical statements (on analogy with analysis and algebra) together with what logicians still call the "quantification theory" of purely formal derivation. By Paragraph 23 he was deriving a general theory of sequences of values by the use of certain propositional functions implying what he called the "hereditary" property. These were not much different from what Dedekind had dubbed the *Kette,* or chain, and what Peano was to call the "successor" relation. Such an implication, or set of implications, is still held to be the only possible logical foundation for the natural numbers and for addition. Frege bravely projected a great future for it in his own preface:

> I am confident that my ideography can be successfully used wherever special value must be placed on the validity of proofs, as for example when the foundations of the differential and integral calculus are established. [23]

In other words, Frege's project had been from the beginning the same as Cantor's and Dedekind's: a solution to the problem of numerical continuity raised by the rigorization of analysis in the 1860s. It was the best solution, but no one took the trouble to learn his complicated new notation. Frege's insights would have to be rediscovered, the long way, by a whole succession of lesser minds than his.

In the *Grundlagen der Arithmetik* (Foundations of arithmetic), published in 1884, Frege tore apart all previous concepts of number going back to Euclid, including those of Newton and Leibniz, Hume, Mill, Grassmann, Lipschitz, Thomae, Hankel, Schröder, Lotze, Jevons, and Boole. [24] At last, using words rather than symbols this time, he set forth his definition of number: "the Number which belongs to the concept F is the extension of the concept 'equal to the concept F'." Bertrand Russell would later phrase it: "The number of a class [set] is the class of all those classes that are similar to it," so that numbers are "the bundles into which similarity collects classes." [25] Having defined number, Frege went on to define those most troublesome of all numbers: zero and one. He also took the opportunity to hail Cantor, from whom he may well have learned the one-to-one correspondence method of comparing the size of sets. With a positivism broader than Berlin's, Frege admitted Cantor's "transfinites"

without difficulty into his system. Indeed, as he wrote eight years later in a review of Cantor's *Mittheilungen zur Lehre vom Transfiniten* (Reports on the theory of transfinites):

> academic positivist skepticism . . . is the rock on which [mathematics] will founder. For the infinite will eventually refuse to be excluded from arithmetic, and yet it is irreconcilable with [finitist] epistemological direction.[26]

In *The Foundations of Arithmetic,* Frege faulted Cantor only for his "lack of precise definitions of following in the succession and of Number" and his appeal "to the rather mysterious 'inner intuition'"—the intuition of the psychology-mongers and philosophical idealists against whom the whole of the *Foundations* is a polemic.[27]

As the century drew to a close there was much hope that the absolute rigor of which so many had dreamed for so long would emerge from mathematics and give mathematics the privileged position among the liberal arts that it had claimed since Pythagoras. In 1893, Frege published the first volume of his third and most comprehensive book, *Grundgesetze der Arithmetik* (The basic laws of arithmetic).[28] Peano had begun to publish a series of propositions on the foundations of arithmetic in his new notation.[29] David Hilbert was preparing to take up the question at Göttingen. One of Weierstrass's most recent students, Privatdocent Edmund Husserl of Halle, had titled his doctoral dissertation *On the Concept of Number* in 1887 and followed it up with a *Habilitationschrift* in 1891 called the *Philosophy of Arithmetic.*[30] While working on them, Husserl had used Frege's *Foundations of Arithmetic,* and he duly sent the two books to Frege with a hopeful letter. Frege soon realized that these works answered the great question of number as if it were a question not of mathematics but of epistemology. Instead of postulating or defining a set, like Cantor and all his successors, Husserl asked how a set (his word was *Vielheit* "multiplicity") could come to be thought of in the first place. His answer was nothing more complicated than that multiplicities resulted as one became conscious of things together (*kollektive Verbindung* "collective combination").[31] A few paragraphs into his introduction, Husserl was able to give an exasperatingly simple answer to the problem of continuity that avoided mathematics entirely. The continuum of real numbers, he wrote, was simply not a multiplicity. It could not be made present to consciousness by a collective combination. Instead a different epistemological process called "continuous combination" or "combination by continuity" created a thing that was partless and therefore whole.[32] Frege did his best to compose a critical but polite reply to Husserl's letter; but after Husserl ignored his critique and went on to publish "Psychological Studies for Elementary Logic" in 1893, Frege lost patience. A few months later he let fly with a review that called *Philosophy of Arithmetic* a "devastation." Husserl's psychologization of the set concept, wrote Frege, was

likely to make mathematical objectivity—even logical objectivity—impossible.[33]

All this intense focus on the mathematical atoms of set-element and number around 1880 was, as we shall see, almost instantaneously reflected in new discontinuous portrayals of other realities: the atomistic statistical thermodynamics of Boltzmann and Gibbs, the stop-motion photography of Muybridge and Marey, the color-plane "cloisonnism" of Bernard and Gauguin, and the "divisionism" of Seurat and Signac. The beautiful continuities of the old calculus had been banished, it seemed, forever, to the same circle of exile as fields in physics, fluidity of motion, and the transitional browns of chiaroscuro in art. The digital had been born.

Perhaps in retrospect it is surprising how few of the mathematicians then realized that the paradoxes of continuity still lurked, like wolves, just beyond the circle of the new campfire, in the realm of sets whose elements were themselves sets, or sets of sets, and which might not be "countable," or even "well-ordered." Less surprising is the fact that it was philosophers and not mathematicians who located the wolves. Positivism had always assigned crucial philosophical importance to mathematics, and in fact philosophy and mathematics were not yet so divorced that a hard-working Victorian academic like Helmholtz or Cantor could not easily do both. The story of how Bertrand Russell and Ludwig Wittgenstein found the unhealable flaws in the very foundations of our logic, and how Edmund Husserl failed so badly that he had to invent a whole new epistemology, is now well known to beginning philosophers. Later chapters will retell it; but the story began with mathematics, with the strange question of Richard Dedekind and the definitions of number and arithmetic that followed it.

4 LUDWIG BOLTZMANN

STATISTICAL GASES, ENTROPY,

AND THE DIRECTION OF TIME

1872–1877

In 1872, the same year Dedekind published his *Continuity* and Cantor discovered his infinite sets, Ludwig Boltzmann founded Modern physics. There was nothing very Modern about his subject. Thermodynamics—the mechanical theory of heat—was the ultimate nineteenth-century field, basically a systematization of what the steam engine could teach you; but Boltzmann looked at it in a twentieth-century way, and became the first scientist to leave off dreaming of fields and commit himself to a universe founded on the averages and probabilities of material atoms.[1] In 1872, Boltzmann was living in the small university town of Graz, Austria, where since 1870 he had been teaching physics and mathematics in the professorship that Ernst Mach had vacated in 1867. Being a theoretical physicist and not a poet, the way he chose to open the new epoch was a long, comprehensive article, bristling with equations, in a specialized academic publication—precisely the form his fellow mathematicians and physicists had made standard in the past century for exhibiting something new. He gave it as a conference paper in Vienna, with the great materialist, Hermann von Helmholtz, in the audience to hear it. Later, he sent off a clean copy to the journal of the Scientific Academy of Vienna. On October 10, 1872 it was published in *Wiener Berichte* (Vienna reports) under the unassuming title, "Further studies on the equilibrium distribution of heat energy among gas molecules." We now call it the "H-Theorem" paper, and to a connoisseur of physics it is like Picasso's *Demoiselles d'Avignon* or Whitman's *Leaves of Grass*—the first step into a new world.[2]

The twentieth century in physics depends on three ways of looking at nature that were quite new when it began. First is the digitizing of matter and of energy, atoms and quanta, a digitizing that has left only a few forlorn "waves" rippling in its wake. Second are the probabilities and

averages that, given the suddenly unimaginable quantities of particles that result, now become necessary to explain how these particles give rise to the events we know—or even appear at all. Third and last is the newly complicated structure of the space or spaces required to comprehend and connect the particles. Each of the three great founders of twentieth-century theoretical physics worked on all three; but after a century, it has become clear that while the restructuring of space was mostly the creation of Einstein and the digitization of energy belongs to Planck, the probabilities and averages—stochastics and statistics—belong to Ludwig Boltzmann, the man from whom both Planck and Einstein learned to do modern physics. "In large measure, it was *his* contributions which made the work of Planck and Einstein possible. . . . *He was at the center of the change.*"[3]

Ludwig Boltzmann had been born on Mardi Gras night in 1844, thirty years after Karl Marx; but with the gimlet glare in his blue eyes, his miniature spectacles, his immoderately curly black hair, and his explosion of a beard he looked more like old Marx with every birthday. He was no socialist, but he was, like Marx, a thoroughly convinced materialist for whom the world was not much more than matter, a stage for the great struggle for existence. There was nothing occult about it; almost everyone could understand it, and for anyone who had a problem, there would be physicists like Boltzmann to explain. The Biedermeier Austria into which Boltzmann was born had no softening effect on this positivist philosophical outlook. It was not his mother, the Austrian Catholic in whose religion Ludwig was baptized, but his father, the Protestant Prussian-descended tax official, who had given him his hatred of mysticism and metaphysics. When he was about ten years old he had been put to studying the piano under no less a master than Anton Bruckner, then the Linz cathedral organist. Ludwig's mother, who had not been suitably awed, had reproached Bruckner for leaving his wet raincoat on the bed, and the lessons had ended.[4] Eventually Boltzmann had learned to play the piano, for he liked music very much; it was only late romantic music that irked him. As for the fashionable decadence of *fin-de-siècle* Vienna, Boltzmann despised it whenever he couldn't ignore it. Late in life he would find himself forced to read Schopenhauer because his scientific opponents insisted on quoting Schopenhauer, and because a series of improbabilities had landed him the job of teaching the philosophy course at the University of Vienna. So horrified was Boltzmann at what he found there that his outrage would shake out over the page, much as his beard must have done:

The result is, making use of Schopenhauer's [own] vocabulary: stupidity, silliness, stubborn thickheadedness, absurdity, idiocy, foolishness, confused nonsense, atrocious imbecility. I hope this dynamite charge is sufficient.[5]

Boltzmann did scare people sometimes, but not for long. He was entirely unselfconscious most of the time, and people still tell of the day he led a cow home after buying it at the Graz farmers' market. His humor was deep, chronic, and often at his own expense; indeed, his report on his teaching stint in California in 1905, "Journey of a German Professor to Eldorado," is, without major competition, one of the funniest things in the literature of science. He taught with such enthusiasm—and such orderliness—that his students adored him. Order, like materialism, was for Boltzmann the route to human freedom. He had, it is true, a passion for Schiller's poetry, but what he saw in Schiller was his commitment to liberty, not his mystical romanticism. Moreover, he did appreciate the avant garde. In a lecture of 1899, half-apologizing that he still stood for the old idea of atoms, he would extend a hand to the cultural revolutionaries he called "the secessionist movement" and wonder out loud whether almost everything else in art that he'd been told was new, from "impressionism, secessionism, plein-airism" to "music of the future," was not "already out of date" just as his atomism was in physics.[6] He was right, but revolutions often come through a rediscovery of the past.

Boltzmann had come to physics in 1863, going from first in his class at the Gymnasium in Linz straight into the Physics Department of the University of Vienna, founded only fourteen years before by Christian Doppler (of the Doppler Effect). It seemed the age of hard facts, but the universe still hung together. Filling the luminiferous ether without a break was that great invention of the romantic era in physics, the electromagnetic field. Using iron filings, Michael Faraday had made its seamless continuity visible, and according to James Clerk Maxwell, the nineteenth century's Newton, all the waves that undulated through such fields—including light—were also continuous. The head of the Vienna Physics Department, Josef Stefan, had given the nineteen-year-old Boltzmann a copy of Maxwell's book when he arrived, thoughtfully throwing in an English grammar so he could read it. Reading was easy for the shortsighted Boltzmann, but he remembered having had to use his imagination a lot as the Vienna professors lectured about solid geometry without models and described the effects of experiments he couldn't see.[7] Fortunately his imagination was brilliant, a very helpful thing for the man who wanted to explain the invisible world of atoms and molecules.

With his doctoral sheepskin in 1866, Boltzmann had brought away from the university a nineteenth-century continuous picture of the universe. If it had atoms and molecules in it, they were those of the lowly chemist. In 1865, with exhaustive elegance Maxwell had reduced all the many effects of the electromagnetic field, known and unknown, to a tight phalanx of four differential equations. The differential equation was continuity's mathematical signature, and by then it had become the exclusive language of mathematical physics. Gravitation, Newton's "force acting at

a distance," seemed ready to graduate to a "field" just like Faraday's, and a grand proliferation of waves, fluids and fields seemed ready to swallow up theoretical physics. Chemists might need concrete atoms because of those stubborn, noncontinuous differences between elements; but physicists could rise above chemistry's messy specifics. Their atoms were general and ethereal. They might, thought Kelvin, turn out to be no more substantial than a sort of vortex or knot in some universal field.

Boltzmann, however, did not buy the extravagances of field theory, either then or later. He had read all of Maxwell, and he knew that Maxwell's genius had never excluded particles in order to make waves. Unlike Carnot and Black for example, Maxwell had not thought that heat was some sort of fluid, even though it flowed from wherever it was hot to wherever it was cooler. He had agreed instead with James Joule, who in 1848 had decided heat could be more easily explained as the movement of sextillions of molecules, and Rudolf Clausius, who imagined them in 1857 as spinning, colliding, and rocketing about like billiard balls or bird shot in a can. In 1859–60 Maxwell had suggested a way of writing out this picture in mathematical terms, so that the heat could be derived from the number of the particles and the way energy was distributed among them. It was a complicated formula that involved assuming each molecule was free to move in each of the three dimensions. Too complicated in fact, for, as Maxwell came to realize, those three "degrees of freedom" would put no limit on any molecule's momentum, and the total momentum of the system could violate the conservation law. In 1866, the year of Boltzmann's doctorate, Maxwell had begun experimenting with formulas that distributed the energy among states of many particles instead of among the particles themselves.

Boltzmann found this "particle Maxwell" much more interesting than the "field Maxwell." Boltzmann's doctoral paper had, in fact, been about a mechanical interpretation of entropy and talked a lot about whirling molecules. Indeed, it was his first stab at the problem that would occupy him all his life and define his scientific career: what is the structure of matter that accounts for the strange relation between heat energy and its darker twin, entropy? Entropy was the name Clausius had given to his measure of the unavailability of energy. This is what the world keeps running up a tab on, in spite of the law of the conservation of energy. Entropy measures the increasing incapacity of heat to do work. In the largest possible sense, entropy is chaos, disorder, capital consumed: the thing that Clausius had asserted must increase without limit as the universe grows old, in a formula that soon got the exalted title Second Law of Thermodynamics. Boltzmann had already echoed Clausius in his doctoral paper by setting the change in entropy (e.g., in a heat engine cycle) equal to the derivative of the amount of heat transferred divided by the absolute temperature of the transfer. But what Boltzmann most wanted

to know was what lay behind entropy. What behavior of matter, on a scale invisible to humans and their instruments, accounted for the work of the steam engine, the feeling of warmth, and the growth of disorder in the universe?

His basic hunch was that it was the movements of a crowd of atoms. In 1868 Boltzmann, then a new instructor at the University of Graz, had announced his first answer to the question in a paper called "Studies on the Equipartition of Thermal Kinetic Energy among Material Point Masses."[8] Non-physicists can recognize the picture even through the technical talk as pretty much like Maxwell's. The "material point masses" are the atoms, assumed to be there, and assumed to have kinetic energy— to be moving—in ways we perceive as heat. They are very small and there are many, many, many of them—in a combining volume of a gas, at least 6×10^{23}, Avogadro's number, whose value had been first approximated by Boltzmann's colleague Joseph Loschmidt in 1865.[9] The best way to think about them, Boltzmann had written, was to assume that every possible position—every "degree of freedom"—was represented somewhere in the crowd. Each degree of freedom had a potential energy, and if there were five hundred sextillion particles, those potential energies must also be distributed all over the map much as the particles were. The equations that emerged were algebraic sums with large numbers of terms. If matter were continuous and not divided into atoms, one would have wanted to integrate the terms in some way. Continuous functions integrate, and integral calculus was after all the basic mathematical tool of nineteenth-century physics. Boltzmann had indeed integrated first, but then he had added all the pieces and worked out a difference sum too, just for good measure.

Maxwell had liked the paper, and had generously proposed that this assertion that all the particles were distributed among all the positions according to their potential energies (and the temperature) be named "Boltzmann's Theorem." The distribution itself, based on Maxwell's, had soon acquired the name of Maxwell-Boltzmann Distribution. In 1872 both the assumption and its consequence remained unproven in the strict sense, but of course no one then could measure the speed and position of a single molecule. (It's still hard to do.) Meanwhile, the averages for 10^{23} molecules would always give figures for the total energy that compared precisely with reality. One would just have to be satisfied with high probability that the average was the real, and that after a time each molecule's energy would be somewhere around RT/N—the gas constant, R, over Loschmidt's number, N, times the absolute temperature, T. The relative (average) numbers of molecules with different energies, E, would be given by an equation depending on the "Boltzmann Factor" of $e^{-E/RT}$. Thus did physics leave the safe harbor of exact measurement and set sail for the first time on the sea of probability.

Then in 1872 Boltzmann went all the way in his identification of the real as the probable. Since his days as a graduate student in Vienna he had been searching for a formula for entropy that would make it obvious that entropy always increased and thus lead to a proof of the Second Law of Thermodynamics. He had offered a sketch of a proof in 1871, in a paper called "Analytical Proof of the Second Law of Thermodynamics from the Law of Equilibrium Distribution of Kinetic Energy," following it up with an equally sketchy first effort at turning thermodynamics into probability.[10] In his papers on energy distribution, Maxwell had anticipated such a formula. He and Boltzmann both began by postulating that if molecules distributed themselves and their energies according to the Maxwell-Boltzmann distribution, the final result would be a statistical average. The proof he found did not come easy, however. In fact, the mathematics still seems inelegant to mathematicians and incomprehensible to laymen.[11]

Boltzmann had shown in 1868 that each molecule in a crowd had a set of kinetic energies, one for each of the three motion vectors. He sketched a function he could not fill out in detail for the distribution of those kinetic energies. For each set of kinetic energies, he further reasoned, there were changes caused by collisions in each small time interval, so what he needed to find was a formula for the change in energy distribution the collisions would cause in that time. The formula he found turned out to be an equation between the derivative with respect to time of the energy distribution function on the left side, and a forbidding double integral on the right. The integral couldn't be evaluated; but happily, when the Maxwell-Boltzmann Distribution was substituted in its largest term, the integral became zero, and so did the other side of the equation.

Encouraged, Boltzmann went on to define a new quantity, which he decided to call E—not the Entropy that fascinated him, but instead its negative or inverse. We might call it the marginal available energy rather than unavailablity of energy, or perhaps the measure of the possibility of heat flow within the gas.[12] E, Boltzmann decided, was to be set equal to the sum of velocity differences in the heated substance, so that near thermodynamic equilibrium, when the velocity distribution of the molecules was as equal as possible, the sum of those differences would be at a minimum. Having found an expression for E in terms of an integral, Boltzmann simply took the first derivative with respect to time and showed mathematically that this derivative was always greater than zero. It would always get smaller as the time increased, and become equal to zero only at the Maxwell-Boltzmann equal distribution. Its negative, $-E$, which always got larger as time went on, looked as if it would be equivalent to entropy. Boltzmann later changed the E for energy to H, and the formula came to be called the H-Theorem.

Boltzmann was pleased. The H-Theorem was the kind of sharp advance that could make a scientist's reputation. Boltzmann soon became, as he hoped, a very celebrated theoretical physicist, invited to give lectures and receive honors all over the Western intellectual world. In 1887, after a promotion brought him back to Graz, he was made president of the whole University, and in 1890, before returning to Vienna, he was made professor at the University of Munich. A professorial editor named Wroblewski asked him to write *On the Kinetic Theory of Gases*, but Boltzmann modestly refused on the grounds of poor eyesight to write the definitive work he would have to compile twenty-five years later, when his eyesight was even poorer. Boltzmann's most immediate honor after the paper was to be made full professor of mathematics at the University of Vienna, making it proper for the Herr Professor to find a wife. One of his math students in Graz, Henriette von Aigentler, accepted his proposal. Boltzmann expected an old-fashioned wife ready to cook and pick up after him, but Henriette would call him "my dear fat little treasure" and get around him fairly well.[13]

But all was not for the best in the best of most probable worlds. What Boltzmann had not known when he put his article in an envelope and posted it to the *Vienna Reports* was that there were at least two hidden gaps in his reasoning. They were, moreover, exceptionally deep difficulties, unusually mathematical and hard for a nineteenth-century mind to understand. Perhaps it is the best measure of the extraordinary Modernism of Boltzmann's mentality that he fought for his theory against both objections and eventually succeeded in answering them.

The first objection came in 1874 from William Thomson, the Glasgow physicist who had invented the absolute temperature scale and would soon become Lord Kelvin. If the probability of every configuration all those molecules can take is the same, and if events and collisions are as likely to happen in one order as they are in any other, why do the highly-ordered states—the ones that can produce energy—always disappear? Why don't ordered states arise from the less-ordered ones just as often as the less-ordered states arise from the ordered ones? Kelvin put the question in a paper in 1874, but Boltzmann didn't read it. It was not until 1876, when his old colleague Josef Loschmidt raised the same objection, that Boltzmann finally realized his theorem was not secure. At the time Boltzmann was planning his wedding and preparing once again to move from Vienna to Graz, but he set to work immediately on the problem.

The objection, which Boltzmann's student Paul Ehrenfest later dubbed the *Umkehreinwand* or "reversibility" problem, is oddly mathematical for a physical theory. Cantor would have recognized its relationship to recent work by mathematicians on probability and to his own nearly simultaneous discoveries in set theory. A system of 10^{23} moving molecules is not an infinite set, but the best mathematical ways to deal

with such monsters are not so different. Boltzmann seems not to have known Cantor's work, but he had both a degree and a professorship in mathematics, and in almost exactly a year he brought his expertise to bear and answered Loschmidt. Once again the work took the form of an article in the *Wiener Berichte,* and once again the customs of physics obscure the art and importance of the achievement in the title of the paper: "Remarks on some problems in the mechanical theory of heat," published on January 11, 1877.[14]

All states of a system of molecules, wrote Boltzmann, are not equal. The ones with order, the ones that can be tapped for heat transport, energy, or work, are quite rare. Improbable. It is not just as likely for an ordered state to develop into a disordered one as for a disordered one to do it. There are so many more disordered states than ordered ones that disorder comes from disorder more often than order does. Much more often. So much more often that the probability of an ordered state of the system arising at all is, for all practical purposes, zero. It can happen just as often as the event when all but one or two of the molecules in your chair move straight up all at once—an exhilarating experience, but not worth waiting more than a few billion lifetimes for. Probability, which Boltzmann had tentatively admitted in 1872 to the rigorous science of mechanics, was now beginning to seem like the foundation of it. The physics of moving matter founded by Galileo and seemingly perfected by Newton had been reduced to a law of averages.[15]

In his next important paper, also in 1877, Boltzmann made his reply to Kelvin's *Umkehreinwand* objection, and went on to follow out the probabilistic implications of his own H-Theorem and produce at last an entirely statistical formula for entropy. What was needed was not only to find all the probabilities for energy states of each of those 10^{23} molecules in a molar volume, but also to compare the probabilities of different states of the entire system—that is, of each different way of putting 10^{23} molecular states together. This was no easy trick to do in mathematical detail, and more than a century later the discovery remains unappreciated. The formula for the probabilities of energy states of an entire system was difficult to begin with; and comparing those probabilities for different systems was even more complicated. What method could sum them conveniently? Probabilities multiply. The probability of rolling a three when you throw a die is just one out of six, 1/6; but if you roll two dice, the probability of getting two threes at once is 1/6 times 1/6, or 1/36. Would all those energy probabilities have to be multiplied together? To the unimaginable power of the total number of molecules in each of a score of systems? Not necessarily. Entropies don't multiply, they add. The entropy of one process is 1/6 and the entropy of another is the same, the entropy of both together would be 2/6 or 1/3. Suppose the probabilities Boltzmann was staring at were expressed as exponents or logarithms of

probability. Logarithms of factors also add, and their sum is the logarithm of a whole. All he would have to do then would be to add the logarithms together. Entropy would turn out then to be a logarithm, the logarithm of the total of all the probabilities, an enormous sum perhaps to be multiplied by some factor for balance.

Boltzmann began by imagining how to number the energy-state origin of each of the N molecules in a state of the system in several different randomly chosen ways. (No one would ever actually do it, but while it might take the lifetime of the universe, it wasn't impossible in principle.) Each numbering he called a complexion. Of those energy states he would discard those in which the energy of all N molecules did not add up to the same total, and of the remaining equal-energy states of the whole system of molecules, distinguish between those that could be produced by many different "complexions" and those that could only be made by a few. Surely, thought Boltzmann, the states that could be arrived at in many different ways must be the most probable, and those that could be arrived at in only a few ways must be the least probable. In the same way, there are only a few states of a deck and only a few deals in a game of poker that will yield a hand as improbable as an inside straight. The total of different ways, or complexions, that could produce one state of the whole would give the "permutability," W, of a state—the total number of permutations leading to it—as $n!$ divided by the product of possibilities for each molecule $(w_0!)(w_1!) \ldots (w_N!)$, where N was the number of the last molecule in the crowd. Of course, $n!$ was very big, but then the product of $(w_0!)(w_1!) \ldots (w_N!)$ was likely to be even bigger, and the denominator ought to balance the numerator. So if W, the permutability of a state, went up, then the probability of the state would go up; and if it went down, the probability would go down. If Boltzmann's mathematics could find the maximum of W, he would have found the most probable state, which would also be the equilibrium state. He could make it a lot easier by taking the logarithm of W, because to get the logarithm of an enormous product, all you had to do was add up the logarithms of each term. That was something you might be able to finish doing before the universe came to an end. Especially if you used a little trick and broke up the continuum of energy change into discontinuous numberable parts, dividing the range of each term up into finite pieces. When Boltzmann evaluated them piece by piece, instead of integrating with calculus, a lot of terms dropped out. How "much clearer and much more intuitive" it is, he wrote, to "treat the energy as a discrete variable rather than a continuous one."[16] And it was easier too. In the end Boltzmann had his formula, and the Second Law of Thermodynamics had a mathematical proof at last. Expressed in the austere language of mathematics there appeared at the end of the paper the famous Boltzmann Law: entropy, S, is proportional to the logarithm of the probabilities, w, evaluated piecewise, of the

states of a system. A promising young thermodynamicist named Max Planck would simplify it later as $S = k \log W$, where W was the total probability of the system and k (which Planck dubbed "Boltzmann's Constant") was the gas constant divided by Avogadro's Number.[17]

There it was—a reliable mathematical measure of the entropy of a heated fluid in terms of the molecular motion that produced the heat. But instead of a neat function of the motions themselves, it turned out to be a purely statistical one that depended on nothing anyone could know for sure about the motions of individual molecules, or even of states of the system. In a way it depended on precisely how unsure one was of those motions. The surer one was, the less entropy there was. Available energy implied not only order but certainty, and the loss of energy—entropy— was nothing more nor less than the uncertainty one had about order.[18] Uncertainty and entropy were the same, and since each had the property of never decreasing, the Second Law of Thermodynamics that the entropy of the universe always increased was indeed demonstrated. The paper was called "On the Relationship between the Second Law of the Mechanical Theory of Heat and the Probability Calculus," and it came out in October 1877.[19]

Not many understood Boltzmann's new way of approaching thermodynamics in 1877. The few that did were philosophically troubled by it. They expected physics to be materialistic, yes, but by the same token they expected it to be deterministic. The state of a system had to be, they thought, completely dependent on the state of its parts, leaving no room for probabilities. The great Laplace had written the definitive text on planetary motions at the beginning of the nineteenth century, and later the definitive text on probability calculus, but neither he nor anyone else had made the great and now fundamental connection between the two sciences. The idea that the future positions of Mars or Jupiter might somehow be merely probable instead of precisely predictable by natural law and previous events would have shocked Laplace's contemporaries. It would have shocked many at the end of the century, too, if they had had an inkling. But only physicists knew that the *Umkehreinwand* debate was on and that Boltzmann's 1878 paper, "Further Remarks on Some Problems of the Mechanical Theory of Heat," was a battle piece.[20] In 1891 and again in 1894, the British Association for the Advancement of Science received reports from entire committees it had set up to consider the *Umkehreinwand* problem; and even Maxwell, just before he died in 1879, wrote a paper that tried to make clear to himself and other physicists the extraordinary direction his younger disciple Boltzmann had taken from his own musings on molecular collisions twenty years before.[21]

Then came the second objection. It was made by none other than Ernst Zermelo, who in 1901 would come up with the Axiom of Choice

that for a time brought order to Cantor's infinite sets. In two papers published in 1896, Zermelo, then serving as junior assistant to Max Planck, pointed out that the probability of any state of any system as big as a volume of gas molecules was never going to be big enough to reduce the probabilities of all the others to zero. No matter what state the system was in or how it had arisen, it would be succeeded by another state, and given enough time it was provable that every state, even the least probable, would occur again. If it were true, however, it would contradict the Second Law of Thermodynamics itself, which outlawed such recurrence just as it outlawed perpetual motion. After reading up on thermodynamics in 1881, Nietzsche had written that in an infinite universe there was room for eternal recurrence, and it was hard to deny that in a finite but very, very large universe there was at least a chance that what went around would come around.[22] In time Ehrenfest would give Zermelo's idea the name *Wiederkehreinwand,* or recurrence objection. Of course, Zermelo had got none of this from Nietzsche, though he happily acknowledged a debt to the incomparable French mathematician Henri Poincaré, who had framed the same truth with algebraic precision five years earlier in a paper called "On the three-body problem and the equations of dynamics," which founded the mathematics of what we now call "chaos."[23]

Boltzmann did not like Zermelo. He called him a *Pestalutz* (Iago) and a *Halunke* (lout), but not because he thought Zermelo's idea was beneath him. Indeed, he wrote two papers almost immediately to reply to it.[24] He did not deny that there was little room for recurrences; he only asked, gently and mathematically, how much room there might be. His own arithmetic suggested that the room required in both space and time was astronomical. More than astronomical—it was inconceivable. Later calculations offered the numbers. Inside a sphere with a radius of 0.00001 cm, a recurrence in a system of gas molecules could be expected only once in every 3,000,000,000,000,000,000,000,000,000,000,000,-000,000,000,000,000,000,000,000 years. The time between two big fluctuations would be 10,000,000,000 to the 23rd power times the present age of the universe, which was more than 10,000,000,000 years already.

Boltzmann cheerfully admitted that with figures like these the whole universe could be a huge nonequilibrium fluctuation, or that the habitability of our own small neighborhood of the universe might be no more than a necessary improbability. For us, time might be going backward, but how could we know? "Thus," wrote Boltzmann, "the two directions of time are indistinguishable in the universe, just as there is no up and down in space," but beings like us are too limited to detect the equivalence.[25] Time had been the denominator in the H-Theorem, but time did not appear at all in $S = k \log W$. Statistics is what time is, Boltzmann offered, and we define it for the universe as going only one way, toward

states of increasing probability, increasing entropy, dwindling energy, and heat death. There might, in a universe sufficiently vast, be places where time would seem reversed; but in this sense it was only in true infinity, a Cantorian set, that everything, including the Eden of available energy, would be bound to recur. Unless this, too, were one of the emerging paradoxes of set theory.

Thus the H-Theorem was saved. The price, only dimly perceived by Boltzmann, was the postulate of complete disorder among molecules, a disorder that was as real and ontological as it was mental or epistemological. Not that Boltzmann's mechanistic atomism was changed by the admission. In 1894, he was made full professor of theoretical physics at the University of Vienna, succeeding his old teacher Stefan. Though no less a materialist and no less a Darwinian, he had cordial talks with his senior colleague Brentano, the idealist professor of philosophy, and still played Beethoven on piano in Liszt arrangements and recited Schiller.[26] His nineteenth-century faith in technology was undiminished. He constructed an electric sewing machine for Henriette, rode a bicycle, and featured Wilhelm Kress's 1880 model airplane in a talk about the rosy future of flight.[27] Boltzmann rose at 5 A.M. to prepare and teach his courses in analytical mechanics, gas theory, electricity and magnetism, optics, acoustics, and thermodynamics, but he partied regularly and late. In time Henriette would have three daughters and a son in his house to help her take care of him.

As for his beloved theories, he thought them grown and on their own. He had successfully defended them against what he reckoned was an old-fashioned distaste for uncertainty in physics. What he had not counted on, however, was an even more old-fashioned distaste for atoms themselves. In 1896, something that looked to Boltzmann like a sudden epidemic of discredited idealism arose, led by a young and gifted chemist, Wilhelm Ostwald, of Leipzig University. Atoms, Ostwald insisted, were no more than warps in continuous fields. They only seemed to have degrees of freedom. There was no void between them. Everything was either ether or energy. The idea was exciting, and it seemed not only new but in profound accord with the mentality of the rising generation, creators of symbolist art. On Ostwald's side were ranged Georg Helm and Emil Wiechert, the popularizers William K. Clifford and Karl Pearson, Lord Kelvin in certain moods, Joseph Larmor, half the ghost of Maxwell, and Ernst Mach, whose path Boltzmann had crossed so often between Vienna and Graz, and who was not convinced that there was any such thing as an atom. There was nowhere near enough evidence, he thought, so why spoil the economy of your explanations by bringing a dogma like atomism into the picture? So sure of the superior reality of energy were the energeticists that they wanted to base all of physics on it; they were capable of imagining an atom of matter as no more than a twist in space,

a knot in a wave, a vortex in a field, or a fourth-dimensional squirt in the three-dimensional ether. In the rising cultural debate between the old militant materialists and the newer positivists, radiation, and indeed energy in general, had begun to seem like the field where the materialists might lose the struggle. After all, the wonders of ether-borne electricity had caused even J. G. Vogt to fall away from the pure materialism of his father.

Boltzmann applied himself to the task of defending atomism with his customary sardonic zeal. Atoms are a phenomenology, not a dogma, he wrote in 1897 with Mach in mind. They are, as he titled his lecture, "Indispensable." You cannot simply integrate them out of existence, reduce them to infinitesimals, as you might in a typical calculus problem. Differential equations lead to a continuum picture, but differential equations don't eliminate discrete numbers.[28] The sheer convenience of calculus may have fooled physics into believing that everything is a continuum; but we forget when we go to calculus that we had started "with a finite number of elements."[29] It may even be that time, which we confidently treat as continuous, is really made up of tiny discrete parts just as matter is.[30] In 1895, in Lübeck, an entire meeting of the larger German scientific association was given over to the debate between Ostwald's "Energeticism" and Boltzmann's "Atomism," with both men defending their ideas in person. Even the old publicists Haeckel and Vogt seemed a bit soft on atomism. Of the very few that could be seen to stand with Boltzmann, someone noticed that all of them were young.[31]

Giving the eulogies for both his mentor, Stefan, and his fellow worker, Loschmidt, in 1895, Boltzmann must have felt increasingly alone. For him the antidote to entropy had always been the progress of humanity—the positivist faith that the direction of history was away from muddled mysticism and toward freedom from tyranny, toil, and cant. He did not at all enjoy the feeling of being left behind in its dustbin, "struggling weakly against the stream of time," so to make the best of it he smilingly adopted the pose of an irreconcilable.[32] "I therefore present myself to you as a reactionary," he told scientists in Munich in 1899,[33] and added, "I therefore shake hands with the secessionist movement," perhaps hoping that he rather than Ostwald could identify with the emerging art.[34] In another essay Boltzmann wryly impersonated Galileo: "I think I can still safely say of molecules: nevertheless they do move."[35] Here too he finds a recursive hope in the thought that "the evolution of a theory . . . is by no means as continuous as one might expect, but full of breaks," which, if true, would make theories of matter as discontinuous as matter itself, and cause atomism to come around again in a *Wiederkehreinwand* of its own.[36] In fact, though Boltzmann was barely aware of it, atomic physics was coming around again at just this time, as Walter Kaufmann, H. A. Lorentz, Jean Perrin, Philipp Lenard, Max Abraham,

and J. J. Thomson closed in on a "corpuscle" smaller than the atom—the electron.

But Boltzmann was not yet down, and could not be counted out. When a professorial appointment was offered him at Ostwald's own university in 1900, Boltzmann picked up and cheerfully left Vienna to offer his courses in the enemy's camp. He had attracted graduate students of superlative quality like Ehrenfest, Fritz Hasenöhrl, and Lise Meitner, who in 1906 became the first woman to receive a Ph.D. from the University of Vienna.

He had also acquired some disciples he didn't know about, like Ludwig Wittgenstein, who planned to study with him when he got out of high school, and Josiah Willard Gibbs, who was reading the *Vienna Reports* in New Haven, Connecticut. Gibbs, who had learned molecular dynamics from Maxwell at the same time as Boltzmann, had been giving papers since 1873 to the Connecticut Academy of Sciences and Arts, papers that no American understood and that for ten years only Maxwell seems to have read. Yale students thought Professor Gibbs kind, modest, and incomprehensible, a rather good fellow unless you had troubles with math. The papers, which ended a year before Gibbs died with the publication in 1902 of *Elementary Principles in Statistical Mechanics,* added up to a complete theoretical foundation for thermodynamics, using mathematical tools so advanced and so thriftily elegant that they made Boltzmann's papers look like mare's nests. Austerely beautiful continuous surfaces in multidimensional hyperspace represented states of atoms and states of systems. Boltzmann's ricocheting atoms were still there, however, for the surfaces were only descriptions. When Gibbs made the rounds of German universities during his one trip to Europe as a young graduate student in 1866–69, he learned from mathematicians like Weierstrass and Kronecker; but Boltzmann was not on his list.[37] The two men missed each other again in 1899 when Boltzmann made the first of his three trips to the United States to speak at Clark University. By 1904, when Boltzmann made his second trip to America, Gibbs was dead, and the best Boltzmann could do was honor him by adopting his name, "statistical mechanics," for their new science. Their joint description of system probabilities would eventually receive the name "Boltzmann-Gibbs Statistics," and would be joined by the statistics of subatomic particles named Fermi-Dirac and Bose-Einstein.

Max Planck, who wrote Boltzmann regularly about thermodynamics, also became a full professor in 1892. In 1897 he published *Vorlesungen über Thermodynamik,* a text in thermodynamics summing up the achievements of Boltzmann and his fellow workers, and bore down on the arcane and seemingly impossible task he had set for himself of finding a thermodynamic formula that would relate the moving particles that were the origin of heat to the frequency and intensity of radiation emitted

by a hot body. There were two formulas for that already, both containing the Boltzmann Factor, but neither of them worked. When Planck at last found the solution, the foundation of quantum mechanics, it would look very much like an H-Theorem for energy.

Meanwhile in Milan in the summer of 1900, the twenty-year-old Albert Einstein was writing to his intended, the physics student Mileva Maric, about his discovery of Boltzmann.

> The Boltzmann is magnificent. I have almost finished it. He is a masterly expounder. I am firmly convinced that the principles of the theory are right, which means that I am convinced that in the case of gases we are really dealing with discrete mass points of definite finite size.[38]

The book was Boltzmann's *summa,* the *Lectures on Gas Theory* of 1896–98. Einstein had had the book sent to him in the summer of 1899, when he first got the idea for Special Relativity.[39] Laying Relativity aside, he took up Boltzmann's book again in 1901, "wrote a short paper myself that provides the keystone in the chain of proofs that he [Boltzmann] had started," and published it, launching his career with a series of papers on thermodynamics that led directly to his classics on the Brownian movement and the photoelectric effect in 1905.[40]

In the fall of 1902, Boltzmann left Leipzig and came back to Vienna again, this time as—of all things—Mach's replacement in the professorship of philosophy. Mach had suffered a stroke and could hardly move or speak. "I offer you something quite modest," said Boltzmann in his inaugural lecture in October, "admittedly for me all I have, myself, my entire way of thinking and feeling."[41] Even so, he threw himself into Hegel, Schopenhauer, and the other standard texts in philosophy, knowing that they would have nothing useful to say about matter and motion, nature as he saw it, or his beloved mathematics. The careful Henriette wrote out his lectures for the five-hour-a-week course and the one-hour-a-week seminar, for by now he had added angina and asthma to his migraine headaches and poor eyesight. The next year he was appointed to another professorship at Vienna, this time in "Natural Philosophy," for which Boltzmann designed a course as a sort of retrospective on his favorite subjects: the mathematics of set theory, the meaning of infinity, the logical foundations of time, number, and especially space and dimensionality, and of course, the atoms of matter, in which he still believed. "I once engaged," he said to the standing-room crowd in the 600-seat hall at the inaugural lecture,[42] "in a lively debate on the value of atomic theories with a group of academicians, including Hofrat Professor Mach, right on the floor of the academy itself. . . . Suddenly Mach spoke out from the group and laconically said: 'I don't believe that atoms exist.' This sentence went round and round in my head."[43]

Other things, too, went round in his head. His letters to Mach's pre-

decessor, Brentano, suggest a philosophical distemper. In his 1905 lecture dynamiting Schopenhauer, Boltzmann talked of how hard it was to produce intellectually when one didn't know what to produce, and compared the process to a "nausea under migraine where one also has the urge to throw up something when nothing is left inside. With this we may compare the attempt to determine whether life has a value."[44] The sentence came straight from the heart. Even his trip to Eldorado (Berkeley, California) did not make it any easier in the depths of his depressions to determine that life had a value, especially his own life.

On the fifth of September, 1906, Boltzmann was vacationing with his wife and daughter at the Biarritz of Austria-Hungary—Duino—on the shores of the Bay of Sistiana on the Adriatic coast, thirteen miles north of Trieste. He was nearly blind, and the seashore was not yet doing anything for his symptoms or his overwork. Boltzmann's mood swings had gotten so bad recently that he had had to spend some time in an asylum in Munich. That morning, he had told Henriette that he wanted to go back to Vienna, but it was impossible because, as his wife pointed out, she had taken his suit to be cleaned. With daughter Elsa in tow, Henriette left him in the hotel room and went for a swim in the bay. When they returned, she found her husband hanging by a homemade noose from the crossbars of the window frame.[45]

On Boltzmann's tombstone in Vienna's great Central Friedhof, under his squint-eyed, bearded bust, is inscribed the single line "$S = k \log W$"— the first of the long line of discontinuous probability functions to afflict modern physics. Atoms are unpredictable, it proclaims, and energy lost forever is a sum of the powers of the possibilities of disorder. Physics itself is not certain, and will never again be anything but probable. Nineteenth-century certainty is no more likely to recur than the highly ordered energy state of a railway engine boiler just before the train pulls out of the station trailing rhythmic puffs of rising steam and smoke—chaos and entropy.

5 GEORGES SEURAT

DIVISIONISM, CLOISONNISM, AND CHRONOPHOTOGRAPHY

1885

In the fall of 1885, in a little fifth-floor studio below the Montmartre district in Paris, a twenty-five-year-old artist named Georges-Pierre Seurat began to rework his new painting by adding little dots of bright new pigment over its areas of color. More than a year earlier, on May 22, 1884, Ascension Day, he had begun this painting with little oil sketches on wood panels about the size of typewriter paper. It would not be shown to the public until May 15, 1886, but the dots Seurat put on in 1885 would make *Sunday Afternoon on the Island of La Grande Jatte* almost immediately into the most celebrated painting of the *fin-de-siècle,* and one of a handful of masterpieces of that time to be called "the first Modern painting." Indeed, it has become one of the most important works in what is still called the canon of Western art. In an absurdly popular 1986 movie, Ferris Bueller, who has taken a day off from school with his friends Cameron and Sloan, spends part of the afternoon with them in the Art Institute of Chicago. There, Cameron is arrested by the *Grande Jatte,* nearly seven feet high and more than ten feet wide, covering an entire wall. Cameron stares at the painting, fascinated, while Bueller and Sloan kiss in philistine oblivion. The camera's eye zeroes in on the center of the canvas, where the figure of a little girl in white holding the hand of an older woman walks straight toward the viewer, and in a series of tighter and tighter closeups, the huge painting narrows to the face of the little girl and finally dissolves into thousands of differently colored patches, each no larger than an eighth of an inch. The experience of first seeing Seurat's *Grande Jatte* is as riveting now as it was when the painting was first shown. In a series of receding planes, each hieratically organized almost like the frieze on a temple, are more than fifty human figures enjoying their Sunday off, plus three dogs and a monkey. Each of the figures is constructed with the same kind of array of little dabs of pigment. It is immediately clear that the painting, though a

harmonious whole that radiates an extraordinary calm, is constructed with thousands of recognizably separate parts.

The *Grande Jatte* was a first, and within a year it was the foundation of a school that converted old Camille Pissarro from simple impressionism, and even affected Paul Cézanne in distant Aix-en-Provence. Adherents came to be called "Neo-Impressionists" by their friends, "Divisionists" and "Pointillists" by others. For the extraordinary artists who would eventually be called the post-impressionists—Paul Gauguin, Vincent van Gogh, Henri de Toulouse-Lautrec, and even Cézanne—the *Grande Jatte* became the gateway to the future. Divisionism was the last stage on the route that led Henri Matisse to fauvism in 1905 and Umberto Boccioni to futurism in 1910. It was still influencing incipient abstractionists like Duchamp and the Delaunays in the 1920s.

Divisionism remade the world of art all the way from the look of a painting to the techniques that made it and the aesthetic theory behind it. And while the divisionists pondered the scattered puzzle-pieces Seurat put before them, a parallel discovery with an equally powerful effect was made by Eadweard Muybridge and Etienne-Jules Marey. They called it, respectively, "zoöpraxiscopy" and "chronophotographie." We call it moving pictures.

It was Seurat's painting, however, rather than Marey's chronophotographs, that gave the unmistakable signal for art to move into the new world. His discovery fascinated artists. Parts can always be made into wholes, but at every level of magnification a different set of parts might appear. By dividing optical perceptions into their discrete elements the *Grande Jatte* suggested, in a way that painting never had before, that the phenomenal world—and perhaps the noumenal one as well—was itself irreducibly divided into parts, that continuity was an illusion and atoms the only reality.

Seurat's creative odyssey is not easy to describe in words. Its artifacts consist almost entirely of sketches, Conté-crayon drawings, and little oil studies on wood. He said little, wrote almost nothing, and painted every day, including Sunday. The *Sunday on the Grande Jatte* had begun with a quick study of a fisherman in a grove of trees along the western shore of Grande Jatte Island.[1] Seurat had seen it a year ago, looking east as he worked on another picture. From his studio near the foot of Montmartre, Seurat would head northwest in the morning, toward a part of the Seine that flowed southwest just before doubling back around the Bois de Boulogne park to go east through Paris. Arriving on the Neuilly side, just downstream from the new factories at Levallois, he would cross the Seine to the Asnières side where the riverbank was still a little rural. At Asnières in 1883, Seurat had made the studies for the first of his mural-scale pictures, *Une baignade, Asnières* (Bathing-place, Asnières), with a composition centered on working-class men and boys swimming in the river at a

place where workhorses were brought to be washed. Right between the smokestacks of Levallois and the horse-wash of Asnières was Grande Jatte Island, a green tongue in the middle of the river whose southern end was a park and promenade for the middle class. The decision Seurat arrived at on May 22, 1884, five days after *Une baignade* went on show at the first Salon of the rebel Group of Independent Artists, was to paint the Grande Jatte next.

Seurat's sketches of Grande Jatte were almost all made on the spot, in oil on rectangles of reddish wood measuring about six inches by ten—cigar-box tops as often as not. Twenty-seven of them survive, small masterpieces of acutely observed color and contrast. Some forty years later, Charles Angrand remembered watching Seurat work on one of them as they painted together on the Grande Jatte. Seurat was complaining that the grass had grown so high that it obscured his view of his motif, a moored boat. Angrand put his brush down and went to cut the grass, "for I suspected he was about to sacrifice his boat."[2] People often did what Seurat wanted without being asked. He commanded respect. At five feet eight inches, as his oldest friend Edmond Aman-Jean remembered, he was as handsome as the marble Saint George of Donatello. Seurat had been no older than seventeen when he met Aman-Jean, but his extraordinary reserve and calm and his taste for reading and theory made everything he said seem important. Seurat and Aman-Jean had found each other in 1876, two local boys learning to draw noses at the Municipal School of Sculpture and Design. Seurat lived a few blocks away with his parents in an apartment on the Boulevard Magenta. The parents, Aman-Jean recalled, were successful, stolid, and a bit pious, *bons bourgeois* who gave Seurat a nice allowance but did not go in much for art.[3] Except for short painting trips to other parts of France, Seurat would spend his entire life in their neighborhood, but long before he had become a man, his mind had moved far away.

Each little sketch Seurat had made in 1884 was a work of its own, crowded with dabs of paint. Seurat called them *croquetons* ("nibbles"), but he almost always exhibited a few of them alongside his big canvases. Art historians have tried to date them according to changes in his palette and the increasing sophistication in his use of contrasting colors, for no one observed nature's colors more insistently than Seurat. At the end of one day painting on Grande Jatte, he and Angrand had ferried over to the new Courbevoie boulevard, where Angrand remembered Seurat "making me see that their green crowns [of the newly planted trees] against the grey sky were haloed in pink."[4] During those first days at Grande Jatte in 1884, Seurat had fixed on a location close to the one he had first spotted from Asnières, a grassy bank near the southwest end where the trees thinned out approaching the shore. Separately he sketched the trees and the grass. Then he took a few "snapshots" of holidaymakers

on the site. Focusing on a few figures as parts of the emerging composition, Seurat next made studies of them in various positions, positions he seems to have chosen because of their calm and harmonious shape.

Leaving the island at the end of a day of painting, Seurat would continue the work in black-and-white with more of those extraordinary little drawings in Conté crayon on paper called "Ingres paper" by its maker, Michallet, because J. A. D. Ingres, the midcentury French master of the drawn line, had favored it. Thick, white, and rich in rag, Ingres paper took the black of the Conté crayon on the prominences of its textured surface, leaving the white of the paper intact under a haze of darkness. Seurat had learned the technique in 1881, and by 1884 he was making it the touchstone of light and shadow, depth and outline. The drawings remain unmistakable. They were "the most beautiful painter's drawings ever made," wrote a fellow artist; and no one but Seurat has ever made anything like them.[5] Of those he made for the Grande Jatte twenty-six survive, some of them quite big—between two and three times the size of the oil sketches. An early drawing had centered on the large tree that divides the whole motif in half, together with eight of its more distant companions. Seurat outlined its complex doubled trunk as sharply as if he had been using an architect's pencil (the shape would be much simplified in the final canvas); but he cut the largest branch, stretching left toward the sun, cleanly off where it began so that he could concentrate on the two small trees behind it to the left. Eventually he would make an oil sketch of the whole motif, empty of people and animals, and comprising nothing but grass and trees. In December 1884 he would show it at the Independent Artists exhibition.

As the sketches accumulated, an overall composition became clear and individual figures began to populate it, many reappearing from sketch to sketch. In one sketch, Seurat put in only two figures, a reclining woman in the foreground and a standing woman in the background. The same women appear in the final study, but Seurat had by then reversed their relationship. Some of the figures walk toward the viewer along the island's long axis, some in repose face west toward the sun, casting long late-afternoon shadows behind them. A northwesterly zephyr fills the sails of two boats on opposite tacks near the Asnières shore, but spares the hats and parasols of the promenaders and a butterfly on the grass. By the end of the summer Seurat could make his final oil-on-canvas study of the whole scene as he had composed it, with all fifty figures and thirteen defining trees. Every figure on the land—except the dogs, the cornet player, and two of the children—is shown either standing or slowly walking, as if Seurat were deliberately trying to crystallize out of the random movement of Sunday leisure a frozen tableau, timeless, like Keats's Grecian urn. In fact, Seurat himself told a sympathetic critic, Gustave Kahn, that his model was the Panathenaic procession in the Parthenon frieze.

But Seurat didn't want to paint ancient Athenians. He wanted "to make the moderns file past . . . in their essential form."[6] By "moderns" he meant nothing very complicated. He wanted ordinary people as his subject, and ordinary life. He was a bit of a democrat—a "Communard," as one of his friends remarked, referring to the left-wing revolutionaries of 1871; and he was fascinated by the way things distinct and different encountered each other: the city and the country, the farm and the factory, the bourgeois and the proletarian meeting at their edges in a sort of harmony of opposites. The figures in *La Grande Jatte* look to the left across the river to Asnières, where *Une baignade, Asnières* had already presented the even more ordinary people of the turn-of-the-century working class looking right back at them. In that painting too Seurat had placed his figures within the hieratic sort of composition used by French old masters since the seventeenth century and still taught in the art academies. An older painter, Pierre Puvis de Chavannes, did large classical-style paintings for public buildings in which he linked many figures in these same broad compositional rhythms.[7] Seurat and his most advanced contemporaries liked Puvis, whose latest was a nineteen–by–thirty-three foot mural for Lyons called *Le Bois sacré* (The sacred Wood). The saturnine aristocrat Henri de Toulouse-Lautrec had made his own exhibit debut with a parody of it, and both could be seen in Paris in 1884 as Seurat was showing *Une baignade, Asnières* and beginning *La Grande Jatte*.

With the coming of fall, the Grande Jatte lost most of its boats and greenery. Seurat stopped sketching and spent more of his day in the fifth-floor studio at 16, rue de Chabrol, where he had painted the final oil study. The time had come to transfer the picture to the big canvas, enlarging it to a size as monumental as any that had ever been exhibited at the Salon. Stretched and lined, the canvas was as long as the wall and more than a foot taller than Seurat himself; but the artist knew exactly what he was doing. He had learned the business of doing studies for a big "struggle picture" at the old Ecole des Beaux-Arts, where he had found himself in the fall of 1878 with Aman-Jean again, making drawings of classical statues. It was serious, the students were told. If you did everything right, your picture would be hung in the official Salon, the jury would give you an award, and you would live happily ever after on commissions from the French Republic. One year had been enough for Seurat; he dropped out in 1879. The curriculum seemed outdated, the pedagogy rigid, and his teacher a pedant. He had found only one Beaux-Arts professor with anything to offer him—the former director, Charles Blanc; but Blanc had been fired in 1873 and his teaching was all in his eleven-year-old book *Grammaire des arts du dessein* (Grammar of the visual arts), which Seurat had read before he came to the school.

Seurat loved theory, and Blanc's was practically his first book on the subject. In it he had read all the many pages devoted to grand and public

art, and what could be learned about it from the ancient Greeks and from the hieratic designs on Egyptian temples, things Seurat liked to see for himself in the Louvre. Should Seurat ever be in danger of forgetting the legends of the Beaux-Arts, Blanc also discussed the stages an artist had to follow in the making of a big, reputation-making picture—one like the *Grande Jatte*. Seurat's great project was in fact an outdoor painting, the genre pioneered by the impressionists in the 1870s, but Seurat hadn't even known about the impressionists until just before he dropped out of the Beaux-Arts in 1879. Thus he found himself in 1884 setting up an outdoor painting in the studio in this complicated sequential academic way, a little like a stage set being readied over many months for a single performance. In fact, the resemblance of the *Grande Jatte* to a stage set remains quite strong, and when Stephen Sondheim made Seurat's construction of the *Grande Jatte* the subject of a musical, *Sundays in the Park with George,* he represented the picture on stage as a series of painted scenery flats.[8] The oil study of the empty landscape Seurat exhibited in December 1884 now looks to us like a stage set; but the people who first saw it would have had no way of knowing how gloriously Seurat was going to populate it.

In the fall of 1884, however, the largest version of the *Grande Jatte* was the scale-model oil study measuring twenty-seven and three-quarters by forty-one inches. Seurat divided it in half with a horizontal midline, then made two more vertical lines to divide the canvas into six equal parts a little less than fourteen inches square.[9] Each would be scaled up to its place on the big canvas. Adjustments to the composition had to be subtle at this stage, since the size of each object in the picture was linked to its depth. The perspective was not at all traditional, however. At nearly all successive planes of depth, Seurat made one deliberate and nonobvious violation of the old Renaissance rules. One of them was literally right up front. If the perspective had been linear the largest figures in the foreground plane, the promenading couple on the right, would have been painted the same size as the woman sewing on the grass directly in front of them. In fact the seamstress is a midget by comparison; if she were standing, her head would come up no farther than the couple's waists. In one of the further planes, Seurat made the uniformed St. Cyr cadets taller than the woman standing to their left on the edge of the shore, though the woman was on a nearer plane. The anomalies can only be resolved by considering the picture to have been constructed from two slightly different perspectives, one from the front and one from the right, a little like the pairs of slightly different pictures that turned into a three-dimensional scene when Seurat's contemporaries looked at them through the popular stereoscope-viewer. No one seems to have noticed when the picture was exhibited, but Seurat had made one of the first real challenges to the linear perspective canonical since the Renaissance.[10] Manet might

have understood what Seurat was doing here. His amazing picture of the tired barmaid reflected in the mirror from two different points of view at the same time had been shown in 1882.[11] Manet, however, had died in 1883, the year before Seurat began composing the *Grande Jatte*. Seurat was alone except for Cézanne, away in the south, who had been straining projective geometry in his still-lifes since 1879.[12]

Among the Ingres-paper drawings Seurat left at his death is one of a jacketed man seen from behind standing on a stepladder with his palette in one hand and his brush in the other, painting a giant picture.[13] If there were any proof that this drawing was of Seurat, we would know it as the only self-portrait he ever made or allowed to survive. In a portrait of his mistress, Madeleine Knobloch, the woman who came into his life in 1889, Seurat may have painted his own face into a little frame on the wall; but if he did, he replaced it later with a potted flower. Whether or not the drawing is of Seurat, it gives us a rare chance to visualize the kind of work that occupied the artist for the next five months or more, as he slowly filled in details of his composition on the fifth floor of 16, rue de Chabrol. Natty and warm in his short jacket, he would stand on a step-ladder in front of his wall-sized canvas. There, in the winter light, he could set about reconstructing the colors and gestures of summer with a brush.

It is in the studio that it helps the most to have a theory, and Seurat was by now plentifully supplied. Blanc's book had led him to many others, notably in optics and psychology; and Seurat wanted not only to paint according to solidly scientific ideas, but also to represent ideas on canvas. His choice of subject had already revealed something of his left-wing "naturalist" social philosophy, and his classicizing composition had demonstrated his strong attraction to the hieratic, the "primitive," and the symbolic. The two tendencies seem incompatible now, but not in 1884, which was the last year the old naturalism and the new symbolism cohabited. The same month Seurat began the *Grande Jatte*, the first *Revue indépendante* was launched by its editor, Félix Fénéon, a philosophical anarchist with a desk job in the War Department—and the most brilliant critic of the age. The *Revue indépendante*, according to Fénéon, combined "declining naturalism and rising symbolism" and put professors from the School of Anthropology together with Verlaine and Mallarmé.[14]

Stéphane Mallarmé, a poet of genius, was the informal leader of the new wave of artists, who had elected him their salon-keeper. On almost any Tuesday afternoon in the 1880s, when the high school where Mallarmé taught English had a short day, you could see most of the so-called symbolists in his Paris apartment in the rue de Rome. Seurat had met Mallarmé in 1884 and come to a couple of the "Tuesdays." The rue de Rome wasn't very far—midway between the rue de Chabrol and the

Grande Jatte. Mallarmé's movement, symbolism in the arts, had set itself the task of representing ideas instead of representing material nature the way naturalism kept trying to do. Naturalism had suited the impressionist painters, but despite all the sketches Seurat had made *sur le motif* (on the site) there was something about his work that was distinctly Symbolist. Certainly he wanted to render nature truly, and he had studied obsessively since the age of seventeen to find ways of doing it; but the reality he wished to seize was ultimately more phenomenological than material. His first sketches from life show that for Seurat a picture was not the same as its subject, and that its focus was on the viewer. He was a painter with a scientific attitude. One might even call him a positivist; but like Ernst Mach, Seurat was more interested in how light was perceived than in how it was emitted or reflected, and the queen science for him was not optics but psychology. Félix Fénéon understood almost immediately. Bowled over by Seurat when he saw the *Baignade* hanging over the refreshment bar at the Salon des Indépendants in May 1884, he knew that something new was happening and that Seurat had not only gone beyond academic painting but also beyond the naturalism of the impressionists. Seurat explained it all to Fénéon in a moment of indiscretion when the *Grande Jatte* was finally exhibited in 1886, and Fénéon wrote it down in review after review, sparing the obsessively reserved Seurat the task of explaining himself instead of making pictures.

Blanc's 1867 book, which said that colors should mix optically rather than on the palette, had led Seurat to a much earlier book by the old head of the dyeworks at the Gobelins tapestry factory, Michel-Eugène Chevreul. *De la Loi du contraste simultané des couleurs* was entirely on the relation of color to color perception.[15] The "law of simultaneous contrast" in the French title meant the effect different colors had on each other when set side by side. A red would evoke its opposite, green, in an adjacent patch of blue; the blue would evoke an orange in the adjacent red; and the result received by the eye would be an orangish-red next to a greenish-blue. In "successive contrast" the eye would carry red's evocation of green as it moved from a red patch in one place to a differently colored patch in another. There was a built-in "duration of impression" (or "persistence of vision," as the first makers of moving pictures were calling it) that made the visual appreciation of an art work successive rather than simultaneous.[16] Chevreul had also noted, as the impressionists did later, that shadows in nature were neither gray nor black, but colored. Chevreul's thoroughly scientific contribution to the psychology of perception struck Seurat before he had even begun to paint in oil, and helped him make sense of the close studies of early nineteenth-century masters he was making to prepare himself for that step. Neither Delacroix nor Corot had followed the rules of academy-class painting that were becoming fixed in Seurat's time, with their insistence on finish and

continuity of *facture*. Like Manet and the impressionists, whose work was still new to Seurat, Delacroix and Corot didn't have much "finish" in the way they treated edges, and were unwilling to shade one part of the painted surface seamlessly into the next, so as to move like Leonardo continuously from light (*chiaro*) into darkness (*oscuro*). Making notes on some Delacroix oils in 1881, Seurat noticed that Delacroix had covered the canvas with brushstrokes he hardly bothered to smooth out, laden with colors whose heightening effects on each other seemed clearly calculated. Millet, whose peasant subjects Seurat also favored, had even mixed sand into his paints.

1881 was the year Seurat made his first big oil painting of the *Woods at Pontaubert*. The earth tones were still on his palette, but the brushstrokes were small and made like the crosshatching in a drawing. He had thoroughly assimilated Delacroix's practice, Chevreul's science, and Chevreul's most important message: that painters ought not to paint what they saw, but instead combine colors in a "harmony of contrasts" composed for the purpose. It was true that Chevreul had confused the way colors of light combined with the way pigments mixed, but Seurat had found another book that year that cleared up the confusion—*Modern Chromatics,* a book on color psychology by Ogden Rood, a professor of physics in New York. The French translation had only just appeared in 1881, and Seurat had seen a review in the *Figaro* that January. Rood's knowledge of the latest in physics and experimental psychology had already earned him a good review in *The Nation* from that American Proteus of early Modernism, Charles Sanders Peirce. It would earn him the undying respect of Seurat the theorist. Rood knew that orange and blue light made white, not green, and he could quote James Clerk Maxwell as his authority that if you painted those same two colors on two halves of a disc they would mix to a brighter green in a "retinal after-image" when the disc was spun.[17] Helmholtz had made the same experiment in his great *Physiological Optics* and, building on *The Physiology of Color* by his old friend, the Viennese anatomist Ernst Brücke, had demonstrated that the receptors in the eye were matched to only a few primary colors.[18] Reviewing their work, Rood concluded that it was the mind that mixed the colors of light. The resulting advice to artists (for Rood was a Sunday painter, too) was that although you could not paint the natural world with pigments whose colors were the same as the colors you saw, it was still possible to evoke those colors in the eye by manipulating the effects of juxtaposed patches of paint.

And so the colors went on the *Grande Jatte* in strokes smaller and even more distinctive than Delacroix's, impressionist brushstrokes but without the impressionist variability. Seeking to do more than render nature, Seurat chose colors from his palette for the same reason he had chosen his motif—the harmony of opposites and their effect on the

viewer. The brushstrokes on the trees went up and down, those on the grass zigged and zagged. On clothes they followed creases. On the water they were horizontal dashes. He widened the skirt of the big woman in the foreground partly to bring her fashion up to date and partly to add a horizontal band of contrasting color just above the level of her hem where the verticals of the composition were strongest. He took the sleeves off of the reclining pipe-smoker to her left, not only to lower his social class a little and contrast him with the others, but also to match a swath of red shirt with an expanse of pink arm.

"If I was alone in 1885, I was nevertheless alive," Seurat would write later. The *Grande Jatte* was finished in March. Seurat had planned from the beginning to have it ready for the third show of the Artistes Indépendants planned for that month. Seurat was a member of the Indépendants. He had helped draw up their jury-free cooperative constitution, and their first show in 1884 had featured his *Baignade*. His *Grande Jatte* oil study had gone on public view for the first time in their latest show, the one that had closed on January 17. The Society's meetings in the Café Marengo had been his whole social life for a year while he soldiered away, brushstroke by brushstroke, to get his second great picture exhibited in the same way as his first.[19] "Punctual as a Swiss express" in the words of his biographer, Seurat came in on schedule; but the Artistes Indépendants did not.[20] Short of money, they had canceled the show. They said they might have another exhibition in October. Seurat decided the time had come for a vacation and got on a train to Normandy.

He returned from Grandcamp in August with five small seascapes in his trunk. Then he had to report for a month of military reserve duty in a town not far from Paris. In October, back at last at 16, rue de Chabrol, he took a long look at the *Grande Jatte*. The next Indépendants exhibition would not come until August 1886. There might be an Impressionist show sooner if old Camille Pissarro could get it together. Plenty of time to rework his picture. So he began to put on what most of us now call the "dots"—the characteristic sixteenth-inch dabs of high color that have been every viewer's first impression since the *Grande Jatte* was first exhibited, and which soon came to stand metonymically for every innovation Seurat brought to art.

The larger dots were probably already there, and Seurat was not yet at the point he would reach at Honfleur in the following summer, of coloring an entire canvas with dots alone; but the fall of 1885 was the moment when Seurat's *Grande Jatte* really began to fit the description Fénéon was to give of it in the 1886 *La Vogue*: "You will find on each centimeter of his surface, in a whirling host of tiny spots, all the elements that make up the tone."[21] Chevreul and Rood could explain their colors and brightnesses, and Rood could explain why they were so pure and unmixed; but why were they so small? Delacroix's brushstrokes had been

much larger. So were the brushstrokes the impressionists had used to bury the chiaroscuro ideal in the mud of its studio browns more than a decade ago. Rood's book made the point that John Ruskin, the respected Victorian art critic who admired painterly strokes of broken color, had once recommended very small dots of pigment on a white ground to evoke the colors of nature in the eye better than more intuitive methods. A suggestion might also have come to Seurat from new technology. The New York Graphic in 1880 had published the first newsprint reproduction of a photograph using the new "halftone screen," which turned it into tiny dots on the printing block. The Paris *L'Illustration,* a large-circulation pictorial, had pioneered a halftone screen process called chromotypogravure in 1881, and in December 1885 the magazine was publishing color photoengravings made with it—pictures Seurat, who loved popular poster art, would have seen.[22] From them it would be only a few steps to the three-color phosphor dots of the color television screen and the pixel of a computerized picture.

One thing was clear in any case. Almost every time Seurat broke up his surface into smaller parts, he would have found it possible to increase the luminosity of his colors. Perhaps Seurat was trying to enhance the effect of what Chevreul called "successive contrast" by multiplying and diversifying the places where those contrasts could be evoked at the same time as he narrowed the distance between them. Fénéon described the whole canvas as "transparent and singularly vibrant; the surface seems to flicker [*vaciller*]."[23] It still does, even after color changes and fading.

Why, Fénéon wondered? "Perhaps . . . the retina, expecting distinct groups of light rays to act upon it, perceives in very rapid alternation both the disassociated colored elements and their resultant color."[24] No, in fact, perhaps not—though it might alternate between one color and another, or colors and their simultaneous contrasts. "Isolated on the canvas," Fénéon thought, "these colors re-compose on the retina."[25] But they don't. The orange dots on the green grass do not "compose" to anything. Instead of altering the green, they disappear from the viewer's eye as soon as she has backed off a few feet from the canvas. To fuse the way TV phosphors do they would have to be as small as TV phosphors are.[26] If they mix at all it is not on the retina but in the mind. Did Seurat misunderstand his method? Did Fénéon misunderstand Seurat? Seurat did not leave enough evidence behind for us to say. Like many art critics since, Félix Fénéon, who later retreated from his high positivist analysis of divisionism, showed more enthusiasm for the results of science than respect for its methods.[27] Together with his friend the poet Gustave Kahn he stood on the threshhold of trends in high culture that would be largely antiscientific. Fénéon and Kahn in turn had another friend, Charles Henry, who lectured on the emotional effects of color and line at the Sorbonne, where he hoped one day to found an institute of experimental

psychology. Henry was writing a complete psychological esthetics in which he expected to give rigorously mathematical scientific explanations for all the elements of art. Having gone even further than Fénéon in completely mastering scientific language without ever coming to grips with its discipline, Henry had a seductive charm for his friends. If there was ever anything to his science, however, scientists have yet to find it.

Seurat's science was mostly correct and always seductive in 1885, but his science of painting was not what projected itself into the twentieth century. Instead it was the habit of analysis that underlay it, and the epistemological discontinuity the practice of it left with artists. Seurat, perhaps because he had not been an impressionist, was the first painter to grasp fully that impressionism was discontinuous—the first discontinuous painting since the Renaissance. Fénéon grasped it too, the first critic to do so. The old painting, he wrote, separated objects, not colors. The new painting, separating colors and shapes, was to be made by Seurat, his immediate disciples, the Norwegian genius Edvard Munch, and the ineluctable threesome of Gauguin, Van Gogh, and Cézanne. "The leader," Van Gogh wrote in 1888, "is undoubtedly Seurat."[28]

In 1885, the year Seurat reworked the *Grande Jatte* in the direction of divisionism, Munch was making his first trip to Paris on a Norwegian state art scholarship. He had already painted *Dansemoro,* a picture of a dance hall constructed with fuzzy blotches of color, like a Seurat sketch. Van Gogh and Toulouse-Lautrec were still learning their craft at Fernand Cormon's studio in Montmartre. Within the year divisionism would lead Van Gogh out of the dark world of Dutch *Potato-Eaters* into the realm of color and the thick, painterly dashes of primary hues that became the building blocks of his art. Paul Gauguin, ten years older than Seurat, was already exhibiting with the impressionists. In 1885 he had not yet left his wife and five children or discovered where his style was leading, but in a painting of 1884, *Sleeping Child,* the color pools had already appeared, and in back of the child's head was a whole wall of insistent indigo.[29] In his wife's city of Copenhagen he was beginning the manuscript published in 1910 as *Notes synthétiques,* aesthetic meditations in which he attacked analysis in a way that made clear his commitment to it.[30] Like Seurat, Gauguin would divide up the canvas into patches of color. His colors would be just as strong, but his patches would be a lot bigger, with colors verging on the deliberately false. "Colors," he wrote to his friend in January 1885, "are still more explicative, though less varied, than lines because of their power over the eye."[31] They come in "units" like musical tones, he wrote in the *Notes,* and like tones they can be harmonized; but the eye takes them in all at once instead of sequentially, and there are many many more colors than there are notes. "Take as many units as there are colors in the rainbow, add to those the units made by the com-

posite colors, and you arrive at . . . an accumulation of numbers, truly a Chinese puzzle." Keep them separate, Gauguin told himself, and choose them so they vibrate against each other in the mind.[32] His style would eventually come to be called "cloisonnism" after the pools of single, un-modulated color that appeared within compartments ("cloisons") out-lined by copper wire in the ancient art of metal enameling.[33]

Sharp-edged, flat planes of color had been experimented with before. Manet had used them in the 1870s. They were part of the charm of the newly fashionable Japanese prints and the poster art of Jules Chéret, which were working their way into the paintings of Toulouse-Lautrec.[34] But Gauguin was the first to paint such planes in nearly abstract shapes and in colors that took leave of nature. He told himself that he was at heart a decorator.[35] By the summer of 1888, Gauguin would be painting *La Lutte de Jacob avec l'ange* (Vision after the sermon), converting dis-ciples of his own in Pont-Aven, Brittany, and rooming with Van Gogh in Arles.[36] The new reason he gave for the choices he was making as a painter was the shedding of bourgeois conventions in order to achieve direct communion with the primitive and the transcendant. That is to say, having understood the division of painted surfaces through conscious analysis, Gauguin was now trying to overcome the consequences of that understanding. Leaving for Tahiti in 1891, Gauguin's intention was to spend the rest of his career trying to paint in the same unmediated way he thought the Tahitians lived, which may be one reason he drank.

But the finite division of surfaces, of space, of canvases was not the only sort of analysis that changed Western art in the twentieth century. There was also the division of time. As plans went forward in the 1880s for the Eiffel Tower to broadcast standard time to France, advances in accurate time division had already converged with faster shutters and the increasing exposure speeds of photographic film to create a new artistic technology, one that could divide time into bits just as multitudinous and discrete as those now found in spaces, and offer, at last, a convincing illusion of motion.

At least one great impressionist painter was already responding. In 1881 and 1882 Claude Monet had gone to the Norman coast and painted the first of his famous "series" paintings of the same subject un-der the successively changing light of different times of day, "fragmenting the object (conceived as a duration) into a succession of observed mo-ments," in the words of an art historian.[37] Monet wrote a friend that he was painting "instantaneity."[38] In 1886 the paintings in this series were exhibited together for the first time, and reviewed (of course) by Fén-éon.[39] However, the innovators who "fragmented the object (conceived as a duration)" into "instantaneity" with the new technology were not painters but engineers: Etienne-Jules Marey, a French professor of experi-

mental physiology and psychology, and Eadweard Muybridge, an English photographer who had changed his name from Muggeridge and emigrated to California.

While Seurat had been learning the "science of painting," Muybridge and Marey had independently been using pictures made by the new fast cameras and film to divide time. In 1877 Muybridge had won a bet for a California railroad baron named Stanford by taking consecutive photographs of a running horse so fast that he could prove that there was indeed one point during a gallop when all four of its hoofs were off the ground. It had taken him five years to get it right. Marey, too, had begun measuring the gaits of horses in 1872. Marey's method was to attach devices he called "inscriptors" to their fetlocks and horseshoes, and he published a book on the results in 1873. In 1878 he published another book about the many methods he had been using for more than a decade to determine and to sequence the movements of all sorts of animals. Marey had adopted more and more photographic methods in the 1870s; and though his shutters were always a bit slower than Muybridge's, his pictures were more precisely timed, dividing the motion he was studying into exactly equal parts. In the autumn of 1878, Marey explained to a scientific congress how hard the timing problem was by using a Phenakistoscope, Joseph Plateau's invention from the 1830s that put a strip of pictures in front of rotating slots to give the illusion of motion.

In December of the same year, Marey saw Muybridge's galloping horse pictures for the first time in the Paris science periodical *La Nature,* together with the news that Muybridge had gotten his shutter speed down to one two-hundredth of a second. Marey was on the same track. He had just borrowed an astronomical camera with an automatic repeating shutter, mounted it on a stock, and announced in *La Nature* that month that he had invented something called a "photographic gun." In 1879 Marey wrote to Muybridge about how his pictures could be shown in rapid sequence to reproduce animal motion, and Muybridge doubled the number of his cameras to twenty-four and came up with a projector. Plateau had shown in 1836 that if pictures succeeded each other at a rate of sixteen frames a second or more, the "persistence of vision" would make it seem as if the motion pictured was continuous. When Muybridge came to Europe in 1881 to tour with his "zoöpraxiscope" projector, a transparent rotating disc with the sequence of pictures overlaid around its circumference, he and Marey met at last. Marey showed Muybridge how he could take twelve photos a second, and Muybridge showed Marey how he had gotten his shutter speed down to one five-hundredth of a second. When Seurat began the *Grande Jatte* in 1884, Muybridge was back in America, showing the painter Thomas Eakins how to use a Marey wheel to time a moving-picture sequence of a male model; Ottomar Anschütz in Berlin was making his first moving pictures; and Ernst

Mach in Vienna was beginning his experiments with stop-motion pho-
tography of bullets in flight. When the *Grande Jatte* went on exhibit in
1886, Marey was in the town of Nancy explaining moving pictures to
the Congress of the French Association for the Advancement of Science.
Thomas Edison got into the game in 1888, but by then moving pictures
were a reality.

In the *Grande Jatte,* however, time still stood still. On May 15, 1886,
the "Eighth Exhibition of Painting" opened on the second floor of a res-
taurant called La Maison Dorée—The Gilded House—where the rue La-
fitte begins off the fashionable Boulevard des Italiens. It was the eighth
impressionist show, but the impressionists were so divided by then that
they would never exhibit together again, and agreed only that they would
not use the word "impressionist" in the title. Nevertheless, Camille Pis-
sarro had patched up as many quarrels as he could. By now Pissarro
was so impressed with Seurat's work that he was practicing divisionism
himself, and he sent no less a personage than Berthe Morisot to invite
Seurat to show the *Grande Jatte.* And so it was that Seurat's painting
went before the public at last, not with the Indépendants but with the
impressionists. No one left any record of what it was like getting Seurat's
picture down five flights of stairs; but it is hard to imagine Seurat losing
any of his preternatural dignity over it. Once on the wall the picture mes-
merized gallerygoers, who stared at it with almost as much intensity as
Seurat had over the past year and a half. It took over the room. It took
over the show, overshadowing the nineteen Gauguins and the wonderful
Degas series of women poised over their bathing tubs. Seurat had his
moment. With his long, square-cut "apostolic beard" he struck one visi-
tor as having the profile of an Assyrian king.[40] He was introduced to
Fénéon (whose own beard, a goatee, reminded his friends of either Meph-
istopheles or Uncle Sam), and Fénéon went off to write his now-classic
review, the first of five he published that year, explaining how Seurat had
made painting "scientific." Seurat also met Gustave Kahn and the Belgian
Emile Verhaeren, symbolist poets, who took time off from inventing "free
verse" to chime in with fascinated reviews. He met Kahn's scientific friend
Charles Henry, who promptly wrote about Seurat as a fellow researcher.
No less than nineteen other writers hastened to publish their opinions.
George Moore, an aspiring Irish writer then at large in Paris, put the
story in his memoirs. The experience of seeing the *Grande Jatte* for the
first time was hard to forget.

Before 1886 ended the *Grande Jatte* was exhibited again. It was the
fall exhibition of the Indépendants, who had finally come through. Seu-
rat's reputation was made, and painters and critics would hang on his
every move. He would go on to produce at least one big picture a year
besides his summer seascapes. Disturbingly punctual with his thousands
of dots, he would paint *Les Poseuses* (Models) in 1887, *Parade du Cirque*

(Sideshow) in 1888, *La Poudreuse* (Young woman powdering herself) in 1889, *Chahut* (Cancan) in 1890, and *Le Cirque* (Circus) in 1891. Each was a new challenge for his techniques: *Models* was his first interior nude, *Sideshow* his first nocturne (illuminated by the frequencies found in gaslight, it takes on a completely different look), and *La Poudreuse* his first portrait. *Chahut* and *Cirque* were nocturnal interiors in movement illustrating theories Seurat shared with Charles Henry about the emotional content of angles and lines. By then many of the dots on the *Grande Jatte* had begun to darken. The emerald greens and oranges had been mixed with a very bad cadmium yellow that Pissarro warned Seurat about just a little too late. Today we have no way of knowing what the *Grande Jatte* really looked like, or of testing whether Seurat really carried out his "chromoluminescent" program.

Six years after finishing *La Grande Jatte,* Seurat suddenly died. He had gone home to his mother's to recover from a throat infection. A few blocks away, at his new studio, *Le Cirque* was left on the big easel and his thirteen-month-old son was showing the first symptoms of the same fatal disease. It was March 29, 1891. Two days after the funeral Gauguin would take ship for Tahiti. He had not gone to the funeral, nor had Seurat gone to the dinner held by Gauguin's symbolist friends to raise funds for Gauguin's trip, for they had quarreled just after the *Grande Jatte* exhibit. Munch had returned to Paris that spring and was painting outdoor scenes with divisionist dots. Lautrec was still painting the lowlifes of his beloved Montmartre; and Cézanne was still going out whenever the weather was good to paint the view of Sainte-Victoire mountain across the valley of the Arc from his hometown studio in the south of France. As for Vincent van Gogh, he was already dead. After several breakdowns and a stay in an asylum, he had gone to Auvers to live and work near the fashionable nervous specialist Dr. Gachet. Gachet loved the new art and liked to hang Gauguins, Cézannes, Van Goghs, and Pissarros all over his walls. In a field not far from the doctor's house, Van Gogh had shot himself on July 27, 1890, a few weeks before Seurat would sum up his artistic credo in the words "Art is Harmony."[41]

In July 1891, a Polish sea captain named Joseph Conrad passed through Auvers. He was hoping Dr. Gachet might help him recover from the lingering effects of his nearly fatal trip up the Congo River in the fall of 1890. He did not stay long. All over Gachet's wall, he wrote to a friend in Poland, were "nightmarish" paintings by the "Charenton School."[42] Eight years later when Conrad came to write his fictionalized account of the Congo trip, he called it "Heart of Darkness" and cast it in the modern-sounding narrative voice of a man trying to recount a nightmare. Modernism in art came before Modernism in fiction, and reactions to it (even by Modernists) were more visceral. A few weeks after Van Gogh's suicide, Seurat had written, "Art is Harmony;" but even if Seurat saw art

as a harmony of opposites, what he had set loose in the world was an art that had so many separable parts—so many potential opposites—that harmony lost its value and the parts took on a life of their own. A better description of Seurat's legacy is the dictum published at the same time by Gauguin's disciple, Maurice Denis. "It is well to remember that a picture—before being a battle-horse, a nude woman, or some anecdote—is essentially a plane surface covered with colors assembled in a certain order."[43]

In fact, Seurat was the first consciously to objectify the painting, separating its rules from those of reality. In 1885, before he finished his reworking of the *Grande Jatte,* the challenge to continuity in the space of painting had not been made explicit. By the time he died in 1891, the challenge was almost unanswerable. Not only had colors been separated from each other; colors had been separated from compositional space, dimensions from each other, and subjects from each other and from all the rest. The dialectic of parts and wholes was inescapable.

In the year Seurat died, the first expressionists had yet to encounter the passionate brushstrokes of Van Gogh. Cézanne had had no effect on Pablo Ruiz, who was a ten-year-old boy in Málaga and not yet Picasso. The first fauves, however, were poised to learn from Seurat's dots and Gauguin's false colors. In October 1891, Henri Matisse gave up his legal career and registered at the Académie Julian in Paris to learn painting.

Also in that year, Edison patented the kinetograph movie camera.

6 WHITMAN, RIMBAUD, AND JULES LAFORGUE

POEMS WITHOUT METER

1886

According to English and American literary histories, Modernism in poetry was created in the years 1910–1913 by some "little magazines" edited by Ezra Pound, and four men with initials—T. S. Eliot, D. H. Lawrence, F. S. Flint, and T. E. Hulme—inspired by Walt Whitman. But almost all of these initiators denied it. Their mentors, they said, were all French, except for Whitman. To Whitman's invention, free verse, they even gave a borrowed French name, *vers libre*. As Pound himself put it in *Poetry,* in 1913, "Practically the whole development of the English verse-art has been achieved by steals from the French."[1]

They were right. Unlikely as it sounds, Modern (modernist) poetry was launched in France, a generation before, in a single year—1886. That spring, Léo d'Orfer, a critic; Gustave Kahn, an adventurous minor poet; and Félix Fénéon, an editor of genius and the art critic who would first explain Seurat, began publishing a new literary weekly in Paris. It was called *La Vogue.* In April, the first issue was confiscated for obscenity. Regular publication, which began in May, ceased in January 1887, never to resume. There were only about twenty numbers all told, and only a few hundred copies of each one, but they contained multitudes. Most importantly, this "little magazine" contained the most powerfully influential work of the three "onlie begetters" of Modern poetry: Walt Whitman, Arthur Rimbaud, and Jules Laforgue.

None of the three lived anywhere near *La Vogue*'s editorial offices on the rue Laugier in Paris, but Laforgue was close enough to visit. In 1886 he was in Berlin, serving as French reader to the old Empress Augusta of Germany. The previous year, 1885, had been endlessly encouraging. Victor Hugo had finally died, removing the weight of his colossal authority from the future of poetry; and Laforgue himself had finally succeeded in getting his first two books into print, one volume of fifty-two poems called *Complaintes* (Complaints) and another of twenty-two called

L'Imitation de Notre-Dame la Lune (Imitation of Our Lady the Moon). Of course, Laforgue had had to pay Vanier, his publisher, for this pleasure; but for his next two books he was negotiating the kind of contract where the publisher paid the writer. Both of the new books, a third volume of poems and his first collection of stories, were well under way. Meanwhile his old friend, Gustave Kahn, was publishing the new poems and stories, one by one, in *La Vogue*. In those same pages, Fénéon was editing, under the title *Les Illuminations,* poems written a decade ago by Arthur Rimbaud, the *enfant terrible* whom everyone in Paris thought was dead. Somewhere else on his desk Laforgue kept the translation he was working on: *Brins d'herbe* (Leaves of Grass), an old book of poems by a bearded patriarch in America named Walt Whitman. Always slightly ahead of fashion, Laforgue had shaved his beard. Twenty-six, and in love with his English teacher, a black-eyed, chestnut-haired Devonshire beauty named Leah Lee, Jules Laforgue's large confidence in his own future was not misplaced. Today there are readers in half a dozen Western languages ready to name Laforgue as the most modern of the three great poets of *La Vogue*.

Laforgue's unusual job had been found for him in 1881 by indulgent friends, including the suave art historian Charles Ephrussi (Proust would later take Ephrussi as a model for Swann), because the pay was comfortable and regular, and the demands were both limited and pleasant, including, for example, long summer vacations in Paris. Laforgue was a handsome cigar-smoking dandy who relished the opportunity to wear frock coats, toppers, and morning dress when he went over to sit with the old empress and read her the tony *Revue des deux mondes* in the language she preferred to German. Just the thing for an artist whose parents weren't rich.

Laforgue's parents were not really poor, just good bourgeois in straitened circumstances. His father had done well as a bank manager, but he had also fathered eleven children. The Laforgues were also, in a curious way, immigrants. Both parents had been born in France, but they had grown up, married, and begun their family in South America. Born in Montevideo, Uruguay (like his predecessor Lautréamont), Jules Laforgue had not come to France until he was six years old, just in time for the French humiliation in the war with Prussia and the Red revolt in Paris.

He had had school problems, too. Although his intelligence had been obvious in the *lycées* of Tarbes and Paris, he had failed his baccalaureate examination in his senior year of high school—twice—while his schoolmate Henri Bergson, who had won lesser prizes, went on to academic glory. That was in 1877, the year his mother died bearing her twelfth child. Ineligible for college, Jules took to hanging out over at the Beaux-Arts School, where his brother Emile was learning design.[2] He audited courses, doodled portraits in his notebook, and showed up at public lec-

tures on art history given by the fashionable positivist Hippolyte Taine. When he tried to continue his education by reading on his own, he found himself turned down for a reader's card at the Bibliothèque Nationale, France's Library of Congress, on the grounds that he had no diploma.

On his second try in 1879 Laforgue managed to get his library card by pleading literary ambition; but by then he was increasingly alone in Paris. He still sorely missed his mother. His widowed father had taken sick and returned to the provinces. His oldest sister Marie, who inherited the job of keeping house for the children still in Paris, moved soon after from the old house on the Right Bank, near Montmartre, to newer but even more crowded digs on the Left Bank. Jules helped by staying out as much as possible. Eventually he got an airless little room of his own, not far from the Luxemburg Gardens. There he read and wrote, publishing occasionally in a provincial paper in Toulouse. "Two years of solitude in libraries, without love, without friends, fearing death."[3] "When I read my journal of that time I ask myself with shudders how I didn't die of them."[4] Among his earliest readings were the German ironist Heinrich Heine, "who sobs and smiles, with a bitter smile,"[5] and Charles Baudelaire, whose single book of "indecent" poems, *Les Fleurs du mal* (Flowers of evil), was beginning to be thought worthy by a few young people to replace the twenty volumes of Victor Hugo as the most powerful French poetry of the nineteenth century.

Laforgue moved on to even more depressing books, like Schopenhauer's *World as Will and Idea,* which insisted on the calamity of too long life brought on by a "will to live" that was blind, inhuman, and irresistible. He pored over Buddhist and Hindu scriptures that swept individuals into a transcendental world-soul. Then there was that strange book, *Philosophy of the Unconscious,* by Eduard von Hartmann, just translated from German into French, whose message was that the world-soul (called "the Unconscious") really existed and that it was malevolent through and through, controlling every random event that surged into consciousness, though consciousness could never perceive it. "I was a believer," he wrote later.

> For five months I played at the ascetic, the little Buddha with two eggs and a glass of water a day and six hours of library. . . . At 19 I dreamed of going out over the world, feet bare, preaching the true law, the abandonment of ideas, the postponement of life, etc. (you know the tunes). Alas! at the first stage, the gendarmes would have arrested me as a vagrant—Prophecy is no longer a trade.[6]

It all qualified him perfectly to belong to the French literary-artistic school called *Décadence,* then taking over from *Réalisme* in the first great revolt against the scientism and positivism of the age of industry. In the view of one of its early leaders, Paul Bourget, Décadence was based on

artificiality and dream. It tended in philosophy toward pessimistic ideal-
ism, and in art and literature toward the celebration of perversity and
luxurious decay. Its progenitors, he wrote, were Edgar Allan Poe, Baude-
laire (who was Poe's French translator), and Count Villiers de l'Isle-Adam
and Stéphane Mallarmé, who were disciples of both of them. "We ac-
cept," wrote Bourget in 1876, "without humility as without pride, this
terrible word decadence."[7] Laforgue's acceptance of decadence seems to
have been nothing more than a bad dose of adolescent depression. He
began a book of poems he called *Le Sanglot de la terre* (The sob of the
earth) about how awful it was to go on existing in a meaningless universe.

> The storm beats on my windowpane, the wind exhales
> To bloom the log where my boredom stirs the coals
> Oh! Autumn, autumn!

As he wrote apologetically two years later, "That is by me. My God,
yes."[8]

Like most poets, Laforgue was more in need of contemporaries than
he was of models. As the winter of 1879–1880 at last began to wane,
Laforgue met the three men who were to become his first great literary
friends and backers. One was Charles Henry, who knew mathematics as
well as he knew poetry and is still remembered as Seurat's mentor on the
meaning of lines. Then there was the man who introduced him to Henry,
Gustave Kahn, a poet who had published "poems in prose" as far back
as 1879, and was thus well on his way to becoming one of the inventors
of something the French were to call *vers libre*. In France the rules of
prosody were taken much more seriously than they ever were in England.
Lines had to have a correct count of syllables, because in French the beat
is too fluid to be the basis for meter. Twelve was classic, ten acceptable;
but lines with eleven or some other uneven number of syllables were
frowned on. Even unrhymed (blank) verse was considered bad form.
Baudelaire had written some "poems in prose," and so had a few of his
successors like Verlaine, Cros, Mallarmé, and Rimbaud; but until Mod-
ernism took over, prose poems were hard to publish in France. As for *vers
libre*, it was unknown. Before 1886, the only French poet who had writ-
ten poems with a different number of syllables in every line was Rim-
baud, and this work was still in manuscript.[9]

Laforgue seems to have met Kahn at a meeting of the Hydropathes
(it translates as either Water-Haters or Water-Curers), a club where bright
young Frenchmen got drunk and entertained each other on Wednesday
and Saturday evenings with contentious talk, humor, and poetry. Here he
seems also to have met Paul Bourget, the oracle of Décadence, who lived
less than a block from the café in the rue Jussieu where the Hydropathes
met, and had been among their founders in 1878, together with the cari-
caturist André Gill, the humorist Alphonse Allais, and the poet Charles

Cros. Cros, who had invented the phonograph and was working on color photography, had a broad curly mop of hair, a generous moustache, and features and coloring that made him look rather like a Pacific Islander. He had been one of the poets Rimbaud had stayed with when he came to Paris in 1871; but when Rimbaud began seducing the poet Paul Verlaine, Cros had dropped him. After all, Cros's close friend, Charles de Sivry, was Verlaine's wife's brother. In the early 1870s Cros had published with Mallarmé, Villiers, and Verlaine in the most adventurous little magazine of 1872, the short-lived weekly *Renaissance littéraire et artistique,* edited by a man named Emile Blémont who had an avant-garde taste for prose poems, monologues, and English literature. Laforgue never did make a friend of Cros, but he must have been pleased to meet him, since he had reviewed a new edition of Cros's only book of poems for the Toulouse *Wasp* the year before, and liked it enough to keep it by him the rest of his life. The Hydropathes kept from drowning in Décadence by making fun of things, and it was Cros's humor that went deepest. "I am the one who got expelled from the old pagodas," one of his poems began, "Having laughed a little during the mysteries."[10] His fellow Hydropathes particularly relished a number Cros would do standing up in the middle of the evening to recite, utterly deadpan, a poem he claimed to have written for Villiers and published as a sort of nursery rhyme in Blémont's *Renaissance* in 1872.

THE KIPPERED HERRING

There was a great white wall—bare, bare, bare,
Against the wall a ladder—high, high, high,
And below, a kippered herring—dry, dry, dry.

.

I composed this simple story—simple, simple, simple,
To infuriate serious people—solemn, solemn, solemn,
And entertain little children—small, small, small.[11]

The Hydropathes did not know it at the time, but the most influential art form they ever sent down into the world below Montmartre turned out to be an extension of "The Kippered Herring." Sometime before the club's founding, Charles Cros's little nursery rhyme had crossed the path of one of France's better-known actors, Ernest Coquelin, known as Coquelin Cadet, or Coquelin the Younger. In the form of a comic lecture in his own voice in 1881, Coquelin Cadet gave his own version of his discovery, calling Cros the "mother" and himself the "midwife" of this "child of bizarre conformation whose first babble was 'The Kippered Herring,'" which Coquelin reports hearing Cros recite at a supper in Batignolles one summer morning at four A.M.[12] Since this was the age of the lecture and the platform performance, Coquelin discovered that there was

both fortune and reputation to be made in reciting "The Kippered Herring." He wanted more like it; but what was it? a poem? a dramatic recitation? a playlet? Today we would unhesitatingly label it stand-up comedy or performance art, but in nineteenth-century Paris such forms had yet to be invented. Over the next ten years Coquelin commissioned at least a dozen of Cros's pieces, gave them the theatrical name *monologues,* and created a rage that spread first to Cros's friends and fellow Hydropathes from Sivry to Allais, and eventually to most of the playwrights and songwriters in France.[13]

The new form was short, but otherwise it resembled the humorous mock lecture with which Americans like "Josh Billings" and "Artemus Ward" had recently learned how to pack houses in New York and London. In 1876, one of the American humorous lecturers—he called himself "Mark Twain"—had begun applying the form to a novel, with the result he described in a letter as "Huck Finn's autobiography." Besides concision, the biggest difference between the monologue and the humorous lecture seemed to be that in monologue the joke was always on the speaker, and also, to some extent, on the universe. Monologue also resembled in more than name something the English called "dramatic monologue," a poetic form that had begun to crowd out the direct lyric back in the 1830s when English romanticism was coming to an end. Dramatic monologue had allowed Robert Browning to avoid being identified with "Porphyria's Lover," and Alfred Tennyson to distance himself from "Ulysses." The difference was that in the best of monologue the distance was harder to assess. Was the man who nails up the herring a moron, a humorist, or the possessor of transcendant wisdom? Was he all three? Was the storyteller any simpler? In any case, could either of them be Cros? The questions are no easier to answer in any of Cros's monologues—for example, "Autrefois" (Yesterdays):

> Long ago . . . but long isn't enough to give you the idea. Still, how better to say it?
> Long ago. Long, long ago. I mean long ago, long ago, long ago.
> So, one day . . . but there was no day yet. Or night either. So. One time . . . but there was no . . . Yes there was, what do you want me to say? So he got it into his head (no, there was no head) He got the idea . . . Yes, that's it. He got the idea to do something.
> He wanted to drink. But what to drink. There was no vermouth, no madeira, no white wine, no red wine, no Dréher beer, no cider, no water! It's because you haven't realized they'd have had to invent all that; and it hadn't been done, that there's been progress. Ah! Progress.[14]

But by 1881 the Hydropathes had stopped meeting, and Laforgue and Kahn were following the crowd to Le Chat Noir.

The Black Cat café opened in Montmartre in 1881, and remained for more than a decade the epicenter of revolt in France's artistic life.[15] It was decorated in high and low relief, inside and out, with caricatures, impossible visions, black cats, and symbols in every size of the tabooed and diabolical. The decorators were the emerging geniuses of the poster and the cartoon, like André Gill and Willette; and their employer, Rodolphe Salis, ran Le Chat Noir as if Montmartre were a foreign country. The patrons were anarchists, artists, and professional eccentrics, and a good many of the best minds in Paris. Even the most proper of intellectuals seldom passed up a chance to go slumming up on the Butte. There, along with undistinguished food and drink, they were offered entertainments whose special feature was that no one knew how seriously they were supposed to be taken. From small platforms in different rooms *chansonniers* in eccentric outfits sang devastating satires against anything official or established, and writers from amateur to disreputable read their stories out loud. It became, even when Coquelin wasn't there, the world headquarters of monologue, the place where one could hear Cros himself, Allais and Sivry, Maurice Mac-Nab and Jéhan Rictus, and the extraordinary *diseuse* Yvette Guilbert.

How much of an impression monologue was making on Laforgue may be judged from his "Tristesse de réverbère" (Sadness of a streetlight), a prose sketch he published in September 1881.

> I'm a streetlight getting bored. Oh! You must have noticed me. You know? at the corner of Mouffetard and Pot-de-Fer streets. A lowdown corner, right? To my right a wine shop, to my left a baker.
>
> Have you considered the fate of a being who can only see at night? . . .
>
> In the wine merchant's shop, they bray, they drink, they smoke, and, through the windows of houses, I see the lamps, those sweet virgins who, in modesty, veil themselves with a lampshade.
>
> At midnight, the wine merchant closes up. Behind the illuminated curtains I make out the forms of good citizens going to bed. And other things, but I am a self-respecting streetlight.
>
> Soon, all the windows go out. Then in the great silence of a deserted neighborhood, I listen . . .
>
> A faraway footstep fades away. A sleepy hansom. A drunk who makes monologues. . . .
>
> What a lousy neighborhood.[16]

Within months of the Black Cat's founding, Salis had launched a weekly paper, edited by Allais, featuring poetry and prose by the café's entertainers and cartoons by those who had decorated its bar. In its pages, *Le Chat noir* preserved the best of Salis's Montmartre leftism and his ephemeral entertainments while it satisfyingly scandalized the good citizens of Victorian Paris. The café served as a base for incursions into

the city, and for elaborately concocted hoaxes like the Salon of Incoherent Arts that went on yearly from 1882 to 1889. One of the inventors of musical Modernism, Erik Satie, was playing "second piano" there around the time of the 1889 World's Fair, and in 1886 Henri Rivière began projecting fantasies of the past and future on the Chat Noir's walls, something Salis billed as the "shadow-theater." By 1898, the Chat Noir itself had closed, but its style and atmosphere were known all over Europe and copied in every metropolis, from Els Quatre Gats where Picasso met the artists in Barcelona to the Griensteidl in Vienna where Karl Kraus composed his anti-Victorian lampoons. The French even had their own word, still untranslatable, for the combination of the outrageous and the deadpan that constituted the Chat Noir attitude: *fumisterie,* or what we might translate as smokescreening.

Laforgue's *Sobs* certainly demonstrate a crying need for smokescreening. Laforgue began adopting the *fumiste* style in 1881, and the Chat Noir was one of the places he picked it up. Willette's early panel cartoon, launched by Le Chat Noir in 1881 and starring a clownish character called "Pierrot fumiste," impressed Laforgue so powerfully that by August 1882 he had borrowed the title and the character for a play. Laforgue's Pierrot was an anguished virgin (Laforgue himself may have been one), maintaining his virginity through a comic honeymoon by regular invocations of Schopenhauer. Clearly ridiculous, but curiously heroic. To Sanda Mahali, a fellow poet, Laforgue wrote that "Pierrot" made him laugh "convulsively," but perhaps that is because he was then flirting very inconclusively with Mahali herself.[17]

It was soon after Bourget and Ephrussi got Laforgue away to Berlin in November 1881 that he finally tried applying the tone of monologue to poetry. He put the *Sobs* away in a drawer and began the *Complaintes.* They were in verse, rhymed and with exact syllable counts, but the counts kept changing. Several different verse-forms often appeared in the same poem. Here and there snatches of cabaret songs and street ballads would bubble up and disappear. The mood was ironic, with several tones of voice working against each other:

> Ladies and gentlemen
> Whose mother is no more,
> The old gravedigger
> Scratches at your door.
> Six feet down
> Is a dead man's place;
> He hardly ever
> Shows his face.[18]

A year later, in December, 1882, Laforgue was "working like a slave ... at night by lamplight" on the new poems.[19] Verlaine had just pub-

lished his advice to poets to "wring the neck of eloquence,"[20] but La-
forgue was doing it better than Verlaine himself.[21]

> The universe without a doubt
> Is inside out! . . .
>
>
> —Ah, if only a woman were to come to me,
> Ready to drink from my lips or die!
>
>
> May God grant me leave until that day
> To live in the same old compromised way.
> Where does human or divine
> Dignity begin or end?
> Let us juggle entities:
> Pierrot trembles, the Almighty leads!
> Now you see them, now you don't,
> Now you don't, and now you do,
> All opposites are the same,
> And the Universe will not suffice!
> And having adopted as my aim
> A life of impossibility,
> I feel less and less localized.[22]

As he wrote his sister Marie in May of 1883,

I've given up my old ideal of Berthollet street, my philosophical poems. I
think it's stupid now to put on a big voice and play at eloquence. Now that
I am more sceptical and get wound up less easily, now that, on the other
hand, I have hold of my language in a more precise and clownlike fashion,
I write little poetic fantasies, with a single goal: making something original
at all costs.[23]

Ten days later, Laforgue sent one of the *Complaintes*, "Complainte des
journées," to Coquelin Cadet as a monologue.[24] There was no reply. La-
forgue had gone beyond such mentors. He was now writing poetry in-
stead of performance art.

Laforgue sent *Les Complaintes* off to Vanier, "the publisher of the
Moderns," in March 1884, little suspecting that Vanier would sit on it
for a year and a half, and began work on a series of verse monologues
he eventually called *L'Imitation de Notre-Dame la Lune* (Imitation of
Our Lady the Moon). As its title suggests, the irony here was even more
pervasive and delicate. To a bookstore browser in 1885, the year Vanier
finally published it, *Imitation* probably looked like the latest thing in Dé-
cadent poetry about ghostly ladies in vaguely medieval settings, but such
a browser would have been quickly disabused. Too much playfulness and

colloquial diction—this writer was not, as the French say, serious. In 1886, when the word "symboliste" began to be applied to young poets, Laforgue's work still didn't seem to fit.

Except to the English poet and critic Arthur Symons. In 1899, for a book version of his 1893 article on contemporary literature, Symons would abandon the term "Decadent" and rename the entire era from 1872 to 1898, including Laforgue, as The Symbolist Movement. Symbolism he would define as the literary group that came to the Tuesday get-togethers at Mallarmé's Paris apartment. Mallarmé's "Tuesdays" had begun very informally in 1872, when the hot literary *-ismes* were realism and Parnassianism. They were still going on when Décadence became fashionable in about 1880, and continued when the poet Jean Moréas published his "Symbolist Manifesto" in 1886, and the word *Symboliste* began to replace *Décadent*. By the time Symons and his friend William Butler Yeats appeared there in the 1890s, nearly every French writer under forty was likely to be labelled a symbolist, together with a gaggle of Belgian poets (like Maurice Maeterlinck and Emile Verhaeren) and several painters (like Odilon Redon and Gustave Moreau). Mallarmé's poetry, sparse and difficult as it was, served as a standard for the rest; but so did the work of of a much stranger person. There was a sonnet by him called "Voyelles" (Vowels) in the October 1883 issue of *Lutèce,* which Laforgue must have read before he sent his *Complaintes* to Lutèce's editor, Vanier. It was the fourth published poem of Arthur Rimbaud.[25]

Rimbaud was poetry's Billy the Kid. Already a vanished legend in 1883, he had crashed into the Paris literary world in 1871, when he was sixteen years old and the Germans were besieging Paris. When the police sent him home as a vagrant, he left, but turned around and walked back. In Paris he had met Cros and Mallarmé, published a single poem in Blémont's *Renaissance littéraire et artistique,* and run off with Verlaine to London. In a Brussels café in 1873, Verlaine had pulled out a revolver and shot him. Rimbaud had survived, and in 1875, in Stuttgart, Germany, he had seen Verlaine for the last time, handing over a handful of manuscripts and saying goodbye. He was barely twenty then, but he was never to write another poem. Blémont and Verlaine kept manuscript copies of "Vowels," which he had written at the age of sixteen when neither he nor anyone else had heard of "symbolism." Now the poem is habitually exhibited as the best illustration of symbolist aesthetics:

> Black A, white E, red I, green U, blue O—vowels
> Some day I will open your silent pregnancies
> A, black belt hairy with bursting flies
> Bumbling and buzzing over stinking cruelties
>
> Pits of night; E, candor of sand and pavilions,
> High glacial spears, white kings, trembling Queen Anne's lace;

I, bloody spittle, laughter dribbling from a face
In wild denial or in anger, vermilions;

U, . . . divine movement of viridian seas

· · · · · · · · · · · · · · ·

O, supreme Trumpet, harsh with strange stridencies

· · · · · · · · · · · · · · · · ·

O . . . OMEGA . . . the violet light of His Eyes![26]

In a letter to his high school teacher written a little earlier than the poem, Rimbaud explained how he aimed deliberately to unhinge himself in order to become a visionary. The interrelation of different sense experiences, technically called "synesthesia," was part of that unhinging. So was opium and hashish. The assault on positivism—on rationality itself—could not have been made clearer, and included references to everything that could charm a Décadent, including occultism. But "Vowels" is no more Modernist than any of the other poems Rimbaud had written before he came to Paris. To begin with, it's a sonnet that rhymes. In 1873 Rimbaud had gone much further than that in a set of poems he had written about the Verlaine affair and privately printed as *Une Saison en Enfer* (A season in Hell). They were partly in prose, partly in unconventional and simplified verse-forms. If the parts were not formally new, the combination was; and it was well suited to convey the mixture of hallucination and confession with which Rimbaud accounted for a relationship that had gone from exchanging poems to crotch-fondling in cafés and had ended with a public shooting.

But it is the poems he wrote last, the ones he gave to Verlaine in Stuttgart, that are the basis of Modernism's claim on Rimbaud.[27] Over the next eleven years, they passed in and out of Verlaine's hands, ending up with his brother-in-law, Sivry, but no one seemed in any hurry to publish them. As they had no collective title, Verlaine took the word "Illumination" from the bottom of the manuscript of "Promontory," a poem inspired by Rimbaud's visit to an English seacoast resort in 1874, and told Fénéon to call them *Illuminations,* an English word for medieval manuscript paintings.[28] In May 1886 Kahn and Fénéon laid out the first *Illumination,* "Après le déluge" (After the flood) in the pages of the fifth issue of *La Vogue.*[29] Five issues later, in June, they had printed them all, the most unconventional and difficult poems French readers had ever seen.

Rimbaud himself had no way of knowing the fate of *Illuminations.* The news that he was alive had no way of reaching Paris. His only correspondents were his mother, his sisters, and business acquaintances, none of whom knew or cared that *La Vogue* existed. Verlaine couldn't be sure whether Rimbaud was dead or in darkest Africa. Actually, that whole

summer of 1886, when *La Vogue* was publishing *Illuminations,* he *was* in Africa, in a native village near the Somali coast, trying to get a camel caravan under way to the interior of Ethiopia with 2,000 rifles and 75,000 cartridges for the rebel army of Menelik, the pretender to the throne. Since the day in Stuttgart when he had handed over his poems, Rimbaud had been living what he had dreamed in them, a kaleidoscope of unreal cities and imperial ports of call. He had been a warehouseman in Egypt, a quarry foreman in Cyprus, an ivory hunter in the Ogaden, a coffee-buyer in Arabia. In the wilds of Java he had deserted the Dutch foreign legion, sent out to quell native "uprisings" in the East Indies. In 1877, in Bremen, Germany, he had tried unsuccessfully to join the United States Navy. Gunrunning in Africa was only the last chapter in the same incorrigible life that had begun when he had run away from home so young. "Allons! the road is before us!" Walt Whitman had called. "Let the paper remain on the desk unwritten."[30] Or, as Rimbaud himself put it, "People aren't serious when they're seventeen."[31]

But the poems were spectacular. Each time he abandoned another rule of poetry-making Rimbaud seemed only to have enlarged his control over the resources of language. As each issue of *La Vogue* came out that spring and summer of 1886, it became clear that *Les Illuminations* were more adventurous than anything in French poetry so far—more adventurous even than *A Season in Hell,* which *La Vogue,* for good measure, reprinted in three of its issues for September. Were the *Illuminations* prose poems? None of them had a consistent meter, only a couple were even presented in lines or verses. And what could they be about? All of them were full of extravagant images that seemed to be resolutely discontinuous and incoherent. In a Mallarmé poem, a reader might slowly succeed in extracting a single poetic subject from the entourage of symbols that suggested it, but in these poems of Rimbaud's the subject was "undecidable."[32] You couldn't tell how the images related or what they all symbolized, unless it was the mind of a maniac. "Mouvement" (Motion), the second free verse poem, which came out in the June 21 issue, seemed somehow to be about passengers on a boat. But was it not also about a city in the artificial light of positivism and industry? Was it not also about a single churning consciousness? What must Laforgue have made of it, arriving in Paris for his long vacation on the day the issue hit the bookstalls?

MOTION

> The swaying motion on the banks of the river falls
> The vortex at the sternpost,
> The swiftness of the rail,
> The vast passage of the current
> Conduct through unimaginable lights

And chemical change
The travellers surrounded by waterspouts of the strath
And of the strom

They are the conquerors of the world
Seeking their personal chemical fortune;
Sports and comforts voyage with them;
They carry the education
Of races, classes and of animals, on this ship
Repose and dizziness
To torrential light
To terrible nights of study.

For from the talk among the apparatus, the blood, the flowers,
 the fire, the gems,
From the excited calculations on this fugitive ship,
—One sees, rolling like a dyke beyond the hydraulic-power road,
Monstrous, endlessly illuminated,—their stock of studies;
They driven into harmonic ecstasy,
And the heroism of discovery.

In the most startling atmospheric accidents,
A youthful couple holds itself aloof on the ark,
—Is it primitive shyness that people pardon?—
And sings and stands guard.[33]

Four years before "Motion" was published, Laforgue had had a pre-monition of it. In July 1882, he had written to Sanda Mahali, "I'm dreaming of a kind of poetry that says nothing, that is made up of bits of dreaming, without coherence. If you want to say, explain or prove something, there's always prose."[34] In 1886 he could see at least in part what Rimbaud was doing. "Never any stanzas, no finish, no rhymes. Everything is in the unheard-of wealth of confession, and the inexhaustible unexpectedness of the always adequate images. In this sense he is the *sole isomer* of Baudelaire."[35] But Laforgue was not Rimbaud. He never did write a poem whose subjects were plural or undecidable. His work remained essentially lyrical and dramatic, reports on his own feelings and those of others. If anything was undecidable in the poems *La Vogue* was now printing next to Rimbaud's, it was the tone of voice or the cast of mind. Laforgue's choice of words, his diction, had always demonstrated a perfect ear for tone. Each *Complainte* had used several different tones, from the exalted and aristocratic to the colloquial and childlike. Switching from one to another, even within a line or phrase, he created a symphony of mutual ironies. The same symphony would appear in all his future poems, and in his *Moralités légendaires* (Moral tales) in prose. The

confessional in Rimbaud is single-minded, like that of the old romantics. Laforgue's is always ironic, like that of the Moderns to come.

If Laforgue were ready to learn anything from Rimbaud, it would have to have been how to write poems in a form of verse with no consistent meter. He had yet to write one himself when Rimbaud's first free verse poem, "Marine," appeared in *La Vogue*'s poetry typeface in the issue of May 29, 1886;[36] but there is another influence, earlier and more probable than "Marine." Sometime earlier that month, Laforgue sat in his sumptuous Berlin apartment, spreading out the turgid pages of the May 1 *Revue des deux mondes* to prepare for his morning reading to the Empress Augusta. There, on page 112, was a review of E. C. Stedman's *Poets of America* by a certain Thérèse Bentzon, who, the *Revue* noted, had first taken aim at Whitman in the same publication back in 1872. She had mellowed only a little since.

> As for the much-touted originality of form, we know how much that is worth. . . . It is easier to attain success by eccentricity than by any other means. . . . It matters little to those who do not make americanism the object of a cult, like someone for whom this self-described citizen of the universe (whose mind is so essentially narrow) the radical, the iconoclastic Walt Whitman is the high priest.

It was more than enough to send Laforgue out after the latest edition he could find of *Leaves of Grass*. In June he began to translate it, starting with eight short poems from the first section, "Inscriptions," which he sent off to Kahn in Paris under the title "Dédicaces." *La Vogue* published them, "Translated from the astonishing American poet Walt Whitman," on the first page of the last issue for June.[37]

POÈTES À VENIR (POETS TO COME)[38]

> Poets to come! orators, singers, musicians to come!
> Not to-day is to justify me and answer what I am for,
> But you, a new brood, native, athletic, continental,
> greater than before known,
> Arouse! for you must justify me.

Ten pages later, Gustave Kahn's own first free verse poem appeared to keep it company.[39]

Walt Whitman was sixty-eight in 1886, older than any of these Frenchmen could imagine. He had worked as a nurse during the Civil War (when Laforgue was four years old and Rimbaud ten). Soon afterward he had been fired from a clerkship in the Interior Department because the new Secretary, snooping in Whitman's desk, had found a working copy of *Leaves of Grass,* and decided it was obscene. Whitman had originally published his book in Brooklyn in 1855, two years before

Baudelaire's *Flowers of Evil,* and had added to it continually since. Obscene or not, it was certainly as candid as anything in Baudelaire. The sections of it called "Children of Adam" and "Calamus" had succeeded in convincing a whole cadre of Americans, from Emerson to Twain, that Whitman's poetry was obscenely heterosexual, and another cadre of Englishmen, from Swinburne to Wilde, that it was liberatingly homosexual. As for Whitman himself, he seems to have been both—or neither. He was as "adhesive" as his phrenologist had told him he was, but like Rimbaud, he could adhere to anybody.

In France, despite Whitman's ardent wish, only two notices of his work had appeared by 1870, both unfavorable and both unknown to him. He did know about a third one, a rave review, but this one now seems to have been secretly concocted by a friend. Whitman loved France, and liberally garnished his poems with misused and misaccented French words; but his love had almost nothing to do with modern French literature. He couldn't understand French any better than he could speak it. As far as Walt was concerned, France was the home of his lifelong political creed—petty-bourgeois democratic radicalism—fondly remembered and imputed to the French since the 1848 revolution of his own youth and the 1789 revolution of his father's. Among his earliest poems is one in praise of the forty-eighters, and he had since produced similar odes to the Convention of 1792 and the Republic of 1871.[40] The only French poets he identified with were Victor Hugo and the forgotten radical songwriter Béranger. Ordinary French people, he thought, were a little more egalitarian, more healthy-minded about sex, and thus a little less "decadent" than the likes of Baudelaire or Wilde.[41] What he never did understand was that in France, one of the definitions of decadent literature was unrhymed free verse poetry, the kind Whitman had all but invented in the 1850s, and had gone on writing as if he owned it.

In fact, the first big foreign response to the poet of democratic solidarity had come from aristocratic England and occupied Ireland. In 1868, admirers like the poet Swinburne had managed to get an edition of *Leaves of Grass* into print there. Abridged and expurgated though it was, it drew a considerable following. Oscar Wilde had visited Whitman in 1882, to recruit him as a precursor of his "Aesthetic" movement. Whitman was now resisting the role, judging the Aesthetes to be mere literary performers, like the French Décadents from whom they took their cue. With or without his blessing, however, the Aesthetes continued to try to catch up with *Leaves of Grass,* writing more and more candidly and colloquially in verse-forms that stretched the already loose rules of English prosody. What they could not do was sing as Whitman did with the wholehearted subjectivity of early romanticism. Whitman did not imagine monologues (like those of Browning and Tennyson) in the voice of the other. Instead he used his own voice, and not only as lyric but also as

lecture or sermon. The combination of high seriousness and colloquial, democratic diction was unprecedented, except in America. Like Yeats, Whitman was not a Modern, but a late-coming romantic who had somehow learned to wring the neck of eloquence. No wonder the French took so long to discover him.

On June 1, 1872, the stodgy *Revue des deux mondes* published what was certainly the worst review Whitman would ever get in France. According to Thérèse Bentzon, the *Revue*'s resident expert on American literature, *Leaves of Grass* was a mess. The long, long line with its varied, natural metric, in which rhyme appeared "as if by chance," was irregular, capricious, barbarous, and ungrammatical. "If you are," she wrote, "imbued with old prejudices against poems in prose, if you take account of the laws of versification, beware of reading what has been compared with too much indulgence to the poetry of the Bible and the rhythmic prose of Plato." Gross in execution, Whitman was equally indecent in theme and in detail. He had no literary culture. His favorite subjects—"egoism and democracy"—were "essentially modern" and equally unsavory. Rough translations Bentzon had made of some of the *Leaves* showed an "excess of energetic bad taste" leading to a confusion of "muscles with genius" and the raw "iconoclasm [and] titanic temperament" of the worst of Hugo or Baudelaire.[42]

Exactly one week later, Emile Blémont, still fascinated by the newer voices in English poetry, began his own series of three articles on Walt Whitman's poetic revolution in his *Renaissance littéraire et artistique*.[43] Here at last was Whitman's French rave. What Bentzon called defects, Blémont simply defined as virtues. If critics made fun of Whitman, "the poets defended him." He was "original," more "American" than the great Poe. His poetry was Wagnerian, his philosophy Hegelian, his aesthetics as revolutionary as Hugo's had once been. A lover of "liberty," "science," "equality," freedom of religion, "the flesh," and "simplicity," Whitman's glory was that he made poems alone in nature, without books. It was his advantage that he had no rhyme or preordained meter. His synthesis of good and evil, self and mass, love and lust was a harbinger of a radical utopia. "Walt Whitman," Blémont apostrophized, "you have addressed to Paris and to France moving words, grand words! You have also addressed yourself to the first comer." Well, he went on, "I am today that first comer, and over the seas I answer to the signal that you have given. . . ."

Whitman had never seen either of these reviews, nor would he have been able to read them if he had; but one person who might well have done so is Rimbaud. Though Rimbaud never, after 1871, acknowledged reading anything but books on science and engineering, we know him as one of the most avid and polymathic readers ever born. In June 1872 he was in a Paris walk-up overlooking the Lycée Saint-Louis playground, seventeen years old and dreaming of being the greatest poet in the world.

Since only two of his poems had ever been published, he was now sending work like "Vowels" to Blémont's *Renaissance,* hoping to break into print in the company of Cros, Mallarmé, and Verlaine. "Don't forget to shit on the *Renaissance,*" he wrote a friend, and indeed, the review only printed one of his poems, "Les Corbeaux" (The crows), holding it back until the September 14 issue, when Rimbaud was long gone.[44] Rimbaud must have made an effort to find and read the poems about which Blémont and Bentzon disagreed so thoroughly. The same 1868 English edition of *Leaves* Blémont and Bentzon had used was being read and talked about when Rimbaud got to England in 1872, and in 1873, when he had secured a British Museum reader's card, learned English thoroughly, and taught it for a living in London. Was that edition—or a less expurgated American one—pressed into Rimbaud's hand by a fellow Décadent, perhaps someone who had heard it said that Whitman was gay? One of the unreal cities Rimbaud names in *Illuminations* is Brooklyn, which, until the Bridge was built, Europe hardly knew except as Whitman's former home town and the subject of one of his greatest poems.[45]

We know one of the places Whitman got his prosodic revolution, his amorphous stanza, and his long poetic line. It was the rolling versicles of the King James version of the Hebrew Bible. We also know that although nineteenth-century France, both Catholic and secular, was largely ignorant of the Bible, Rimbaud wasn't. He was the only major French writer of the time for whom the Bible had been a childhood book and who knew firsthand the rhythms of prophecy.[46] Besides the Law and the Prophets, Rimbaud and Whitman shared a dithyrambic democratic mysticism, and here too they had read the same book: *The People,* by the French historian Michelet. They even shared a forlorn hope of somehow weaning the century of its scientific materialism by wedding it to its contrary, visionary idealism.[47] In any case, out of a whole generation of French poets who eventually threw themselves into free verse, Rimbaud is the only one who left no acknowledgment of the influence of *Leaves of Grass.* Those who happily recognized and used the Whitman legacy included the pioneers Kahn, Krysinska, Moréas, and Maeterlinck; the Modernist galaxy Guillaume Apollinaire, Francis Vielé-Griffin, André Gide, Charles Péguy, and Paul Claudel (who learned from both Whitman and Rimbaud); and their successors from Larbaud and Cendrars to St.-John Perse. Besides the French, there were Italians like Gabriele D'Annunzio, Spanish-Americans like José Martí, Germans like Stefan George, English like D. H. Lawrence, and Russian poetic geniuses from Khlebnikov to Mayakovsky. Of all of them, only Emile Verhaeren and Stephen Crane ever claimed they had learned to write free verse before they found out about Walt Whitman.[48]

Laforgue made no such claim. His third Whitman translation, "Une femme m'attend" (A woman waits for me), from the most controversial

section of *Leaves of Grass,* called "Children of Adam," appeared in *La Vogue* for August 2, 1886.[49]

A WOMAN WAITS FOR ME

A woman waits for me, she contains all, nothing is lacking,
Yet all were lacking if sex were lacking, or if the moisture of the right man
 were lacking
Sex contains all, bodies, souls,
Meanings, proofs, purities, delicacies, results, promulgations,
Songs, commands, health, pride, the maternal mystery, the seminal milk,
All hopes, benefactions, bestowals, all the passions, loves, beauties,
 delights of the earth,
All the governments, judges, gods, follow'd persons of the earth,
These are contain'd in sex as parts of itself and justifications of itself.[50]

As he composed a letter to Whitman through an intermediary asking permission to translate the whole of *Leaves of Grass,* Laforgue was reexamining his own poems in its light. Whitman had no irony to speak of, and just one tone of voice; but Laforgue saw no difficulty in using Whitman's open-ended lines of free verse to show off his own mastery of juxtaposed tones and dictions. One of the first to be finished, called "L'Hiver qui vient" (The coming of winter), was sent to Kahn at *La Vogue* in that summer of 1886. Even in translation, the ironies of diction come through:

THE COMING OF WINTER

Sentimental blockade! Cargoes due from the East! . . .
Oh rainfall! Oh, nightfall!
Oh, wind!
Halloween, Christmas, and New Year's
Oh, my smokestacks lost in the drizzle, all
My factory smokestacks!
Where can one sit? The park benches are dripping and wet;
The season is over, I can tell it's true;
The woods are so rusty, the benches so dripping and wet,
And the horns so insistent with their constant halloo! . . .
. .
Now is the time when rust invades the masses,
When the rust gnaws into the kilometric spleen
Of telegraph wires on roads where no one passes.[51]

"The Coming of Winter" appeared in *La Vogue* on August 16, Laforgue's twenty-sixth birthday. A famous letter to Kahn went with it, describing his achievement with unconvincing nonchalance: "Roughly what [my next book] will look like is that piece on Winter I sent you. I forget

to rhyme, I forget the number of syllables, I forget to set it in stanzas—
the lines themselves begin in the margin just like prose. . . . And I'll never
write poetry any different from what I'm writing now." [52] So he resigned
his post as reader, proposed marriage to Leah Lee, and returned to Paris
in September to become a great writer. In his luggage was the new book,
Fleurs de bonne volonté (Flowers of good will), a finished sheaf of poems
he was now systematically pulling apart and turning into free verse.

Laforgue timed his return to full-time writing to coincide with his
own banner year, but in 1886 it was a considerable risk for him to quit
his day job. Poetry paid no better then than it does now. *La Vogue* could
not give him a paid column. *La Revue indépendante,* which went on the
stands a bit before *La Vogue* folded in 1887, picked up some of the slack.
It was edited by Edouard Dujardin, who had met Laforgue in Berlin in
March 1886, and talked a lot about the relation between writing and
music. Laforgue sent him a few more of the poems he was revising from
the *Flowers,* plus the last of his *Moral Tales,* which Dujardin promised
to turn into a separate book. In December, he crossed the Channel in a
winter gale to meet Leah Lee in London; and on New Year's Eve 1886,
at Saint Barnabas Church in Addison Road, he married her. Before 1887
was out he and Leah were both dead of tuberculosis. Rimbaud survived
him by four years.

Whitman was destined to survive them all. On April 14, 1887, as on
other 14ths of April since 1879, Whitman was at Cooper Union, in New
York City, giving his bread-and-butter public speech, "The Death of
Abraham Lincoln," accompanied as usual by a recitation of "Oh Captain,
My Captain!" the only poem he had ever written in traditional form (and
just about the only one audiences had ever asked him to recite). At the
end of the performance a young American joined the line to meet the old
patriot, clutching a paper-covered book. Stuart Merrill had been born in
Virginia, but in 1884 Merrill had graduated from the Paris lycée where
Mallarmé taught English. Now he was a dropout from Columbia Law
School, and an aspiring French poet. *La Vogue* had published one of his
first poems, "Flûte," in May 1886, and the book in his hand was the
August 2 issue with Laforgue's translation of "A Woman Waits for Me."
Awestruck, he offered it to Whitman, who beamed when he learned
"they have translated me into French." He asked which poems Laforgue
had translated. Merrill told him, "The Children of Adam." With a mis-
chievous look, Whitman replied, "I was sure that a Frenchman would hit
on that part." [53] He had in fact given this section a French title to begin
with: "Enfans d'Adam."

There is no getting around the fact that the French found Whitman
before the Americans did. Pound had a deep quarrel with Walt Whitman's
"barbaric yawp." [54] Pound's friend William Carlos Williams, who thought
Whitman was the only American poet, didn't discover him until just be-

fore the First World War. T. S. Eliot not only didn't think much of Whitman, he once wrote, "I must say frankly that it seems to me you are wasting your time in attempting to relate my work to that of Walt Whitman in this way. . . ."[55] But Eliot did like Laforgue. He discovered him in a chapter of Arthur Symons's book, and mail-ordered his complete works in 1908 during his junior year at Harvard. Eliot's reading of Laforgue that summer changed his style completely, sent him to Paris, and emancipated him from the last traces of Victorian America's genteel style. It may have turned him into a poet. Pound marveled that Eliot was the only writer he met who had "modernized himself on his own;" but if he had tried to do it without Laforgue, it is unlikely he would have been anything other than a professor of philosophy. When he married Vivienne Haigh-Wood rather hastily in 1915, Eliot arranged for the little ceremony to be held in the same Saint Barnabas Church on Addison Road, where he found the names of Jules and Leah Laforgue on the register.

For if Laforgue was not more of a Modern than Rimbaud, or even Whitman, he was at least less of a romantic. After he abandoned *Sob of the Earth,* he embraced, as wholeheartedly as a modern mind can embrace anything, the failure of certainty—even subjective certainty. "Aux armes, citoyens. Il n'y a plus de raison!" as he wrote to Kahn—"To arms, citizens! There is no more Reason." Ambiguity is more than a style, and irony more than an attitude. It is the epistemological principle of Modernism. Emotions superimpose themselves in the minds of poets and succeed each other in the hearts of readers without predictability, logic, or coherence. Modernism discovered that they cannot be rendered by rant, or even monologue, however comic. Probing for that incoherence and evoking it with words has been, since Laforgue, the poet's work.

7 SANTIAGO RAMÓN Y CAJAL

THE ATOMS OF BRAIN

1889

> But when classicism says "man," it means reason and
> feeling. And when Romanticism says "man," it means
> passion and the senses. And when modernism says
> "man" it means the nerves.
>
> —Hermann Bahr, *The Overcoming of Naturalism:*
> *Sequel to "Critique of the Moderns"*

In October 1889, at the Congress of the German
Anatomical Society at the University of Berlin, a short, powerfully built
Spaniard with penetrating black eyes set up a small exhibit of drawings
done on paper with colored inks. For the past two and a half years, alone
in a spare room behind his house in Barcelona, he had been drawing them
from nature through the eyepiece of a Zeiss, the most powerful optical
microscope yet made. His subject was the brain of the embryo of a small
bird, its cerebellum to be exact, and each thin slice of it had been cut,
prepared and dyed using his own improved version of a painstaking two-
step process recently discovered in Italy. Because Spain was not a place
where new science was published at the turn of the century, he had had
to edit and print his own journal in order to make his results known.
Some of the German biologists at the Congress had made the effort to
read those articles when they arrived in the mail in 1888, but the Spanish
language had given them trouble. Cajal had tried giving his talk to the
Congress in halting French (which was not much of an improvement),
but it was the drawings and slides around which the professionals now
crowded, amazed. Seeing made it plain. Each stained cell stood out per-
fectly against a background of staggering complexity, and no matter how
many times the tiny fibers of one nerve cell met those of another, there
was clearly no physical connection between them. The basic unit of the
brain—the neuron—had been isolated.

The maker of these mind-changing pictures was not Picasso, who
would not strut the streets of Barcelona for another seven years, or paint
its Avinyo Street prostitutes until 1906. Eight years old in 1889, young
Pablo Ruiz was already making accomplished drawings of birds, but they
were of whole·birds. No less diminutive, pugnacious, brilliant and ambi-
tious than Picasso, this other Spanish artist, standing behind a laboratory

table in Berlin beside his pictures of birds' brains, was thirty years older. His art was the one we now call neuroscience, one which, a century later, has begun to look like the most promising of all the twentieth-century sciences. The artist's name was Santiago Ramón y Cajal.

Cajal could not be a neuroscientist in 1889, for the field had yet to be staked out. He had made his scientific debut as a medical researcher in the area called histology, or the study of tissue structure, a field first laid out by Bichat in the early years of the nineteenth century. The job of a histologist was to use that supreme biological tool of the nineteenth century, the optical microscope, to find and describe the cell structure of a heart muscle or a stomach lining. The hope was to discover how they worked and how they might go wrong, but the basic task was simply to classify—that is, to offer a taxonomy of the different tissues and the cells within those tissues. Of all sciences, taxonomy—Adam's task of distinguishing among things and naming them—is probably the least glamorous. Ernest Rutherford was later to say that all science was "either physics or stamp-collecting." Taxonomy was stamp-collecting. A good taxonomist had to be humble, as well as extraordinarily thorough and persistent, like Linnaeus, who founded biological taxonomy in the eighteenth century by naming and classifying some 4,000 species of animals and 6,000 species of plants.

This kind of tireless single-mindedness was very much in the character of Santiago Ramón y Cajal. He was the sort of person who would teach himself how to play championship chess, how to drop animals with a slingshot, or how to use a camera and make his own photographic plates. He was capable of spending months in a gym building up his body; of stealing books, eagles' nests, and even the bones in a graveyard for study. Tempted by the glamorous new subspecialty of bacteriology in 1885, and by medicine's sudden fascination with hypnotism in 1886, he always came back to general histology and its vision of life as a function of matter. Not many could have watched through a microscope for two hours straight, fascinated, as he was, by a white blood cell oozing its way through the wall of a capillary.

Tenacity showed up early in Cajal. When he was a boy of eleven, according to his own irresistible account, he built a cannon in his back yard. Once the gun was ready, he loaded it with stones and blew a good-sized hole in a neighbor's garden gate. The constable jailed Cajal for three days, much to the satisfaction of the boy's outraged father; but the sentence, which would surely have deterred almost any other child, made no impression on Cajal. As soon as he was released, he proceeded to build another cannon; and when that one blew up in his face and nearly blinded one eye, Cajal went on to steal the flintlock blunderbuss his father kept for show and shoot it off in secret with gunpowder he had made in a makeshift laboratory on the roof.[1]

Cajal described his motive in blowing things up as "a lively admiration for science and an insatiable curiosity regarding the forces of nature." Doubters may be reassured by the tale of how Cajal managed to hold on to his deepest vocation against the the kind of fundamental and long-term opposition that would have discouraged almost anyone else. That vocation, Cajal's first love, was not science, but painting. At "eight or nine years old I had an irresistible mania for scribbling on paper, drawing ornaments in books, daubing on walls, gates, doors, and recently painted façades." He could not do this at home "because my parents considered painting a sinful amusement."[2]

> My father . . . was almost completely lacking in artistic sense and he repudiated or despised all culture of a literary or of a purely ornamental or recreative nature. . . . This somewhat positivistic tendency I believe to have been not innate but acquired. . . .[3]

Deprived of paper and pencils by his family's poverty and his father's positivism, Cajal saved his centavos for them. Growing up in the classically rural town of Ayerbe in the shadow of the Pyrenees, he found color "by scraping the paint from walls or by soaking the bright red or dark blue bindings of the little books of cigarette paper, which at that time were painted with soluble colours."[4]

Such persistence finally wore down Cajal Senior, to the point where he was willing to take advice as to his son's vocation. He went straight to the town's leading painter-plasterer with Santiago in tow, showed him one of the boy's drawings and asked him whether it showed any talent. The contractor looked the picture up and down and pronounced it "a daub! . . . the child will never be an artist."

"'But does the boy really show no aptitude for art?' 'None, my friend,' replied the wall scraper. . . ." But it would be years before Cajal himself could be convinced of this expert's wisdom. His father's dream was for Cajal to become a doctor, but Cajal remained an artist no matter what he did with him. Why, Cajal demanded, "exchange the magic palette of the painter for the nasty and prosaic bag of surgical instruments! The enchanted brush, the creator of life . . . be given up for the cruel scalpel, which wards off death. . . ." And so Cajal engaged his parents in what he called "a silent war of duty against desire" that went on for years. At his first school, Cajal neglected his classical subjects and caricatured the master with such persistence and skill that school administrators concluded the only way to stop him was to lock him up. The lockup was "the classic dark chamber—a room almost underground, overrun with mice," but even there Cajal found a way to make art. There was a tiny hole in the wall facing the town, and on the wall opposite the hole there appeared, to the boy's delight and astonishment, a moving picture of what was going on in the town square. It was upside down, but it was

quite clear enough to draw. Thus Cajal, prohibited from going to the square, found that science could arrange for the square to come to him. He had discovered the camera obscura, "a tremendous discovery in physics, which, in my utter ignorance, I supposed entirely new."[5]

The discovery gave Cajal "a most exalted idea of physics," but his teachers continued to find him hopeless. Eventually he was sent away to the town of Jaca to learn his Latin from friars. Under the friars, who beat students and threw them at blackboards, Cajal quickly "conceived a loathing for Latin grammar" and a recurrence of his "madness over art." He didn't blame the friars much, for he knew his mind "wandered continually." Cajal judged his own understanding to be about as mediocre as his diligence, and his "verbal memory" to be less reliable than his "memory for ideas." When he reached age twelve his father tried him in another school in a larger town called Huesca—so large that Cajal later seriously opined that it had altered and enriched the neural connectivity of his brain. Within hours of arriving he had spent lunch money on paper and a box of paints. Within a week he was "drawing on the walls with chalk," and not long after, he remembered, he was able to draw a map of Europe for homework freehand and from memory. Proudly he included the many scores of noncontiguous states in the old German Confederation. After that the basket cells in a cerebellum would be child's play.[6]

In later years, Cajal professed to be happy he had not become an artist. His early drawings, he concluded, had shown an anatomical ignorance and a caricatural understanding of his subjects—"a tendency which many modernist and futurist painters to-day cultivate systematically with rapturous applause from superficial critics." He considered himself to have been an indifferent colorist who never understood the basic insight of his contemporaries, the impressionists, "that nature seldom presents an absolutely pure colour," or that gray is less a color than it is a scale of brightness. Here again he found the necessary self-deprecatory language in the Modern art that had since arisen in spite of him. "Who does not detect at first glance, by the loudness of its colouring, the unfortunate product of the unskilled painter or the dissident modernist, who from snobbery pays homage to the 'loud' school, slipping back unwittingly to the infantile phase of art?" Cajal finally extracted a year of artistic training from his father by spending a year as apprentice to a cobbler, but that year was the finish of his ambition. Once his slow and reluctant abandonment of art was complete, he remembered its lessons as lessons of failure. It had, he wrote, "led me to sharpen my observation of nature and to distrust memory;" or, in short, to become an observational scientist.[7] Cajal often called himself modern but never Modernist, and he used the word "modern" as a synonym for realistic, scientific, and materialistic. He seems never to have become aware of the literary and artistic movement turn-of-the-century Spanish critics were

calling *Modernismo,* which was a Spanish version of French *Décadence* and symbolism. He became, in the end, more of a positivist than his father, intent on erasing every trace of the transcendent and mysterious in the study of nature, of mind, and of brain. If the true vocation of the artist is simply to see, Cajal's great discovery was that of an artist; but it was as a medical researcher, an analyst, a phenomenologist of the discrete that Cajal was to become a Modernist.

Taxonomy actually requires more than tenacity. It is more epistemologically challenging than any other science, more so even than fundamental physics.[8] It makes more innocent assumptions, and rarely examines them from the perspective of phenomenology—the mind's take on the putative outer world. What, in fact, are you seeing when you classify a thing and give it a name? Why are the edges that mark one thing off from another found in one place and not in another? Why are some categories appropriate for bringing things together and not others? If categories dictate or are dictated by a hypothesis, then why that hypothesis and no other? The mere act of distinguishing one thing from another raises the phenomenological problem. Worse, it raises the problem of infinites. Linnaeus, for example, had subscribed to the basic assumption we have come to call the great chain of being, including the so-called "plenitude" principle that there was no vacant place or "missing link" in the chain. If the principle were true, then nature would have to be a continuum, and if nature were a continuum, then the differences between species would have to be infinitesimal and the number of species infinite. This objection never seems to have occurred to Linnaeus, who died expecting the number of species in the world to top out at around 15,000. It did not take the nineteenth century long to show that there were more than twelve times that number of beetle species alone, and of course that is nothing compared to infinity.[9] As we shall see, it was only in 1900 that the concept of finite numbers of simple parts was brought in to solve the problem of species.

One might have expected it sooner. Mendel had in fact proposed it in 1865. As for the hypothesis that reduced all living things to a concatenation of similar parts—the celebrated "cell theory"—it was even older, dating from an article by Schleiden and Schwann back in 1839. Cells themselves had been found much earlier than that. In 1837, for example, Jan Purkinje had found the prominent cerebellum cells now named for him. Within the nervous system proper, histology had placed several kinds of cells before 1888, and some of the classic nineteenth-century textbooks of general histology, like Albrecht von Kölliker's in 1853 and Ranvier's in the 1870s, actually began with an exemplary nerve cell as the best way to introduce a student to the cell concept. Nevertheless, most of the central nervous system looked to nineteenth-century scientists as if it were mostly a partless, continuous mass.

Of course, the nerves were the object of intense attention in the old century, especially in Germany. There the universe that Hegel and the Hegelians had filled with spirit was being rapidly reduced to mere matter. Karl Marx was out of school. For young scientists, the goal that emergent positivism and fashionable materialism seemed most of all to demand was scientific proof that consciousness was only a byproduct of electricity and chemistry in the nervous system. It was in 1842 that four students of the great biologist Johannes Müller—Carl Ludwig, Hermann Helmholtz, Emil DuBois-Reymond, and Ernst Brücke—had sworn their oath never to admit that any "other forces than the common physical chemical ones" were needed for life.[10] That same year Helmholtz had submitted as his doctoral thesis measurements of the speed of an electrical impulse along the nerves of a frog. DuBois-Reymond would go on to publish the standard work on electrical transmission in the nerves, called *Studies on Animal Electricity*. Brücke would bring the neural materialist faith to Vienna, where he eventually passed it on to his lab assistants, including an aspiring young neuroscientist named Sigmund Freud.

For a while the brain seemed to yield to this latest attempt to associate it with mind. It was in 1861 that French anthropologist Paul Broca discovered the area in the temporal lobe of the human brain that, when injured, seemed to prevent a patient from using grammar. Carl Wernicke found his own language "area," complementing Broca's, in 1874. For a while phrenology, the fashionable therapy of the 1840s that read mental function from the bumps on one's skull, looked like something more than junk science. In 1881 Freud's colleague Sigmund Exner wrote the standard text on the localization of functions in the brain, and in 1884 Exner's teacher, Theodor Meynert (who also taught Wernicke, Freud, and Auguste Forel), built his own general psychiatry text on his former student's localizations. Next to these philosophically adventurous experiments in physiology, collecting, observing, and describing nerve tissue— mere neurohistology—lost a lot of its glamor. It became an exercise for students and a subspecialty for cheerful toilers like Cajal.

The ancient discipline of psychology was powerfully affected by neural materialism. Professors of psychology, especially in Germany, began to worry that if the materialists were to achieve their goal of proving that the human psyche had no autonomy, no selfhood, then the psychology profession, the study of mind as a whole, might have to be abandoned. Both Wilhelm Wundt, a former Müller student who founded the first experimental psychology laboratory in Leipzig in 1879, and William James, the trained physiologist who founded the first U.S. Department of Psychology at Harvard in 1875, were driven by this anxiety.[11] Both found themselves in the 1880s writing their way toward philosophy and out of physiological psychology. By 1913, the American intellectual descendants of Wundt and James would find a paradigm for psychology that was both

more materialistic and less, one that allowed the mind its wholeness by simply disallowing any questions as to how it worked. For vain efforts to understand mind and inconclusive investigations of brain function "behaviorism" substituted a bare input-output model, called the mind a "black box," and cut the whole subject of psychology loose from neuroscience for a century.

These sorts of attitudes meant that in the 1880s, as Cajal was beginning to publish his researches and before the microbe hunters had made their mark, neurohistologists were pretty solidly ensconced in a small corner of the learned world. Their territory was vast and various but no longer galvanizing for other scientists, since none of their new findings seemed to offer a major philosophical challenge. The decade's new terms—"cytoplasm," "nucleoplasm," and "mitosis" (complete with "prophase," "metaphase," and "anaphase")—and its new tool, the microtome tissue-slicer, invented by von Gudden, Mad King Ludwig's psychiatrist, presaged no new paradigm. The single great problem for the field was how to distinguish one structure from another in any nervous system larger than a snail's. Some worked with leeches, crayfish, and lampreys, dauntingly complicated but simpler than mammals or human beings. The central nervous system in *Homo sapiens,* which we now know contains something on the order of ten billion nerve cells with perhaps a trillion connections, appeared to histologists like Kölliker to be an inextricable tangle of fibers, interrupted only occasionally by cells with a recognizable structure. The fibers often thinned down beyond the resolving power of microscopes, and teasing them apart with dissecting tools seemed "an undertaking for a Benedictine."[12] Massed fibers seemed to form a good part of the cerebrum and spinal cord, which the professionals dubbed "gray matter;" and there was also a lot of "white matter," which some were beginning to understand took its color from the myelin sheathing around nerve fibers. Under the cerebrum there was even a patch of black matter, learnedly called, in Latin, *substantia nigra.* Differentiation of parts, or what the histologists called the "fine structure" of this great tangle, came with frustrating slowness. Between 1836 and 1838, a Müller student named Robert Rémak had suggested that most of these myriad fibers in the brain were processes attached to cells. In 1839 J. B. Rosenthal had described the *Achsencylinder* or axon, an extended fiber on some cells of the central nervous system, and in 1855 Rémak had proposed that each nerve cell had only one of them—though most of Rémak's students, including Kölliker, found the conclusion too bold. Otto Deiters, who died young after years of dissecting the neural tangle with threadlike needles and staring at it through his microscope, had left notes asserting that though axons were single and did not branch, other parts of the nerve cell did have tiny "protoplasmic processes" (we call them "dendrites") branching out from them.[13]

Optical microscopes had their limits, even with oil-immersion lenses; microdissection seemed beyond human skill; and dyes and stains were fuzzy, unpredictable, and unreliable. Locked away from the "fine structure" of the nervous system in the heroic age of chemistry, histologists fixed on the dyes and stains. They tested nearly every kind of chemical that came along in the nineteenth century, trying to find an elixir that would make nerves stand out against their impossibly undifferentiated background by coloring only one or two at a time. Their first historian, Gustav Mann, wrote in 1902 that "to be an histologist became practically synonymous with being a dyer," except that "the professional dyer knew what he was about, while the histologist with few exceptions did not know, nor does he to the present day."[14] The carmine dye pioneered by Joseph von Gerlach in the mid-1850s had one advantage: it was red. Aside from that it could not stain a single nerve with precision, and it could not stain all its processes, in particular the long axon, out to their ends. Indigo proved a little harder to work with and not much of an improvement. The new aniline dyes, tried out in 1859, were brilliant but they had much the same limitations, as did the methylene blue first applied by the soon-to-be famous bacteriologist Paul Ehrlich in the 1870s, or the "haematoxylin" he pioneered in 1886.

To the workers most involved, like Carl Weigert, who had invented several staining methods, it soon became clear that it was not just the dye that made a difference, but the preparation of the tissue both before and after the dye was applied. Tissue had to be "fixed" or it would alter or decay, but it shrank in some fixatives and lost features in others. Tissue's refractive index had to be chemically "cleared" or optical microscopes wouldn't work. Some procedures had to be done in the dark; some in acid-clean test tubes without metal touching the contents. Some dyes were oxidizing agents and had to be reduced in order to work; some were reducers that needed oxidizers; some worked better if they were allowed to deteriorate for a while. The relationships of reagents were so close and so hard to understand that the task of histologists became not to make a stain work, but to figure out how it had worked the first time—that is, to make it work more than once. Chromic acid, pioneered as a stain in 1843, eventually turned out to be more useful as a tissue bath, preparing cells to absorb more distinctive stains. In the 1860s Deiters and his teacher Max Schultze successfully used a salt of chromic acid, potassium bichromate, to give cells that had been fixed with the acid a purplish color, and tried the old carmine stain to make the result stand out further. Exner had found in the 1870s that "osmic acid" (osmium tetroxide in water) worked both as a preparation and as a stain, but that it only colored the sheathing of a fiber—the myelin—which meant that an axon's all-important terminations, which were unmyelinated, could not be seen. The extra time all these measures took is a good measure of the size of

the dye obstacle. In the spirit of trying everything, someone was bound to try gold, and in 1872 Gerlach, the inventor of carmine, did so. He used the chloride, gold's only generally available salt, and found that it stained cells well enough to be worth its price. Gold quickly earned a place in the repertoire and inspired a long string of efforts to improve it. Freud's sixth published paper, in 1884, was a report on the improvements he had made in gold chloride staining.

In the end, however, it was not gold that did the trick, but silver—silver nitrate, in fact, which was one of the family of chemicals that had made photography possible at the beginning of the nineteenth century. The man who first used it correctly was a histologist named Camillo Golgi, from the Italian city of Pavia, who began publishing his observations "on the structure of the gray matter" in the *Italian Medical Gazette* in the summer of 1873.[15] He made it work by soaking the gray matter in potassium bichromate as before, but then he added a dilute solution of silver nitrate to the bath. The potassium bichromate already in the cells reduced the silver nitrate to metallic silver, which fell out as a precipitate. Silver stained the inside of the entire cell black, magnificently distinct against the yellow left by the chromates; but the real beauty of the new substance was that somehow it could stain cells in the middle of a three-dimensional cube of tissue, one cell at a time, all the way out to their ends, so that they stood out "like trees in a winter mist."[16] With it Golgi could make out a dendrite only 30 millionths of a meter long. Under proper conditions Golgi found he could even see the long axon of a nerve cell stained almost as far as the axon extended, and could at last distinguish between long- and short-axon nerve cells.

The idea was not altogether new, silver nitrate having been used by one histologist along with ammonia to stain nervous tissue,[17] and by another preceded by acetic acid to stain motor nerves, but the stain was very temperamental. So much depended on what you did to prepare the tissue before adding the silver that Golgi never stopped working on it. His papers began appearing in French and English journals in the 1880s, and his most comprehensive work, published in 1886, would eventually win him a Nobel Prize. By then the new staining method was being tried in histology labs all over Europe.

Spain, however, seemed not to be in Europe at all. In the nineteenth century Spanish medical researchers never considered the brain without leaving room for the soul, and it often took whole decades to naturalize a new technique. As an assistant in the Zaragoza Medical Faculty in 1880, Cajal had had to learn the art of lithographic engraving in order to get his papers illustrated accurately. He had been advanced enough to use gold chloride staining in his first published paper, and to suggest ammoniacal silver nitrate in his second, but no one else in Zaragoza had ever

tried silver. At the University of Valencia where Cajal had secured his first professorship in histology in 1883, researchers were still innocent of Golgi and his stain. When Cajal had interrupted his own researches to return to Zaragoza and pitch in as a bacteriologist on the cholera epidemic in 1885, he was still using the older stains himself. Cajal didn't get his first chance to see the silver-bichromate technique in use until 1887, when he paid a visit to Madrid as a judge for the national exam in descriptive anatomy and visited Luís Simarro, who had just come back from France. Simarro showed Cajal some examples of Golgi staining he had in his house, and later took him down to his lab in the unofficial biological institute in Gorguera Street to show him more. Cajal remembered being so impressed that he gave up all other methods, and began not only to apply the new staining technique but to tinker and improve on it. Soon he had added an extra step to the preparation sequence by making two separate soaks out of what had been a continuous procedure. His great discoveries were less than a year away.

Cajal had found his method just in time. The extraordinary hypothesis that the entire mass of the central nervous system was composed of the extensions of separate and distinct cells had already been advanced. In October 1886, Wilhelm His of Leipzig had asserted that there was no continuity between nerves, just as (recent research had shown) there was no continuity between nerves and the muscle cells they controlled. In January 1887 Auguste Forel, the Director of the Burghölzli Asylum in Zurich who would in the same year begin his work on hypnotherapy, published a paper on brain anatomy pointing out that "no one has yet seen" any such continuous connections between "outgrowths of the ganglion cells, the fibres [axons], or the protoplasmic processes [dendrites]" of one cell and those of another. Four months later in Oslo, Norway, Fridtjof Nansen, about to set off on the first expedition to cross Greenland, put a finishing touch on his neuroanatomy Ph.D. thesis and made the same observation. "A direct combination between the ganglion cells, by direct anastomosis of the protoplasmic processes does not exist." [18] Cajal had only just gotten his first look at the Golgi-stain lithographs in Luís Simarro's biology lab in Madrid and already there had been three separate attacks on the old theory of brain histology. Of course now, a century after the fact, it seems like an edifice was crumbling, but in 1887 the old hypothesis that all the nerve fibers of the gray matter were mutually connected in a single network was in no real trouble. This so-called reticular hypothesis (*reticulum* is the Latin word for network) was in fact vigorously promoted by Joseph von Gerlach, the man who had brought carmine and gold chloride to histology, and Theodor Meynert, the formidable Viennese. Its great champion was in fact none other than the discoverer of silver-chromate, Camillo Golgi himself. "Ruled by the theory,"

Cajal remembered, "we who were active in histology then saw networks everywhere." It was a beautiful theory and, he wrote, "As always, reason is silent before beauty."[19]

The way was therefore open to Cajal. He was the only one working on the problem who had both the technique and a mind that was ready to change. In November 1887, when he took up his new professorship in Barcelona, the first thing he did after moving his growing family into their new house in Riera Alta street was to set up his laboratory and start staining brain tissue. First came a two- to four-day soaking in 1 percent osmic acid and 3 percent potassium bichromate solution to harden the tissue and pervade it with chromate; then the 20 percent silver nitrate solution and thirty more hours of soaking to precipitate the silver. Next he would put the specimen in pure alcohol to harden it, mount and slice it with a microtome, then soak the slices in six to eight changes of pure alcohol to get rid of all the water. Finally he would clear their refractive index with oil of clove or bergamot, wash out the oil of clove with a solvent, varnish with a resin, and mount the specimen.[20]

Early the next year, after moving to a larger house in Bruch Street, Cajal began to work on the nervous system in earnest. 1888 was to be "my greatest year, my year of fortune."[21] Sensing the commitment it would require, he gave up chess, in which he had made himself an expert, for the next twenty-five years. In the back room he used as a laboratory Cajal had made one more change in the methods used by Golgi and the earlier researchers, one that had been missed by all his contemporaries, including His, Forel, and Nansen. He had decided to use embryos. "Since the full-grown forest turns out to be impenetrable and indefinable, why not revert to the young wood, in the nursery stage . . . ?"[22] was how he explained coming up with the rather off-putting idea of using unfledged, unhatched chicks to study the central nervous system. Its brilliance lay in the fact that the nervous system in almost all vertebrates is incomplete at birth. Though the nerves have grown dendrites and axons, not all of these are fully extended. Moreover, the "glial" cells have hardly begun their task of covering the nerve extensions with the ubiquitous white insulation called myelin.

Best of all, the silver-chromate stain works better in embryos. When Cajal looked at the first chick cerebellum, what he saw was a lot of extraordinarily long axons, completely uncovered and stained brownish-black to their very tips, exposed to his objectifying gaze. It was obvious to him that every fiber belonged to a particular cell. They did not go through the wall of any other cell; they came up close enough to touch it, but they never actually did. He could see where they ended. Obvious as always were the Purkinje cells with their many thick branches and prominent cell bodies, but now it became clear that the fuzzy structures enclosing those bodies were the branching ends of the axons of entirely

different nerve cells whose own cell bodies were tiny. They enclosed the Purkinje cell like a basket around a melon, but they never penetrated it. Cajal stared through the microscope and drew exactly what he saw. Then he drew his conclusion: the famous central network, "that sort of unfathomable physiological sea, into which, on the one hand, were supposed to pour the streams arising from the sense organs, and from which, on the other hand, the motor or centrifugal conductors were supposed to spring like rivers originating in mountain lakes" did not exist at all. "By dint of pretending to explain everything [it] explain[ed] absolutely nothing." The truth was that the entire central nervous system was like a telephone exchange in which each nerve cell communicated only with such other nerve cells as were touched by the ends of its axon. The alternative was "protoplasmic pantheism . . . pleasing to those who disdain observation. . . ."[23]

Today Nansen is remembered as an Arctic explorer and statesman; Forel as Jung's predecessor at Burghölzli, Kokoschka's portrait subject, and one of Freud's sources on hypnotism. As for His, he is best remembered as the doctor who stood by when they exhumed the body of Johann Sebastian Bach, and made careful measurements of the great man's skull. The reason is that they had only guessed at Cajal's conclusion. They had not proved it. Proof required that patient, endless work with chemicals, needles, microtomes, microscopes, and lithographic plates, the sort of work Freud had learned how to do long before he became a doctor, when Brücke had set him to study the nervous system of the lamprey in 1876. In 1882 Freud gave a lecture on "The Structure of the Elements of the Nervous System" based on what he had learned from the lamprey and later the eel and the crayfish. At the point in this lecture, published in 1884, where he had taken up the implications of the network theory, three of Freud's biographers pronounced that he had proposed the neuron and anticipated Cajal.[24] They were wrong. Freud had not seen through the network and, as we shall see, had a very different professional destiny.[25] Soon he would abandon the psychological microcosm for what he hoped was the Big Picture. In 1889, two months before Cajal traveled to Berlin to convince the Congress of Anatomists of his new idea, Freud went to Paris to learn from the Experimental and Therapeutic Hypnotists, whose Congress coincided with the World's Fair. (The Congress of Physiological Psychology also met in Paris during the Fair, and there, just to compound the irony, was William James.) Thus Cajal brought his new idea, together with the indispensable hard-won proof, to a rather small gathering of men who practiced a well-established but not very fashionable discipline. Perhaps because of that, they treated him extremely well. The Belgian van Gehuchten, who had been Cajal's faithful correspondent, withdrew his opposition to the new hypothesis on the spot, as did, soon after, the Basel professor, Lenhossék. The Swede, Retzius, was skeptical

but kind. Even Wilhelm His marveled and applauded, and the formidable Berlin expert, H. Wilhelm G. von Waldeyer-Hartz, was unexpectedly welcoming. As for the patriarch of the Society, Albrecht von Kölliker, he swept Cajal into his carriage, took him to his hotel, and gave him a dinner. Promising to have everything Cajal wrote published in Germany, Kölliker said, "I have discovered you and I wish to make my discovery known in Germany."[26]

In November, Cajal returned to Spain and got back to work; but the rest of the histological world continued to reverberate. Between October and December 1891, the great Waldeyer published a series of six long articles in the *German Medical Weekly* on the whole state of the question of the fine structure in neuroanatomy. There he attributed the new gray-matter-discontinuity hypothesis to Cajal and gave it the name "neurone doctrine." These articles gave rather more credit to Waldeyer than Cajal thought he deserved, but there is no doubt they secured Cajal's scientific reputation for the rest of his life.[27] News of his discovery passed beyond the small world of histology and became an example of "science," ever progressing in the nineteenth-century manner. Soon people who knew no science to speak of would have some inkling of what Cajal had found. Never again would he be anonymous and unsupported, though he never stopped behaving as if he were. In 1894 the British Royal Society offered him its most prestigious award in biology, the Croonian Lectureship.[28] England's leading neuroanatomist, Charles Sherrington, invited Cajal to stay with him in his home in London when he gave the lecture. There Sherrington was amazed to discover that Cajal would clean his own bedroom, hang out his sheets, and lock his bedroom door in order to prevent the traveling laboratory he had set up there from being disturbed.[29]

In the 1890s Cajal advanced and provided evidence for four additional hypotheses about the nervous system. The first of these, which has acquired the name of the "Law of Dynamic Polarization," asserts that the axons of nerve cells are always outputs for nerve impulses and that dendrites are always inputs. Signals did not, therefore, spin around in an endless circuit, but instead went only one way until they stopped and were received.[30] The second of Cajal's later hypotheses is the idea that neurons grow from the ends of the axons at a point analogous to the root hair of a plant. Cajal found this in chick embryos in 1890 and called it the "cone of growth."[31] The third of these ideas Cajal advanced in 1892 and eventually called the "Chemotactic Hypothesis." Wondering why the growth cones of axons followed one trajectory instead of another and how growing axons could go such long distances to make the "right" connections, Cajal suggested they found their way by following trails of chemicals already laid down among the other nerves.[32] These three hypotheses are now conventional wisdom so taken for granted that Cajal's name has become completely detached from them, and they are

taught as if anatomists had always known them. Fair enough, since Cajal never found a proof for them and indeed there was never anything in his experimental repertory that could have provided one. The fate of the fourth hypothesis, as we shall see, is not yet known.

In 1899, when Clark College in Worcester, Massachusetts celebrated its tenth anniversary, its president, William James's first Ph.D. student, G. Stanley Hall, invited the stars of European science to give lectures to celebrate. Ludwig Boltzmann arrived to discuss the paradoxes of physical and mathematical continuity. The mathematician M. E. Picard talked of Peano's foundations of arithmetic. The three other speakers were all brain scientists: Ramón y Cajal, Forel, and Angelo Mosso, who had all sailed over together on a French Line ship from Le Havre. Cajal spoke first, trying to sum up in three lectures what was then known about the structure of the cerebrum. Using large colored placards, he described all the new neurons and neural fibers he had isolated, the consequences of their separate existence, the direction of impulses in the fibers, and the curiously precise way in which the fibers extended themselves into the numbingly complex space made up of the cells and fibers that were already there. Forel followed with a flamboyant talk on the possibilities of brain science in which he claimed that he and Wilhelm His had been first with the neuron doctrine. Of this claim Cajal says nothing in his autobiography beyond profuse references to Forel's intelligence and charm.

What struck Cajal more than Forel's belated claim was the astonishing attitudes the Americans demonstrated on the subject of his homeland. When the invitation came in the mail, Cajal had asked his government whether he ought to accept it. It was, after all, only a few months after San Juan Hill and the devastating defeat of Spain by the United States in the Spanish-American War—a war the United States claimed had been fought to free Cuba from Spanish cruelty. Cajal knew exactly what Spain had done in Cuba, because he had seen it for himself. In 1874, doing his military service in the Spanish army's medical corps during an earlier colonial war, he had watched as the Spanish Governor-General tried to cut Cuba into three pieces with two barbed-wire fences running north and south, the better to control the insurgent population. In Cajal's view, the scheme, which inspired a later Governor-General named Valeriano Weyler to develop the concentration camp, had been not only cruel but impractical. As skeptical of Spanish intentions as he had been of Spanish strategy, Cajal hadn't liked having his patriotism called on to endorse the incompetence, peculation, and stupidity of Spanish imperialism in Cuba. Indeed, soon after this trip, in order to reconcile his deep and continuing loyalty to Spain with honest criticism, Cajal would begin writing his memoirs. But the Americans he met during his east coast tour struck him as obtusely simple and bewilderingly oblivious of the effect they had had on so many of the world's peoples. In the

unexpected heat of a New York City hotel in July as he waited to go on to Worcester, Cajal found triumphant modernity in the sixteen-year-old Brooklyn Bridge, but a touch of irony in the newer Statue of Liberty. To insistent questions from the American press about how he would improve the United States, Cajal tactfully offered little beyond uniform praise of democracy, except a Victorian putdown of feminism and a suggestion to build laboratories for bacteriology and histology. He reserved for a foot-note in his memoirs the point he had wanted to make about American imperialism. "One cruelty never justifies another [and] those who argue thus seem to forget that only powerful nations can commit certain ex-cesses with impunity."[33] He arrived in Worcester with a raging headache on the eve of the Fourth of July, and was treated next day to twenty-four hours of songs, cheers, rocket explosions, and citizens firing rifles into the air.

As Cajal dealt with his increasing fame, the "neuron doctrine" was becoming orthodoxy with histologists, neuroanatomists and psycholo-gists, and Cajal's extraordinary pictures began to enter the ken of nonsci-entists. In 1900 northern Europe's greatest early Modern artist, the Nor-wegian Edvard Munch, painted a picture of his sister Laura, wrapped in a shawl and seated forlornly in a chair. She was chronically insane and Munch would paint her many times; but in the foreground of this paint-ing, now called *Melancholy (Laura)*,[34] there is a table with a strange de-sign in dark blue, red, white, and gray. As the viewer comes in for a closer look she realizes that the strange design has come out of the sketch book of Santiago Ramón y Cajal. It is a sagittal section of cerebral nerve tissue viewed in tight perspective and painted in the colors of histological stain.

In 1906, the sixth Nobel Peace Prize was awarded to Rough Rider Theodore Roosevelt, a decision which, as Cajal wrote drily, "produced great surprise, especially in Spain."[35] Cajal was himself in Stockholm to see Roosevelt accept the prize, because the Swedish Academy had awarded Cajal the 1906 Nobel for medicine. Half of it, anyway. The other half had gone to Camillo Golgi, "very justly adjudicated to . . . the origi-nator of the method with which I accomplished my most striking discov-eries,"[36] wrote the ever tactful Cajal. They met for the first time when they were introduced at the ceremony. The next day Golgi gave his Nobel acceptance lecture, and the day after that Cajal gave his, both in French. Cajal's lecture, "The Structures and Connections of Nerve Cells," was a sustained defense of the independence of the neuron. Golgi's, "The Neu-ron Doctrine, Theory and Fact," was a sustained attack on the same idea.[37] To the end of his life, Golgi, the inventor of the reduced silver nitrate stain, would maintain his faith in undifferentiated neural net-works. Cajal, who had made the stain his instrument for discovering the neuron, was unable to convince Golgi of the truth of his discovery even as they shared a Nobel Prize for it.

It was in the year 1906 that Cajal's disciple Sherrington coined the word "synapse" to describe the junction between one nerve cell and another.[38] Cajal was increasingly lionized as evidence continued to mount for his central doctrine of neural atomism, and for the Dynamic Polarization, Growth Cone, and Chemotactic hypotheses. Cajal's fourth hypothesis, however, never proved out in his lifetime and remains in dispute at this moment. This is the view that the phenomenon we call memory is a product of particular states of the entire brain or neural network. Memory, thought Cajal, was not the effect of some chemical or of changes in one or a few nerve cells; it was, he thought, a global property of the entire brain. Such a view is very much in the center of debate in the last decade of the twentieth century—the Decade of the Brain—and, if it turns out to be true, could make Cajal the most important progenitor of twentieth-century neuroscience, and turn Freud (who was the star attraction at Clark University's twentieth anniversary ten years after Cajal) into an artifact.[39] The brain may not govern, as the nineteenth century thought. It may simply "emerge," an undetermined consequence of the simple interactions of more than ten billion cells making a trillion connections. The mind may not govern either, as Freud would insist ten years after Cajal had found the neuron. It may emerge instead, conscious and unconscious, in the same way, a way that never occurred to the nineteenth-century mind of Sigmund Freud, but did occur to the nineteenth-century mind of Santiago Ramón y Cajal once he had made a twentieth-century hypothesis about the atoms of brain.

8 VALERIANO WEYLER Y NICOLAU

INVENTING THE CONCENTRATION CAMP

1896

In 1896 a Spanish army officer named Valeriano Weyler y Nicolau was Captain-General (governor) of the colony of Cuba, which Columbus had claimed for Spain 400 years before. The newly appointed Weyler was fighting an especially nasty uprising, which Cubans call the Third War of Independence; and in 1896 he decided to implement the vague suggestion of his predecessor, Martinez Campos, to separate the rebels in the province of Pinar del Rios from the civilians who supported them by relocating all the civilians into guarded enclaves. This "reconcentration" had been tried briefly in three Cuban towns during Weyler's first tour of duty there in 1869. The civilians were to be put in camps, rustic but adequate, and surrounded with barbed wire, an 1874 American invention for controlling cattle. Anyone outside the camps who was not in uniform could be safely shot at as a rebel, so it was all for the civilians' "own protection." Weyler called them *campos de reconcentraciòn.*

A concentration camp was not a death camp. Not yet. The death camp had still to be invented. Now that the Holocaust has coopted awe, the knowledge of how the instruments of holocaust were devised is slowly being forgotten. Important though it might be, it has seemed too prosaic, too secular. Writing as a believer means writing a different story, or perhaps not writing at all. The historian can only moralize by default. For us there is nothing to say but what happened, how the little precedents and habits built up, in every part of Western culture, until it became possible for civilians to be stripped of citizenship on the basis of their genetic inheritance, imprisoned wholesale, worked to death, and deliberately exterminated by public authority.

The story of the death camp is not the story of human territoriality or simple brutality, both of which go back too far to get us anywhere. On the other hand it is not simply the story of anti-Semitism, which in

any case has been told well and often. Anti-Semitism, certainly, is at the origin of one genocide; but there have been many. True, the Holocaust was the largest (perhaps even after Cambodia) and the most efficiently organized of all genocides. But it was far from the first, and it has not been the last. When Emily Hobhouse saw the first British concentration camps in 1901, the comparison that occurred to her was Nebuchadnezzar's deportation of the Israelites to Babylon. What comparison occurred to us in 1992 as we heard the first news of concentration camps for Bosnians in Serbia? What the Holocaust was was the first genocide both deliberately designed and designed for the extermination—as opposed to the mere displacement—of peoples. Since it was also the first genocide designed around camps or prisons, the true story of the death camp must begin with the prisons and workhouses of premodern Europe. Nevertheless, the camp descends not only from traditions about incarcerating individuals, but also, and even more intimately, from traditions about segregating groups, including the imperial habit of enclaving and resettling entire peoples. This story seems to begin in resettlements made by the ancient Assyrians, in the medieval pales set up by England in Ireland and by Russia in Poland, in the deportation of the Acadians, in the Ottoman administrative device called *millets*—rural villages separated by religion—which the Russians seem to have copied, and in a notable American contribution known as the reservation.

The concentration camp, however, seemed new, and its newness came from ideas. Among these ideas was the change the Mendelians helped wreak in biological thought from "soft" inheritance theories, where characteristics acquired during the life of an organism can be biologically transmitted to its offspring, to those of "hard" inheritance, in which whatever appears in the children must have come from one parent or the other—a fortiori from one of the eight great-grandparents, exclusively, and so on by squares.[1] Concentration camps were in fact a very Modern invention—Modern in their insistence on analysis and fragmentation. The camp begins in the minds of those who have begun to see the human species as fundamentally discontinuous, capable of being separated into parts like Dedekind's number line, or assigned like elements to Cantorian subsets that can be precisely and unambiguously defined. Used by nineteenth-century Marxists like Stalin, or nineteenth-century romantic nationalists like Hitler, it could and did turn into an instrument of extermination. Just as the nineteenth century's legacy to political thought was a plethora of ideologies, so the most memorable legacy of the twentieth century, if it cannot make democracy work, may end up being the concentration camp. For the concentration camp was invented and given its name at the same time as cubism and quantum physics, by the same civilized Westerners. Its story begins in 1896 with Valeriano Weyler and his *campos de reconcentraciòn*.

Weyler's policy lasted a year and a half. Thousands were dying in the camps by 1898 and in the United States a strong political and humanitarian interest in the Cuban situation had developed. On June 24, 1897, Secretary of State John Sherman had handed a note to the Spanish ambassador in Washington protesting what he called the "policy of reconcentracion" of the new governor of Cuba. Editorials in the United States called it "cruel." So did at least one newspaper in Spain—giving Weyler credit, in an August 15 editorial titled "Crueldad espanola," for "inventing *la concentracion*."[2] But Secretary Sherman probably knew better than any Spanish journalist how "cruel" Weyler's policies were, for he was the brother of William Tecumseh Sherman, the general who had become famous by marching from Atlanta to the sea and becoming the first to treat civilians as combatants in a modern war. The Spanish knew it, too. With a fine sense of irony, Madrid replied to Secretary Sherman's protest against what Spain was doing in Cuba by calling attention to what the Secretary's brother had done in Georgia and Carolina thirty years before.

We don't know who in the Spanish foreign ministry put that reminiscence in the note, but the odds favor Weyler himself. At the time of the March to the Sea, the future Captain-General of Cuba had been twenty-five, serving as the Spanish military attaché in Washington, and writing home about how impressed he had been by General Sherman's remarkable new interpretation of the laws of war. Civil wars do not teach magnanimity. Later, Weyler had fought in his own civil war, the 1870s Carlist Revolt in Spain. Still later, as Captain-General of Spain's Pacific colony, the Philippine Islands, Weyler had learned even more about the attitudes one takes toward a conquered people. His last job before going to Cuba had been Captain-General of Catalonia, in which capacity he had become the target of a bomb thrown at the Corpus Christi procession in Barcelona. His response had been to order a roundup of some seventy anarchists to be hustled through torture, confession, and drumhead court-martial. Five were executed by garroting. In Weyler's experience, egalitarianism, like generosity, was a fault.

In the event, at the end of 1897 Weyler was removed by the Spanish government, but no one changed the reconcentration policy, despite growing disapproval from what was, even then, world opinion. Finally, Congress and the President of the United States began making a series of demands on Spain. To these Spain replied, and each reply contained further concessions, and each concession had less effect. On March 31, 1898, the Spanish ambassador delivered a note offering to do most of what the United States asked, including putting an end to *reconcentracion*. On April 9, Spain even agreed to an armistice in the War of Independence. President McKinley's reply to that, two days later, was to ask Congress to declare the Spanish-American War. Three weeks after that

the United States was in possession not only of Cuba, but also of Puerto Rico and the Philippines, putting an end to the Spanish Empire, the oldest Western colonial empire in the Americas. Deeply disillusioned, Valeriano Weyler returned to Spain to resume his brilliant military career, serving the first of several terms as Minister of War in 1901 and putting down the great Barcelona labor uprising in 1909. He lived until 1930, devoting himself to the training of a new generation of dedicated officers, including a hero-worshiping cadet named Francisco Franco.

In retrospect, the Spanish-American War seems the end of the vintage years for imperialism. Before 1898, empire had had honest advocates, and for more than fifty years colonization as uplift had made sense. After 1898, all the old rationalizations, not to mention all the new events, seemed unable to bear scrutiny any longer. In 1899, after months of serious debate, the United States invoked its long anti-imperial tradition and agreed to set Cuba free; but at the same time it agreed to annex all the other conquered Spanish colonies, including the Philippines, to a new overseas American empire. In 1899, after raiding for three years across each other's borders, the two European uplifters of southern Africa, Dutch and English, went to war against each other. The year of disillusion had begun in February with the magazine serial "Heart of Darkness," Conrad's story of the scandal in the Congo colony. A day or two later, on February 4, 1899, the United States Army opened hostilities against the people of the Philippines in a bloody three-year colonial war that came to be called (by the few who had the stomach to remember it) the Philippine Insurrection.

Both the Boer War and the Philippine Insurrection were wars for independence and survival. The Dutch had been in South Africa long enough to consider themselves native to the place. The Filipinos felt even more native, having been there about 10,000 years. Both fought with deteriorating respect for Western rules of engagement, and after a year of guerrilla war, the English and the Americans had largely abandoned their own commitment to the rules as well. In September 1900, General Roberts reported to General Kitchener, commanding the British Army in South Africa, on a new strategy involving the construction of camps within the disputed areas. They were for "burghers who voluntarily surrender," Robertson wrote on September 3, and were designed (of course) for the burghers' own protection.[3] Their builders called them *laagers,* a Dutch-Afrikaans word originally used for a defensive circle of wagons and meaning, roughly, "encampment." One month later, in October, it was the turn of the United States War Department to consider more radical strategies for taking over from the Spaniards in the Philippines. The election in November forced them to shelve the planning, but it went forward again once McKinley had been reelected.[4]

It was only a week or two after election day that the news leaked

to that hotbed of anti-imperialism, Boston, Massachusetts. There it was reported in the *Herald* on November 19 that the Kitchener "plan of reconcentration" in South Africa was being carefully studied in Washington for possible use in the Philippines; and in the *Globe* that the War Department thought the Insurrection could not be suppressed "unless the Filipinos are forced to leave the country districts and settle in the towns where they can be kept under the eye of the military authorities."[5] As near as we can tell, the first American concentration camps were built for the Filipinos in that month of November 1900, which means that the British were just ahead of the Americans in adapting Weyler's invention. By December 20, when General Order Number 100 on the treatment of civilian "war rebels" was issued by General MacArthur (this was Arthur MacArthur, whose son Douglas was to follow in his and Weyler's footsteps as proconsul of the Philippines), the "reconcentration camps" were there to receive them.

On the same day, halfway across the world in South Africa, Kitchener issued a memo on how *laagers* were to be designed, with fenced areas and "blockhouses" used as they were in prisons to observe and prevent attempts at escape. By January 1901, *laagers* had been built for Boers at Bloemfoentein, Norval's Point, Aliwal North, Springfontein, Kimberley, and Mafeking in the Transvaal. There would eventually be forty-three of them, plus thirty-one more for those the Dutch called *kaffirs*, the original black natives of South Africa.[6]

Thus our century, whether it began in 1900 or 1901, has been from birth the century of the concentration camp. Once the *laagers* were available in South Africa, the generals could dream up new ways of using them. In March 1901, Kitchener conceived a new strategy in South Africa involving "drives" and "bags" of "refugees" to fill the *laagers* and assigned the civilian governor, Milner, to execute it.[7] By the end of June, Kitchener estimated that over half the population of South Africa was in either the *laagers* or conventional prisoner-of-war camps, and he so reported to Broderick in the War Office with the suggestion that the inmates be deported permanently to South America so that there would be "room for the British to colonize."[8] By the end of July, Kitchener was pushing for a policy of executing or deporting persistent rebels, and at the end of August he was advocating selling their property to pay the cost of the ever-expanding camps.

It quickly became clear that *laagers* were not exactly for the convenience of "burghers who voluntarily surrender," and that once one got into a *laager* it would be the very devil to get out again. As for those incarcerated in the *laagers*, many had begun to suffer before the first month was out. An appalling death rate established itself during April (the South African autumn) and then proceeded to rise inexorably. By October, published reports put it at 34.4 percent, which included the 60

percent death rate for children.[9] Because the main cause of death was disease, this was not evidence of deliberate extermination; but to many who did not like it (and a few who did), the rates made it seem hardly less deliberate than a shooting.

We owe most of the foregoing knowledge to an inspection trip by an extraordinary woman named Emily Hobhouse. On December 27, 1900, Hobhouse stepped off a steamship at Table Bay, South Africa, intent on spending the first weeks of the new century seeing what her taxes were accomplishing in the Boer War. She succeeded, and was horrified. "Since Old Testament days," she asked, "was ever a whole nation carried captive?"[10] In a month, she had found her way to the Bloemfontein *laager*, and was intimidating British camp officials into letting her check things out. From there she went from camp to camp for a stay she extended to two full months, sniffing her way to the inadequate rations, the infected water, the primitive sanitation, and the ever-increasing suffering. When she came home, she went right to the press with her neatly written reports and got them into print, bit by scandalous bit, from the end of April to the end of June.

Her timing was exquisite. The Liberal anti-imperialists in Commons had already broached the issue. On March 1, two radical members of Parliament, C. P. Scott and John Ellis, had used the phrase "concentration camps" for the first time in English referring to the *laagers* in South Africa.[11] No less than the leader of the Liberal shadow-cabinet, Henry Campbell-Bannerman, soon made a speech at a Party dinner in a London restaurant calling the British camp policies "methods of barbarism," and comparing them to their originals, those of the Spanish in Cuba. Three days later, on June 17, 1901, the Party's rising star, David Lloyd George, rose in the House of Commons to answer Brodrick of the war ministry, stripping the weasel words from the debate and unambiguously branding reconcentration as "a policy of extermination." Replies from the government bench were unconvincing. Tory MP Winston Churchill, elected the year before on the strength of his intrepid escape from a Boer prison in December 1899, knew better than to say anything at all; but then, he was in the habit of getting out of countries just as concentration was about to begin. In 1895 he had accompanied the Spanish colonial army in Cuba, getting out just before Weyler's appointment, and remembering only the thrill, on the day he turned twenty-one, of hearing the shots of rebel Cubans "whistle through the air." On December 12, 1900, when Hobhouse was on the boat for South Africa, Churchill had been lecturing about the Boer situation in New York, trying to ignore the fact that Mark Twain had taken it upon himself in his introduction to call the British war in South Africa the twin of the American war in the Philippines, and to remind the audience that the two aggressors were united in Churchill's ancestry. Churchill's simple Tory militarism might fill halls and sell books;

but the dissent launched by the Liberals in the Commons debate of 1901 was a rising tide, a tide that had much to do with stopping the Boer War and eventually putting the Liberals in power.[12] It seems it was still possible to stop barbarism by bringing it into the light, at least as long as most of its victims were fellow Europeans.

The British Army didn't like it a bit. Hobhouse's reports and their reception were one of the reasons Kitchener pushed harder and harder for deportation and dispossession of rebels in the summer of 1901; but the day when a government could commit atrocities in total secrecy still lay in the future. Besides, Hobhouse was irrefutable. In August the government found Millicent Fawcett, a woman who proved to be clearly in favor of the war and was willing to visit the camps and file a counter-report. Unfortunately Fawcett's figure for the death rate was no better than Hobhouse's (20,000 or more died in the camps from January 1900 to February 1902), and her recommendation to continue the camps, but with better plumbing, arrived too late to turn the tide of opinion.

The spring of 1901 was not much better for the United States Army than it was for the British, though the opposition had no Hobhouse and was never as well informed. Opposition to annexing the Philippines was led by the New England Anti-Imperialist League, a classic Boston institution, and a phalanx of Senators headed by George Frisbie Hoar, a pink-faced Republican radical from Worcester, Massachusetts. Hoar had put himself on record back in 1898 against acquiring the Philippines at all, and was doubly outraged in the next few years to see them being secured by a war against the Filipinos. In January 1901, the League, which had been founded to prevent the acquisition, heard a speech by Gamaliel Bradford describing something called "the water cure," which U.S. troops were now using against captured Filipinos. It was a way of getting a prisoner to talk. To administer the water cure, one inserted a funnel in the prisoner's mouth and poured water down it until the victim "swell[ed] up like a toad" and he either cooperated or drowned.[13] According to Bradford, the Americans had learned it from the Macabebe minority of the Philippines, who were said to have learned it in their turn from the Spanish Inquisition early in their history as a Spanish colony. On March 30, as Hobhouse was visiting the *laagers,* an aroused League held a mass meeting in Faneuil Hall, Boston, where the abolitionists had spoken two generations ago, and cheered as speaker after speaker denounced the "reconcentration" policy of the United States Army in the Philippines.

Unfortunately, in America the effect of protest was minimal. The Anti-Imperialists were a fringe group and Hoar was rapidly becoming a fringe Senator. The Army listened to neither. After a successful Filipino surprise attack on his troops on September 28, which he dubbed the "Balangiga Massacre," General Jacob Smith introduced "reconcentration" on Samar Island. The Manila *Times,* organ of the elite, endorsed

it.[14] Only later was it learned that Smith's oral order had been to turn Samar into a "howling wilderness." Later, in December, General J. Franklin Bell issued the first of a series of thirty separate orders implementing the "concentration" of nearly 100,000 civilians in the Batangas province of southern Luzon. This figure makes it clear that the Americans were working on the same scale as the British, who, from December 1900 to February 1902, had locked up about 120,000 Boers.[15] On the whole, too (I think), it is the Americans who came closest to turning a resettlement or concentration policy into a policy of extermination. The 20,000 Boers who died in the British camps died almost exclusively of epidemic disease; but we do not yet know how many Filipinos died in the American camps, or how they died.

As a colonial settler state, the United States had a history going back nearly three centuries of dealing brutally with colonized peoples. It was the United States that invented, in about 1834, the reserve or reservation for indigenous ethnic minorities. It was the governor of the American state of Missouri who first suggested, apropos of the Mormons in 1838, that expulsion or extermination was an appropriate policy for fellow citizens, and it was a Missouri militiaman, explaining his execution of that policy on a nine-year-old Mormon boy, who first said, "Nits will make lice." It was an American, Philip Sheridan, commanding general of the U.S. Army, who polished up the thought by observing that the only good Indian was a dead Indian. Indeed, in that year of the Philippine Insurrection, 1901, while the Apache chief Geronimo was spending his fifteenth year of imprisonment at Fort Sill, Oklahoma, General Nelson Miles, whose false promises had induced Geronimo to surrender, was concluding his own career as the Army's overall commander and accepting a final promotion to lieutenant-general.

Of course, there was a debate in the Senate, and after that a Senate Committee to investigate the atrocities in the Philippines. The investigation began in February, hearing from officers and noncoms about torture, concentration, and massacre, and sent many on to courts-martial. It adjourned in June, after the courts condemned several enlisted men to prison and fined and "severely admonished" several colonels and generals. The new president, Theodore Roosevelt, promised a full investigation. He never delivered. He did send a general over to the Philippines to "inspect" the Army's treatment of the Filipinos; but for some reason the general's report did not name very many names or place very much blame. Perhaps this general—Lieutenant-General Nelson Miles—had not been the right man to send.[16] Of course, by then the Insurrection was over, its leader had been captured, and the Americans had won. Besides, it was Roosevelt who, as Secretary of the Navy, had ordered the fleet to take the Philippines in the first place.

"There is no special Providence for Americans and their nature is the

same with that of the others," John Adams wrote in 1787, and John Adams did not think there was a special providence for any other nation either.[17] In 1904 it became the turn, at last, of the Germans, who until then had been leveling withering moral criticism against the uncivilized behavior of the British in the Boer War. Their colony, called South-West Africa, was just north of British South Africa. Their man in charge there, General von Trotha, issued an order on October 2, 1904 that came to be known as the *Vernichtungsbefehl*—the Annihilation Order. Designed to avoid the sort of failure Spain had suffered in Cuba, it required the German troops in South-West Africa, who had just attacked and defeated the troublesome Herero tribe, to hunt them down, drive them past barbed wire into the waterless Kalahari Desert, and exterminate them if they came back. The troops did their best: estimates conclude that only 15,000 Hereros remained out of a total of 80,000 after their work was done. Forced to retract his order in December, von Trotha provided two concentration camps, where survivors were branded and put to forced labor nearby; but the massacres had already happened, and most of the Hereros who were to die had already done so by the time the camps were opened.[18]

In 1904, when Adolf Hitler was sixteen, extermination and concentration were still separate policies. Eight years later, for example, in 1912, a private entrepreneur seems to have become the first to use concentration camp inmates specifically for forced labor. This was Julio Arana, the South American rubber baron, who employed a private army of Barbadian blacks to round up nearly 30,000 of the 50,000 Indians of the Bora, Andoke, Huitoto, and Ocaina tribes, put them in camps, and use them as slave labor in the rubber harvest. It was said that before he was stopped, there were fewer than 8,000 Indians remaining along the Putumayo River between Peru and Colombia, and that the rubber Arana produced was costed out at seven lives per ton; but this, it could be argued, is more carelessness than policy.[19]

The problem of definition cannot, I think, be reduced to a question of scale. The famous Turkish extermination of the Armenians, which had been adumbrated already in 1909, got under way in earnest in 1915 as Turkey lumbered into World War I. An order may have come in a cipher telegram from Enver Pasha to his provincial army commanders on February 27.[20] The Turkish method was to send military units from village to village, drive the Armenians out onto the roads as refugees, and then massacre them in the countryside. In cities, they simply laid siege to the Armenian neighborhoods, or if necessary, to the whole city. The precedent it set for the appalling future was in the use of neighborhoods as temporary prisons and in the understanding of how much easier it was to kill moving refugees than rooted villagers. Although there is a cave near a place called Deir ez Zor that was used at the end of one march to

store prisoners until they starved, no "camp" seems ever to have been planned for the Armenians. It was not the technique of concentration that made this massacre the largest so far (at least eight hundred thousand and probably more than a million killed), but military technology, organization—and sheer ruthlessness.[21]

Next after the Turks came their ancient enemies, the Russians. Under the Czars, Russia had become expert at handling national minorities through ethnic repression and by applying the old Turkish policy of divide and conquer. It was the homeland of the pogrom, or officially sponsored anti-Semitic raid. After the Revolution, though official sponsorship was withdrawn, the pogroms did not stop; and the first concentration camps appeared. The order was Leon Trotsky's, dated June 4, 1918, proposing "concentration camps" for insubordinate Czechs. In August, Trotsky ordered two "concentration camps," in Mourom and Arzamas, for a mixed bag of offenders, including "underhanded agitators, counter-revolutionary officers, saboteurs, parasites, and speculators." That same week, Lenin ordered "massive terror" against kulaks and white guards in Penza and added, "Lock up doubtful elements in a concentration camp."[22] Ethnic minorities were not included in these August orders, which means the term "concentration camp" had clearly acquired, in Russian, an additional, penological meaning.

It is, however, to the Russians that we owe the final conflation of concentration and extermination. It dates rather precisely to an order given not by Lenin or Trotsky, but by the man who ended up in charge of all these new penal institutions demanded by the Revolution: Felix Dzerzhinsky, the head of the secret police. On September 17, 1918, eager to open up more space in the camps and convinced that the fact of being in a concentration camp in the first place was evidence of treason to the Revolution, Dzerzhinsky ordered the "liquidation of suspended affairs." He meant the killing of every prisoner whose case was under investigation.[23] A few months later, after the protests within the Communist Party had been settled, Dzerzhinsky was made People's Commissar of the Interior, and his Cheka was given official control of the entire metastasizing network of concentration camps, including the right to put people into them and, it was understood, the right to put people out of them, dead or alive. In April 1919, the Central Committee defined two kinds of camps: "forced-labor camps" for those who had been sentenced as criminals, and "concentration camps" for those who had not faced a trial but were merely "administratively detained." In May, Dzerzhinsky followed it up with a decree that there would be one camp in each province of the new Soviet Union, each holding at least 300 prisoners in one of 16 categories.[24] Some of those categories were individual, many were class or economic, and a few (a very few) were essentially ethnic. By the end of 1919, they were part of the fabric of the Soviet Union.

These camps survived Dzerzhinsky and all but the last of his sinister successors in the commissariat of state security. In the late 1930s deaths from disease and malnutrition in the camps were probably exceeded by deliberate executions. Inmates in the 1950s, like Solzenytsin, referred to them as the "Gulag Archipelago." When Hitler and Himmler opened their first camps (Oranienburg, Dachau, and Columbia House) in 1933 and 1934, the first two years of his Chancellorship, their most important models were the labor camps in Russia, then beginning a major expansion under Stalin. True, they thought they knew what had really happened to the Armenians, thanks to the publication in 1920 of the purported extermination order of Enver Pasha, and they even knew of official Germany's complicity in the crime of her Turkish ally, thanks to the publication in Russia in 1918 of the papers of a murdered German socialist. Nevertheless, they had not yet designed for extermination, and would not until after Hitler's oral order of January 21, 1939. That order was followed seven months later by Hitler's invasion of Poland and the Führer's famous question, "Who talks nowadays of the extermination of the Armenians?"[25] If they had any usable memory of the *campos de reconcentraciòn*, the South African *laagers*, the Philippine concentration camps, or even the Herero massacre, it has not so far shown up in the documents. The concentration camp, with a built-in auxiliary capacity for extermination, was now a general, noncopyrighted product of Western civilization, and, as it happened, soon to be available to the entire world. To historians, who have seen it used since by the Japanese against the Taiwanese and Koreans, by the descendants of the Boers against the Africans, by the Kenyans against their Indians, by the Khmer Rouge against their city-dwellers, and even by the Israelis against the Lebanese Moslems, it was not surprising to see it used by the Americans against the Nisei in 1941, and it is more than irony to see it used by Europeans once again against each other in the Balkans.

The West's invention of the twentieth century's classic political weapon has left our culture with a bad conscience. Resolution can only begin with words like those that old Calvinist John Adams could not resist putting into his *Defence* of the American constitutions: "There is no special Providence for Americans, and their nature is the same with that of the others."

9 SIGMUND FREUD

TIME REPRESSED AND EVER-PRESENT

1899

On the fourth day of the new year, 1899, Sigmund Freud wrote to Wilhelm Fliess, his intimate friend, confessor, and scientific sounding board, "today I cannot go on writing along the lines I intended because the thing is growing. There is something to it. It is dawning." [1]

Freud was at his desk on the second floor of Berggasse 19, the mezzanine floor below his apartment, trying to find something beyond his livelihood as a doctor that would bring him recognition as a scientist. For seven years he had spent most of his late evenings here alone, smoking and scratching away with a steel-point pen at articles for medical journals. Before him were the ashes of spent cigars and a large, disorderly, steadily growing manuscript that he called the "Egyptian Dream-book" and sometimes just "the Dream." He had been thinking about it for six years. In 1897 he had begun putting it on paper and given it a working title: *Die Traumdeutung*—giving meaning to dreams. Six months ago Freud had put the manuscript away in a drawer; but in this wintry first week in January 1899, he pulled it out again. One of his memories—two boys and a girl eating fresh bread near a field full of dandelions—had just proved to be in the wrong place in time, projected from his early childhood (when it had really happened) to his teens. In its new place it had acted like a screen, veiling a youthful sexual longing that he hardly remembered at all. This discovery of what Freud decided to call a "screen memory" was no more strange and counterintuitive than so many other discoveries he had been making since beginning his psychotherapeutic practice in 1886; but this was the one that brought *Die Traumdeutung* out of the drawer and onto the desk for good. He began a short paper on it, centered on a dialogue between Doctor Freud and himself disguised as his own patient, a sly transformation of confession into case history that pointed toward a new and final form for the "Egyptian dream-

book."[2] In ten months of late evenings and a summer at Berchtesgaden he had the manuscript finished. Published by Deuticke of Vienna in November 1899, but dated 1900, *The Interpretation of Dreams* became the breakthrough work of Sigmund Freud's scientific career, a career that has changed not only the twentieth century's psychology paradigm, but its whole moral world.

Die Traumdeutung is a treatise in the area of medicine that in 1899 had been known for more than a century as psychiatry (roughly "soul-craft"), and in the last fifty years of the nineteenth century as nerve therapy or neurology. It is at once a summary of new therapeutic techniques and an introduction to a theory of why they work—a new theory of how the central nervous system meshes emotions, ideas, and imagination, and occasionally produces nonorganic or "functional" diseases like hysteria. That at least was what Freud said it was in the opening pages. *Die Traumdeutung* insists on its form as a scientific treatise, an extended argument for Freud's hypothesis that the mental activity called a dream is always, however disguised, the fulfillment of a wish.

But what are we to make of it when we learn, in the pages of a purported work of science, that its author was born with black hair, wet his bed, fought with his nephew John, and was told by his father that he would come to nothing; that in middle age he slept soundly, suffered a boil "the size of an apple" on his scrotum, lusted to be made a university professor, and not only smoked too much but even spat on the stairs?[3] Such revelations are scattered everywhere, with no regard to the chronology of a life, presented as material for interpreting dreams—for most of the dreams interpreted in *Die Traumdeutung* are Freud's own. The fact is that "the Dream" is no less an autobiography than *Portrait of the Artist as a Young Man*, jammed with Freud's own subjective experience—his youth, his family, his career, and of course his dreams. Neither framed as autobiography nor disguised as a novel, *Die Traumdeutung* is instead dressed as science. Since it is thanks to Freud that Westerners can no longer judge a conscious act without raising the question of unconscious motive, we have Freud himself to blame if we ask about his book: why the disguise?

Was it prudery? Although Freud firmly believed in 1899 that sexual life was at the root of all neurotic disorders, he believed that he himself was cured of neurosis, and indeed he let his own sex life sink beneath the surface of *Die Traumdeutung,* with no more trace than a few hints that some of his dream-interpretations were not complete. More likely, however, is that Freud was trying to disguise not what he left out of his book but what he left in it: his ambition.[4] Sigmund Freud wanted to be a great scientist; and his dreams, insofar as he reported them in *Die Traumdeutung,* were dreams of glory.

Freud had come to science late, and he had come to it for its fist-in-

the-air promise, rather than any unalloyed intellectual pleasure he took in a particular discovery. "For eight whole years," Freud wrote in *Die Traumdeutung*, "I sat on the front bench as top of the class" at the Sperl-gymnasium, one of Vienna's most competitive high schools. His best subject had been "history, in which I did brilliantly," and the few problems he had encountered were with music and math. He could have become anything from a barrister to a professor of Greek. His family had emigrated to Vienna from a "small town in Moravia," and their early poverty would have made any lucrative profession attractive; but Freud wanted more. His mother had favored him outrageously. When young he had fantasized himself as Hannibal, as Alexander and Moses, as Cromwell, Napoleon, and Napoleon's marshal, Masséna, as Schliemann, the discoverer of Troy, and even as Columbus. When he was eleven or twelve a poet in the Prater had wandered over and prophesied that "I should probably grow up to be a cabinet minister." Now forty-two, Freud was fantasizing himself as Joseph (Joseph was the Bible's interpreter of Egyptian dreams and the son, like Freud, of a patriarch named Jacob), and remembering that as a student what he had wanted above all was fundamental, philosophical knowledge. Just before he entered the University of Vienna, he had switched from law to medicine, after hearing a reading of Goethe's *Nature* and deciding that biological research seemed more likely to lead to fame and new truth than politics. It had not been easy. At the university, he wrote, "I . . . failed Forensic Medicine," and in Chemistry, which he knew was a prerequisite for the cutting edge of experimental medicine, "I worked for a long time . . . without ever becoming proficient."[5]

Once he had become a scientist, however, Freud never stopped insisting that what he was doing was good old-fashioned nineteenth-century science. He would come to compare himself with Copernicus and Kepler, Leonardo and Darwin. Stung by criticism that his system was unprovable and unscientific, he countered that his highly novel psychology was an observational science, like astronomy, where experiments were irrelevant.[6] Nevertheless, in the back of his mind (to use a pre-Freudian phrase) Freud always remained true to the earliest of all his ideals. As he explained to Fliess as "the Dream" went into print, he was "actually not at all a man of science, not an observer, not an experimenter, not a thinker. I am by temperament nothing but a *conquistador*— an adventurer, if you want it translated."[7] Near the end of his life (by which time he was comparing himself with Moses) Freud would even begin to claim that his theory was the third great blow to the naïve megalomania of mankind (after the heliocentric universe and the evolution of species), and he accepted from the novelist Arnold Zweig the judgment that what he had created "has reversed all values, it has conquered Christianity, disclosed the true Antichrist, and liberated the spirit of resurgent life from the ascetic ideal."[8]

But that was long after. In 1899, the Emperor Franz Josef's fifty-first year on the throne, Freud's approach was no more than a medical oddity. Freud had never dreamed of being a healer. He had gone into medical practice in order to have the income to found a family while he made his name in original research; and neither practice nor research had gone all that well. Freud was already past forty when his great discoveries at last began to fall into publishable order in January 1899, and the recognition he so deeply desired would not come until he was almost fifty. His neatly trimmed mustache and beard were already beginning to gray. It had been eighteen years since he had gotten his M.D. in 1881, a long apprenticeship during which he had missed at least two research opportunities and was now exploring his third borrowed therapy. The first missed opportunity, while he was still a research biologist, had been in neuroanatomy. The second had been on the effects of a brand new pharmaceutical—cocaine. The first of the three borrowed healing methods was electrotherapy, the second hypnosis. The third was Josef Breuer's "talking cure," a psychotherapy that had nothing whatsoever to do with brain structure. Here and there in *Die Traumdeutung* Freud would refer to it by the term he had first used in 1896—"Psychoanalyse." But only years afterward would it be clear that the therapy and the theory behind it were not only Freud's to name but also one of the great formative intellectual innovations of the new century.

It is hard now to imagine how easily a medical scientist like Freud could have felt himself, at the close of the nineteenth century, to be a lone hero. Histology was a science when Cajal began his work, but medicine—curing people—was at best an art. It was a scientific profession only in the laboratories of men like Ernst Brücke in Vienna ("the honored teacher of my student years"[9]) and Jean-Martin Charcot at the Salpêtrière in Paris. Not only the general public, but most practicing physicians, were convinced that uninvestigated, possibly occult or spiritual factors were as likely to bring on and cure disease as any known manipulation of tissues and chemicals. It was the heyday of homeopathy and allopathy, patent medicines, healing spas, and hydrotherapy. The germ theory of infection was still new. Surgery had only recently been naturalized as a medical specialty. Psychiatry—the treatment of mental diseases—was much older; but its condition was the most problematic of all, littered with diseases like neurasthenia and hysteria whose names now mean little. Beset by the ancient mind-body problem, psychiatry was disfigured with bizarre therapies based on every conceivable approach to its solution. Practitioners were still called "alienists" and were liable to try anything. Anything might work, too, for no one had yet studied the phenomenon we call the placebo effect. The goal for Freud, who was an atheist no less "full of materialistic theories"[10] than Helmholtz and other heroes of the previous generation, was to find neurological and neuroana-

tomical causes for what to him were not mental or emotional problems, but "nervous disorders."[11] Jean-Martin Charcot had provided an example in 1869 when he published his painstaking proof that amyotrophic lateral sclerosis—Lou Gehrig's disease—came from the destruction of certain nerve cells and not from hysterical imaginings.

Charcot's specialty, neurology, was a branch of internal medicine, not of psychology. Psychology, in turn, was not a medical but an academic subject. Philosophical psychologists like Freud's old teacher Brentano had nothing to say about the brain; and the pioneering "scientific" psychology labs like Wilhelm Wundt's in Leipzig and William James's at Harvard had not got much beyond the measurement of "stimulus" and "response," just as neurology had not got much beyond the typical "reflex arc" of the knee-jerk, discovered in 1875. The neurophysiological question was, rather, where nerves were, what they did, and precisely how they did it. That they did it electrically had been known since DuBois-Reymond's book on "animal electricity" in 1848, and Helmholtz himself had measured an electric impulse along the nerve of a frog and found its speed to be finite. That is where Freud had started, dissecting eels in the University of Vienna's marine biology lab at Trieste, and later, under the "terrible blue eyes" of Ernst Brücke,[12] tracing the long axons of the nerve cells of lampreys (*Petromyzon*) and crayfish in the microanatomy lab. These were, he wrote, "the happiest hours of my student life."[13] "The five years which are prescribed for medical studies" were, he wrote, "too few for me. I quietly went on . . . for several more."[14]

Brain anatomy seemed the royal road to psychology in the late nineteenth century. William James's student, Gertrude Stein, had done a microanatomical study of the brain's "nucleus of Darkschewitsch" for Professor Barker at Johns Hopkins—published in 1899, as it happens, in Barker's textbook. Freud had studied neighboring parts of the brain with Darkschewitsch himself back in 1885, and planned a textbook of his own. Cajal's neurons had inspired many bright young medical researchers like Stein; and in the summer of 1899, Cajal himself was inspiring some of them directly. As Freud was finishing the last chapter of *Die Traumdeutung* in Berchtesgaden, Cajal, Forel, and Angelo Mosso were in Worcester, Massachusetts to accept their honorary degrees from Clark University and to lend luster to the new college on its tenth anniversary. Cajal's lectures explained his delicate pictures of the cerebral neurons. Auguste Forel's summarized the new neuroanatomy and reminded his American audience of the work he had done since then as director of the Burghölzli Asylum in Switzerland and as a pioneer in psychiatric hypnotism. In Worcester, which may have been a bit behind the pace of innovation in neurology, Freud was a footnote, as unknown in 1899 as Cajal himself had been in 1888. Forel mentioned Freud's *Petromyzon* dissection in his lecture and disparagingly noted the Freud-Breuer view of hysteria.[15] Cajal

was even good enough to mention one of Freud's publications of 1884, a gold chloride stain for nerve cells that was, like Cajal's own, a variation on Golgi's. Cajal was not quite generous enough, however, to credit Freud with proposing the independence of the neuron, and he did not mention the other paper Freud published in 1884 that had seemed to suggest that.[16] After all, Cajal could see Forel right there on the same dais, claiming that Wilhelm His had published the same discovery in 1886 and Forel himself in 1887.[17] No, we cannot make too much of Freud's attempt to become a Columbus of neuroanatomy. When he was finally invited to America for Clark's twentieth anniversary celebrations in 1909, it would be as the conquistador of imagination. He never made much of neuroanatomy, and he surely would have done so if he could, for his ambition was very large—large enough to invade his dreams.

Freud had been tempted away from neuroanatomy by the prospect of making his reputation with a wonder drug and getting enough money to marry on. His failure to accomplish that with cocaine was to nag at him for the rest of his life. As Freud was writing "the Dream" in 1899, the fifteen-year-old cocaine episode came up in nearly every chapter, and prominently at the very beginning of the book. To open his argument, in what is now chapter 2, Freud used a dream he had had on the night of July 23, 1895, now famous as the first dream he ever got to the bottom of. Calling it "The Dream of Irma's Injection," he reconstructed it as the book's armature—a representative interpretation of a sample dream, whose repressed theme or wish, his analysis proceeded to reveal, was to excuse his own failings as a doctor. "I had been the first," Freud wrote, "to recommend the use of cocaine, in 1885 and this recommendation had brought serious reproaches down on me. The misuse of that drug had hastened the death of a dear friend of mine. . . . I had advised him to use the drug internally only . . . but he had at once given himself cocaine injections. . . . As I have said, I had never contemplated the drug being given by injection."[18]

In discovering what the dream had disguised, Freud did not quite tear away all its masks. It was not in 1885 but in 1884 that he had become not the first but the second person to publish the news that cocaine was psychoactive and to recommend it for fatigue. (The first was Theodor Aschenbrandt, who had tested it on the Austrian army in 1883.) Freud's 1884 article had raved that cocaine was the specific antidote to that great scourge of the nineteenth century, "neurasthenia" (weak nerves), first diagnosed and described by an American doctor, Charles Beard, in 1869 (and now known not to exist). What Freud had done in 1885 was try to cure his old friend and fellow student, Fleischl-Markow, of his morphine addiction by prescribing injections (not ingestions) of cocaine as a substitute. The article he had written hailing the success of the substitution had appeared just as Freud was at Fleischl's bedside, watching him die slowly

of cocaine abuse, an agony he refrained from describing in *Die Traum-deutung* because "the sacrifice demanded of me would be too great."[19]

Freud's advocacy of cocaine was so passionate and indiscriminate that even his admiring biographer, Ernest Jones, thought he might nowa-days seem "a menace to society." In addition to prescribing it for Fleischl, Freud admitted, "I was making frequent use of cocaine at that time."[20] Taking a new drug yourself was the quick way to test it, and not as unpro-fessional as it seems a century later. William James, who was no doctor, had begun investigating psychoactive drugs in 1870 by taking a dose of chloral hydrate, then popular in Bowery dives as "knockout drops," and had followed it over the years with self-tests of amyl nitrate, nitrous oxide (laughing gas), and peyote. In 1897, Freud would deliberately apply his own psychotherapy to himself in the famous "self-analysis." But cocaine was more than an experiment. Freud swallowed cocaine to raise his spir-its, dosed himself with it to relieve migraines, and painted it on the inside of his nose with the blessings of Fliess, ignoring the possibility that it was causing the irregularity in his heartbeat, and never even suspecting that it might bring on mania or paranoia. He went further, sending doses of cocaine to his fiancée, Martha Bernays, and prescribing it for his "neur-asthenic" patients. Only much later did he realize that of all the prescrip-tions he had made and all the uses he had suggested for cocaine, all but one were either too dangerous or too useless to remain in therapeutics. The only one that did do any good, topical anesthesia, Freud wrote, "I had not been thorough enough to pursue."[21] Attempting to inject cocaine into a single nerve to block its action, Freud's hand had not been sure enough for a conclusive experiment. Instead it was a Viennese colleague who scooped him with the news that a topical application of cocaine hydrochloride was a perfect anesthetic for eye surgery.

Fresh from the failures of cocaine, Freud had gone to Paris, "for many long years [a] goal of my longings."[22] The occasion was a travel grant he had won in the fall of 1885 to pursue his studies of brain anat-omy under Charcot at the Salpêtrière asylum-*cum*-teaching hospital in Paris. In the 1880s *tout-Paris*—"all Paris"—was coming on Tuesdays and Fridays to the asylum's lecture hall to see Charcot demonstrate his remarkable discovery, "hystero-epilepsy" or *grande hystérie*. Grand, or gross, hysteria was truly spectacular, consisting of seizures, followed by contortions, paralyses, distortion or loss of the senses, fits, fainting, and foaming at the mouth. Moreover, by hypnotizing the patient or by putting pressure on her ovaries, Charcot could bring on the whole thing, in just that order, before an audience, and stop it the same way. Writers like Léon Daudet, Jules Claretie, and the Goncourt brothers were fascinated. So was the playwright Strindberg, who was mad himself at the time; and doubtless those Tuesday and Friday performances were contributing, along with cabaret, to the development of the mad monologue and the

shifting tones of the new poetry. Medically, however, Charcot presented grand hysteria as the latest and most sophisticated result of a scientific lifetime spent defining "organic" mental diseases caused by actual physical damage to the nervous system. Charcot had not yet found the damage that caused hysteria, but he had (or so he thought) the etiology down as pat as the symptoms. It was, he said, a hereditary degenerate condition a bit like epilepsy whose indicators were local losses of feeling and susceptibility to hypnotism. Grand hysteria notwithstanding, the Charcot Freud had come to see in 1885 was the world's leading neurologist, and the one who seemed to have the best chance of finding a solution to the hysterias that would finally place them with syphilitic paralysis and multiple sclerosis in the "organic" category of nervous diseases. Freud had learned hypnosis in Paris; and he was so proud to have been at the great man's feet that he named his first son Jean Martin.

But that was only three years after his trip to Paris. Now, writing *Die Traumdeutung* thirteen years later, Freud mentioned the city only twice, describing the "blissful feelings with which I first set foot on the pavement" and the pleasure of clambering "on the towers of [Notre Dame] between the monsters and the devils." In a dream he identified himself with "Gargantua . . . Rabelais' superman, [who] revenged himself . . . on the Parisians by sitting astride on Notre Dame" and urinating on them from the heights.[23] Charcot he mentioned not at all. All of Charcot's lore about grand hysteria had been dropped from medicine after the great man's death in 1893, and we now know that none of it was true. When the mind produces physical symptoms all by itself, it tends to produce what therapists expect and, in a sense, train it to do. Even a hypnotic trance, Freud had learned later in Hippolyte Bernheim's lab at Nancy, was not an indication of hysteria, but something even a non-neurotic could undergo. (August Forel had come to Nancy from Zurich in 1887 to learn the same lesson.) The only thing Freud learned in Paris that stayed with him was about sex: something he had not really thought about before (even after keeping his fiancée, Martha, waiting for four years), and something he was now going to considerable lengths to keep out of his autobiography in *Die Traumdeutung*. The root of many if not all hysterias, Charcot had said, was something sexual.

When Freud had left the brain lab of "the great Meynert, in whose footsteps I had trodden with such deep veneration,"[24] and gone finally into private practice, the object had been to end a five-year engagement by marrying his dowerless Martha. Psychoanalysis did not yet exist, so he decided to go with hypnotism as a treatment for the functional nervous diseases. For the organic ones Freud opted for electrotherapy, which stimulated the nerves in the "natural" way, electrically, by applying "faradic brushes" to the throat if you had a nervous cough or by putting live electrodes on your bare skin if you had a paralysis. And so, after spending

a good bit of precious capital on some of the impressively high-tech equipment recommended in the textbook of a highly respected electrotherapist (the knee-jerk discoverer, Dr. Wilhelm Erb), Freud had hung out his first shingle as a *Nervenarzt* (psychiatrist/neurologist) at Rathausstrasse 7, Vienna on Easter Sunday, 1886. His thirtieth birthday was in two weeks. The wedding was set for September.

The failure came more slowly this time. With electrotherapy (and later hypnosis as well) Freud had once again bet on the wrong horse. Writing up dream after dream of youthful ambition in *Die Traumdeutung,* Freud was managing to leave out the electrotherapy episode as completely as the name of Charcot—or that of Paul Möbius, who had successfully asserted that electrotherapy too worked by suggestion on the mind and not physically on the nerves. Not until he took time out in 1925 to write a conventional autobiography would Freud remind himself in writing of that third false start, and he never referred to Rathausstrasse 7, where he practiced for more than five years before moving to the apartment in Vienna's Ninth District he was to make the most famous street address in the "City of Dreams," Berggasse 19.

It was at this juncture that Freud had grasped the possibilities of a career on the model of Josef Breuer's. Dr. Breuer had managed to combine science and private practice without holding a university post. His reputation as an internist had made him family physician to the best of Vienna's medical faculty, and his reputation as a researcher had been sealed by two of the century's important discoveries in human physiology. In Freud's first year with Meynert, Breuer had "taken over the duties which my father could no longer fulfill,"[25] become a mentor to him, and had even loaned Freud considerable sums of money with no prospect of repayment, to keep him in research. In his own practice of internal medicine, Breuer had treated several patients for functional neuroses, including hysteria. One of these, Bertha Pappenheim, had led him in 1881 to a curious new therapy according to which Pappenheim would relive feelings evoked by early traumatic experiences she remembered under hypnosis. Breuer called it "analysis" followed by "abreaction" or "catharsis." Pappenheim had called it "chimney-sweeping" or *Redecur* (talking cure). We have as much reason to give her name to the therapy as we do Breuer's, for this was the famous "Anna O.," the first person in the world to undergo psychoanalysis.

Freud had been fascinated by the story when Breuer told it to him in 1882. Might this therapy work for others? Freud had tried it out on several cases. Breuer was alternately scientific and paternal. The therapy took many hours, even with hypnosis, and though Freud could use the business, Breuer had more patients than he needed. Besides, after using hypnosis from 1887 to 1889 in much the same way Breuer had, to get neurotics to reveal their traumas and to open them up to the "talking

cure," Freud had found hypnotism too controlling to evoke the truth and abandoned it for a procedure of allowing "the unconscious" to bubble up through conscious talk—something he would eventually dub "free association" and compare to reporting the sights that appear in the window of a moving train.[26]

As the number of patients mounted, Freud's mind had turned to scientific glory. Might all their hysteria cases add up to something? Together they had agreed to publish a general treatise on hysterias.

Meanwhile, as the cases came in between 1893 and 1898, Freud had become increasingly sure that all the neuroses were based on sexual dysfunction. The "neurasthenia" epidemic, he had then believed, was due to the increase in masturbation, and "anxiety neuroses" to the abstinence and *coitus interruptus* to which the rising middle class was being driven in its attempts to avoid syphilis and reduce its birth rate. As for hysterias, he thought, they came from unassimilable sexual experiences perpetrated on innocent children. Most of his papers talked relentlessly and defensively about the need to bring "sexual life" and "sexuality" into diagnostic consultation. As for Freud himself, he was a male Viennese burgher, and his thoughts about sex ran to form, especially from a man who was not much better at abstaining from sex than he was at giving up cigars. In his view, anything that got in the way of regular sex was a bad thing. For some the importance of sex was Freud's contribution to modernity; but in fact, prudery had been dying in Vienna a decade before Freud (and twenty years before Lytton Strachey said, "Semen?" at Virginia Woolf's house in Bloomsbury). "Sexology" had become a major medical topic with Krafft-Ebing, who had coined both "sadism" and "masochism" in his famous compendium of perversions, *Psychopathia Sexualis,* published in 1886 and reprinted a dozen times since. Albert Moll had coined the word "libido" in his *Libido Sexualis* in 1897. In 1899, as Freud was writing the "Dream-book," Magnus Hirschfeld was putting together the first number of a journal called *Yearbook for Sexual Deviations,* and the Cambridge University Apostles were debating "Masturbation, End or Means?" Havelock Ellis in England and Mantegazza in Italy had begun publishing sexual lore in multivolume series that would become bestsellers as the century turned. Even the sexuality of infants had already been noticed by medical research.

What sex did for Freud was provide four separate indispensable (and largely material) agencies. First, sex was the source of the chemical substance Freud believed to be the direct cause of some neuroses (the *aktuelle* neuroses). Second, sex was the constant source of the electric energy he needed to postulate so as to "cathect" (charge up) and run his theoretical nervous systems. Third, sex gave an explanation in terms of biological evolution of the peculiar kinds of symptoms neurotics displayed. Fourth

and most important, sex was the all-purpose cause behind that curious mental faculty that was to be the greatest of all of Freud's ideas, *Verdrängung*—the "repression" that put memories into an unreachable "unconscious" part of the mind.[27] In 1895 it had begun to look to Freud as if this concept of repression, which had first appeared in his writings in 1893, might be the discovery that could make him a *conquistador,* and he defended it like one. His theoretical absolutism on this point even turned away Breuer himself, though Breuer had loyally called repression "exclusively Freud's intellectual property." As Freud came to tell the story later, he would picture Breuer turning prudish, complaining that Anna O.'s remarkable sexual abreactions had once come close to wrecking his marriage, but that was a fairy tale. Breuer had simply been too careful a scientist and too eclectic a healer to commit himself to so categorical a conclusion as the sexual origin of all neuroses.

"My emotional life," Freud wrote in *Die Traumdeutung,* "has always insisted that I should have an intimate friend and a hated enemy."[28] When the first part of *Studies in Hysteria* reached print in 1893, Freud's friendship with Breuer had begun to sour, and he had already found a substitute in Wilhelm Fliess, a Berlin doctor whom Breuer had brought to his lectures in 1887. "My friend in Berlin,"[29] as Freud was calling Fliess in the book, specialized in curing his patients of "nasal reflex" neuroses by applying cocaine to and performing delicate surgery on the inside of their noses, and was in 1899 refining his "discovery" that everything in human physiology came in periods of twenty-three and twenty-eight days. The relationship with Fliess, improbable as it seems, had become by 1892 the most intimate friendship in Freud's adult life. He told Fliess everything, including the fact that he and his wife had given up sex in 1893 in order to prevent another pregnancy, and a few other things that even his wife did not know. He allowed Fliess to see things he hid from others, like his neurotic fear of trains (the same form of travel that would later provide him with his metaphor for free association). It was on Fliess's prescription that Freud had cocainized his nose and tried repeatedly to give up smoking. At least once a year the two would meet tête-à-tête to exchange ideas. Although what Fliess told Freud is largely unknown, since Freud seems to have destroyed his letters, what Freud wrote to Fliess survives: a week-to-week record of genius at work unlike anything in this era except Van Gogh's letters home.

In October 1895, Freud had sent Fliess a draft of a theory of the mind intended to yield eventually a detailed explanation of how repression could happen. He had never asked for it back. Those two notebooks we now know as Freud's "Project for a Scientific Psychology," the first-ever theory of nervous system operation based on the conservation of energy in and among neurones, and the first general explanation of re-

pression. It was also the first writing by Freud that included an explanation of dreams.

It was to Fliess that Freud had confided his growing conviction that the "anxiety neuroses" resulted from the repression of early sexual trauma. Fliess had independently concluded that sexual energy was the fundamental force of mind, and had no problems with Freud's insistence on a more and more exclusively sexual etiology of neurosis. Both men, too, had been collecting evidence that sex was older and more general than what happened after puberty. Like Freud, Fliess believed in Ernst Haeckel's Biogenetic Law, by which the young of every species were supposed to recapitulate the evolution of that species. A human child would, as he or she developed, recapitulate in this way the development of the whole human race. From aquatic beginnings in the womb where erotic feeling is everywhere, human children must, on this view, find sensual satisfaction first in the mouth, then in the anus and urethra, and finally in the genitals. Freud located each of his distinguishable psychoneuroses in a failure of one of these recapitulations due to sexual trauma or abuse. The overcoming of primitive stages, he had thought, was what repression had been evolutionarily designed to do. And this meant dreams were the marks of repression in all its stages. Dreams were like the mushrooms Freud so loved to hunt in the mountains on his summer vacation, arising from their hidden mycelium like the oracles of Delphi from the navel of the species.[30]

On November 2, 1896, Freud had begun to tell Fliess about his own vivid dreams. The occasion was the death of his father, Jakob Freud, "the most important event, the most poignant loss, of a man's life." The night after the funeral Freud had dreamed of passing a sign something like a no-smoking sign that said either "You are requested to close the eyes" or "You are requested to close an eye."[31] What did it mean? He had indeed closed the eyes of his father's corpse, which was a Jewish son's traditional duty; but, thought Freud, there must be more to it than that, someone's duty to overlook something, to "close an eye" to it. Perhaps it was the duty of the rest of the family to overlook the "puritanical simplicity" of the funeral Freud and his father had wanted. Perhaps it was to overlook something else that Freud had done or something that his father had done, like the way he had soiled himself in his last illness (a sour memory that would come up in a different disguise in a later dream). Or perhaps it was something Fliess had done, and Freud's dreaming mind had displaced his father with a sort of father-figure. With the recent publication of the missing letters in the Freud-Fliess correspondence we now have evidence that Freud indeed knew something about Fliess that he was desperate to excuse or overlook: the fact that an operation Freud had asked Fliess to do on the nose of one Freud's patients had been almost fatally

botched. The patient, Emma Eckstein, had been, in fact, the Irma of "Irma's Injection" in 1895.

There is yet another possibility, which even Freud was not indiscreet enough or perhaps not yet brave enough to write about. If his current theory were true and hysteria were really due to the effects of the sexual abuse of small children by their parents and caretakers, then Freud would not only have to aver that this terrible offense was widespread; he might even have to acknowledge it in his own father. The idea had come to him early in 1897, when he had first begun to write "the Dream"—to dream it, in fact, in his famous "self-analysis." It was not pleasant to suspect his father of perversion; but there had seemed no way to close his eyes to it except by denying the whole theory, which up to that time had explained hysterical repression better than anything else. After wrestling with the dilemma for nine months, Freud had finally given up the so-called "seduction theory" that fall.[32] The would-be materialist had been left for once with nothing but psychology to go on, and only the fantasies of dream-life to make sense of. Within a few months, with the help of Fliess, he had come up for the first time with a general thory of all the neuroses based on the stages of development in the sexuality of children, and re-placed child sexual abuse as the basic cause of hysteria with child sexual fantasies. Along with the new theory came the discovery of a new re-pressed sexual fantasy. As he put it in *Die Traumdeutung,*

> In my experience, which is already extensive . . . being in love with the one parent and hating the other are among the essential constituents of the stock of psychical impulses which is formed [in childhood]. This discovery is confirmed by a legend that has come down to us from classical antiquity: a legend whose profound and universal power to move can only be understood if the hypothesis I have put forward . . . has an equally universal validity. What I have in mind is the legend of King Oedipus. . . . It is the fate of all of us, perhaps, to direct our first sexual impulse towards our mother and our first hatred and our first murderous wish against our father. . . . Like Oedipus, we live in ignorance of these wishes . . . and after their revelation we may all of us seek to close our eyes to the scenes of our childhood.[33]

Thus did Freud's dream of "closing the eyes" find its ultimate root in the story of a man who had torn his own eyes out. No wonder he would say of this book in 1930 that "Insight such as this falls to one's lot only once in a lifetime." The veiled self-revelation of the Oedipus insight was a crowning moment in *Die Traumdeutung* but, as Freud told Fliess in August, the whole book was designed to have the effect of climbing a concealed pass in a dark forest until it opens out on a view of the plain.[34] It was in between hikes in the mountains of Berchtesgaden during his

vacation that Freud was writing the final, theoretical chapter of "the Dream," in which his charged-up (*besetzt*, cathected) "neurones" of brain are irrevocably transformed into pieces of mind, and where he raises for the first time in print that imposing structure of unconscious, preconscious, and conscious that has bound the twentieth-century psyche ever since. The unconscious part of the mind is vast, says *Die Traumdeutung*, and contains multitudes, most of which are silently censored and repressed by the preconscious part. Dreaming is much more purposeful and life much less so than we thought. Nor are those purposes consistent, for not only dreams, but lapses of memory, jokes, and even slips of the tongue betray their contradiction. We are of two minds (at least) about everything, and we do not really know what we are doing. The thought would occur to Freud himself not long before he died in 1939 that his own unconscious might have fooled him into believing that his ideas were original, that he could "never be certain, in view of the wide extent of my reading in early years, whether what I took for a new creation might not be an effect of cryptomnesia."[35] As for the rest of humanity, potential analysands cannot expect to do much better than the first analyst. After *The Interpretation of Dreams,* self-knowledge becomes recursive, an infinite task undertaken against a fierce resistance that comes from the self. The human mind for Freudians is neither continuous nor whole.

The past, too, is not past but ever-present. Psychoanalysis may cure neurosis, but no nervous energy is lost, and thus no memory-trace is ever completely erased. Repression is normal, required by civilization. Perhaps that is why Sigmund Freud—the *conquistador* in an age of public modesty—insisted in 1899 that his sly autobiographical "I" was not really there, and that if it were, "I should have to give away so much of my own private character."[36]

It was not the best of private characters. Freud was wise to try to ironize and downplay his ambition, which became, when psychoanalysis finally triumphed in the years 1906–1913, intolerant, jealous, and exclusive. As Wilhelm Fliess obligingly proofread and mailed the last of the "Dream-book" galleys that September, he had no inkling that he would soon meet the same fate that Breuer had before him, and Adler, Jung, and Rank would after him, or that when Freud came to write his next autobiography in 1925, he would not even mention Fliess's name. As the 600 copies Deuticke had printed of *Die Traumdeutung* slowly sold over the next eight years, Freud would settle into his preferred role of lone ranger. There would be no more missed opportunities and no more borrowings from seniors—none he would acknowledge, at any rate—only pure and persecuted originality. Nothing less than a complete takeover of psychiatry by a band of his loyalists would satisfy his dream of glory. That dream, as it happens, came true, for Freud really was a genius and the idea of Repression one of the great ideas of the new century. Still, like

Columbus, Freud never quite realized the New World was new. Out of the heroically "objective" nineteenth-century science to which he thought he had dedicated his life, Freud had brought forth a psychology that divided the mind against itself and made "objectivity" into a wish that could be realized only in dreams.[37]

10 THE CENTURY BEGINS IN PARIS

MODERNISM ON THE VERGE

1900

Inevitable Paris beckoned. . . .
—*The Education of Henry Adams*

Vienna was *fin de siècle,* a phrase that came from Paris; but Paris in 1900 was not at the end of a century. It was at the beginning of one. Already, in the 1880s and 1890s, it had provided a medium (and a stage) for the invention of modern poetry. By 1900, with department store millionaires buying Monets and Sisleys, impressionism was already the establishment in Parisian galleries, and in its journals and reviews the *Décadence* that still captivated Vienna was moribund by the 1890s. In Parisian faculties of philosophy, the scientism and positivism taught in Vienna had already been dissected. To Vienna in that last decade of the old century had come ambitious young men from the polyglot provinces of a geographically compact empire; but to Paris in 1900 came the young of both sexes and from every corner of the globe. One attraction was the World's Fair, a larger edition of the Eiffel Tower fair of 1889; but more important may have been the sense these young people had by 1900 that France's leadership was more open to even the odder kinds of creative ambition than that of any other nation. It may even have been the strength of Parisian anarchism; but at the time Paterson, New Jersey was the world center of anarchism, and the only creative Modernist Paterson ever attracted was William Carlos Williams. Whatever the reason, they came in droves, transient and permanent, provincials and foreigners, poets and physicists, painters and politicians, until, swamping the Parisians themselves, they had made a graceful nineteenth-century city into the epicenter of Modernism. Paris in 1900 became the first world cultural capital of the twentieth century, a position it would hold for more than two generations.

As the trickle grew to a flood in 1898, Paris already housed some of the most creative young minds in the Western world. At number 7, rue Cassette, floor two and one-half, a strung-out Breton named Alfred Jarry was writing things that would have deeply shocked a Pole named Marie

Curie, who was in a shed near the Physics Faculty, one neighborhood east, refining tons of Czech pitchblende ore into the first milligram of radium. In the same city where the now ailing Mallarmé had held his poets' Tuesdays, Professor Henri Poincaré was pursuing the strange implications of Cantor's sets and Maxwell's radiation laws, and composers Gabriel Fauré, Claude Debussy, and Erik Satie were stretching key signatures to the breaking point. Painting in Montmartre in complete obscurity were a German named Hansen, who would become, as Emil Nolde, one of the founders of expressionism, and the Czech Frantisek Kupka, soon to be among the founders of abstraction. In nearby Fontainebleau, the English composer Frederick Delius, who had been there since the last World's Fair in 1889, was composing *Paris: The Song of a Great City* in 1899.

Among Parisians who had already made their mark by 1900 were an American painter, James Whistler, one of the town's toasts; and an Irish writer, Oscar Wilde, who was one of its scandals. Wilde's compatriot, William Butler Yeats, had learned the symbolist aesthetic in Paris after his friend, the English critic Arthur Symons, brought him there in 1896. Symons had written the symbolists their history in 1899, and Jean Moréas, a Greek, had written their manifesto in 1886. Two Poles, Wyzewa and Krysinska, and two Americans, Merrill and Vielé-Griffin, had expatriated themselves in the 1880s to join the movement, and, as we have seen, to Whitmanize it. Paris was full of Belgian writers, too, like the Whitmanesque poet Emile Verhaeren; the symbolist novelist Georges Rodenbach, author of *Bruges-la-Morte,* who died there in 1898; and Maurice Maeterlinck, who had moved to Paris for a year in 1886, written the classic symbolist play *Pelléas et Mélisande,* and settled there for good in 1897.

Makers of theatrical modernism were drawn here from every country in Europe. The Irish playwright George Moore had come as early as 1873, making friends with Mallarmé and Dujardin and bringing back to the English-speaking world the first news of symbolism. Synge and Yeats came in the nineties, confirming Moore's message. The Austrian theater critic Hermann Bahr had learned *Décadence* in Paris in 1888, and his friend, the playwright Arthur Schnitzler, paid a visit in the spring of 1897. The German Frank Wedekind had been in Paris between 1891 and 1895, haunting circuses and cabarets and drafting plays about a whore named Lulu. The Norwegian, Bjørnstjerne Bjørnson, who had written realist dramas before Ibsen, was there in the 1880s, and was thus able to meet and quarrel with a young Swedish genius named August Strindberg, a visitor from 1876 who was there again in 1883 checking out the Paris cabarets. Returning to Paris in 1894–96 to conduct alchemical experiments and write his madman's diary, Strindberg had met and argued with still other venturesome Norwegians, like the writer Knut Hamsun, whose

Hunger had foreshadowed the modern novel in Oslo in 1890, and the painter Edvard Munch, who had learned enough in Paris to change the course of his art in 1889. There were even a few Russians. Chekhov came in 1891 and again in 1897. In 1895 Vladimir Ilyich Ulyanov, a young rebel known only to the Russian police and a few comrades, came several times to Paris. By 1908, having renamed himself Lenin, he would move the whole Russian Social Democratic Party to the City of Light.

In retrospect it is clear that what all these debutants needed was an all-around impresario. This they got in 1899. On the night of October 4, a bastard Monégasque with the Polish name of Kostrowitsky took his mother's instructions and, neglecting to request his bill, strolled out of their fancy hotel in the Belgian resort of Stavelot and boarded the night train for Paris. It would be a cold, hard winter, but Wilhelm Kostrowitsky emerged from it a Parisian. Within a dozen years, having dubbed himself Guillaume Apollinaire, he would be Paris's best-known poet, and the leading journalist of the avant garde. But for that first spring in Paris, Kostrowitsky would be watching the arrière-garde stage its last great self-congratulation, the Grande Exposition Internationale et Universelle de 1900: The Paris World's Fair.

> New Year's Eve, at half past one, I begin the great journey. . . . Hurrah! . . .
> And in the new century when I am in Paris, the great pit of sin, I shall often
> think of your sweet and peaceful little house. . . .[1]
>
> —Paula Becker

The "sweet and peaceful little house" was Otto and Helene Modersohn's in the little art colony of Worpswede, near Bremen, in north Germany. Their departing friend was Paula Becker, a twenty-three-year-old painter. Just ending her apprenticeship, she had begun to paint in curiously flat, monochromatic planes. Becker was an original, quite probably a genius. Clearly, she had to get to Paris, but unlike Apollinaire, she would plan her trip in advance. On New Year's Eve, 1899, she presented her ticket at the Hamburg railroad station. Traveling on the line Apollinaire had used, Becker arrived in Paris as the sun rose on the first morning of 1900, ready to take a deep draught of the new century at its source.

> One hour from Paris and my heart is full of anticipation. . . .[2]
>
> —Paula Becker

A "clattering carriage" took her off to a tiny studio in Montparnasse where she fell asleep, ecstatic and exhausted. Fellow Worpswede artist Clara Westhoff, nearly three years younger and also unmarried, knocked on her door and woke her, and they talked until daybreak. Becker quickly enrolled at the Académie Colarossi, one of the few art studios in the

world where women were permitted to study. Within twelve months, Becker's harbinger would be followed by an extraordinary parade of genius, from Isadora Duncan in May to Bertrand Russell in August to Pablo Picasso in October.

> I am in Paris. I departed on New Year's Eve. . . . And now I am living here in the bustle of this great city. . . .[3]
>
> —Paula Becker

The Great Exhibition wasn't open yet, but on February 25 Becker and Westhoff wandered over to the fairgrounds on the right bank, peeked into the huge art exhibit hall called the Grand Palais, where "the poor little sculptor's apprentices from the evening life-drawing class . . . are doing the stucco work."[4] One was probably Matisse.[5] His wife was expecting another baby, and at thirty-one Henri Matisse was earning his bread with his friend Albert Marquet, painting the laurel leaves on the cornice of the Grand Palais ceiling. Becker did not know who Matisse was in 1900, and hardly anyone else did either. He had been a gifted Beaux-Arts student and had had a show in 1896 that provoked Maurice Denis to call him "the Mallarmé of painting;" but by 1899 his mentor, Gustave Moreau, was dead and Matisse had given up a promising academic future to do things his own way. From the small income earned from the laurel leaves, Matisse had just laid out a rather large chunk, 1,300 francs, for a little painting of bathers by an ex-impressionist named Cézanne. At sixty-one Cézanne was still painting in his beloved Aix-en-Provence, but not many knew it. Moneyed collectors didn't like his strange perspectives and "differentiation of the color planes . . . toward the infinitely small." Roger Marx had fought tooth and nail to get three little Cézannes hung in the French exhibit in the Grand Palais. The only dealer in Paris who had Cézannes was Ambroise Vollard, who kept one of the many small art shops in Montmartre's rue Lafitte. Born on Réunion in the Indian Ocean, Vollard was also one of the few dealers who could show you a Gauguin—Matisse had bought one from him in 1898. Paula Becker never found Matisse; but in late May 1900, she found Vollard's shop and saw her first Cézannes.[6] They confirmed everything she was doing and changed her life. That was the sort of thing that was happening all over Paris in 1900.

The France they came to was still quaint with the preindustrial. Toilet paper was unknown, and house-to-sewer connections as rare as bathtubs and toothbrushes. In 1883 Strindberg called France "a bloody country" where "a piss costs 5 centimes, to shit at least a franc, and [friends] who were here a few days ago said one couldn't get a fuck for less than 10 francs."[7] Nonetheless, it was uniquely lively. By Eugen Weber's count it published 2,857 periodicals, of which more than 70 were Paris dailies.[8]

Americans may be shocked to learn that Paris had nearly 350,000 electric lamps, and France more than 3,000 automobiles; but in fact France was as far ahead of the United States in the development of the automobile as it was in that of the bicycle. The first Michelin Guide had just come out, nearly a hundred automobiles from several countries were on display in the Palace of Civil Engineering and Public Transport just up the Champ de Mars from the Eiffel Tower, and the Vélodrome Buffalo, the world's most advanced bicycle track race course, had just opened on the site where Buffalo Bill had made his Wild West Show the hit of 1889.

As the Fair's opening day approached, France was just getting over the most egregious political *affaire* since the founding of the Third Republic. The retrial of Captain Alfred Dreyfus in August 1899, and his release from jail in September, had been preceded by an attempted right-wing coup in February and followed by the death of a Dreyfus partisan in a duel with an anti-Dreyfusard member of the French parliament. So convulsive was the Dreyfus Affair that at its height, in 1898, the French foreign office had had to order a French army detachment in the Sudan to haul down its flag and pull out to Somalia. Fashoda was abandoned largely because France felt too little domestic unity to sustain a possible conflict with England. Even cyclists divided. In 1900, auto enthusiasts on the staff of *Le Vélo,* uniformly anti-Dreyfus, seceded to found a new journal, *L'Auto.*

In the midst of it all, there had had to be an extraordinary presidential election on February 29, 1899, because President Félix Faure had been found in bed in the Elysée Palace, dead and nearly nude, just after his meeting with the Cardinal Archbishop of Paris. Security men had bundled the president's mistress, Meg Steinheil, out of a side entrance, but not quickly enough to prevent gossip. Then in June the new president, Emile Loubet, had been assaulted by anti-Dreyfusards at the Auteuil race-track. A week later, 100,000 liberals, moderates, and socialists had paraded through Paris in defense of Dreyfus. A week after that the anti-Dreyfus government fell and a Dreyfusard took over as premier. Georges Clemenceau, the editor who in 1898 had printed Emile Zola's great attack on the anti-Dreyfus government, "J'Accuse," called the new government's enemies *fauves* (wild beasts), and in other countries there were even calls to boycott the Fair. Vienna heard about it all from the dispatches of the Paris correspondent of the *Neue freie Presse,* who had been reporting on it since his eyewitness account of Dreyfus's public derogation back in 1895. This was, of course, Theodore Herzl, who had by 1900 founded a small movement that was coming to be called Zionism.

But the government held, with its coalition of socialists and democrats, and so did Dreyfus's vindication. On January 8, 1900, a week after Paula Becker's arrival, a French court finally convicted the anti-Semitic leaders of the attempted coup of February 1899, and the famous Affair

began to cool down. By April 1900, Dreyfus himself was able to get away to the provincial town of Carpentras, to try to recapture his peace of mind. By April 14, when President Loubet finally opened the Great Exhibition, Paris was ready to forget politics for a moment and celebrate.

Opening ceremonies were elaborate and leisurely. The French president, accompanied by the Republic's new ally, the Czar of All the Russias, dedicated a new bridge across the Seine to the czar's father, Alexander III. (Alexander had been a bit bloodthirsty, but only the anarchists were tactless enough to dwell on that.) The Alexander III Bridge was the Fair's axis, connecting the great esplanade of exhibits on the left bank north of the Invalides with the two major exhibition halls on the right bank between the Seine and the Champs Elysées: the Petit Palais and the Grand Palais. In the "Great Palace," the beaux-arts greenhouse where Matisse had painted the laurel leaves, were hung works of art the various nations had judged and sent as their best, including huge symbolist fantasies by the Finn, Gallen-Kalela, varnished historical tableaux by the likes of Meissonnier and Bouguereau which the Academy considered France's best, and a large sentimental piece called *The Last Moments* by a gifted Spanish teenager named Pablo Ruiz Picasso. Later, the ribbon was cut on the entrance of the new Métropolitain subway, sculpted by Hector Guimard in a shape suggesting giant blooms and tropical vegetation.

> But more about the Exposition, also in fragments, because everything is still whirling and tumbling before my eyes. . . .[9]
>
> —Paula Becker

On hand to film the ceremonies were Raoul Grimoin-Sanson, with 10 synchronized 70-millimeter cameras in a tethered balloon, and the two "light brothers" from Lyon, Auguste and Louis Lumière, the first Frenchmen to perfect the fascinating sequential picture-taking of Muybridge and Marey. The Lumières had given the world's first public exhibition of movies in Paris in 1895. One of their favorite subjects was the two-speed electric moving sidewalk that ran down the Esplanade of the Invalides and along the right bank of the Seine past the national pavilions. Though a lot shorter than the new Métro subway, it was, at five miles an hour, at least as good a way to travel as the Fair's electric train; and it made a delightfully disconcerting film. On the two opening nights, April 14 and 15, the Lumières took a shot at filming the complicated illuminations along the Seine and at both ends of the Champ de Mars, the Eiffel Tower and the Palace of Electricity.

On May 20, Baron Pierre de Coubertin, inventor of the modern olympic movement, proudly opened the Second Olympiad, the first ever to admit women, in the City of Light. Overshadowed by the Fair, the events were so scattered in Parisian time and space that even after com-

peting some athletes were still unaware that they had been in an Olympic Games. By the time the Olympiad petered out in October, French athletes had taken the marathon and 28 other gold medals. The Americans had won only 20, including women's golf; but they had bettered their great showing at the first Olympiad in 1896, and Frank Jarvis had won the emblematic 100-meter dash.

> Eating is very expensive here. . . . One can just manage to get one's fill for a franc.[10]
>
> —Paula Becker

At Maxim's, the luxurious café near the fairgrounds founded in 1892, champagne flowed for the Fair's opening, while the more disdainful voices of the avant garde could be heard in Le Départ on the threshhold of the Latin Quarter, the Sélect in Montparnasse, the Deux Magots and the Café de Flore in St. Germain-des-Prés. In Montmartre the old Chat Noir had finally closed in 1898, its shy pianist, Erik Satie, self-exiled to the Arceuil suburb; but other alumni like Alphonse Allais and Jules Renard were still entertaining Paris with absurdist humor, and Albert Robida, who had put on the Chat Noir's precinematic "shadow-theater," was emerging as one of the Fair's stars for his plaster reproduction of medieval "Old Paris" on the right bank near Alma Bridge. In any case, the Montmartre cabarets, weird and legion, were very much in business in 1900. Aristide Bruant, his anarchism mellowed a bit, still held forth at the Mirliton. Frédé's café, the Zut (Damn), and Adèle's Lapin A. Gill (Gill's Rabbit—the old Cabaret des Assassins) sold drinks for twenty-five centimes or less, and it was still under fifty centimes to go to the Quat'Z'-Arts or the Moulin de la Galette. At the Moulin Rouge (two francs), open in Montmartre since the last World's Fair, the dwarfish figure of Count Henri de Toulouse-Lautrec could be seen, joking over a drink about his recently concluded stay in the Neuilly alcoholism clinic. The Moulin's great cancan dancer, La Goulue, had gone out on her own in 1895, and the minuscule Count had painted some flats for her performing booth far from Montmartre and from the Fair. There at the Trône fairgrounds Lautrec was to see her for the last time, in the late September of the World's Fair year, her figure raddled, "living between a stray dog and a tame swallow." Montmartre was the place for dancers. There were even two circuses in Montmartre, the Nouveau Cirque and the Cirque Médrano (formerly the Fernando). In the same neighborhood, a Dutchman named Kees Van Dongen, who that March had come to Paris to stay, was cadging food. Five years later wildly colored paintings by him would hang with Matisses, Dufys, and Derains in the famous "Fauve" room at the Salon des Indépendants.

In the age of limelight, the theaters were open too, in every sense of

the word. It depended entirely on your subscription, or your aesthetic— or both. If you were ready for anything, the Théâtre de la Gaité would produce it, from the most paper-thin farce to the strangest novelty. In the spring of 1894, the Gaité had reluctantly allowed itself to be hired for a play called *Axël*. The author, Villiers de l'Isle-Adam, had died some years before, vainly trying to produce it. ("Living?" says Axël in the last act, "Our servants will do that for us.") If you liked short pieces strung together (this would soon get the name vaudeville) you could go to the Folies-Bergère, the Olympia, the risqué Eldorado, or the Eden-Théâtre, where Yvette Guilbert sang songs and "said" monologues. If you preferred Sarah Bernhardt, you could go to the Théâtre Sarah Bernhardt and see her play, *en travesti*, the lead role in *Hamlet*. If you favored realism or naturalism, you might have felt a bit at a loss between 1894, when André Antoine closed his Théâtre Libre (where "modern" theater was said by so many to have begun in 1887), and 1897, when he reopened his place as the Théâtre Antoine; but there were plenty of slice-of-life plays in the interim, and in the end Oscar Méténier hired a chapel and opened the Théâtre du Grand Guignol especially for blood, gore, and terror. Connoisseurs of magic went to the Théâtre Robert Houdin, where director George Méliès worked little miracles with the new lighting and stage machinery, and indulged a growing fascination with the movies. Occultists not on call at the Rose + Croix chapel of Joséphin "Sâr" Péladan went to the Théâtre la Bodinière, where in 1899 Mina Mathers had staged *Rites of Isis,* somewhat disconcerting her brother Henri Bergson. Symbolists with subscriptions gathered to see symbolist plays at Paul Fort's Théâtre d'Art, now renamed the Théâtre de l'Oeuvre and run by a mad impresario with the improbable name of Aurélien-Marie Lugné-Poë. At this theater symbolists could hobnob with anarchists. On the night of December 10, 1896, at the Nouveau Théâtre in Montmartre, Lugné-Poë had staged one of the great scandals of the history of French theater, *King Ubu,* by Alfred Jarry, in which a royal figure waddles on stage in Act One, Scene One, and says, "Shit!" (Jarry had tried to establish a certain distance by adding an extra consonant to the word; but everyone heard "shit" just the same.) A week later, Lugné-Poë had calmly opened a medieval fantasy by Maeterlinck at the Théâtre de l'Oeuvre.

On the Champs Elysées in May, just north of the fairgrounds, a theater was opened especially for one performer, the extraordinary dancer Loïe Fuller, late of Fullersburg, Illinois, and her company of women. On a stage illuminated from every direction by the new electric light (in 1898 she had written to Marie Curie asking whether radium would work as theater lighting) Fuller spun herself and the various parts of her thin, loose robes, catching the reflections, and looking for all the world like the fluid vortex in some strange apéritif. This was art-nouveau dancing, "modern style" as some Germans called it; but in America, you

simply called it "skirt-dancing." Fuller's breakthrough solo, "Serpentine," had been developed not long after her New York début in 1890. Mallarmé had been delighted by it when he first saw Fuller at the Folies Bergère in 1893. "La Loïe" was filmed in 1895. By the time she opened on the Champs Elysées in 1900, Raoul Larche and Koloman Moser were trying to capture her in bronze, but the continuity of her performance seemed to defy anything but film.

From London, where she was dancing "Spring Song" in bare feet, a twenty-two-year-old Californian named Isadora Duncan arrived to join her brother at 4, rue de la Gaité and see La Loïe for herself. Fascinated, she went backstage, and soon accepted Fuller's invitation to join the troupe. Isadora's stint with the Fuller company was brief—as a militant heterosexual, she felt a bit out of place—but the lessons about choreography and publicity were forever.

For Ruth Dennis of Somerville, New Jersey, a year younger than Duncan, the trip to see La Loïe and the Great Exhibition was no less educational. Dennis came in the summer, following her run in the London tour of David Belasco's *Zaza*, and Loïe's work delighted her. When *Zaza* returned to New York and Dennis to Brooklyn, the stage was set for her eventual transformation into Ruth St. Denis. Fuller, Duncan, and Dennis were not the first dancers—and would certainly not be the last—to remake themselves in Paris. Vaslav Nijinsky, Irina Pavlova, and their fellow performers of the Russian classical ballet, for example, would be transformed into the avant-garde Ballets Russes by six successive seasons in Paris starting in 1908; and Josephine Baker, born on the wrong side of the tracks in St. Louis in 1906, would debut as an exotic in Paris in 1925. In the end, however, Paris's most notorious dancer would be its least revolutionary. Margaretha Geertruida Zelle MacLeod was a Dutch single mother who came to Paris in 1903 to launch herself as a model, only to be turned down by the first painter she went to because he found her breasts too small. At that MacLeod, too, became a dancer, the talk of a certain *haut monde* at whose parties, wearing nothing but the predecessor of the brassiere, she danced things vaguely East Indian and called herself Mata Hari.

Not all the Americans in Paris in 1900 were dancers. Did Isadora Duncan notice another woman who had grown up in her old home town of Oakland, William James's young psychology student Gertrude Stein? Stein passed through Paris for the first time that summer, touring with her brother Leo and Mabel Weekes, the girlfriend through whom, a few months later, Gertrude was to meet May Bookstaver, her first love. Did Gertrude notice the distinguished-looking black man with the goatee, who had traveled to the Fair in steerage to install his grand-prize-winning exhibit on black economic development? He was William James's old philosophy student, W. E. Burghardt Du Bois of Great Barrington, Mas-

sachusetts, who would go on to the Pan-African Congress in London that year and would, a decade later, found the NAACP. James himself might have introduced them, but he was skirting Paris, resting in European health spas and trying to finish *The Varieties of Religious Experience*. Did Natalie Barney of Philadelphia, the future lesbian militant who caught the eye of Colette in the Bois de Boulogne that summer, also catch the eye of Stein or Duncan?[11] Or that founder of American art photography, Edward Steichen? Or the bald and dignified Bostonian, Henry Adams, who had moved into a hotel near Trocadéro Palace on May 12, hoping to make sense of the twentieth century? The Trocadéro, across the Seine from the Eiffel Tower, was the center of a vast French colonial exhibit that included Cambodian temples and North African villages, and would soon house a permanent ethnographic museum of "primitive" and colonizable peoples. Adams made no mention of the colonial exhibit, but at sixty-two, he belonged to a generation sensitized against racism. Radioactivity baffled him, and even the art officially exhibited at the fair was not to his liking. Still, he knew a historic event when he saw it.

> Scores of artists,—sculptors and painters, poets and dramatists, workers in gems and metals, designers in stuffs and furniture,—hundreds of chemists, physicists, even philosophers, philologists, physicians and historians,— were at work, a thousand times as actively as ever before, and the mass and originality of their product would have swamped any previous age, as it very nearly swamped its own.[12]

Little did he know what was really being prepared in Paris for his swamping; though he may have got an inkling in July, when Samuel Langley, confident that he would soon invent the airplane, showed Adams the colossal electric dynamo in the industrial exhibition hall. As he fought the urge to pray to it, Adams thought, so much for Mont Saint-Michel and Notre Dame.

But the old gave way to the new in unexpected ways. In his mother's house at 9, boulevard Malesherbes, a breathless young dilettante named Marcel Proust was finding his long, slow, strange way to a novel by translating John Ruskin's paeans to Gothic style for the *Figaro* and the *Gazette des beaux-arts*. Like so many real Parisians, Proust left town just before the Fair opened, spending that spring retracing Ruskin's footsteps in Venice. In Paris, literature still mourned the death of Mallarmé in 1898, but the newest and youngest of his disciples were about to be heard from. On February 1, 1900, one of them, André Gide, took over from Léon Blum as literary critic of the *Revue blanche,* the most influential desk on what was then France's most influential avant-garde review. Founded and subsidized by the Natanson brothers, it had published

everything from Jarry's *Ubu,* Teodor de Wyzewa on Walt Whitman, Mallarmé on theater, and Félix Fénéon on Van Gogh to Paul Signac's famous definition of post- or "neo-impressionism." On March 19, Signac and Fénéon had opened a Seurat exhibition in the *Revue*'s reception rooms, whence the great canvases, from *Une Baignade* to *Le Cirque,* had finally been sold. As for Gide, by 1900 he had published books in every genre, and by 1913 he would be a dean of the French literary world, just powerful—and foolish—enough to turn down Proust's *Remembrance of Things Past* for publication without reading it. On the last day of May 1900, he went not to a desk but to the church of St. Honoré d'Eylau, north of the Trocadéro, where he and his old friend Pierre Louÿs were to stand witness to a wedding. Gide had introduced Louÿs to Mallarmé, and almost everyone at St. Honoré was veteran of Mallarmé's Tuesday salon, except Pablo Casals, who had played his cello at the engagement party five days before. As for the groom, he was Paul Valéry, who was then trying to decide between mathematics and literature. Louÿs had introduced him to Mallarmé's poetry ten years before, and Valéry would eventually succeed to Mallarmé's eminence as the most deliberate, hermetic, and challenging French poet of his time. There was a German poet who would one day be matched with him, Rainer Maria Rilke, but Rilke was touring Russia that May. He would not get to Paris until 1902, to write about the sculpture of Auguste Rodin, and was not to find out about Valéry until 1921.

The best-selling book of 1900 was nothing so daunting, however. It was a new novel called *Claudine à l'école* (Claudine at school), equally titillating but considerably more upbeat than its competition, *Journal of a Chambermaid,* by the surviving Decadent Octave Mirbeau. Supposedly it was by "Willy," Henri Gauthier-Villars, whose attacks on Dreyfus had just cost him his job as music critic on the *Revue blanche.* "Willy" used to say that the young wife he had imported from Burgundy in 1893 and kept carefully housebound in Paris had helped by telling him "the most delicious things about her school." In fact, it was precisely his wife, Sidonie-Gabrielle Colette, who had written the book, and to Willy's order in the first year of their marriage. For years, until Colette finally left him, they kept the secret: not an easy thing for Colette, since her creation became so famous in 1900 that people used to say Claudine was better known than anyone except God and Dreyfus. *Claudine à l'école* sold 40,000 copies in two months, and became one of the first successful media tie-ins in publishing history. Stores all over Paris were selling "Claudine" lotion, "Claudine" ice cream, "Claudine" hats and collars, "Claudine" pefume, "Claudine" cigarettes. There were postcards with Colette's picture dressed as Claudine, and at the Samaritaine department store, you could even get "Willy" rice-powder.[13] Just the thing for the summer of the Fair.

The weather that summer was particularly beautiful. The senior innovator of French music, Gabriel Fauré, was rehearsing three separate bands in the open-air ampitheater at Béziers in the south to première his new opera, *Prometheus*. As always, painters who could manage it left Paris for places where nature came on stronger. The young and obscure either went back where they came from or made do with the valley of the Seine outside Paris. Paula Becker's friend, Otto Modersohn, came to Paris, but was almost immediately called back to Worpswede to attend his dying wife. Maurice de Vlaminck, whose small income came variously from competitive cycling, contributions to left-wing papers like *La Revue anarchiste*, and playing in a gypsy orchestra at the Great Exhibition, painted where he lived, on the banks of the Seine at Châtou. That meant a lot of commuting. Sometime in June or July, the train that took him to Paris went off the rails, and in the confusion he met a fellow commuter for the first time. This was Matisse's friend André Derain, who was studying his craft at one of Paris's many studios. They made a date to paint together the next day, and within the year they were sharing a studio in Châtou and experimenting with the flat planes of increasingly brilliant colors that would be christened fauvism in 1905.[14] At about the same time Becker, who had, without ever meeting them, learned the same new way of painting, returned to Germany to sit in the claypit at Worpswede, read Hamsun, and absorb the lessons of Paris at leisure.[15]

I *love* color. It must submit to me.[16]

—Paula Becker

As summer went on, Paris emptied of painters and began to fill up with professors. The great international scholarly associations, most of them formed only during the past decade, had arranged to have their conventions coincide with each other, and with the Great Exposition itself. A special building had been built for them on the right bank, downstream from the Horticulture greenhouses next to the Alma Bridge. The homeopaths and battleship designers had already met there in July; but August was when the Thirteenth International Congress of Medicine planned to bring Santiago Ramón y Cajal to Paris and give him its 5,000-franc prize for the most significant work since their last conference in Moscow. The most abstract thought also waited for August. The International Congress of Philosophy was scheduled to take place August 1–5. Mathematics would follow immediately on the 6th, simultaneously with physics. Electrical engineering (like the Society against Tobacco Abuse) would meet last, from the 18th to the 25th. Addressing or attending all four conferences was France's senior polymath, Henri Poincaré, whose clear and graceful essays stood on Paul Valéry's night table next to Cantor's papers on set theory. Poincaré had made fundamental contributions to the epis-

temology of science, the logic of sets, the mathematics of function theory, the old physics of gravitation, and the new physics of electrodynamics. A paper Poincaré published in 1895 had helped invent a new branch of geometry to deal with continuity in the abstract, which he called *analysis situs* or topology. The third and final volume of his monumental *Celestial Mechanics,* building on the great works of the French Newtonians Laplace and Lagrange, had just come out, with the foundation of the future "chaos theory" buried in it.[17] As each of the great discoveries made by his guests in Paris was announced to the world, Poincaré was there to explain and promote it. His address to the physicists on the relations between the experimental and the theoretical was among the first to question the existence of the ether.[18] He was there in the audience with Max Planck as Planck's Berlin colleague, Willi Wien, questioned Planck's radiation theory, and Otto Lummer explained, in French, the odd new results he had begun to get that spring in his black-body experiments.[19] For Poincaré, physics, philosophy, and mathematics were all approaches to the same great questions. It would hardly be his fault if at these conferences he so often missed the trees for the woods.

The Congress of Philosophy, in fact, proceeded to try to define the foundations of mathematics. A phalanx of Italians, led by the amiable Giuseppe Peano, descended on the Palace of Congresses with papers about reducing geometry to three undefinables and discussing whether "definable" was definable. Peano himself gave a paper on August 3 describing the power of his new notation for a symbolic logic of propositions (a sort of logical algebra), and a stab at the long-sought definition of number. The talk overwhelmed a twenty-eight-year-old Englishman named Bertrand Russell. He and Alfred North Whitehead had come on the invitation of Louis Couturat, Russell's correspondent about Cantor's sets and the foundations of geometry, and author of what in 1896 was the definitive study on the mathematical infinite. Russell's conference paper was about what "between" and other positional concepts might mean (a Dedekind sort of question), but Peano seemed to have all the answers. "I observed," wrote Russell, "that he was always more precise than anyone else, and that he invariably got the better of any argument upon which he embarked. As the days went by, I decided that this must be owing to his mathematical logic."[20] Thereupon Russell went to Peano and asked for copies of everything he had written. The day the Congress closed, he went home to Fernhurst to apply Italian methods to the foundations of arithmetic, missing not only the final philosophers' coffee at the Café Voltaire but also the first meeting of the Second International Congress of Mathematics on August 8. As we shall see, the work led him to the discovery of the first of the new century's daunting list of logical undecidables, and demolished one of the foundations of nineteenth-century thought.

At the Mathematics Congress, which almost instantly withdrew from the Palace of Congresses to the more familiar precincts of the science Faculties (not far from where Marie and Pierre Curie tended their vats of uranium salts), the keynote address was given by Germany's greatest mathematician, David Hilbert of Göttingen. Like Poincaré, Hilbert was one of the last mathematicians in history who could see the subject whole, and he seized the opportunity provided by the new century to propose its agenda. There were, he told the Congressists, twenty-three outstanding problems in mathematics in 1900, and their solution would be the business of the twentieth century. He was very nearly right. Of the twenty-three "Hilbert Questions," twenty have been either solved or otherwise disposed of, and little has been done in twentieth-century mathematics that has not been related to their solution.[21] All of Axiomatic Set Theory has come out of attempts to answer Hilbert's first Question, which was none other than Cantor's Continuum Problem. The theoretical invention of the computer came in an attempt to answer the Tenth Question, which had asked for proof positive that you could always decide whether a certain kind of equation was solvable and decide it in a finite number of steps. There turned out to be no such proof, because, in fact, there is no such decidability. Hilbert's declaration, "There is always a solution. There is no ignorabimus," and Poincaré's reply, "today absolute rigor has been attained," have the fragrance now of pressed flowers from the old century. When mad Nietzsche finally died of tertiary syphilis in Weimar on August 25, he too seemed like a nineteenth-century figure. Only later would thinkers realize how much he had claimed we did not and could not know.

In the Worpswede art colony, where Rilke had spent September talking art and idealism and casting his spell over Clara Westhoff, Paula Becker was falling in love with the widower Otto Modersohn, and he with her. As Remy de Gourmont wrote that year in an essay called "La Morale de l'amour" (The morality of love), loves born of idealism have unpromising futures.[22] Rilke and Westhoff were lovers by February 1901, married that spring, parents by December, and separated within the year. Marriage to Modersohn soon got in the way of Becker's originality, not to mention her painting trips to Paris.

At the end of the first week of September, the great International Congress on the Rights of Women was gaveled to a close, and the painters began to return to Paris. Out on the Channel coast, three ambitious Normans—Raoul Dufy, Othon Friesz, and a powerfully built youth named Georges Braque—got on the train for the center of the art world. Two future fauves for Montmartre, and one cubist. In October, a small Spanish teenager with enormous black eyes, fresh from his first local one-man show in February, decided to see what his prizewinning picture looked like on the wall of the Spanish exposition at the Grand Palais. In the

bargain, he would at last see the city where most of his Catalan friends were getting their cues—Paris, the European center of artistic and political anarchism. He got on a train in Barcelona with his best friend Carles Casagemas, and jolted through the Pyrenees in a third-class carriage. When they arrived at the d'Orsay station (today a museum of the art of the old century) with lots of appetite and not much money, they must have made a beeline for Montmartre. Casagemas wrote home on October 25 that they liked the Clichy cabarets, but couldn't afford to stay long at hotels like the Nouvel Hippodrome and had jumped at the chance to take over a cheap studio their compatriot Nonell was vacating at 49, rue Gabrielle.²³ This forgettable Montmartre address thus became Pablo Ruiz's first studio in the city that would turn him into Picasso. *The Last Moments* doubtless pleased him up on the wall, and so did his luck. He found an agent, Pere Mañach, who wasted no time in putting a few of Picasso's bullfight pastels in with the marvelous Gauguins and Van Goghs at Berthe Weill's gallery in the rue Victor Massé in Montmartre. Three of them sold in three weeks. There was a Seurat show over at *La Revue blanche,* but Seurat was dead, and Lautrec was still alive. Picasso went to meet him, painted a Lautrec-like café scene, and sold that, too, to the left-wing editor of the *Dépêche de Toulouse* for 250 francs. It was enough for a night or two at the brothels on the rue de Londres, with perhaps some laughs at the expense of the legislators running this year's big campaign to regulate prostitution and prevent syphilis. Picasso, who could offer women little more than a vast and appreciative appetite, watched disapprovingly as Casagemas slowly began to fall for a semiprofessional named Germaine Gargallo.

After more than 50 million visitors, the Fair closed on November 12. Stein went back to Johns Hopkins resolved to start an affair with May Bookstaver. Henry Adams packed his trunks for Washington. It was a Paris autumn, no different from those that had inspired Laforgue in the 1880s:

> Where can one sit? The park benches are dripping and wet;
> The season is over, I can tell it's true;
> The woods are so rusty, the benches so dripping and wet,
> And the horns so insistent with their constant halloo!²⁴

On the last day of November, Oscar Wilde was found dead in his hotel room. Much that he represented had died with him, including the lush "decadent" style of the 1890s, but Wilde's delight in contradiction and paradox lived on in the young Frenchmen he had met in Paris, like Jarry, Louÿs, and Gide. As for his *Salomé* and other symbolist plays and poems, their future would lie with composers like Richard Strauss.

Or the thirty-eight-year-old Claude Debussy. He was very good, but

almost unknown. His opera of *Axël* had never been produced, and only his short *Prélude* to Mallarmé's *Afternoon of a Faun* (1894) had given the Paris musical public any idea of his colossal originality. His friend, the ubiquitous Pierre Louÿs, was doing his part by inviting Debussy home to lunch, and had introduced him that fall to Valéry. In return, Debussy had been setting Louÿs's 1894 book of poems, *Les Chansons de Bilitis*. On December 9, the beginning of the concert season, Claude Debussy saw the première of two of his orchestral *Nocturnes*. In *Nuages* (Clouds), a pentatonic tune seemed to move through assorted minor keys suggesting an impressionist seascape. In *Fêtes* (Festivals) the World's Fair found its musical commemoration. Ethereal themes represented the illuminations (and perhaps the new generation) in triple and quintuple meter, while a brass band playing patriotic chestnuts in 4/4 time seemed to wander tactlessly through them, its predictable chords clashing with the new harmonies everywhere until the end. In the first week of February 1901, as the season was ending, Debussy would première yet another piece, the finished first section of the *Chansons de Bilitis*. That same week Gabriel Fauré would see the first Paris performance of his *Pelléas et Mélisande.* Debussy's own *Pelléas,* begun in 1893, would definitively establish his reputation in 1902; but the *Revue blanche,* avant-garde as always, had given Debussy the column Willy used to write on music in 1901.

On December 20, Picasso, Pallarès, and Casagemas got on the train to return to Barcelona. Though Germaine had cooled to Casagemas, it had taken his two friends some doing to convince him to leave her behind (they had even visited the terminal syphilis ward at the Saint-Lazare Hospital), and their work wore off as the train journey wore on. Casagemas went as far as Picasso's parents' home in Málaga, but then he turned around and took a train back to Paris. With a shrug, Picasso went back to work. In February, he got word announcing that Casagemas had pulled out a revolver in the Hippodrome café, shot vainly at Germaine, then put the barrel to his head and killed himself. Picasso was devastated. His first "blue" paintings followed, eventually including *The Burial of Casagemas* and the huge canvas of his friend and a woman that expressed Picasso's new understanding of the relation between sex and death, *La Vida* (Life).

Like so many others, however, Picasso could not stay away from Paris. He was back in June 1901, skipping a show of his work in Barcelona in order to enjoy his first one in Paris among the Cézannes at Vollard's. It was then he met the poet Max Jacob and discovered how cheap the beer was at the Zut. He was back again in October 1902, to see his second Paris one-man show at Berthe Weill's, and to visit a painter friend named Paco Durrio who had a studio near the galleries in a ramshackle building at 13, rue Ravignan. There Paco and Picasso found themselves

discussing Gauguin far into a December night, and when Picasso came back to Paris for good in the spring of 1904, it was to live and work where Durrio had.

> [T]his Paris is a city and I am not here for the last time.[25]
>
> —Paula Becker

Far to the east, Paula Modersohn-Becker couldn't stay away either. Each New Year and each February 8 (her birthday) Paris seemed to beckon. With Otto's permission, she went to study in Paris for February in 1903, and again for February and March in 1905. On February 23, 1906, she left her husband without permission, intending never to come home again; but Otto followed her to Paris that fall and managed to change her mind. In March 1907, she said goodbye to the Cézannes in the Collection Pellerin and went home with her husband. She was pregnant. In November of 1907, the year Picasso broke through into the artistic realms Becker had always been headed for, Paula Modersohn-Becker died of an embolism brought on by the birth of her first child.

> It's like being a child who wishes to be big and grown up, the fact of adulthood has long since lost its excitement. That is why my stay in Paris was such a happy one. I had such strong hopes.
>
> —Paula Modersohn-Becker[26]

11 HUGO DE VRIES AND MAX PLANCK

THE GENE AND THE QUANTUM

1900

The last year of the nineteenth century began on January 1, 1900. The "civilized" world, less numerate than it thought it was, celebrated the beginning of the twentieth century on that New Year's Day; but it was not so far wrong. Two of the most fundamental scientific discoveries of the new century would be made in 1900. One of them, the quantum of energy, would be found by a physicist so conservative he had devoted his whole career to "finishing up" thermodynamics by ridding it of the last trace of statistical uncertainty. The other, the gene of heredity, had already been found by a physics teacher, a part-time biologist who had devoted seven years of his life to a statistical study of garden peas. The discovery of the physicist would be announced at the very end of 1900 by the physicist himself, Max Planck, forced by the results of a new set of experiments to make a strange new assumption. The discovery of the physics teacher would be announced when 1900 began, and the teacher himself, Gregor Mendel, had been dead for fifteen years. It was one of the classic cases of an idea whose time had come.

Father Gregor, born Johann Mendel, was a peasant boy from Moravia, the same Habsburg backwater as Freud and Husserl. His brains had earned him a chance at a university degree, but in 1843, instead of completing physics, he had become a monk. Seven years later, after a year teaching science as a high school substitute, he went to the University of Vienna to try again. He had been a teacher for seven years when he failed his second teacher exam in Vienna in 1856. There is no way of knowing how that failure affected him; but we do know that almost the first thing he had done after coming home to Brno, a provincial town in what is now the Czech Republic, was to begin collecting carefully chosen examples of *Pisum sativum*—garden peas—to plant in a special section of his monastery garden. For seven years thereafter he had controlled their pollination, cultivated and cross-fertilized six generations of their offspring, carefully **159**

noted the incidences in each plant of seven distinctive traits, and applied the statistical tools he had learned in Vienna to his growing mountain of data. All along he had thought he was studying hybridization, one of the standard questions of nineteenth-century plant biology; but actually he had been penetrating to the underlying regularities in all inheritance.

By the early 1860s, as the old Austrian Empire that had nurtured him began to reel and the new German Empire began to emerge, Mendel had found what he called the rule of Independent Assortment, now called the Law of Segregation. Explaining it to the Brno Science Research Society in two papers he had read in February and March 1865, Mendel had emphasized that the traits, or "factors," paired in each generation of peas did not shade into one another, but continued to appear (or not appear) independently, "segregated" from each other.[1] Moreover, when one counted up the plants that showed one trait of a pair and then counted the other, the ratio of the two counts could be reduced to within a few hundredths of a simple whole number ratio. In the second generation, for example, 5,474 plants gave smooth-skinned peas and 1,850 gave wrinkled ones, giving "a ratio 2.96 to 1."[2] The average of seven different pairings of what he called "dominating" and "recessive" traits was 2.98 to 1, "or 3 to 1" as Mendel wrote, springing over the last of his carefully computed statistics to a historic conclusion.[3] Successive ratios in successive generations came close to "the terms of a combination series."[4] With the same sorts of ratios, years before, Dalton had segregated the chemical elements, postulating the atoms of chemistry to explain them. Mendel's ratios were the telltale signature of the atoms of heredity; but Mendel did not go as far as Dalton had, and it was left to his successors to postulate the genes.

The Scientific Society had published Mendel's papers in its little journal the following year, and given him forty offprints. Mendel must have sent some of these to friends and family, as scholars will, but the important thing was to send them to all the botanical experts whose names Mendel had learned at the University of Vienna, and who would be, he knew, unlikely to be regular perusers of the *Proceedings of the Science Research Society of Brno*.[5] Four of those offprints have since been located, and only one of the botanists wrote back.[6] He was Karl Nägeli, an important scholar whose response to Mendel's result was polite but incredulous. The only thing that impressed him was the careful design and seven-year length of the study Mendel had done on plant hybrids. Why not study a different plant, Nägeli advised—hawkweed, for example? So Mendel had abandoned his peas and studied hawkweeds (genus *Hieracium*) for the next five years, trying and failing to find true-breeding traits in it, while Nägeli, like Laban, gently encouraged his Jacob from afar. Mendel's new findings did not surprise his correspondent, for Nägeli had already worked extensively with hawkweed species and had

long found them to be a perfect illustration of his own view of biological inheritance—shared by almost all the experts—that hereditary traits never bred true but always shaded from one to another on a continuous spectrum of alternatives.[7] Darwin himself agreed. He had always assumed that "natural selection," whose discovery he had announced in 1859, selected differences in offspring that were almost infinitesimal to produce an "evolution" that was all but continuous. In the end, Mendel, now abbot of Brno, gave up on his plant-breeding, and also gave up writing to Nägeli, his only contact in the world of professional biology.[8] Thereafter Nägeli referred to Mendel's work as if those seven years of crossing and counting peas had never happened. In 1884, the year Mendel died, Nägeli published his huge, theoretical masterwork on plant heredity, in which no work by Gregor Mendel was mentioned, not even the papers on hawkweeds.[9] The book, though hardly more than speculation, was respectfully quoted by everyone in the field, and for the next twenty years it was generally agreed that what Nägeli hadn't known wasn't really worth knowing.

The other scholars followed suit. The Brno Proceedings had managed to get a little further than its offprints did, into all the important academy and university libraries of imperial central Europe, and others, including nine in the United States; but no one with an interest in the heredity problem seems to have read them.[10] A German professor mentioned Mendel's pea experiments in a book in 1869, but said not a word about segregation or ratios. A Swede cited Mendel in his doctoral thesis in 1872, and a Russian did it in his master's in 1874, but only the Russian seems to have understood the numbers, and besides, both were only graduate students.[11] Finally, in 1880, when Mendel had three years to live, Wilhelm Olbers Focke published his monumental work on *Plant Crosses* with a small skeptical sentence on page 108 ending, "Mendel thought that he found constant ratios between the hybrid types."[12] Still no one noticed. Charles Darwin himself got a copy of Focke, but he passed it on to a colleague before he had cut all the pages apart. The colleague, who was writing the article "Hybridism" for the *Encyclopedia Britannica,* simply read one of the cut sections on hybrids in Focke's book, lifted the names of experimenters from it, Mendel's included, and listed them in his article. When Liberty Hyde Bailey, a member of the brilliant generation of American plant and agricultural scientists that included Luther Burbank, found the Mendel reference in Focke, all he did was transcribe it to the bibliography of his own essay. By then it was 1892. For the next seven years there would be no mention of Mendel at all. The physics teacher who had discovered the gene would seem to have been completely forgotten.

In October 1899, Carl Correns was thinking of how to put his results together for a paper in the leading German-language journal of plant

biology, *Berichte deutsche botanische Gesellschaft* (German Botanical Society reports). Correns was a botanist at the prestigious University of Berlin who had spent several years crossing hybrids of Indian corn, looking for the "xenia" effect of foreign pollens. Corn, *Zea mais,* is a common American plant with a not so common characteristic—very obvious traits that do not blend in hybrids. Peas are the only common European plant with traits that segregate and stand out in this convenient way, and Correns had just recently begun to do a little work with peas. In the fourth generation after the first cross (F4, as the breeders called it), Correns found the same simple ratios of traits Mendel had found more than thirty years before. "I only know it came to me at once 'like a flash,' as I lay toward morning awake in bed, and let the results again run through my head. . . ."[13]

Correns then looked up what Focke had written about Mendel's study of peas. He remembered that his teacher, who was also his father-in-law, had taught him something about a hawkweed study by the same obscure experimenter. But he could not find what Mendel had done with *Pisum* in any of his teacher's writings, for his teacher had been none other than Karl Nägeli.[14] Within a week Correns tracked down Mendel's original publication by following up Focke's footnotes and bibliography. He put a footnote to Mendel in his article on corn, sent it off to the November-December *Berichte,* and began to work on a new paper.

The New Year came and went as Correns worked. On January 17, 1900, an Austrian aristocrat with a bent for botany went to the University of Vienna with his thesis under his arm. Erich Tschermak von Seysenegg was to do an oral defense of his *Habilitation* that day for the next step on his academic ladder, a lectureship at the Vienna Agricultural Institute, where he had first become a student of botany. Two years earlier, in 1898, after visiting a Dutch botanical garden and reading Charles Darwin's little book on cross-fertilization, Tschermak too had begun breeding peas.[15] Some time later, he had found a neglected article on peas by a compatriot named Mendel, and put a footnote to it in his thesis, which was published later in 1900 in the Austrian *Zeitschrift* for agricultural research.[16] In his own research Tschermak had not yet found the whole-number ratios; and they indicated nothing extraordinary to him, least of all the molecular nature of heredity. For Tschermak, Mendel's most useful idea was the one about dominant and recessive traits (actually discovered well before Mendel), whose dependence on the idea of segregation Tschermak could see only dimly. Even so, something was clearly happening to Mendel's work that had never happened before—appreciation.

Two months after Tschermak's paper, the first signs of spring came to Brno—pea-planting time. In the second week of March 1900, a Dutch botanist named Hugo de Vries sent off a new paper from Leiden Univer-

sity to the *Berichte,* beginning with the assertion that the "character" of a species is "built up of distinct units . . . elements of the species" which "like chemical molecules . . . have no transitional stages between them."[17] The paper was called "Das Spaltungsgesetz der Bastarde" (The law of segregation of hybrids), carrying Mendel's word "segregation" in its title and Mendel's *Versuche* in its footnotes. Published late in April, this is the paper that established de Vries's credit for the "rediscovery" of Mendel's genetic law.[18] Since 1896 de Vries had been crossbreeding hybrids in more than twenty different species of plants, corn and peas among them. He had found Mendel's law of segregation, he wrote, in every one of the twenty-odd species, though he only put two of them in his article—dihybrid species he had followed through no more than two generations. De Vries was publishing to protect his priority.[19] He had read Mendel's paper around 1899, after finding it in Liberty Hyde Bailey's bibliography at about the same time a friend sent him one of the offprints. At the time, however, his interest was not in hybrids, but in new species—the mechanism of evolution.[20]

At fifty-two, Hugo de Vries was not simply a botanist; he was also, with Jacobus Hendricus Van't Hoff and Hendrik Antoon Lorentz, one of the three leading scientists in the Netherlands, all of whom published, as Dutch scientists must, in at least three languages. Each of them was a partisan of the particulate. Lorentz, a physicist, was trying to find out how much of Maxwell's classic electromagnetic field theory could be replaced by an electrodynamic particle theory of the electron. Van't Hoff was about to be nominated for the first Nobel Prize in chemistry for his theory, based on Boltzmann's particle dynamics and Svante Arrhenius's idea of ionization (that chemicals in solution came apart into charged particles called "ions"), to explain osmotic pressure in dilute solutions. In fact, it was de Vries who in 1884 had called Van't Hoff's attention to the essential data, which came from a series of experiments he and another worker had done on osmotic pressure in models of plant tissue from 1882 to 1890.[21]

After providing data on osmosis to Van't Hoff and the ion counters, de Vries had given up his work on plant hydraulics and turned to the general question of heredity, one of the most vexed and ancient problems in biology. In 1889, he published, in German, his general theory, *Intracellular Pangenesis,* which argued that traits are carried by independent units in each cell called "pangenes."[22] Earlier theories of Herbert Spencer, August Weismann, and Nägeli de Vries criticized as inconsistent or insufficiently testable. Charles Darwin's own theory of pangenesis, published in 1868, de Vries called both consistent and pioneering; but he also found it untenable, since Darwin had postulated so many different kinds of heredity-bearing molecules or particles ("gemmules") freely transported all around the body that it was difficult to imagine how they might act

together to transmit a species. As for Weismann, he had postulated a strict separation of germ cell descent from that of all other cells, but he had not provided for a multiplicity of particles equal to the multiplicity of traits. De Vries's "pangenes" were multiple, like Darwin's, but like Weismann's they were intracellular—that is, they would not move from one cell to another except to daughter cells after mitosis. Since not all traits were expressed, de Vries argued that a pangene for every trait must exist in the nucleus of every cell in an organism, but that only a few could enter a given cell's cytoplasm and have an effect. Occasionally, a pangene might change its character, causing what de Vries called a "mutation;" and a few of these mutations could set off a new species.[23] The theory, supported only by inference in 1889, was easier and easier to prove as the twentieth century progressed. Today the largest difference we can see between de Vries's "pangene" and our "gene" is a sequence of nucleic acids and a Greek prefix meaning "universal."[24]

"Mutation" was an idea that was about to become de Vries's signature. All through the 1890s de Vries had been working on hereditary mechanisms. Since 1886 he had become fascinated not with peas, but with evening primroses, *Oenothera lamarckiana*. That year, out walking in a fallow field in Hilversum, he had found the botanical equivalent of a four-leaf clover: two varieties of primrose growing wild, apparently new to the world and apparently true-breeding. Delighted, he took home the seeds. Not only would botany be excited by a new species, but the thirty-year-old study of evolution would be revolutionized. Here was the raw material selected by nature in Darwin's "natural selection," and this must be how it arose—suddenly, from within the cells. By the time *Intracellular Pangenesis* was published, de Vries was pretty well convinced that the way to prove its thesis was to become the world's foremost expert on every species, variety, and hybrid of *Oenothera* and where it had come from. The first volume of his book, *The Mutation Theory*, came out in 1901, a year after his Mendel papers.[25] By the time he died in 1935 he had produced hundreds of primrose "mutations" and published more than thirty papers on the genus. Alas, de Vries's mutated primroses eventually turned out to be hybrid varieties instead of new species, but his idea—that evolution was a "discontinuous, as opposed to a continuous, process"—survived the evidence and contributed to the value de Vries placed on Mendel's achievement.[26]

Adding up everything de Vries had been doing up to 1900 can seem like an argument for serendipity, if not for *Zeitgeist*. He had approached what we now call Mendelian genetics from not one or two, but four directions at once: not only hybridization, hereditary mechanisms, and mutation, but also statistics. The statistics he borrowed from Darwin's cousin, Francis Galton, an English polymath now chiefly remembered for that fearsome outgrowth of modern biology called eugenics. Galton,

however, had anticipated de Vries's particulate pangenesis in 1876, and he had invented the two great tools of statistics: regression analysis and correlation. De Vries took up statistics in the 1890s and published five papers between 1894 and 1899 about how regression analysis could reduce fuzzy masses of scattered data points not only to the famous "bell" curve of normal distribution (which he called a Galton Curve), but to two or more such curves lurking superimposed in the data.[27] The curves revealed by regression analysis would then yield what the data had hidden most deeply—a simple numerical ratio of two or more factors, the signature of particulate heredity.

De Vries had been just in time. In the last week of April 1900, less than a month after his articles appeared, Carl Correns's new paper arrived at the *Berichte*. Its title was unambiguous: "G. Mendel's Rule Concerning the Behavior of Progeny of Varietal Hybrids."[28] "I thought that I had found something new," wrote Correns, "But then I convinced myself that the Abbot Gregor Mendel in Brünn, had, during the sixties, not only obtained the same result . . . as did de Vries and I, but had also given exactly the same explanation. . . ."[29] Finally, on May 8, the British botanist William Bateson chimed in with a report to the Royal Horticultural Society on hybridization, rewritten after reading Mendel's *Versuche* for the first time on the train from London. Led to Mendel by de Vries's article, and remembering de Vries from the 1899 meeting of the Horticultural Society as a fellow partisan of discontinuous evolution, he now returned the favor by bringing Mendel's law and de Vries's terminology into English for the first time.[30]

Why, after thirty-five years, was Mendel finally read and understood by three different biologists in three different countries within a few weeks of each other? The question has provoked a small library of scholarly inquiry, all of it suspicious of *Zeitgeist*-type explanations. In fact, however, Mendel offered the intellectual world a discontinuity drawn from statistical regularity it was not ready (or readied) to accept in 1865, but was in 1900. The heredity problem had always been important to biology. Darwin's evolution, in 1859, had made it essential; but the model of gradual, continuous change was so strong that only a genius like Mendel could model heredity without it. The old continuity, characteristic of the old century, is exemplified in Haeckel's biogenetic law, that the development of an individual organism smoothly recapitulates the evolution of its species. Following the same mode of thinking, botanists like Gaertner envisioned the homogeneous mixing of hereditary material. So did Darwin himself. It was not until after Carl Correns and Hugo de Vries had raised their own peas that they could appreciate the mathematical simplicity of the segregation of pea traits; and it was not until many months after his own paper was published that Erich Tschermak saw just what it was that was revolutionary in Mendel's. It was left to Mendel's

twentieth-century successors to move from analog to digital thinking, to postulate genes, to find out where they were, and eventually to describe them. It is not really strange that 1900 was the year such thinking should begin in biology. Nor is it any stranger that 1900 was the year it appeared in physics.

"A new scientific truth does not triumph by convincing its opponents and making them see the light, but rather because its opponents eventually die, and a new generation grows up that is familiar with it."[31] This, Max Karl Ernst Ludwig Planck's most famous dictum, was more than a witticism; it was autobiography. Planck had come up slowly through the ranks of the German scientific establishment, editing the works of his predecessors and doing his duty by the book. Lifelong habits of probity, deference, and uncomplaining modesty disguised Planck's genius and tenacity for a ninety-year lifetime; but just before he died he did admit in a memoir that he had deplored his elders' teaching style and disagreed profoundly with their ideas on thermodynamics, and that "one of the most painful experiences of my entire scientific life [is] that I have but seldom—in fact I might say, never—succeeded in gaining universal recognition for a new result" in any reasonable time after proving it.[32] How ironic, then, that Planck himself should appear to the twentieth century as a conservative, or that he himself should have had to be convinced of the importance and even the truth of one of the most consequential ideas in all of twentieth-century physics, the most revolutionary idea he ever had: the elementary quantum of energy.

The quantum began on October 7, 1900, with an inspired guess, an equation sketched by Planck on a postcard to enable his Berlin colleague, Heinrich Rubens, to make sense of his new data on black-body radiation.[33] Herr Professor Doktor Max Planck was forty-two that fall, and at the top of his rank in Germany, a member of the Prussian Academy and full professor at the University of Berlin. He had eighty-nine students enrolled in his lectures, up from eighteen a decade before. For each course there were four lectures a week and one period of problem-solving. If you stayed with Professor Planck for three years, you could get all of physics, as complete as everyone thought it was, in a six-course cycle: "mechanics, hydrodynamics, electrodynamics, optics, thermodynamics, kinetic theory—once every six semesters."[34]

As a researcher, Planck was even more orderly. A purely theoretical physicist, he had written his dissertation on thermodynamics and entropy back in 1879, finishing it in Munich a week before Einstein was born. Now, twenty-one years later, he was still working on the same problem. It was, Planck thought, the last big problem in physics. His physics profes-

sor at the University of Munich had told him years ago that physics was "just about complete,"[35] but Planck had not been daunted and resolved to complete it. His imagination had been caught way back in high school, when the man who had taught him mathematics and physics told a story about the First Law of Thermodynamics that involved a construction worker heaving a roofing stone to the top of a building. The stone and its new location would motionlessly store the energy the worker had used to get it there until, long after the worker had died, it fell back to earth, possibly on a passerby. Energy, said the Law, was neither created nor destroyed; and to every effect there was necessarily a cause. To Planck, the scion of generations of Protestant ministers, the elegance of nineteenth-century physics had offered a brief glimpse of eternity. "I had always looked upon the search for the absolute as the noblest and most worth while task of science."[36]

But not all of the energy the construction worker had expended got all the way to the roof to be frozen in position with the stone. Some had been dissipated in the heaving, a dissipation Rudolf Clausius in 1850 had identified as a change in "entropy," and defined as the fraction formed by dividing the quantity of heat transferred in any process by the temperature of the transfer. Clausius's conclusion was that although the energy in any defined system was always conserved without increase or decrease, the entropy could only stay the same in a system where transfers of energy were completely reversible. In real systems, entropy would almost always change; and the change would never be negative. Entropy would always "strive," as Clausius put it in 1865, "toward a maximum." This postulate, made in Berlin, had been handed on to Planck's contemporaries as the Second Law of Thermodynamics, and Planck was soon drawn to the Second Law as he had been to the First. At about the same time that Boltzmann was reconceptualizing entropy as the logarithm of the probability of all configurations of atoms, Planck was formulating an approach to entropy that would dispense with atoms and prove that probability had nothing to do with it.[37] Planck's 1879 Ph.D. thesis was an argument for Clausius's conviction that entropy was always increasing in every real instance in nature, and that the probability of it ever remaining the same was not unimaginably small, as Boltzmann had just implied, but zero— an absolute.

On the day Planck traveled to Bonn to deliver his thesis to Clausius in person, Clausius had not been at home. He never did see it, thus becoming the first of the academic mandarins to ignore Planck's work. Eventually the list came to include Helmholtz, Kirchhoff, and Boltzmann, the greatest minds in German thermodynamics. It had not been deliberate, or even entirely unfair, because Planck was wrong about atoms, which have proved indispensable, and wrong about entropy, which is a

statistical and not an absolute measure. Planck's lofty project was, in fact, impossible; and Planck's great discovery stood out almost from the moment he made it in the fall of 1900 as the best proof of its impossibility.

In 1880, Planck had submitted a *Habilitation* on equilibrium conditions in liquids and gases to the University of Munich. Not long after, a more elegant derivation of Planck's results had turned up in papers published in 1875 by Willard Gibbs. After Planck had secured his first salaried job at Kiel University (thanks to his father's pull) he had married Marie Merck and begun producing both books and children, but the bubble, reputation, continued to elude him. Marching doggedly on with the thermodynamics of fluids, Planck had managed to prove, without using Arrhenius's new postulate of charged "ions," that chemicals in solution must be dissociated into submolecular particles. Then Arrhenius himself had paid Planck a visit at Kiel in 1888 and dismissed his work as incomplete.

The panjandrum of nineteenth-century German science, Hermann von Helmholtz, who had published the First Law of Thermodynamics back in 1847, had not criticized Planck. Like Clausius, he had ignored him. Planck had attended the great man's perfunctory lectures as an undergraduate at Berlin University in 1878–79, staying until the students dwindled to a corporal's guard, but there was no reward for his loyalty. Undergraduates were never Helmholtz's highest priority. Ten years later, as an obscure assistant professor at Kiel, Planck had entered an essay on energy and entropy in a contest at the University of Göttingen and received second prize—the only prize they gave—because he had opposed the view of a Göttingen professor on the prize committee. It was brought to Helmholtz's attention that Planck in so doing had aligned himself with Helmholtz, and the upshot was that in 1888 Planck was offered a professorship in Berlin. There he was to replace the third of the great stars of Berlin physics, Gustav Kirchhoff, who had just died.

Planck had taken courses from Kirchhoff, too, during his student year in Berlin. They were, he would remember, perfectly organized, but dry, memorized and monotonous.[38] Planck knew, however, that Kirchhoff had discovered one of thermodynamics' most precious and puzzling absolutes—an unspecified function called the "black-body" equation—not long after Planck's birth. Kirchhoff had shown that when a totally nonreflecting body (he called it a "black body") was heated and began to emit radiation, the strength of its glow in any color would depend only on its temperature, no matter what you made the body out of. At any wavelength or frequency from blue to red, Kirchhoff had postulated, the total radiation energy emitted by a black body in a given time would be a mathematical function only of that wavelength and of the absolute temperature. "It is a highly important task to find this function,"[39] Kirchhoff wrote in the 1860 paper announcing his result; but what the function

was he did not know. Forty years later, when neither Kirchhoff nor any-one else had found out, and the problem had become a classic challenge to physics, Planck discovered it. It was precisely that unknown function that Planck wrote on his postcard to Rubens in October 1900.

By then Planck was deliberately looking for the black-body function; but he had come at it in the most roundabout of ways. He had not begun looking until 1897, and even then it was still entropy he had cared about most. He had written another book on entropy eight years after his dissertation, and he was still at it when he became a professor in Berlin in 1889. As Kirchhoff's successor, he had dutifully taken on the editing of Kirchhoff's papers, just as he had before with Clausius's, expecting the task to turn up support for his view. However, when Planck got to volume 4, and the master's six lectures on gas theory, he discovered that in one of them Kirchhoff had advanced a probability model for the structure of an ideal gas.[40] If even Kirchhoff was not safe for nonstatistical methods of proving that the increase of entropy was irreversible, then perhaps there was something in probability after all.

If probability and statistics were indeed the way to go, then the right guide would have to be Boltzmann; but Planck was wary of the man and wary of his models, and he took his time about following up. Long before he had studied Boltzmann's key works, he found himself defending Boltzmann's atomism in the "energetics" debate that came to a head at the German Association meeting in Lübeck in September 1895. The "energeticists" thought physics could be centered on equations for energy rather than matter—scientists like Ostwald, Helm, and Wiechert who had so provoked Boltzmann, together with the like-minded English thinkers Clifford, Pearson, Larmor, Lord Kelvin (occasionally), and others who had made atoms seem like waves and vortices, and materialism look old-fashioned. Planck thought the whole idea was an aberration—worse, he thought it was too radical, "encouraging young scientists in dilettantish speculation instead of in a thorough grounding in the study of established masterpieces."[41] His critique of Mach had begun in earnest with a letter to Ostwald in 1891. Energetics seemed to him an outgrowth of Mach's "positivism" and notorious insistence that atoms did not exist. Boltzmann's zestful militancy was alien to Planck's character;[42] but at Lübeck in 1895 he engaged himself at Boltzmann's side and found himself in the company of the younger generation of physicists.

Rather suddenly Planck, who had been largely indifferent to atomism up to this point, had begun to understand that his search for the absolute had a better chance of success under atomist than under positivist banners. The stakes were high by now. If gases were continuous, the most satisfactory theory of the origin of heat would collapse. If liquids were continuous there would be no way to explain osmotic pressure, the rate of electrolysis, or the Brownian motion of suspended particles under a

microscope. If solids were continuous there would be no way to explain their specific heats. If matter in general were continuous there ought to be an infinite number of chemical elements, whereas in fact there were less than a hundred.

Planck's old hope that assuming a continuous, nonatomic matter might help him prove entropy absolute was expressed for the last time in 1897 in a letter to a friend.[43] After that, he never looked back. He was still smiting Mach-ism and positivism hip and thigh in 1908 and 1910,[44] by which time Boltzmann was dead, the Machians in disarray, and Mach himself immobilized with a stroke. But then, neither of the Vienna giants had noticed Planck's efforts when they were alive and well. Ignored by Mach when he was not an atomist, Planck found himself, as a convert, ignored once again by Boltzmann and the atomists. Even Planck's assistant, Ernst Zermelo, got more attention from Boltzmann when he published a deep critique of the "ergodic" hypothesis that underlay Boltzmann's statistical picture of entropy.

To be fair, Planck had not noticed when Boltzmann had said at a meeting back in 1891 that there was "no reason why energy shouldn't also be regarded as divided atomically."[45] Perhaps it registered subconsciously. In 1896, Boltzmann had summarized twenty years of work in his *Lectures on Gas Theory*. Planck seems to have read it when it was published, but while there was a summary statement of the H-Theorem and statistical entropy in the first chapter, and a discussion of combinatorials in sections 6 and 8, it had no immediate effect on Planck's work.[46] He was no longer so interested in gas or matter. Already in 1895, the year of the energetics debate, he had published the first report on his next research project—the radiation question.

In the 1890s radiation was fashionable, and physicists everywhere were converging on phenomena that tested the borderline between energy and matter. Helmholtz's most successful student, Heinrich Hertz, had made and detected the first electromagnetic waves in the radio band in 1887. Cathode rays, known since the 1860s to be both electric and magnetic, had recently been shown by Jean Perrin in Paris and J. J. Thomson in Cambridge not to be rays at all, but charged particles smaller than atoms. Thomson had called them "corpuscles" in 1897; George Stoney's 1894 suggestion, "electrons," eventually prevailed. In 1895 Wilhelm Röntgen had discovered that when cathode rays hit some metals, new rays were set off—real rays, not particle streams, so powerful they could go right through his own body and picture his skeleton on a camera film. The name he gave them—X-rays—has stuck. Most recently the Dutch physicist Hendrik Lorentz had been trying to reduce the theory of electromagnetism to a theory of electron dynamics. Radiation, though it was clearly energy, seemed to interact with matter without any intermediates.

Maxwell had shown that it even exerted "pressure." For Planck, who had begun this new quest as an anti-atomist, the elegance of radiation was that hardly anything more continuous could be imagined. His hope was to find out if it had entropy as well, and to find in the entropy of radiation what he had found so elusive in the entropy of matter—the proof that entropy increase was absolute.

Oddly, Planck began with an image of radiation that was not continuous at all. In the paper he published in the spring of 1895, he had set up the radiation model that remained his touchstone for the next decade and would soon make his analysis of a radiating black-body possible. Planck imagined it as an enormous collection of tiny elements he called "oscillators" or resonators that could receive or "resonate" to waves of certain frequencies, absorbing and sending them out again. Perhaps Planck, who had an achingly perfect musical ear, was thinking of the strings of his piano, vibrating to each other's overtones as he played his beloved Schubert and Bach.[47] For those with more poetry than physics, the model makes one think of a wheatfield in a breeze, with each ear responding to wind changes in its own way. If, as Planck also assumed of his oscillators, each ear contributed to a sort of counter-breeze whenever it swayed back, the image might not be far from the physical model. Boltzmann would have called these oscillators molecules, but Planck was not yet entirely convinced that the molecules were there, and he restricted his resonators to the single task of responding to radiation from each other and from outside the system. He also wanted as few oscillators in his field as possible, so he could handle them mathematically. For some time his standard procedure was to work out the average or equilibrium behavior of just one of them and then multiply to get the rest.

In 1896 a friend of Planck's youth, Wilhelm ("Willi") Wien, had made a discovery that drew Planck's attention back to Kirchhoff's black-body problem. Working over in the physics faculty at the Imperial bureau of standards, Wien had drastically reduced the number of unknown parts in the Kirchhoff equation until there was only one left, a function of the frequency (a kind of reciprocal of the wavelength that gets smaller as wavelength gets bigger) divided by the temperature. A couple of years later Wien found a version of it that could be tested by experiment. The tests had looked good, especially for wavelengths in the range of visible light.

Planck was no experimenter, but he was in the right place to find out what experimenters were doing. There were three black bodies in the German Empire, and two of those were in Berlin. They were the Superconducting Supercolliders of their day. The one Wien's department worked with was at the Imperial Physical-Technical Institute, the bureau of standards in the suburb of Charlottenburg. It had been made out of

porcelain and platinum in 1896 by a team under Otto Lummer and Ernst Pringsheim, and as soon as it came on line Wien had used its results for his Relation, and later for his Distribution Law. The other one was at the Polytechnic School near the city's center, fired up most days by Ferdinand Kurlbaum and Planck's friend Heinrich Rubens. Rays emerging from the black bodies were focused onto a device called a bolometer, whose heart was a strip of blackened platinum that absorbed the radiation and registered its total energy.[48]

At about the same time, Planck was realizing that a promising route toward a solution of the entropy riddle lay in the assumption that radiation too could have entropy. At least the radiators could have it, if the radiation did not. In February 1897, Planck had read the first paper in a series he called "On Irreversible Radiation Processes" to the Berlin Physical Society, using the resonator model in an attempt to prove that radiation entropy was irreversible. It was then that Boltzmann finally noticed him, filing a paper of his own at the Berlin Physical Society in June with the same title as Planck's. In it Boltzmann demonstrated that Planck's basic model was mistaken. Planck had assumed that a resonator would send off a spherical wave, expanding in all directions, and would receive whatever waves or parts of waves it got in the way of. Boltzmann simply asked why—in the fullness of time—a spherical wave might not converge right back on a resonator. Indeed, it could. Planck's proof had rested on an unconscious assumption, and the assumption had turned out to be wrong. Back he went to his desk in Berlin and switched from the average of resonators to the average of one resonator. From now on each new paper in his series on "irreversible radiation processes" would take him closer to Boltzmann's statistical approach and further away from his absolute. By the time his fifth Irreversible Radiation Processes paper had appeared in May 1899, Planck had "conceived the idea of connecting the entropy . . . of the resonator with the energy" instead of the temperature; and using his new equations, had found a way of deriving Wien's new distribution Law from them.[49]

Meanwhile, Rubens and Kurlbaum had reset the newest black body at the Polytechnic to measure radiation that had never been measured before, beyond the 8-micron wavelength where redness can no longer be seen and the far infrared begins. Using crystals of rock salt or fluorspar so as to reflect only those longer wavelengths, the Rubens team had focused the rays onto their bolometer and found intensities that shrank steadily. By the end of 1899 and the beginning of 1900, first from the Polytechnic and then from Charlottenburg, results were beginning to trickle in. At any given temperature, the radiation intensity characteristically peaked at a particular wavelength but, the experiments showed, at the longer wavelengths it came down from the peak. That confirmed Wien's three-year-old relation, but flatly contradicted his new Law—and

Paschen's Law and Thiesen's even newer Law. At these wavelengths, no known Law made sense of the data.

At the end of the academic year in June, an Englishman, John Strutt, Lord Rayleigh, entered the debate with a distribution law of his own. Rayleigh was already a good atomist, having shown in 1877 and again in 1899 that the reason the sky was blue was that atom-sized particles making up the gases in the air diffracted sunlight back to earth in the blue wavelengths. Having thus brought the very continuity of the air in the sky into question, Rayleigh made no use of discontinuity in his new distribution law, though he did hit on the idea of putting wavelength into the equation as a square and as an exponent. Worse, Rayleigh's Law gave reasonable figures only for radiation at long infrared wavelengths. At the smallest (ultraviolet) wavelengths, it predicted an infinite radiation intensity, an "ultraviolet catastrophe" that made no sense at all.

One commentator on the Physics Congress at the Paris World's Fair thought that of all the physicists in Paris, only four cared much about thermodynamics.[50] Doubtless he meant Planck and his colleagues from Berlin. In August 1900, Planck sat in a lecture hall in Paris and heard Wien's colleague Otto Lummer give a paper in French on the latest black-body data in the far infrared. The news was still bad for the Law that Wien had proposed and that Planck thought he had just proved. Would new runs in the fall give better results? Would it matter? Lummer's paper undid the reasoning Planck had just used to derive Wien's Law. Was it really possible, Lummer wondered, to assume that one resonator's equilibrium multiplied by the number of resonators would equal the equilibrium of the whole radiating body?[51] The next paper raised the same question—and it was by Willi Wien. For Planck, Paris was not nearly as encouraging as it had been for Paula Becker.

In the early fall of 1900, the World's Fair wound down and intellectuals dispersed to their home cities (except for Hugo de Vries, who had never left Amsterdam). In September, at the annual meeting of the German Association of Doctors and Scientists in Aachen, Wien raised one last question about the new data coming from his own laboratory in Charlottenburg. No, replied Pringsheim, "That source of error I consider completely excluded by the type of experiment."[52] A few weeks later, on October 7, the head of the other black-body team came to dinner with Max and Marie Planck at their home in Grunewald, Berlin. There Rubens wondered if an equation would ever be found to relate the intensity of each wavelength of radiation to the temperature of the black body. After Rubens left, and his four children were in bed, Planck stayed up to wonder more precisely. If the intensity (energy) at a given temperature peaked at a particular color and then came down again, the formula for intensity must have quantities in it that varied in opposite directions. Such a formula or function could be most easily constructed mathemati-

cally if it had "two terms, one involving the first power, the other the second power of the energy, so that the first term was the predominating term for small values of the energy, the second term for large values."[53] Planck tried putting the wavelength λ in the denominator of one term as a negative power of base e, and a negative power of the wavelength $λ^2$ in the numerator of the other term. That way as λ went up, the function would go up first following the shrinking denominator, and then down as the more rapidly shrinking numerator took over. It was this formula, $E = Cλ^{-5}/e^{c/λT} - 1$, that he put on a postcard and sent to Rubens the next day.[54] (E stood for the intensity, T for absolute temperature, while C and c were two different constants.)

It worked, reported Rubens and Kurlbaum. It worked better than Wien's Law in the infrared, better than Paschen's or Thiesen's, and better than Rayleigh's in the ultraviolet. On October 19, Rubens, Kurlbaum, and Planck announced it together to the Berlin Physical Society, Kurlbaum going first with the data and Planck next with a question and a short paper proposing his new law. But Planck did not yet know *why* the law worked. It was "an act of desperation," he wrote in 1931. "I had to obtain a positive result, under any circumstances and at whatever cost."[55] What was really going on in red-hot black bodies? What did his strange little formula say about nature? That October and November Planck spent most of his time between classes "trying to give it a real physical meaning."[56]

What did Planck do in those four weeks at the end of October and the beginning of November? In fact the sketch of the law he had provided for Rubens had several details that hinted at an underpinning in the mathematics of combinatorial analysis—counting the possibilities for factors to combine. It had, for example, the base of natural logarithms e raised to a power, which suggested the formula he had learned in college for turning giant factorial expressions into simpler logarithmic ones. "After a few weeks of the most strenuous work of my life, the darkness lifted and an unexpected vista began to appear."[57] Twenty years of designing mathematical expressions for entropy had finally yielded one that worked—that had verifiable consequences in other parts of physics.

Planck had finally bought into Boltzmann's conception of entropy as the sum of logarithms of probabilities. The probabilities, in turn, were of different combinations of bits and pieces. If the radiation energy itself could be divided up into equal parts, Planck could devise a formula whereby the total number of tiny, equal energy parts e would be distributed in every possible combination over the total number N of oscillators in his system. The logarithm of the number W of possible distributions, times the Boltzmann constant k, would be the entropy S of the whole radiating system, given in terms of its total energy, and the entire equation

would have the same basic shape as Boltzmann's H-Theorem. As soon as he had this equation (Planck was the first to write it in the form $S = k \log W$, and to call k "Boltzmann's Constant"), he proceeded to plug its terms into Clausius's revered old formula that equated a change in entropy to the change in energy divided by the absolute temperature. That brought temperature into the equation. After some hectic manipulations whose difficulties and frustrations might draw sympathy from algebra students anywhere, including a second division and multiplication by the number N of oscillators, Planck could finally see emerging the frequency-intensity distribution law he had proposed to Rubens in October, using frequency ν instead of wavelength λ: $E_{\nu, T} = 8\pi\nu^2\varepsilon/c^3 \times 1/(e^{\varepsilon/kT} - 1)$.[58] There, too, was the energy part ε obvious in the numerator and in the exponent in the denominator. Since Wien's relation required that the missing element of the function involve the frequency divided by the temperature ν/T, Planck tried replacing ε with the product of the frequency ν times a small constant, an operation that would leave ν/T obvious in the denominator. He labeled his new small constant h. Since everything else—π, e, and even k—was also a constant, Planck knew that the formula Kirchhoff had challenged physicists to find more than a generation before was in his hands. It had been derived from first principles—and the principles were Boltzmann's.

On November 13, Planck wrote to Wien that he had a theory to support the formula he had suggested in October, which was proving more successful every day in the black-body laboratory of Berlin Polytechnic.[59] On December 14, in the last month of 1900, Planck rose before his distinguished colleagues at the Berlin Physical Society and announced his derivation. They asked no questions. The great mine he had laid under nineteenth-century physics was not clear in Planck's paper, and it was by no means clear even to Planck how enormous was the novelty of those tiny but irreducible bits of energy ε or $h\nu$ that had made the derivation possible. Walking with his seven-year-old son Erwin as 1900 drew to a close, Planck told the boy he had made a discovery comparable to that of Copernicus or Newton. It seems, however, that he was not talking about $h\nu$. Instead it was his proof that one of the newer constants of nature, Boltzmann's Constant k, was applicable to both matter and energy.[60]

As for the little constant he had labeled h and used to multiply the frequency, Planck kept quiet about it. He did not even give it a name until 1906, when he wrote his book and decided to call it the "elementary quantum of action." According to his new formula, there could be no smaller step than h in the increase or decrease of energy. It was very small, 6.55×10^{-27} or about six and one-half nonillionths of a very small energy unit, the erg, each second. Small as it was, Planck could not get rid of it. It had appeared in his first step and it was ineradicable in his last. He had

not only accepted the Boltzmann principle that entropy increase was a matter of probability; he had run up against a new sort of atomic structure in energy—an atom of radiation. *Natura non fecit salta*, Aristotle had said long ago, and the seventeenth-century godfather of German science, Leibniz, had repeated the dictum, "Nature makes no jumps." But it did. "Nature certainly seems to move in jerks, indeed of a very definite kind."[61]

12 BERTRAND RUSSELL AND

EDMUND HUSSERL

PHENOMENOLOGY, NUMBER,

AND THE FALL OF LOGIC

1901

In the spring of 1901, Bertrand Russell was work-
ing with pen and paper in the back room of his little country cottage,
"The Millhangar," near the small villages of Fernhurst and Haslemere,
south of London. May 18 would be his twenty-ninth birthday. He was
planning a book that he expected to refound the whole of mathematics,
purge all metaphysical nonsense from philosophy, and change the world.
The title he eventually gave it wasn't modest either—*Principia Mathemat-
ica,* the first words of the title Newton had used for his masterpiece of
1687; but Russell had an aristocrat's self-assurance without having the
title. Grandson of a Whig Prime Minister and three other lords and la-
dies, Russell had won a prize Fellowship at Newton's Cambridge Univer-
sity and intended the book for its venerable Press. *Principia Mathematica*
was to be a second volume—extended, rigorous, and written in symbols
instead of prose—of a book called *The Principles of Mathematics,* which
Russell had already completed "on the last day of the old century," De-
cember 31, 1900.[1] At any rate, he thought he had completed it. There
were hundreds of thousands of words in the fourth manuscript of *The
Principles of Mathematics.* By comparison with the remains of the three
nearly complete earlier drafts he had produced since 1897, the pages of
the fourth were clean and neat. Russell had expected to send it to the
publisher in a few weeks; but because of what he found in May 1901,
he would postpone publication for more than a year. He discovered that
Part 1 was all wrong. Looking back years later over the ruin of his hopes,
Russell would write:

the end of the century marked the end of this sense of triumph, and from
that moment onwards I began to be assailed simultaneously by intellectual
and emotional problems which plunged me into the darkest despair that I
have ever known.[2]

Despair did not set in immediately. It took time for this new discovery to sink in. Russell's old "sense of triumph" had lasted for nearly a year, ever since he had heard Giuseppe Peano and his company of Italian mathematicians declaim at the Paris Congress of Philosophy during the first days of August 1900, the event that rekindled his youthful dream of finding intellectual certainty and giving it to the world. His own description of his intellectual triumph writing *The Principles of Mathematics* that fall of 1900 is one of the most positive—and lyrical—passages in a lifetime of writing.

> I spent September in extending his [Peano's] methods to the logic of relations. It seems to me in retrospect that, through that month, every day was warm and sunny. The Whiteheads stayed with us at Fernhurst, and I explained my new ideas to him. Every evening the discussion ended with some difficulty, and every morning I found that the difficulty of the previous evening had solved itself while I slept. The time was one of intellectual intoxication. My sensations resembled those one has after climbing a mountain in a mist, when, on reaching the summit, the mist suddenly clears, and the country becomes visible for forty miles in every direction. For years I had been endeavouring to analyse the fundamental notions of mathematics, such as order and cardinal numbers. Suddenly, in the space of a few weeks, I discovered what appeared to be definitive answers to the problems which had baffled me for years. And in the course of discovering these answers, I was introducing a new mathematical technique, by which regions formerly abandoned to the vaguenesses of philosophers were conquered by the precision of exact formulae. Intellectually, the month of September 1900 was the highest point of my life. I went about saying to myself that now at last I had done something worth doing, and I had the feeling that I must be careful not to be run over in the street before I had written it down.[3]

The "new mathematical technique" was a logic he had baptized the "logic of relations." Instead of relying on sentences, predications, wholes, parts, and inclusions, or Aristotle's ancient syllogisms, one would begin by defining a limited number of relations (among them the axioms of Cantor's set theory), construct propositions like mathematical functions using Peano's symbolic terminology, give them content, and draw their truth-values and implications more precisely than had ever before been possible. Number could be defined at last, and since all depended on number, mathematical truth could be built up, proposition by proposition, until it was one and indubitable.[4] "Every day throughout October, November and December," he tells us in his autobiography, he had written his ten pages in *The Principles of Mathematics*.[5] In November he had written to his wife, the former Alys Pearsall Smith, giving a slightly patronizing description of one of the things he was doing with the "suc-

cessor relation" by which Peano (and Frege and Dedekind before him) had built up the structure of "ordinary" arithmetic.

> I am just beginning to get a glimmering of the nature of numbers. . . . I can now prove that no number is very large. For 1 is certainly not so, and if any number you like to take is not very large no more is the one next after it: and so no number is very large because they can never begin being so.[6]

Six hours before midnight on the last day of 1900, he had written to his American friend Helen Thomas a letter he would later call "boastful," announcing the completion of his book and rejoicing in his enormous accomplishment.

> Thank goodness a new age will begin in six hours. . . . In October I invented a new subject, which turned out to be all mathematics for the first time treated in its essence. Since then I have written 200,000 words, and I think they are all better than any I had written before.[7]

But Russell was wrong. Inconsistency of a very precise kind lay right at the root of mathematics and at the root of logic itself. Dedekind had not found it, and neither had Frege or Peano. Russell himself did not discover it for some time after completing his manuscript. In the first months of 1901, Russell had busied himself writing a layperson's introduction to the foundations of logic and mathematics, and finishing up several papers based on his new logical technique for publication in Peano's journal, the English philosophical journal *Mind,* and even a general-interest magazine.[8] Returning to The Millhangar in May 1901, Russell was hoping to finish up *The Principles of Mathematics* and begin that even more ambitious *magnum opus,* volume 2, in which the truths of volume 1 would appear in the same austere, symbolic form as Euclid's *Geometry* and Newton's original *Principia.* He had taken up his manuscript of *The Principles* to shake the last little wrinkles out of its first two sections, and to that end was going over one of the many odd results of Georg Cantor's new set-theoretical mathematics, which he had devoured in 1898.[9]

> Cantor had a proof that there is no greatest number, and it seemed to me that the number of all the things in the world ought to be the greatest possible. Accordingly I examined his proof with some minuteness, and endeavoured to apply it to the class of all the things there are.[10]

Some sets (Russell called them "classes") were infinite. Some infinite sets, like that of the real numbers, were larger than other infinite sets. Some sets were infinite in that they had an infinite number of sets as members. If the set of all sets of all kinds could be constructed, surely, thought Russell, no set could be larger. A few months earlier, on January 17, he had written about the problem to Louis Couturat, the French author of *The Mathematical Infinite* who had discovered his early work,

had gotten it reviewed by Henri Poincaré in the Paris *Revue de métaphysique et de morale,* and had been responsible for his invitation to the Mathematics Congress:

> Concerning the class of classes, if you admit a contradiction in this concept, infinity will remain forever contradictory, and your works as well as Cantor's have not resolved the philosophical problem. For there is a concept class and there are classes. Therefore, class is a class. . . .[11]

That is, the concept "set" is itself a set and must belong to the set of all sets. But at some point in May, Russell asked himself not about sets that include other sets as members but about sets that include themselves as members—and sets that specifically *ex*clude themselves as members. The set of all large sets, for example, is a large set and ought to include itself. The set of all books is not a book and so ought not to.

"This led me to consider those classes which are not members of themselves, and to ask whether the class of such classes is or is not a member of itself."[12] In other words, how about taking the set of books and all the other sets that do not include themselves and making a set of them? Now comes the problem. Is that set of sets a member of itself or not? If it is a member of itself then by definition it cannot be a member of itself. But if it isn't, then it has to be.

> I found that the answer implies its contradictory. . . . Burali-Forti had already discovered a similar contradiction, and it turned out on logical analysis that there was an affinity with the ancient Greek contradiction about Epimenides the Cretan, who said that all Cretans are liars.[13]

Russell did not take the snag very seriously that May. His book had been going so well that he had simply assumed that any contradictions that might appear would come from his own mistakes and not from the foundations of mathematics, whose very nature was consistency. "At first," he thought, he "should be able to overcome the contradiction quite easily, and that probably there was some trivial error in the reasoning. Gradually, however, it became clear that this was not the case."[14] The problem was deep. To base all of mathematics on set theory as expressed in his new propositional logic, Russell had to satisfy himself that set theory was completely free of contradictory implications. Here however was a contradictory implication that was inextricably entangled with the concept of set. Worse, the paradox was fundamental. It did not appear as a distant consequence; it emerged instead among the most basic propositions logic could begin with—not a minor twig at the end of a branch, but the taproot itself. Ever since the work of G. B. F. Riemann and Felix Klein on non-Euclidean geometry, mathematicians had known how they might demote an axiom to the status of a proposition and vice versa, or

to pose its converse and build a new mathematics. Russell tried that; but no matter what status he gave it, the contradiction survived. Worst of all, perhaps, it seemed a little silly.

> It seemed unworthy of a grown man to spend his time on such trivialities, but what was I to do? There was something wrong, since such contradictions were unavoidable on ordinary premisses. Trivial or not, the matter was a challenge.[15]

Russell adored mathematics in all its austerity, but there was nothing cold in this or any other of his loves.[16] He had a young American-born wife whom he thee-ed and thou-ed in Quaker intimacy and with whom he had taken time in 1896, after lecturing on non-Euclidean geometry at Bryn Mawr College in Pennsylvania, to visit the grave of Walt Whitman. He had put aside his thesis on space and geometry to publish as his first book a profile of the Socialist movement in Germany. Just three months before he discovered the paradox, he had had an experience so unrelated to logic that he called it mystical, but which he remembered ever after as having changed his life. Returning from a performance in Cambridge of a Greek tragedy,

> we found Mrs Whitehead undergoing an unusually severe bout of pain. She seemed cut off from everyone and everything by walls of agony, and the sense of the solitude of each human soul suddenly overwhelmed me. Ever since my marriage, my emotional life had been calm and superficial. I had forgotten all the deeper issues, and had been content with flippant cleverness. Suddenly the ground seemed to give way beneath me, and I found myself in quite another region. Within five minutes I went through some such reflections as the following: the loneliness of the human soul is unendurable; nothing can penetrate it except the highest intensity of the sort of love that religious teachers have preached; whatever does not spring from this motive is harmful, or at best useless; it follows that war is wrong, that a public school education is abominable, that the use of force is to be deprecated, and that in human relations one should penetrate to the core of loneliness in each person and speak to that. . . . At the end of those five minutes, I had become a completely different person.[17]

Russell had been orphaned at three. The loss of love and the loss of intellectual certainty were not entirely separate in his mind. Indeed, as the paradox continued to plague him, Russell became sadder and sadder. He could not solve the problem and he could not lay it aside.

> Throughout the latter half of 1901 I supposed the solution would be easy, but by the end of that time I had concluded that it was a big job. I therefore decided to finish *The Principles of Mathematics,* leaving the solution in abeyance.[18]

That meant volume 2. Russell knew that his new logic, even with its fundamental flaw, was still a vast improvement on the methods then taught at Cambridge, and that there were far more confusions and contradictions in the logics of Peirce, Schröder, Venn, and Boole—not to mention the logic of Aristotle—than there were in Russell's. Courses could be taught on what he had done so far, and in the winter term of 1901–1902, Russell accepted an invitation from his college to give two sets of lectures at Cambridge. They were a first draft of volume 2. He had still not told anyone of the hole in his structure. He still expected to find it and fix it himself. And he still thought mathematics could requite his love and be perfect. On the next-to-last day of 1901, he wrote again to Helen Thomas at Bryn Mawr:

> The world of mathematics, which you contemn, is really a beautiful world; it has nothing to do with life and death and human sordidness, but is eternal, cold and passionless. To me pure mathematics is one of the highest forms of art; it has a sublimity quite special to itself, and an immense dignity derived from the fact that its world is exempt from change and time. I am quite serious in this. . . . [M]athematics is the only thing we know of that is capable of perfection; in thinking about it we become Gods.[19]

The lectures went well—all of logic and mathematics derived from eight undefined ideas and twenty unproved propositions,[20] until February, when the next blow fell. While bicycling on a country road near the Whiteheads' house in Grantchester, Russell discovered that he "no longer loved" his wife. He told her and asked for separate sleeping arrangements. His mystical experience in February 1901 may have shown him that "the loneliness of the human soul is unendurable;" but it seems not to have prevented him, in February 1902, from choosing loneliness for his own soul—and not incidentally, his wife's. Alys was so devastated that in April she undertook a rest cure under a doctor's care in Brighton.[21] Alone in Grantchester, Russell used the time to finally finish *The Principles of Mathematics*. He was to remain largely celibate for the next eight years.

> The most unhappy moments of my life were spent at Grantchester. My bedroom looked out upon the mill, and the noise of the millstream mingled inextricably with my despair. . . . [In 1902,] at the very height and crisis of misery, I finished *The Principles of Mathematics*. . . . The day on which I finished the manuscript was May 23rd.[22]

Russell was never to be very pleased with *The Principles of Mathematics*, either. The memory of finishing the book five days after his thirtieth birthday, without fully solving what he called "The Contradiction" (now called "Russell's Paradox"), was to haunt him for years. To one of his friends in the English Department at Bryn Mawr, Russell confided,

I finished today my magnum opus on the principles of mathematics, on which I have been engaged since 1897. This has left me with leisure and liberty to remember that there are human beings in the world, which I have been strenuously striving to forget. . . . The hardest part I left to the end: Last summer I undertook it gaily, hoping to finish soon, when suddenly I came upon a greater difficulty than any I had known of before. . . . And long ago I got sick to nausea of the whole subject, so that I longed to think of anything else under the sun. . . .[23]

As he had predicted to Alys in May, it did "not give me any feeling of elation, merely a kind of tired relief as at the end of a very long dusty railway journey. . . . There is a great deal of good thinking in it, but the final product is not a work of art, as I had hoped it would be. I shall send it to the Press at once. . . ."[24]

But Russell still had proofs to correct, and on the early proofs Russell, like Freud in 1897, was doing the least original part of his writing task, reading the work that other scholars had already done so that he could properly acknowledge them in the introduction and footnotes. Rereading his predecessors, Boole and Venn, Peirce and Schröder, Russell took up once again the 1893 *Grundgesetze der Arithmetik* (Foundations of arithmetic) of Gottlob Frege. In 1900 he had not been able to make head or tail out of it, but this time it was clear—and clear, too, that all along Frege's project had been much the same as Russell's. The reason Frege's symbolic language had seemed so obscure was that he had invented his own; and he had done it back in 1879, a good ten years before Peano and Schröder and Dedekind had begun to do similar work. So it was the same project—an unshakable grounding for arithmetic—and if it was the same project, it must have the same fundamental problem. In between one sheaf of proofs and another, Russell wrote a letter to Frege. Had Frege noticed, Russell wondered, that "there is no class (as a totality) of those classes which, each taken as a totality, do not belong to themselves?"[25]

"Many thanks for your interesting letter," Frege replied, having considered the question for less than a week. "Your discovery of the contradiction caused me the greatest surprise and, I would almost say, consternation, since it has shaken the basis on which I intended to build arithmetic." That is to say, it had dealt the same fatal blow to Frege's lifework that it had to Russell's.[26] Misery loves company, goes the old saw; and now two people were miserable. It was at about this time that Russell began to glimpse a rather inelegant solution to his difficulty—a way around it if not a way out—which called for declaring the troublesome sets not to be sets at all. By the time he had formulated it in August, he had named it the theory of types.[27]

At the end of June, Alys returned from her rest cure and immediately

went to Switzerland to convalesce. Russell went back to Cambridge, staying at his old college to finish correcting his proofs, "pretending as best I can, to renew the joys of youth, which is rather like trying to eat cold bacon."[28] It was a "strange life in the Past . . . where the real world seemed a dream, and only the dead appeared real. And I sat alone, reading ghostly books; and I worked at Frege, Meinong, and proofs, feeling all work a mere hollow sham."[29]

The theory of types, basically a rule by which sets that were the wrong level or which included themselves too often could be banned from foundational statements of mathematics, was developed by Russell in August while he and Alys were staying together at a place in the country called Little Buckland. Neither the theory nor the stay inspired hope. Russell was a bit less gloomy in September 1902, when his friend and Fernhurst neighbor, Bernard Berenson, introduced him to a bright young art lover from America and his sister Gertrude Stein. Russell debated American culture with Gertrude. Not long after, Russell was writing to Couturat, admitting the paradox to him for the first time (his letters had been hinting at it since May 1901) and lamenting that it took a great deal of value from the work.[30]

He never quite got over it. He did publish *Principia Mathematica,* hauling the manuscript to the Cambridge University Press in a wagon in 1910; but deep down he knew his theory of types was an externality. The fundamental paradox of logic is with us still, bequeathed by Russell—by way of philosophy, mathematics, and even computer science—to the whole of twentieth-century thought. Twentieth-century philosophy would begin not with a foundation for logic, as Russell had hoped in 1900, but with the discovery in 1901 that no such foundation can be laid.

There was another junior philosopher working on a big book in 1901. Like Russell, he was a professor, for philosophy had been a chiefly academic discipline for centuries. Like Russell, too, he had been fascinated as a student by the curious questions blooming in mathematics since Weierstrass's arithmetization of analysis, Cantor's invention of the set, Dedekind's definition of real numbers, and the axiomatization by Frege, Dedekind, and later Peano of ordinary arithmetic. Like Russell, he had begun his graduate studies in mathematics, had studied them in Berlin, and was writing about their logical foundations. Like Russell, too, he had found a central difficulty in 1901 that seemed to require a whole new point of view. There, however, the similarities ended. Edmund Husserl, more patient, less exacting, and thirteen years older than Russell, finished his book in 1901 and published it. It was, Husserl admitted, seriously incomplete, but his reaction was more like a grumble of impatience than a cry of despair. Frege's devastating review of his first book had done no

more than slow him down a little. It never occurred to Husserl not to go on with his work.

What Husserl proposed to do in *Logische Untersuchungen* (Logical investigations) was to derive logic from consciousness in a way that would keep logic from losing any of its rigor. He was sure self-evidence could be preserved without separating logic from raw mental activity, turning it into rules dictated by experience, or exiling it into some nonexperiential world of ideas. In a German as murky and humorless as Russell's English was clear and witty, Husserl would show how this could be done and how, as a consequence, logic could be refounded. Not surprisingly, the refounding of logic was not produced, or even inspired, by Husserl's book. What was produced instead was a resurgence of German idealism—indeed, of European idealism—based on a new taxonomy of conscious experience that came to be called phenomenology.

In 1901, Max Niemeyer was printing the *Logical Investigations* right in Halle, Husserl's university town in Saxony. Back in 1900, Veit in Leipzig had been entrusted with the job, but Veit had fallen behind after printing the introductory section, and Husserl, in order to keep his eye on them, had had to decline what Russell had accepted—Couturat's invitation to the Paris Mathematics Congress. Later in 1900 Malvine Husserl, the professor's wife of twelve years, had helped get the manuscript to Husserl's old thesis adviser, Carl Stumpf, who delivered it to Niemeyer so he could print the rest of volume 1, *Prolegomena zur reinen Logik* (Prolegomena to pure logic), and all of volume 2, *Untersuchungen zur Phänomenologie und Theorie der Erkenntnis* (Investigations on phenomenology and epistemology). In May 1900, as Russell was polishing his Paris paper, Husserl was at Halle, delivering the obligatory lecture summarizing his forthcoming book. In October, when Russell was writing ten pages a day in Fernhurst and every day was sunny, Husserl's volume 1 was already in print and he was finishing up the last and most important of the six *Investigations* in volume 2. In February 1901, when Russell was falling out of love with his wife, the print run for Husserl's volume 2 resumed at Niemeyer after a month's interruption, and Husserl was teaching Kant's *Critique of Pure Reason*. The *Logical Investigations*—both volumes—was in print at the end of April, not quite in time for Husserl's forty-second birthday.

Edmund Husserl had been born on April 8, 1859, in the same year as Freud, and in the same Habsburg province—Moravia—as both Freud and Mendel. In 1901 he spent his birthday with his mother and brother in the home she had moved to in Baden, but demonstrated that his polestar was Vienna by paying two visits to the metropolis, one before the 8th and one after, during one of which he had a serious chat with Ernst Mach.[31] Mach had proposed in *The Science of Mechanics* (1883) a general solution to the problem of how the mind made science out of the

data of nature—positivism, as Planck always referred to it, or thought-economy, as Husserl came to call it. In Mach's view, "what we really do is extricate a group of sensations on which our thoughts are fastened and which is of relatively greater stability than the others, from the stream of all our sensations."[32] The mind, designed by evolution to save on memory, gathers natural events into categories, the fewer categories the better. Mathematics, helpful in this science-creating process, is also one of the sciences created. The aging Mach, who thought single consciousness was "irretrievable," had never liked Brentano's ideas about the mind having independence and intention, which Husserl had picked up when he had first taken Brentano's courses in Vienna in 1882. (Freud had been there some six years before him.) Husserl must have been neither clear nor insistent, because Mach liked what he heard, and on May 21 he sent Husserl a copy of the latest edition of his *Science of Mechanics*. Husserl seems not to have sent Mach in return a copy of *Logical Investigations,* whose first volume, in print for six months, had already dismissed Mach's thinking as irrelevant.[33] "Objects," to Husserl, had almost nothing to do with what the senses might perceive, but instead with what the mind might attend to—"intend," as Brentano had taught him. The only relevance of "science" to the higher logic he felt he was describing was that of analogy—logic as a science of sciences. In a sense, Husserl's logic was not a logic at all, but a metalogic; and sometimes, when it got out of control, a meta-metalogic.

Husserl's book had begun, like Russell's, in the 1890s, with an attempt to solve the suddenly urgent problem of finding foundations for arithmetic. Husserl's mathematical training had led him to the same doubts about the foundations of mathematics that every other mathematically savvy thinker was experiencing at the turn of the century. In 1889, as he was writing the second of his two dissertations on the underlying principles of arithmetic at Halle, Husserl had taught his first course in logic and his first on "Selected Questions from the Philosophy of Mathematics" as an unsalaried Privatdozent. Year after year, as he returned to the problem, Husserl's approach diverged more and more from those of the other investigators. In 1894, the year Frege's review demolished his three-year-old *Philosophy of Arithmetic,* Husserl concluded an article titled "Psychological Studies for Elementary Logic" with a ringing call for more of the same.[34] A year later, in 1895, Husserl had introduced a course "On Recent Investigations in Deductive Logic" and a seminar on Mill's *Logic* of 1843. By then, Husserl had abandoned any attempt to solve Frege's and Russell's problem of founding mathematics on logic. In a bid to rise above it all, Husserl had given himself over completely to the even more abstract problem of founding logic itself. This foundation he fully expected to find in what his philosophy professors, Wundt, Brentano, and Stumpf, then confidently referred to as the psyche or mind.

Logic must have mental origins, must begin in mental objects, or phenomena, from one red ball to the set of all things red and the concept of redness. The notes for the Logic course Husserl gave in 1896 already look like a first draft of the *Logical Investigations*. By the time volume 2 of *Logical Investigations* came out in 1901, he was fully committed to an epistemology that began, like those of Descartes and Kant, not with the world but with consciousness. Only with the third Logical Investigation in the middle of that second volume do we catch a glimpse of the Husserl who had written mathematics for Weierstrass and Cantor and who had once known the difference between a set and a series, and between both and a heap of words.

Investigation number 3 was called "The Theory of Wholes and Parts." It was an inquiry into the way the mind goes about naming things, the principles by which thought manages to decide what a mental "object" might be, to distinguish one object from another, to sort out how an object can be part of another object or not, and to deal with the fundamental principle that no object is without connection to some other object. To anyone acquainted with the new set theory, it reads very strangely. Instead of sets Husserl tells us about Wholes, entities which Russell had already realized could not be sets or the basis of logical axioms.[35] The language, the problems, and even the solutions come not out of the mathematics Husserl had studied and lectured on, but out of the old philosophic logic of Trendelenburg, Lange, Lotze, Erdmann, and even Hegel. Mill is taken seriously, for Husserl wants to be empirical and "scientific." Peirce, however, is never mentioned. Nor does Cantor figure in the story, although Cantor was Husserl's senior colleague at Halle and had sat on his thesis committee in 1887. For that matter, no mention is made of the two contemporaries and compatriots whose work Husserl had reviewed: Frege, who had invented relational symbolic logic, and Schröder, whose less rigorous symbolic logic had been widely read. In effect, what Husserl tried to set up in Investigation Three was not a set theory, but an examination of how the mind could arrive at any set theory, or, once it had done so, be confident of its truth. That is, it was an attempt to find, in the old philosophy of mind, a set theory of set theory. As such, it was just opaque enough to obscure the fact of its failure. Writing an abstract of the work for a philosophical journal, Husserl claimed to have marked out "a theoretical science independent of all psychology and factual science, a science which embraces within its natural boundaries the entirety of pure mathematics and *Mannigfaltigkeitslehre* [set theory]."[36] In fact, however, Husserl's six theorems of Wholes and Parts, meant to be objective in the Fregean sense that more than one mind could agree on them, are logically trivial, psychologically implausible, and metaphysically unhelpful.[37]

In May 1901, as Bertrand Russell was discovering the contradiction

through an examination of Cantor's theorem on cardinals, Husserl was writing to Paul Natorp, his first sympathetic colleague, that most of his problems were solved and the only trouble he would have finishing the book was deciding where to break off in describing a new total system. That spring Husserl offered his course of lectures on "Free Will" for the eighth time, the last course he was to give as an unsalaried Privatdozent and his last at Halle. Rumor had it that *Logical Investigations* had impressed the right people and that Husserl's thirteen-year quest for an assistant professorship was about to be fulfilled. During the Pentecost vacation, Husserl got together with his old graduate adviser, the philosophical psychologist Carl Stumpf, and toured the Hartz Mountains with him for five days. Soon after their return, on June 13, the appointment came: Professor Extraordinarius at the University of Göttingen. In that famous nest of mathematicians, Husserl would teach philosophy, guarding the independence of *Erkenntnistheorie* (theory of knowledge or epistemology) from the encroachments of mathematical logic and the axiomatics of the dean of the faculty, David Hilbert.

However pleased Husserl may have been, he did not show it to established scholars. On June 18, he wrote back to Ernst Mach, but the letter dwelt mostly on the difference between the *erkenntnispraktischer*—the epistemologically pragmatic that Mach had been pushing for a lifetime—and the *reinlogischer,* or purely logical, that Husserl considered to be his own department.[38] Göttingen confirmed his call a week after that, and when August came around, Husserl celebrated by going on his third holiday of the year, a four-week tour of the Hartz Mountains, where he had been with Stumpf in May. While he was in the mountains, Russell was on a Mediterranean cruise with his wife, Alys, and the Whiteheads, from whom he had learned that he was alone in a universe that might be beyond comprehension. Neither Russell nor Husserl wrote home.

In September, Husserl moved his family to Göttingen, and wrote to Paul Natorp a kind of farewell to geometry and to what he was rapidly concluding was a lack of purity in its logic, and of certainty in the mathematicians who practiced it.[39] He settled in, and in November gave an inaugural lecture to the Göttingen Mathematical Society, "Über definite Mannigfaltigkeiten" (On definite collections), about his new, oddly nonmathematical view of sets. On November 5, David Hilbert gave a university lecture on the completeness of axiom systems. Husserl attended, but if the lecture had any effect, nothing in his work betrayed it. Husserl continued to think that his own investigations into the way the mind paid attention to the phenomena within were yielding propositions more fundamental than any axiom—that they were the stuff of which, by comparison, even the most rigorously simple axioms were merely derivative. Hilbert had never had much respect for the externality of mathematical objects, but had he known of Husserl's view, he would probably have

found it absurd. Russell, too, would certainly have smiled, having just begun the lecture series at Cambridge in which he would derive the whole of mathematics from a few principles of logic, "eight undefined ideas and 20 unproved propositions [axioms]."[40] By contrast, Husserl gave the same lectures that winter term at Göttingen that he had given at Halle: his ninth series "On Free Will," his fourth on "Logic and Theory of Knowledge." In addition, he offered a seminar on Berkeley's 1710 *Treatise Concerning the Principles of Human Knowledge*—the bible of solipsists who believe that to make a noise when they fall in a forest, trees absolutely have to have an audience.

There was much of Berkeley in the *Logical Investigations*, which had been in print for five months by the time Husserl got to Göttingen. The sixth "Investigation" at the end of volume 2, the last he had written, took up more space than all the others. Its title was "Elements of a Phenomenological Elucidation of Knowledge," the first exposition of what was to become the famous Phenomenology of Husserl. The word "phenomenology" already existed as a philosophical term, but before 1901 it had meant nothing more than the study of Kant's "phenomena." Phenomena were what the mind had at hand and could know directly, as opposed to what was beyond the mind, or outside it, or perhaps what the mind could never know because of its own structure. For example, a mind clearly had at hand the phenomena of its surroundings, things heard, seen, smelt, touched, and tasted. It might not "know" what was making the noise or the odor, might not even be assured in a philosophically rigorous way that something was "out there" at all; but it could know the phenomena. It could know "objects," as Husserl called them, "intended" by the mind, or presented to it or perceived by it. Was it possible, Husserl wanted to find out, for the mind to know as "objects" the mental means by which it became aware of such perceptions, or thought about them? The sixth Logical Investigation concluded, gropingly, that it was not only possible to know this, but essential. The mind—the "subject"—not only can "intend" itself and all its means, but must do so in order for any science to be rigorous, because that is what all sciences depend on.

The first job of philosophy, then, is to try to distinguish phenomena one from another and consider them clearly—to name them and taxonomize them. That great nineteenth-century discovery, the stream of consciousness, had been named by William James in 1880 and would soon be rendered by novelists. Husserl named it *Erlebnisstrom*, the stream of experience. But is the stream continuous? Is it orderly? If order is imposed, how many dimensions has it? Is it digital? The taxonomy of phenomena is complicated (think of doing this, as Husserl tried to do, for the phenomena of internal time-consciousness). The task may indeed be infinite, for consider trying to establish where one phenomenon ends and another begins. Both phenomena must be in consciousness, after all, and

if, as Husserl always assumed, consciousness is continuous, then any phenomenon one chooses must have what Husserl called a moving "horizon" receding in all directions toward neighboring phenomena, and indeed all other phenomena. And what of the phenomenon of self, or consciousness? If the mind or subject can "intend" itself, this must privilege the subject among other phenomenological "objects." That, in turn, could annihilate "objectivity," in the sense of objects to which more than one subject can agree to refer in common. Which, in turn, could drain what philosophers call "intersubjectivity" of all meaning. It is another version, in a sense, of the paradox of recursion Russell had found in sets of sets. Wasn't there a difference between consciousness of something and consciousness all by itself? How then (assuming Brentano had been right) could pure consciousness "intend" itself?

What Husserl called a Logical Investigation was, in fact, something neither Russell nor Frege would have recognized as logic. Frege ignored everything Husserl wrote after 1900. Russell never bothered to read it.[41] Husserl himself went on to a book called *Ideen, Ideas for a Pure Phenomenology*, in which he claimed to have found a way to think a mind completely and transcendentally apart from the rest of the universe.

Max Scheler understood very well where all this must lead. When he met Husserl in 1901 and became what can only be called the first convert to phenomenology, Scheler called the new philosophic stance a "surrender to being . . . characterized by love."[42] So logic was not at all refounded through phenomenology. Instead, through it, the experience and mysteries of consciousness were preserved in twentieth-century philosophy. Husserl's most famous disciple, Heidegger, would make his name—and many disciples—with a thick book on the phenomenology of Being itself, a phenomenon almost impossible to distinguish or objectify. Nothing daunted, Jean-Paul Sartre would write *Being and Nothingness* to draw out the full ethical implications of such a phenomenology of Being. By then Maurice Merleau-Ponty would already have brought phenomenology to France. By the 1950s Jean-François Lyotard would write the standard French student manual on phenomenology, Paul Ricoeur would begin his assault on the phenomenology of narrative and history, and the man who would one day be Pope John Paul II would start contributing articles to *Husserl Studies*.[43]

Russell, too, acquired disciples, even after he had thrown up his hands and published the theory of types. Not everyone was willing to abandon the nineteenth-century project of a complete and consistent logic, including Ludwig Wittgenstein, an even deeper thinker, who walked in on Russell in his rooms at Cambridge one October day in 1911 after dropping out of the aeronautical engineering program at Manchester. "Obstinate and perverse, but I think not stupid," Russell reported to Ottoline Morrell, who had just become his first mistress. Not exactly an

amateur at philosophy either, wrote Russell. "I asked him to admit that there was not a rhinoceros in the room, but he wouldn't."[44] Wittgenstein never did develop a sense of humor, but he did carry on the foundational project for logic beyond where Russell had left it, emerging with doubts so severe about the possibility of meaning that he eventually stopped writing altogether. The Analytic tradition, so-called, continued through A. J. Ayer in England, W. V. O. Quine in the United States, and Otto Neurath and Rudolf Carnap in Austria. It continues to this day, since the fact that the foundations can never be firmly laid has never dissuaded philosophers from trying to clean up the structure. Alfred Tarski managed to extricate "meaning" from the graveyard of nineteenth-century objectivities in 1933, but he and other mathematicians have driven their wedges deeper and deeper into the possibility of certainty. Kurt Gödel, a colleague of Carnap and Neurath, was able to prove in 1931 that any mathematics at all, if it is not trivially limited, must have propositions in it that are neither true nor false but simply unprovable. Indeed, says Gödel's famous Proof, if every proposition is provable then the axioms will turn out to be contradictory. Six years after this amazing result, a young English mathematician named Alan Turing invented a machine in his head that could, by writing nothing but ones and zeros on a tape, do enough calculations in a finite time to begin to distinguish between the propositions that could be proved in a mathematics and those that could not. In 1940 he was given a chance to build one and use it to break the German military communications codes. Thus did the electronic computer appear as a direct product of the analytical philosophical tradition.

The intellectual descendants of Bertrand Russell have since included John von Neumann, Gilbert Ryle, and Saul Kripke. Those of Edmund Husserl have run through Emmanuel Lévinas and Jürgen Habermas to Jacques Derrida and Roland Barthes. At the end of the twentieth century, some argue, there are only two branches of philosophy in the West, one called Phenomenological or Continental and the other Logical or Analytical; so that putting the two together has become a philosophical task in itself.

Analytical philosophers mark "Here be dragons" on the part of the intellectual map that belongs to phenomenology. Phenomenologists are the mystagogues, they say, that Russell tried to expel from philosophy. Once grant the kind of solipsistic idealism that seems to emerge from the last of Husserl's *Logical Investigations,* and you may grant anything. The Continental school of philosophy has no anchor in either logic or science. The dragons, however, are to be found near analysis as well, for number is an episteme that provides proof of its own incompleteness. Taxonomy may be impossible without number and set, and if so, Husserl may yet be justified in taking refuge in a transcendental ego separate from everything else in the world.

Philosophy may have lost the spotlight in this century, but it has lost very little of its old ambition. Even physics is still attached to philosophy, and it is much harder to write its history than the many histories of philosophy would have you suppose. Philosophers consider to be philosophy everything that restructures the way we think about thinking, and confronts the fundamental paradoxes of consciousness and finitude; whatever answers the unanswerable questions of ontology (What is, if any?), ethics (What should one do and why?), and epistemology (What do we know, if any, and how?). It was epistemology—the problem of knowledge—that most engaged both Russell and Husserl. What they both wanted most was to understand how one can know one thing from another. They began at the same place, with the question of what a number was and what a set was. Then each, in his own radically different way, found a profound new uncertainty through his rediscovery of discontinuity.

The result of this double assault has been the ultimate finitization of logic. The project of making all our ideas clear that began with Peirce and perhaps with Boole, and went on to engage Schröder, Frege, and Peano, failed with Russell and Husserl. The analysts among their successors, much humbled, are reduced to upholding rigor wherever it is threatened, and have their hands full trying to avoid dropping through the holes that are bound to open up in an infinite system.

In this sense there has always been an "analytical philosophy," and Bertrand Russell's achievement was to dress it for the twentieth century. In the same sense, however, there has always been a "phenomenology," and Husserl did for it what Russell did for the analytical. In both cases, though, it was the concentration on the meaning of a thing or object as distinguished from another thing or object that distinguished their philosophies from those of their predecessors. This is the twentieth century in philosophy. Now at the end of the century, like the two Ways—Swann's and Guermantes's—in Proust's novel, Russell's analysis and Husserl's phenomenology have found themselves meeting in a new discipline called cognitive studies. Atomic logic provides the digital hardware required for understanding and modeling the mind's basic operations. Phenomenology provides the goal of explanation. And all to answer the twentieth century's favorite question, What was I *thinking?*

And logic and arithmetic are still where the two men left them—untrustworthy as a Pentium chip.

13 EDWIN S. PORTER

PARTS AT SIXTEEN PER SECOND

1903

As the year 1903 began, Edwin Stanton Porter was in the Edison film lab, making a movie. He would be thirty-three in April, and the Edison Kinetograph Department was paying him $20 a week, not a bad living, for work that was thoroughly new and exciting.[1] Edison and his gifted employees had been the first to see how the chronophotography of Muybridge and Marey could be combined with the breakthrough technology of continuous celluloid film. Edison Kinetograph had made its first films in 1891, and in 1894 opened on Broadway the first place in the world where the public could pay to see movies. (Called a "Kinetoscope Parlor," it had rows of film-viewing machines or "peep shows.") Toward the end of 1902, the Kinetograph Department crew had moved in from the suburban Oranges, in New Jersey, and were now ensconced on the top floor of 41 East 21st Street in New York City. Two blocks north at 23rd Street was the new Flatiron Building on Madison Square. A block to the west was Fifth Avenue, part of the stretch that had come to be called "Ladies Mile" for its lengthening lineup of new department stores. Seven blocks south was the big horse-car trolley turn on the west side of Union Square, and on the east side of the square the new subway tunnel was being cut and filled. From Union Square south stretched teeming neighborhoods of immigrants from every country in Europe and in the rest of the world. Porter and his fellow Edison cameramen had filmed them all; and when they were not filming outside with their hand-cranked cameras, they were filming inside, in the three-month-old studio on the roof, one flight up from the lab. After making their "shots," crews that often included the cameramen developed and edited them in the lab, sometimes assembling several of them to make a single movie. Porter was doing that now, assembling nine separate camera shots he had made that fall in New Jersey into a single long film that told a story—*The Story of*

an American Fireman. Of all Edison's cameramen, Porter understood this process best, not so much because of his camera and darkroom experience, but because he had once worked at one of New York's leading vaudeville houses, the Eden Musee on 23rd Street, maintaining the big movie projectors, running them, and choosing what to show and in what order. Today's "projectionist" spends a lot of time waiting, not always even watchfully; but for Porter and his like there had been a lot more to do. The longest films of the 1890s were rarely longer than three minutes, and most took less time to show than it took to take them off or put them on a projector.

The Story of an American Fireman was quite a long film—more than 400 feet, or about six minutes. One of its nine shots, just made in the new studio, showed the fireman-hero sleeping at home while a mother threatened by fire appears in the air over his bed—a dream. Most of the others had been made in New Jersey firehouses near Edison's East Orange laboratory, including one in which a fire engine sped down the street past Porter's camera and Porter, to keep the engine in view, swung the camera on its tripod from left to right. This was a "panorama" shot, the one we now call a "pan." Two of the shots had been made right in East Orange, on a bright autumn day two months before. On November 15, 1902, the town's Hose Company Number 5 had pulled out of Halsted Street with their hook-and-ladder, squealed to a halt in front of an abandoned tenement building on Rhode Island Avenue, and raised their apparatus against the wall. While Porter cranked away at the movie camera and flames and smoke from smudge pots rose against the sky, the manager of the Edison Kinematograph Department, James White, had climbed the ladder in a fireman's outfit. For the other shot, Porter had taken his camera inside the building and filmed White coming through a frantic mother's bedroom door, carrying her out the window, and then returning for her baby. It was an exciting, sentimental film—bound to be a "headline attraction" at the vaudeville houses. In 1903, people, especially working people in the burgeoning cities, revered their local firemen; and there had been several films already on the theme, not to mention a couple of magic lantern ("slide") shows, sketches, an illustrated ballad or two, and a series of plays that had run since 1848.[2] Porter had been Edison's chief cameraman since 1901, part of a group of less than a dozen people who did the work at the Edison Kinematograph Department.

Edison's was the world's first moving-picture production company, ten years old in 1903, the year Porter finished his two greatest movies. In January of that banner year Edison released *The Story of an American Fireman.* Eleven months later, Porter's *The Great Train Robbery* hit the theaters of New York just before Christmas, bringing filming at the Edison Company to a near standstill until well into 1904, as print after print of *The Great Train Robbery* was turned out to fill the deluge of orders.

With these two films, and Porter's creative stroke, the century truly began for movies—their public, their practice, and their art.

Porter was not the only genius in this raffish new art, and by 1903 the Edison Kinematograph Department was no longer the only movie production company. In the decade since Edison had gone into business, filming twenty-second shots of sneezes, kisses, and dances, and selling peep-show "Kinetoscopes" to see them with, some twenty-five production companies had been founded in fifteen countries. The shrewd old entrepreneur had tried his best to corner all the patents, but except for a few months in 1901, it had proved to be impossible. His big mistake turned out to be trying to specialize in making the high-profit, single-viewer peep-show machines—and in failing to patent the machines abroad. By the end of 1895, three years after the first film had been made in his "Black Maria" studio in West Orange, Edison had two competitors grinding away in France, one each in England and Germany, and three right at home in the United States.

The Europeans' advantage lay in having beaten Edison to the punch with the move to screen projection. In France, in February 1895, Louis Lumière had patented a camera that advanced the film frame by frame much as a sewing machine advanced a hem stitch by stitch. By March Lumière had filmed his company's workers leaving their factory in Lyon, and in December had shown this shot and others to a paying audience in the Grand Café in Paris. That same March in England, Birt Acres had used Robert W. Paul's slightly different camera for a shot of the Oxford-Cambridge boat races; he projected it in May at an exposition in London. That November, the Skladanowsky brothers, Max and Emil, having perfected a complicated gadget they called the Bioskop, had screened shots that included a boxing kangaroo to an audience at the Berlin Wintergarten—the first audience that ever paid to watch a projected film.[3]

In America that year, Phantoscope and Vitagraph were founded, and Mutoscope (later Biograph) was incorporated by Dickson, who had designed the original "Edison" movie camera. Biograph would still be there when Edison was driven out of the movie business entirely, but in 1903 it was a scruffy little outfit located in a brownstone at 11 East 14th Street, Union Square, seven blocks by streetcar downtown from Edison's.[4] It had just moved a block north from where it had operated since 1896, a roof-top studio at 841 Broadway. When Biograph had filmed *Rip Van Winkle* on that rooftop in 1896, Theodore Roosevelt was New York City's police commissioner, and the first films were being made in Copenhagen, Denmark. The first films in Spain, Sweden, Japan, and Belgium followed in 1897; in Austria, Hungary, Bohemia, and Mexico in 1898; and in Uruguay in 1899. In 1903 the first film was just being made in New Zealand, birthplace of the celebrated physicist Ernest Rutherford and a schoolgirl who would one day become the writer Katherine Mansfield.

The market all these new companies supplied was for bits in variety shows—vaudeville "attractions"—and to that end they filmed virtually everything that moved, as Porter was now doing for Edison: trains coming down the tracks, emperors on parade, natural wonders, street scenes, and sight gags. In June 1896, Porter, just mustered out of the Navy at Brooklyn Navy Yard, had begun his career with the projectionist's job at the Eden Musee, a wax museum with "added attractions" and a reputation for fairly classy vaudeville. One turn on the Eden's program was nearly always a series of single-shot films, each lasting less than a minute, all quite mute, and Porter's job would be to line them up in some way that would be entertaining, and possibly even coherent. For six months in 1898, the Eden had screened *The Passion Play of Oberammergau*, which at fifty-five minutes was the longest movie made anywhere in the world before 1913; but even this was a series of single shots shown in sequence by the projectionist. In July 1896, working with a company of friends from Connellsville, his home town near Pittsburgh, Pennsylvania, Porter had shown faraway Los Angeles how it should be done, projecting the first program of movies the city had ever seen. With a transportable projector and temporary tenure of the first Edison franchise for California, the Connellsville cronies had managed for three weeks to sell out Walter's Orpheum Theater in L.A. with shots of Broadway, Atlantic breakers, four different solo skirt dances, a costumed Uncle Sam forcing John Bull to his knees, and actor John Rice kissing May Irwin in a scene from the 1895 Broadway hit *The Widow Jones*.[5]

The effect this program had on the first moviegoers in Los Angeles is preserved only in short newspaper reviews ("a wonder, a marvel, an outstanding example of human ingenuity").[6] Most of the extraordinary effects of early cinema can never be recovered, but the strangeness is never absent. In culturally distant Russia, only a few days before the movies reached Los Angeles, Maxim Gorky saw a program of them in a restaurant in Nizhni Novgorod, and wrote in the local paper, "Last night I was in the Kingdom of Shadows. If you only knew how strange it is to be there. It is a world without sound, without color. . . . It is not life but its shadow, it is not motion but soundless specter."[7] The main impression these programs left behind seems to have been one of wild discontinuity. The following description survives in a 1915 memoir, also by a Russian, recalling films he saw in Paris:

> The Spanish monarch and the British king jumped out after each other on a piece of white sheet, a dozen Moroccan landscapes flashed past, followed by some marching Italian cuirassiers and a German dreadnought thundering into the water.[8]

Was this a selection of news shots about one of the Morocco Crises in 1905 or 1911? We do not know.

Films that told stories had been made by 1903, but they were rare. Most of them were films of theater pieces, plays truncated to fit into a few minutes but beloved enough that an audience that knew them well could supply what had been left out by the filmmaker. In America, some were so well-worn that audiences knew the scenes and even some of the dialogue by heart. There was George Aiken's 1852 dramatization of *Uncle Tom's Cabin,* for example, which had played for fifty years in nearly every one-horse playhouse in the United States—including the Newmyer Opera House in Connellsville, Pennsylvania, a railway town of two or three thousand people where Edwin Porter had spent the first twenty-three years of his life. It was *Uncle Tom's Cabin* that Porter filmed in late July 1903, in the rooftop studio on 21st Street. Fourteen shots and 1100 feet long, it ran about fifteen minutes—more than twice as long as *Fireman.* Porter had never made a longer movie, but long as it was, it was not very easy to follow for anyone who had not seen the play at least once, or served (as Porter had) as an usher in a theater like the Newmyer.

An even older chestnut was John Kerr's 1819 *Rip Van Winkle.* Joseph Jefferson, who was seventy-four in 1903, had toured the play for nearly forty years, rewritten it extensively, and had been so unforgettable in the title role that the whole country—Porter, too, no doubt—could chime in on Rip Van Winkle's oft-repeated toast, "Live Long and Prosper!" Small wonder, then, that the fledgling Biograph company had scrambled to film three scenes from Jefferson's *Rip* in 1896, or that it would splice its eight shots together and re-release them as a single movie in 1903.

We now call these artifacts "filmed theater." The camera was set up and fixed in front of the players as if it were a member of a theater audience. There was a stage to play on and curtains to separate the scenes. Conventions that had grown up in the thousands of years of theater tradition helped the audience keep track of the play's time and space, and to make sense of successive scenes meant to convey simultaneous actions. There was no way for dialogue to fill that role in the first movies, because there was no sound. Titles, if any, were expected to be supplied by the person who showed the movie, the projectionist or a lecturer of some sort. Theater conventions, however, were strong enough to provide the necessary audience cues. Georges Méliès, for example, knew them well. After years of experience producing and performing in magic shows in his Paris theater named for the great French magician, Robert-Houdin, Méliès had gotten into filmmaking in 1896. By 1902, when he made his famous *Voyage à la lune* (A trip to the moon), his catalogue included scores of movies we now categorize as the first fantasy films with "special effects" ever made. One of them, *Cendrillon* (Cinderella) (1899), may have been the first "story" film ever made, and another, *L'Affaire Dreyfus,* made in the same year, may have been the first to use a magic lantern "dissolve" as a substitute for the theater curtain—the same dissolve Por-

ter had used to separate the nine shots of *Fireman*.[9] But in 1903 Méliès too filmed theater. Indeed, it was not yet clear what filmed nontheater would look like.

Inklings of the next step appeared in England early in 1903 when the pioneer cameraman Robert Paul, who had made two story-films in 1901,[10] produced *Bloodhounds Tracking a Convict,* a chase-and-capture movie in several shots made mostly out of doors. A trend began, and for a while it looked as though every cameraman in England was shooting a crime and chase story set largely in the open. Frank Mottershaw's was called *A Daring Daylight Robbery,* Walter Haggar's a *Desperate Poaching Affray.* Alf Collins of British Gaumont made *The Runaway Match,* which was an outdoor comedy with a chase.[11] Other English moviemakers were also making story films that year, but indoors. Cecil Hepworth made an *Alice in Wonderland,* and George Albert Smith made *Dorothy's Dream,* using all he had been learning for the previous three years pioneering what we now call the "intercutting" of shots and the "insertion" of one shot into another.

Inside the Kinetograph Department's 21st Street darkroom, James White spent part of the summer of 1903 making duplicate prints of *Bloodhounds, Daylight Robbery,* and *Poaching Affray* for out-of-copyright sale to Edison's main customers, the variety theaters between the seamy Bowery and the still genteel Madison Square. Down at Biograph, cameramen A. E. Weed and Wallace McCutcheon were impressed, and made plans for longish films with chases and story lines, three of which—*Kit Carson, The Pioneers,* and *An Escaped Lunatic*—would be in the theaters by year's end. Cameraman Edwin Porter of Edison was also impressed by the English films. He had not titled *The Story of an American Fireman* idly. At the Eden Musee and the Orpheums of California, Porter had perfected the sequencing of single-shot films into something like a story with enough connectivity to please a crowd. For *The Story of an American Fireman,* he had, of course, actually spliced the ends of the films together with acetone, and he had sequenced quite differently from the way writers assembled scenes into a play. Stage producers Klaw and Erlanger had mounted a chariot race on a treadmill for *Ben-Hur* in 1899; but even the most imaginative producers in the nineteenth-century theater would have found it impossible, for example, to juxtapose without intermission Porter's scene inside the burning building with his exterior scene of the fire. Even at the "Fire and Flames" show, put on at least twice a day at the just-opened Luna Park in Coney Island, you could not plausibly cut into a fire to move from an exterior to an interior.

Before and after making *Uncle Tom's Cabin* in late July, the Edison cameramen fanned out around the New York suburbs to film the usual summer round of sight gags, sports, and holiday scenes at resorts. Porter cranked his camera at the beach in Atlantic City, New Jersey, made a

studio comedy about a shoe clerk who gets familiar with a lady customer (the second shot was an insert close-shot of the lady's un-petticoated calf), and filmed—on location at Coney Island, America's greatest center of attractions—*Rube and Mandy*, a two-character episodic comedy with a lot of interesting camera movement. In August he began putting together shots he had made in April along Pennsylvania railways into a 275-foot movie called *A Romance of the Rail*, a travelogue about the Lackawanna line whose six shots were held together by a hint of a love story. A photographic portrait from the time presents Porter in profile as a bright-eyed young man, his hair cut rakishly short, with a mustache modeled on Teddy Roosevelt's and a waistline more reminiscent of Cleveland's or Taft's. This was how a young family man was supposed to look in turn-of-the-century America (Porter had married his Pennsylvania sweetheart in 1893). A bourgeois look might be thought incongruous on someone who was about to become one of the great innovators of the cinema; but this was the summer when Porter must have planned a big crime, chase, and train film of his own. *The Great Train Robbery* would also tell a story, and although cribbed from a play of the same name that had premiered in 1896, it would be even less like its theatrical models— and more of a story—than *Fireman* had been.

Soon after he got his five-dollar raise in October, and inspired perhaps by the news story of September 24 about a foiled train robbery in Oregon, Porter took a crew of actors and half the staff of the Kinetograph Department and set off for the far west—South Mountain Reservation near Orange, New Jersey—to make the nine shots (out of a total of fourteen) in *The Great Train Robbery* that had to be filmed outdoors. In the shot that appeared as number two in the final movie, Porter photographed Justus Barnes, as the leader of a black-hatted gang of bandits, hiding with his men behind the tank of a railroad water tower and boarding a train in secret as it pulled out. To make shot number four, Porter put his camera on the back of the coal tender of a locomotive and filmed one of Barnes's bandits getting the drop on the engineer while another struggled with the actor playing the railway fireman, eventually knocking him out with a piece of coal and dropping him (actually a dummy in stop-action) off the moving train. The fifth shot, from beside the tracks, shows the engineer stopping the train and uncoupling his engine. The sixth shows the passengers disembarking with their hands up to be relieved of their valuables; one passenger, played by actor George Anderson (his real name was Max Aronson), is shot to death trying to escape. Shot seven shows the engineer starting up his locomotive again with the bandits aboard holding him at gunpoint, and shot eight shows him stopping again near the park's South Mountain for the bandits to disembark. Shot nine, like shots seven and eight, was filmed from beside the Lackawanna tracks, but the camera jerkily pans down the adjacent hill to follow the

bandits as they cross Thistle Mill Ford and find their horses tethered in the woods. In shot twelve the bandits ride furiously down a path to the right of the camera, followed closely by a mounted posse, shooting. In shot thirteen, Porter's camera shows the bandits dismounting in the woods and dividing the loot, while the posse sneaks up behind the more distant trees, attacks, and kills them all in a firefight.

The five studio shots, made at 21st Street, included two set in the interior of a railroad telegraph office. In the shot that opens the finished movie, the telegrapher is knocked out and tied up after being forced at gunpoint to send a message that seems to stop the train, while in the shot that became number ten, the telegrapher runs out after having been revived and freed by a little girl. The telegrapher appears again in shot number eleven, where he is filmed racing into a Western-style dance-hall set, interrupting the dancing and exhorting every man to pick up his gun and join the chase. Shot number three shows a set representing the interior of the baggage car; the bandits enter, kill the attendant in a revolver duel, blow open the strongbox, and exit with sacks of loot. The last studio shot, which the Edison catalogue offered separately under the subtitle "Realism," was of Justus Barnes against a neutral dark background, taking aim with his revolver and shooting at the camera.

The "Realism" shot, said the catalog, could be used at either the beginning or the end of the movie; but the rest was sold as is, fourteen shots in an order chosen by Porter. The order suggests two lines of action, both originating with the tying up of the telegrapher in the first shot. Along one of the lines the robbery takes place, in several stages; and along the other the telegrapher is released and the posse is called. The two lines meet up again in shot twelve, the chase, and shot thirteen, the shootout with the bandits. Though he missed the chance to "cross-cut," as Griffith would do later—that is, by cutting his shots into pieces and splicing the pieces from one line of action alternately with those from the other—his two extended lines of action in *Robbery*, together with the briefer episode in *Fireman*, made Porter the inventor of what is now called "parallel action," and even of a rudimentary form of "parallel editing." [12] It was a milestone in the history of continuity.

There was continuity in movies from the first, or so they thought. "The moving picture machine," wrote a contemporary expert named Jenkins in 1898, "is simply a modified stereopticon or lantern, i.e. a lantern equipped with a mechanical slide changer." [13] That was almost three years after the Lumières had projected the first movies to a paying public; but it was not enough time for Jenkins or anyone else to understand how big a break had been made with the past. The original appeal of movies, like that of so many other art forms in their infancy, was the improvement they made on the illusion of "reality," and this in turn depended on the illusion of continuous motion. No "mechanical slide changer" could ever

have done the job the way movies did—unless it could change the slides at the rate of sixteen or more every second. The brain, we now suspect, sweeps the optical cortex for a scene at a rate a little faster than that,[14] and if it detects changes in the scene when it is repeated at that rate or faster, it infers motion. The illusion was attempted many times, but it was not achieved until Joseph Plateau made his Phenakistoscope in 1826 and abandoned the attempt to make continuous motion come out of some kind of continuous picture. Dividing a scene into several different frames, each of them motionless by itself, and presenting them to the eye one after another, Plateau not only made the brain see motion; he was also able to measure the sixteen-per-second rate that was the psychological threshold of the illusion. He was the first to realize that the true atom of the visual stream of consciousness must be smaller than one-sixteenth of a second.

But the frame, or "still," is only the smallest of the bits and pieces out of which movie continuity is built. After the frame comes the tableau, then the theatrical scene, and finally a redivision of the scene into shots, and the shots into parts of shots. The illusion of continuity in fact depends on a whole hierarchy of parts or units that must be thought of discontinuously by a filmmaker. In fact, the audience's illusion of continuity is in direct proportion to the filmmaker's awareness of the discontinuity of the units.

The paradox had been already apparent at the first ever public demonstration of Edison's films at the Brooklyn Institute of Arts and Sciences, in May 1893. There a slow-moving line of several hundred technological sophisticates had filed past one by one to peep at *Blacksmith Scene* on the earliest Kinetoscope, but not before many of the film's 1½-inch (35mm) individual frames had first been projected through a magic lantern.[15] Ten years later, in 1903, American law was still insisting that each of the thousands of photographs, or frames, in one "moving picture" had to be individually copyrighted.

But films were not merely made up of nearly identical frames; they were also divided into scenes of the kind we might casually call "pictures," or that the nineteenth century might have called tableaux, like Edison's *The Monroe Doctrine* or Lumière's *L'Arroseur arrosé* (The waterer watered), which has exits and entrances and appears to have parts, though the camera never moves.[16] Then there were scenes of the sort found in a theater, where the set or background and the characters (if any) remained the same. All of the films of theater manager Georges Méliès were clearly divided into scenes of this kind, not shots, and Méliès routinely interrupted and resumed a shot in order to manage a stop-action or other more complicated trick within a scene. The division of scenes into shots, and indeed of the whole of a movie into shots, each filmed separately and then intercut with each other, had had to wait at

least until movies got longer than a single shot. The discovery that parts of shots could also be units, and intercut with each other, would not be perfected until the work of D. W. Griffith in 1908 and 1909. Not until 1905 did an American court hold that an entire film, from the frames to the shots and scenes, and whatever was deemed to hold them together, could be copyrighted as a single story.[17]

The full implications of the remarkable role of high-level editing in movies began to be seen in England in 1899 when James Williamson filmed *Englishman Swallows Photographer: Eaten Alive,* pasting parts of two different shots together, or "intercutting," and making what is perhaps the first example of what we now call a "close-up," the one that looks down the main character's mouth before he (apparently) swallows the camera.[18] Another Englishman, George Albert Smith, made a film called *Grandma's Reading Glass* in 1900 by stringing together shots we now call "close"—shots of objects as seen, enlarged, through an old lady's magnifier. These were the first so-called insert shots, an important first use of the new medium's extraordinary power to take over and direct an audience's point of view. Close shots and close-ups couldn't be done on stage. The only way the theater had of imagining such an extraordinary alteration of an audience's focus was to do what the movies did and project a picture on a scrim. This trick could be used for dreams and visions, but it could do nothing to enhance a theater audience's perception of a lead actor, playing a crucial scene with all her physicality. For that an actor had to rely on gesture—gesture so broad as to seem ridiculous in our film-familiar culture.

The fact is that movies, the most continuous of all the arts in their effect, are the most discontinuous of all the arts in their composition. The word "montage," devised by Sergei Eisenstein to describe the juxtaposition of "attractions" on the movie screen, applies to every level of filmmaking, from the frame on up. The very word "continuity" is now a movie term for a director's precise simulation of the temporal and spatial coherence of a real world in the mind of the spectator.[19] Indeed, the most naive moviegoers will need to be convinced that the continuity was not there on the screen in the first place. Beginning film students are routinely presented with the celebrated jump-cut between two shots (two entire sets of shots, in fact) in Stanley Kubrick's movie *2001,* a jump-cut that successfully cozens the spectator into establishing "continuity" between entirely imagined events four million years apart, one on earth and one in interplanetary space. When Porter had begun as a projectionist in 1896, the leaps he had made were smaller, for example between a shot made by Edison of firemen on a fire truck and a shot made by Vitagraph of a burning building. When Porter joined Edison in 1901 the continuity problem began moving into the production laboratory, making it possible

for Porter to do what Georges Méliès had been doing since building his studio in 1897: match the various parameters of one shot with those of the shot it would be spliced on to, or "cut" with, as we now say.

Most important of these parameters were the four dimensions of space and time. Porter could set up and film a shot at almost any time and in almost any place, but that freedom raised questions that were both elementary and exceedingly odd—questions that are still raised by the two shots Porter made of the same rescue in *The Story of an American Fireman,* and by his *Great Train Robbery* as a whole. Should the completed film imply to an audience that time had elapsed between shots, or between scenes within shots, as theater had long accustomed its audiences to do; or should the audience be allowed to infer that the time of a subsequent shot followed the time of the preceding one without a break? How could the camera, whose implied time was always its own present, succeed in presenting the past? A pleased film scholar noticed recently that in *The Great Train Robbery* the time on the clock in the telegraph office is nine o'clock in shot one and still nine o'clock in shot ten.[20] Would the movie make more sense if the clock in shot ten showed a later time? Or if shot ten were reinserted back between shots three and four when the robbery had just begun? Within two years all these clock-hung frames of reference would suggest something quite Einsteinian (and still later Daliesque), but not in 1903.

As for time, so also for space. Could one put together two shots that portrayed the same event from two different spatial points of view? Three years after *The Great Train Robbery,* Picasso would begin to show different views of the same object simultaneously; but the only way film could accomplish this feat was to shoot two scenes side-by-side on the same piece of film. (This primitive "split-screen" technique had been tried out by Méliès in *L'Affaire Dreyfus* in 1899.) Perhaps one could show an audience two shots of the same event one right after the other. The old lantern-slide shows had done something like that, but what would audiences make of it if the pictures moved? Should two different shots of the same event imply the same space? How was that to be done? Indeed, how much of the potentially infinite space of events should be shown? The space of theater had been framed conventionally by the proscenium, but should film accept that limitation? How much unseen space could an audience infer? If the medium was so much freer than theater to play with the dimensions, then should its sets be more "realistic" or less? In 1903 these questions were all so new that they could not even be asked. Nor could the relation between them and the questions contemporary philosophers were already asking yet be seen. Could James's stream of consciousness, Poincaré's conventionalist geometry, or Bergson's continuous "duration" be modeled with film?[21] Could Husserl's implication of

an infinite phenomenality beyond the brackets of a single phenomenon be mapped onto the implication of a whole world beyond the framing of a single film shot?

Such questions must be left to the scholars of film. Their answers already fill bookshelves.[22] What was most immediately apparent about the art called movies was its overwhelming popularity. To the "cinema of attractions" had succeeded the "highly sensationalized headliner."[23] Porter's parallel action was action first of all, and the story of his story-film (with killings in four of its fourteen shots) was gripping. A number of the great entrepreneurs of what would soon be Hollywood began their careers by trying to get a piece of it. Adolph Zukor, who once confessed to having seen *The Great Train Robbery* more than a thousand times, moved out of the fur business and into movie history in the year of its release. By 1904 he and his partners, including Marcus Loew, had built a theater on 14th Street called Automatic Vaudeville and founded a company with the same name. In 1905 Zukor would open movie theaters in Newark, Boston, Brooklyn's Coney Island, and Pittsburgh, where he would see the first nickel movie theater, called "Nickelodeon," and begin building a chain of them. In 1903, William Fox installed a movie theater in Brooklyn one floor up from the penny arcade he had bought the year before. Six years later his Fox Amusements (not yet "Twentieth Century") would own nine movie houses, and would begin to invest in production. A few years after 1903, near Youngstown, Ohio, where *The Great Train Robbery* was still attracting audiences, an unemployed rail-wayman named Sam Warner would buy a movie projector with a copy of Porter's masterpiece thrown in. The profits he, Harry, and the other Warner Brothers would make from showing it in a tent would be enough money to start their company.

Meanwhile, down Fifth Avenue and Broadway where the mainstream of popular entertainment flowed past the Edison studio, Tin Pan Alley was healthy but the "legitimate" theater was in a slump.[24] A sharp economic downturn during 1903 was cutting theater attendance for the 1903–4 season, even on Broadway. A monopoly called The Syndicate, founded by the producers of *Ben-Hur,* Klaw and Erlanger, threatened to engulf every theater in the U.S. circuit. The dwindling holdouts included the theater-owning Schubert brothers, and producers Weber and Fields, a comic duo since Bowery days. In September Weber and Fields had opened what was to be the last show of their twenty-five-year partnership on Broadway—*Whoop De-Doo,* starring Lillian Russell—something they called a "musical comedy," since it had more narrative continuity than their usual variety show. The flames that destroyed Klaw and Erlanger's "fireproof" Iroquois Theater in Chicago on December 30 slowed the progress of The Syndicate; but ultimately, because of new theater regulations, they delivered the coup de grace to Weber and Fields.

Actors on a stage, however, could no longer deliver the most successful illusion, as playwrights like Strindberg were very soon to discover. On the day of the Iroquois fire, *The Great Train Robbery,* which had opened just before Christmas at Huber's Museum on 14th Street, was playing in nearly every variety theater in New York that had a projector, ten in Manhattan and one in Brooklyn. It opened the same week the Wright Brothers had made their first powered flight; but New Yorkers were not hearing about that. Instead Porter's movie, the original shoot-em-up Western, was proving to be the first of the great "blockbusters," bringing in paying customers by the thousands to convince them for a time of the reality—and continuity—of an alternate world.

14 MEET ME IN SAINT LOUIS

MODERNISM COMES

TO MIDDLE AMERICA

1904

The lyrics to "Meet Me in Saint Louis" came to songwriter Andrew B. Sterling one evening in New York City in 1904. He was in a Broadway saloon when someone hailed the barman for another beer. The barman's name was Louis, the beer had been brewed in St. Louis; and what Sterling heard was, "Another Louis, Louis!"

> Meet me in Saint Louis, Louis,
> Meet me at the Fair.
> Don't tell me the lights are shining
> Any place but there.
> We will dance the Hoochee Koochee,
> I will be your tootsie wootsie,
> If you will meet me in Saint Louis, Louis,
> Meet me at the Fair.[1]

St. Louis, Missouri brewed a lot of beer, and a lot of it was drunk in New York. If the beer was draft, it was probably Busch; if bottled, probably Budweiser. Leading St. Louisan Adolphus Busch, who had named his company after himself and his wife Lilly Anheuser, had pioneered the sale of pasteurized beer in glass bottles in 1876. By 1904 he was one of the nation's richest men, and bottles of his Budweiser could be bought almost anywhere in it.

Sterling's lyric began with Louis and his wife, Flossie, New Woman enough to run away to the St. Louis World's Fair.

> When Louis came home to the flat,
> He hung up his coat and his hat.
> He gazed all around, but no wifey he found,
> So he said, "Where can Flossie be at?"
> A note on the table he spied,
> He read it just once, then he cried.

It ran: "Louis, dear, it's too slow for me here,
So I think I will go for a ride."
"Meet me in St. Louis, Louis, . . ."

New Yorker Kerry Mills wrote the melody that has helped make Sterling's verse immortal, and it is the song, revived for a movie in 1944 and for a musical in 1993, that has done the most—even at home in St. Louis—to keep the memory of the great World's Fair green.

St. Louis itself has faded a bit since 1904. Even in that year it had already passed its peak, as Americans measure peaks, in population and wealth. "The first time I ever saw Saint Louis, I could have bought it for six million dollars," wrote Mark Twain, "and it was the mistake of my life that I did not do it."[2] The Louisiana Purchase Exposition—the world's fair—was intended to commemorate the hundredth anniversary of President Jefferson's purchase of the vast territory of Louisiana from its original colonizers, the French, in 1803. In the sixty years that followed it, the Purchase had made St. Louis the principal gateway for the great imperial movement of the United States westward toward the Pacific and Asia. It had been to the 1860s what Los Angeles became to the 1960s. Only a slight delay in St. Louis's railway construction had given the edge to Chicago after the Civil War. More recently, Milwaukee, Chicago, and Philadelphia brewers, adopting Anheuser-Busch's glass-bottle, pasteurized-beer process wholesale, were out-exporting St. Louis from second to fifth place in beer sales, and the city's great tobacco packers were being bought out by an Eastern monopolist. On the eve of the Fair, Lincoln Steffens had published an article on St. Louis in his "Shame of the Cities" series in *McClure's,* and St. Louis was having to face the fact that in the matter of municipal corruption, as in professional baseball, it was in the big leagues.

St. Louis at the turn of the century was the nation's fourth most populous city after New York, Chicago, and Philadelphia, and one of its five richest; but perhaps it was the nagging suspicion that St. Louis would never be those things again that induced its civic leaders to bid against Chicago for the Columbian Exposition of 1893 and to win the next World's Fair for themselves. St. Louis was unquestionably fit for the role. It was a real city, with a coherent commercial aristocracy serving as a fount of classic civic pride. It had taxed itself for a third of the Fair's symbolic $15 million price tag, the price Jefferson had paid for Louisiana. St. Louis was also a very Western city, looking up the Missouri River over the Great Plains to the Rocky Mountains, whose merchants had equipped every sort of emigrant from cowboys and farmers to gold diggers and sheepmen. Custer had passed through it on his way to the Little Big Horn in 1876, probably without pausing to reflect on the bones of the once prosperous Mound-Builders that lay beneath his feet; and it was

the war he began with the Sioux that had ended St. Louis's sixty years as the western outpost of Western civilization. Finally St. Louis was a thoroughly American city whose neighborhoods were a palimpsest of successive tribes of immigrants. Ethnic layering is not what the French poet Baudelaire had meant to refer to when he coined the word *américanisé* during the Paris World's Fair of 1855; he meant instead the industrial progress that homogenized traditions, speeded up manners, and concentrated men and women into masses—or sometimes the unmannerly freedom of settlers on a frontier. Still, no matter how industrial St. Louis was and no matter how close to its frontier past, it was the city's bubbling mix of peoples that today seems most American. Of 575,238 St. Louisans in 1900, 19.7 percent were foreign-born and 41.6 percent had foreign-born parents. Only six American cities had more immigrants than St. Louis.[3]

Its founders had been French, many of them emigrés from the Haitian Revolution who had come via New Orleans. They were no longer "foreign-born"; but there had never been very many of them, even a hundred years before when the city became American. The Irish had come in much larger numbers after the 1840s. By 1850 revolutions in Germany had sent the city enough Germans to completely supersede both French and Irish. Newspapers were still printed in German in 1904, and from 1864 to 1887 the city's own German-language primary schools had defied Missouri's ban on bilingual education. All three of these ethnicities, plus the numerically smaller Italian, Polish, Czech, and Slovak communities, had contributed to making St. Louis one of a Protestant nation's most Catholic cities. *The Awakening,* by St. Louis writer Kate Chopin, was the sort of story such a city could both engender and execrate: a creole wife who takes a lover and leaves her husband and children. St. Louis made Chopin a pariah when the novel appeared in 1899, and in 1904 she died of heart failure after her first visit to the Fair.

If St. Louis had a hometown writer in 1904, however, it was not Kate Chopin but Mark Twain. By 1904 Mark Twain had been just about everywhere on earth, but his life had begun on the Mississippi about 130 miles upriver from St. Louis, and piloting riverboats had been his first profession. In 1902 he had been invited back to St. Louis to dedicate a part of the World's Fair grounds and to help give a new name, *Mark Twain,* to the old steamboat *Saint Louis,* but that was at least his third time back. His most enduring book, *Huckleberry Finn* (1884), was a comic autobiography whose axis was the River; and as it was being printed, Twain had been in St. Louis reading parts of it to paying audiences. *Huckleberry Finn* was "a masterpiece," thought T. S. Eliot, but Eliot, who had grown up in St. Louis, had Yankee parents who had forbidden him to read it.[4] The Mississippi River, as Twain saw it in 1884, "from end to end was flaked with coal-fleets and timber rafts;" while

Eliot, sixteen in 1904, and just gone east to boarding school, would re-member a "river with its cargo of dead Negroes, cows and chicken coops."⁵ To "Huck Finn's autobiography," Twain's incipiently Modern monologue, Eliot would add a modern monologue of his own, "The Love Song of J. Alfred Prufrock"; but not until 1910, by which time he would have read Laforgue and gone to Paris.

Twain loved the Mississippi, except when it came through a faucet. The drinking water in St. Louis was, he wrote, "too thick to drink and too thin to plow." "A score of years," he wrote after his 1884 visit, "had not affected this water's mulatto complexion in the least. . . . It comes out of the turbulent bank-caving Missouri, and every tumblerful of it holds nearly an acre of land in solution."⁶ Such richness had undoubtedly played a large part in giving St. Louis its taste for beer. Nevertheless, for the millions of visitors it expected for the great Exposition, St. Louis was prepared to provide something better. On March 21, 1904, a new filtra-tion plant north of the city came on line, coagulating and settling the Missouri silt with large doses of ferrous sulfate and milk of lime, and the first clear drinking water in the history of St. Louis began to run out of the taps. The Fair could begin, on schedule, a month later.

When the Louisiana Purchase Exposition was opened to the public on April 30, 1904, President Theodore Roosevelt was not on hand. Re-membering, perhaps, that he had come to the presidency because an as-sassin had shot William McKinley at a Fair in 1901, the president instead stood up in Washington, D.C. and pressed a gold telegraph key. Simulta-neously (that is, five thousandths of a second later), the lights went up on the largest World's Fair site ever assembled (then or since)—nearly two square miles in Forest Park and the Washington University campus, in-cluding a central complex of exhibition buildings called the "Ivory City," a mile-long amusement midway called "St. Louis Pike," and the Fair's technological centerpiece, a great complex of electrically illuminated fountains, artificial waterfalls, and watercourses called "The Cascade Gardens." On the podium as the Cascades were lighted, David R. Francis, the Fair's tireless fundraiser, intoned, "Enter herein ye sons of men." Rep-resenting Roosevelt was his Secretary of State, John Hay, author of the Open Door Notes to the great powers on China, and Hay's old friend Henry Adams, who had by now become something of a collector of inter-national expositions.

Adams had just published *Mont Saint-Michel and Chartres,* an ex-tended meditation on the cathedrals and how the spiritual sources of en-ergy that had built them might stack up against the gargantuan power generators he had seen in Paris in 1900. "The new American . . . was the servant of the power-house, as the European of the twelfth century was the servant of the Church. . . . The St. Louis Exposition was its first cre-ation in the twentieth century, and, for that reason, acutely interesting."⁷

Adams was in St. Louis to peer once more into the future, and to try to understand the twentieth century he knew he would not long inhabit. What he saw instead with increasing clarity was how the mental world of the nineteenth century had run down. He had just finished reading the new 1900 edition of Karl Pearson's *The Grammar of Science,* which strictly limited physical science to operations with phenomena—mental manipulation of mental events.[8] In *The Grammar of Science,* Adams read that "in the chaos behind sensations, in the 'beyond' of sense-impressions, we cannot infer necessity, order or routine."[9] Pearson led him on to Ernst Mach, who had made the same points in Vienna and undermined the nineteenth-century *summa* of Ernst Haeckel, who still clung to his faith that the universe was at bottom composed of only one substance.[10] The French polymath Poincaré also had a book in print suggesting that science was convention rather than reality. Mach, Pearson, Poincaré, and Wilhelm Ostwald had convinced Adams that the singleness of mind he so yearned for, and which nineteenth-century science had made so difficult to achieve, was in the next century doomed to become impossible. Not only would Complexity replace Unity; matter itself would become a philosophical construct and "the kinetic theory of gas . . . an assertion of ultimate chaos."[11] In this state of mind Adams came to St. Louis, "a third-rate town . . . with no tie but its steam-power and not much of that," and watched it "thr[o]w away thirty or forty million dollars on a pageant as ephemeral as a stage flat." As the lights went on, he mused, "The world had never witnessed so marvelous a phantasm . . . with its vast, white, monumental solitude, bathed in the pure light of setting suns."[12]

Adams left for Paris before the month was out. He had not quite perceived what the new world would bring, the modern become Modernism. Of course the Fair, like so many fairs, tried very hard to look forward, and there was in every exhibit an attempt at what the 1939 New York Fair would call "futurism." In retrospect, however, the only certain leap into the future at the St. Louis Fair came at the very end of its last conference, when Henri Poincaré, who had been the keynote speaker in three separate Congresses in Paris in 1900, spoke on the "crisis" of current physical theory. Within six months of his talk Einstein would show just how far Poincaré had managed to see into the next century—and how narrowly he had missed becoming its Newton.

In the meantime, the Fair made at least one contribution to twentieth-century culture that still passes for permanent. As the hot continental summer came to the Pike, it suddenly occurred to ice cream vendors, who usually sold the delicacy in dishes accompanied by a French waffle-baked cookie, to try rolling the waffle into a cone and serving the ice cream inside it. The "ice-cream cone" has proved as enduring as the earlier "ice-cream soda," but no more so than George W. Ferris's 250-

foot Wheel, which had first appeared at the Chicago Fair of 1893 and was back by popular demand at St. Louis. On the Pike where the Ferris Wheel was set up, there were diving elephants, visits to the moon, alpine climbs, Jim Key the educated horse, and daily reenactments of the Galveston Flood, the Battle of Santiago de Cuba, Custer's Last Stand, and the Boer War. Exclusive rights to film the Fair had been secured, to the dismay of Edison's western distributor, by Biograph, and the results could be seen at the moving picture exhibits on the Pike. (Downtown St. Louis had only one movie house in 1904, the brand-new World's Dream Theater.) The obligatory Near Eastern exhibit, "Cairo," with twenty-six buildings and a bazaar, suffered from the absence of Fatima, the dancer who had stolen the show in Chicago with "hoochee-koochee," and who, in spite of "Meet Me in Saint Louis," had been prohibited from belly-dancing in St. Louis. (Undaunted, she had opened in Coney Island under the name of "Little Egypt.")

The St. Louis Fair did better with mass culture than it did with class. One of "The Eight," William Glackens, won a silver medal for what the East Coast would later dub the Ashcan School of American art; but the newest, "post-impressionist" art was hardly there, any more than it had been in Paris in 1900 while Matisse was decorating the hall where Picasso's last academic painting would be hung. Forty-five of the United States had separate exhibits at the Fair, and forty-three nations; but of all of them only the Austrian Pavilion showed any systematically Modern design. Gustav Klimt's Vienna University mural, *Jurisprudence,* had been cut from the Austrian exhibit as too stark and explicit, and there was as yet no cubism, or even fauvism to speak of; but there was one altogether original artist exhibiting there: Frantisek (or Frank) Kupka, born in the Austrian provinces near Prague and now living in Montmartre (since 1895 or 1896). An anarchist and a mystic, Kupka had just met Marcel Duchamp and was already on his way toward the invention of nonobjective art. Also on display in the Austrian pavilion were designs for interiors that Koloman Moser and his students from the Vienna Kunstgewerbeschule had made in 1901. Everything in Forest Park was in the old Beaux-Arts style, in spite of the fact that St. Louis had had at least one Chicago-style skyscraper since 1890—Louis Sullivan's 135-foot, steel-skeleton Wainwright Building, and there was at least one tomb designed by Sullivan in Bellefontaine Cemetery. Louis Sullivan and his colleague Frank Lloyd Wright had said the Chicago Fair had set back the development of modern American architecture by a generation. St. Louis proved their point—to an extent Wright himself may have ruefully assessed when he visited the Austrian pavilion to marvel at the designs of Joseph Maria Olbrich, the architect of the Vienna Sezession. Already Adolf Loos, who had visited Chicago in the year of its Fair, was putting up buildings with a spare Modernist look in the middle of old Vienna.

The St. Louis that had built the Ivory City and cultivated the approval of Europe studiously avoided any mention of Dred Scott, the slave who had lost his freedom in its courts. Its baseball team, the Browns, had inaugurated the racial segregation of the professional game by refusing to play mixed-race teams in 1887. The city could scarcely be brought to admit that more than 35,000 of its citizens were black, or that black neighborhoods like Mill Creek Valley, Chestnut Valley, and the old water-front's Biddle Street existed. In spite of official silence, something was brewing in those neighborhoods that would prove even more exportable than beer, and might fairly be called the city's largest single contribution to the arts of Western or any other civilization—jazz. In 1904 the new word "jass" was not yet its name. It was still a music formed of a series of fusions between Western and West African, some of which went as far back as the creolized common languages of the slaves of the West Indies, and some of which were as recent as the infiltration of the guitar from Mexico into Texas at about the same time as the boll weevil. The compli-cated, largely oral history of all these fusions, combining everything from melody and tonal scales to performance practice and rhythm signatures, has been giving musicologists something to argue about for half a cen-tury. About the only thing certain is that all of them have involved trans-mission up and down the Mississippi among most of the towns and farms in the great basin once called *La Louisiane*. Here field hollers and festival dances mothered in Africa could meet the mainstream's most popular music—brass band marches, Protestant hymn tunes, and sentimental waltzes like "Meet Me in Saint Louis"—in a fertile region where the combination could hope to bear fruit. As racial segregation began to be-come law in the 1880s (and the first phonograph recordings began to be made), Mississippi River cities like New Orleans, Memphis, and St. Louis, creole and formerly slave, became known as places where people who called this music "low-down," and could not make it themselves, could at least go down and hear it. In 1892 W. C. Handy, down and out in St. Louis, heard "shabby guitarists" sing a tune he remembered calling "East St. Louis."[13] With a one-line verse of less than twelve bars it wasn't formally a blues, but others like it with three-line verses and flatted thirds and sevenths, including "One Dime Blues," "Red River Blues," "Jim Lee Blues," "Crow Jane," and "Sliding Delta" were then making their way toward the American mainstream.[14] Between 1909 and 1914 Handy would write and publish three blues of his own, the third being the in-stant classic "St. Louis Blues." A decade after Handy's discovery, the per-former Gertrude ("Ma") Rainey made a similar one. Working a tent show near St. Louis, she heard "a girl from town" sing a "strange and poignant" song. "It's the Blues," the girl told Rainey, and Rainey began to perform the Blues.[15] When "St. Louis Tickle" was published in 1904, its tune already had a long history, beginning with Mississippi River

roustabouts from New Orleans to St. Louis. It would be no surprise to see it turn up years later in Jelly Roll Morton's "Buddy Bolden's Blues."[16]

In a town like St. Louis, you could even hear the new music under a roof, at the Rosebud Café at 2220 Market Street, near where Frankie had shot Johnny,[17] or the Booker T. Washington Theater, or the New Douglass Hall, or at one of the attractions of St. Louis never described in World's Fair brochures—the Castle Club, usually referred to by its madam, Babe Connors, as a "sporting house." In September 1895, the white singing star May Irwin premiered a number she called the "Bully Song" in a show called *The Widow Jones* at New York's Bijou Theatre.[18] The lyric was in something then called "negro" dialect and the music was "stride," "jig," or "barrelhouse." Irwin, who made the song her signature in succeeding years, always claimed she had learned it from a ragtime guitar player on the San Francisco to Chicago train in 1894; and that the guitarist in turn had learned it from a singer named Mama Lou who sang it at the Castle Club.[19]

Fairs, whether county or world's, always attracted music, and those in the Mississippi basin tended to pull in the scattered and itinerant artists who made the earliest jazz, whether or not the fairs sponsored the music. At the Chicago World's Fair in 1893, ukelele players from the recently annexed territory of Hawaii inadvertently passed the sliding-stop technique on to guitarists like Blind Lemon Jefferson.[20] Outside the fairgrounds, *The Creole Show* had played at Sam T. Jack's Opera House, the first black-run show with black performers that was not a minstrel show. Not far away theatergoers could hear the great black musicians, soprano Sissieretta Jones and violinist Joseph Douglass.[21] "Sporting house" entertainers gathered from all over the Mississippi valley to play on the "Midway" (the Chicago Fair's amusement mall), or at houses like Pony Moore's at 22nd and Dearborn in the red light district. Among them was a young composer-entertainer named Scott Joplin. In the city of Chicago, or on the Chicago fairgrounds, called "The White City," where the only restaurant or toilet facilities available to him were in the Haiti Pavilion,[22] Joplin earned his keep playing "jig" piano, using tunes then loosely called "cakewalks" after the black dances that parodied the white "promenade" steps. They sounded something like a broken- or double-rhythm version of the marches John Philip Sousa's Marines performed daily on the World's Fair bandstand.

Eleven years later at the St. Louis Fair, Joplin was better prepared. He had been in St. Louis as far back as 1885, when he played jig-piano at a "joint" called the Silver Dollar Saloon owned by "Honest John" Turpin. Born in Texas in 1868, the child of freed slaves, Joplin had come up the Mississippi in his teens and made himself a Missourian, defining a route later followed by Jelly Roll Morton and King Oliver. After the Chicago Fair closed he had gone to the central Missouri town of Sedalia,

where he combined gigs at the Maple Leaf Club with studies of music theory at George R. Smith College for Negroes, and where, a year later, he had published his first two songs. In 1896 he had started in Sedalia what seems to be the first band ever to play "ragtime;" and in 1897 he had written "Maple-Leaf Rag," the rag that had hit the charts and defined the style when it was published in 1899. In the next ten years, a time when most American music came out of parlor pianos and local bands and choruses, "Maple Leaf Rag" sold 500,000 copies, making its Sedalia publisher rich and giving Joplin a chance to get married and move straight down the Missouri River into St. Louis. In the years before the World's Fair the country was just about convinced that Joplin had invented ragtime. He hadn't really. Even in St. Louis there were rag composers who had beaten him into print, like Honest John Turpin's son Tom, the three-hundred-pound black proprietor of the Rosebud Café.[23] In polyglot New York City, Ben Harney, whose race no one was ever allowed to determine, had performed ragtime at Tony Pastor's Music Hall in 1896; and in Tin Pan Alley down around Union Square, whites had already found the beat and tried to pick it up.[24] Kerry Mills had written and published his own rags seven years before he found his melody for "Meet Me in Saint Louis," and in 1904 Charles Ives, an insurance executive who moonlighted as an organist and composer, was finishing something he called "Ragtime Pieces (Dances)."[25] Further downtown at "Nigger" Mike Kelley's Pelham Café in Chinatown, a newly hired Jewish singing waiter named Israel Baline was drinking it all in in 1904, assembling the makings for the international hit "Alexander's Ragtime Band," which would make his name as Irving Berlin in 1911.

But Scott Joplin had probably written the most rags of all—three in 1904 alone.[26] Moreover, Joplin was in St. Louis, where ragtime had been born, and where, on February 22, 1904, a "cutting contest" of ragtime pianists (won by a hometown genius named Louis Chauvin) had opened the year of the Fair.[27] Of course, Joplin had other musics in mind. Soon after moving into St. Louis Joplin had gone back to studying the likes of Beethoven with a German-born St. Louis conductor, with the idea of colonizing musical forms he took to be more demanding, more Western, and more respectable. His aspiration, familiar to many creators of this American music of fusion, had resulted in the premiere of Joplin's first opera, A Guest of Honor, performed by "Scott Joplin's Ragtime Opera Company" in St. Louis a few months before the Fair. It failed; but its failure had not discouraged Joplin. When the World's Fair opened, he was there with his piano and his pen writing a rag called "Cascades" to commemorate the Fair's symbolic centerpiece. Ragtime meant exactly that in 1904—a tearing up of the standard pop music beat (4/4 and occasionally 3/4 time) into smaller bits of not always equal sizes and stitching them back together again to allow polyrhythm and syncopation. The

name "stride" piano was attached to it because of the strict pace or stride kept by the left hand while the bits and syncopations were played count-errhythmically by the right. You could march to it if you had to, but its real message was a dance. At the Fair, Joplin's own performance of "Cascades" must have been easier to understand than the one by Sousa's Marine Band.

We do not know whether Scott Joplin could find a place to eat or to go to the bathroom in Forest Park. The odds are he could, but the circumstances may have been worse. The Louisiana Purchase Exposition's exhibits had been planned by Frederick J. V. Skiff to illustrate the "development of man," and Skiff was convinced that the course of this development had culminated in the worldwide expansion of Western races and cultures. He had hired the leading Americans in the young field of anthropology—William McGee, Ales Hrdlicka, and Franz Boas—to provide for Fair visitors a living museum of the differences between the races and cultures of humankind. This took the form of the largest encampment of the world's non-Western peoples ever assembled, considerably larger than the one Henry Adams had seen in Paris in 1900. At the height of the West's imperial moment in the world's history, looking out over the Great Plains that had been cleared of Sioux and Cheyenne only a generation before, from a site that had once been a Mound-Builder capital, the encampment was a thinly veiled monument to Western victory; and behind its fences it bore disturbing resemblances to a human zoo. There were Inuit from the Arctic, Patagonians from near-Antarctic South America, "Hairy" Ainu from northern Asia, Zulu from southern Africa, a Philippine negrito dubbed the "Missing Link," and no less than fifty-one different tribes of Indians, together with such chiefs as Quanah Parker of the Kiowa, Chief Joseph of the Nez-Percé, and Geronimo of the Chiricahua Apache, who was not a "guest" but a prisoner of war. "Natives of North America," one called these chiefs, though the continent was named in none of their languages, any more than Africa had been named in Zulu or Asia in Ainu. At one point a "Wild West Indian Congress" was held among the representatives of the fifty-one Tribes, although (fortunately, perhaps, for the anthropologists) no American Indian union emerged from it. Later in the year Chief Joseph of the Nez-Percé would die in the state of Washington twenty-seven years after he had surrendered his exhausted people to the U.S. Army.

The Philippine Islands, newly pacified by the United States, were assessed more than 1,100 natives by the U.S. War Department. Members of several of their indigenous peoples, including Moro, Bagobo, Visayan, and Igorot, were deconcentrated from the Philippines in order to be reconcentrated on a 47-acre military-run reservation right on the fairgrounds. The Igorots' native costume, or lack of it, so fascinated the press and public that President Teddy Roosevelt felt it necessary to order that

the tribe put on clothes in order to avoid the charge that the United States was failing in its duty to "civilize" the Philippines. At about the same time this order was issued, in mid-June, a ship docked in New Orleans carrying a certain Samuel P. Verner, a Protestant missionary turned African explorer, sent up the Congo River by the Fair's anthropology department nearly a year before to bring in a dozen central Africans. Near Stanley Pool, he had found three Baluba tribesmen and five Batwa, or pygmies, one of whom, Ota Benga, he had bought from a Baluba for a few bolts of cloth at what amounts to a slave auction. After landing at New Orleans, the travelers entrained for St. Louis, and Verner delivered his eight Africans the last week in June. For Verner, the trip up the Congo had been much easier than it had been for Joseph Conrad in 1890, and any resemblance to a heart of darkness seemed to have escaped him. The pygmies, as everyone called them, were a great hit with the public.

So was Geronimo. The press referred to him as the "Human Tyger," but he wept upon meeting a long-lost daughter and made an arrowhead as a gift for Ota Benga. He also rode the Ferris Wheel, saluted the American flag, and took a part in the periodic reenactments of Custer's Last Stand on the Pike. Will Rogers, the part-Cherokee comic whose career in vaudeville began with a bit part as the last cavalryman to die in the Last Stand, remembered Geronimo playing the juicy role of Chief Sitting Bull to perfection.[28]

But first came the Olympic Games. St. Louis had gotten them too, as Paris had in 1900, the third in this lengthening series of exercises in internationalism. On July 1, track and field events began at Francis Field, the stadium of Washington University, whose new campus next to Forest Park had been temporarily lent to the Fair.[29] Archibald Hahn, "The Milwaukee Meteor," won the hundred-meter dash in 11.0 seconds, and his U.S. team went on to win eighty gold, eighty-six silver, and seventy-two bronze medals, better than any other. Second in these unofficial standings was Germany, with five gold, four silver, and six bronze medals. Third with five, four, and six respectively was Cuba, whose independence had just been guaranteed—somewhat reluctantly—by the United States Senate. As the Games dragged to a close on November 23, it was clear to at least a few that the home team's victory had not been entirely pure. Only twelve nations, all told, had participated, and Hahn had won his hundred meters against a field of only five other runners, all Americans. When the United States swept the tug of war, it had done so by fielding four separate teams against opponents who had only one apiece. Team depth insured a U.S. sweep in three kinds of tennis, roque (a sort of croquet), and team golf—Canada's gold-medal individual golfer being unable to stem the tide. The last ignominy came when a lone Cuban came in fourth in the marathon with only his street shoes to race in, while the American gold medalist was found to have hitched a ride in an automobile and had

to return his prize. From all these sports women were blandly excluded, though they had played Olympic tennis in Paris in 1900. The six women athletes at the 1904 Games (as against 681 men) were there only for the four archery events. In histories of the Olympic movement, St. Louis often figures as the low point.

But the St. Louis Olympics had a low point all their own. The Fair called them the "Anthropology Days." On August 12, all those whose misfortune it had been to be part of the great ethnic exhibit were pitted against each other in a meet of their own. The organizers (all white) seem to have conceived of this intercultural Olympics as a way of determining the differing fitnesses of the races of humankind. George Poage of Milwaukee had won the first Olympic medals ever awarded to a black man— including a silver medal in the high hurdles—so perhaps it preserved self-esteem all around to give the ethnics their own "games." In the event, a Negrito won the pole climb, a Crow the mile run, Patagonians the tug-of-war and the baseball throw, and Sioux the running high jump, the quarter-mile run, and the hundred-yard dash.[30] The "Pygmies" were set up in an intramural mud fight. A Moro from the Philippines took the javelin throw (the Pygmy who came in second gave Fair anthropologists much to think about), a Chippewa the low hurdle, and Cocopa Indians the archery and something called the distance baseball kick. Geronimo, who did not compete, looked on impassively from the bleachers. No Fair facilities were officially segregrated, as they had been in Chicago in 1893; but the larger point was made in these "native" olympics.[31] The future of racial separation seemed both secure and universal.

Soon after the Olympics had opened, the Democratic National Convention came to St. Louis. The city had lobbied hard to add the Convention to its banner-year list, and although the result was a bit of a bust for the city, it had many meanings for one of the delegates, William Jennings Bryan. His career as a left-wing agrarian reformer from the Great West had been made in St. Louis in 1896 when the radical People's Party convention had nominated him for president, seconding the Democrats. His Republican opponent, McKinley, had also been nominated in St. Louis. In 1900, across the state from St. Louis in Kansas City, the Democrats had nominated Bryan again, seconding the Populists. Despite two nominations, Democratic and Populist, Bryan had lost to McKinley in 1896, and again—very badly—in 1900. In a children's book called *The Wonderful Wizard of Oz*, published during the 1900 campaign, Bryan had been a model for the wizard. At St. Louis, on July 10, 1904, the Democrats chose Alton B. Parker to run against Theodore Roosevelt, perhaps the surest loser ever to be nominated for president by a major party. Bryan did not interfere, expecting Parker's loss in 1904 to be his gain four years later. Indeed, Bryan would get the Democratic nomination again (and lose yet again) in 1908, while a Populist remnant would convene in

St. Louis and disintegrate completely. Harry Truman, twenty years old in 1904 and just starting work as a banker in Kansas City, had been a page at the 1900 Democratic Convention there. He had visited St. Louis once in 1901 to see his Aunt Hettie and to bet on a horse, but he never seems to have gone back there for the Fair.[32] Nevertheless, Missouri's conventions may have taught him an enduring lesson. A major party might survive a split over a candidate, but a third party was doomed no matter what candidate it chose.

Toward the end of the summer came the first of many meetings, intended, attempted, and omitted, that together make 1904 into a kind of comedic curtain for the literature of the old century. On August 30, Henry James, alighting from the ferry that had taken him to Manhattan on his first trip back to his own country in twenty years, was told to turn around and go back to New Jersey. An old friend wanted him to meet Mark Twain. The dinner that night was animated, but no meeting of minds occurred. Twain that year had lost both his wife and his sister-in-law. His daughter Clara had collapsed, his sister was ailing, and he was not even planning to go back to St. Louis for the Fair. James wasn't sure he wanted to go either. The next day he went up to see his brother William at his summer house in Chocorua, New Hampshire. The brothers' reunion was not a long one. William was expecting a raft of intellectual friends to visit him on their way to St. Louis. Heinrich Høffding, the philosopher of psychology, and Otto Jespersen, the linguist, were coming from Denmark, and Charcot's former pupil, Pierre Janet, was coming from France. William met them on his porch, in shirtsleeves and shorts, and fighting off depression, which greatly impressed Høffding.[33] They all went down to Harvard and gave lectures, whereupon William James left rather suddenly to tour Greece. Brother Henry decided to motor around the Berkshires with Edith Wharton. He too had had a few invitations to lecture, and he accepted one at the University of Pennsylvania to speak on "The Lesson of Balzac." Among the undergraduates at Penn that fall were Hilda Doolittle (H. D.) and William Carlos Williams, but if they learned anything from Balzac or from James during the long process of becoming leading Modernist poets, they never said much about it. Their friend Ezra Pound missed the lecture, having just transferred from Penn to Hamilton College in upstate New York because it was stronger in classical languages. Later, when James came back east to Philadelphia and gave the same lecture at Bryn Mawr, he had the same null effect on Marianne Moore, who had only just been admitted and had not yet arrived on campus.[34]

At Harvard, Høffding gave a lecture to William James's students. Called "A Philosophical Confession," it was a very personal account of his lifelong fascination with the difficult philosophy of Søren Kierkegaard, unknown until recently outside Denmark. Every year Høffding

taught Kierkegaard's concept of disjunction, or discontinuity, in ethics, and this last academic year, in his required freshman course in philosophy at the University of Copenhagen, he had taught it to a young aspiring physicist named Niels Bohr. Neither he nor James had much to say to the Harvard students about James's friend Charles Sanders Peirce. Peirce's long series of papers on the foundations of logic had begun in the 1860s, and some of the first had been published in St. Louis, in the *Journal of Speculative Philosophy*. In 1878 Peirce had invented the pragmatism for which James was now celebrated,[35] and at Harvard's Sever Hall in 1903 he had given, under James's sponsorship, the last lectures of his crabbed and checkered career.[36] As for Bertrand Russell's book, which had appeared the year before at the same time Peirce was giving his lectures, neither James nor Høffding mentioned anything about it. Høffding's subject at St. Louis in September, like Janet's, would be psychology.

Conventions held at St. Louis to coincide with the World's Fair included the National Education Association, the National Federation of Women's Clubs, the Ancient Order of Hibernians, the Catholic Total Abstinence Union, and the National Nut Growers' Association. Scientists were coming from Europe for the International Electrical Congress and the International Congress of Arts and Sciences. Many had never been to America before and were looking forward to seeing the "Wild West," an invention of the East Coast press already thoroughly romanticized in Europe.

The International Congress of Arts and Sciences had its opening session on Monday, September 19. The plan of the conference was to sum up the nineteenth century and try to project the twentieth. William James's colleague, Hugo Münsterberg, was given the outsize task of allotting to each academic discipline its place in the totality of human knowledge as of 1904. He knew what he had to do: "A mere heaping up of information can be merely a preparation for knowledge, and that the final aim is a *Weltanschauung,* a unified view of the whole of reality."[37] For that world view he chose the familiar positivist hierarchy of Auguste Comte, published more than eighty years before.

The psychology section met on September 20, after philosopher Josiah Royce had tried to set the tone for what the planners had called the Division of Moral Sciences. James's student G. Stanley Hall spoke, followed by James Mark Baldwin, who pointed out that despite all the fashionable talk about experimental psychology and the indivisibility of consciousness, the psychological laboratory, invented in Germany, was as much a product of the dubious eighteenth-century doctrine of the "association of ideas" as any of the works of John Stuart Mill. In the audience was John B. Watson, who would go on to found "behaviorist" psychology, in which no examination or study of consciousness would be permitted.

The new president of Princeton, Woodrow Wilson, gave the keynote address for the Division of Historical Sciences on the 20th. The president of Harvard, A. Lawrence Lowell, did the same for the Division of Social Regulation. Franz Boas described the past and future promise of Anthropology, that section of the Division of Physical Science responsible for distinguishing the world's races. The next day, September 21, was the day Chief Joseph died.

The chemists gathered on September 21 heard Moissan, the man who had purified fluorine, and Ramsay, who had discovered the noble gases argon, neon, krypton, and xenon one by one over the preceding decade. The sociologists of religion heard from Ernst Troeltsch. The sociologists of politics were addressed by the German communitarian Ferdinand Tönnies, the American left-wing evolutionist Lester Ward, and Max Weber, who had just recovered from his five-year nervous breakdown. (Weber's *Protestant Ethic and the Spirit of Capitalism* would appear in the year following the Fair.) Finally, the biologists heard a paper by Hugo de Vries, comparing "Natural and Artificial Selection." De Vries, just in from lecturing in California (and hunting *Oenothera* primroses), talked of mutation and heredity without a single reference to Mendel or the segregation law he and Correns had helped to rediscover. Thomas Hunt Morgan, Columbia University's new man in "experimental biology," was in the chair. Soon Morgan's *Drosophila* fruit flies would begin breeding proofs of the theory unimagined by de Vries.

On September 22, the three musketeers of ionized particle theory took three separate podiums. Svante August Arrhenius, a Swede, had won the third Nobel Prize in chemistry awarded through the Swedish Academy in 1903 and was about to be offered the directorship of the Nobel Institute of Physical Research, newly founded in Stockholm by his (and Alfred Nobel's) king, Oscar II. As a young graduate student in 1883 he had discovered that compounds in solution dissociated into charged particles smaller than atoms, called ions. (Among the first people he had gone to for support was young Max Planck.) Jacobus Hendricus Van't Hoff, a Dutchman, had won the first chemistry Nobel in 1901 with an explanation of osmotic pressure that assumed these ions behaved according to Boltzmann's thermodynamic principles. (Some of Van't Hoff's data had come from de Vries.) Wilhelm Ostwald, a German, had been the first to accept Arrhenius's results, remained in his corner as the brickbats flew, and in the end would apply particle thermodynamics successfully to the problem of predicting the speed of a chemical reaction. Arrhenius, Ostwald, and Van't Hoff had stood for more than twenty years in the vanguard of ionization theory and its deeper implication that all of chemistry could be reduced to the movement of charged bits of atoms. Of course, Ostwald saw no reason to give up his view that ions, like any other "atomic" particles, could more easily be thought of as twists in a

field, while his friend Boltzmann insisted they were bits of matter. As recently as 1903, Boltzmann had opened his course in the philosophy of science at the University of Vienna by insisting that atoms were real and attacking the curious positivism of Mach, which had led him to think that atoms were merely hypothetical.[38] In 1904 the polemic relation of Ostwald and Boltzmann flared up again with Ostwald's "Faraday Lecture" against "those pernicious [atomic] hypotheses,"[39] followed by Boltzmann's "Reply to a Lecture on Happiness Given by Professor Ostwald," delivered to the Vienna Philosophical Society.[40] When they all came together at the International Congress of Arts and Sciences in September, it seemed certain the fur would fly.

It didn't. Ostwald did indeed define mechanics, physics, and chemistry in his paper as "Energetics," but he admitted that his program of replacing expressions of mass in equations with expressions of energy had "not yet got far enough to justify publication."[41] Instead, Ostwald made bold to sum up the entire scientific enterprise, beginning with an epistemology based on "the continuous flux of our experiences"[42] that was pure Mach, and continuing with a discussion of the basic science of arithmetic that was pure Frege. He mentioned neither man, but instead built to their conclusions from scratch, going on to order the sciences in the Comtean manner depending on how many and how inclusive their laws were, and stressing how much uncertainty remained in all of them. His discussion of continuity in the human experience of nature was tentative. If Boltzmann was in the audience, he might have thought he had won, except for the fact that Ostwald had begun with consciousness, and anyone who does that cannot be depended on to be solidly materialist about the world outside the mind.

On the same day the Logic section met, saying nothing about Frege or Peano or Russell, not to mention Peirce. The Psychiatry section met and heard nothing about Freud. The Neurology section heard references to the neuron theory, but no mention of either Freud or Cajal. In a long speech to the Anatomy section on the wonders of recent neuroanatomy and histology, Wilhelm Waldeyer made a brief reference to Cajal—as the man who had improved the Golgi stain. (On the last day of the conference, Freud was finally mentioned in the Abnormal Psychology section, not by Pierre Janet but by the American alienist Morton Prince, who offered a sentence citing Freud and Breuer as experts in "subconscious automatism.")[43] Meanwhile, the Social Regulation division was hearing from the English historian James Bryce, who had pondered why there were no distinguished people going into American politics, and the German economist Werner Sombart, who would soon write "Why Is There No Socialism in the United States?"[44]

The next day, the 23rd, was the turn of the newest section of the Physical Sciences, "ecology," whose short history was summarized by one

of its pioneers, Oskar Drude. At the same time the General Psychology section of the Mental Science division was lectured to by Harald Høffding, who presented the subject confidently as both philosophy and science, and echoed his friend William James on the continuity of consciousness.[45] That evening the scholars gathered for a banquet at the Tyrolean Alps exhibit. Among those who offered toasts were James Bryce and a professor of law from the University of Tokyo, representing the only non-Western country at the Fair that could claim this year that it had fought a war with a Western nation and won. Once again, briefly, knowledge looked unified.

The last day of the Congress was the 24th. On that day, Brander Matthews, the critic who had first noticed that *Huckleberry Finn* was a monologue, gently poked fun at the task he had been given, summing up the past and future of prose literature in an hour and a half. He did his best, but no author or work he mentioned gave much of a hint of what Hamsun, Schnitzler, Stein, and Joyce had already set out to accomplish. Thomas Wolfe, who was visiting the Fair at about this time, already knew enough to have laughed. Meanwhile the Physics section called Physics of the Electron was hearing from Paul Langevin that these lately discovered "movable charges" were subatomic particles on which "the experimental facts impose . . . a discontinuous, granular structure."[46] Next after Langevin came Ernest Rutherford. In the past five years, at Cambridge University and Canada's McGill University, Rutherford's inspired tinkering with radium samples, foil, and evacuated tubes on a laboratory bench had made him the founding father of atomic physics. He summed up for the Congress the simple history of his eight-year-old science, including his most recent discovery of five distinct and elemental decay products of radium and his growing conviction that radioactivity was like alchemy, transmuting one element into another, atom by disintegrating atom, and producing a new kind of energy in the process. His work was big news for scientists everywhere. In 1904 he had already given substantially the same talk to the International Electrical Congress in St. Louis, to the American Association for the Advancement of Science, to the Royal Institution in London as the Bakerian Lecture, and as a published book called *Radio-activity.* Before the year was out he would receive the Royal Society's Rumford Medal and an invitation to give the Silliman Lectures at Yale.[47]

At 3 o'clock that same afternoon, the inventor of statistical thermodynamics, Ludwig Boltzmann, took his place at the lectern in Hall Number 9 to sum up theoretical physics.[48] The title of the section, Applied Mathematics, was a consequence of the intellectual plan that had put theoretical and experimental physics in two completely different divisions of knowledge. The Congress was "a flood," said Boltzmann (ironizing perhaps on the Cascades outside), "a Niagara of scientific talks,"[49] so

instead of trying to sum up mathematical physics in general, Boltzmann proposed to deliver something more concise: a defense of his own celebrated and still embattled contribution to it, the hypothesis that nature was discontinuous.

In the new twentieth century, said Boltzmann, theoretical physics, like experimental physics, "is in the course of a revolution." The job of theoretical physics is to make sense and system of the facts, and to do that it must make bold hypotheses. The "most modern" theories call for hypotheses that have even an element of fantasy—like the luminiferous ether or electrical "fluids." Boltzmann's own hypothesis was that material nature was composed not of continua like ether and electrical fluid, but of molecular, atomic, and subatomic particles with nothing between them but empty space. Such hypotheses raised "questions as old as science itself" that had until recently been left to philosophy. Boltzmann, who had just taught philosophy at Vienna in the chair previously occupied by Mach and Brentano, was convinced, however, that "the query whether matter is to be conceived as continuous or as composed of discrete constituents (of very many but not mathematically speaking infinitely many individuals)" could not be answered by an appeal to pure reason, whether Zeno's or Kant's. The so-called laws of thought were not a priori true, but only an evolutionary legacy in the brain; indeed, they were not even laws. Cause and effect was not a "law," but simply the repeated experience of linked events. The job of philosophy should be not to ask these illusory questions, but to explain why they are pointless and retire them. Physicists ought not to try to make sense of infinite quantities or to work with the continua of monists and energeticists. They should ask instead "which represents the observed properties of matter most accurately, the properties on the assumption of an extremely large finite number of particles, or the limit of the properties if the number grows infinitely large?"[50]

> We cannot define infinity in any other way than as the limit of ever growing finite magnitudes. . . . If, therefore we wish to form a verbal image of the continuum, we must necessarily begin by imagining a very large finite number of particles endowed with certain properties and then examine the way this aggregate behaves. Certain of its properties may approach a definite limit when the number of the particles is made ever larger and their size ever smaller. We can then assert of these properties that they belong to the continuum, and this in my view is the only non-contradictory definition of a continuum endowed with certain properties.[51]

Planck, whom Boltzmann did not mention, would have been pleased at this formulation, since it was the lack of just such a definite limit that had led him to rule out the continuum, apply Boltzmann's summation strategy, and postulate the quantum. The resulting science, said Boltz-

mann, had been called "statistical mechanics [by] one of the greatest American scientists, perhaps the greatest . . . namely Willard Gibbs," thus gently offering to Gibbs, who had just died, the honor of naming their field.[52] The field was not ancillary, as Ostwald had argued in 1895, but fundamental. There was possibility in it, and even a kind of liberty. Statistical mechanics and Boltzmann's equation, $S = k \log W$, relating entropy to probability, went to the heart of the deepest questions raised by the newest physics about time, space, and causality. In a universe of great but not infinite size made of enormous but not infinite numbers of particles, even reversals of entropy were "not absolutely impossible according to the theory, but merely highly improbable."[53] Indeed, quantum electrodynamics has since shown us that they happen all the time.

Following Boltzmann to the podium was Henri Poincaré. Unlike Boltzmann, he had no quarrel with the plan of the Congress and intended, he said, to discuss the past, present, and possible future of "The Principles of Mathematical Physics." Like Boltzmann, he saw, at the beginning of the twentieth century, "the eve of a second crisis" akin to the one that had been resolved by Newton.[54] Every basic principle was in question: increase of entropy, conservation of mass, the equality of action and reaction, conservation of energy, the principle of least action, and even the old "principle of relativity, according to which the laws of physical phenomena should be the same, whether for an observer fixed, or for an observer carried along in a uniform movement of translation."[55]

Poincaré thought Gibbs "difficult to read," and was not convinced by Boltzmann's solution to the entropy paradox—that entropy could possibly decrease, but only in a time comparable to the lifetime of the universe.[56] The Brownian movement of tiny particles in suspension looked like perpetual motion to Poincaré. As for conservation of mass, Poincaré thought it shaky. He had been reading the latest papers of the cathode-ray theorists, Abraham and Kaufmann, and their suggestion that at high velocities the electron might gain mass electrodynamically. He had also read Hendrik Lorentz, who was pretty sure that the mass increased electrodynamically *and* mechanically.[57] But if this were true what would happen to Newton's principle that equated action and reaction, since both depended on constant masses multiplied by constant velocities? Could light or any other radiation exert pressure on matter? Under these conditions, Poincaré realized, the whole of Newtonian mechanics would collapse. What would then become, he must have wondered, of his own *magnum opus,* the three-volume *Celestial Mechanics,* which had sealed his reputation at the time of the World's Fair Congress in Paris? Although it offered a mathematical demonstration of the ultimate unpredictability of the planetary orbits (the first step in "chaos theory"),[58] it depended completely on the Newtonian system. As for the principle of the conservation of energy, it was clearly threatened by the radioactivity first de-

tected by Becquerel in 1896, and even more by the extraordinary energy output of radium measured by Pierre Curie in 1903.[59] Not far from where Poincaré was speaking, on that same September afternoon, Ernest Rutherford was pointing out how inexplicable that energy was, while over at the technology exhibit, a small sample of radium itself was demonstrating its inexhaustible glow to visitors.

The principle of relativity too, Poincaré asserted, was "battered."[60] Maxwell had shown how any electric charge in motion ought to produce an electric current (light or electrodynamic radiation) "in the ether," but which motion counted? Any electric charge fixed on earth automatically moved through space at a great rate, since the earth was rotating, revolving around the sun, and who knew what else. Efforts to reduce all of these motions to one absolute motion with respect to a stationary ether had run up against Michelson and Morley's experimental proof in 1887 that the "ether," if it existed, had no such effect. Lorentz had offered a solution, said Poincaré, but the solution amounted to an "accumulation of hypotheses." The most plausible of Lorentz's hypotheses was the idea of "local time,"[61] which was the time of a moving reference system; but although Poincaré had already shown that events were simultaneous only by convention,[62] he could not quite give up the possibility of a nonlocal "absolute" time, applicable to several moving systems at once. Lorentz's other hypothesis, that bodies contracted in the direction of motion, Poincaré thought much too convenient. "Thus all is arranged," he said, "but are all doubts dissipated?"[63] Perhaps, Poincaré suggested, all would be swept away, even the principle of least action, the only grand principle left that was still unchallenged. However, he said as he finished his talk, "we should not have to regret having believed in the principles . . . the surest way in practice would still be to act as if we continued to believe in them. They are so useful."[64] A century later, we can read this as prophecy.

That October, as the New York Giants refused to play a baseball World Series, the visiting scholars returned to their universities. Boltzmann returned by way of Niagara Falls, that great American sight—model for the St. Louis Fair's Cascades to which he had compared the Congress. His son Arthur Ludwig was delighted, and thought Niagara the most exciting event on the trip.[65] Ostwald, who returned directly to Germany, was en route on October 2, when General von Trotha issued the now famous "Annihilation" Order in the German colony of Southwest Africa to exterminate all members of the indigenous Herero tribe who remained in rebellion against the colonizers. How Ostwald reacted, if he reacted at all, we do not know, any more than we know whether Skiff and the other designers of the "Development of Man" exhibit saw any connection between this event and the human zoo now being slowly dismantled in St. Louis.

At the beginning of November, Theodore Roosevelt was elected to

the presidency. His huge majority included the electoral votes of the state of Missouri, which broke the "Solid South" of Democratic states for the first time since the Civil War. Missouri also elected as its governor State Attorney Joseph Folk, who had convicted twenty-three people for bribery in a year-long assault on St. Louis's municipal corruption. Folk's phrase, "aggressive honesty," became part of the national Progressive movement as the "Missouri Idea."

The Louisiana Purchase Exposition finally closed on the first of December—its last day was named "David R. Francis Day," after its organizer—and the year-long, state-sponsored disneyworld slowly packed up and went home. The hot Midwestern summer had long since been succeeded by the cold continental winter, which, by January, would freeze Niagara Falls for the first time in living memory. The troupe that had so assiduously reenacted the Boer War on St. Louis Pike went east to Coney Island to go on with the show. Samuel Verner took Ota Benga and the remaining tribesmen and headed for Africa. The first stop was New Orleans, where black musicians still gathered on Sundays to perform in "Congo Square" and Buddy Bolden was playing trumpet in the seven-year-old legal red light district called "Storyville." Ota Benga was delighted with Mardi Gras, and joined the parade when it went by. Soon afterward Verner returned him, as promised, to the Congo. Once there, Ota Benga found he no longer felt at home in Africa, and decided to sail with Verner back to the United States. The trip to New York took most of Verner's savings. He found a job selling tickets on the Wall Street station of the new New York City subway, and lent Ota Benga for safekeeping to the new Bronx Zoo, where the pygmy made good his room and board by going on exhibit one Sunday in an animal cage.

On March 15, 1905, Geronimo paraded down Pennsylvania Avenue in Teddy Roosevelt's inaugural at the president's invitation. Afterward he saw the president alone and asked to be allowed to "die in my own country," Arizona, to which Roosevelt replied that he was sorry but it couldn't be done.[66] That same month, lecturing, as always, on "The Lesson of Balzac," Henry James finally reached St. Louis, and Scott Joplin left it for good, making his way east to Chicago and New York. As for Henri Poincaré, he had gone back to Paris with Paul Langevin, marveling at the great open spaces he had seen and the crisis in physics that continued to widen.[67] Paris would next hear from St. Louis twenty years later, when the last wisp of 1904's confident Western Spirit of St. Louis flew east from New York and electrified the Old World.

15 ALBERT EINSTEIN

THE SPACE-TIME INTERVAL

AND THE QUANTUM OF LIGHT

1905

The man who was to answer Poincaré's challenge within the year—Albert Einstein—was nowhere near St. Louis in 1904. He was in Bern, Switzerland, holding down a desk job in the federal capital, a civil service appointment that had just been made permanent that September. He was grateful to have had two years' steady work at 3,500 Swiss francs annually, enough to get married on in 1903 and enough to take care of his brand new son. He was even more grateful that the job left him some time to read theoretical physics (including Boltzmann and Poincaré), and to write a few scientific papers of his own. Einstein was not yet a Zionist, a genius, or even a great physicist, except to a small circle of friends in Switzerland who called themselves, with great good humor, the Olympia Academy, but who were not themselves physicists. Some of them still came to visit Einstein at his new second-floor apartment at 49 Kramgasse in Bern. There was his college classmate Marcel Grossman, for example, a budding professor of mathematics who had helped Einstein get his job; and Michele Angelo Besso, for whom Einstein had done the same favor in 1904. There was Maurice Solovine, who had wandered into Einstein's poverty flat in Bern in 1903 to take him up on his offer to tutor physics and stayed to become an Olympian; and Conrad Habicht, now teaching science in the Protestant public school in Schiers, Graubünden, who had met Einstein in 1901, when both of them were novice teachers in Schaffhausen. There was also Mileva Maric, another classmate, who may have thought Einstein was special; but Mileva had married him, and that was after she had failed her exams twice.

Einstein himself was a college graduate, however, with a physics degree and a teaching certificate dated 1900 from the Swiss Federal Institute of Technology, "ETH," in Zurich. He was also already an exile (like Stein and Joyce) and already a pacifist. Because the academically elite Luitpold **227**

Gymnasium in Munich had tried to teach him classics in the military manner so prized in Germany, Einstein had run away without getting his high school diploma. As a final flourish he had even paid three marks to have his German citizenship taken away. Stateless at sixteen, and a dropout, Einstein had made up his missing courses in a Swiss cantonal high school. At college he had remained an outsider. He had tangled with his faculty adviser, and for two years after graduation he had not been able to get anything better than temporary teaching jobs. Then his father, having twice gone bankrupt in the electrical equipment business, had died in poverty in Italy in 1902, and Albert had been reduced to living on 100 Swiss francs a month. His wife Mileva was a Serbian emigrant as poor as he was, and both were politically on the left. Though he had not wasted much time reading Marx, he was letting his hair grow a bit long and continuing to resist wearing the uniform of the turn-of-the-century professional man except when it was required at his new job. There are some pictures of him at the office dressed in a three-piece suit of bold plaid, a striped tab-collar shirt, and a black necktie with a broad knot at the throat topped off with a stickpin. This dandy with the mustache and the dark curly hair is standing where most of his world-changing ideas came to him—at the desk of a Third-Class Technical Assistant in the Federal Office of Intellectual Property—the Swiss Patent Office.

In physics, light dawns. It has a suddenness rare in painting or fiction. Einstein's four greatest ideas—the quantum interaction of light with matter, Special Relativity, the equivalence of matter and energy, and General Relativity—were all conceived in and out of that little office in Bern. The first three were all published in 1905 in the *Annalen der Physik,* the oldest established German-language journal in the field. Two of them (with another fundamental paper on molecular forces thrown in) have made volume 17 of *Annalen* the equivalent in physics of the 1886 *La Vogue*. The resemblance to poetry is all the stronger for those who can appreciate the beauty and elegance of physical theories and who believe, as Einstein did, that they are "fictitious"—"freely formed concepts" "produced by a creative act."[1] Of course, once they are conceived they must be rigorously, mathematically consistent and they must fit experience without exception—constraints that still deter artists from classing Einstein as one of their own.

On March 17, 1905, three days after his twenty-sixth birthday, Einstein put his first paper of the year, the one on the interaction of light and matter, into an envelope in Bern. It arrived in the mail at the offices of the *Annalen der Physik* in Berlin the next day. The editor, Paul Drude,[2] would have seen his first clue as to its novelty in the title—"On a Heuristic Point of View Concerning the Production and Transformation of Light"—because "heuristic" means a way of looking at the facts that is helpful even if it cannot be proven true. Light, on the other hand, was

quite a commonplace subject in 1905. There was a practical interest: the new electric power industry, which had seemed such a juggernaut to Einstein's father. Edison had launched the industry in Lower Manhattan in 1882, when Albert Einstein was three years old, and it had long ago turned Paris and most other Western capitals into cities of light. On the theoretical front, Maxwell's equations, which turned light into an electromagnetic field effect, had inspired many experiments and a fund of new questions. Physicists everywhere were converging on radiation phenomena. Hertz had made his radio waves in 1887. Jean Perrin and J. J. Thomson had recently shown that cathode rays, known since the 1860s to be both electric and magnetic, were not rays at all, but streams of subatomic particles for which Stoney had recently coined the word "electrons." Röntgen had set off his X-rays in 1895, the year the energeticists had debated old Boltzmann at Lübeck. In the four years since Planck had solved Kirchhoff's old black-body radiation problem, the trend had intensified. Most recently the Dutch physicist Hendrik Lorentz had been trying to reduce the theory of electromagnetism from a theory of fields and waves to a theory of electron dynamics. No one, not even Planck, had found a general solution to the puzzle of the unmediated interaction of matter with radiation energy. In the rising cultural debate between the old militant materialists and the newer positivists, energy, and especially radiation, had begun to seem like the field where the materialists might lose the struggle. After all, the wonders of ether-borne electricity had caused even J. G. Vogt to fall away from the pure materialism of his ancestors.

Up until 1905, Einstein's own work had been largely in the materialist vein. The fact that his adviser in the ETH physics department, Heinrich Weber, had been something of an energeticist gave Einstein good reason to be a dissenter, for Weber, who would not teach Maxwell's field equations, had been the man responsible for Einstein's not getting an assistantship after college.[3] Einstein had begun his career as a productive physicist in 1900 with a paper on capillary action, where he considered energy to result from the activity of material particles, not ethereal waves. His next four papers had all been in that domain, and so had the eight books he had analyzed for the *Annalen*'s book review section. The doctoral dissertation he began working on in 1904 was about the activity and dimensions of atoms and molecules. Einstein's model was the old warrior Ludwig Boltzmann, then in St. Louis defending his beloved atomic model. Einstein had begun reading Boltzmann's summaries of kinetic theory in 1899, the year before he graduated from ETH. It was in September 1900, when he was in Milan, trying to convince his father that he should be allowed to marry Mileva Maric, that Einstein wrote that love letter to her with the paragraph beginning, "The Boltzmann is magnificent."[4]

The program in Einstein's first five papers had been to recast Boltzmann's theory in a more economical, elegant form; and to put it on a firmer basis so that entropy, dependent as it was on statistics and probability, would be less of a threat to the assumption that, at least where individual molecules were concerned, causality remained absolute. (It was something like what Willard Gibbs had done with his *Statistical Mechanics* in 1902, but Einstein, like so many physicists, did not yet know that Gibbs existed.)[5] In 1903 and 1904, the final two papers of the series proposed a new general theory of thermodynamics. Even Einstein's dissertation was intended to top things off by offering a new way of measuring just how many molecules there were in a gram-molecule (or "mole") of any chemical compound and just how big each molecule was likely to be. The number ought of course to be Avogadro's number, which Loschmidt had first estimated back in 1865; and the size of a molecule was tied to the number one could pack in a space.

For those with a philosophical bent toward materialism few things were more satisfying than being able to count the number of atoms in a bottle. How could an anti-atomist like Ernst Mach reply to that? The French physicist Jean Perrin was working his way toward a Nobel Prize, accumulating as many different ways of counting atoms and molecules as he could find, delighting that each one gave almost the same figure for Avogadro's number: 6.5×10^{23}, or about 650 sextillion. (In May Einstein's dissertation would provide Perrin with one more method, and his paper on the Brownian movement would provide yet another.) Even full-time socialist revolutionaries like Vladimir Ilyich Ulyanov—Lenin—took time out to appreciate the help they could get from a physics that counted atoms. Lenin was very disappointed in fellow socialists like Bogdanov and Avenarius, who had been led with Mach to lose their faith in atoms.[6] Friedrich Adler, a promising Marxist and son of the chairman of the Austrian socialist party, had become an energeticist while studying physics at ETH and decided that his fellow Viennese, Mach, was right after all. Adler, in fact, had known Einstein in Zurich. Schoolmates from 1897 to 1900, Adler and Einstein even became housemates for a time in Zurich in 1909. Adler's wife remembered Einstein once asking her what it was she was bringing in from the market; told it was toilet paper, he drew himself up and announced that he and Mileva would continue to use newspapers.[7] On atoms their disagreement was more fundamental.

Einstein's "rapturous amazement" at the underlying "harmony of natural law" was passionate and all but religious.[8] He had always loved the experience of becoming conscious of design. He explained the fact that he did not talk until he was three by the efforts he had made to compose his sentences before he spoke them.[9] He had become convinced while still a child that elegant patterns ultimately informed the whole of nature, and he used to relate a story about the "miracle" of a pocket

compass his father had given him at the age of four or five: the orientation of its needle becoming for him a visible proof of some invisible harmony so deep that he "trembled and grew cold." [10] He treated his copy of Euclid like a Bible and called it his "Holy Geometry Book." One of his writing exercises has survived from the Aarau cram school where he prepared for the ETH entrance exam, an essay in French called "My Future Projects." Between the lines a nameless teacher has marked the spelling and grammar errors, while in the text Einstein announces his intention to become a professor of theoretical science above all because of "my individual disposition toward abstract and mathematical thinking, and my lack of aptitude for either fantasy or practical matters." [11]

No matter how much Einstein appreciated both the complexity and the hiddenness of the patterns in nature, however, he always believed the elements that made up the pattern were real. The world was real, an assemblage of facts, not a concatenation of sensations. Atoms were more than plausible elements; they were hardly worth bothering about unless they were really there. As for patterns, if macroscopic amounts of substances continued to be describable by small, rational numbers, and often by simple integers, the pattern could only be explained by assuming discontinuity at the root of material nature.

Einstein was lucky enough to come of age as a thinker at a time when, as Poincaré had said at St. Louis, some of the broadest of all the accepted laws of nature were in crisis. Little flaws and asymmetries were always showing up at the edges. In the matter of atomic theory, there were as good reasons to believe matter was discontinuous as there were to believe the ethereal media that pervaded it were not—and vice versa. Cathode "rays" had turned out to be particles in 1897. In 1899 Rayleigh had shown that the very air in the sky was discontinuous—or what could be diffracting white sunlight to shades of blue? Was sunlight itself discontinuous? Maxwell had assumed that light, like all electromagnetic radiations, was continuous; yet the sun's spectrum could be analyzed into an assemblage of narrow colored bands, each band radiated at a precise frequency by a particular chemical element. And then there was what we might now call the "interface" question. Just how did these waves of radiation interact with atomized matter? If Planck were right, matter could produce radiation by a discontinuous process. Perhaps radiation itself was discontinuous. Let us assume that it is, Einstein wrote in his paper, and see what happens.

For four years no one had written about Planck's radiation law this way. Indeed, no one had written about it at all—not even Planck. Experimenters cited the law as they continued to confirm it, but Planck was unhappy with the quantum postulate that made it work. With the boldness of youth, Einstein called the quantum postulate "heuristic," meaning that it could be assumed without contradicting what was already known.

"The wave theory of light . . . has proved itself splendidly . . . and will probably never be replaced by another theory." And yet, he wrote,

> optical observations apply to time averages and not to momentary values, and it is conceivable that despite the complete confirmation of the theories of diffraction, reflection, refraction, dispersion, etc., by experiment, the theory of light, which operates with continuous spatial functions, may lead to contradictions with experience when it is applied to the phenomena of production and transformation.[12]

In the course of the paper Einstein cited Planck's law, showed that part of its derivation was faulty, and that it could be used without assuming the existence of Planck's "resonators." Then he dropped Planck completely in favor of Willi Wien's earlier black-body radiation law that worked only for high frequencies, low intensities, and low temperatures. Let us now assume, suggested Einstein, that radiation can get randomized and equally distributed in a space—that it has entropy just like matter. Let us further choose a radiating volume and divide it mathematically, the way Boltzmann had done with gases, into an enormous number of little subvolumes.[13] Using the old Wien law to give him a distribution, Einstein then proceeded to derive the entropy of the radiation from the logarithm of its probable configurations—Boltzmann's 1877 idea, to which Einstein here gave the name "Boltzmann's Principle" for the first time.[14] The resulting entropy formula looked simple, and there, right where it should be in the exponent, appeared the action quantum of Max Planck.

All that was left for Einstein was to provide a natural phenomenon that would prove the usefulness of this new formulation. This was Philipp Lenard's experimental investigation of a strange effect initially discovered by Hertz in the 1880s, and now coming to be called "photoelectric." If you beamed light of fairly high frequency at metal plates of a certain composition, electrons shot out of the plate, often sparking as they came. Einstein had seen the results when they were published back in 1902 and had written excitedly to Mileva, "I have just read a marvelous paper by Lenard on the production of cathode rays by ultraviolet light."[15] Particles, that is, could be elicited—bumped out or released—by the immaterial energy of radiation. It seemed to Einstein like the precise reverse of Planck's resonators: energy causing the emission of matter instead of matter causing the emission of energy. With his new mathematical insight, Einstein could make a prediction about the precise quantity and energy content of the electrons a given measure of radiative energy could release. It depended on the size of the quanta $h\nu$ of radiation. Only at high, ultraviolet frequencies ν were the quanta sufficiently energetic to bounce electrons out of the material Lenard had used. Beyond that threshold each increase in frequency ν should lead to a corresponding increase in the

yield of electrons. Einstein, who had no laboratory facilities, invited readers who did to perform the experiment. Sure enough, they would find, the quantum heuristic made true predictions. Einstein had fixed Planck's quantum and given it a broad new understanding. The result would launch a deep-rooted revolution in the way physicists imagined the interaction of energy and matter. Einstein's "photoelectric paper" turned a unique and bizarre approach to the classical black-body radiation problem into a general approach to physical explanation, "quantum theory."

Spring came to Bern. Einstein finished his dissertation at the end of April and filed a copy with the Cantonal (State) University of Zurich. His advisers approved. Einstein was now Herr Doktor. Some ten days later, he finished writing the paper on Brownian motion that had come out of his doctoral work and sent it off to the *Annalen*. Then something even bigger happened. Later that May, about the 20th, Einstein arrived at the apartment of Michele Besso, his old friend from the Olympia Academy, badly needing to talk. "I have recently had a question which was difficult for me to understand," he said. "So I came here today to bring with me a battle on the question." [16] His tenacious mind had just returned to a problem that seems to have first struck him when he was sixteen, a problem whose solution would come to be called the Theory of Relativity.

What was the problem? Essentially it was the whole question of the nature of light, and specifically the sense in which light could be considered dependent on space and time. The question that had come to Einstein at sixteen was what might happen—what he might see—if he rode alongside a light wave. [17] By 1900 he knew that the answer to the question, if any existed, involved electrodynamics as well as kinematics, and that he had to gain a thorough understanding of Maxwell's electromagnetic wave theory of light. Since Weber at ETH would not teach it, Einstein had dug up the newest textbook on Maxwell by August Föppl. Föppl was very good on the subject, and he was honest, too, for he had deliberately pointed out where the electromagnetics of Maxwell, and even that of his predecessor Faraday, depended on models that contradicted each other. If a magnet moving past a wire circuit made a current in the wire, then a wire circuit moving past a magnet ought to make the same current for the same reason. The most up-to-date theory distinguished between the two reasons, making a distinction that ought to be without a difference. Perhaps the stationary ether made the difference; but if it did, the speed of light should be affected by the ether, too. Föppl had also taken up that question, referring to an old experiment by the French physicist Hippolyte Fizeau, who had found in 1851 that the speed of light was completely unaffected by running it back and forth through a fast-moving column of water. Fizeau's work had so moved Einstein to doubt the existence of ether that a similar, but much more elegant and accurate, experiment designed by the American physicist Albert A. Mi-

chelson in Berlin in 1881, and rerun at Case Institute of Technology in 1887, had never taken its place in Einstein's thinking. Indeed, Einstein hardly knew that the Irish mathematician George FitzGerald, followed by Hendrik Lorentz, had suggested that the reason Michelson's apparatus could not register differences in the speed of light was that the apparatus itself was shrinking in the direction of the earth's motion.[18]

What Einstein did know, oddly enough, was not the work of experimenters, or even of the most recent theorists on electrodynamics, but that of philosophers of science. The Olympia Academy he and his down-at-the-heels friends had formed in Bern in the summer of 1902 was a reading society. The list, as Maurice Solovine later remembered it, began with Karl Pearson's 1892 *Grammar of Science,* in the new revised edition of 1900 (later adding the essays of Pearson's mentor William Kingdon Clifford). Next came the only works Pearson had recommended as sound: Ernst Mach's two great theoretical books, *The Analysis of Sensations* and *The Development of Mechanics.* After Mach came his disciple Avenarius, plus Mill, Hume, and Spinoza on logic and epistemology, Helmholtz's *Popular Lectures,* and Ampère on electrodynamics in nature and in the mind.[19] After these old masters came masterworks of foundational mathematics: Bernhard Riemann's legendary treatise on non-Euclidean and field metric geometry and Dedekind's derivation of the fundamentals of arithmetic. The last work Solovine mentions the Academy reading was the most recent, published in 1902: "Poincaré's *Science and Hypothesis,* which engrossed us and held us spellbound for weeks."[20]

It would be hard to think of books that would be better calculated to undermine the scientific epistemology of the nineteenth century. Clifford, Mach, and Pearson (and their eighteenth-century philosophical forebear, David Hume) all insisted that human beings knew no more than their own sensations, so whatever mental model could make sense of them was "science." Science, for them, did not describe "nature" (at least not directly), and could entertain alternatives. Dedekind, as we have seen, had revolutionized the foundations of ordinary arithmetic; Riemann had done much the same thing for geometry. Even the Helmholtz book contained an epistemological examination of geometry that made the old assumption that space was Euclidean seem childish. As for Poincaré's book, it was a small encyclopedia of all these unsettling ideas. In prose of Cartesian clarity, *Science and Hypothesis* took on the mathematical continuum, the foundations of arithmetic, non-Euclidean geometry, the relativity of space, time and motion, the indefinability and discontinuity of mass, the possible discontinuity of energy and the failure of the energeticists to define it, the aleatory and the statistical in physics, and the entire epistemological problem of the relation of science to nature, beginning with the relation of geometry to space. "There is no absolute space," the book asserted. "There is no absolute time."[21] "It is quite possible,"

Poincaré wrote (in a chapter revised from his address to the physicists at the 1900 Paris World's Fair), that any contradictions between competing theories of the same phenomenon "only exist in the images we have formed to ourselves of reality." The "electro-dynamics of moving bodies" just developed by Lorentz and Larmor does everything but make sense of the interaction of ether and matter. Perhaps the ether does not "actually exist."[22]

Perhaps, indeed. The complete artificiality of space and time and the interdependence of all four of these dimensions with velocity had begun to become clear to Einstein back in December 1901, when he wrote to Mileva that "I am now working very eagerly on an electrodynamics of moving bodies, which promises to become a capital paper,"[23] and that his fellow Olympian Michele Besso had given him "a book on the theory of ether, written in 1885. One would think it came from antiquity, its views are so obsolete."[24] When Einstein burst in on Besso in May 1905, three and a half years later, it was time, light, and the ether that were on his mind. Sure enough, talking with Besso worked. "Trying a lot of discussions with him," Einstein wrote in 1922, "I could suddenly comprehend the matter. Next day I visited him again and said to him without greeting: 'Thank you. I've completely solved the problem.' "

> My solution was really for the very concept of time, that is, that time is not absolutely defined but there is an inseparable connection between time and the signal velocity. With this conception, the foregoing extraordinary difficulty could be thoroughly solved. Five weeks after my recognition of this [that is, about May 20], the present theory of special relativity was completed [about June 30].[25]

We know he had the concept clear in his mind on about May 25, when he wrote to Conrad Habicht, another former Olympian. "What are you doing, you frozen whale?" he asked, and told him about his own four new papers: a "revolutionary" one on radiation (the photoelectric paper), one on the "true size of atoms" (his dissertation), one on the Brownian movement, and a fourth which "lies at hand in drafts and is an electrodynamics of moving bodies that requires a modification of the theory of space and time."[26]

The new article was in fact called "Zur Elektrodynamik bewegter Körper" (On the electrodynamics of moving bodies). We now call it the Special Relativity paper. It is Einstein's best-known work, if not to scientists then certainly to the rest of the world; but the title Einstein chose for it was remarkably unrevolutionary. Paul Drude of the *Annalen der Physik,* who received it on June 30, would have found it very familiar, similar to eight other papers the journal had published in the past three years; but it would not have taken long for him to realize that the subject of this paper, like the one in March, was light. Possibly he and the other

editors wondered about Einstein's professionalism, for although the *Annalen* had a policy about not over-referencing other work, this paper cited only one experiment, offered only one acknowledgment to another worker in the field (Besso, of course), and gave no footnotes at all. Yet in it Einstein calmly walked his reader through a complete reorganization of the concepts of space and time. Redefining time so that simultaneity no longer had any meaning, and asserting that the maximum velocity and the only absolute in the universe was the speed of light in a vacuum, Einstein rewrote the ancient science of kinematics. Then he reconnected it with electrodynamics, the newest science of all, and eliminated the ether. Along the way, he solved several problems that had baffled some of the best physicists of the day and caused Poincaré's "crisis [in] the principle of relativity" to vanish.[27]

To explain the theory of relativity you need to imagine what Einstein called an "inertial frame of reference"—that is, something three-dimensional moving steadily. Actually you need at least two of these, because "moving" is not something one can do alone. To get them "moving" you need them to have different speeds or directions, because of the basic "principle of relativity" that nothing moves in any sense unless there is something else against which you can measure its motion (and vice versa). Einstein imagined three rigid rods at right angles to each other and joined together at one end like the x, y, and z axes of analytic geometry. What actual things Einstein had in mind when he came up with the theory that May we do not know—perhaps bicycles; but when he wrote a book to explain it to laypeople in 1916, he used a railroad car moving past an embankment.[28] To get the most startling results, the movement of the frames of reference with respect to each other should be very fast; by 1925, Russell's colleague Alfred North Whitehead was using automobiles.[29] Now we tend to use spaceships, as Paul Langevin was the first to do in 1911—a "Jules Verne projectile," he called it in French.[30] Once you have your spaceship—in relative motion with the moving earth—you must festoon it with clocks, because time, as Einstein pointed out in his paper, is what we measure with a clock and nothing more. The earth, as it happens, is already a clock—the standard, in fact, for all terrestrial clocks since long before 1905. With the imposition of railroad "standard time" in the 1880s, all those clocks had been synchronized in defiance of their local noons, which is one of the reasons a scientist would find it easier not to take earth-time for granted if, like Einstein, he had been born in 1879.

But, as Poincaré had elegantly demonstrated in his essay "The Measure of Time" in 1898, time was not material like a body. Time was not even as real as a field or a wave. Time was a mental construction, exactly like space. Measuring it was like measuring a dimension, the fourth dimension that writers like Edwin Abbott and H. G. Wells had been specu-

lating about since the 1880s.[31] Einstein had picked up this way of think-
ing about time indirectly from Abbott and Wells and directly from a line
of thinkers that stretches unbroken from the Hume and Kant he had read
as a schoolboy to the Poincaré, Mach, and Pearson he had read with his
friends in Bern.[32] Swiss chronometry aside, how could one guarantee that
all those terrestrial clocks would tell "the same" time? Telegraph signals
adjusted the clocks in railway stations to standard time, but telegraph
signals themselves took time. Electrical signals sped along at close to the
speed of light, but wouldn't that still be appreciable? Could anything go
faster? And what do we mean by a "fast" speed anyway, if not a certain
space divided by a certain time? How then could that time be measured?
Most importantly, how could time be measured in two different reference
systems when the distance between them was constantly changing? Was
it possible, in other words, to tell the time on vehicles moving at near
light speeds by an exchange of light signals?

During that intense talk with Besso, Einstein had seen the light. The
heart of his problem was the concept of time. Lorentz had been right
about the changes in length that were associated with a fast-moving elec-
tron—right, that is, about his famous "Transformations" and how they
translated the description of an event from one moving frame of reference
to another. All Lorentz had missed was that what he called the "local
time" of a moving electron was in fact the only time that could be known
in the electron's frame of reference. All other times were relative to it. To
send that local time to another place took time, the time it took was the
time to send a message, and the speed of the fastest message was the
speed of light. Simultaneity does not exist. If separated in space, two
events cannot possibly be simultaneous. The clock tower in Bern could
tell Einstein what time it was, but only the time in Bern. A telegraph
message could inform a John Hay in St. Louis of President Roosevelt's
time in Washington; but it could never tell him more than the time on
Roosevelt's clock when the message was sent, for all messages took time,
even over a telegraph wire.[33] And if St. Louis and Bern were not on the
same earth—if Bern and St. Louis were moving in different directions—
the time taken by a message would keep changing. This meant that the
time of every clock was a function of the distance between clock and
clock-watcher, their relative motion, and the speed of light.

How, then, could one tell the time on a moving spaceship or ex-
change that time with the time on another spaceship? Easy, thought Ein-
stein, now that he had found his key. Assume, he wrote, that the velocity
of light in a vacuum is fixed in such a way that it bears no relation at all
to the speed or direction of the light source. The velocity of light "c" is a
ratio of space (distance) to time, and it never changes, "it" being the
ratio—not the space or the time. If you hold c constant, and try to locate
an event on one spaceship in the space and time of the other, a new set

of equations results: the Lorentz Transformations, in which every other distance and time is modified by a mysterious factor, $\sqrt{1 - (v^2/c^2)}$, the square root of 1 minus the square of the difference between the velocities of the spaceships divided by the velocity of light.

The Lorentz Transformations take into account the speed and direction of light, which is, after all, the only thing you can use to locate the events. If it is only a particular velocity that is constant, it suddenly becomes understandable how everything else can begin to vary. Time depends on distance. Velocity, which depends on both time and distance, is always relative. Not only can lengths change, as FitzGerald and Lorentz had suggested, but time, too, can dilate, and even mass can wax and wane. It's because they all depend on how fast your reference system is going in relation to that particular velocity. Back in the cantonal cram school in Aarau, the sixteen-year-old Einstein had asked himself what would happen if he chased a light wave until he caught up with it. Would the vibrating field that Maxwell said produced the wave change shape? Would the wave stand still? Would the ether that supported the wave stop vibrating? For ten years none of these had seemed at all plausible to Einstein. The answer now turned out to be (a) light waves always went the same speed no matter how fast the source or the receiver was going; (b) no one could ever catch up to a light wave anyway because it was the limiting velocity in the universe; (c) there was no ether to vibrate; and (d) everything else in the universe could change except light.

Summer came to an end in Bern, but Albert Einstein's *annus mirabilis* was not yet over. Around September 25 he sent another paper to the *Annalen der Physik,* a very short one, in which he noted that the new transformation equations could be manipulated with simple algebra to yield the strange equation $m = E/c^2$.[34] "Does the Inertia of a Body Depend on its Energy-Content?" Einstein's title asked. It does indeed. More important, the energy-content of a body depends on its inertial mass: $E = mc^2$. One can give either one in terms of the other, and since the mass must be multiplied by the speed of light—twice—to get the energy, there are colossal consequences. Some of those consequences, Einstein suggested, could already be seen, like the radioactivity Becquerel had discovered in 1896, which the Curies had first named in 1898. Pierre Curie had found more heat coming from Marie's radium than any conceivable chemical reaction could release, and at St. Louis, exactly a year before Einstein's $E = mc^2$ paper, Rutherford and Poincaré had wondered how to explain it. Thirty-three years after Einstein's paper, the discovery of nuclear fission in Lise Meitner's laboratory in Berlin would show how mass could be deliberately converted to energy in microgram quantities. In another seven years came proof that that was more than enough to annihilate a city.

At the end of 1905 Albert Einstein knew he had had an astonishingly

creative year. He and Mileva hoped for recognition; but had to be content with a mention from Max Planck in the Berlin Physics Colloquium in November. Recognition would not come until 1909, by which time even Poincaré had become aware of what Einstein had done and universities, even in Zurich, were offering him professorships. World celebrity would come in 1919, when an eclipse provided astronomical proof of General Relativity. In an art where, as Karl Popper showed, excellence is equivalent to falsifiability, science paradoxically provides more opportunities than any other area of intellectual creation for long-term, nonsupersedable fame. By now ignorance has domesticated Einstein into a gently mystifying guru who learned from the stars, opposed war with everyone but Hitler, and refused an offer to be the first president of Israel. Nearly a century after Relativity, fewer people understand Einstein's law of gravity than could have understood Newton's law of gravity a century after Newton's *Principia*.

Einstein himself may have ended by misunderstanding what he had done. He thought of Special Relativity as a brand new epistemology, and so did many of his contemporaries in physics. To scientists at the end of the twentieth century, however, Relativity looks like a smooth development, evolutionary rather than revolutionary, from the precise investigations of electron physicists like Lorentz and the subjectivization of scientific metaphysics by the likes of Clifford, Pearson, Mach, and Poincaré.[35] Having found the relation between space-time and uniform motion and called it Special Relativity, Einstein found it natural to try to find out the relation between the space-time continuum and non-uniform (accelerated) motion. In 1907, "sitting in a chair in the patent office in Bern," he had what he remembered as "the happiest thought of my life," the realization that there was no objective way to tell the difference between being held against falling in earth's gravity and being pulled through empty space at an acceleration of 32 feet per second per second.[36] Years of mathematics would eventually turn this Machian insight into the General Theory of Relativity.

The paper Einstein called "revolutionary" in his letter to Habicht in May 1905 was not the relativity paper, but the photoelectric paper. Considering what we now know about the development of modern physics and the eclipse of what Poincaré had called "classical physics," Einstein was right. It was the photoelectric paper that founded the characteristic physics of the twentieth century, quantum theory, and won Einstein the 1921 Nobel Prize. Where Planck had quantized only the interaction of matter with energy, Einstein had quantized energy itself. In fully developed quantum theory the continuity of everything—energy, matter, motion, and even space and time—is always in question. Fields and particles give rise to each other, and matter and energy interact with each other in ways that run headlong into paradox and indeterminacy. These things

would continue to make Einstein uneasy, even as he continued to make contributions to quantum theory. In 1909 he would offer equations where expressions for waves and particles coexisted, and in 1924 he would even develop a statistical theory of the behavior of subatomic particles with whole-number spin. In the end, however, Einstein would choose the Maxwellian field over the Boltzmannian particle, the space-time continuum of his "Holy Geometry" over the birdshot in a box of materialist atomism. Rejecting statistical explanations as incomplete, he would yield completely to what can only be called his deep need for specific events in nature to have specific causes. The herald of twentieth-century physics would end his career in dogged efforts to restore a nineteenth-century paradigm.

16 PABLO PICASSO

SEEING ALL SIDES

1906–1907

In the early months of 1907, a twenty-five-year-old Picasso set out to remake the history of art. In Paco Durrio's old upstairs studio in the Bateau-Lavoir, he drew and painted studies of women far into the night. A candle flickered. By the wall stood his new blank canvas, eight feet high, sized and lined for a *succès de scandale* and a frontal assault on immortality. Everything in art would go into it; and (such was the hope of the most ambitious painter in Paris) all subsequent art would grow out of it. It would be called *Les Demoiselles d'Avignon* (Avignon young ladies), and the first people to see it would call him mad.[1]

The Laundry Barge, as Max Jacob had nicknamed it, the *Bateau Lavoir* had not changed in the five years since that long December discussion of Gauguin.[2] It was an anthill, unsupervised by its concierge, who lived, sensibly, in another building. Picasso had almost starved his first year there—1904, his first full year in Paris—when neither Mañach nor Vollard would buy his lugubrious blue paintings and they had to be sold through secondhand dealers like papa Soulier in the rue des Martyrs, or Vollard's grasping rue Lafitte neighbor, Clovis Sagot, who had once been a circus clown. In Picasso's studio, no more than four sticks of furniture, no running water, a bucket for a toilet. Along with a little rain, there was light; but Picasso had more convivial uses for his days, and painted after the sun had gone down.

Picasso himself had changed somewhat since 1902: some new friends, a mistress, a major shift in painting style, a slight improvement in income. His faithful friend, the gay poet Max Jacob, had been joined in 1904 by two more poets, André Salmon and Guillaume Apollinaire. He had also met two rival painters, the future fauves André Derain and Maurice Vlaminck. In the fall of that year Picasso had put the make on his neighbor, Fernande Olivier, beautiful as she drew water from the Bateau-Lavoir's only faucet, and he had stopped going regularly to the

whorehouse. In shades of pink rather than blue, late in 1904 or early in 1905, he had painted *The Actor* and begun what the art historians would later call his "Rose Period." By the end of 1905, Vollard had taken some of the pink pictures for sale, and at the junk shops lightning had struck—twice. At papa Soulier's, a young dealer named William Uhde had found *Le Tub,* all blue, and liked it enough to track the artist to his new hangout, the old Cabaret des Assassins in Montmartre, now named Lapin Agile for one of the pictures in its assassin gallery, a picture of a rabbit (*lapin*) signed A (for André) Gill. A little later an American with a prophetic beard who had also settled in Paris in 1904 had bought a Picasso at Clovis Sagot's, and had come back with his sister Gertrude to buy *Young Girl with a Basket of Flowers.* Like all Picasso's pictures by now, it had his name, the date, and his address on it. Soon Leo and Gertrude Stein too had come hiking up Montmartre to the anthill at 13, rue Ravignan, and to the threshold of the studio where, as the lady of the house, Fernande Olivier, once put it, "Despite the almost complete absence of furniture, you wondered by what strategies it might be possible to get in."[3]

By 1906 Fernande was receiving Picasso's friends, usually without warning; but now that some of them were patrons she could do it on the more princely budget of one or two francs a day. The lean years were over. Big things could be tried. In the spring, Picasso began portraits of Leo and Gertrude Stein; he finished Leo but was blocked by Gertrude. He went to the Louvre and saw the exhibit of primitive Spanish sculpture from Osuna. The heads were square, the ears schematized, the noses like quarters of cheese. He decided to spend the first real painting summer he had ever been able to afford in Spain, at the tiny village of Gosol—all terracotta, pink and white with angular roofs and one hotel. Fernande made him jealous, allowing herself to be seen in negligee, and one day he made a quick wash sketch of her, nude and sleeping, replacing her face with a hard-edged open-eyed mask. On returning to Paris in August, Picasso found his sitter again (Gertrude Stein was then working on something she called the "great American novel") and painted her once-blocked portrait at one fell swoop, together with a companion portrait of himself. The eyes were simple almonds, seemingly misplaced. Soon after, he made a large painting of two monumental nudes, using planes of color, like Cézanne. Something was definitely up. The simplified studies of women began. "I make a hundred studies in a few days while another painter may spend a hundred days on one picture. As I continue I shall open windows. I shall get behind the canvas and perhaps something will happen."[4] The summer of 1907 Picasso would spend in Paris, in the studio, alone.

Les Demoiselles d'Avignon has become the *Last Supper* of twentieth-century painting; and, like the *Last Supper,* it has become better known

than seen—loved, as it were, in effigy. It may not even be so good a paint-
ing, great though it certainly is. Few of Picasso's friends and allies men-
tioned *Les Demoiselles* (though they could easily have seen his obsession
with it) in the year it was made. In April of 1907 the huge canvas was
already obscuring a wall in Picasso's studio. It remained there, gurning
like Proteus, until 1908, when it was rolled up. Not until 1912 did anyone
describe it in print. Not until 1916 did a gallery put it on display. By that
time, however, it had long since done its work. Already in 1912 it could
seem to André Salmon that almost all Picasso's art and all the painting
of the Moderns had passed through his giant *Demoiselles* like the lines
through one of Paris's new telephone exchanges.[5]

By May 1907, as the masterpiece emerged, Picasso hid it from every-
one except the silent Fernande. He told his band of friends what its sub-
ject was and they began to refer to it as *The Philosophical Brothel*. It was
in fact a picture of prostitutes and clients from a house in Avinyo Street
near Picasso's former studio in Barcelona.[6] It was around May that Pi-
casso pushed out of the design both of the girls' customers, a sailor and
a medical student, moving them off-canvas to join us. Onlookers ever
since have been in the role of customer, under the riveting stare of five
giant prostitutes. Five figures make a major picture, five nudes a classical
one, but five whores make an outrage, particularly in 1907, and the dis-
appearance of the clients also removes from the painting the cautionary
tale of sin and disease that might yet have justified the shock. Picasso,
who had come to Paris years ago to see a very moral painting of his hung
in the Spanish pavilion, was now drawing on outrage to seize a place in
Western iconography.

A large canvas to a painter is like two or more volumes to a novelist.
It is hard to remember, in an age of constant out-of-scale reproductions,
the fact that each size blank is a completely different space for a painter
to encompass and master, like different pieces of marble for a sculptor;
the bigger the space, the harder it is to control both parts and whole. In
1907, even after the defeat of the official Salon by the impressionists in
the 1870s, big canvases meant high drama and many figures. Picasso
must have begun work on his much the way a general risks his army on
a decisive battle.

Picasso did not enter salons, but he knew his competition better than
many who did. It included the rumored final masterpiece in Cézanne's
series of studio oils of bathers, the huge *Large Bathers I* which the master,
dead the previous October, had left in his studio at Aix and now could
never surpass. It included the *Blue Nude* and the great *Joie de vivre* of
the young Matisse, whose dinners Picasso had been going to since the
fall. It also included another outsize *Bathers* by his friend André Derain,
shown at the Independants' Salon a couple of weeks earlier, in March
(and bought by the Steins), and Maurice Vlaminck's *Bathers*, now under

way in the nearby Châtou studio he shared with Derain. It probably even included Greco's *Vision of Saint John* from Picasso's Spanish past, and the famous houri-filled *Turkish Bath* of the dead classicist Ingres, which had been on show in the Autumn Salon more than a year ago, in 1905.[7]

That 1905 Autumn Salon, as any art historian will tell you, was one of the key exhibitions in the history of art. One notorious room had contained pictures so outrageously colored that they seemed to spit fire at a calm Renaissance-style bust left on the center table. "Donatello among the wild beasts (*fauves*)," critic Louis Vauxcelles had written; and from that point on Matisse, Derain, Vlaminck, Rouault, and even the little civil servant Henri Rousseau had been called fauves.[8] The illusionist expectations of the art audience, already considerably frustrated by Monet and Seurat about light and shadow, and by Manet and Cézanne on line and space, had been dealt yet another blow. From now on, as Gauguin had demanded in 1888, not even color would have to be "true-to-life."

Picasso was no fauve, and as a nonexhibitor he was a bit behind them in his career. If Fernande Olivier is any guide, his "palette" in the Bateau-Lavoir that May was old newspapers laden with muted oils. He had been painting not in "simultaneous contrasts," but in shades of blue and pink. He had learned, it seems, from Manet and Degas, from other impressionists, and particularly from Gauguin and Toulouse-Lautrec, but not how to splash on primary colors. The youngest painter who might seem to have influenced him in these early days was the strange Norwegian Edvard Munch, but though Picasso may have appreciated his subjects (Munch had by now completed a whole *Frieze* of pictures on life's miseries), he had yet to use Munch's cloisonnist forms.

Except for puddles of background blue, the colors of the *Demoiselles* were not primary and arbitrary like those of Derain and the fauves; but their application was. Picasso applied his expanses of flesh-tones as large patches, quadrangular and uniformly colored, placed right next to each other with transitions either factitious or nonexistent. In Derain's big *Bathers,* thick lines had separated vaguely anatomical parts from each other and bodies from their background. Picasso's lines were few and thin. To distinguish the leg of the "curtain-raiser" nude on the left, Picasso doubled the right edge of her flesh with a gratuitous inner seam of pastel blue, perhaps a boast to Derain—or to the spirit of Ingres, who had talked so exaltedly of "line."

Wrote Salmon:

> He created for it an atmosphere, by a dynamic decomposition of luminous forces; an effort leaving far behind the attempts of Neoimpressionism and Divisionism. Geometric figures—of a geometry at the same time infinitesimal and cinematic. . . .[9]

Indeed, Picasso's patches of color were not the pools of Derain (or of Gauguin, Sérusier, and Bernard before him), but the planes of Cézanne of Aix. At first glance, the women looked as if they had been constructed out of lozenge-shaped pieces of construction paper, like the houses in the shadow of Cézanne's Mont Sainte-Victoire. Seurat had found out how to break down a scene into visual atoms. Cézanne had found an intermediate level—molecules, if you will—of reflecting planes of color. Six months after Cézanne's death, Picasso showed that this, his strangest discovery, had finally been taken in. Only Paula Modersohn-Becker, who was to die three months after the *Demoiselles* was finished, had been, in portraits and still lifes of the last two years, so close to the same realization.

Picasso had also learned another tactic that Cézanne had taken from the dean of modern painters, Manet. Flatten and lower the foreground, strain the composition by making the relationships of figures work against their placement in the design, and above all pierce the lies of artificial perspective. As Cézanne had laid his mountain on top of a village, and Manet had shoved his audience into a small sailboat, so Picasso threw his onlookers into the whorehouse.

Seven feet tall, the five women confronted Picasso in June. He would allow no one to see the work at this stage. Above the schematic bodies he had painted faces of absurd simplicity. The eyes were almonds with circles in them, the mouths simple slits, the ears figure-eights, the noses nothing but one-line arabesques, left-right-left, extensions of an eyebrow. A child might draw like this—or a fourth-century Spaniard from Osuna. Picasso now had in his studio two of those Osuna stone heads, stolen from the Louvre by a crony of Apollinaire. But what was the point of trying to make something from the high tide of Western progress and guiltless domination of the world look like it had been made by provincials during the decadence of ancient Rome?

Gauguin, buried in Tahiti, would have understood. Where the fauves raided Gauguin for color, and celebrated the 1906 retrospective of his work, Picasso rediscovered the symbolism, occultism, and primitivism that Gauguin himself had thought central to his achievement, and trembled. Picasso had never been anything but a respecter of the strange and the dark. He was Spanish; positivism and materialism had never claimed him. He would have feared death no less if he had believed in Hell. The strangely familiar quality of unfamiliar symbols among "Primitives" (the name then covered any art that came from non-Western cultures, and everything in Western art that came before the Renaissance), and the simplicity of their conventions, had attracted him from the beginning, as attested by many blue allegories and pink acrobats. The *Demoiselles* was no joke. The simplicity of the women's faces was meant to work like an icon or a fetish, and it did.

Sometime around the end of June, Picasso took a break. Leaving Montmartre for something other than Saturdays at Stein's or Thursdays at Matisse's, he visited the sculpture museum at the Trocadéro Palace, across the Seine from the Eiffel Tower. On leaving Picasso chanced to try the facing door to the Ethnographical Museum. "There was no one there, just an old custodian. It was very cold; there was no fire. Everything was verminous and moth-eaten; the walls were covered with turkey twill."[10] Then suddenly he was overwhelmed by a roomful of tribal masks.[11] At that moment he knew that whatever the Osuna sculptures were, the carvings from French West Africa were more so.

He had seen them before, though not in such spellbinding numbers. Vlaminck had bought a couple, including a Fang mask, from a dealer in bric-a-brac. He had passed one on to his friend Derain. Matisse had begun collecting them no later than 1906. In distant Dresden, Ernst-Ludwig Kirchner had been amazed by them in the year before he founded the Brücke artists' movement in 1905. In the Trocadéro Museum, smelling of dust and decay, Picasso instantly saw what these objects had been for their makers. Talismans and magic things. Fetishes against fear of the unknown. Gods.

He returned to the Bateau-Lavoir and made more studies. "His eyes widen, his nostrils flare, he frowns, he attacks the canvas like a picador sticking a bull."[12] He painted out the faces of the two prostitutes on the right of the canvas, replacing them with terracotta masks. On them he painted ski-jump noses, shadowing them with striations like tribal scars. On the upper face he left one almond eye an open black pool and outlined the other with red-orange. Adding striations of blue and green to the nose, he doubled them below in the shadow of a rectangular left breast. On the lower face, he darkened the white of the left eye and dropped and canted it weirdly below the right. The left ear began to resemble the skinned leg of a hapless animal. The painting that had begun as an assault on convention was now an assault on the supernatural, a Gauguin enigma using symbolic and evocative elements simpler and starker than even Gauguin had been able to marshal. It was, he said to Malraux long after, his "first exorcism painting."[13]

Exorcism of fear, or inspiration of it? Probably both. Fear both spiritual and material. Picasso, habitué until recently of Paris whorehouses, knew that syphilis was a silent, recurrent menace. He could not have forgotten the debate on the regulation of prostitution that had enlivened Paris in 1900, or the sight of women deformed by tertiary syphilis during his visit to the Hôpital Saint-Lazare in 1901.[14] In the Morgue behind Notre Dame cathedral, there had been regular public viewings of the bodies picked up by the police, until the Prefect of Paris stopped them in mid-March 1907. He knew the disease had helped kill Gauguin himself in 1903. *Les Demoiselles* is Picasso's "Heart of Darkness" and like it, a

token of having struggled with the deep temptation of barbarism. It is not, like Gauguin's *Where Do We Come From? What Are We? Where Are We Going?*, a token of having surrendered to it.[15]

But Gauguin was dead. Other symbolists survived, but their day seemed past. In Paris, the Nabis Bonnard and Vuillard showed paintings at the Indépendants. Sérusier taught his color theory and brought out *Talisman, The Bois d'Amour* for special friends. Maurice Denis still wrote exaltedly for *L'Occident*. Félix Fénéon was still the chief art critic for the symbolist flagship, *Revue blanche*. Even the Tuesday meetings of Mallarmé disciples at the Closerie des Lilas were still going. Salmon occasionally took Picasso there to hear Moréas and Paul Fort hold forth, and none suspected that this large-eyed little man on their outskirts was lifting the symbolist legacy from under their noses. Brought to see the *Demoiselles* a month or so after its completion, Fénéon, the discoverer of Seurat, could only drop a hand on Picasso's shoulder and say, "Interesting, my boy. You should take up caricature."[16]

Not for nothing had Gertrude Stein taken to calling the five-foot three-inch Picasso "little Napoleon." The *Demoiselles* had, without ceasing to be original, pulled in almost everything new since the attack on chiaroscuro had begun in the 1870s: the primitivism and symbolism of Gauguin, the counterintuitive perspective and flatness of Manet, the volumetric color planes of Cézanne, the disconcerting color of the fauves, and the modern low-life subjects of everyone from Manet to Toulouse-Lautrec. Everything was there except divisionism, which Picasso had dabbled with and dropped; and the predecessor of them all, *plein-air* impressionism, to which Picasso had always preferred the more subjective air of the studio. Picasso had encompassed everything. It remained only to see whether a picture so widely based on the latest thing could possibly lead to anything new.

In July, the painting was more or less finished. It stood deep in the ramshackle studio, ready to receive visitors like real *demoiselles*. The first were his oldest cronies, Jacob, Salmon, and Apollinaire. They joked about the painting and nicknamed it. Apollinaire even described it tactfully as a "revolution," but clearly it was a revolution for which his poetic heart was not ready. Indispensable patrons came next, and they were pretty discouraging. Leo Stein came and felt assaulted. Was Picasso painting the fourth dimension? Leo's final judgment, in his memoir of 1947, was that the painting was just a "horrible mess."[17] Gertrude Stein remained loyal, breaking with Leo, but she said nothing at all. The Russian collector Sergei Shchukin, introduced to Picasso by Matisse in 1908, thought, "What a loss for French art."[18] (What a loss, in fact, for Russian art, which had to wait several more years to see Picassos.)

Painters took sides. Montmartre buzzed with the rumor that Picasso was mad. Matisse was overheard by Picasso himself saying that the paint-

ing was an effort to ridicule modern art, and a betrayal.[19] Derain was quoted as saying the thing was "a desperate enterprise" and that Picasso would soon be found a suicide, hanging behind it.[20] In fact it was Derain whose career would be ruined by the picture; he would later be found burning many of the works he had done in its shadow over the next year.

Dealers showed more promise. Vollard came by and soon after pronounced Picasso finished as a painter; but Uhde was interested and told a new young dealer named Daniel-Henry Kahnweiler that Picasso was painting "something Assyrian" and to go and see it.[21] He did, arriving just as Vollard was going out the door, and Kahnweiler, with his readier eye, became one of the first to really see what had happened to the strangest of the *Demoiselles*. Squatting with a vulgar spraddle in the bottom right of the picture was something unique. No matter how closely you looked, you could not tell whether she was facing in or out. Was her chin resting in her right or left hand? Or was it rather supported by some weird prosthetic device? Was that her buttocks you saw below the small of her back, or something even more shocking below her navel? Or was it both? You could not tell. Looking back on this *Demoiselle* seven years later in his history of the rise of cubism, Kahnweiler saw that she had been the first of all figures in Western art to have been painted from all sides at once.[22] Quickly, Kahnweiler made an offer. He bought most of the preliminary studies, but Picasso insisted that the *Demoiselles* was unfinished. He would not sell.

Those who saw the painting were still few, but they all had good eyes, and the *Demoiselles* acquired more and more of a reputation. In November, Matisse took a young Norman painter named Georges Braque to see it and he was speechless. "But Braque," said Picasso, "noses are like that." Braque finally blurted out, "Your painting, it's as if you wanted us to eat tow and drink kerosene in order to spit fire."[23] But Braque was hooked. That winter, he tried to assimilate what he had learned from it by painting an oversize *Large Nude* with schematic features and striated shading. In the summer of 1908, he went to l'Estaque, Cézanne country, and found himself turning the old village motifs into simple irregular solids and sliced-off parallelepipeds.

That fall, when Braque and Picasso compared what the one had done at l'Estaque with what the other had done at La Rue-des-Bois near Paris, they discovered that they had jointly become the inventors of a new method of putting three-dimensional reality on two-dimensional surfaces, the first entirely new method since the Renaissance. The method was not at all mystical, however disconcerting the results. You took the motif, looked at it from several opposing points of view, divided the results into volumetric planes, and painted these planes in the place of the subject so that they interfered with each other. The viewer who wished to could reassemble the planes and reconstruct all of the original points

of view (preferably not sequentially, but simultaneously). In other words, you treated a subject exactly as Picasso had treated the squatting prostitute in the *Demoiselles d'Avignon.*

Picasso and Braque so loved their new method that they began to work together, and the time came when you could look at a picture and not know which one had painted it. In 1908 Matisse, who didn't like Braque's pictures, said they were full of "little cubes." In 1909 Louis Vauxcelles, who had coined the term "fauvism" four years before, struck again by calling Braque's paintings "cubic bizarreries."[24] Cubism was not the best name, and still prevents newcomers to the style from discerning the nature of the revolution it made. In effect, Picasso had done for art in 1907 almost exactly what Einstein had done for physics in his "Electrodynamics" paper of 1905. Fiddling with what people meant by "simultaneous," Einstein had ended by concluding that light's speed alone was absolute, and that every other measurement could vary in relation to it. No observer had a privileged point of view, and observations even from several points of view were not enough to make reality determinate or "objective." Similarly, Picasso had pictured the fifth *Demoiselle* from two diametrically opposed points of view simultaneously, which not only exploded the Renaissance convention, but also undermined a whole series of the conventions by which we represent simultaneity in an art object that doesn't move.

Cubism, the new perspective, not only represents the final breaking of both the painting and the world into discrete parts or atoms; it also opens the way to recombining those parts in new and startling ways. As we shall see, only four years after the *Demoiselles,* as cubism conquered the exhibition halls, Picasso and Braque were to show how to combine the parts of a painting on the same canvas with parts of the world. They called it collage. In the same years, the futurists would discover how a moving object can be painted on a single canvas not only from several points of view, but also at several different times. Having done something like this already, Marcel Duchamp would go on to see how to represent movement in a fifth (spatial) dimension beyond the old three of space and one of time. The expressionists would take up Gauguin's task and discover how to represent the world of feelings with more or less conventional combinations of the parts of a painting. Finally, Čiurlionis, Kupka, Kandinsky, Delaunay, and Mondrian would discover how to start with nothing more than the pure parts of a painting and use them to represent parts of the world that cannot be seen at all.

In November 1908, Picasso rolled up the *Demoiselles d'Avignon,* and he and Fernande cleared the studio for a grand dinner. The guest of honor was to be the funny little man with the long mustaches who may have been the only painter in Paris with plans as big as Picasso's, the *douanier* Henri Rousseau. Braque was there, and André Salmon, and the eternal

Max Jacob. Gertrude Stein came, together with her lover Alice B. Toklas. Apollinaire came with his mistress Marie Laurencin, whom Rousseau had delighted and amused by painting their portrait as *Poet and Muse*. There were also the Ageros, the Pichots, the Fornerods, Montmartre friends and painters. Toasts were proposed, much was drunk, some sang, some reeled, some feigned madness, some fell asleep. Apollinaire stood with great ceremony and read a long celebratory poem as wax from the candle above built up on Rousseau's forehead. A donkey wandered in and ate Stein's new straw hat. Picasso, who had already bought Rousseau's *Portrait of a Woman (Yadwigha)* and had a yen for *Sleeping Gypsy*, stifled a chuckle as Rousseau, serene amid chaos, pronounced judgment on his great rival. "You and I, sir," he said, "are the two greatest painters of our time. You in the Egyptian style, I in the modern."[25] History has reversed his verdict.

17 AUGUST STRINDBERG

STAGING A BROKEN DREAM

1907

A little after eight o'clock on the evening of April 17, 1907, inside the thirty-year-old Swedish Theater in downtown Stockholm, the house lights dimmed. The curtain rose on the planet Jupiter shining against the constellations of Leo, Virgo, and Libra through a backdrop of cloud formations painted to resemble ruined castles. On one cloud stood Harriet Bosse, the third wife of the play's fifty-eight-year-old author, playing the lead. In her opening lines, she called on her father, Indra, the chief of the Hindu gods, to tell her where this low and stuffy part of heaven was that she had gotten lost in, and the voice of Indra, offstage, answered "you have departed and are entering / the dusty atmosphere of earth." Moments later, after a year of theatrical time, Bosse in her character as Indra's Daughter was standing before a fantastic castle growing steadily out of a pile of manure and crowned with a gilt roof and a huge chrysanthemum bud—a metaphor for life. Thus began the world premiere performance of *Ett Drömspel* (A dream play), by Bosse's ex-husband, Johann August Strindberg, the exasperating Swedish genius who has today the strongest claim to having brought Modernism to theater.

A curtain going up anywhere seems an easy moment to freeze in time. Strindberg himself, who never went to openings, was at home at 40 Karlavägan in Stockholm, writing a letter to his German translator. At number 13, rue Ravignan in Paris, Picasso was preparing the huge canvas for the painting that would become the *Demoiselles d'Avignon*. At number 8, Helblinggasse in Vienna, twenty-one-year-old Oskar Kokoschka, in love with Lilith Lang, the sister of a fellow student at the State Arts and Crafts School, was printing anguished figures of naked adolescents in black, white, and red. He was also writing his second play—a single, symbol-freighted scene called *Murder, The Hope of Women* that would

earn him the label "expressionist" when it was produced two years later at the summer Kunstschau exhibition.

"Parallel action" is what filmmakers called that when they took it from Modernist theater. It involves "cutting" back and forth between scenes understood to be taking place simultaneously either in the world or in the mind, and Strindberg's *Dream Play* was full of it. There were sixteen identifiably separate scenes in it, in several sequences "intercut" with each other and with elements repeated often enough to loosen the audience's whole sense of time and place. The scenes seemed at first to have no order, then the order of hallucination. When everyday reality did appear it was displaced and truncated, unsettling rather than reassuring. In the nineteen distinct sets for *A Dream Play* the same props appear again and again, including a gate, a billboard, a bed that doubles as a tent, a linden tree that becomes a hatrack and a candelabra, and a door with a four-leaf hole used in three different ways. The advantage Strindberg took of the basic drama in a scene's opening became Modernism's way of doing most of what it has done to theater. He designed the scene changes in *A Dream Play* to be so abrupt that when Victor Castegren, the Swedish Theater's director, was unable to execute them as Strindberg had planned, by projecting them on scrims from behind with magic lanterns, the playing time was lengthened by the better part of an hour, and some of the elements became, as he put it, "too tangible for the Dream Image."[1] The opening night audience liked it, but subsequent audiences were bewildered and the play closed after twelve performances.

Kokoschka's plays, like his paintings, were expressionist from the start. Strindberg's expressionism came at the end of his playwriting career, in *A Dream Play* and its successors, *A Ghost Sonata* and the other one-acters he called "Chamber Plays." He had begun in the 1870s as a romantic, an epilogue to the age of Victor Hugo. Late in the 1880s he had turned himself into a realist, then a naturalist, a Zola of theater and the heir to Ibsen. Finally, in 1898, as the old century was drawing to its close, Strindberg began to write the plays that have made him a Modernist, the man Eugene O'Neill called

> the precursor of all modernity in our present theater . . . among the most modern of moderns, the greatest interpreter in the theater of the characteristic spiritual conflicts which constitute the drama—the blood—of our lives today.[2]

Strindberg was ten years older than Freud, born when the nineteenth century was not yet half over. He died when the twentieth century was only twelve years old; but all through his life he seemed to see the new century somehow projected on his brain. Before the Chat Noir was founded, in 1879, Strindberg was learning how to make mad monologues by translating the works of Mark Twain. When Laforgue and Kahn were

just beginning to write in 1883, Strindberg was writing rhymeless verse in Paris and sending it to Stockholm to be published. When Freud was giving up on cocaine and turning to hypnosis in 1887, Strindberg's essays on hypnotic suggestion were appearing in Vienna's *Neue Freie Presse.* When Gertrude Stein, Joyce, and Schnitzler were children in 1890, Strindberg was working passages of interior monologue into his latest novel. Some time later he posed for his friend Edvard Munch after Munch's first show, and wrote a catalogue essay for Gauguin's last show; and after that he sold a few of his own paintings, landscapes in a style that paid homage to both and looked forward to the expressionists. After World War II, one critic was comparing him to an early-warning seismograph. Where had he come from?

The shortest answer is Sweden—specifically, Sweden's capital, Stockholm. Though he spent more than a dozen years of his productive life in self-imposed exile and always thought of Paris as the place to make a career in theater, Strindberg had returned to Stockholm for good in 1899. His *Dream Play* premiered in the same city in whose center he had been born in 1849, a backwater European capital of less than 100,000 people where the king's palace and the Royal Dramatic Theater (then the only theater in town) were still set about with windmills, dirt roads, cow pastures, tobacco patches, and open sewers. His mother, as Strindberg never tired of reminding his readers, had been a housemaid; but his father, a shipping agent, had done his best to give him a first-rate education. When he dropped out of college it was in order to get back to Stockholm, and it was in Stockholm's Royal Dramatic Theater that the twenty-year-old Strindberg, who until then had seemed destined to become a schoolteacher, had his first brush with his future vocation. In September 1869, he presented himself as an actor and was given a single line to say in Bjørnstjern Bjørnson's costume drama, *Mary Stuart in Scotland,* plus a role in the next production.[3] They fired him in November. It seems likely that even then what he wanted to be was a playwright, because he had already written his first play before the axe fell, and four days later he had written another.

This set a pattern for Strindberg, who wrote the fastest of all the twentieth century's literary geniuses, and who never embarked on a project without thinking of whose face it would be flying in. In the next two years two plays, *In Rome* and *The Outlaw,* were accepted for production by the Royal Dramatic Theater. *In Rome,* written while Strindberg was briefly reenrolled in college, ran for eleven performances, and Strindberg was hooked, his quest for a diploma at an end. Although he failed to get his next play, *Master Olof,* produced by the Royal despite three rewrites, and although he subsequently bloomed as a journalist, a novelist, a poet, and a short story writer, he kept on concocting plays. Two of them he managed to have produced at the Royal in 1880 and 1900, and the city's

second theater, appropriately named the New Theater, produced *Master Olof* in 1881. The New Theater, eventually renamed the Swedish Theater, put on three of Strindberg's plays in the 1880s, and three more, including *A Dream Play,* in the years 1900–1910. Swedish stages were polar in Strindberg's personal life as well. The first woman he married, Siri von Essen, was an actress who played Margaretha in his *Secret of the Guild* at the Royal Theater in 1880. The third woman he married was Harriet Bosse. He had fallen in love with her in the fall of 1900 when she was rehearsing The Lady in *To Damascus I,* in the same Royal Theater. Backstage at the Royal, Strindberg had waited for Bosse in front of a door with a four-leaf hole—the same door that appeared seven years later in so many guises when *A Dream Play* premiered at the Swedish.

A *Dream Play* did not pack them in, but it did have a respectable run, which in 1907 was more than five performances. Its success was the latest of several encouragements for Strindberg. In the previous banner year of 1906, two of his proto-expressionist mystery plays had been produced for the first time—*The Crown Bride* (1901) and *Easter* (1900), both in Helsinki. There had been revivals of his early play *The Secret of the Guild* (1880) and the newer guilt fantasy *There Are Crimes & Crimes* (1899) in Stockholm, and one in Munich of the realist *Comrades* (1886–88). His great naturalist play of 1888, *Miss Julie,* had at last been seen in Sweden and had reached as far as Russia. England had just seen its first Strindberg, as *Simoom* (1889) and *The Stronger* (1889) were produced in London. The death of Henrik Ibsen had removed a rival from the scene. Nor could Ibsen, whose last words had been "On the contrary . . . ," make any objection to expressionist versions of his great naturalist masterpieces being presented in 1906 by Max Reinhardt in Berlin, Vsevolod Meyerhold in Saint Petersburg, Gordon Craig, the English set designer, and other theater artists of genius. Looking back on it from the end of the century, Western theater seems to have been poised in 1907 for the final thrust into phenomenological space that Strindberg's *Dream Play* gave it.

It is hard to imagine now how success in the theater worked in nineteenth-century Europe and America without drawing analogies to movies or pop music performances. Now that the pop is almost gone from theater and only the art remains, it seems incredible that Mark Twain was better known (and better paid) as a reader-performer and playwright than he ever was as the author of *Huckleberry Finn.* For authors who did not perform, a successful play made one's name as well as a novel did—or better. Somerset Maugham reached what his contemporaries all thought of as the top of the heap when he had four plays running at once in the West End of London in 1908. In 1895 Knut Hamsun, after publishing several pioneering—and successful—novels, turned to the theater to increase his reach. In the same year, Henry James met his

greatest disappointment as a writer with the failure of his play *Guy Domville.* Success in the theater was the early dream of Robert Browning, Stéphane Mallarmé, Franz Kafka, and, as we shall see, James Joyce. And what was success? Arthur Schnitzler could attain it by having a play run more than ten performances. More than twenty performances in the same run at the same theater made a smash hit. Two or more plays with runs of a dozen performances made the playwright a celebrity. Productions of translated works outside the playwright's own country brought something that could seem like immortality.

The plays of the nineteenth century's immortals do not look like they have legs today. We know of some, like *Ben-Hur* and *Around the World in Eighty Days,* only because they were subsequently "remade" as movies. Others are remembered only through a line or two, like *Rip Van Winkle,* which ran for nearly a century and made Rip's greeting, "Live long and prosper!" unforgettable. Many of the most celebrated authors have been completely forgotten, like Sardou and Scribe, or remembered only for the name of a theater, like Belasco, or an opera libretto, like Halévy. Even some of Strindberg's plays are dated, like *Erik XIV, Charles XII,* and *Gustav Vasa,* cast in the old late romantic history form. The plays of Anton Chekhov have survived, and indeed prospered, but not because of their careful plots, realistic sets, and plausible continuity. Plays old and new may survive as classics when their fashions change, but not these. What sank the old plays was a series of changes of extraordinary magnitude—changes we may call Modernist because the German word *Modernismus* made its debut as a label for the first change, and because the meaning "Modernism" eventually acquired is linked to theater even now.

As Strindberg himself defined the new meaning of "Modern" a year after he wrote *Miss Julie* and joined the movement, theater is "Modern" when it comes out of realism or naturalism. Modern theater tells the unadorned truth, the kind of truth Zola had told in the play he made in 1873 out of his first successful novel, *Thérèse Raquin.*[4] To be Modern, theater must consist not of historical tableaux, romantic melodramas, actors' showcases, or "well-made plays" by decadent farceurs, but plays that reach individual psychologies, and the basic power relations of modern social life, perhaps with a touch of the radical's zeal. Molière might do, but Sardou was merely "claptrap," as George Bernard Shaw called it in 1895, "a high modern development of the circus and the waxworks."[5] Dialogue should be rough-edged, as it is in real life, and plays should be shorter. As for scenery and stage business, they could get in the way more often than they helped, as Shakespeare himself had known.

Strindberg was hardly the first Modern playwright in this sense. That distinction belonged to Ibsen, a literary genius who burst upon the Western world, like Munch and Hamsun, from Norway, an improbably dis-

tant province ruled by Sweden with a language derived from Danish. More than twenty years older than Strindberg, Ibsen had made his reputation with verse dramas and costume historicals; and then, beginning quite suddenly with the publication of *The Pillars of Society* in 1877, he abandoned the old forms for twenty years. Instead he produced a succession of tragic plays set in the ill-lit rooms of middle-class houses and written in a prose that shunned the old exaltation but seemed to approach poetry by the back door. The most "Modern" of them all (that is, the most scandalously realistic) were *Ghosts* (1882), about trying to hush up adultery and syphilis, and *A Doll's House* (1880), the subject of which was female dependence, and which included the emblematic line, spoken by the newly liberated Nora, "this is the first time we two, you and I, husband and wife, have had a serious conversation."[6]

Others soon followed Ibsen into the field of what might be called the "well-made realist" play. The German Gerhart Hauptmann caught the public eye in 1889 when the birth scene in his play *Vor Sonnenaufgang* (Before sunrise) scandalized the audience at Berlin's Freie Bühne (Free stage). Strindberg arrived in 1887 with two plays called *Kamraterna* (Comrades) and *Fadren* (The father), about sex, power, couples, and doomed relationships. He was discovering Nietzsche, and having concluded that life belonged to the stronger, he tried not to fall too hard for Ibsen. Strindberg never met Ibsen, and eventually became his greatest rival, but in his autobiography he described how excited he had been by Ibsen's early play, *Brand*, and in a private letter he admitted how much he continued to admire *Ghosts*. "And yet, it's true, he wrote *Ghosts*. I musn't hate him. No. I'll follow his example and become a Moses on the mountain."[7]

On the other hand, Strindberg hated *A Doll's House* from the moment he read it. He could share Ibsen's political radicalism, his heroic materialism, and the moral elitism both playwrights had learned from Nietzsche; but Ibsen's putative feminism outraged him. Though the feminist movement was very strong in Scandinavia, where some women got the vote in 1906, long before any in Britain, Germany, or the United States, Strindberg thought it unnatural. In his experience almost all the relationships of men and women were power struggles men like himself might lose. He thought men made a greater sacrifice in marrying than did women, the sex whose destiny was entirely shaped by its ability to bear children. In his view women should have careers; but that to skimp at all on child care was no better than to abandon one's offspring. Sir Bengt's wife, in Strindberg's play of that title (1882), had been a reversal of Ibsen's Nora. All the stories in Strindberg's short story collection *Giftas* (Getting married) (1884–86) had been on this theme, and one, called "A Doll's House," was paired with a preface that specifically targeted Ibsen. Nietzsche, fresh from publishing *Zarathustra*, was much impressed by

Getting Married, and later when Strindberg wrote to him they found they were both antifeminists and believers in the Overman.

Strindberg's animus against Ibsen would be more amusing if its implications had not become all too clear later. In general no other art form has been more constantly concerned with the re-gendering of the world and the changing role of the sexes in twentieth-century society than has theater, and it is a fact that Strindberg and Kokoschka launched the expressionist theater with plots that specifically attacked twentieth-century feminism.[8] Ibsen dealt with the rivalry more generously. He read Strindberg's *The Father* soon after it was published and praised it as potentially "shattering" on stage.[9] He described Strindberg as "my enemy," but in 1895 he bought a painting of him and hung it on the wall of his workroom for inspiration.[10] In a speech he gave in 1887, Ibsen relinquished the leadership of his art to those like Strindberg whom he suspected would take it much further. "I, on the contrary, believe that the time in which we now live might with quite as much reason be characterized as a conclusion and that something new is about to be born."[11] At the same time Strindberg was asserting that Modernism had all begun not with Ibsen, but in a "new theatre which under the name of the Théâtre Libre practises its craft in the heart of Paris."

On March 30, 1887, André Antoine, a clerk at the Paris gas company, had opened a theater at 37, passage Elysée-des-Beaux-Arts, just off the Place Pigalle in Montmartre. The amateur actors of the Cercle Gaulois dramatic club had put in its 343 seats, and Antoine had financed it mostly with his own salary and savings, carting furniture for sets from his mother's house and rehearsing the first season in a wine bar billiard room while he waited for the theater to be completed. The Théâtre Libre (Free theater), as one of Antoine's playwrights dubbed it, was an alternative to both commercial and state-subsidized theater that was then new in Europe and has since become the mother of experimental theater anywhere off Broadway.

Even more revolutionary than its finances was its repertoire. The fourth and last play presented on that opening night, a one-acter about working-class radicals set in the backroom of a butcher shop, brought down the house. To match the slice-of-life plot and the raw dialogue, there were bloody sides of real meat hanging from the walls. "Naturalism," the ultimate realism, had reached the theater at last. Paris newspapers, always alert to the arts, noticed immediately. In Copenhagen, *Politiken's* critic, Edvard Brandes, read the review in the Paris *Figaro* and sent it on to his friend Strindberg, who went wild with excitement. He had just finished *The Father,* and he knew that what he was writing was what Antoine was producing. Paris performances meant a lot to Strindberg. He knew how venturesome they could be from the time he had lived in Paris, first in 1876 and again in 1883 when the original parody caba-

ret, the Chat Noir, was two years old. When *The Father's* success in Co-
penhagen was followed by failure in Stockholm in January 1888, Strind-
berg's response was to send it to Antoine and sit down to write another,
even more shockingly realistic play. By August he had finished *Miss Julie*,
and was making plans to use it to set up a Free Theater of his own in
Stockholm or Copenhagen.

Miss Julie remains today the most concentrated example in the reper-
tory of the first step in the development of Modern drama—the move to
naturalism. Strindberg was well aware of its importance, and commended
it to his publisher as "the first Naturalistic Tragedy in Swedish Drama
. . . this play will go down in the annals." [12] An intense one-act tragedy of
a noblewoman who makes love with a servant and destroys herself, it has
all the elements of the new esthetic: simple sets, colloquial dialogue, and
the sustained illusion of ordinary life. Strindberg, however, went further
than Zola, Ibsen, or even the playwright-protégés of André Antoine. As
he explained it in the play's preface, he had deliberately broken the per-
sonalities and motivations of his characters to pieces so he could put
them back together again in a way that would seem more real:

> This multiplicity of motives I would like to boast of as being modern. If
> others have done it before me, then I congratulate myself for not being
> alone in respect of these "paradoxes" (as all new discoveries are called). . . .
> My souls (characters) are conglomerations of past cultures as well as pres-
> ent ones, scraps from books and newspapers, fragments of mankind, torn-
> off samples of Sunday-best clothes that have become rags, just as the soul
> is patched together. . . . As modern characters, living in an age of transi-
> tion, an age more restless and hysterical at any rate than the preceding one,
> I have portrayed them as unstable and split, as a mixture of the old and the
> new! . . . The dialogue therefore meanders around supplying themes in the
> first scenes, which are then developed, taken up, repeated, expanded, aug-
> mented like the themes in a musical composition. [13]

He was right about this mixing and matching of slices of life. It was
the essence of what was to become the ultimate Modernism of composi-
tion. Eventually Strindberg would figure out that he could do this kind
of mixing and matching with scenes, and thereafter it would be only a
matter of time before he would discover how to mix in slices of what
happens only in memory or imagination—the discovery we now call the-
atrical expressionism.

Before he could make this discovery, however, he had to lose his
mind. This happened after he lost his second wife, Frida Uhl, who parted
from him in Paris in 1894. For the next two years, mostly in tiny pensions
in Paris's Left Bank, Strindberg made gold, tried to prove that the sun
was not round and sulfur not an element, wrote treatises on chemistry,
studied the world of spirits, was jolted from sleep by "electrical dis-

charges," and exasperated everyone who knew him with what most of them called "persecution mania." We don't know just what happened or how, though many books have been written about it, including one by Strindberg himself called *Inferno*. All we can say is that whatever humor we might see in it, Strindberg saw none. In fact, one of his closest friends reports never having heard him laugh. On the night of December 11, 1896, when Alfred Jarry's *King Ubu* opened with a shouted "Merdre!" in Montmartre and inadvertently launched the theater of the absurd, Strindberg was in his room at the other end of Paris writing a sentimental letter to his two-year-old daughter Kerstin about how he looked in bicycle socks.

It might have been paranoid schizophrenia, except that he always seemed to recover from his periods of real delusion. Perhaps it was a chemically caused psychosis, since hardly a day went by that Strindberg was not heating mercury, lead, zinc, sulfur, phosphorus, iodine, and other toxic chemicals in his tiny rooms. When he first checked himself into a hospital in January 1895, his most immediate complaint was that the skin of his hands was black, cracked and bleeding. Recovery did not fully begin until Strindberg had left Paris to consult a doctor in a seacoast village in Sweden; and as he slowly came to his senses during 1897 and 1898, he concluded that the only way to understand the whole experience was as a religious conversion. He had been put, he thought, through a personalized Purgatory constructed by God with the help of the spirits of the departed. It all had meaning, from the ominous shape he saw in his pillow to a door with a four-leaf hole in it. Material events and his own experiences had been used to wean him, through suffering, from his old ambitions, from positivism, materialism, and the Nietzschean ethic of the stronger—that is to say, from the intellectual fashions of the nineteenth century. As he put pen to paper to write his first play in six years, this occult personal redemption became its theme, and the result was Part One of *To Damascus,* the play Harriet Bosse starred in in 1900.

Some critics labeled *To Damascus* and most of the other post-Inferno plays, including *A Dream Play,* as symbolist, belonging to a new style of drama pioneered by Villiers de l'Isle-Adam and Maurice Maeterlinck in the *fin-de-siècle* and given the same label as their friend Mallarmé's poetry. Villiers was a man of one masterpiece, *Axël,* published in 1885, which was finally performed posthumously in 1896. Maeterlinck was a Belgian who had gravitated to Paris at about the same time as Strindberg to make a name for himself in literature. His best-known play, *Pelléas et Mélisande,* had received its first performance there in 1886, and became so celebrated that (as we shall see) no less than three of the pioneer Modernist composers set it to music. *Pelléas* is a fairy tale about a knight and a naiad, unmistakably romantic in everything but the way it substitutes figures of speech for the histrionic and rhetorical excesses of the old ro-

manticism. Set in a vague Middle Ages, *Pelléas*'s great novelty was a met-
aphorically allusive and elliptically discontinuous prose dialogue in-
tended to open up spaces in the mind of the audience and allow it to
infer a more than material reality. Later plays with a similar setting and
effect, like *La princesse Maleine* and *L'Intruse* (The intruder), made
Maeterlinck the leader of the symbolist movement in theater. A new ex-
perimental company in Paris, the Théâtre d'Art, had been founded in
1891 to present their work.

Strindberg had devoured Maeterlinck's essay on dramatic writing,
"The Tragical in Everyday Life," and approved of his work. His post-
Inferno plays like *Swanwhite* (1901), *The Crown Bride* (1901), and even
Erik XIV (1899) have the same sort of setting and some of the same
atmosphere. Other elements, however, make it clear that Strindberg was
headed in a different direction. He seemed to want the realism of sexual-
ity and emotional pain he had first dramatized in the 1880s not to be
implied offstage, as in Maeterlinck, but to be transcended right in front
of the footlights. His idea seemed to be to combine somehow the more
than material consciousness of a *Pelléas et Mélisande* with the contempo-
rary setting, fragmented characters, and disjunctive dialogue of *Miss Ju-
lie*. The plays *Advent* (1898) and *Easter* (1900), set in the present, are
guilt mysteries that move subtly back and forth between material and
mental landscapes. Even *To Damascus*, the earliest of his new plays,
lacked the continuous story line and the consistent external location of
Maeterlinck's plays. If Strindberg had a source for his new ideas in Paris,
it was probably the deadpan satire, comic monologue, and shadow plays
he had heard of (and probably seen) on the chamber stage of the Chat
Noir in 1883–85. Or perhaps it was the book he had read by Freud's
teacher, Charcot, about the public paces Charcot's nonprofessional
"grand hysterics" were put through on Tuesday afternoons at the Salpê-
trière.[14] Whatever their sources, the *Dream Play* and its chamber play
companion the *Ghost Sonata* broke through into a new theatrical space,
discontinuous in all its parts, whether spatial, temporal, internal or ex-
ternal.

Strindberg had finished *A Dream Play* in November 1901, in his
house at 40 Karlavägan in Stockholm. He had begun it in May, the sum-
mer Bosse had married him, and he had continued it while she honey-
mooned without him, left him a second time, and then returned, pregnant
and unforgiving, to continue their arguments at close quarters. He wrote
almost all of it in the mornings, alone in his workroom, smoking ciga-
rettes and cigarillos after his eight A.M. walk. (Strindberg did give up the
nicotine habit for a few weeks when Bosse returned for the last time and
made it clear that, in her fourth month of pregnancy, she was sensitive to
the smoke.) The play took him longer than any other to write, and re-
quired an elaborate outline—something new for an author who habit-

ually wrote one sheet after another and dropped them to the floor un-edited. That was because it had started out as two plays—one called *Corridor Drama* about waiting at the stage door for an actress, and one called *The Growing Castle* about the redemptive sufferings of a life like Strindberg's own. When he began putting the two together in August, he did it rather as a dealer might shuffle together the two halves of a deck of cards, and out of it came a sequence of events that could only occur in a dream. As he described his result in the preface:

> The author has tried to imitate the disconnected but apparently logical form of a dream. Everything can happen; everything is possible and likely. Time and space do not exist; on an insignificant basis of reality, the imagination spins and weaves new patterns: a blending of memories, experiences, free inventions, absurdities, and improvisations.
>
> The characters are split, double, redouble, evaporate, condense, scatter and converge. But one consciousness remains above all of them: the dreamer's; for him there are no secrets, no inconsequence, no scruples, no law. He does not judge, does not acquit, simply relates.[15]

Strindberg knew nothing of Freud when he wrote that in 1902, but he did know of other playwrights who had put dreams on stage before he had—notably Shakespeare, whose *Midsummer Night's Dream* Strindberg had come to appreciate even more after Harriet Bosse played Puck just before he met her in 1900. Strindberg himself referred to the three parts of his *To Damascus* as "dream plays." Perhaps the nearest thing to what Strindberg attempted in *A Dream Play* are not continuous dreams put on the stage, like *Peter Pan* (1904), but the "vision" scenes that were then becoming important—oddly enough—in naturalist theater. Strindberg's rival Hauptmann had put Heaven's scenes on stage in his 1893 play, *Hanneles Himmelfahrt* (Hannele), by having his heroine Hannele, the abused daughter of a bricklayer, dream them. Another naturalist, Frank Wedekind, author of *Die Büchse von Pandora* (Lulu), had put a dream-apparition scene into the end of *Frühlings Erwachen* (Spring awakening), his otherwise realistic 1891 play about adolescent sexual ignorance, finally staged in 1906 by Max Reinhardt. The American playwright James A. Herne (or Ahern) had put a much-discussed dream sequence into his temperance tragedy, *Drifting Apart*, in 1888. The idea had been taken up to great effect by photographers, cartoonists like Winsor McCay, and filmmakers like Edwin S. Porter, who had put vision scenes into his 1903 movies *The Story of an American Fireman* and *Uncle Tom's Cabin*. Nevertheless, despite all the precedents, Strindberg's result was unique.

As his *Dream Play* went into rehearsal in March 1907, Strindberg was finishing another dream play, the third in a series he called "Chamber Plays." His plan was to put all of these on in a tiny new theater, christened

the Intimate, that would open in Stockholm in December. The new play, like its companion pieces, was in many ways a miniature. In its short playing time and constricted cast it harked back to *Miss Julie,* and like *Miss Julie* it tightly observed the old dramatic unities of time, place, and action. Yet it was a discontinuous dream from beginning to end, the least "realistic" serious play Strindberg ever wrote and easily the most disjunctive. It would premiere at the Intimate Theater the following January 21, the day before Strindberg's 59th birthday, under the title *Spöksonaten* (The ghost [or spook] sonata). In the first of its three scenes, an old man named Hummel and a young Student stand in front of a Colonel's house while Hummel tells bits and pieces of old stories and a dead man attends his own funeral. In the second, the Colonel's entire family implodes emotionally around the dinner table as the old stories turn out to be untrue, after which Hummel hangs himself in the closet on the orders of Mummy and a "death screen" is put in front of them. In the last scene, the student talks ideal love to the Young Lady of the family, who loves hyacinths, and the Cook to whom the Young Lady has played a Cinderella resigns. Finally the "death screen" is put before the Young Lady as she too dies, poisoned by flowers. Only the magic of theater could make something so implausible into something so real and riveting. In American literature alone you can hear echoes of it from T. S. Eliot to Arthur Kopit.

August Falck watched Strindberg as he worked on *The Ghost Sonata.* Falck was the Intimate Theater's director-manager, and on spring evenings he came by 40 Karlavägan to plan the Chamber Play productions. He found Strindberg writing at his usual "rattling pace, throwing the finished pages unblotted on the floor" and scattering notes "on the table, in drawers, in his pockets." He seemed to Falck "the most coquettish man I have ever met . . . for ever patting his moustache into place even when we sat alone." The mustache, which had gotten whiter and smaller since Paris, was matched by the devilish goatee that failed as always to meet the chin. 1907 was a difficult spring for the inner Strindberg. Bosse had spent occasional nights at 40 Karlavägan for years after the divorce was final; but on January 20, two days before Strindberg's fifty-eighth birthday, she had slept over for the last time. All that was left of Bosse in the apartment was a portrait of her in her Puck costume. Strindberg had hung it from rings behind a curtain in the drawing room, and, as Falck observed:

> As we sat and talked, it often happened that Strindberg became restless, got up and went into the drawing-room. Suddenly I would hear the rattle of brass rings. There would be a moment's silence, then I would hear the rings rattle again, and he would return with his hand pressed tightly against his eyes as though he wished to shut out everything except the picture. . . .[16]

The eleventh set of *A Dream Play* is composed of a canopied double bed, a stove, a window, and a door. Here Indra's Daughter, now married to a once idealistic lawyer, fights the primal marital battle over money, children, and career. The lawyer leaves through the door. In set number thirteen, they are suddenly together again. Says the lawyer, "All of life is only repetitions." By the age of fifty-eight, Strindberg had concluded that the only way to overcome these repetitions (the French word *répétition* means "rehearsal") was his art, an art that reduced experience to its parts and then put them back together. His own life was in pieces by then. The two largest were the period before and the period after his madness. Then there were the three separate families, the three different languages he wrote in, the string of publishers, the scores of addresses, the incompatible ideologies, the contradictory forms. Strindberg's collected writings fill fifty-five volumes in the standard edition and include not only sixty-one plays, but seven novels and novellas; seven volumes of autobiography; one-hundred-odd short stories; essays on philosophy, theology, chemistry, and biology; two books of poetry; a history of Sweden; and a guide to gardening. Writing fast and revising little gave him the spare time to paint in oils; play the guitar, piano and cornet; make and develop photographs; conduct scientific experiments; and write more than a thousand letters. Strindberg was an obsessive antifeminist who idolized women and married three times. He was unfailingly kind to children, but left his own to their mothers after his divorces. He had many admirers and correspondents, and often betrayed old friends. He was a noisome anti-Semite nearly all of whose many loyal publishers were Jews. His smile was wide and his sense of humor was leaden. He was an elitist, a democrat, a socialist, an atheist, three different kinds of Christian, and an expert on China who believed he could turn lead into gold. He was often paranoid, as well as manic and depressive, disorders which could not be named until the last decade of his life. On every level, from the abstract to the personal, Strindberg exemplified the divided self the twentieth century has since taken as its representative subject.

As he put that self back together on the stage, simultaneously reordered and disordered, he was able to multiply the dimensionality of theatrical space and the relation of parts to continuity. Strindberg, no less than Mach and Einstein, brought into question the old absolutes about space and time, and did for theater what cubism was to do for painting, and multiple montage for the movies. After Strindberg, the only thing that remained for Pirandello to break down was the distinction between the actor and the role, between the cast and the audience.

In the penultimate scene of *A Dream Play,* the door with the four-leaf hole reappears as the door to ultimate truth before which all the faculties in the university have drawn themselves up in a travesty disputa-

tion. Indra's Daughter then arrives, tells them off and opens it. Behind it there is—nothing. When the university's Chancellor asks, "Will you please tell us what you intended by the opening of this door?" the Daughter replies, "No my friends! If I told you you wouldn't believe it." It was Bosse's line.

At eleven o'clock that night, the phone call came from Bosse at the Swedish Theater. His *Dream Play* was a success. Somehow, out of the posturing regret of a penitent Nietzschean and the more genuine sorrow of an aging antifeminist married to a young wife he could not please, Strindberg had brought forth a genuine tragedy about the pitiability of the human condition. Here was a Modern subject if there ever was one, staged in a way that shattered not only old illusions about the meaning and worth of human existence, but most of the assumptions the nineteenth century had made about the way that existence could be presented in the theater.

18 ARNOLD SCHOENBERG

MUSIC IN NO KEY

1908

I feel the air of other planets.
—Stefan George, "Entrückung"

Music is confidently referred to as the most universal of the arts, but there have always been many planets in it. For complex, largely social reasons, Western music seems always to have come to Western audiences piecemeal, a handmaiden of nationalisms and a token of class. At the same time Gustav Mahler conducted the premiere performance of his huge post-Wagnerian Seventh Symphony in Prague, his fellow Viennese flocked to operettas. While New Yorkers were buying Scott Joplin's utterly tuneful "Pine Apple Rag," and Irving Berlin of Tin Pan Alley was selling his first song to Broadway, Charles Ives of the Ives and Company insurance agency far downtown was composing works so revolutionary that no orchestra would perform them. At the moment blues and jazz were being first transcribed from folk to sheet music and carried up the Mississippi River into popular immortality, Arnold Schoenberg was in Vienna composing the first piece in Western music that was deliberately designed without a key signature.

It was 1908. Strindberg's *Ghost Sonata* had premiered; and Schoenberg, the Strindberg of Modern music, was living with his wife and two children in a small apartment on the Liechtensteinstrasse in Vienna's not-very-fashionable Alsergrund district. His domestic life, apart from money worries, was as conventional as bourgeois Vienna could wish to imagine, and it had been so since his birth thirty-four years before, to the same sort of striving new Viennese who had raised Freud and Schnitzler, Karl Kraus, Hermann Bahr, and Adolf Loos. Schoenberg's mother had been a cantor's granddaughter from Prague, his father Samuel a shoemaker from Pressburg, in the Slovakian part of the empire.[1] Samuel's ambitions for himself had been exhausted by the shoe-shop and the move to Vienna. The next step would have been to make his son Arnold an engineer, and he had sent him to Realschule to prepare, as other Vienna fathers had sent Ludwig Wittgenstein and Robert Musil. There had been some room

for violin lessons when Schoenberg was about eight; but when the boy discovered a disconcerting ability to compose violin duets he found his family indifferent to the accomplishment, and there seems never to have been any thought of a conservatory education. Because Vienna was such an irrepressibly musical city, Arnold had been able to meet friends at Realschule who could make up a string quartet with him. In the end, however, he had had to drop out of school at the age of sixteen, just before finals and soon after the death of his father had made it too expensive. For the next four years he had toiled as a bank clerk, balding precociously, living for music after business hours with the same extraprofessional informality and the same absolute commitment. Playing cello in one of Vienna's many amateur orchestras, he had made a fast friend of the conductor, Alexander von Zemlinsky, who not only taught Schoenberg musical composition, but introduced him to his future bride, Zemlinsky's sister Mathilde. After losing his job at the bank in 1895, Schoenberg had plunged into music professionally, conducting working-class choral societies, scoring operettas, orchestrating and arranging the work of more popular composers, and even publishing a handful of his own accumulating original works. As a composer he had soon equalled Zemlinsky, and by 1904 he had become a teacher of composition himself. The work of a full-time musician, though consuming and difficult, had never paid very much, but it did allow him to marry in 1901, to try to support a family, and to maintain a certain regularity and respectability in his life.

Musical composition is, like mathematical discovery, one of those places where unique creative originality—genius—is easiest to see. Schoenberg's genius had been obvious to musical friends since the turn of the century. Genius, however, was up against Vienna when the time had come at last for Schoenberg's own compositions to be published and performed. From the unnumbered *String Quartet* of 1897 to the *String Quartet #1* of 1907, only half a dozen of his shorter pieces had been played, and every premiere but the first had been a scandal. As Schoenberg himself would remember it years later, "I had had to fight for every new work. . . . And I stood alone against a world of enemies." [2] The narrative mode of Schoenberg's career began as genius misunderstood, and since Schoenberg, like Strindberg, had no sense of humor, the mode never changed.

But Schoenberg had never thought of himself as a revolutionary. He had learned "primarily," he wrote, from Bach and Mozart and "secondarily" from Beethoven and Brahms. A bit later he had picked up on Richard Wagner, the Brahms-lovers' nemesis, and after that on Wagner's Viennese disciple, Anton Bruckner. [3] Indeed, the *String Quartet in D Major* he had composed in 1897 may sound to the casual classical listener a lot more like Mozart than Wagner, Brahms, or even the late quartets of Beethoven. As Schoenberg matured, his harmony became ever richer and

more complicated. He loved counterpoint and would now and then com-
pose a difficult canon for the sheer pleasure of it. Though he would gain
his greatest fame after 1908 for the attempted elimination of the key
signatures and the key system from Western music, the key of D got into
much that he wrote, and one critic has described D minor as Schoenberg's
"lifelong obsession."[4] He considered himself not a rebel but a German
composer, heir to an unbroken musical tradition stretching back to the
Renaissance.

In 1908, the world of Western "art music," as distinguished from
popular music, was dominated by this tradition, still anachronistically
called "Germanic," whose leading composers, Richard Strauss and Gus-
tav Mahler, were both German-speaking. For the past ten years, Strauss
had been director of the Berlin Opera, under the patronage of Kaiser
Wilhelm; and Mahler had been director of the one in Vienna, under the
patronage of Kaiser Franz Josef. Like almost every art musician, they did
their performing during the concert season from September to May, and
their composing from June to August, spending their summers in moun-
tain retreats on opposite sides of the Austro-Bavarian border. Strauss,
who had begun his composing career with orchestral tone poems like
Also sprach Zarathustra, had moved into the prestige form of opera after
1900 and was best known in 1908 for his three-year-old opera, *Salomé,*
based on Oscar Wilde's French-language play of the 1890s. The subject
of *Salomé* was a *femme fatale,* sex, violence, and a soupçon of blasphemy
pitched at the very edge of acceptability, or in other words exactly the
thing to bring well-turned-out patrons of opera in by the carriageload in
1905 when it had premiered in Dresden. Austrians had first seen it a year
later, when it was put on in the university town of Graz. Vienna had at
first turned it down, though the Vienna Opera's director, Mahler, went to
Graz to see it (as did an Italian opera composer named Puccini and an
obscure Viennese music-lover named Adolf Hitler). The year after that in
New York, where the Bible was taken more seriously than it was in Vi-
enna, *Salomé* had been decidedly too much. Critics described its subject
as "a psychopathic condition literally unspeakable in its horror and ab-
normality" with a theme of "erotic pathology" that was "monstrous,"
"pestilential," "intolerable and abhorrent," "mephitic, poisonous, sinister
and obsessing in the extreme." After only one performance in 1907 the
Metropolitan Opera had been forced to withdraw it.[5]

The music of *Salomé,* described by one of those same New York
critics as able to "sicken the mind and wreck the nerves,"[6] was in fact
rather typical of the art-musical mainstream as it had been established in
Germany and the West by Richard Wagner's operas a generation before.[7]
The ideal was for each sound to be implied "logically" by those around
it, not only harmonically but melodically and rhythmically as well, like
the color areas in the old academic painting. Full "development" of

themes was essential, and the ways to do it—inversion, variation, etc.—
were canonical. Rhythmically, the ideal called for tempos that were more
often lumbering than brisk and usually marked legato rather than stac-
cato. Harmonically speaking the music was "chromatic," which is the
term for music that moves from key to key through chords common to
both, endlessly postponing a resolution in the place where it began. The
classic example of this "extended implication" was Wagner's *Tristan and
Isolde* (1865), where the love duet of Act 2 broke off on the way to a
tonic it would not reach until the love-death at the very end of Act 3.
Chromaticism made room for new "dissonances," notes sounded to-
gether in ways forbidden by earlier rules of harmony, not always resolved,
and jarring to audiences. Chromaticism likewise made the classical "so-
nata" form less relevant, because this century-old form required a devel-
opment so firmly rooted in key as to make key, in fact, its subject, with
the result that the symphony—a kind of sonata of sonatas—became
larger and larger and more and more unruly, like a sentence with too
many clauses. Dynamically, the music was as loud—and sometimes as
soft—as music could be before the age of electronics. Following Wagner's
ideal of bringing everything available to bear, enormous orchestral forces
were matched with massed choruses and the strongest solo singers, in
ways that sometimes made the result seem more like a competition than
a collaboration. In 1909, singing the title role in the premiere of *Elektra,*
the opera Strauss was composing in 1908, Madame Schumann-Heink
would be onstage singing forte for two hours straight. "It nearly killed
me," she would say, and she would never sing it again.

The other towering figure in the German art-music tradition, Gustav
Mahler, had directed the Vienna Court Opera since 1897, converting
from Judaism to Catholicism in order to qualify for the job. In 1907,
however, the long fight against Vienna, the conservatism of its audiences
and its court, and its fashionable anti-Semitism had driven him to resign
and accept the directorship of the Metropolitan Opera in New York. On
New Year's Day, 1908, he had debuted at the Met conducting his produc-
tion of *Tristan and Isolde.* Mahler had been a Wagnerian from his youth,
and his productions of the Wagner operas in Vienna had been widely
considered the finest in the world. When not conducting, he went, like
Strauss, to his summer retreat and there, from June to August, composed
about a symphony a year. In 1907 he had finished orchestrating his
Eighth and, despite the tragic death of his four-year-old daughter, had
begun to compose his ninth, to which he would give a title, *Das Lied von
der Erde* (Song of the earth) instead of the fatal number nine, which
death had prevented Beethoven, Schubert, and Bruckner from exceeding.
The symphonies, like the operas of Strauss and Wagner, were as vocal as
they were orchestral; and they were enormous. The orchestration Mahler
had completed in 1907 for the Eighth Symphony called for at least three

choruses, and earned it the title "Symphony of a Thousand" when more than a thousand performers were used at its premiere. The Seventh Symphony, whose premiere Mahler conducted in Prague on September 19, 1908, had five movements instead of the usual four, modulated through seven distinct keys, and took almost an hour and a half to play. As if to make up for the absence of a chorus, the score called for twenty-one woodwinds (including three different pitches of clarinets) and a percussion battery augmented by deep bells, a triangle, a glockenspiel, a tambourine, a tomtom, a cane, and a couple of cowbells.[8]

Mahler and Strauss had both composed under the inspiration of Nietzsche's *Zarathustra,* and both thought of themselves as *Übermenschen.*[9] Their publics did too. For Arnold Schoenberg, who had met Mahler in 1903 and Strauss during a brief emigration to Berlin in 1902, and had received substantial backing from both titans, there seemed to be hardly an alternative to the tradition they represented. The English composers, Edward Elgar and Ralph Vaughan Williams, were thought to be very English in that era of emotional nationalism, but formally their music was in the German tradition. The leading composers in Scandinavia, Finland's Jan Sibelius and Denmark's Carl Nielsen, worked the same vein. Antonin Dvorak, who had written the "New World" Symphony on a visit to America in 1893, was a Czech nationalist, but while he used folk themes, he did not work them out in Czech forms because he had not found any. In the far west, the only American composer not enmeshed in the tradition was Charles Ives, but Ives had no stature because he had no audience. In the far east, Russian music had exhibited some idiosyncrasies during its late nineteenth-century surge, but the harmonic differences between Alexander Glazunov and Modest Mussorgsky on the one hand, and the more orthodox Peter Tchaikovsky on the other, had been put down to naiveté or primitivism. The most unusual sounds coming from Russia in 1908 were thoroughly *fin-de-siècle,* composed by the pianist Alexander Scriabin, whose Third Symphony of 1904–5, subtitled *The Divine Poem,* had been premiered in Paris in 1905 to some consternation, and whose Fourth Symphony, subtitled *Poem of Ecstasy,* was scheduled for a world premiere with the Russian Symphony of St. Petersburg at the end of February 1908. (Its cancellation gave the premiere to the Russian Symphony of New York in December.) Scriabin was a Wagnerian whose chromaticism was beginning to go over the edge with the six-note dissonance: C, F-sharp, B-flat, E, A, and D. Scriabin's plans included a Fifth Symphony based on this "mystic chord" (eventually subtitled *Prometheus: Poem of Fire*) and a giant work to be called *Mysterium,* inspired by Rudolf Steiner's new religion of theosophy, which would combine sounds, text, pictures, sculpture, and dance, and include in its scoring a color keyboard which could project red as C Major.[10]

One of the factors that maintained the distinction between Russian

music and the German tradition was the ongoing musical entente between Russia and France. The connection had been made especially clear in the spring of 1907, when the St. Petersburg impresario Sergei Diaghilev, who had brought Russian art to Paris in 1906, returned for a second year, this time with Russian music. The concert series had included works by Glazunov and Borodin, arias by Mussorgsky sung by Fyodor Chaliapin, excerpts from Scriabin's forthcoming *Poem of Ecstasy* played on piano by Scriabin himself, a Rachmaninov concerto played by Sergei Rachmaninov, and music by Nikolai Rimsky-Korsakov conducted by Rimsky-Korsakov. Following the band had been a group of young musicians that included sixteen-year-old Sergei Prokofiev and twenty-five-year-old Igor Stravinsky. This early effort at cultural exchange had been a rousing success and French audiences had professed to be greatly stimulated; but it had been the Russians who had learned the most, especially the younger ones. There was, in fact, much to learn. Paris in 1908 was the home of the only art-musical tradition in the West that could be clearly distinguished from what was called the Wagnerian or Germanic (or late-romantic) mainstream.

The leading figure in French music in 1908 was Claude Debussy, who debuted as a conductor with his orchestral suite *La Mer* on January 19. Since his orchestral *Prélude à l'après-midi d'un faune* (Prelude to the afternoon of a faun) in 1894, based on Mallarmé's poem, and his opera *Pelléas et Mélisande* in 1902, setting Maeterlinck's play, musicians had been looking to him for a direction variously referred to as "impressionist," "symbolist," or simply anti-Wagnerian. Wagner's music and Wagner's forms had nearly overwhelmed French artists in the 1880s. Musicians like César Franck adopted nearly all his harmonic manners, and poets from Baudelaire to Mallarmé became ardent disciples. Edouard Dujardin, whom the reader may recall as Laforgue's editor and the pioneer of stream-of-consciousness, had organized the younger French Wagnerites in 1885 through his *Revue Wagnérienne*. Debussy had made the pilgrimage to Bayreuth in 1888 and 1889, but he had recovered quickly. He had always preferred Mallarmé's Tuesdays and the Black Cat cabaret to Wagner's Festival Theater, and in 1889 he had been more impressed by the Javanese gamelan orchestra at the Paris World's Fair than by Wagner's *Valkyrie*. Of the older French composers, only a few had avoided Wagner's polar attraction—notably Emmanuel Chabrier, who had written a decidedly un-Wagnerian comic opera,[11] and white-haired Gabriel Fauré, the dean of the secessionist National Music Society, who had been to Bayreuth repeatedly, beginning as early as 1879, but whose fascination had never turned to imitation. Fauré wrote miniatures. His reputation rested on chamber music, song settings of symbolist poems, and short pieces for solo piano.[12] The *Prometheus* put on in the World's Fair year in 1900 had been his longest, most richly scored work, the closest he had

ever gotten to the prestige of a real opera. In the summer of 1908 he was supposed to be working on another opera; but as in summers past, he was turning out another song and a piano nocturne instead. In these short works, however, Fauré had gone through a virtual symphony of harmonic experiments. One of his early songs, *Sérénade toscane* (Tuscan serenade) of 1877, used the whole-tone scale, and another, *Les Présents* of 1886, started off in F and modulated to half a dozen far-off keys and back in less time than it took Wagner to get from A to B. Fauré's nine little piano *Nocturnes* and eight *Barcarolles* had shown how to stretch (or compress) every rule of harmonic and melodic logic, and more was still to come. Marcel Proust would use Fauré as one of his models for Vinteuil, who plays Swann's love theme in *Remembrance of Things Past*.[13] At sixty-three, Fauré had lived to see his miniatures become a kind of rallying point for twentieth-century French composers against late nineteenth-century music, a sort of musical *revanche* for the French defeat of 1871, whose overall effect was to shrink the units of which music was constructed and to aim for an effect on the listener's feelings that would be more direct, more immediate, and above all more momentary.

Debussy had taken up Fauré's cause (not to mention Fauré's former mistress, whom he married in January 1908). His leadership of the succeeding generation rested on much longer, fully orchestral compositions: the immediately successful *Prélude à l'après-midi d'un faune,* the *Nocturnes* of 1897, *La Mer,* first heard in 1905, and the opera *Pelléas et Mélisande* of 1902; but all these works had been built up from the new kind of component Fauré had made available. Instead being guided by a kind of inevitable "musical logic," as the Germans called it, Debussy's tone poems, unlike Strauss's, often used the time-honored musical transitions—melodic, harmonic/chromatic, rhythmic, coloristic, and dynamic—one at a time as if they did not imply each other. At forty-five years old in 1908, he was putting the finishing touches on the first two of his *Images* for orchestra, "Ibéria" and "Rondes de Printemps" (Spring Rounds), for an inaugural performance in early 1909. The music was heard by many as a concatenation of "cells" rather than as continuous music; rather, its continuity seemed to be emotional instead of musical. As in the "Fêtes" section of *Nocturnes,* where he had marched brass band music through an unrelated orchestral fantasy, so in "Rondes de Printemps" Debussy again quoted his favorite children's tune, "Nous n'irons plus au bois" (We'll to the woods no more).[14] Like Laforgue, whose work he particularly appreciated, Debussy never took on a serious tone without adding a note of irony.[15]

A younger friend of Debussy's named Maurice Ravel premiered his own four-movement orchestral suite in Paris on March 15, 1908. *Rapsodie espagnole* was billed as "symphonic," but critics noticed easily and quite correctly that it was made up of little parts—parts that seemed

much smaller and less obvious than Debussy's. One critic compared *Rapsodie espagnole* implicitly to a divisionist painting. It is, he wrote,

> not mere impressionism, but "pointillisme" in music. . . . Even Mr. Claude Debussy's musical poem *La Mer* is painted in broader strokes. Mr. Ravel throws in tiny dabs of color in showers upon his canvas. There is not an outline nor an expanse in the sketch; everything is in spots.[16]

Erik Satie, another friend of Debussy's, had gone even further on this route. He was an odd man with an even odder career, a pianist from Normandy dropped from the Conservatory in his youth for laziness, who had embraced poverty in the 1880s and gone to play in the Black Cat and Nouvelle Athènes cabarets on Montmartre. In 1908 he was living in a single room in an unfashionable suburb south of Paris, commuting the six miles to Montmartre on foot in one of his twelve identical gray corduroy velvet suits. His works, though tonally adventurous, were even shorter than Fauré's. They were seldom more than a minute long, even with repetitions, their pretensions limited by deficiencies of training and the sense of humor that was perhaps Satie's deepest trait. The biggest things he had written were settings of pageants for the Paris Rosicrucians, the *Gymnopédies* (Greek adolescent dances), which Debussy had orchestrated for him in 1897, and *Trois morceaux en forme de poire* (Three pieces in the form of a pear) for piano, four hands, presented to Debussy in 1903 after his friend had expressed reservations about a "certain lack of form" in his work. Like Debussy and Fauré, Satie composed songs, but they were hardly "art" songs. Instead of setting symbolist poets he supplied material for the cabaret singers, incuding one, *La Diva de l'Empire* (The Empire's goddess, 1904), with a ragtime beat. On June 15, 1908, at the age of forty-two, he finally completed his formal education in music, receiving a doctorate with honors in counterpoint from the Schola Cantorum in Paris, whereupon the twelve little keyboard chorales that had been a byproduct of his education slipped onto the pile of unpublished manuscripts in his tiny apartment. A man of genius but little talent, in the words of one critic,[17] Satie was laying the musical foundations for The Six in the 1930s; for Steve Reich, Philip Glass, and the Minimalists in the 1980s; and even for Muzak in the 1950s and rap in the 1990s; but he had no way of knowing this in 1908.

Satie had met Ravel in about 1894 when he was playing cabaret piano at the Nouvelle Athènes in Montmartre and young Maurice came in with his father. He met Debussy in Montmartre as well. All three French composers were more at home in cabarets than they were in concert halls. All three were comfortable with the connection the Black Cat had established between high culture and low, and the distinction it had made between pretentiousness and art. All three had learned from the blooming cabaret tradition that "musical logic" did not require long-windedness,

and that the relation between music and feeling had less to do with counterpoint than with tone and color. As they continued to analyze music into its component parts and put them back together in novel and emotionally appealing ways, they tempered their classical training with half an ear tuned to the popular. There was no other musical subculture in the West where this sort of balance was being struck, with the possible exception of a one-man musical subculture in New York City.

On June 9, 1908, Charles Ives of New York married Harmony— Harmony Twichell of Hartford, Connecticut, daughter of an old friend of Mark Twain. His honeymoon with Harmony took the form of a two-week walking tour of the Housatonic River valley in the Berkshire Hills of western Massachusetts. The newlyweds came home to 70 West Eleventh Street on June 25, but the very next weekend Ives took Harmony back to the valley, and there he had a vision. Five years later that vision would become "The Housatonic at Stockbridge," part of a dauntingly original orchestral masterpiece called *Three Places in New England*.[18]

Ives's music had been heard by few outside two Presbyterian churches in New Jersey and Manhattan, where Ives had been organist and choir director. This was America, whose polyglot popular music was poised to conquer the Western world, but whose art music was called "longhair" and remained provincial, enthralled by the late-romantic tradition. German music was classiest, and classically trained musicians were as often as not German immigrants, like the leaders of musical life in Chicago and St. Louis. The few professors of music in the United States, like Horatio Parker at Yale, had few disciples. Charles Ives, Yale '98, had studied with Parker but found him a fuddy-duddy when it came to the rules of harmony and unmoved by the combinations of competing rhythms Ives had been taught to enjoy by his father, the bandleader of Danbury, Connecticut. Parker couldn't discourage him, though. Ives had continued to compose music, and by the time he graduated he had composed his first symphony, his first string quartet, and part of a choral cantata. He had also composed marches, fugues, Protestant church anthems, and about fifty songs, including a couple for the Delta Kappa Epsilon fraternity show, *Hell's Bells or The Fight that Yaled*, a campaign song for President McKinley, and a polyrhythmic collision called *The Yale-Princeton Football Game*.[19] None of the carefully drawn distinctions that kept American musicians apart had ever seemed to limit Charlie Ives. After a stint as an organist at Central Presbyterian, Manhattan, where he played riffs on traditional hymns and had a disappointing production of his cantata, Ives had gone full time into the insurance business and done extremely well at it.

By 1908 Ives had completed his second String Quartet, and the idea for "The Housatonic at Stockbridge" was in a drawer with the beginnings of a complex *Browning Overture* and an *Emerson Concerto*. The

music of this self-made genius who spent his days training insurance agents had moved well down the road from what even educated contemporaries could appreciate. In 1906 or 1907 (memories differ) Ives had persuaded a theater orchestra in New York to play something he had composed called *A Contemplation of Nothing Serious, or Central Park in the Dark In the Good Old Summertime.* Separated from its companion piece, *A Contemplation of a Serious Matter, or the Unanswered Perennial Question,* it was half of a tone poem—the less demanding half—but the orchestra had not seen it that way. To perform the work the orchestra had to divide itself into two separate ensembles, one of which would play snatches of perfectly diatonic melodies like "Hello My Baby"[20] while the other accompanied with an independent, highly chromatic, boldly dissonant piece that had a different rhythm signature. The orchestra couldn't handle it, and after that, Ives had mostly given up on performances. In 1908, he filed his new *Violin Sonata #1* with the rest of his compositions in the safe at Ives and Company insurance agency at 51 Liberty Street.[21]

Meanwhile, uptown on 28th Street—Tin Pan Alley—American pop music was taking off. The latest sheet music hit was a waltz by one of the von Tilzer brothers about a girl named Katie who preferred Cracker Jack to dinner on the town and urged her beaux to "Take Me Out to the Ball Game." Also just published was a song called "Down in Jungle Town," written to accompany the "King of the Zulus" parade that highlighted the last night of Mardi Gras in New Orleans. The song started as just another Tin Pan Alley race-baiter, but it was destined to be made a "standard" by a new form of pop called "jazz," polyrhythmic music in non-European tonalities, which was just then emerging from the Cajun-African musical life of New Orleans and moving up the Mississippi. Ferdinand Joseph Lamothe, an eighteen-year-old black Creole pianist from New Orleans who performed under the name of Jelly Roll Morton, was already playing jazz in Chicago. At least that's the way he remembered it, talking thirty years later about hearing Freddy Keppard's first five-piece "Dixieland" ensemble in 1907 and picking up a song called "The Dirty Dozens" in a Chicago "sporting house" in 1908.[22] Jazz was raunchy. Still a decade away from respectability, even the word "jazz" would not be deemed fit to print for another year.[23]

Jazz's rhythmic ancestor, ragtime, by contrast, was on all American piano stands in 1908. Scott Joplin, who now lived in New York, published a rag in that year called "Fig Leaf," billed as "High-Class," and a book called *The School of Ragtime: Six Exercises for Piano,* which began by asserting, "What is scurrilously called ragtime is an invention that is here to stay."[24] No need to convince young Irving Berlin, who had already published "Yiddle on Your Fiddle Play Some Ragtime."[25] In the three years that remained before Berlin's "Alexander's Ragtime Band" became

the most popular song in the world, Joplin would remain the more respectable composer. He also understood what ragtime was, and he could read and write notes. The trade press reported that he was working on a ragtime opera,[26] and the next year, 1909, he would publish "Euphonic Sounds," a "novelty" in ragtime rhythm that made a quick chromatic tour of five different keys.

Jazz's other ancestor, the blues, was only a year or two away from the dignity of copyright. In 1909 W. C. Handy's band would be playing "Mr. Crump Don't Like It," a campaign song for a political boss in Memphis that became the first version of "Memphis Blues." Publication would domesticate the blues melodies, often "dissonant" by Western standards; but jazz, later in the century, would re-release them to the wild.

Schoenberg knew nothing at all of Morton, Ives, or Satie. He knew little about the music of Debussy, and what he did know he didn't like. For him music required more formal logic, not less; and on the subject of its ultimate meaning, he was a mystic. He had none of Satie's irony, no Black-Cat hoaxing *fumisterie;* but he did have, like the French masters, a sense of paradox and a mordant wit. Like Satie and Ives, he had composed cabaret songs, but he had done it *faute de mieux,* turning them into art songs as well, which may be one of the reasons the Überbrettl cabaret in Berlin had not asked for any more of them in 1902. Schoenberg had also shifted, after 1904 when he became a teacher, to the shorter, sparer forms favored by the heirs of Fauré. Did he do it merely in the hope of hearing his works performed? It is certainly true that only months after he scored it for fifteen instruments, Schoenberg had been able to hear his first *Chamber Symphony* played, whereas for his enormous, Mahlerian *Gürrelieder,* scored for a reciter, four soloists, chorus, and full symphony orchestra, he had already waited six years, and would have to wait six more. On the other hand, the desire for an audience was never the paramount motive for Schoenberg. He had become as resolute as Satie about stepping to the music that he heard; and the real reason for the move to shorter forms seems to have been his rapid and almost ceaseless development as a composer. *Gürrelieder* was behind him and so was his big Straussian tone poem *Pelleas und Melisande.*[27] His new music was being broken down and reassembled from smaller parts into smaller wholes.

Schoenberg was an inventive type with the education of an engineer, forever tinkering with whatever in his surroundings seemed to need exact and devoted attention. He carved his own chessmen and bound his own books. At one time or another he would suggest detailed methods for notating tennis, playing chess on a 10 by 10 board, operating on the eye with magnetically positioned instruments, combining bus, tram, and subway fares into a single ticket, and regulating the flow of auto traffic with freeways. He invented a typewriter for music, and a notation for

multikey music that eliminated sharps, flats, and naturals. Writing in 1926–27, he considered the "possibility of a man-made holocaust like the atom bomb."[28]

His most recent discovery had been what he was beginning to call "developing variation," which essentially means to develop a theme without ever precisely repeating it, putting a new variation on a musical phrase whenever it appeared. Repetition is the soul of popular music and perhaps its basic means of accessibility, so developing variation requires of the listener even more than a well-educated ear.

Schoenberg had already written two String Quartets when he sat down to work on the new one in 1907. The first Mozartian one in D Major he hadn't numbered because he did not think it was mature enough. The most recent one, *String Quartet #1 in D Minor,* had been one of his two big achievements of 1905, and its performance the scandal of 1907. Its most obvious innovation was that it was written in only one gargantuan movement instead of the usual four. Moreover, although a quartet score has only four staves, developing variation made this one so complex harmonically that Mahler, who had become Schoenberg's protector, professed himself unable to follow it. "I have conducted the most difficult scores of Wagner;" Schoenberg remembered him saying, "I have written complicated music myself in scores of up to thirty staves and more; yet here is a score of not more than four staves, and I am unable to read them."[29] Mahler was the best of supporters, though, and loyal to a fault. At the raucous premiere of the D Minor *String Quartet* and of the E Major *Chamber Symphony* in February 1907, Mahler had stood applauding, glaring at would-be booers, until the last listener had left the hall. Schoenberg had expressed his gratitude and put the affair behind him. Already back in April 1906, when the first *Chamber Symphony* was finished, he had begun to write a second one in much the same style. He had, he thought, "enjoyed so much pleasure during the composing, everything had gone so easily and seemed to be so convincing," that "I believed I had now found my own personal style of composing."[30]

Nevertheless, the completion of *Chamber Symphony #2* would be delayed for more than thirty years. In March 1907, Schoenberg remembered, "after having composed almost two movements, that is, about half the whole work, I was inspired by the poems of Stefan George, the German poet, to compose music to some of his poems."[31] The effect had been electric. George's post-Mallarmé symbolism and lush idealism released something in the composer, and caused all his plans to be laid aside. By 1908, he had set a dozen poems and made three compositions out of them: one small set of piano-accompanied songs, one large set, and a new string quartet, the Second in F-sharp minor.[32]

It would hardly be noticed during the revolution sparked by this work that it was the first string quartet in Western music to have a text

or to be scored for a soprano. Neither feature was in the first movement, whose first notes Schoenberg inscribed into his sketchbook on March 9, 1907. The key, F-sharp minor—six sharps on the treble clef—was a black-key tonality, the parallel minor to the ragtime and blues key that Irving Berlin would use in 1911 for "Alexander's Ragtime Band." Already, however, the songs had shown Schoenberg an even more radical treatment of key, a treatment beyond chromaticism, in effect no key at all. After only six bars, the first movement was already C Major—nearly as far way from F-sharp minor as it was possible to go.

> Surprisingly, without any expectation on my part, these songs showed a style quite different from everything I had written before. . . . It was the first step towards a style which has since been called the style of "atonality." . . . New sounds were produced, a new kind of melody appeared, a new approach to expression of moods and characters was discovered.[33]

He had been, he thought, drawn naturally into a new attitude toward the octave of notes hitherto labeled F-sharp minor and the triads of notes which, as chord or melody, reminded a listener of the key. Notes outside the key, labeled "accidentals" on the staff, must hereafter not be thought of as accidental to the emerging composition. As he worked away with his usual speed at the first and second movements Schoenberg simply dropped the standard attempt to compose F-sharp harmonies wherever the developing variations of his themes crossed paths—even though F-sharp minor continued to be "presented distinctly at all the main dividing-points of the formal organization. Yet the overwhelming multitude of dissonances [could not] be counterbalanced any longer by occasional returns to such tonal triads as represent a key."[34]

By September 1907, Schoenberg had finished the first movement and was well under way on the second. He remembered composing three-quarters of it in less than two days, probably that winter.[35] It was the winter that Mahler resigned, and a little after eight on a clear Monday morning in December, Schoenberg took a few hours off from his work to be at the Westbahnof with his student Anton Webern and his brother-in-law Zemlinsky to see the great man off to New York. Two hundred admirers on the train platform waved and were silent. Gustav Klimt whispered, "Vorbei [It's over]," and Schoenberg went back to the Liechtensteinstrasse, knowing he had lost his most important supporter, the only senior man in music who had begun to understand him. Sometime later he took two poems from Stefan George's just-published cycle, *The Seventh Ring,* and began to set them, making the first sketches of the third and fourth movements of his new quartet. At that point there came a moment of truth. As he was setting "Entrückung" (Ecstatic transport) for the fourth movement, he left out all six sharps of the key signature. Then, beginning on the blank staff that indicated C major by default, he

wrote out a string of pianissimo 16th and 32nd notes, scores of them, all accidentals, spiraling from the cello's lowest bass to the very top of the violin's treble. By measure 21, with nothing left to anchor the listener's sense of key, Schoenberg brought in the soprano with the opening line of George's poem: "Ich fühle Luft von anderem Planeten"—I feel the air of other planets.

> I feel air of other planets blowing
> Toward me through the darkness of the faces
> That friendly ever nearer to me drew
>
>
>
> I am dissolved in tones, and circling, weaving
> Unfounded thanks and unaccustomed praises
> I offer without will to the great breathing
>
>
>
> I am only a flicker of the sacred fire.
> I am only a mumbling of the sacred voice.

> *Ich fühle Luft von anderem Planeten*
> *Mir blasen durch das Dunkel die Gesichter*
> *Die freundlich eben noch sich zu mir drehten*
>
>
>
> *Ich löse mich in tönen kreisend, webend*
> *Ungründigen Danks und unbenamten Lobes*
> *Dem grossen Atem wunchlos mich ergebend*
>
>
>
> *Ich bin ein Funke nur von heiligen Feuer*
> *Ich bin ein Dröhnen nur der heiligen Stimme*[36]

Seldom in Western music has a text corresponded so well to its setting. Dissolved in tones, the piece itself circled and wove and seemed unfounded, though these lines, at measures 51 to 62, were accompanied by a theme Schoenberg was so convinced was a fine melody that he never changed a note of it.[37] "It seemed inadequate," Schoenberg remembered thinking, "to force a movement into the Procrustean bed of a tonality without supporting it by harmonic progressions that pertain to it."[38] So he simply left off trying and let his developing variation go its own way, while continuing to think of the whole piece as "in" F-sharp minor.[39]

As the third and fourth movements of the second String Quartet took shape in the spring of 1908, Schoenberg continued to add to the second Chamber Symphony without kicking over the traces of its key of E-flat minor; but elsewhere the new ideas were insistent. In March he began work on George's *Book of the Hanging Gardens* song cycle, and in April the *Three Piano Pieces,* making use in each of his new "atonal" freedom—or rather "pantonal," since "atonal" means without notes and he

was using them all. And when he was not composing, or teaching, he painted. In the early summer of 1908, Richard Gerstl was again his house guest, as he had been the summer before. Gerstl, a painter, was in his mid-twenties and worked more or less in the proto-expressionist style of Oskar Kokoschka and Egon Schiele. Introduced to the Schoenbergs by Zemlinsky in 1906, he was helping Schoenberg learn to paint in return for house room. Under Gerstl's tutelage, Schoenberg was beginning to sketch the deeply emotional self-portraits that would bring him a one-man show in 1910 and a long friendship with Vassily Kandinsky.

But something was not quite right in the Schoenberg house that summer. Gerstl's solo portrait of Mathilde in a flowered dress was serene; but his family portrait of Arnold and Mathilde holding six-year-old Gertrud and two-year-old Georg in their laps was unfinished, a swirl of pigment for faces with colored holes for eyes. His portrait of himself, lean, young, nude to the waist, and staring straight ahead under his new short haircut, suggested both resolution and regret. He had begun an affair with Mathilde. At the end of the summer she ran away with him. In November, she found him dead. He had piled his paintings in his studio, set fire to them, stabbed himself in the heart with a kitchen knife, and hanged himself over the blaze.[40]

On July 27, 1908, Schoenberg entered the last bars of *String Quartet #2* into his notebook, the end of the second movement with its sudden quotation of the old Austrian folk song, "Ach du lieber Augustin, alles ist hin" (Oh my dear Augustine, it's all over). The affair between his wife and Gerstl had already begun. Domestic disorder amounting to nothing less than disaster had followed the leap away from classical tonality. Mathilde was living with Gerstl as arrangements were being made for the Quartet's first performance in December; and Gerstl's suicide came just as the concert season began. Not long after, in a mood both were wise enough never to write about, Schoenberg took Mathilde back and Mathilde decided to return. At about the same time he passed out to the men of the Rosé Quartet the rehearsal part scores of his revolutionary new work, dedicated "To my Wife."

The Rosé Quartet was just about the best chamber ensemble in Vienna, unlikely to be caught off guard by Schoenberg's music because it had already premiered Schoenberg's *String Quartet #1* the year before. Its leader, Arnold Rosé, was Mahler's brother-in-law and violinist/concertmaster of the Vienna Philharmonic, which Mahler had once conducted. The soprano was also first-rate—Marie Gutheil Schoder of Mahler's Court Opera. It was as if Mahler had arranged it, and indeed he had helped a bit in the summer, when he was in Austria composing *Das Lied von der Erde*. On December 8, however, Mahler was far away conducting the fledgling New York Philharmonic orchestra in a performance of his *Symphony #2*.

With or without Mahler, rehearsals went well; and Schoenberg must have appreciated the treat of watching such master musicians learn to play his work. There was, however, at least one upsetting reminder of how demanding the music really was, an incident, he remembered, "as strange as it was significant." It happened as the rehearsal got to measures 53–62 of the fourth movement, under the soprano line, "I am dissolved in tones, and circling, weaving / Unfounded thanks and unaccustomed praises." Schoenberg began trying to explain the phrasing. "Please," he asked the string players, "Would you not try to play this melody so and so?" What melody? asked an old friend of Schoenberg's who had been attending the rehearsals. "I hear you talking about a melody; where is there a melody at all?"[41] It was, in fact, the melody Schoenberg had thought so highly of as never to change a note.

The moment turned out to be prophetic. On the evening of December 21, as the house lights went down and the Rosé Quartet began to play, the Bösendorfer Saal was silent; but when the music reached C Major in the sixth bar, the sounds of discomfort began. "After the end of the first movement," wrote the reporter for the Vienna *Daily Times,* "there were heard some signs of approval. This gave a signal for a regular *scandale,* which increased like an avalanche, subsided, again grew in force, and finally reached fortissimo. . . ."[42] There were jeers and catcalls, angry epithets, and whistling on door-keys. When the "Ach du lieber Augustin" quotation came in the second movement there were bursts of laughter, rather than the half-smile that Schoenberg was ready for.[43] "Suddenly the music critic Karpath rose and cried out, 'Stop it! Enough!' His colleague Specht countered by shouting, 'Quiet! Continue to play!'"[44] Protesters and supporters stood each other off like sports fans.[45] These were not just music-lovers, but Viennese music-lovers, trained to love music in the city of Mozart, Haydn, Beethoven, and Brahms, the city where three generations of Strausses had turned the peasant *Ländler* into the waltz. They were not pleased. "The majority of the public was against the music. Some discords made elegantly dressed ladies cringe under the painful impact on their delicate ears, and elderly gentlemen were at the point of tears from fury."[46]

The journalists and critics, however, *were* pleased. They knew they had been presented with a rare opportunity to pull out all the stops on sarcasm and to perform, if they could, on the level of the master, Karl Kraus himself. The next day's papers were epics of *schadenfreude,* that fine Viennese enjoyment of someone else's humiliation. One headlined: "Scandal in the Bösendorfer Saal."[47] The Vienna critic of the Prague *Times* opened his account by referring to Schoenberg as "the ultraviolet musical secessionist."[48] The *New Vienna Daily* printed their review in their "crime" section, and opined that Schoenberg had "already created a public nuisance with others of his products. But he has never gone so

far as he did yesterday . . . it sounded like a convocation of cats."[49] The *New Vienna Evening Paper* went right to the question of key:

> anxious to make the acquaintance of the composer Arnold Schoenberg at last, we were completely cured by a String Quartet by that gentleman, allegedly in F-sharp minor. . . . Out of respect for the composer we will assume that he is tone-deaf and thus musically *non compos* . . . otherwise the Quartet would have to be declared a public nuisance, and its author brought to trial by the Department of Health. . . .[50]

In the midst of "all this tumult" stood Schoenberg, gesturing "towards the performers in an expression of gratitude and encouragement."[51] When it was over, "someone said: 'Now they will play Beethoven, so let us first ventilate the hall.'"[52]

It was that last remark that resounded furthest and may have hurt Schoenberg the most by impugning his sense of membership in the great tradition.[53] The composer wrote thirty years later that this premiere was "one of the worst occasions" in his long memory of unsuccessful performances, calling the essay "How One Becomes Lonely."[54] Schoenberg tried to fight back the next day by composing two sarcastic replies to the critics, and sending the best one to Karl Kraus at *Die Fackel,* but Kraus rejected it.[55] For the rest of his life Schoenberg would be wounded by the chronic critical accusation that his music had no melody, and he would write again and again not only to call attention to the basic themes and ideas that were at the root of each work, but even to point out where the tunes were. His music, he continued to insist, was not "atonal," meaning without tonality or (absurdly) without tones, but "pantonal," meaning using all keys and all tones. Disappointed by how easily distracted listeners were by dissonance, he continued to defend his rich and complicated harmony, and would eventually write a classic book on harmonic theory. In 1923 he would rescue "atonalism" from anarchy with a set of compositional rules called the twelve-tone system. The composer of the *String Quartet #2* in F-sharp minor would always insist that he did not hate keys or indeed any rule of "musical logic;" and he would repeatedly point with pride to the almost complete absence of repetition developing variation had enabled him to achieve. Chromatic his music certainly was; but the chromaticism was total, so radically condensed as to be beyond the requirement of canonical transitions—or any need for transitions at all.

"Many people," Schoenberg lamented long after, "instead of realizing its evolutionary element, called it a revolution."[56] It was no such thing, he always insisted. "I have not discontinued composing in the same style [as in 1899] and in the same way as at the very beginning. The difference is only that I do it better now than before; it is more concentrated, more mature."[57] It is the fashion among musicologists at this end of the century to agree with Schoenberg and emphasize the continuity of

his music with Mahler's;[58] but in 1908 audiences knew they were hearing something very new. As his song cycle *Pierrot Lunaire* was to make clear in 1912, Schoenberg had accomplished something Satie and Ives were already in a position to understand—the rediscovery of the smallest parts, the atoms and molecules of music. By explicitly emancipating notes from key for the first time in 1908, Schoenberg placed himself at the headwaters of a complete reevaluation of the relation of the parts to the whole in "classical" music, and of the place of transitional material in that relation.[59] As Schoenberg described it later:

> By abandoning the one-movement form and returning, in my Second String Quartet, to the organization of four movements, I became the first composer of the period to write short compositions. Soon thereafter I wrote in the extreme short forms. Although I did not dwell very long in this style, it taught me two things: first, to formulate ideas in an aphoristic manner, which did not require continuations out of formal reasons; secondly, to link ideas together without the use of formal connectives, merely by juxta-position.[60]

The next generation that was to profit from Schoenberg's revolution was already at work in 1908. In Vienna, two of his own favorite students, Webern and Alban Berg, were composing small masterpieces.[61] Béla Bartók was collecting tonally challenging folk songs in Hungary and composing his little piano *Bagatelles*.[62] In St. Petersburg, Stravinsky premiered the short orchestral fantasy, *Fireworks*, the fourth of his works to be performed; and in the same city on the last day of 1908, ten days after Schoenberg's disastrous concert in Vienna, seventeen-year-old Sergei Prokofiev played a set of four short piano pieces he had composed called *Reminiscences, Elan, Despair,* and *Diabolic Suggestion*.[63] Modernism in music was in place.

19 JAMES JOYCE

THE NOVEL GOES TO PIECES

1909–1910

In January 1909, the Berlitz English teacher in Trieste told one of his private pupils, a paint manufacturer named Ettore Schmitz, that he was a "neglected writer" worthy of comparison with Anatole France. Since both of Schmitz's novels had been published privately under a pen name years ago with small sales, the pupil was as pleased as only a gentleman amateur could be. As the pseudonymous "Italo Svevo," Schmitz also knew how his tutor must feel, coming to his twenty-seventh birthday with nothing in print but a single slim volume of poetry. He even offered, as a kind of birthday present, to read chapters 1–3 of the English teacher's unfinished novel to see if he might return the encouragement (or at least improve his English). We do not know if Schmitz had any second thoughts as he stared at page one and discovered he had been set down without explanation smack in the middle of the limited consciousness of a two-year-old:

> Once upon a time and a very good time it was there was a moocow coming down along the road and this moocow that was coming down along the road met a nicens little boy named baby tuckoo. . . .
>
> His father told him that story: his father looked at him through a glass: he had a hairy face.
>
> He was baby tuckoo. . . .[1]

As Schmitz read forward, this same consciousness remained open on the page, growing from observant childhood to brilliant and rebellious youth in Catholic Ireland, a character named Stephen Dedalus, apparently in honor of the first Christian martyr and the maker of the Labyrinth. Soon, to Schmitz's relief, the novel seemed to leave the mind of the main character and to begin to refer to Dedalus in the third person as part of an observed world. By the time Schmitz finished reading the

manuscript, he had decided he could indeed be encouraging. On February 8, he handed the three chapters, together with a formal letter explaining what he thought was good in them, back to their author. "Dear Mr. Joyce," he wrote:

> Really, I do not believe of being authorised to tell you the author a resolute opinion about the novel which I could know only partially. . . . I like very much your second and third chapters and I think you made a great mistake doubting whether you would find a reader who could take pleasure in the sermons of the third chapter. I have read them with a very strong feeling. . . . I object against the first chapter. I did so when I had read only it but I do so still more decidedly after having known the two others. I think that I have at last also discovered the reason why these two chapters are for me so beautiful while the first one which surely is of the same construction by the same writer who has surely not changed his ways, written evidently with the same artistic aims, fails to impress me as deeply. I think it deals with events deprived of importance and your rigid method of observation and description does not allow you to enrich a fact which is not rich of itself. . . .[2]

Thus did Ettore Schmitz become the first, and by no means the last, to receive Joyce's early masterpiece, *A Portrait of the Artist as a Young Man,* as a reading assignment from an English teacher. From the hundreds of thousands of readers who have come after, Schmitz should get a lot of credit, considering that he read it in a foreign language course, without the aid of worshipful commentaries, notes, or critical editions. *Portrait* was not the first novel to use the techniques or attitudes we now call Modern, but it was the breakthrough work, and after Schmitz became its first reader there was, as at San Salvador in 1492, no turning back. Joyce himself was pleased. In 1909 he had only one other reader, his loyal younger brother, Stanislaus, who had recently joined him teaching English in Trieste. His common-law wife, Nora Barnacle, read little that he wrote and thought her Jim should have been a singer. His two children, Giorgio and Lucia, were, at three years and eighteen months respectively, too young to read at all. Journal editors occasionally printed his reviews but had stopped printing his fiction. In 1904, *The Irish Homestead* had refused to print any more of his short stories after readers found the first three discomfiting. Book publishers didn't like his stories any better. All had sent them back; even Elkin Matthews, who had done so only after sitting on them for eleven months in 1907. Printers objected when publishers didn't. Publisher Grant Richards had accepted them in 1906, only to have his printer come to the conclusion that some were too risqué and refuse to set them up in type. Eight long years would pass before the Richards edition of *Dubliners* would finally appear. Joyce at twenty-seven had no income from writing at all; nor had he written any-

thing in particular since *Dubliners* had been rejected. He had just quit Berlitz, reducing his income to tutorial fees of 10 crowns (about $5) a lesson, plus whatever he could cadge from his bachelor brother and wary friends, students, and fellow teachers. Trieste was a minor Italian-speaking seaport in the polyglot Austrian Empire, not a bad place to teach languages—or to learn them, as Fiorello LaGuardia, the American assistant consul in nearby Fiume, had discovered. It was only a few miles south of Duino, the seaside resort where in 1906, as Joyce was writing *Dubliners,* Ludwig Boltzmann had hanged himself. Joyce and his family were living in a tiny apartment on rundown Santa Caterina street, hoping to move but standing by until they could find a way to keep the landlady from confiscating their furniture for back rent.

No one but a few friends and family members knew what Joyce was creating in a succession of tiny apartments in Trieste, or what other exiles were scribbling away at in rooms of their own in 1908, inventing what was to become the Modern novel. In London, the nineteen-year-old Katherine Mansfield, of Wellington, New Zealand, was writing her first mature story, "The Tiredness of Rosabel," in stream of consciousness. In Bloomsbury, the student neighborhood around the British Museum, two formerly proper young ladies, Virginia Woolf and Dorothy Richardson, who had not yet met, were writing about the world they had left behind. Richardson, who supported herself by working as a dental assistant and had recently made the mistake of letting H. G. Wells into her room, had made several starts on novels that year. She wanted to organize them around ideas, but phenomenology kept scrambling them up. In three more years she would finally stumble unaided on the nearly pure experience of *Pilgrimage.* Woolf, who had inherited some money, was writing draft after draft of a book called *Melymbrosia,* a novel of empire that was slowly turning into a moment-by-moment exploration of the feelings of a doomed young woman. Seven years later it would see print as *The Voyage Out.* A little south of London, in Croydon, a miner's son named D. H. Lawrence was teaching school and starting a third draft of his first novel, *The White Peacock;* while in a house in Paris and a villa outside of Florence Gertrude Stein, of Oakland and Baltimore, was writing the far more Modern and far less publishable *Making of Americans.* In the Czech capital of Prague, Franz Kafka had joined the Kingdom of Bohemia Workman's Accident Insurance Company and begun to publish the short plain descriptions of fantastic events he had been writing in the evenings since 1904. In Moscow, Andrey Bely, who had just published the fifth and most baffling of his prose *Symphonies, Goblet of Blizzards* (Kubok metelei), told his friend Valentinov that he had started a book about the 1905 Russian Revolution. Five years later it would appear in print as *Petersburg,* the earliest masterpiece of Russian Modernism. At the end of 1908, in the middle of Paris, Marcel Proust, just returned from his

summer at a beachfront hotel in Normandy, was alone in his room at night, writing an article on literary critics. Without warning the article began to fill up with reminiscence, and *A la Recherche du temps perdu* (usually rendered in English as *Remembrance of Things Past,* but better translated as *In Search of Lost Time*) began to pour out onto the page. It would not be fully published for nearly twenty years.

But a novel is born when it gets its first reader, and Ettore Schmitz, whom we know better by his pen name, Italo Svevo, is the one who brought *Portrait of the Artist* into the world in the first weeks of 1909. Writers are made by readers, and writers return the favor by being the most voracious readers of all. Joyce himself read more than anybody. Too ornery to take Schmitz's advice about *Portrait of the Artist,* Joyce never touched a line of chapter 1, but Schmitz's interest was enough to set him back to work on the manuscript. Joyce had planned out *Portrait* in 1907, but the origins of the project were much older. Way back in January 1904, before he had left Ireland, before he had published a single story or even written one, Joyce had dashed off an essay on the life of art that his younger brother Stanislaus, considering its use of autobiography, dubbed "A Portrait of the Artist." A month later, using this essay as a blueprint, Joyce began to write a huge novel about growing up gifted in benighted Ireland. This work, too, was named by brother Stannie, this time ironically, as *Stephen Hero.* By June of 1905, he had written twenty-four of thirty-odd planned chapters of *Stephen Hero,* doggedly filling up paper in the midst of chaos. He had finished chapter 11 at his honeymoon hotel in Zurich, three days after eloping from Ireland, and chapter 12 in Trieste, not long after finding out that the job he had traveled across Europe to report for did not exist. Over the next nine months, as he put it,

> I have begotten a child, written 500 pages of my novel, written 3 of my stories, learned German and Danish fairly well, besides discharging the intolerable (to me) duties of my position and swindling two tailors.[3]

In 1906 most of his writing had been for *Dubliners,* but soon after the birth of his daughter Lucia in the Trieste pauper ward in July 1907, Joyce had gone back to thinking about *Stephen Hero.* In the first week of September, as soon as he had put the finishing touches on "The Dead," the last and greatest of the stories in *Dubliners,* Joyce told his brother that his new idea was to cut *Stephen Hero* to pieces, and distill the twenty-four existing chapters into five "long chapters" of a much shorter and more focused work. And he would give it a new title—or rather, give it back its oldest one, *A Portrait of the Artist as a Young Man.*

Portrait was so foreshortened from *Stephen Hero* that it had become a miniature. Though Joyce had one of the most retentive memories for detail ever known, he managed to cut everything out of Stephen's life that

would not contribute to the theme of a modern artist's awakening, and to set external events, even politics, as completely as he could into the cockpit of a single person's consciousness. He left out his birth and everything he could not know at any stage of his growth. His first sensual memories made one page; his family, his culture, and his nation another three or four. Baby tuckoo learns right away the priority of politics over art in his part of the world. The Ireland James Joyce was born into on February 2, 1882, had been a cradle of enlightenment once, when the Roman Empire was collapsing; but in 1882 "the afterthought of Europe" owed too much to Rome for anything Modern to survive in it.[4] If you were a respectable Catholic, you could not argue any point against the Church without declaring for anticlerical nationalism, like Joyce's father. But if you were a nationalist you could only argue a point against Ireland if you could find it in Catholic doctrine, like Joyce's mother. Education was Catholic to a fault. After three asterisks on page two of *Portrait*, Dedalus is away at school, six years old as Joyce had been and at the mercy of hundreds of boys anxious to prove that they had not come to the Jesuit flagship of Clongowes Wood College in order to learn to create beauty. Three more asterisks, and Dedalus is back home in Bray for a disastrously political Christmas dinner. Three more and he is in middle school, collecting words and sensations, peering through stronger and stronger eyeglasses, protesting against the injustice of a teacher.

Joyce's father had always been improvident. Now he was becoming a drunk. When the money began to run out in 1891, Joyce was taken out of Clongowes and sent to the local Christian Brothers school, so dismal that Joyce never put it in *Portrait* at all. Eventually, his old headmaster at Clongowes found out what he was doing and got him into Belvedere, a Jesuit college in Dublin, on scholarship. From this "day-school full of terrorised boys," in 1896, Joyce discovered Nighttown, Dublin's red light district, reveled in lust and ladies' underwear, repented grandly after hearing ghastly sermons on hell and damnation, considered the priesthood, then lost the faith for good. So did Dedalus in *Portrait*. "The end he had been born to serve yet did not see had led him to escape by an unseen path."[5]

The next year, 1897, Joyce wrote his first "Silhouettes." They were first-person prose sketches, something like prose poems. None has survived, but Stanislaus's reports make them seem like narrated street scenes, narrowly observed. By 1900, long after his loss of faith, Joyce was writing another kind of prose sketch, which he called by the intriguing name *epiphanies*. "By an epiphany he meant a sudden spiritual manifestation" of a thing no more spiritual than a street clock, such that it stood out as a thing, one and integral, "its soul, its whatness, leap[ing] to us from the vestment of its appearance."[6] Not an easy thing for a man with thick glasses to pick out.

Being as weak of sight as he was shy of mind, he drew less pleasure from the reflection of the glowing sensible world through the prism of a language manycoloured and richly storied than from the contemplation of an inner world of individual emotions mirrored perfectly in a lucid supple periodic prose.[7]

With his microscopic eye for detail, Joyce had discovered that experience, like matter and energy, comes in bits and pieces. The "silhouettes" and "epiphanies" were the first ways he found to reflect it. They aimed at an immediacy of description even the most realist of novels had not yet attained as the nineteenth century ended. Dickens had made his characters real by making them extravagant, Flaubert had brought Madame Bovary to stirring life by describing the world through her eyes; but Joyce, reading everything in sight at century's end, had yet to find a writer who could enter the mind of a character completely enough to give him the sense of living another life from the inside. Certainly not a life as Joyce was beginning to understand it, full of fits and starts, lacking the coherence and "self-control" by which the old century had set so much store. You could only experience this sort of falling-apart of consciousness in the theater, the era's most stirring form. In the theater it was cues, not exposition, that connected one set of lines to another, and speeches had to establish their own coherence. There was almost never a narrator, and characters still gave monologues directly from the heart, agitated and interrupted by the feelings of each moment as it passed. We have already seen the effect theatrical monologue could have on poetry. Joyce, who had acted, sung, and spoken his own monologues almost before he wrote any, was destined to become responsible, together with Katherine Mansfield, Franz Kafka, and Arthur Schnitzler, for the even greater effect of monologue on fiction. Meanwhile, as the century ended, he was becoming one of the biggest theater fans in Dublin.

It began in 1899, in February, when one of Joyce's fellow students gave a paper in the University College Literary and Historical Society on the "evil effect" of the Norwegian playwright Henrik Ibsen and other unpleasant non-Irish, anti-Catholic writers. Joyce rose to attack it, and soon found himself cast as an Ibsenist, almost the only one in Ireland (though Bernard Shaw was carrying the flag in London). The city's small intelligentsia took note. Things got back to his mother. "What does Ibsen write . . . ?" she asked. "Plays," he said and gave her some to read, hoping she would not find the same terrible scandal in the uppitiness of Nora Helmer or Hedda Gabler that had been detected by respectable burghers everywhere in Europe.[8] He watched with interest as William Butler Yeats and company organized the new Irish Literary Theater. He would soon have to admit to Stanislaus that he might never be able to write better poems than Yeats, but perhaps he could write better plays. On May 8,

Joyce went to the Theater for the premiere of Yeats's *The Countess Cathleen*. In the audience with his University College cronies, Joyce clapped vigorously. They booed. Joyce said the purpose of the theater was to portray real life and experience. They said it wasn't, especially if in the process it made "Irish Catholic Celts" into "a loathesome brood of apostates." Their patriotic letter to the editor appeared on May 10 in *The Freeman's Journal*.[9] Joyce did not answer right away. He began to read all the modern European playwrights, and to draft a paper of his own for the Society that would prove the monumental superiority of Ibsen and the modern theater. When the paper was rejected as un-Catholic by the faculty adviser, Joyce appealed and managed to convince Father Delany that Ibsen's work had been covered by Saint Thomas Aquinas when he wrote that beauty was what pleased.

On January 20, 1900, to inaugurate the new century, Joyce rose before the University College Literary and Historical Society to deliver his paper under the title "Drama and Life." He read it in a very even tone, letting the words themselves carry the emphasis. Sophocles and the Greeks were played out, he said. Shakespeare was dead. Wagner's *Lohengrin* and Ibsen's *Ghosts* (a play about hereditary syphilis) represented the future. Real life, not "faery," had to be put on the stage in modern cities and "common parlors," otherwise drama could never attain to its ideal, the changeless truths of human nature. When he finished, questions broke over him in waves from the floor. He answered them all, when his turn came, in a single speech. As a public lecture, Joyce's first, it was a considerable performance in itself, and so encouraging that Joyce went out and got a French translation of Ibsen's new play, *When We Dead Awaken*, and began writing the article about it that had been vaguely suggested to him by the editor of *The Fortnightly Review*.

Fresh from his triumphant assertion of artistic supremacy, Joyce went the next month to the Irish Literary Theater for the premiere of *The Bending of the Bough*, a collaboration by Edward Martyn and George Moore. We have already run into George Moore among the poets. He was the Irishman who had gone to Paris in 1873 to become an artist, and returned as a French-speaking aesthete with a mission to renew his native literature. His first real book had been *Confessions of a Young Man* (1888), which chronicled his coming-of-age as a writer, starting with his discovering novels at eleven and hiding poems by Byron and Shelley from his Catholic teachers in Dublin. In Paris, after giving up painting and writing a play, Moore went to the exhibitions of the impressionists and met their friends the symbolists at Mallarmé's Tuesday salon. He had discovered Baudelaire and Poe, met Villiers de l'Isle-Adam, laughed at the monologues of Cros, learned from Verlaine, and, without meeting Rimbaud or Laforgue, made lifelong friends of their editors, Gustave Kahn and Edouard Dujardin. At the time of his play's premiere, he was

at the center of the English literary avant garde, together with his fellow Irish expatriates Wilde and Yeats and the Welsh symbolist Arthur Symons. Joyce, who was just beginning to look longingly in their direction, opened relations by planning a play of his own with a political theme much like Moore's.

When Joyce's review, "Ibsen's New Drama," appeared in *The Fortnightly Review* for April 1, he was eighteen years old, thrilled to be both published and paid (the fee was twelve guineas). His friends were awed and envious. Perhaps there was a future in this apostasy. Ibsen himself wrote to his English translator, William Archer, thanking Joyce for his kind words, and in May Joyce took his father to London to meet Archer and turn him into a patron and mentor. While there he devoured theater, going to music halls and watching Eleanora Duse act in plays by Gabriele D'Annunzio, the Ibsen of Italy. The following month his father took him along to Mullingar in central Ireland; and there, while his father was adjusting the voting rolls, Joyce sat in their hotel room and wrote plays. One, in verse, was called *Dream Stuff*. Another was the Moore-inspired problem play—in prose. He sent the completed work to Archer in August under the title *A Brilliant Career*, inscribed:

> To
> My own soul I
> dedicate the first
> true work of my
> life[10]

Promising himself to become a hero-playwright, Joyce had become a bigger Ibsenist than Ibsen himself.

"The minds of the old Norse poet and of the perturbed young Celt met in a moment of radiant simultaneity."[11] It was in Ibsen that Joyce found the justification he needed for being an egoist in the cause of his art. There too he found a liberating insistence on using ordinary life as his material. Most importantly, it was in Ibsen, and in other works for the theater, that Joyce could find the narrative immediacy that would make his fiction so revolutionary. The man who read nearly everything could not find it in fiction, where it had been used only in works he either did not find or did not fancy: American set pieces like the confessions of Poe's protagonists in "The Cask of Amontillado" and "The Tell-Tale Heart" (1843), the monologues in Herman Melville's five first-person novels and those of Ahab, Stubb, and Starbuck in the sixth, *Moby Dick* (1851), or the long comic lecture Mark Twain had put in the mouth of Huckleberry Finn (1876–84). He had certainly missed Charlotte Perkins Gilman's monologue of madness, "The Yellow Wall-Paper," in *The New England Magazine* of May 1892. If he read Poe he certainly never mentioned it. The only American writer he ever borrowed from was Twain's

friend, Bret Harte, whose "Gabriel Conroy" gave him a name and a Rocky Mountain snowfall for his own story, "The Dead." It was an American philosopher, William James, who had coined the term "stream of consciousness" in an article in *Popular Science Monthly* in 1880, before Joyce was born; but Joyce knew neither the term nor James's name (any more than he knew the term "free association" or the names of Freud and Jung, whom James was hosting in Worcester, Massachusetts when *Portrait* found its reader in 1909). It was Henri Bergson who had launched the study of the mind's phenomenology in 1889, when Joyce was six; but between college and the writing of *Portrait,* Joyce read no more modern philosophy than he did American fiction. In fact, he thought he had found all the philosophy he needed in Aquinas. Ibsen was more important to him in 1900. It was Ibsen who gave Joyce a meaning for the word "modern."

Ireland knew what "Modern" writing meant around 1900. It meant curse words like "bloody" in print, descriptions of bodies and physical intimacy between the sexes, or stories about independent unmarried women. It meant most French literature (and English politics). It meant the plays that were regularly banned or shouted off the stage for dealing with social problems which in Catholic (or even Christian) countries must not exist. It meant individualism, that heady legacy of non-Irishmen from Voltaire to Nietzsche, which advised making rules for yourself whether or not they could be derived from the rules being made for everyone else. It meant destructive, "vivisective" analysis of what should be left alone.[12] Finally, it meant any outrage to the ancient rules of grammar, punctuation, and prosody, or to Irish patriotism or Christian theology. Joyce would pioneer in giving Modern a different meaning, but in 1900 the old one slipped on like a glove. Already he was coining new words by running two old ones together, substituting an initial dash for quotation marks, and making rude remarks about the Resurrection.

But outside Ireland Modern meant more. Joyce began to read everything he could get his hands on that would enlarge his provincial world, not only in English but in French, Italian, the Dano-Norwegian of Ibsen (which he could barely decipher), and the German of Ibsen's putative heir, Gerhart Hauptmann. Prosaic though it may be, there is very little that is more important to a writer than reading, and Joyce read the way a famished person eats, trying with the fervor of a convert to find out what was out there and what his opportunities might be. What he found was memorable, but what he did not find is even more so. It sometimes seems as though he had deliberately avoided anything that might later compromise his priority in the invention of the Modern novel.

In Dano-Norwegian, for example, Joyce went from Ibsen to Bjørnson, and by 1905 was reading Jens Peter Jacobsen's celebrated 1880 novel of a decadent's education, *Niels Lyhne.* No one knows, however,

what chance made him miss the work of Ibsen's young Norwegian rival, Knut Hamsun, until 1910 or so. Hamsun had come back from America in the middle of 1888 with a first novel percolating in his head, and by November had managed to get parts of it written and anonymously printed in the Copenhagen review *Ny Jord.* Like *Portrait,* Hamsun's *Hunger* takes place entirely in the single mind of an artist, a starving writer in the Norwegian capital of Christiania, who in the course of a week or two wanders the streets, provokes citizens, looks for work, and finds ways to eat and sleep without bartering his aristocratic soul. The character's immediacy is established instantly, in a way that is both profound and sustained. He tells the story of what went on in his own head, in the first person, with few transitions. Only the past tense gives the reader any chance of establishing a distance between this strange consciousness and her own. *Hunger* caused an immediate sensation everywhere in Scandinavia and, thanks to its polylingual title and fine fast translations, it was being read and admired everywhere in German-speaking Europe (and in Russia, too) by 1891. *Hunger* even appeared in English in 1899, but the translation was weak, and it sold only a few copies, none of which seems to have turned up in Ireland.

Swedish is not very different from Ibsen's Norwegian, but Joyce also missed the work of the scandalous Swede, August Strindberg, whose plays were nearly as controversial as Ibsen's. His 1890 story, *By the Open Sea,* recounted the sojourn of a would-be superman-scientist among the boors of the Baltic coast. It was written entirely from the protagonist's point of view, its third person slipping regularly into the ambiguous indirect discourse mode that allowed Strindberg to hold onto an omniscient narrator but still get straight into the lone mind of his protagonist.[13] This mode, which critics now capitalize as Free Indirect Discourse or FID, was older than Strindberg, but it was becoming more and more central in late nineteenth-century fiction. Strindberg used it instead of the monologue of Paris cabarets (which he had heard) or of Twain (which he had translated). It was an indispensable tool for Joseph Conrad, the Polish seaman who had become an English author, particularly in his strange brief masterpiece, "Heart of Darkness," which came out in *Blackwood's Magazine* in three monthly installments between February and April 1899.

"Heart of Darkness" is a tale told in the first person by Charley Marlow, an old seaman Conrad invented in part to speak for him; but Marlow's yarning is related in turn by one of his listeners, and behind the listener is, of course, Conrad himself, who made the original voyage up the Congo River as a steamboat officer in 1890. Through these two consecutive frames, in discourse both direct and indirect, we hear Marlow talking, constantly hesitating in his narration, reflecting, jumping ahead, drawing back and falling behind his own story until its pace and direction are blurred in a most un-Victorian way. Paradoxically, the distance be-

tween Marlow then and Marlow now—and between Marlow and the reader—is almost annihilated, so that Conrad, who was even more inhibited about confessions than most Victorians, seems to have contrived a story through which he could open up the self without a qualm.[14] "Heart of Darkness," however, was not a story that reached Joyce. Though American curricula feature it as an imperialist's attack on imperialism, it was hardly canonical or so celebrated in Joyce's time, and he may never have heard about it. Among his books, the oldest Conrad work dates from 1908.

So it boiled down to Ibsen. In March 1901, Joyce picked up his pen and wrote a fan letter to the great man. It was long, with a first draft in English, which has survived:

> I have sounded your name defiantly through the college where it was either unknown or known faintly and darkly. I have claimed for you your rightful place in the history of the drama. . . .
>
> I did not tell them what bound me closest to you . . . how your wilful resolution to wrest the secret from life gave me heart and how in your absolute indifference to public canons of art, friends, and shibboleths, you walked in the light of your inward heroism.[15]

The second draft, in Joyce's newly-mastered Dano-Norwegian, went to Ibsen, who was probably embarrassed and did not keep it. In fact, by 1901 Ibsen had stopped writing plays. Strindberg had not penetrated Joyce's consciousness; and Maeterlinck, Joyce thought, was all dream. So the nearest thing to an active Ibsen was Gerhart Hauptmann, whose plays were labeled *Réalisme* in France and *die Moderne* in Germany. Joyce began reading Hauptmann in 1900 starting with *Hannele* (1893), famous for its long dream sequences; and the next two summers, at loose ends in Mullingar again, he began translating Hauptmann's work into English with an eye to producing it in Dublin. Since Archer had already done *Hannele* in 1894, Joyce translated *Vor Sonnenaufgang* (Before sunrise, 1889), an exercise in slice-of-life realism, and *Michael Kramer* (1900), about an artist who drives his son to suicide. By 1900, however, German fiction had moved on wholesale from realism to phenomenology with Richard Beer-Hoffmann's story *Der Tod Georgs* (The death of George), Thomas Mann's first novel *Buddenbrooks*, or Arthur Schnitzler's novella, *Leutnant Gustl*, in the Christmas 1900 issue of the Vienna *Neue Freie Presse*. *The Death of George* centers on George's deathbed thoughts recounted in the third person. *Buddenbrooks*'s most celebrated passage is a display in FID of the scattered consciousness of Thomas Buddenbrook, the decaying heir to the family fortune.[16] *Leutnant Gustl* (None but the brave) goes even further. Schnitzler, primarily a playwright, had already put a third-person interior monologue into his story *Ein Abschied* in 1895, but *Gustl* is a stand-alone interior monologue in the first person.[17]

In fact, it is the first fiction in German to be set entirely in one character's consciousness—that of a cowardly Austrian army officer agonizing about having to fight a duel. Schnitzler got so truthfully and so immediately into Gustl's head that he was accused of damaging the reputation of the officer corps and was sued by a military fraternity.

Joyce's mastery of Hauptmann's German was shaky in 1901, much improved by 1902, but he never did like the language. He didn't read Mann, Beer-Hoffmann, or Schnitzler. Nor could anything he did read threaten his ambition to be the Irish Ibsen, unless there were to appear some other Irishman with the same cosmopolitan aim. At the time he had not taken account of the fact that there was one of these already in the world, George Moore, whose play he had called progressive in 1900. Sometime in 1901, Joyce picked up a copy of Moore's novel, *Vain Fortune,* and read its account of an apostate artist from Ireland. Moore himself had just moved back to Dublin, and from then on Joyce made it his business to keep up. That October, when a much less progressive folkloric play Moore had written with Yeats was mounted at the new National Theater, Joyce attacked the play and Moore's whole *oeuvre* in a pamphlet he called "Day of the Rabblement." Spending money he could ill afford, he had several hundred copies printed up and sent Stannie to drop one personally *chez* Moore.

Late in 1902, Joyce finally got to Paris. He had missed the confluence of 1900, but not by much, and could easily have bumped into Picasso. Like Moore, he disguised his literary ambition with one that was more respectable. In 1873 Moore had claimed to be studying painting; Joyce announced that he was going to medical school. What he did was teach English, write reviews and "epiphanies," and read. In the evenings he would be at the Sainte-Geneviève Library, in the daytime at the Nationale. What did he read? Realist playwrights? Perhaps Russian novels? These had been fashionable in France, if spottily available, since the late 1880s. Already at the time of Melville and Dickens, Russian masters had begun to experiment with extended passages of FID. In 1903 Stanislaus Joyce picked up the first of them, Tolstoy's 1854 piece, "Sebastopol in May," which gave without comment the contents of the mind of an officer named Praskukhin as he died of his wounds. Stanislaus liked the piece so much he wrote another one like it about a man falling asleep, and showed both to his older brother James. Jim tossed Stannie's story aside, dismissing it as "early Maupassant," but he had seen then what a Russian could do.[18] When Stannie wrote to Jim two years later that he thought the *Dubliners* story "Counterparts" showed "a Russian ability in taking the reader for an intercranial journey," Joyce found himself replying disingenuously that his brother had "set me thinking what on earth people mean when they talk of 'Russian.' You probably mean a certain scrupulous brute force in writing."[19] Probably not. In 1902, two years before *Stephen*

Hero and five before *Portrait of the Artist,* Russians were known not for brute force but for introspection and scope.

After Tolstoy, whom Joyce in this same letter called "magnificent," had come several other Russian fictions of consciousness that Joyce seems not yet to have read, but which stunningly anticipated his ideas. In 1867, for example, Dostoevsky had used Tolstoy's method to get into the mind of Raskolnikov as he stalked the pawnbroker in *Crime and Punishment;* Dostoevsky had even experimented with the first-person theatrical monologue in *Notes from Underground* (1864) and "A Gentle Creature" (1887). In 1877, Vsevolod Garshin had published a celebrated story called "Four Days" that used both the first person and Tolstoy's subject, a dying soldier; and in 1889 Chekhov, fresh from a monologue for theater called *The Harmfulness of Tobacco,* had published "A Boring Story (From an Old Man's Notebook)," in which the narrator-protagonist writes his story in the first person, but less and less retrospectively, as he begins to record events as they happen in what engineers call "real time." And of course there was Boris Bugaev, whose father had dandled him on Tolstoy's knee when he was five. Bugaev's *Second (Dramatic) Symphony* was published in Moscow under the pseudonym "Andrey Bely" in April 1902. Written by an undergraduate in the sciences in detached short paragraphs a little like a mathematics text, it was as strange and as hard to break into as any piece of twentieth-century fiction until Joyce himself wrote *Finnegans Wake.* Not even the French knew anything about Bely. Only a few Muscovites would see the original publication, and it was not to be translated into English until 1986. In 1903, Bely was preparing to further confuse his tiny readership with his *Fourth Symphony.* Joyce never did learn Russian, and in Paris he seems to have read no Russian besides Tolstoy.[20]

But he did read French. In the spring of 1903 Joyce took one of his only day trips to the countryside outside Paris. With a Thai he had met at the Sainte-Geneviève, he went to Tours by train. The station had a bookstall, and in it he caught sight of the name of Edouard Dujardin on the cover of a novel called *Les Lauriers sont coupés* (We'll to the woods no more). It rang a bell. Dujardin was the French editor and friend . . . of George Moore. Joyce bought the book and discovered that *Les Lauriers sont coupés* was in the form of an extended monologue. In fact it reads rather a lot like an extended version of Charles de Sivry's monologue, "L'Indécision," published in 1878.[21] In each, the protagonist is involved with a woman, and the woman is very much in control of a remunerative and hitherto chaste relationship. The humor in each is entirely at the protagonist's expense, though neither one perceives this. Of course, Sivry's monologue had been meant for oral delivery as a stage soliloquy, while Dujardin's work was on paper. The more private form of written prose helped to sustain the illusion that the monologue is a direct and

impromptu record of the consciousness of a man named Daniel Prince, over the course of the evening in which he was visiting his ladylove, Léa d'Arsay, hopefully and unsuccessfully, for the dozenth time. The book had originally been published (along with poems by Laforgue) in Dujardin's own journal in 1887. At the end of his long literary life, Dujardin was to write his own history of *monologue intérieur,* in which he would give himself full credit for inventing a new form; but it was Joyce who first offered that credit, once he had thoroughly outdone *Les Lauriers* in *Ulysses.*[22]

A few weeks after discovering Dujardin, Joyce returned from Paris to attend his mother in her agonizing last illness. He would not spend two consecutive nights in the city for another fifteen years. By contrast, that spring, Gertrude Stein broke up with May Bookstaver, gave up on medical school, left New York, and settled in Paris for good. In September 1903, her brother Leo, who had just decided he was a painter, invited her to share his new studio at 27, rue de Fleurus near the Luxembourg Gardens. Stein used it to finish her first novel, *QED,* inspired by her just-ended love affair. There was nothing the least bit modern about its style or phenomenological about its form, but the relationship was so Modern that the only thing to do with *QED* was hide it in a drawer. Meanwhile James Joyce had no stories to hide at all.

As every Joycean knows, it was the next year that made the writer. 1904 was the year Joyce put playwriting aside and first began (under the pseudonym "Stephen Dedalus") to write and publish fiction. It was the year he met Nora Barnacle ("All the dirty things I made her say")[23] and the year he decided to elope with her and leave Ireland to the devil. To memorialize the moment forever he would set his great novel *Ulysses* (a Dublin "Peer Gynt") on the exact day—June 16, 1904—he had first walked out with Nora in Dublin's Ringsend. He even included in it his falling down drunk in Camden Street four days after the date, and his all-nighter in Nighttown three months before it. "Break my spirit, all of you, if you can! I'll bring you all to heel." He also set the greatest story of *Dubliners,* "The Dead," in the first week of 1904, January 2–6, a week in which he had begun a sort of essay called "Portrait of the Artist." It was on February 2, 1904, his 22nd birthday, that Joyce began to turn the essay into a novel. A novel about himself for the man who had thought, not too long ago, that all forms progressed from the merely self-expressive to the dramatic, "reached when the . . . personality of the artist, at first a cry or a cadence or a mood and then a fluid and lambent narrative, finally refines itself out of existence" and the artist, "like the God of the creation, remains within or behind or beyond or above his handiwork, invisible . . . indifferent, paring his fingernails."[24]

Joyce's first stories appeared in *The Irish Homestead* in August and September, the second, "Eveline," cast in FID so the reader never left the

mind of the main character. Joyce had ten chapters of *Stephen Hero* written by fall. On September 15, a week after he'd walked in, he walked out of the Martello Tower in Sandycove, leaving his roommate, stately, plump Oliver Gogarty, holding the lease. On September 16, Joyce and Nora confirmed their plans to go away together, and Joyce wrote letters to Yeats, Symons, and everyone else he knew asking for money. On October 8, they boarded the ferry at Dublin's North Wall and sailed for England. As he wrote at the end of *Portrait,* in an echo of Ibsen's Brand, "Welcome, O life!"

It was a hectic trip. Joyce knew better than to put it in any of his books. An hour after they reached Trieste Joyce was arguing with an official about his identity papers, and spent the evening under arrest. Now he was an exile, like most of the Modern novelists: Gertrude Stein, the Californian in Paris; Katherine Mansfield, the New Zealander in London; Knut Hamsun, the peripatetic Norwegian; Joseph Conrad, the Pole who wrote all his work in English in England; George Moore, the Irishman who wrote French in Paris and English in London; Schnitzler, whose internal exile deepened with every rise in Vienna's anti-Semitism; Kafka, who was a German-speaking Jew in a Slav capital; and Proust, who had, without leaving Paris, succeeded in moving his residence from the day to the night and his social and sexual life to a parallel universe. Together they render inescapable the conclusion Joyce reached when he fled the ignorant jingoisms of his native Ireland: Modernist writing was not national but European, perhaps the West's first truly cosmopolitan literature since the Middle Ages. "Rootless intellectuals!"—one can almost hear the complaint of Adolf Hitler, that failed artist from the German borderlands, who was spending those same nights in a furnished room in Vienna, writing play outlines and railing at the non-German intellectuals of the imperial capital. And so the Joyces lived from hand to mouth in an Austrian seaport, while Nora, pinched but never disloyal, marveled that Jim could spend so much of his time reading.

Joyce's eyes got worse and worse, but his goal in reading was to write like a genius, so he kept at it. In December, he got hold of an old book by Moore, three novellas published under the title *Celibates* in 1895, which Moore himself thought of as "a frontier book, between the old and the new style."[25] The first of the novellas, "Mildred Lawson," was about a woman painter, or rather a run of her soul. It opened with an unadulterated interior monologue, and returned to this mode at regular intervals. Clearly Moore had known just what his friend Dujardin had been doing in *Les Lauriers sont coupés,* discovering, as he told him, "the form, the archetypal form, the most original in our time."[26] Joyce didn't say much about "Mildred Lawson" or what he learned from it or what it meant for his ambitions, but in December he and a new friend began to translate it into Italian, and after the New Year, 1905, he gave the book to Nora

to read. "[W]hen she read [it]," he crowed to Stannie, "she said Moore didn't know how to finish a story."²⁷ Nora was hardly a sophisticated reader, but she knew enough not to make Jim jealous. Still, "Mildred Lawson" had a great deal of what Joyce was after—the immediacy of first-person monologue, the discoveries, or "epiphanies" of consciousness at the very time a consciousness might make them.

The novelists and the philosophers were beginning together, as if driven by the same forces, to change the rules of epistemology. The old insistence on objectivity, the strict separation of the observer from the observed, seemed to vanish for both of them at the same time. In 1860, the reader had been cordially invited to know everything: the inside of a character as well as the outside, the public as well as the private, one closed room as well as another. The only thing he would not know immediately was what "had not happened yet"—the end of the story. That and any direct reference to sex, of course, and also the author's mind, which should float like God, "within or behind or beyond or above his handiwork, invisible . . . indifferent," transcending its fictions, as Joyce himself had thought in 1901. Writers who thought of themselves as self-conscious artists, like William James's brother Henry, were beginning to push at the envelope in the 1890s, but although Henry James insisted on a "single point of view" for the narrators of his novels, he only tried once to write a novel in the first person, *The Sacred Fount*. He finished it and published it in 1901, but he didn't like it. Modern readers don't like it either. The narrator prowls around at a house party seeking to unravel the mystery of two relationships that intrigue him; but the narrator's consciousness behaves like a circling beacon, restlessly aiming outward, and inwardly empty of all the little involuntary perceptions modern readers now require of a character before they will believe in him, or care. The so-called omniscient author remains omniscient even if she writes herself into or out of a story. The true narrator of *Fount* is James, no less a searchlight for having turned himself into a houseguest; and like all of James's narrators, he is all judgment—something Joyce did not overlook as he began reading James intensively in Trieste in the early months of 1905.

Today it is clear that James was the last of the nineteenth-century pre-Modern novelists, certainly the last great one. In 1904, when James had returned to his native America to give speeches about literary art in Philadelphia, the Bryn Mawr and Penn students listened raptly, but only William Carlos Williams of the next generation of writers was among them. Gertrude Stein was in Paris, writing her second novel about the scandalous relationships between the president of Bryn Mawr, her lover Mary Gwinn, and Alfred Hodder, the professor of history who had left his wife to run away with Gwinn in 1904. A year later, in the summer of 1905, in the Villa Bardi outside Florence, Gertrude Stein began writing

her story about an untamable young black woman, "Melanctha," the third of her *Three Lives.* The story was in the third person, but it rendered Melanctha's conversation without quotation marks, and spiraled so freely in time that readers have never felt they were anywhere else but the mind of Melanctha, or that of her hapless fiancé. Returning to Paris, Stein continued writing *Three Lives* at night, on "the long Florentine table in the studio room. Under the watchful eyes of Cézanne's magisterial portrait, in the dim light, she . . . would sit for hours, filling up the pages of a child's copy book with her exuberant scrawl."[28]

Joyce, who knew nothing of Stein's nights, kept following Moore's work more and more closely as it continued to cross his chosen path. Moore's aestheticism, his defiance of sex codes and censorship, his hatred of Irish provincialism, his discovery of Paris and cultivation of Symons, Yeats, and Verlaine—in short Moore's subjects, Moore's forms, Moore's stylistic experiments, and even his life—never failed to strike Joyce as commentary on his own, and he rejoiced whenever he was able find them inferior, which was all the time.

In the fall of 1905, Joyce was writing more of *Dubliners,* designed as a set of modern realist stories of benighted Ireland. As his little stack of publisher's rejections grew, he got hold of a copy of a book called *The Untilled Field,* realist tales of a benighted Ireland. It was Moore's of course, but as luck would have it, the book was somewhat lacking in execution. "I read that silly, wretched book of Moore's 'The Untilled Field' which the Americans found so remarkable for its 'craftsmanship,'" he wrote to Stannie. "O, dear me! It is very dull and flat, indeed: and ill-written."[29] A year later it happened again. This time it was a novel by Moore called *The Lake,* full of the reveries and interior monologues of a failing priest named Gogarty, and ending with Gogarty baptizing himself out of the Church with a symbolic plunge in an Irish lake. The real Gogarty, Joyce's sometime roommate, would appear in *Ulysses* as Buck Mulligan. Within weeks of *The Lake*'s abortive first publication in November 1905, Joyce wrote to his aunt asking for Dublin's reaction to it.[30] He seems not to have gotten through the book until the following summer, when he wrote to his brother Stanislaus that the Preface was "written in French to a French friend who cannot read or write English (intelligent artist, however, no doubt)" without bothering to tell him it was Moore's mentor in interior monologue, Edouard Dujardin.[31] He did tell Stanislaus he would send him *The Lake,* but only after he got money.[32] In his next letter Joyce showed his anger, saying he had written "quite enough" without being paid and offered one more attack on Moore's book, which was selling well—"Yerra, what's good in the end of *The Lake?* I see nothing."[33]

The end of *The Lake* was the anti-baptism of Father Gogarty, a theatrical wade very much like the one Stephen Dedalus takes at the end of

part four of *Portrait*.[34] Today Moore is almost forgotten, but one gets the oddest feeling, reading him, that he was Joyce's own John the Baptist. Keeping his head, he lived to see *Ulysses* published, in which he appears half a dozen times and is compared to Don Quixote. "Our national epic has yet to be written, Dr. Sigerson says. Moore is the man for it. A knight of the rueful countenance here in Dublin."[35] But in fact—much to Ireland's dismay—it was *Ulysses* itself that turned out to be Ireland's national epic, just as it was *Portrait of the Artist* and not Moore's four memoirs that became the fictional autobiographical model of this century.[36] At least, one might say, Joyce and his characters *read* Moore, which was more than they or almost anyone else was doing for Gertrude Stein. In 1906, Stein was beginning the *Making of Americans,* her longest book, meant as a sort of epic, but mainly the transposed story of her own family. It was less Modern than *Melanctha,* more distant and third person, judgmental, Jamesian, but still strange. In fact, Stein was finding a new sort of space- and timelessness through the use of constant repetition of all the novel's parts, from the chapters to the phrases. It would be regularly rejected by publishers until 1924. That spring of 1906, as Stein trudged back and forth to Montmartre to pose for Picasso, she began getting the first of many rounds of rejection letters for *Three Lives.* Brother Leo was no comfort, and it would be another year before Alice Toklas came into her life. As she wrote to Mabel Weekes: "I am afraid that I can never write the great American novel. . . . I am very sad Mamie."[37] *Three Lives* would not be published until July 1909, six months after Schmitz's momentous first reading of *Portrait;* and Stein would be paying the printer.

Joyce was getting the same rejections, sometimes from the same publishers, but there was no way he could ever afford a vanity press. Like Stein he kept on writing. Not long after his twenty-fifth birthday in February 1907, Joyce began writing "The Dead," a deceptively simple, flawless short story about a failing writer at a New Year's party in Dublin, his mind elegantly rendered from inside in fully mastered FID. A rereading of Moore's *Vain Fortune* had suggested the story's shape, and Joyce had it finished by the second week in September. This "linchpin in Joyce's work" became the last story of *Dubliners*.[38] Another story was still in the works, conceived a year before, based on a recent Dublin divorce case and tentatively titled "Ulysses," but Joyce decided to leave it out of *Dubliners* and expand it into a novel instead.[39] The same week he finished "The Dead," he picked up *Stephen Hero* and began turning it into *Portrait*.

Cutting was required, and cutting is harder than writing. The remaining manuscript of *Stephen Hero,* two hundred and thirty pages in the standard printed edition, became only one chapter, ninety-two pages of *Portrait*. Joyce saved phrasing he liked, and some of the dialogue (with its characteristic dashes instead of quotation marks). For the most part,

however, what happened was a concentration on Stephen Dedalus, or rather *in* Stephen Dedalus. The world is what impinges on his consciousness, "events deprived of importance," as Ettore Schmitz called them, or a fact "your rigid method of observation and description does not allow you to enrich [if it] is not rich of itself." But the richness and importance of facts—epiphanies—comes from what the character makes of them, not the writer. The writer pares his fingernails, leaving it to the reader to muster the heightened empathy and freer moral imagination required by the new method, and the learning time that Schmitz did not have. Schmitz even had to wait a few years before he could read the last two chapters, describing Stephen Dedalus as he goes to college, loses his faith, and heads for Paris to become an artist. Not until 1914 did James Joyce add Stephen's famously pretentious valedictory to the end of *Portrait,* "I go to encounter for the millionth time the reality of experience and to forge in the smithy of my soul the uncreated conscience of my race."

Nevertheless, the three chapters Schmitz read in 1909 constituted the first fully Modern masterpiece of fiction, the first totally immediate portrait of a literary artist in the age when the artist's mind had become the last remaining flimsy absolute. What was finally published in *The New Freewoman* in 1914–15 (thanks to Yeats, Pound, and Dora Marsden) as *Portrait of the Artist as a Young Man* was a story, a history, whose details were the unmarked contents of consciousness, chronological but otherwise random, left in the lap of the astonished reader with the challenge to put them together. Virginia Woolf's *The Voyage Out* and Dorothy Richardson's *Pointed Roofs,* two other first novels that accompanied *Portrait* into print that year, had some of the same quality; not to mention Ring Lardner's first story, the comic monologue "A Busher's Letters Home," which appeared in the *Saturday Evening Post* in March. H. G. Wells, the father of Richardson's miscarried child, caught on immediately: "It is a mosaic of jagged fragments," he wrote in his review of *Portrait.* "The technique is startling, but on the whole it succeeds."[40]

Writing the history of Modernist writers is a lot like their own writing of fiction. The spread of events defies our chronicle scheme. We can date Planck's insights to the week he arrived at them, and Cantor's almost to the day; but fiction requires greater execution. It not only takes years to write a novel; it takes years to prepare to write one. Conceiving *Ulysses* in 1907, Joyce planned to hinge the whole of human experience on a single day in June, but it took him fifteen more years to do it. Bely tried to do the same sort of thing, but it took him eight. Proust allowed twenty years to unfold gracefully out of one cup of tea, but writing it down took sixteen years—the rest of his life—and Proust reckoned the fourteen years before 1909 as his apprenticeship. Stein tried the contrary strategy of eliminating the distinction between one day and another, but even she took six years. Richardson could write a novel a year when she hit her

stride, but in fact her novels were all one novel, published over twenty-three years, in installments, like Proust's. Woolf, whose novels were part of no whole larger than her own genius, came late to her last, like Richardson, partly because her first novel had taken her six years. Only Kafka and Mansfield were spared this longest of arts, for tuberculosis killed them both in 1923–24, when their novels were unfinished and only their stories and sketches had reached print. How may all these writers and all these scattered and simultaneous marathon acts of writing be fitted into a single narrative? Ask the writers. They faced the same problem. Wrestling with the sheer size of the modern world and the centerless, forever expanding universe of undifferentiated human experience, they came up with the fiction we now call Modernist. The failure of focus and the collapse of traditional narrative is part of their discovery. Perhaps history should struggle, too.

But History, as James Joyce put it, "is a nightmare from which I am trying to awake." It may never be a historian's fate to feel the exaltation Joyce felt when he first saw *Portrait of the Artist* whole, or the sort of ecstasy that came over Marcel Proust as he sat up in bed in January 1909, surrounded by the accumulating sheets of his incoherent essay on criticism, put a spoonful of herb tea into his mouth with a bit of toast, and felt the whole past begin to unfold in his mind with perfect focus, like a child's paper flower.

20 VASSILY KANDINSKY

ART WITH NO OBJECT

1911–1912

> The tall, narrow roofs of the Promenadenplatz and
> Maximiliansplatz, which have now disappeared, the
> old part of Schwabing, and especially the Au, which I
> discovered by chance on one occasion, turned these
> fairy-tales into reality. The blue trams threaded their
> way through the streets like an incarnation of the air of
> a fairy-story, which one inhales with delightful ease. The
> yellow mailboxes sang their shrill, canary-yellow song
> from the street corners. I welcomed the label "art-mill,"
> and felt I was in the city of art, which for me was the
> same as being in fairyland.
>
> —Vassily Kandinsky, *Reminiscences*

The city was Munich, the capital of the southern
German state of Bavaria. The artist was Vassily Kandinsky, who in 1911
was living and working in Munich's bohemian suburb of Schwabing. His
studio at number 36 Ainmiller Street was a whirlpool of activity, and
1911 was to be his *annus mirabilis*. During the twelve months of his
forty-fifth year, Kandinsky was to paint a dozen major paintings, together
with innumerable studies and sketches, and show his work in four cities
in three countries. In addition, he would publish two articles and a germi-
nal book on the theory of modern art, edit a second book bringing most
of the important central European voices in the arts together for the first
time, and lead in the planning and execution of an international exhibi-
tion that is still considered one of the two most important group shows
in the early history of modern art. A final divorce decree would end his
first marriage halfway through 1911. Finally, somewhere along the way,
Kandinsky would paint one of the first pictures ever to deserve the desig-
nation "abstract," "nonobjective," or "nonrepresentational" art.

Kandinsky's marvelous year began when he went to a New Year's
party at the home of another pair of Munich artists, and went on with
them to a concert of works by a new composer, Arnold Schoenberg. One
of the out-of-town guests was a painter named Franz Marc, who there
began his lifelong friendship with Kandinsky. Within a month Marc was

writing that the "hours spent with [Kandinsky] belong to my most memorable experiences."

> My initial response is to feel the great joy of his powerful, pure, fiery colors, and then my brain starts working; you can't get away from these pictures and you feel your head will burst if you want to savor them to the full. . . .[1]

The maker of these mind-blowing pictures had a mustache, a sharply pointed black beard, and mephistophelean almond eyes behind thick glasses. Kandinsky's housemate, Gabriele Münter, an excellent painter herself, had already made several small portraits of him in which the professorial rumple was set off by an unfathomable reserve and an oddly authoritative, almost prophetic gravity. He was quite sure of what he was doing. He was so assured, in fact, that whenever his fellow artists got together they elected Kandinsky to run the show for them. The fact that he had a bit of an independent income helped. In 1909 the Schwabing avant garde had responded to his call to found an exhibiting society, the New Artists Organization of Munich (NKVM), and promptly elected him president. In that capacity he had mounted a show in the fall of 1910 that for the first time brought work by the French cubists and the new Russian painters to Germany. Kandinsky was Russian himself, a Muscovite, and half the NKVM was Russian too. They had come to Munich to study art, and having studied it, had stayed.

Munich was yeasty with cultural pioneers. The journals *Simplicissimus* and *Jugend* (Youth), together with their art-nouveau style called *Jugendstil*, had begun there. The Eleven Executioners cabaret, one of the first outside of Paris, had been in Munich since 1900, and the playwright Frank Wedekind was part of it. Thomas Mann wrote stories there, and Stefan George wrote poems. But it was the artists, and especially the painters, who were the yeastiest of all. Munich was home to several hundred thousand people, and at times it seemed half of them were artists. Many had come from rather faraway places, like Pittsburgh, Glasgow, and Odessa. At least one Munich art show in 1869 had attracted 100,000 visitors, more than 60 percent of its 1869 population.[2] Munich's Glyptothek was the oldest public museum in Central Europe, and its Neue Pinakothek had been the only German public collection of contemporary art until the 1890s. There was a third museum for art that was neither Antique nor contemporary, a fourth small gallery for the Sezession, a fifth hall dedicated to industrial exhibits but often used for art, and a sixth, the Glass Palace, the largest in Germany, which was used on occasion for great exhibitions. The Munich artists' Sezession had been, in 1892, the first in Central Europe to declare its independence. Though it was a spent force in 1911, and its members had become respectable, a group of new artists were already pushing the envelope. In 1911, people were beginning to call them "expressionists."

The term *Expressionismus* was first used by Germans in 1911 to describe the new trend in French painting[3] that had taken up where Matisse and his co-conspirators had left off—the fauves whose work Kandinsky, who had spent a year in Paris in 1906–7, could describe firsthand. Forms were simplified, colors saturated, and surfaces laden with paint. First in painting and later in theater and poetry, *Expressionismus* would be used after 1911 to describe the German avant garde much as *Futurismo* described the Italian. It would be used retroactively to describe Strindberg's drama. For painters, it represented the replacement of Seurat by Van Gogh as a model; and the assertion of a new goal: to paint not the observed moment in the life of nature, but nature's inner life, and the inner life of the artist as well. The style had come to Germany at the turn of the century, well before the word was coined. Among small artists' associations like Die Brücke (The bridge) in Dresden, the Worpswede Group near Bremen, the Neu-Dachau, Phalanx, and Scholle (Clod) groups around Munich that had succeeded the Sezession, expressionism was already under way. Kandinsky had seen some of this French, German, and Russian work that was about to be dubbed expressionist, and he had liked it. He had, in fact, founded the Munich Phalanx and helped mount all ten of their shows. His new friend Franz Marc painted blue horses and yellow cows in a village not far from Munich, and Münter, Marianne Werefkin, Alexei Jawlensky, and other neighbors who had helped him found the NKVM were making equally proto-expressionist art in Schwabing. Nevertheless, Kandinsky's own work was rather different. Though he had done some excellent woodcuts, often achieving the simplified forms beloved by Die Brücke, he had nearly given it up recently, turning instead to painting on glass the way folk artists of the Munich countryside had done for generations, and simplifying not his forms but his subject matter. Instead of using color as a fauve might, to make a white sailboat orange, Kandinsky splashed primary colors onto scenes from the past, from fairytale and myth. Where he had once painted trains rushing through a recognizable countryside, lately he had been painting mounted archers posting through fantasy landscapes under the outlines of mountains.

Even his picture titles were changing. "The direct impression of 'external nature,' expressed in linear-painterly form" he now called an "Impression," though it rendered something very far from a momentary effect of light. He made the first of his Impressions in 1911. Two years before, in 1909, he had painted the first painting to which he attached the label "Improvisation." The source for an Improvisation, he wrote in 1911, was "chiefly unconscious, for the most part suddenly arising expressions of events of an inner character, hence impressions of 'internal nature.'" Another sort of picture was what he called a "Composition." He had painted his first three of these in 1910. A Composition expressed the same inter-

nal events, but took more time because "after the first preliminary sketches," Kandinsky "slowly and almost pedantically worked out" how to express them.[4]

Kandinsky, in other words, was not trying to paint what he saw, but what he felt, or rather what he knew inside himself. Though the things he knew inside had no shape at all, Kandinsky was quite certain they were substantial, and well worth painting. He was convinced they were undergone in turn by a faculty that could be found within himself, and that could be reached in others—something he called the "soul," using an unabashedly religious term. He had been born in 1866, ten years after Freud, who called the soul "psyche" and thought its mysteries were material; but Kandinsky did not think, as Freud did, that the materialist millennium was coming in. He thought it was coming to an end. He saw no conflict between religious belief and the radical remaking of art, and indeed thought the two would reinforce each other. Except for some aging Russian symbolists, not many other artists still felt that way. Perhaps one key to Kandinsky's views was synesthesia, the condition Baudelaire had written of in his sonnet "Correspondances" where the sensations produced by any one of the five senses can evoke corresponding sensations in the others. Kandinsky was a cellist and a poet, and every one of his five senses was resonant. He was acutely sensitive, especially to color.

> As a thirteen or fourteen-year-old boy, I gradually saved up enough money to buy myself a paintbox containing oil paints. I can still feel today the sensation I experienced then—or, to put it better, the experience I underwent then—of the paints emerging from the tube. One squeeze of the fingers, and out came these strange beings, one after the other, which one calls colors—exultant, solemn, brooding, dreamy, self-absorbed, deeply serious, with roguish experience, with a sigh of release, with a deep sound of mourning, with defiant power and resistance, with submissive suppleness and devotion, with obstinate self-control, with sensitive, precarious balance.[5]

Indeed, it was a synesthetic moment of vision that had come to him long ago in his native Russia that had turned Kandinsky into an artist. Sometime between 1891 and 1895, Kandinsky, a newly married, newly hired law school teaching adjunct with research interests in economics and ethnography, had gone to an exhibition of French impressionists in Moscow, and "suddenly, for the first time" seen a picture. It was a Monet painting called *Haystacks,* part of a time-series, fixing the effects of light. But Kandinsky had not seen the haystack. What he had seen, instead, was the picture.

> That it was a haystack, the catalogue informed me. I didn't recognize it. I found this nonrecognition painful, and thought that the painter had no right to paint so indistinctly. I had a dull feeling that the object was lacking

in this picture. And I noticed with surprise and confusion that the picture not only gripped me, but impressed itself ineradicably upon my memory, always hovering quite unexpectedly before my eyes, down to the last detail. It was all unclear to me, and I was not able to draw the simple conclusions from this experience. What was, however, quite clear to me was the unsuspected power of the palette, previously concealed from me, which exceeded all my dreams. Painting took on a fairy-tale power and splendor. And albeit unconsciously, objects were discredited as an essential element within the picture.[6]

It had been the first in a cascade of insights that sent Kandinsky from Moscow to Munich. At about the same time, he recalled, he had been amazed to experience the music of Wagner's *Lohengrin* as colors and lines, and he had learned of "the further division of the atom," probably the discovery of the electron between 1894 and 1897. "The collapse of the atom was equated, in my soul, with the collapse of the whole world. Suddenly, the stoutest walls crumbled. Everything became uncertain, precarious and insubstantial."[7]

In 1911, some twenty years later, Kandinsky, his marriage at an end and his career in law no more than a memory, was still working out the consequences of these sudden revelations. It was the year he painted the first five of his numbered *Impressions,* variously subtitled *Moscow* (no. 2) or *Park* (no. 5). The motifs in them could be found by a viewer, but only by one intent enough to pick them out amid Kandinsky's insistent shapes and colors. *Improvisations* 19 through 22 were still more subjective. *Composition IV* and *Composition V* would take painting to the edge of complete subjectivity. He painted all of them in 1911.

Although few painters waste much time writing, Kandinsky wrote well enough and often enough to make his intentions clear even to some who could not make head or tail of his new work. He had already written a monumental attack on positivism and materialism, the book that was to explain his unique approach to painting. It was called *Über das Geistige in der Kunst* (On the spiritual in art). He had read it to an audience in October 1910, and would persuade the adventurous Munich art publisher, Piper, to print it in 1911. Painting, he wrote, used three distinct instruments—color, form, and subject—to cause what he called "sounds" in the soul. Each instrument worked its own magic; color and form, for example, did not exist merely to serve the subject. Instead each one operated independently, creating consonances and dissonances with the others in the inner responses of a viewer. Arnold Schoenberg had much the same idea of how music worked, and Kandinsky, who had heard Schoenberg's breakthrough *String Quartet #2* with his Munich friends on New Year's Day 1911, saw the point immediately. He began to write Schoenberg letters about the correspondence between their arts.

His book *On the Spiritual in Art* likened painting to music in that both could go directly to the soul; but argued that the various means by which painting could do this had never been as well understood as those of music.

All through 1910, Kandinsky painted so as to increase his understanding of the separate roles of color, form, and subject, and as 1911 began he was approaching what he thought of as the next step: how to separate the way he used form or color to delineate a subject from other ways he used it that were more "abstract." The outline of a face, he thought, conveyed two things at once. One was the shape of a known subject—a face; the other was a variation on the ellipse—an absolute, *abstraktes* form that had quite different connotations of its own. The color of a face was yet another sort of abstraction, implying infinite extension in a way form did not. In the half-dozen paintings of 1911 whose subject was a horse and rider, Kandinsky left the subject recognizable, but dwelt more and more on the abstract forms it suggested to him, other shapes whose inner "sounds" set up consonances and dissonances with the "sounds" of a horse and a rider, and were thus much more than the mere outlines of straining man and beast.

Kandinsky began to paint *Composition IV* in February 1911. As he recalled it, his "inner necessity" required that he put eight "basic elements" into play in it, including "acute movements to the left and upward," "contrast between blurred and contoured forms," and "predominance of color over form." In fact, though a viewer is still hard put to see it, *Composition IV* was a painting of a battle, centered on a castle-crowned mountain, with struggling knights and horses to the left, lancers in the middle, and two wanderers and a reclining couple to the right. The only clue to their placement in space is in the overlap of one subject by another. Skeptics, knowing that Kandinsky found his thick eyeglasses indispensable, still try to blame the artist's myopia for their own problems discerning the subjects of his paintings, but this is no solution.[8] Independently of vague representations of people and natural objects in *Composition IV*, overwhelming colors struck "sounds" of their own, much as Kandinsky intended them to: a rainbow-like parabola of red, yellow, green, and dark blue; the intense cold blue of the mountaintop; the bright yellow of the hill on the right behind the reclining couple. Kandinsky saw this yellow in fact as an entirely independent second meaning for the painting. As he recalled it two years later, "The juxtaposition of this bright-sweet-cold tone [yellow] with angular movement (battle) is the principal contrast in the picture."[9]

Kandinsky's colors had been intense for years, but now, as the result of another moment of vision, the true depth of their effects began to become clear to him. It was summer.

The summer of 1911, which was unusually hot for Germany, lasted desperately long. Every morning on waking, I saw from the window the incandescent blue sky. The thunderstorms came, let fall a few drops of rain, and passed on. I had the feeling as if someone seriously ill had to be made to sweat, but that no remedies were of any use. . . . One's skin cracked. One's breath failed. Suddenly, all nature seemed to me white; white (great silence—full of possibilities) displayed itself everywhere and expanded visibly. . . . Since that time I know what undreamed-of possibilities this primordial color conceals within itself.[10]

White, Kandinsky had discovered, was a color, a color as evocative as the primaries themselves, needing only to be set somewhere in its range, a range no less infinite than all color ranges. The experience also seems to have nudged him over the edge into complete abstraction.

This revelation turned the whole of painting upside-down and opened up before it a realm in which one had previously been unable to believe. I. e., the inner, thousandfold, unlimited values of one and the same quality, the possibility of obtaining and applying infinite series simply in combination with one single quality, tore open before me the gates of the realm of absolute art.[11]

In August, Kandinsky began to paint *Composition V.*[12] This painting too had a subject—the resurrection of the dead at the Christian Apocalypse; but by the time Kandinsky had arranged his forms and colors to evoke this climactic vision, even less of the actual subject was left to be perceived on the canvas than had appeared in *Composition IV.* The subject had clearly been in the painter's mind for a year or more; and along the way, Kandinsky made one picture of Gabriel himself blowing his horn and several others of the saints in concert that could easily have called up a chorus of "The Saints Go Marching In" from a brass band in New Orleans.[13] Among the many riders Kandinsky painted in 1911 is a *Rider of the Apocalypse* in tempera on glass. There are also two glass paintings and an oil of Saint George that seem related, and another small glass painting of a bird of paradise and a hellhound.[14] All the many aspects of the subject were evoked on a deep level in the final painting, not by representing the subject but by the use of forms and colors. "I deprived my colors of their clarity of tone," wrote Kandinsky, "dampening them on the surface and allowing their purity and true nature to glow forth, as if through frosted glass."[15] By now Kandinsky had finally seen the new Picassos; photographs of some of his cubist paintings had been sent to Kandinsky by the Paris picture-dealer Kahnweiler. Kandinsky, fascinated, wrote to Marc in October that Picasso

splits the subject up and scatters bits of it all over the picture; the picture consists of the confusion of the parts. . . . This decomposition is very interesting. But frankly "false" as I see it. I'm really pleased with it as a sign of the enormous struggle toward the immaterial thought.[16]

About this time Kandinsky found the immaterial thought for himself, a picture that was neither an Impression, nor an Improvisation, nor yet a Composition. He called it, simply, *Bild mit Kreis* (Picture with a circle). It was pretty big, roughly three and a half by four and a half feet. Until quite recently, it lay in storage in the State Museum of Art in Tbilisi, Georgia, while a little watercolor focused the attention of scholars, an apparently purely abstract watercolor dated to 1910 by its owner, Kandinsky's second wife. This watercolor, however, looked so much like Kandinsky's first fully abstract Composition of 1913 that when *Picture with a Circle* was finally brought out in 1989, after sixty years, the "First Abstract Watercolor" was relabeled "Study for *Composition VII*," and the debate became moot.[17] According to Kandinsky himself, *Picture with a Circle* was "my very first abstract picture of 1911," the first picture he ever painted that had no subject at all.[18]

He seems to have painted it sometime after *Composition IV* and perhaps after *Composition V*, which probably means the winter of 1911. As Kandinsky remembered it, *Picture with a Circle* was "a very large picture, almost square, with very vivid shape, and a large, circular shape top right."[19] A memory without color, in other words; but that was when he had not seen it for years. The "circular shape top right" is yellow with an almond-shaped navy blue spot in the middle, like an animal's pupil, impossible to overlook. Equally compelling are the lower edge of the picture with its pink on one side and its deep rose on the other, the great yellow proto-sphere on the left split by a red zigzag, or the dark blue bubble with its black armature intruding from the right. Kandinsky was "dissatisfied" and did not feel that the colors and the forms quite achieved his aim of setting off the deepest resonances in the soul, so he neither signed the picture nor entered it into his home catalog. He did remember it later, however, as "a 'historic picture' . . . the first abstract picture in the world, because no other painter was painting abstract art at that time."[20]

But that was not quite the case. In that same year, 1911, in a little house in the village of Puteaux, a mile or two up the Seine from Seurat's Grande Jatte, Frantisek Kupka was also moving down the long road toward abstraction. Indeed, he had embarked on it before Kandinsky. He had been working on a single large painting in stages for nearly three years now. In his modest studio at 7, rue Lemaître, studies for it had piled up, some in pencil, others in crayon or pastel. The latest studies in early 1911 were oil paintings of discs with colored sectors, abstractions in

themselves, and there was an enormous oil study that had become, in 1909, a painting on its own, a great purplish canvas with paler discs overlaid on it in a majestic spiral. One might guess that its subject, if it had one, was the evolution of the solar system, but Kupka's title was simply *The First Step*. Finally, looking a bit forlorn in the back of the studio, there was Kupka's oil portrait of his stepdaughter, Andrée, awkwardly, immaturely nude, poised to play in the back garden with a red and blue striped ball. Kupka had painted that piece of realism in 1908, the year Braque and Picasso had stepped off from the *Demoiselles* into cubism, but *Girl with a Ball* was the picture that had become the trigger for Kupka's whole project,[21] a project that would reach completion in the middle of 1912 under the title *Amorpha*—Greek for shapeless.

Kupka was another of Paris's immigrants, a Czech who had dropped out of both the Prague and the Vienna schools of fine arts to come to Paris because it was the capital of the new. He had starved for a while on Montmartre, had a brief affair with the former cancan star La Goulue, and made large oil paintings of Rubenesque women in symbolic settings, one of which had won a prize at the St. Louis World's Fair. Eventually he had found a way to make his living as an illustrator, picturing everything from popular science to the poems of Mallarmé. For an occasional pittance he made cartoons for the anarchist papers, including three entire series of full-page cartoons for *L'Assiette au beurre* (The butter-plate)— which also employed Vlaminck—on the themes of peace, religion, and that old corrupter, money. In an unguarded moment in 1909 he had made a classic "artist's reconstruction" of anthropologist Marcellin Boule's Neanderthal Man of La Chapelle-aux-Saints—a wild, brutish, stooped ape—for the mass-circulation weekly *L'Illustration*. He was a convinced evolutionist himself, and politically on the left; but he was no more a materialist than Kandinsky was, and he had plucked from the various spiritualisms at large in the 1890s a sense of hidden meanings in the universe—meanings that could be painted by the methods of the symbolists.

Not that *Amorpha* was Symbolist. If anything it was cubist or even futurist. What Kupka had decided to do after painting Andrée standing with her ball was to try to paint the motion that would have followed the snapshot: a moving ball, a moving girl, throws and catches, stops, starts, and reversals of field—everything the movies were just beginning to capture in the first decade of the twentieth century. As the cubists had painted all sides of an object on one picture plane, so Kupka conceived of painting all moments of a complex motion on one unmoving canvas. In his first sketches of 1908, he had suggested the outlines of the girl and of the ball in swirling strokes of pencil. Then, in each succeeding sketch, he made the arms and legs less recognizable, as he added positions they might assume in play. Black crayon sketches suggested an interplay of

color, the ball's red and blue stripes whose constantly changing positions would also have to be painted somehow. When Giacomo Balla and his fellow Italians—the futurists—began to paint motion in 1911, they used a technique suggested by double-exposed photographs, but this idea does not seem to have occurred to Kupka. Instead he seems to have tried to find a way of sampling all the curves described by all the moving points of Andrée's game and melding them together into just one or two complex curves. The oil studies of red and blue discs he made in 1911 were stills of a spinning color wheel intended to explore how the red and blue stripes of the ball might blend in motion. *Amorpha* was well under way before the futurists published their first technical manifesto in 1910 or mounted their first shows in Milan in 1911 and Paris in 1912, and Kupka's project owed little to them.[22]

If Kupka owed anything to anyone else, it was to the other members of a group of mostly cubist artists that had slowly found each other in Puteaux, including Francis Picabia, Fernand Léger, Albert Gleizes, Jean Metzinger, Emile Le Fauconnier, and the Duchamp-Villon brothers. One of the brothers, Jacques Villon, had befriended Kupka when they were both still living in Montmartre, and another, Marcel Duchamp (who would in 1911 paint *Nude Descending a Staircase*), had met Kupka back in 1904 in the year his picture had gone to the World's Fair.[23] There was still another member of this group who was not a painter but an insurance actuary, Maurice Princet. Fascinated by mathematics and proud of his friendships with artists, Princet was the theoretician of the Puteaux Group, taking the same role Charles Henry had played in the Laforgue-Seurat circle. It was Princet who talked most about things like the classical ratio of the golden section, and Princet who read and recommended to his friends the writings of people like Charles H. Hinton, René de Saussure, and Einstein's mentors Henri Poincaré and Karl Pearson on the subject of non-Euclidean and multidimensional projective geometries.[24] Kupka must have understood early on that the problem of painting complex motions was a dimensional problem in which time was a fourth dimension, and that representing four-dimensional events on a two-dimensional canvas could be accomplished only by analysis into elements and some sort of projection routine. If Kupka had been as mathematical as Princet he might have worked out a sort of four-dimensional version of the Renaissance rules of linear perspective, but instead he worked largely intuitively, as Giotto had. *Amorpha,* which would resolve itself in 1912 into two paintings—*Amorpha, Chromatiques chauds* (Hot chromatics) and *Amorpha: Fugue à deux couleurs* (Fugue for two colors)—defies step-by-step analysis as serenely as Picasso's cubist *Ma Jolie,* painted at the same time. Both *Amorphas* are full of continuous curves, but this is especially true of the second, where a sharply defined central swath of bright purple suggests where the red and blue stripes of Andrée's spinning

ball ended up. The paintings would finally be exhibited at the Salon d'Automne in Paris in 1912, where they would seem much more abstract than the Kandinsky Improvisations seen earlier that year at the Salon des Indépendants.

Kupka was a central European who had become part of the French art world and remained on its edges, but Robert Delaunay was French by inheritance. In 1910 and 1911 he was painting things no less French than the rooftops of Paris and the Eiffel Tower. One subject was the little medieval church of Saint Severin in the Latin Quarter, close enough to walk to, a few blocks up the Left Bank of the Seine from his studio on an upper floor of number 3, rue des Grands-Augustins. All his pictures of Saint Severin were of its interior, a dark forest of recognizable Gothic pillars and ogives, but every painting in the series portrayed those verticals as bowed out, the interior fantasized. His pictures of the Eiffel Tower showed the Tower increasingly broken up into red modules and surrounded by patches of white and pastel, patches that may have begun as representations of clouds but ended up representing no more than themselves. Cubism had reached Delaunay early, but unlike Picasso and Braque, he had persisted with color and stuck to an intuitive rather than a precise analysis of space.

Delaunay knew Maurice Princet and Princet's friends in the Puteaux group. When their work went on show in Room 41 of the Salon des Indépendants in March 1911, the first "Cubist Room" in exhibition history, Delaunay's paintings were there. In October he came to know Kandinsky when his wife persuaded one of her art-school friends, who was also a friend of Kandinsky's, to write and bring them together. Sonia Terk Delaunay, Robert Delaunay's wife, was more than a mere helpmeet. Russian-born like Kandinsky, she was a particularly adventurous painter who got into abstract art early in 1911 by way of design. When she presented Robert with their first and only child, Charles, on January 18, she made the baby a quilt of sharp-cornered patches dyed in primary colors that her friends instantly dubbed "Cubist." Soon after, she painted Charles a toy box in the same style.[25] Who influenced whom we cannot say, for the Delaunays always cheerfully supported each other's efforts, but we do know that very late in 1911, after he and Kandinsky had begun writing to each other, Robert Delaunay set to work on a new series of paintings called *Windows* made of intersecting planes of bright color. Playing with the time dimension, he called one of them *Simultaneous Windows*. By 1912 they would bring him into the same new world of pure abstraction that Kandinsky and Kupka had entered just before him.

There was yet a fifth artist in this new world in 1911, and he was an American. A laconic upstate New Yorker, Arthur Dove had thrown up his job as a commercial illustrator in 1907 and gone to Paris, where he had had a momentous encounter with the work of Cézanne. After two

years he returned, married, and never painted another representational picture. However, Alfred Stieglitz, the photographer who had established what he called the "Photo-Secession" in a storefront at 291 Broadway, had arranged for Dove to show a painting and managed to convince him to go on. In 1910 and 1911, while Dove was living and working in a house in what is now the New York City suburb of Westport, Connecticut, he made six paintings historians now agree are the first abstract or nonrepresentational paintings ever made by an American. Indeed, if they were made in 1910, they would be the first ever made in the West. The pictures are all owned by a private collector and rarely seen or studied, but enough is known to make it likely that when Kandinsky was painting *Picture with a Circle* in 1911, Dove's *Six Abstractions* were already leaning against the studio wall in Westport.

There were even a few seemingly abstract pictures made before 1910. In fact they were in Kandinsky's own native country, all made by a rather mysterious artist named Čiurlionis who had been born and brought up in what was then the Russian province of Lithuania. 1911, as it happens, was the year he died. Mikalojus-Konstantinas Čiurlionis, nine years younger than Kandinsky, had started out as a musician. After graduating from the conservatory and composing some successful tone poems on nature themes, he had given it up at thirty and turned to painting. The pictures had begun to appear in 1906 in series of from four to thirteen at a time, under a musical title, with each individual picture given a tempo marking, like a musical movement: *Sonata of the Stars, Andante,* or *Sonata of the Sea, Allegro.*[26] Since the medium Čiurlionis used, tempera on paper, was fragile, the pictures never traveled and have rarely been reproduced. Kandinsky is unlikely to have seen them, even after 1909, when Čiurlionis had moved to St. Petersburg and become better known. In St. Petersburg, Čiurlionis had been accepted easily as a late-arriving symbolist, championed in fact by Vyacheslav Ivanov, Russian symbolism's leading critic. These strange paintings seemed quite symbolist to Ivanov, and probably were to Čiurlionis; but although some shapes vaguely recalled objects fraught with symbolism—mountains, water, planets, pyramids, networks of bubbles—few had subjects that were recognizable from either the natural or the man-made world. Čiurlionis's pictures were "about" transcendent universes; but rather than representing transcendent things on canvas the way earlier symbolists like Mikhail Vrubel had tried to do, or reproducing them in the soul as Kandinsky had, Čiurlionis made his paintings point toward the transcendent in the same indirect way as Alexander Blok's poetry or Maeterlinck's plays. Ivanov had begun to believe they reflected the fourth dimension.[27] One so charmed young Igor Stravinsky around 1909 that he bought it. Were they the first abstractions? If the symbolist esthetic can be understood to produce pictures entirely without subjects, it seems that they were.

Then there is Piet Mondrian, who is more or less familiar to everyone as the creator of the primary-color rectangles outlined by straight black stripes. Mondrian was in Paris in 1911. The Dutch painter and spiritualist had gone to the French capital and seen works by Cézanne and the cubists. Then, as the story goes, Mondrian slowly but surely simplified the Dutch trees and waterways in his memory until he had brought them down to the simplest linear elements. Thereafter he kept the elements and dropped the subjects. The story has an irresistible dramatic shape, and a clarity that matches Mondrian's late paintings, but it occupies the wrong historical stage. In 1911 Mondrian's trees were still trees, and the nearest thing to an abstraction that Mondrian worked on that year was the incipiently cubist *Ginger Pot* he showed in 1912 in the Salon d'Automne. Mondrian was in fact the last of all the canonical founders of abstractionism to arrive in the new world; and he would not complete a purely abstract painting until his *Composition no. 7* of 1914.[28]

There is, of course, something puerile in determining priority in art. Unlike new science, new art does not replace the old, and the greatness of an artist, like that of a novelist, is not in the innovation but in the execution. Critics who know both artists have invariably found, for example, that there is more in the abstractions of Kandinsky than in those of Arthur Dove. A drift of opinion continues to find the Delaunays' work to contain more riches than Kupka's, even when they all painted the same nonsubject, the color disks of 1911–13.[29] But it is not the priority that makes the difference so much as the effect of the innovation. Frantisek Kupka had little effect on his fellow artists, and Dove and Čiurlionis almost none at all. In the end it was Kandinsky whose hallucinatory color harmonies made the first impression and carried the day for "abstract" art.

Abstract art has always been a gift to skeptics. It is perennially necessary to contend against them that the first abstraction was not made by the Chat Noir wit Paul Bilhaud when he painted a canvas black and hung it at the first Salon of Les Arts Incohérents in 1882 under the label *Negroes Wrestling in a Cave at Night*. Nor was the first abstraction made by backing a donkey up to a canvas and putting paint on its tail. It is true that a certain Joachim-Raphael Boronali exhibited this asinine picture at the Paris Salon d'Automne in 1910 under the title *And the Sun Dozed Off over the Adriatic*. The title, however, gave away the game. Boronali's idea was to reserve his joke and keep the painting's secret for a while; but the effect of it was to give the painting a subject—in the visitors' minds certainly, and in Boronali's too, though perhaps not in the ass's. In that case, one can legitimately wonder whether it is possible in any philosophically precise sense to paint a picture without a subject. Did not Kupka's *Amor-*

pha have as its subject a girl and a ball in motion? Did not Čiurlionis put stars in *Sonata of the Stars*? Did not Delaunay paint *Windows* as he said they were, windows in the light? Did not every expressionist at least paint states of mind? Did not even Kandinsky, who snorted at the idea that he might be painting music, claim to strike notes in the soul and there compose something, however ideal? Kandinsky painted colors, as did every other painter; and are not colors in some sense a subject?

We might call this art "nonobjective," but if the philosophical meaning of "abstract" is a problem, the philosophical meaning of nonobjective is a bigger problem. "Objective," for philosophers, at least since Frege, is a condition of thoughts or things thought about that makes it possible for two or more minds to communicate about them, instead of just one. It is the contrary of "subjective," which is the condition of a thought or a thing that restricts it to one mind only. Kandinsky, however, was convinced that he was painting in a way that would evoke the same "sounds" in every soul that it did in his own—or in every soul that was sufficiently evolved. In its intent, therefore, philosophically speaking, his painting was objective. Robert Delaunay was among the first to use the adjective "nonobjective," or rather "inobjectif," in the nonphilosophical way that gives this chapter its title.[30] This separate sense of the word describes a painting offering a viewer no object that he or she is expected to be able to name or to recall from nature. A similar struggle with meaning leads to the term "nonrepresentational" art. A nonrepresentational picture would be one that deliberately does not represent anything we can agree is part of a "reality" external to paintings, and possibly anything external to the mind. This would at least leave out Boronali's ass and Allais's put-ons, but could it not also threaten to exclude Kandinsky?

Better than philosophical wrangling is the careful study of where this impulse to nonrepresentation began, and one source must certainly be the cabaret-born irony that inspired Bilhaud. (Alphonse Allais had followed up Bilhaud's black painting in 1883 with one that was all gray and titled *Drunkards Dancing in a Fog*.) Another influential source of nonrepresentational art must be its arch-representational opposites, photography, illustration, and cartooning, the last two of which were the bread and butter of Arthur Dove and Frank Kupka.[31] There was considerable appeal for many artists in doing the contrary of what they had to do for a living. There may have been still more appeal in being first with the new, especially in an art market as crowded as that of some twentieth-century cities—Munich, for example—and it may well turn out that crowded markets can explain the birth of the "avant garde" more satisfactorily than an innovative spirit.[32]

By and large, however, the inventors of abstraction were a solemn group. Irreverence was rare, and even irreverence was taken seriously. Čiurlionis, for example, read some theosophy and cast himself as one of

the prophets of a new spiritual epoch. Others too, including Mondrian, were attracted by theosophy, the new religion founded by Madame Blavatsky at a series of table-rappings in a New York apartment in 1875. Kandinsky took it seriously as well, and in 1905, as historians of art have since noticed, the theosophists published a book in which the abstract experience of thought was represented by Kandinskyesque colors, abstract shapes, and the complex curves formed by metal filings on a vibrating plate.[33] Frank Kupka was also interested, despite his biological and political materialism, in drawing an intricate and eclectic spiritualism of his own from Blavatsky, the French guru Sâr Péladan, and anyone else with a pipeline to the ideal universe. Even Robert Delaunay, who was no fan of spiritualisms, wrote about trying to transcend the medium of painting in order to approach an ideal truth.

Often allied with theosophy, artistic symbolism made an even more powerful contribution to nonrepresentational art, seemingly from beyond the grave. Art, said the symbolist esthetic, was an attempt to point to the ineffable using symbols of the occult, the primitive, or the bygone. Gauguin and his friend Mallarmé had shown the way. The idea was hostile to positivism and not at all uncongenial to theosophy, but it was no longer very popular in 1911. Čiurlionis owed much to Russia's lateness in giving up symbolism, and so did Kandinsky, who exhibited with the Russian symbolist group Blue Rose after 1900, admired Maeterlinck, and seems to have brought the symbolist esthetic with him to Munich. Kupka too adopted symbolism, which he found in painter predecessors, in theosophical speculation, and in the writings of Mallarmé, which he illustrated. As the word "expressionism" came into use in 1911, it became clear that some of the more prominent of the old symbolist ideas of art were being absorbed into the new style, whose idealist premises were similar. Where symbolists found ultimate reality in alternate universes, expressionists found it in their own souls; and both made nonrealist art. Then, as the word "expressionism" began to mean anything new or French, or avant-garde, some of the old symbolism went along with it.

The abandonment of representation was also helped along by the rising status of ornament, which had rarely been more than a stepsister to architecture. In the 1870s William Morris's Arts and Crafts movement had become the first to reconstitute decoration as "decorative art." In the late 1890s, with styles like *Jugendstil* and art nouveau, and the founding of institutes like the Vienna Werkstätte (Workshops) and Kunstgewerbeschule (Handcrafter school), decorative art began to become what we now call "design." *Jugendstil* decorative art in particular, very strong in Munich, moved the work of Hermann Obrist and Hans Schmithals quite close to abstraction around 1900.[34] Short of wallpaper patterns, or art nouveau's mania for plant forms in cabinetry, there wasn't much in decorative art that could be called representational, and at one time or another

virtually every nonrepresentational pioneer described how decoration had helped him or her see the nonrepresentational light.

The emancipation of color by the fauves, of course, was another influence. So was the study by both artists and scientists of the foundations of geometry. The paintings of cubists and futurists depended on four-dimensional thinking as much as did the physics of Einstein and the mathematics of Hilbert and Poincaré. Kandinsky himself, following his compatriot Peter Ouspensky, thought of the spiritual world as more than three-dimensional;[35] and Kasimir Malevich, who would paint his first abstraction, *Black Square*, in Russia in 1914, came to believe that he was painting entities of four or more dimensions geometrically projected onto his two-dimensional canvas.[36]

What is ultimately clear about abstraction, however, is not where it came from, but how it was done. The analysis of the subject of a picture into its smallest components, a procedure that had begun with the impressionists and was systematized by Seurat, reached a final point with the abstractionists of 1911. They broke up the subject into parts, and then used the parts more and more selectively. Finally the subject itself disappeared as the parts no longer recalled it.

By the time autumn came to Munich, Kandinsky was working nearly full time on the Blaue Reiter, the exhibiting and publication society he had conjured up in a letter to Franz Marc in June, choosing the name "Blue Rider" because Marc liked horses, he liked riders, and both liked them in blue. Already in January he wrote about getting one or more letters in each of Munich's five daily mail deliveries.[37] By September he was in correspondence with artists in every art capital in Europe, soliciting pictures for the exhibition and essays and cuts for the "almanac" Blaue Reiter would publish summing up the situation in the world of Western art. He asked Delaunay for pictures. He asked two Russian music critics to write essays. His correspondence with Schoenberg having revealed that the composer was also a painter, Kandinsky asked him for everything: pictures to exhibit, an essay on music, and some of the music itself, by himself or his disciples, for publication in the almanac. He gave himself the agreeable but time-consuming task of writing the article on the combination of theater and music, adding an example of his own composition, *Der gelbe Klang* (The yellow sound), a symbolist-expressionist play.

The painter Paul Klee, who was living and working two doors down from Kandinsky at 32 Ainmillerstrasse, wrote in his diary that autumn about the strange man

who lives in the house next to ours, this Kandinsky, whom Luli [Klee's friend] calls "Schlabinsky." . . . Luli often goes to visit him, sometimes takes

along works of mine and brings back nonobjective pictures without subject by this Russian. Very curious paintings.

Eventually these two future founding members of the Bauhaus met in a Munich café and Klee became a cautious believer. "Kandinsky wants to organize a new society of artists," Klee continued in his diary. "Personal acquaintance has given me a somewhat deeper confidence in him. He is somebody and has an exceptionally fine, clear mind. . . . in the course of the winter, I joined his 'Blaue Reiter.'" [38]

By December the Blaue Reiter, both the almanac and the exhibition, was ready to go, but the NKVM artists' society was mounting its show at the same time. Kandinsky, who was still a member, made a final offer of his *Composition V* for the NKVM show; but on December 2 the picture was rejected, ostensibly because it was a little larger than their rules allowed. Kandinsky and his friends resigned immediately and *Composition V* was brought over to Thannhauser's Moderne Galerie in time for the opening of the Blaue Reiter show on December 18, two weeks after Kandinsky's forty-fifth birthday.

The Exhibition was a triumph. On the dark walls at 7 Theatinerstrasse, Munich, hung forty-three avant-garde paintings and drawings from half a dozen countries. There was a fantasy by the *douanier* Rousseau, a *Saint-Severin* and two *Eiffel Tower*s from Delaunay in Paris, two of Schoenberg's *Visions* from Vienna, several canvases in the primitivist style by the Russian Burliuk brothers, another from the Swiss Jean Niestlé, several from Gabriele Münter, August Macke, and other German Expressionists, and several major pictures by Franz Marc, including the exuberant *Yellow Cow*.[39] Kandinsky himself showed *Composition V, Improvisation 22,* and *Impression-Moscow,* all on the brink of abstraction. Reviewers were fascinated and artists were galvanized. It felt like a whole new era.

The same month of December, Piper published *On the Spiritual in Art,* and in January the long-awaited *Blue Rider Almanac.* Kandinsky had clearly caught a wave. As 1912 unfolded, show after show in country after country affirmed expressionism and launched abstraction. Early in 1912, the Blaue Reiter itself went to Cologne and then on to Berlin, Bremen, Hagen, and Frankfurt am Main, shocking the academy at every stop and changing the direction of German art. To everyone's surprise and delight, several of the paintings sold, including three of the five Delaunays.

It was as if a signal had been given. In February 1912, Arthur Dove had a one-man show at Stieglitz's "291" in New York that included ten pastels with titles like *Based on Leaf Forms and Spaces* (or *Leaf Forms*) and *Movement No. 1;* the show later went on to Chicago.[40] The "Ten

Commandments," as they came to be called, were the next generation of Dove abstractions after the original six of 1910–11, and neither city could make much sense of them. It was Dove's first one-man show—and his last—but it was also the first show of abstract paintings ever mounted, at a time when Kandinsky's new pure abstractions had yet to leave his studio.

One month after Dove's show, a world away in Moscow, painters Mikhail Larionov and Natalia Goncharova named their new artists' society The Ass's Tail, in honor of Boronali's hoax, and put on another scandalous art exhibit in Moscow. They accused the Munich crowd of being already "decadent" and ready to be superseded. At the same time, Blue Rider exhibitor David Burliuk and a small band of Russians soon to be labeled "Cubo-Futurists" published a doubly outrageous *Blue Rider Almanac* of their own called *A Slap in the Face of Public Taste*. (Kandinsky had to write to them protesting that they had used his poems without permission.) From May to September the fourth Sonderbund Special Exhibition of "Expressionisten" brought together Munchs, Kandinskys, and works by Die Brücke, amazing the Rhineland city of Cologne. In December the Russian "Slap in the Face" group became an exhibiting society and mounted an expressionist art show, while the newest Russian art society, "Soyuz Molodezhi" (Union of youth), put on its own first show. It was at the Union of Youth that Larionov showed a work whose subject had been almost completely turned into painted rays of light. Exhibiting another like it at the Society of Free Esthetics show later that same month, Larionov called the approach Luchist or Rayonnist and founded yet another school of abstract painting.[41]

Kandinsky wrote that he had no wish to displace representational painting, and representational painting has indeed survived; but so has the nonrepresentational. Since Kandinsky's *Picture with a Circle* there has been no going back.

21 *ANNUS MIRABILIS*

VIENNA, PARIS, AND ST. PETERSBURG

1913

In 1913 H. G. Wells described a "Last War" that would be fought with "atomic bombs," creating a "moral shock" that would end all wars. The German general Friedrich von Bernhardi had already predicted World War I, the German expressionist Ludwig Meidner had painted it, and the English historian H. N. Brailsford had argued that no such war was likely.[1] It is always possible, in a field littered with facts, to find the one that foreshadows what hindsight knows is coming. The great Russian poet Anna Akhmatova, who was not above hindsight, found the meaning of her youth in a poem she wrote at the height of Stalin's terror but set in the first days of January 1913:

> And always, something not thunder
> Under the profligate frost, a rumble
> Of war before it began.
> But then it was heard so faintly
> It scarcely touched the ear, as flakes to
> The Neva's drifts it drowned.
> As though, in night's terrible mirror
> Man, raving, denied his image
> And tried to disappear,—
> While along the embankment of history,
> Not the calendar—the existing
> Twentieth century drew near.[2]

Indeed, in 1913 the politics of the twentieth century was scarcely touching the ear, especially in a huge, polyglot city like Vienna and its equally multicultural colonies. Josef Dzugashvili, the Bolshevik organizer from the Caucasus, was there writing a policy paper for the party on how a Communist state ought to deal with Russia's ethnic minorities. Vienna—Lenin had told him on his way there—was the place to learn **321**

about the issue. There was a standard work on the subject, written by the Austrian Socialist Otto Bauer (brother of Freud's "Dora"), but it was too liberal and needed refutation. "Koba," as they called Dzugashvili, wrote his paper in jig time, leaving Vienna on February 16.[3] It was the farthest west he had ever been, or would ever go. Soon after his return, he was arrested by the Czar's secret police in St. Petersburg and sent east to Siberia. Later, after he had changed his party pseudonym to Stalin, he would enter the new Soviet government as its first Commissar for Nationalities, with results so far-reaching that some are only now beginning to be fully appreciated.[4]

It was in Vienna that Stalin met Lev Davidovich Bronstein for the first time. Bronstein, whose own pseudonym was Trotsky, was editing the party paper, *Pravda,* there and smuggling copies into Russia across the border from the Austrian province of Galicia. Trotsky had been at the famous party congress in 1903 when Bolshevism began, and was now helping Lenin plan a new party congress in the mountains of Galicia in the fall of 1913. In July, just before Lenin came through Vienna, Trotsky left for Serbia to cover the Second Balkan War for his paper. Not much had changed there, he reported, since he had covered the First Balkan War the year before. Socialism, it appeared, was having remarkable difficulties in overcoming nationalism, difficulties Marx had regrettably not foreseen. Croat socialists still hated Slovene socialists, Serbs of all stripes still hated Muslims, Bulgarians hated Macedonians, and all of them hated the Austrians, who were trying to run their multicultural province of Bosnia from its capital, Sarajevo. Sarajevo was where the new Inspector-General of the Austrian army, Archduke Franz Ferdinand, appointed in August, was saying he planned to oversee maneuvers in 1914. Gavrilo Princip and the other Serbs who would join to assassinate him there had already found each other in Sarajevo, and were training themselves for nationalist self-sacrifice on the oracles of Nietzsche and Walt Whitman. Josip Broz, the Croat who as "Tito" would one day put a temporary lid on this cauldron, was working as an automobile mechanic in the new Daimler plant south of Vienna. Tito's meeting with Stalin would not come for many years, and he would never meet Trotsky at all.

Besides Stalin, Trotsky, and Lenin, a fourth political "man of the future" left Vienna in 1913. He left for good because although he had been born in Austria, he had grown to hate Vienna's incomprehensibly complicated mosaic of ethnicities and the seeming inability of its German-speaking political elite to force its culture on the empire. Adolf Hitler had also come to hate all twentieth-century ideas. Vienna's journals, its theaters, and its art academy had all rejected him—probably, he thought, because he was so passionately German. Besides, he had just turned twenty-four, which meant he had successfully avoided military service and would no longer be turned back at the border as a draft-

evader. On a Saturday in May, the same day the former chief of Austro-Hungarian military intelligence was arrested for betraying the imperial army's strategy to the Russians, Hitler left the municipal men's homeless shelter in Vienna and took the train to Germany to start a new life as an artist in Munich. He would be there in time to join the German Army in World War I—and to lead it in World War II.

While politics remained in the shadows in 1913, the culture of the twentieth century did more than simply draw near. It exploded. From a vantage point near the end of our century, the year looks like a cultural Vesuvius whose fallout irrevocably buries the 1800s and whose eruption backlights what is now more than eighty years of the life of the mind in the West. As the late twentieth century has accustomed us to randomness of event and the inspired "happening," we have become better able to understand 1913, a year that began with a meeting of poets at the Stray Dog cabaret and ended with the absurdist theatrics of *Victory Over the Sun* at the Luna Park Theater, both in St. Petersburg, Russia. In between came the Armory Show that brought cubism to America via New York, a Russian Ballet production called *The Rite of Spring* that shocked Paris, the first quantum model of the atom announced by a Dane in England, and a relativistic non-Newtonian theory of gravity proposed by a German in Switzerland. In Spain in 1913 Santiago Ramón y Cajal found yet another new stain for neurons. In Germany, Wilhelm L. Johannsen first called the gene by name, while De Vries in the Netherlands wrote a book about looking for primroses in Texas. In Vienna, Freud published *Totem und Tabu* and "On Beginning the Treatment," and in Berlin, the Viennese Arnold Schoenberg wrote the second of his strange atonal monodramas, *Die glücklische Hand* (The lucky hand). In southern California, Edwin Porter, D. W. Griffith, and Cecil B. De Mille were all making multireel moving pictures and the Beverly Hills Hotel was new. At West Point, Knut Rockne's Notre Dame beat Army and showed the New York sports-writers their first forward pass. In the French colony of Gabon in Africa, a doctor of medicine, theology, and the music of Bach named Albert Schweitzer went up the Ogowe river to open a free hospital for the Africans; and in Rondonia, Brazil, the founder of Latin American environmentalism floated down the River of Doubt with Teddy Roosevelt. 1913 was the year Bertrand Russell allowed himself to be convinced by Ludwig Wittgenstein to abandon his nearly completed *Theory of Knowledge,* and the year Husserl published his "breakthrough to pure phenomenology," the *Ideen.* It was the year Ezra Pound, indefatigable London publicist for a circle of Modernists on two continents, drew two new "ordinary language" poets—Amy Lowell and Robert Frost—and an unpublished novelist—James Joyce—into a "vortex" that already included Yeats, H. D., William Carlos Williams, D. H. Lawrence, and the editors of *Poetry, The New Freewoman,* and *Blast.* Frost and Lawrence published their

first books of poetry in London that year, part of an avalanche of European publication that included Lawrence's third novel, *Sons and Lovers,* Andrey Bely's first novel, *Petersburg,* and the first installments of Proust's *A la Recherche du temps perdu* (usually rendered in English as *Remembrance of Things Past,* but better translated as *In Search of Lost Time*) and Franz Kafka's first novel, *Amerika.*[5] In the offing in 1913 were three more first novels: Virginia Woolf's *The Voyage Out,* Dorothy Richardson's *Pointed Roofs,* and James Joyce's *Portrait of the Artist as a Young Man.* The year 1913 seems to have been the one in which the Modernists found their audience, their age, and each other.

New Year's Day, 1913, arrived in St. Petersburg later than it did in the rest of Europe (where it was already January 12), and it was indeed "not the calendar, but the existing twentieth century" that came with it. Russia had already had a revolution in 1905, but the St. Petersburg intelligentsia in 1913 were still in a mood of frivolity, consumed with costume and cabaret, imagining their low-lying city as a Venice of the north. One of them, Anna Akhmatova, would describe them all in a poem, "Poem without a Hero," that came to her unbidden in a winter of war almost thirty years later: a vision of her friends, masked for Carnival, descending on her apartment once again as they had during New Year's and Twelfth Night of 1913. These revelers, most of them no longer living at the time of Akhmatova's vision, were the same brilliant vortex who had brought Modernism to Russian literature in the years 1910 to 1913. They had been Akhmatova's fellow poets, many had been or would be her lovers, and one—Nikolay Gumilyov—had married her. In 1911, a year after their marriage, she and Gumilyov had founded the Acmeist poetic movement with Osip Mandelstam and a couple of others. Their aim had been to put the tortured allusiveness and mystagoguery of symbolism behind them and write instead their quick, clear impressions—connected by feeling—of the world at hand. That January, Akhmatova's first book, *Vecher* (Evening), had been in print for months under the Acmeist flag, and Mandelstam's first, *Kamen'* (The stone), was about to be published.

Writers still loyal to symbolism were also among Akhmatova's masquers, like Alexander Blok and his friend Andrey Bely, who in 1913 had been abroad finishing his novel, *Petersburg.* Others in the crowd, Muscovite visitors for the most part, called themselves futurists—Velimir Khlebnikov, the lapsed mathematician, and Vladimir Mayakovsky, who had written "And Could You?" in 1912, a poem some were beginning to call "cubist." Mayakovsky, like Mandelstam, would publish his first collection of poems in 1913. There were also Vsevolod Meyerhold, who had founded the Moscow Art Theater; Boris Pasternak, a young composer known to have written a few poems; Bakst, Fokine, and Diaghilev

of the Ballets Russes; Artur Lourié, the singer-composer; and a Harlequin named Mikhail Kuzmin, who could do all that Lourié did and in addition write brilliantly in every form, from poetry to Strindbergian chamber theater.[6] In 1912 Kuzmin, besides writing the preface to Akhmatova's *Evening,* had published the first extensive free verse in Russian; and in 1911 he had composed the theme song for Brodyachaya Sobaka (The stray dog)—Petersburg's Chat Noir, a cabaret in an old private wine cellar that was the hangout for the whole city's intelligentsia. Most prominent of all in Akhmatova's vision were the Sudeikins: Sergei, the painter who had decorated The Stray Dog, and his wife Olga Glebova-Sudeikina, Akhmatova's best friend, who recited Mallarmé poems, danced, sang, and acted in Kuzmin's playlets there.

During those January revels of 1913, the habitués of The Stray Dog learned that one of their Pierrots, Vsevolod Knyazev, had shot himself on New Year's Eve on the doorstep of his Columbine, Olga Glebova. No one was sure why. He may have thought Olga was loyal to her husband, or in love with Alexander Blok. He may have despaired about failing with Olga so soon after breaking up with his first love, Mikhail Kuzmin. Kuzmin, who had just cast Olga in his masque-comedy *The Venetian Nights,* would soon find another lover, Yury Yurkun. How young they had all been, Akhmatova would remember in 1940, these architects of Russian Modernist literature. How determined they had been to allow no Victorian strictures to spoil their brief Bloomsbury. In 1913 the Acmeist group had already begun to show strains; and so had Akhmatova's marriage to Gumilyov. After their divorce, Nikolay would be shot as a subversive, and their only child Lev would spend years in Stalin's prisons. Akhmatova would survive to see history cave in on all of them.

Vienna, meanwhile, was in its last years as a great capital, and its last year of peace. Against the hothouse machismo of Weininger, Krafft-Ebing, and the rest of Vienna's sexologists Rosa Mayreder was shooting her last bolt—an article called "Sex and Culture"—but Vienna still dreamt of the past as if it were the future.[7] A new song by Rudolf Sieczynski was bidding to become the city's anthem—"Wien, Du Stadt meiner Träume" (Vienna, city of my dreams). At Berggasse 19, Sigmund Freud was writing a posthumous psychoanalysis of prehistoric hunter-gatherers, *Totem und Tabu,* diagnosing them as Oedipal and asserting that an Oedipus Complex could be acquired not only by an individual, but also by a group, and could even be inherited by a race or species. Over at the University, biology professor Paul Kammerer was running an extended experiment with exotic midwife toads, with the idea of proving that Darwin had been wrong about the inheritance of acquired characteristics. Working in Kammerer's laboratory as an assistant was Alma Mahler, widowed two years before by Vienna's emblematic music director. In the spring Alma met Oskar Kokoschka, and in an abandoned studio in

Semmering that turned out to be weirdly full of ordinary Austrian toads, they began an affair Kokoschka celebrated by painting the two of them floating seminude across a huge expressionist canvas he called *The Tempest.* At the university's Theoretical Physics Institute, sex played second fiddle. Fritz Hasenöhrl, Boltzmann's old student and successor, was heading up a committee to put up a monument to his teacher. Boltzmann's nemesis Mach remained vocal, though still incapacitated by the stroke he had suffered in 1898, but he was beginning to suspect that atoms might not be quite as "occult" as he had contended for so long.[8] Robert Musil, the graduate engineer who had secured his doctorate in 1908 with a thesis on Mach, set out in 1913 on the road to becoming a novelist by accepting the editorship of the new literary journal *Neue Rundschau,* but to do that he would have to move to Berlin, as Schoenberg had done two years before. When Musil finally came to write his great novel of Vienna, *Der Mann ohne Eigenschaften* (The man without qualities), he would set it retrospectively in 1913.

In Halle, Germany, the university town where he had spent most of his life, Georg Cantor had only five years of it remaining to him; but the set theory he had discovered was very much alive. Indeed, it was now old and accepted enough to have its history written. One its many subarchitects, Arthur Schoenflies, had begun the job in a journal article in 1900, and in 1913 his big book on the subject appeared, highlighting Cantor as the discoverer of the transfinite new world.[9] Alas, Schoenflies's Columbus could not enjoy his vindication. In 1913, he was in the Halle Nervenklinik, permanently committed for intractable manic-depressive psychosis. As for Cantor's sets, they raised issues that made logic falter in 1913, and they still do. The proof of the Continuuum Hypothesis was still undiscovered, having eluded Cantor, Hilbert, and the whole world of mathematicians Hilbert had challenged to find it in 1900. In Italy, the Peano school, and in particular Mario Pieri, were considering the paradoxes that still emerged one after another from the depths of the foundations of arithmetic. In 1913 Waclaw Sierpinski brought set theory home to a country that would in five years become Poland, where a younger generation of mathematicians were to find extraordinary new implications in it.[10] Joining him was Zygmunt Janiszewski, who had already wondered about the ontological status of the infinitely discontinuous "Cantor line," and Jan Lukasiewicz, who had begun considering the fundamental questions of logic Frege had raised from obscurity back in 1879. Could a proposition be other than true or false? Was a set more than a number?[11] A Dutch mathematician named Brouwer thought so, and had begun to ask what mathematics would look like if it were fenced in—strictly limited to statements about finite, and therefore constructible, sets.[12] Bertrand Russell and Alfred North Whitehead thought not. They had finally given up on the unconstructible "set of all sets,"

finished the manuscript of *Principia Mathematica* in 1910, and loaded it into a cart to haul it over to the Cambridge University Press. 1913 was the year in which the last of its three thick volumes appeared.

Art entered the spotlight in February. On February 17, one day after Stalin got on the train to leave Vienna, the art show of the future opened in New York City between Madison Square and the just-reopened Grand Central Station. At Lexington Avenue at 25th Street a thousand invited guests made their way into the 69th Regiment Armory under an outsize stone eagle and a banner proclaiming "International Exhibition of Modern Art." Inside, brass bands played and the guests were greeted by New York lawyer John Quinn, patron of all things Modern, already a friend of Yeats and Pound, and soon of T. S. Eliot. This is, said Quinn, "the greatest exhibition of modern art ever held here or abroad."[13] The cavernous main hall, designed for mass drill competitions, had been domed with cloth streamers, partitioned into roofless spaces with walls of burlap and greenery, and packed with some 1,300 works of art, large and small, in every medium. Two-thirds of them were American, for the show had been mounted by an American secession group, the Association of American Painters and Sculptors, founded the year before to challenge the establishment and its National Academy of Design. The rest was what the Association's secretary, painter Walt Kuhn, had managed to assemble during a grand tour of Europe in the fall of the vintage year of 1912— some of the most challenging new art in the Western world. "Art is a sign of life," the organizers had pronounced. "There can be no life without change. . . . To be afraid of what is different or unfamiliar, is to be afraid of life. And to be afraid of life is to be afraid of truth, and to be a champion of superstition."[14]

There were paintings by everyone from Ryder to Kandinsky, and sculptures by Brancusi and Picasso. Mindful of the American reverence for "progress," Walt Kuhn and association president Arthur Davies had found some twenty-, thirty-, and fifty-year old works and hung them as a short course in art history to demonstrate where cubism and futurism had come from. This scheme had yet to be tried by the art exhibitors in Cologne, The Hague, Munich, Berlin, Paris, and backward London, where Kuhn had found the works, but it suited the education-minded Americans. With it a visitor could find her way from Delacroix and Ingres to Corot and Courbet, and then launch herself toward Modernism with the color planes of Manet's *Bullfight*. She might then stand before the Monets and Pissarros and discover impressionism, and go on to trace symbolism through the paintings of Redon, Maurice Denis, and Puvis de Chavannes. She could confront divisionism in Seurat's oil sketch of *Poseuses,* flanked by Crosses and Signacs; post-impressionism with eighteen Van Goghs, fourteen Cézannes, and two Gauguins; fauvism with four Vlamincks and a Derain plus Frieszes and Marquets; and cubism in

the "Cubist Room," lined with paintings by Duchamp, Picabia (who was there in person), and Braque, a sculpture by Alexander Archipenko, and *La femme au pot de moutarde* (Woman with a mustard pot) by Picasso. Expressionists, like Kirchner and Munch, were grouped nearby, and the abstractionists were represented by near-abstractions: Kandinsky's *Improvisation #7* and one each of the *Laon, Windows,* and *City of Paris* series by Robert Delaunay. What we now know as the classic narrative of Modernism in art was being cobbled together before the visitor's eyes, together with the canon of artists, works, and subsidiary -isms that has since become almost absolute. The futurists, for example, are still set to one side in that narrative, and it is no coincidence that they were the only sizable movement that did not appear at the Armory Show.

From the first reports of the opening in the New York papers, the Show was a scandalous success. From a trickle the visitors grew to a flood—12,000 it was said on the last day, March 15, and 75,000 all told. The single most incomprehensible artist turned out to be Matisse, eighteen works, including the large *Red Studio* and Leo Stein's prize *Nue bleue, souvenir de Biskra* (Blue nude), one of whose blue feet, visitors began to observe, had only four toes. The star attraction, as everyone still knows, was Marcel Duchamp's big oil painting, *Nu descendant un escalier* (Nude descending a staircase), the largest cubist work in the Armory, made immortal by the critic as *Explosion in a Shingle Factory*. Visitors would march directly to it to gape and laugh, and one woman was seen to fall to the floor giggling.[15] When the show's organizer, Arthur Davies, brought ex-President Theodore Roosevelt in to see what he was told was *Woman Descending the Staircase,* Roosevelt said, "Where is that woman?" and interrupted the answer by observing that Duchamp was "nuts."[16] Some weeks later, Roosevelt wrote that Duchamp's painting (whose title he insisted on properly translating as "A naked man going down stairs") could just as easily have been called "A well-dressed man going up a ladder." The former Progressive presidential candidate was no fan of "simpering conventionality," and was full of praise for the naturalist "Ash Can" painters. Harvard historian and amateur anthropologist, he was capable of seeing comparisons between the figures in "Futurist" paintings and the newly discovered cave art of paleolithic Europe, but this did little more than convince him that the new art was retrograde instead of "progressive." It might even be mad; "lunatic fringe," after all, was Roosevelt's own coinage. Worse, he thought, was the possibility that it was either pretentious or insincere. He was no rube, to have his leg pulled by artists as it had been by the Barnums of his New York childhood. What American critics like Roosevelt found hard to grasp was the growing reluctance of the new artists to offer a point of view that was single or unambiguous, their willingness to express their own attitudes and emotions not only in the subjects they chose to paint but also in the

ways they chose to paint them. Hardest of all to understand was their growing confidence in their ability to analyze a subject into constituent parts and to render them serially or simultaneously in each of the four dimensions. To Roosevelt, *Nu descendant un escalier* was no more than design, and "on any proper interpretation of the Cubist theory, [a far less] satisfactory and decorative picture" than the Navajo patterned rug in his own bathroom.[17] To painters like Stuart Davis, collectors like John Quinn, and poets like William Carlos Williams, on the other hand, the show was a revelation.

A month before the opening, Mabel Dodge, like Quinn an emerging American *maecenas* of Modernism, had written to her friend Gertrude Stein in Paris that the Armory Show would be "the most important event that has ever come off since the signing of the Declaration of Independence and it is of the same nature."[18] It wasn't quite that big. On the other hand, it was unquestionably no less than the long-awaited American "secession." The Armory Show, whose symbol was the lone pine tree of the American Revolution, was the moment when artists in the United States successfully broke from the academic strictures of the previous century as artists already had in Paris, Munich, Berlin, and Vienna. What Eakins had tried to do in the name of realism in 1886, and The Eight—the "Ash-Can" School—in the name of naturalism in 1908, was accomplished in the name of "Modernism" at the Armory in 1913. It appeared, wrote one artist fifty years later, "as an amazing spastic convulsion in American provincial art culture."[19] Yet it was almost entirely as organizers that American artists produced this convulsion. The art works shown by Americans at the Armory were predominantly in styles no newer than naturalism, symbolism, and impressionism. The American painter Max Weber (the sociologist Max Weber was in Germany), whose most recent works were experiments in collage, cubism, and abstraction, was not in the show, because he had tried to drive too hard a bargain. The most "Modern" American painting in the show may have been *Battle of Lights, Coney Island,* which Joseph Stella had painted the summer before. As one historian wrote, American "critics 'thanked the Lord' for 'American sanity' and 'honest craftsmanship,' [but] the Europeans stole the show."[20] Perhaps—but the show they stole was big, as big as Quinn claimed it was, bigger in that well-known American way than any of the landmark European shows, from the Salon des Indépendants to the Blaue Reiter, from which it took its cue. American artists may have brought in Europeans to make their secession for them; but by so doing they ended American exceptionalism in the arts and began the generation-long process that would end in the translation of the art capital of the Western world from Paris to New York.

The capital in 1913, however, was still Paris. Gaslight was yielding to electric, the *pneumatique* to the telephone, and popular theater to film,

whose receipts in Paris for the year were nine million francs.[21] Mata Hari, too, was drawing an audience, but the best gig she could get in her tenth year in Paris, even at the Folies Bergère, was as a Spanish dancer, fully clothed. As the last horse-drawn streetcars and buses were taken out of service, Guillaume Apollinaire, Paris's impresario and Modernism's happy warrior, was beginning a banner year. Since *Mona Lisa* had been found and he was no longer suspected of stealing it from the Louvre, he could move out of hiding at the Delaunays' apartment and into an apartment of his own. In January Apollinaire wrote an essay on Robert Delaunay to introduce the painter's huge one-man show in Berlin, and added a poem called "Les Fenêtres" (The windows) to introduce the exhibition catalogue. Then, for Picasso and the cubists, who had been friends of his for a decade, he completed a defining book of criticism, *Les Peintres cubistes* (The cubist painters). Announced on March 17, 1913, two days after the Armory Show closed in New York, *Les Peintres cubistes* would include the hospitable Delaunays under the new label "orphic cubism," and would feature the Duchamp brothers, whom Apollinaire had met in 1911.[22] On March 18, Apollinaire's long article on the spring Salon des Indépendants appeared, including the first real notice to be taken in Paris of Piet Mondrian. A "very abstract cubism," he wrote, referring to the *Trees* Mondrian had been painting since arriving in Paris a year ago, and thereby changed the course of the word "abstract."[23] In April, returning to his own art-poetry, Apollinaire published *Alcools* (Liquors), a collection he now centered on the long poem, just completed, called "Zone." "Zone" was in many ways a fulfillment of Laforgue's polytonal free verse of 1886; but it is still seen as a breakthrough work in the history of the fragmentation of poetry, because punctuation vanished in it and even the ironic lyric voice seemed to withdraw. Apollinaire's endearingly outrageous metaphors (the Seine bridges bleating, shepherded by the Eiffel Tower) were as evident in "Zone" as they had ever been, but the poem depended more on phenomenology than it did on metaphor. Set in six cities, from Amsterdam to Prague, and a dozen Paris neighborhoods, it passed from one noticeable thing to another, with a frayed randomness just barely patched together by the sensibility of a detached and almost disembodied poet.[24] As a technique, Apollinaire sometimes called it "simultaneism," meaning that events were brought together by ignoring the time dimension, as in the latest paintings of Robert and Sonia Delaunay and the "simultaneous clothing" Sonia made and wore that summer to the Bal Bullier dance hall.[25]

On the Western front in 1916, Apollinaire was to write glorious poems patching together love, barbed wire, and artillery bursts, one of which wounded him in the head. He was mustered out, and died of the postwar flu.

As April approached in Paris, Ezra Pound, the American gonfaloner

of London's avant garde, paid a visit. He was not yet aware of Apollinaire, and he didn't read "Zone," but he did meet French poetry head-on. He borrowed a friend's book on the French poets and found a good deal more in Laforgue, Mallarmé, Rimbaud, and Moréas than Arthur Symons had found there twenty years before. "Practically the whole development of the English verse-art has been achieved by steals from the French," he opined on his return.[26] One day, standing in the new Paris subway, he wrote a poem of his own. A single bold metaphor, two lines, and no rhymes at all, it was a poetic atom.

> The apparition of these faces in the crowd;
> Petals on a wet, black bough.[27]

Pound titled it "In a Station of the Metro." It appeared in the April issue of *Poetry*, the new review he all but edited, together with "A Pact," the poem in which he made his final peace with Walt Whitman.[28] Then he founded a new movement to suit it. *Imagisme*, he called it, using French to emphasize its origins—a poetics that would center on single, clear images, suppressing all words of comparison. "In a Station of the Metro" is still the representative poem of Ezra Pound, and a pivot point in the English-language poetry of the twentieth century.

In May Pound was back in London. At the new Théâtre des Champs-Elysées, Sergei Diaghilev's Russian Ballet was preparing for the opening of its sixth season in Paris. Diaghilev, as masterly a collector of genius as Apollinaire or Pound, was the impresario who had been bringing the best of the young Russian artists to Paris since the 1905 Salon d'Automne, and who had settled on ballet in 1908 because ballet could showcase so many different arts at the same time. Vaslav Nijinsky, Diaghilev's spectacular principal dancer, was the choreographer for two of the new works for 1913, the first called *Jeux* (Games), composed by Claude Debussy, and the second something called *Le Sacre du printemps* (Rite of spring), another original work for the company by the composer Igor Stravinsky. Nijinsky's debut as a choreographer had been the year before in the scandalous *Afternoon of a Faun*. Nijinsky's design had matched Debussy's music and Mallarmé's subject with a constricted, hieratic dancing of a discontinuity never imagined by Fuller, Duncan, or Dennis. People who had been to one or another of the sixteen full rehearsals for the 108-player orchestra of the *Rite* were saying that this new ballet would be just as Modern. They also said that the music would be as demandingly new as the dancing. Stravinsky, a St. Petersburg aristocrat, had composed the hits of the 1910 and 1911 seasons, *The Firebird* and *Petroushka*. Both the harmony and the rhythm of these two earlier ballets had been a bit experimental; but *Rite* was something else again. Even the subject of this ballet was a challenge. *Rite of Spring* was no fairy tale, but instead a reenactment of the sacrifice of maidens in prehistoric Russia. Perverse

and compelling as the archetypal murder in *Totem und Tabu,* the myth in *Rite* reversed Freud by having the daughter die instead of the father. Stravinsky later remembered it as coming to him in 1910 in a sudden vision; but the vision was more likely that of its set designer, Nicholas Roerich, who was the symbolist prophet of Diaghilev's company and a self-educated expert on the "primitive."

On May 29, opening night, the buzz was strong and "all Paris" was there. Indeed, "all Paris" could not be quieted down, even by the dimming of the house lights. It seemed to have decided that the judgment on the *Rite*'s artistic merit would have to be made there and then, in the theater, before the wrong side could default. The muttering grew to a grumbling and the grumbling to a mighty rumbling until soon little could be heard of Stravinsky's music beyond the rhythmic undercurrent in the bass. That, of course, was weird enough, since the rhythm signature changed from bar to bar. Indeed, after the opening bassoon solo in what might have been the key of C, it seemed as though the instruments were all coming in at different tempi, one or two at a time, until everyone in the orchestra was playing his own ballet and the key seemed more and more uncertain. A little over three minutes into the performance, the women dancers entered, dressed like Pocahontases in red, and began to move in stiff little hops, while another insistent beat with another odd and changing rhythm signature began in the lower strings. What ought to have been a trumpet fanfare appeared out of nowhere and stopped without a cadence. The antis began to hoot and whistle, the pros to cry "bravo." The New York critic Carl Van Vechten remembered not noticing for the longest time that the man seated behind him was trying to beat time on his head. Nijinsky's mother fainted.[29] Camille Saint-Saëns, composer of *Carnival of the Animals,* left the hall. Another composer shouted, "Genius!" It was Maurice Ravel, who had worked alongside Stravinsky in Switzerland when the *Rite* was being orchestrated. Someone shouted, "Where were these pigs brought up?"[30] and catcalls so much worse that even Arnold Schoenberg had yet to hear them from an audience. Would the performance have to be stopped, like the new music concert in Vienna back in March?[31] From his seat in the fourth row Stravinsky watched the imperturbable back of the conductor, Pierre Monteux, and realized that Monteux was going to play on no matter what the audience might do. He got up and went into the wings where Nijinsky was trying to keep his dancers on beat by shouting numbers at them in Russian. Several times, Stravinsky remembered later, he had to lay hold of Nijinsky to stop him from going on the stage itself and shouting directly to his dancers—or at the audience.[32] Diaghilev loudly ordered the show to go on, and began signaling his electricians to switch the house lights off and on to see if that would quiet anyone down. It didn't. Not until the *prima,* Maria Piltz, began her solo dance of death in the last

tableau did the Parisians show any respect at all for what they had actually come to see.[33]

"Exactly what I wanted," said Diaghilev to Stravinsky as they sat in a restaurant after the performance.[34] "Massacre du Printemps," wrote a reviewer for the Paris *Comoedia* the next day.[35] On balance, the *Rite*, unlike Schoenberg's *String Quartet #2*, was an enormous success. Reviewers were rather ashamed of how the audience had acted and made a beeline for the high ground. The critic of *Le Figaro* even wondered aloud if he had been too hidebound to appreciate what might well become an important event.[36] In fact it is now routinely judged the most important single event in the reception of both Modern music and Modern dance.[37] There had been scandals to spare in the years from 1872 to 1913,[38] but the scandal of the first public performance of *The Rite of Spring* was to outlast them all. Though Nijinsky's choreography lasted only eight performances (Diaghilev fired Nijinsky in late 1913 and had the *Rite* rechoreographed by Léonid Massine in 1920), it remained an inspiring legend until succeeding dance designers, notably Merce Cunningham, found their way back to its asymmetric, cellular, and discontinuous style nearly a half-century later.[39] Stravinsky's music fared better. His *Rite* was immediately picked up as a concert piece, and a great many music-minded people came to think of it as the ultimate source of the musical innovations of the century. Its tonalities wandered almost as much as Schoenberg's, and it had a kind of polyrhythm that was serial instead of simultaneous, like the rhythms of Charles Ives, who was finishing his *Second String Quartet* that year. Its rhythmic structure was in fact spectacularly new—irregular, full of ostinato (brief repetition), and staccato in the extreme. Schoenberg had tried to eliminate repetition and recapitulation from music; but the *Rite* brought them back with a vengeance.

The only thing that could be compared with the rhythms of the *Rite* was emerging that year at Russia's antipodes, an edge of the Western world where musical influence had been African rather than Asian—the valley of the Mississippi. On July 7, 1913, at London's Hippodrome, Irving Berlin played and sang "The International Rag," a song he had written in his hotel room the night before, whose lyrics celebrated Americans for setting off the current transatlantic epidemic of ragtime rhythms and indecorous dancing. The bragging was for Londoners who thought Berlin, a New York Jew born in Russia, had invented the craze; but Berlin knew that he was a popularizer, not an innovator. His domesticated ragtime was already old hat in America, where ragtime's Mississippi valley roots had already sprouted two even newer kinds of music. One was blues. In 1913, a black musician named W. C. Handy, who led a band in Memphis, Tennessee, published "Jogo Blues," later renamed "The Memphis Itch." (The word "Jogo," like "jigwawk" or jig-walk, was a word the South's "colored" African Americans used to refer to themselves.)[40] The

year before, 1912, Handy had published "Memphis Blues," the first blues ever published, but failed to hold onto the copyright. A year later Handy would publish his classic "St. Louis Blues." With these sheet-music hits, the blues, whose folk origins still lie muddied with myth in the delta of the great river, was launched upon the world. So was "jazz." The word had first appeared in American writing as a kind of dancing, but in 1913 the San Francisco *Bulletin* used it in quotation marks to refer to a music akin to ragtime.[41] It was the year the new piano player in St. Louis, Ferdinand LaMothe, better known as Jelly Roll Morton, began playing a new song called "Pretty Baby" in that swinging style he had learned in whorehouses down river. In 1913 the Memphis Students no longer played, and Buddy Bolden continued to languish in the asylum; but in New Orleans a motherless child named Louis Armstrong was sent to the Colored Waifs Home for Boys, where he would learn to play cornet.

As jazz began to flourish on official disapproval, so did expressionist theater. In June 1913, Oskar Kokoschka had another play stopped by the police, *Der brennende Dornbusch* (The burning thornbush). In Paris, literary editor Jacques Copeau founded the Théâtre du Vieux Colombier in succession to the old Théâtre Libre and Théâtre de l'Oeuvre. In Stockholm, Strindberg, who had died the year before, was still mourned; but his successors were already in the theater. And in New London, Connecticut, in June, James O'Neill, who had incarnated the Count of Monte Christo on a thousand stages and in a film in 1912, welcomed home his son Eugene from the Fairfield County Tuberculosis Sanatorium, where the young man had filled himself to the brim with Strindberg and decided to write Modernism onto the American stage.

At Vienna University Fritz Hasenöhrl, who had edited Boltzmann's collected works, had decided that the monument to his teacher in the graveyard of Beethoven would consist solely of a sculpture of the old man's combative, haphazardly whiskered face and the inscription "$S = k \log W$." Hasenöhrl wrote that "the theorem that entropy is proportional to the logarithm of the probability, is one of the most profound, most beautiful theorems of theoretical physics, indeed of all science."[42] Beautiful—and true, truer every day by 1913. Its probability basis held that year even when two theorists, a Frenchman and a German, simultaneously demolished the ergodic hypothesis from which Boltzmann had first mistakenly derived it.[43] The royal road it provided to the measurement of the numbers and sizes of atoms continued to broaden, and in Paris, physicist Jean Perrin's new book, *Atoms,* exulted that "the atomic theory has triumphed," and listed sixteen different ways of determining by experiment the number of molecules in a mole.[44]

For several of his molecule-counting methods Perrin credited Albert Einstein, and Einstein in 1913 was still a leading particle man. In an

informal article published in 1913 he looked back on the long effort to quantize energy and forecast—not without irony—more of the same.

> It would be edifying if we could weigh the brain substance which has been sacrificed by the physicists on the altar of the [Kirchhoff blackbody function]; and the end of these cruel sacrifices is not yet in sight.[45]

Einstein had even bearded Ernst Mach. Sometime in the previous two years, his younger friend Philipp Franck had taken him to see the septuagenarian philosopher in Vienna. According to Franck, Einstein there persuaded Mach that Boltzmann's atomic theory of gases was "thought-economical" in the Machian sense because, although the equations were about probabilities, they nevertheless condensed an improbably vast array of facts and made it possible to manipulate them.[46]

Albert Einstein was now a grizzled thirty-four and full professor in, of all places, the Zurich ETH, the same institution that had brushed him off when he graduated. He was in demand everywhere. None other than Max Planck came to Zurich in person to persuade him to take a research professorship in Berlin, capital of the educational system that had driven him to give up his German citizenship at sixteen. In the spring Einstein lectured in Paris, where he met two important physicists: the popularizer of relativity Paul Langevin, who had been in St. Louis with Poincaré, and the widowed Marie Curie.[47] In August Einstein vacationed in the Alps with Marie and her daughters Irène and Ève Curie as Marie tried to escape the effects of the publication by Langevin's wife of her love letters to Paul Langevin. Neither love nor ambition, however, was on Einstein's tenacious mind. Instead, it was something he was already calling "general relativity," the fully generalized equations of space, time, and motion that would include his uniform-motion relativity of 1905 as a special case. "You understand," said Einstein, seizing Marie Curie's arm, "what I need to know is exactly what happens to the passengers in an elevator when it falls into emptiness."[48]

The basic idea had come to Einstein in the Patent Office back in 1907 when he had visualized himself being drawn through the cosmos in a closed elevator car at a constant acceleration of thirty-two feet per second per second and realized that without windows there would be no way to tell that the car was not resting firmly on the earth. If (he reasoned) a light beam perpendicular to the car's trajectory entered the car through a hole above him, he would see it hit the opposite wall below the hole it had entered. If acceleration could thus curve a light beam, why should not gravity do the same? Inertia and gravity should be equivalent if their effects were equivalent. The "hypothesis of the relativity of inertia" was in Mach, who had also insisted on the relativity of all physical phenomena to the observer, and Einstein knew it. In June 1913, he wrote to Mach

that if gravity could be shown to bend light, it would be "a brilliant confirmation of your ingenious investigations on the foundations of mechanics,"[49] and in September he referred to Mach's hypothesis in a lecture he gave in Vienna.[50] To make the idea concrete, however, Einstein knew he needed to find a geometry general enough to relate any kind of motion to any other. In addition it would have to do it in all four dimensions of a multiply curved space-time and yield an improved law of gravity as a consequence. It wasn't easy. "Compared with this problem, the original theory of relativity is child's play," he wrote toward the end of 1912 to his old friend Marcel Grossman.[51] Grossman was then in Zurich teaching absolute and multidimensional geometries, and Einstein asked him for help. In 1913, he and Grossman published a paper together in Zurich called "Entwurf einer Verallgemeinerten Relativitätstheorie und Eine Theorie der Gravitation" (Sketch of a generalized theory of relativity and a theory of gravitation). It was the first in a series of papers that would end triumphantly two years later in wartime Berlin.

In Copenhagen, Denmark, during that same summer, twenty-seven-year-old Niels Bohr was finishing something physicists would come to call "The Trilogy," a three-part paper on the structure of the atom. Bohr hoped it would justify his postdoctoral fellowship of 1911–12 in the English laboratories at Cambridge and Manchester, decide between their competing atomic models, and perhaps win him a professorship. He had transferred from Cambridge to Manchester to work with Ernest Rutherford (at about the same time an aspiring aeronautical engineer named Ludwig Wittgenstein had transferred from Manchester to Cambridge to work with Bertrand Russell). Rutherford, who had come to the St. Louis Fair as the world's leading experimenter on radioactivity, had been most recently associated with the 1909 discovery of a dense positively-charged nucleus in the middle of atoms. In 1911 he had proposed that atoms were put together much like the solar system, with negatively charged electrons orbiting the positive nucleus like planets instead of sitting here and there in a positive cloud like raisins in a plum pudding. As his fellowship ended in June 1912, Bohr had written to his beloved brother Harald from Manchester, "Perhaps I have found out a little about the structure of atoms. Don't talk about it to anybody."[52] It was the first inkling that Bohr had begun what would become a year-long struggle to make theoretical sense of Rutherford's no longer partless atom. He had already picked up his lifelong working habits: talking exhaustively to everyone who knew anything, scribbling on the blackboards in his dyslexic-looking handwriting, and dictating the resulting papers in one language or another to his brilliant wife Margrethe. The rest of 1912 and the first half of 1913 Bohr spent in a small house in the Copenhagen suburb of Hellerup, to which he had taken his bride in September 1912, and from which on weekday mornings he would bicycle into the city to the office of the physics teach-

ing assistant at the Technical College. In these tiny quarters Bohr prepared to make the next great advance in the particulation of matter and energy.

Early in February, a fellow student had drawn his attention to the strange constant by which, years before, Balmer and Rydberg had linked a series of lines in the spectrum of hydrogen. The nineteenth-century spectroscopists had shown that the spectrum radiated by heated hydrogen, and indeed by every element, was entirely composed of specific narrow lines, each with a precise frequency—discontinuities that field and wave theory could not explain. In a series of such lines in hydrogen, the Balmer series, lower frequencies all differed from higher ones in the series by the mysterious Rydberg number 3,287,870,000,000,000 divided by the square of a small whole number—i.e., 4, 9, 16, 25, 81, or even 1. To a twentieth-century mind like Bohr's these telltale simple whole numbers instantly signaled that underneath the seemingly random frequency measurements lay an ultimately discontinuous process. Nineteenth-century minds, balking at discontinuity even above the subatomic level, had never hit on it. Even Rutherford, in his new model atom, assumed that the electrons moving around the atom would radiate continuously in all frequencies. Yet current theory required that if orbiting electrons did indeed radiate, they would lose energy, spiral into the nucleus, and wink out like dying satellites.

Bohr had already guessed that the reason electrons did not wink out and that some frequencies rather than others were produced was that the electron motion was quantized somehow. Someone else had already suggested that it was the angular (orbital) momentum that came in pieces. Angular momentum would have to be some multiple of Planck's constant h, divided by 2π, and could change only by adding or subtracting integral packets of exactly that amount. Electrons did not spiral down, or up—that was continuous. Instead, they vanished from one orbital condition and reappeared instantaneously in another—the now proverbial "quantum leap." In late February Bohr found the connection between quantized orbits and Balmer's formula. By March he had finished dictating part one of the Trilogy to Margrethe, and sent it to Rutherford to be forwarded to the Royal Society's *Philosophical Magazine*. In July 1913, it appeared and immediately took its place as the third great advance in quantum physics after Planck's in 1900 and Einstein's in 1905, establishing for the first time not only that the atom itself was particulate but that each of its known parts behaved discontinuously. On its ninth page Bohr produced a formula, whose terms were the charge on the nucleus, the charge and mass of the electron, and the quantized angular momentum. When the known experimental values were plugged in, the formula spit out Rydberg's number, 3.28787×10^{15}, which turned out to be roughly equal to twice the electron's tiny mass times the square of

π divided by the cube of Planck's constant h.[53] The quantum had been resoundingly located in the fundamental structure of the atom, and proved to govern absolutely the motion of its parts, the release of its energy, and most likely all of its chemistry. By the time part three of the Trilogy appeared in November, a young experimenter named Henry Gwyn Jeffries Moseley had confirmed Bohr's postulate that the nuclear charge of a chemical element had to be a simple whole number, the "atomic number."[54] As Jean Perrin's book exulted:

> The atomic theory has triumphed. Its opponents, which until recently were numerous, have been convinced and have abandoned one after the other the sceptical position that was for a long time legitimate and no doubt useful. . . . But in achieving this victory we see that all the definiteness and finality of the original theory has vanished. Atoms are no longer eternal indivisible entities, setting a limit to the possible by their irreducible simplicity. . . .[55]

"You see, I'm sorry because most of that was wrong," Bohr said in 1962, not long before his death.[56] As twentieth-century science came to accept the full consequences of Mach's limitation of all scientific truth to phenomenology, Bohr's atom of 1913, with its regularly arranged stretched-oval orbits, lost its explanatory power and began to look like the last true "picture" in the history of physics. Bohr himself always argued that we achieve objectivity only to the extent that we can find a common language to describe nature. He came to realize, however, that such a common language had to form on a deeper level of metaphor than pictures. By 1925, three more quantum numbers would have been added to the one for angular momentum, and atomic spectra could no longer be described with ordinary algebra. In 1926, after Schrödinger's elegant equation reintroduced the wave metaphor for radiation and brought the mutual exclusivity of waves and particles to a head, Niels Bohr would come up with one of the most fundamental philosophical insights of the twentieth century: the "complementarity" of measurement of all mutually exclusive phenomena, like waves and particles. Now we know that whatever we measure with must itself also be measured, and that the choice of what to measure not only excludes the alternatives but often prevents us from even perceiving that they exist.

Delving into epistemology that fall of 1913 was T. S. Eliot. He was at Harvard working on his Ph.D. in philosophy, with seminar papers on Bergson and James and plans for a dissertation on F. H. Bradley. In a few months he would be struggling through Husserl. It was hard, he wrote to his friend Conrad Aiken, but epistemology seemed a lot more relevant than the symbolic logic being taught by Bertrand Russell. Conrad Aiken was the only person in London that fall with a copy of *The Love Song of J. Alfred Prufrock*. He had great faith in his friend Eliot and would

eventually bring the poem to a reading—a "squash," as they called it in London—where the editor of *Poetry* would condemn it as "insane." Eliot was about to become a poet. He would leave philosophy in Germany, arriving in London to enter Pound's magic circle just before the armies marched in 1914.

In Husserl's philosophy Eliot would find a term that appealed to him—"objective correlatives," for objects corresponding to feelings;[57] and it was in 1913 that Husserl's thought clearly took the direction that would bring such terms to center stage. Having satisfied himself that the ground of logic was phenomenology instead of the other way around, Husserl was now following the phenomenological route backwards from the mathematical foundations "whereby indeed nothing truly new has to be won," and within sight of the psychological conclusions that had gotten him in such trouble with Frege.[58] In that year the final installment of his classic work, *Ideen zu eine reine Phänomenologie* (Ideas for a pure phenomenology, or *Ideas*, for short) appeared in volume one of *Jahrbuch für Philosophie und Phänomenologische Forschung* (Yearbook for phenomenology and phenomenological research), the journal Husserl and a growing band of disciples had just founded under his editorship. *Ideas* was an extended attempt to analyze what in an *Erlebnisstrom* (Husserl's term for stream-of-experience or stream-of-consciousness) was precisely describable as a phenomenon, a presentation to the mind of something single, knowable, and distinct from its phenomenological neighbors, the other things.[59] From such disjunct phenomena, in turn, he aspired to segregate those which, like the law of identity (a = a), belonged to abstract thought. After having done that, his plan was to ground all the abstract phenomena together in an absolutely pure and trustworthy "transcendental ego"—consciousness somehow "bracketed" or isolated from the stream-of-consciousness—which would offer its guaranteed rigor to every positive science. Although positive scientists would in fact see no need for this, philosophers like Martin Heidegger would. Within a few years it would become clear that Husserl had opened the route to an idealism as uncompromising and almost as unmediated as Plato's own.

In November, Edwin S. Porter was in California, where he had introduced projected movies back in 1896, with a production unit of his new company, Famous Players. Making the most of the one-year contract with which Famous Players had wooed the "star," Mary Pickford, away from Biograph, Porter was filming Pickford's fourth and fifth features of the year, *Hearts Adrift* and *Tess of the Storm Country*.[60] Famous Players had jumped into producing the multireel or "feature" films that had suddenly begun to take over the market in 1912, and had just become the first production company to release them on a regular schedule. While Porter and Pickford were in California, Famous Players released the first feature Porter had made for them, *The Count of Monte Christo*, filmed in the

old West 26th Street Armory in late 1912, with James O'Neill, Eugene's father, as the Count. (The stage role had been James O'Neill's meal ticket for years.) Porter was on the comeback trail, and, flush with success, had claimed in an interview in the May issue of *Theatre Magazine* that his *Story of an American Fireman* had been the first ever narrative film. This was the selective memory of a pioneer hanging on in what was quickly becoming a new world. The fact was that when true narrative-centered parallel editing, with intercut shots and interscene crosscutting, had appeared in 1908–9, Porter had not followed suit, and in 1910 the Edison Company had fired him, nearly putting an end to his career as a moviemaker. Porter had helped to engineer his own eclipse, in a small way, when he hired a certain Lawrence Griffith in 1908 to star in a film called *Rescue from an Eagle's Nest,* one of the unconvincing, narratively confusing studio films that had begun the decline in his reputation. His star had gone on to Biograph on 14th Street, where within a few months he had risen from actor to director and resumed his real name. David Wark (D. W.) Griffith had gone on to make the 202 Biograph one-reelers that had virtually invented the new style and done so much to fill the new storefront nickelodeons.[61] By 1913 Porter had updated his own style, and though there was still a certain "staginess" to his work, he was again a top director. Griffith, meanwhile, had resigned from Biograph in September, determined to make a multireel feature of his own, and was secretly filming a Biblical epic, *Judith of Bethulia,* in California. It would be followed by *Birth of a Nation.*

For the movies it was a memorable autumn. At the Pine Ridge Reservation in South Dakota, film cowboy "Bronco Billy" Anderson (who had played the passenger shot down in *The Great Train Robbery*) was financing the white-haired Buffalo Bill (whose thirty-year-old Wild West Show had finally gone bankrupt that summer) to direct General Miles, the U.S. cavalry, and some of his old Sioux troupers in the first film documentary—a recreation of the "Battle" of Wounded Knee where the Sioux had been massacred in 1890. At about the same time, in a sleepy town near Los Angeles that Biograph had discovered in 1909, Cecil B. De Mille was settling down in a stable to make a Western for Sam Goldwyn called *The Squaw Man.* The town was called Hollywood.

Summer and early fall were the conference season in Vienna. The Peace conferees came in August, worrying whether the Balkan peace treaty they had signed in Bucharest would last. In September, the insurance experts of the Second Annual Conference on Accident Prevention were in the city. One of their speakers was one of the coming men in the royal Worker-Accident Insurance office in Prague, Franz Kafka, whose first book, *The Stoker,* and first mature story, "Das Urteil" (The judgment), had just been published. Kafka stayed around after the insurance men left so he could attend the eleventh annual Zionist Congress in the

Vienna Philharmonic's Musikvereinsaal, and hear the disciples of Theodore Herzl, who had died in 1904, consider how and where to build a Jewish state. There was some anxious talk about the arrest of Mendel Beilis for ritual murder in Kiev. In October, after Kafka's tuberculosis had cut short a steamboat excursion to Trieste and landed him in a sanatorium, the Austrian Jewish community, including anti-Zionists like Hermann Bahr and Viktor Adler, rallied in the Musikvereinsaal once again to organize Beilis's defense. Such Gothic anti-Semitism, they agreed, was typical of Russia and could hardly occur in Austria.

Sigmund Freud would have agreed, but he did not attend. The week of the Zionist Congress he had been away in Munich, attending the International Psycho-analytic Association's fourth annual congress in the city where Kandinsky was painting *Composition VII* and Adolf Hitler was painting postcards. There, Freud and his loyalists politely attended as the Association elected Carl Jung to its presidency, having already decided in August at a mountain resort in the Dolomites to drive Jung out of the movement as an apostate. Lenin too had a hidden agenda for those three days, September 7–10, 1913. In the Tatra Mountains of Austrian Galicia, Lenin had been addressing the "summer" conference of the Russian Socialist Party on the need to expel the Mensheviks from the cadres in St. Petersburg. Nothing much had changed. Vienna continued to decay, shooting energetic particles in every direction like a morsel of radium on its way to becoming lead.

On Friday, November 14, the small Paris publisher Grasset, subsidized discreetly by the author, published Marcel Proust's *Du Coté de chez Swann* (Swann's way). The thick volume was only the first of the colossal novel that had risen almost five years ago out of a spoonful of herb tea and cake. There was no discontinuity and hardly a trace of stream-of-consciousness in the nineteenth-century elegance of Proust's style, and his *belle-époque* Combray was nothing at all like Joyce's Dublin; but it was soon clear to readers that in his accumulating epic of hindsight Proust was grappling with the most Modern of all epistemological questions, the relation of the observer with the observed and of both with time and space. *Swann's Way* begins with the narrator, Marcel, describing how he has had a problem since childhood determining where he is or what time it is when he awakes from sleep. Then he innocently describes two Sunday walks, Swann's way and the longer Guermantes way, and how, on the return trip from the Guermantes way, the steeples of an intervening town are observed moving around each other in a stately dance choreographed by parallax and point of view. One discovery Marcel makes is that Swann's way and the Guermantes way ended up in the same place. When complete, *A la Recherche du temps perdu* (In search of lost time) showed that life, too, when led by way of the brilliant Swann ended up in the same place as life by way of the noble Guermantes. The novel would

stand as a single extended demonstration that all directions in a life lead ultimately in a circle and that, no matter how privileged they might seem at first, all perspectives on it are equivalent.

In Virginia Woolf's *The Voyage Out,* accepted for publication by her cousin Gerald Duckworth on April 12, 1913, there was not much more stream of consciousness than there was in Proust; but the main concern of this novel, too, was the puzzling disorientation of inner experience. *Pointed Roofs,* which Dorothy Richardson began working into shape that spring, had the same quality with perhaps even more subjectivity. Duckworth would accept it in 1915. In July, Franz Kafka's first great story, "The Judgment," written in one sleepless September night in 1912, appeared in the review *Arkadia.* Its spare, simple German described a hallucinatory inner consciousness. In September, in the *Chicago Tribune,* a sportswriter named Ring Lardner published three columns under his rubric The Wake of the News, titled "The First Game (By a Athlete)* *Unassisted." Lardner's comic monologue in the voice of an uneducated baseball player would eventually strike Virginia Woolf as the first stream of consciousness from America.[62] In October, the first installment of Andrey Bely's *Petersburg* was published in the St. Petersburg journal *Miscellany.* Uncomplimentary reviewers failed to see how it had drawn a whole city and a whole revolution from a single heightened consciousness. Joyce's *Portrait of the Artist as a Young Man* had long since been completed; but in December 1913 it reached Ezra Pound, who would find it a publisher in the following year. 1913 had become the breakthrough year for Modernist fiction.

On December 3, *Victory Over the Sun,* billed as the first futurist opera, was presented in St. Petersburg in the same theater where, seven years before, Vera Kommissarzhevskaya and Meyerhold had put on the naturalism of Ibsen and the symbolism of Maeterlinck. Since 1906, an amusement park had grown up nearby and the theater had become known as the Luna Park Theater in homage to Coney Island. The resemblance of *Victory Over the Sun* to an amusement park attraction was not lost on audiences. It was as wild as anything put on stage in the West since Alfred Jarry's *King Ubu* in 1896. Its creation had been announced in a Finnish spa in July by three young men calling themselves the First Pan-Russian Congress of the Bards of the Future. Velimir Khlebnikov, a mathematician turned philosopher, had written *Victory's* prologue based on his theory that the truest poetry must be beyond language. Alexey Kruchenykh, a caricaturist turned poet, had written the libretto, on the principle that language could penetrate to what he called the "transmental" by stripping itself of logic and incrementally limiting itself to phonemes and nonsense syllables. (Both writers had made their mark in 1912 with a pamphlet called *A Slap in the Face of Public Taste.*) The lights, sets, and costumes were designed by the young cubist Kasimir Malevich,

who used the opportunity to swing over the brink into abstraction. Another modernist painter, Mikhail Matyushin, gave Malevich a hand in the moments when he was not putting together atonality, quarter tones, and polyrhythms to compose the opera's score.

Matyushin was a founding member of the Union of Youth, the most exuberantly avant-garde arts group in a notably exuberant Russia. The Union had produced *Victory Over the Sun,* but having secured the theater, discovered it had no money left for actors or an orchestra. In the end, amateurs sang the roles (the librettist Kruchenykh played Voyager), and the singers were accompanied by a single out-of-tune piano scrounged on the day rehearsals began. Almost the only thing that was working well was the lighting, a battery of electric spots Malevich used to banish shading and throw whole sections of a tableau into the starkest of white or the pitchest of black. After two rehearsals, the opera opened almost as noisily as *Rite of Spring.* Before the painted curtain could rise, two "Futurist Herculeses" came onstage and ripped it down, singing "All's well that starts well," and the racket began. "Down with the Futurists!" yelled the antis. "Down with the scandalizers!" countered the pros.[63] On the stage, actors dressed in cubes and toruses sang roles personifying abstractions. The targets of their attack were Plato, symbolism, complacency, vulgar materialism, logic, and anything older than twenty. A character named "Nero/Caligula" was demolished to bitonal music as it stood for the classical past. Rather than acts, it had two "actions" divided into six "tableaux." It seemed to have no dramatic continuity, despite the fact that in tableau number two the sun was ripped from the sky by the two futurist Herculeses, and in tableau number six a poet crashed in an airplane. In the same sixth tableau, the demented verses of the earlier tableaux ("I eat a dog / And for white paws / For grilled meatballs / For deflated potatoes / Space is limited")[64] were supplemented by an aria and a chorus constructed entirely of detached phonemes:

> yu yu yuk
> yu yu yuk
> grr grr grr
> pm
> pm
> drr drr rd rr!
> u u u
> k n k n llk m
> ba ba ba ba . . .[65]

It would be hard to imagine a "total-art-work" more totally Modernist than *Victory Over the Sun.* Indeed, it leads to the suspicion that not all we have seen of the avant garde since 1913 has been quite as original as its billing. And it suggests, as much as anything revolutionary that

came after it, that St. Petersburg had become a center of Modernism by 1913. Just before Christmas, the second part of Bely's novel, *Petersburg,* appeared in Sirin's blandly named journal, *Miscellany.* It was a thriller whose protagonist was the city itself. In the novel's opening pages a radical Petersburg youth sets a time bomb to blow up his father and launch a revolution much like the one Bely had seen in 1905. The remaining events of the novel take place as the bomb ticks toward detonation, providing an illusory net of time-lines for events all over the city, including those whose phenomenal existence is limited to the dreamings of the characters. Bely was a symbolist, but Akhmatova approved of *Petersburg,* and saw it as a prophesy. So did the futurist Mayakovsky, whose play, *The Death of Mayakovsky,* premiered at the Luna Park Theater on the day after *Victory Over the Sun.*

That day in Vienna was already December 16. Carnival time had begun, and almost everyone celebrated Christmas. The Wittgensteins were no exception. Their youngest son, Ludwig, had come home from Cambridge University to be with his large family over the holidays. It was not easy for even such a gifted family to understand what he was doing, but they knew it was remarkable. During a trip to England in 1912, Bertrand Russell himself had told Ludwig's sister Hermine, "We expect the next big step in philosophy to be taken by your brother."[66] Reader of Mach and Boltzmann (and Weininger), designer of airplane propellers, child of privilege in Vienna, schoolmate of Hitler in Linz, Ludwig Wittgenstein was now the student and successor of Russell, and he had had a big year. In March he had persuaded Russell to abandon his effort to expand logical analysis into the quicksands of epistemology and to embrace instead the idea that all truth was divisible into irreducible "atomic propositions." In August he had traveled to Norway with his companion David Pinsent, and in September, in Bergen, he had written "Notes on Logic," the first sketch of his disturbing first book, the *Tractatus Logico-Philosophicus.* Returning to Norway, he had holed up for a month in a tiny village on the Sogne fjord north of Bergen; and from there, as the days grew shorter, he wrote to Russell, "All the propositions of logic are generalizations of tautologies."[67] It was just as both of them had long suspected; no proposition could ever be forced by mere logic to yield a new truth. When the *Tractatus* finally appeared in 1921, it began with the words, "The world is all that is the case." It ended with the famous line, "Of that of which we cannot speak, we must be silent."[68]

In the last hours of 1913, the Viennese celebrated New Year's Eve as they had for many years, by gathering in the great square in front of St. Stephen's Cathedral. Many of the celebrants, now well-informed about time zones, observed that although it was New Year's in Vienna, Trieste, and Sarajevo, it would be hours before 1914 would arrive in Paris, London, Madrid, or New York. St. Petersburg, with its Julian calendar,

would be last of all. At midnight the big bells were rung from the cathedral tower, and the people in St. Stephen's Square began marking the moment according to a newer, more self-conscious urban tradition—taking men's hats off to put them on the heads of the women and women's hats to put them on the men. Some of those who partied at home tried to forecast the future by pouring molten lead into champagne ice buckets, reading the flash-frozen drops like tea leaves. In 1,300 years, as Rutherford and Curie had discovered, half of the radium found in the pitcheblende ore of Austria-Hungary decays into lead. It would soon be known that some of the other constituents of pitcheblende can fission and explode.

22 DISCONTINUOUS EPILOGUES

HEISENBERG AND BOHR, GÖDEL AND
TURING, MERCE CUNNINGHAM AND
MICHEL FOUCAULT

Among the first of the Modernists to die in World War I was August Macke of the Blue Rider, who was killed with the invading German Army as it dug in in France. Henri Gaudier-Brzeska died a year later in French trenches near the Channel. Henry Moseley died at Gallipoli, Alan Seeger on the Somme, and Franz Marc at Verdun. Futurist Umberto Boccioni was killed on Italy's Austrian front, physicist Fritz Hasenöhrl on Austria's Italian front, and the poet Wilfred Owen was shot down on the Western front a week before the Armistice. Opponents of the war were sent to jail like Bertrand Russell, ostracized like Einstein, declared insane like Siegfried Sassoon, or rescued from suicide like Georg Trakl. Oskar Kokoschka was severely wounded, and Apollinaire came home with a hole in his head. At the end of the war, when Austria collapsed, Lieutenant Ludwig Wittgenstein was interned in "Campo Concentramento," his name for the POW camp in Italy from which he sent his completed *Tractatus* to Russell. Modernists not deemed fit to fight the war were devastated instead by the loss of those they loved on one or another of its many battlefields, as Max Planck was by the death of his son Karl and Virginia Woolf by that of her friend Rupert Brooke. Even the protagonists of Modernist fiction vanished into shellfire, like Thomas Mann's Hans Castorp. The Modernists who remained most productive were often those who remained on the sidelines: Joyce and Stravinsky in Switzerland, Picasso in Paris, Kandinsky in Russia, T. S. Eliot in England, and William Carlos Williams in America.

Not even the war, however, could shoot down the new thinking. After the public fireworks of 1913, the fundamental ideas of Modernism buzzed across the landscape of Europe like the newly invented airplanes. Most of the intellectual casualties of that nineteenth-century extravaganza they called the Great War were not twentieth-century ideas, but lingering nineteenth-century notions, including the simple nationalism

and imperialism that had started the war, and the naïve faith in speed, horsepower, and material progress that had multiplied its effects. Such faiths did survive, of course, to form the basis of a powerful anti-Modernism—among Americans, for example, who had not felt the full effects of the war, Germans who gave traditional reasons for their defeat, and a handful of futurists who became fascists. To be sure, Hitler nearly wiped out expressionism, and Stalin abstraction, but opposition to the complex of ideas called Modernism proved to be costly, especially if you included among them not only painting and sculpture, but the free application of statistics, computerized cryptanalysis, moving pictures, and nuclear physics.

A close look at the origins of Modernism now allows us, I think, to conclude that among its ingredients were at least five major related ideas. These are: first, that there is embedded in every system for arriving at truth a recursiveness or self-reference that automatically undermines the consistency of the system. Second, that objectivity, the possibility of mutual agreement on "reality," gets no closer to truth than its contrary, a radical subjectivity bordering on solipsism. Third, that every truth implies the subjective perspective from which it was derived and that no one of those perspectives is privileged. Fourth, that any "objective" truths there are to be found are inductive in the extreme, seeming all to lie in statistical regularities. Modernism's dependence on these four ideas is already fairly well understood, to use a scientist's phrase; but they all derive from the fifth and last, which has up to now been described only at the level of matter: the assumption of ontological discontinuity—of atoms and void.

SELF-REFERENCE AND RECURSION

The self-referential tale of the twentieth century began not with an infinite regress of faces in a barbershop mirror, but with the question of whether the barber shaves himself. It began with a general effort to use logic to refine and establish the fundamentals of logic. This had been Frege's program since 1879, when he discovered how to axiomatize arithmetic and embed it in classical logic. At first this self-referential procedure seemed to work; but then, seemingly without warning, problems mushroomed all over the discipline of mathematics until finally Russell, and later Frege himself, had to give up and shorten sail. Since the paradox of recursive self-reference was first found in mathematical logic, only mathematical logicians could see at first how fundamental it was. Nonmathematical minds found out about it later, when writers began to write about writing, artists to make art out of art, and languages to describe only languages. Philosophers, beginning with Wittgenstein, slowly came to understand that every general proposition conceivable in philosophy would

undermine itself through self-reference—as this one has just done.[1] Science, though it continued to make its discoveries, also became enmeshed in self-reference. Quantum electrodynamics was founded in 1947–48 by Richard Feynman and three other young physicists to get around the infinities that arose in the old equations when the electron's "self energy" was taken into account.[2] By mid-century De Vries's genes were found to generate themselves, and not much later the first retroviruses were found. Computer programs could embed recursive loops within loops and turn out unexpectedly to be loops in themselves. When the century began, Poincaré had been deep into his long, filial, and finally unsuccessful effort to find exact solutions to Newton's equations for three or more mutually gravitating bodies.[3] As it ends we are discovering that Poincaré's failure has been transformed into a success: the birth of a new recursive and non-Newtonian mathematics of "sensitive dependence on initial conditions"—the mathematics of chaos—and its "strange attractors" that describe "emergent" regularities.

RADICAL SUBJECTIVITY

For nonmathematicians at least, self-reference implied a turn toward subjective solutions to the problem of knowledge. Even the mathematicians' and scientists' mania for objectivity could lead perversely to a revival of subjectivity. For Auguste Comte and a legion of nineteenth-century positivists, inductive experimental science became the model for the acquisition of all knowledge. The experimenter, or observer, was "objective," meaning he or she was separate from the material reality he or she observed. For positivists, any knowledge of what purported to be independent of material reality was suspect as theological or metaphysical until its relationship with matter could be shown. Furthermore, the sciences were related in a hierarchy of materialist rigor, with the simplest and most objective "mechanics of a material point" (that is, physics) at the root of all the rest. Points, however, were like numbers. They were in no way material, and their objectivity was difficult to establish. It was on such points that positivism began to self-destruct, first in mathematics and logic, and then in physics with the statistical mechanics of Boltzmann and Gibbs. Soon after, the radical subjectivity of the old romantics, already ironically revived by Nietzsche and the Chat Noir monologists and restored to poetry by Rimbaud, Whitman, and Laforgue, was almost inadvertently reintroduced into epistemology by Husserl and into psychiatry by Freud.[4] In streams of consciousness Dujardin, Hamsun, Schnitzler, Joyce, Proust, and Woolf restored it to prose fiction, and Kokoschka and Strindberg did the same in theater. Without intending to, Vassily Kandinsky completed the efforts of painters from post-impressionism onward to

subjectivize art. By mid-century Husserl's subjective epistemology had given birth to a subjective ethics called existentialism.

MULTIPLE PERSPECTIVE

Subjectivity, however, was no guarantee of singleness of vision. Narrators like Stephen Dedalus were no longer omniscient, and even an author with an ego as large as Joyce's could no longer claim to have the whole world simultaneously in view. In the 1873 essay "On Truth and Lies," Nietzsche had made the first argument, never published, that a single true view of reality was rendered impossible by the structure of language. It was a painter, Edouard Manet, who showed in *Bar at the Folies Bergère* (1883) how one might see the world from two different points of view at the same time. Vincent Van Gogh's *Bedroom at Arles* accomplished the same task without duplicating any of the objects in the room. Picasso, Braque, and the cubists mentally tore objects apart, rearranging the elements so as to present them from a dozen points of view simultaneously. The techniques of collage and subsequent mixed media further frustrated the seekers of singlemindedness. Physics followed suit. Einstein had already shown that the measurement of space and time depended on where you were and how fast you and they were going when you measured them. His last little paper of 1905 had suggested that even the distinction between matter and energy might depend on point of view. You could forget such details if you lived, like most of us, at ordinary velocities; but the quantum mechanics of the 1920s made even the light in your eyes problematic. What was wave from one point of view was particle from another; what was field in one experiment was trajectory in the next. Physics could only be rescued from permanent anomaly by Niels Bohr and his principle of complementarity, which essentially turned the double point of view into a new law of nature.

Even in literature, points of view began to multiply. With irony, it was no trouble to speak one's piece in more than one tone of voice. Irony was the literary equivalent of multiple exposure in photography, or cubist and futurist perspective in painting, not to mention Cézanne's multiple versions of Mont Sainte-Victoire and the apples on his tablecloth. It was this technique above all that Laforgue passed on to Eliot.[5] In fiction too, narrative voices spawned narrative voices to ironize each other, and the not very experimental Conrad made the device work in "Heart of Darkness." Proust achieved a similar effect by allowing the narrator of his gigantic novel to change his voice and comment on himself at many times of life. Freud too seemed to explain both psychoneurosis and the psychoanalytic cure as two different effects of a change in one's point of view; and he once compared his method of listening to his patients "free associate" to adopting the perspective of the window of a moving train. By

century's end, irony was being read back into authors who probably never intended it, turning Montaigne into a Nicodemite and Francis Bacon into an untrustworthy narrator. Theater, which is the classic way to multiply an author's voices, has not received the same scrutiny; but the ironic and other effects of multiple perspective are to be heard there, too, from the Chat Noir to *Cabaret*.[6]

STATISTICS AND STOCHASTICS

The multiplication of perspectives leads many to seek truth by the method of assembling all the possibilities. Modernism pioneered the abandonment of the bright, precise proposition for the fuzzy statistical regularity, and the all but causeless "crass casualty," of Thomas Hardy's 1898 poem, "Hap." Many in science have by now come to suspect the so-called Law of Large Numbers of being the only real law in the universe, allowing patterns to be perceived in what is at bottom nothing but random action. Humans seem equipped by the structure of the brain to perceive patterns, and the trick has survival value, but that does not prove that all the patterns we perceive are really there. Boltzmann's law $S = k \log W$ is only the consequence of assuming the utter randomness of matter at a particular scale. Atomism works with atoms, as scientists first began to suspect when the atomic spectra were found to have disconcertingly hard edges and no overlaps. At the even smaller scales of quantum electrodynamics, there seems to be hardly any fuzziness to the measurements (unless you insist on measuring both the position and the velocity of an electron), and none at all to the measurements of quantum chromodynamics (again, unless you insist on measuring what each quark is doing). We can never be sure, however, of the meaning of this success. Perhaps we have not yet reached or been able to measure the possibly random events that underlie what we are measuring. On the larger scale of living bodies, national economies, or galaxies, randomness returns. The great scientific "laws" of the nineteenth century are thought of at the end of the twentieth as derived statistical descriptions of stochastic processes, which can come into being only if abetted by the sheer quantity of such processes to be described. The paradox of this is that the only things in nature that human beings cannot mathematically describe are, in fact, infinity, continuity, and true randomness itself. The so-called random number generator inside most computers these days cannot, in fact, generate random numbers. It cannot because by definition one cannot specify randomness by any general instruction or algorithm—not, in other words, by any computer program. The very existence of randomness is a philosophical riddle. "A throw of the dice will never abolish chance," as Mallarmé's last poem put it in 1897. Even Boltzmann might quail at what has developed out of his law.

DISCONTINUITY

But the heart of Modernism is the postulate of ontological discontinuity. So much of the thought and art of the twentieth century follows from atomism that thus far there has been no going back on it, even in the ages of structuralism and postmodernism. We cannot help seeing the objects of our knowledge as discrete and discontinuous—digital rather than analog. Everything from the gene and the quantum to the image and the phenomenological *epoché* defies the insistence on evolution, fields, seamlessness, and *Entwicklung* to be found everywhere in nineteenth-century thought.

The continuity-discontinuity antinomy is permanent. Discontinuity is a choice, a choice Western thought has been forced to make many times. The atom that had begun as Demokritos' bold solution to Zeno's Greek riddles was turned by Epicurus and Lucretius into a reason to dismiss the gods.[7] Galileo's talk of it had helped to make the church his enemy. Descartes and Malebranche had tried to tame it. Newton had proposed a particulate theory of both matter and light, but remained uneasy about what it might do to his reputation for theological conformity. When John Dalton first proposed an atomic explanation for the regularity of the ratios of combining weights in chemical reactions, he shared some of Newton's uneasiness. Atoms invited materialism. It was no accident that Karl Marx would write his thesis on Demokritos. With infinitesimal parts even a bounded universe could be both full and infinite, but a universe with nothing but atoms and void would leave no room for gods. The differentials postulated by the calculus were not atoms. An atom was indivisible by definition, while a differential was divisible *ad infinitum*. Differentials were therefore theologically unthreatening, however perverse they clearly were in their behavior. Just as a division by zero threatened to make it infinitely large, a differential became "vanishingly small." To its inventor, Leibniz, this was proof of the "Principle of Continuity"—that nature made no jumps. To many mathematicians it was a principal reason why the calculus had made such rapid progess in the two centuries of glory that led up to the discoveries announced by Karl Weierstrass in 1872.

Weierstrass and H. C. R. Méray arithmetized analysis. In a sense everything in our century followed from that. Analysis, the new name for the calculus, became a mathematics of finite domains from which the concept of "approaching" a limit and all other metaphors of continuity and continuous motion had been purged. The arithmetization of analysis was the starting point of Dedekind's definition of a real number, of Cantor's definitions of infinite sets, of Frege's rigorous redefinition of arithmetic, of Peano's axioms, and of the efforts of all four of them, and many others, to define the concept of number. Modernist thinking began with

mathematics, in a pattern closely resembling the way another revolution in thought had begun 250 years before with the profound mathematical meditations of Descartes.

Mathematics is a humanity. As the Italian humanist Vico pointed out, mathematics is the most completely nonnatural, man-made thing in the world. "Number, is *solely* the product of our mind," wrote Kronecker in his essay on the concept of number, "whereas Space as well as Time have also a reality, outside our mind, whose laws we are unable to prescribe completely *a priori*." [8] Moreover, although life may imitate art, art can imitate philosophy and mathematics. That mathematics and philosophy should have taken the lead at a moment in the late 1800s when Western culture changed its ideas is no surprise, since it was hardly the first time. For any referee wishing to call a "paradigm shift" it makes sense to look at mathematics to see what shape the shift may take. Sensing something potentially much more far-reaching than anything in architecture or literary theory, historians of ideas are already looking closely at what Abraham Robinson proposed in 1961 and called "Nonstandard Analysis." Robinson proved to his fellow mathematicians that the infinitesimals Weierstrass had banished from calculus could be used to lay an incomparably more rigorous foundation for analysis than the real numbers Weierstrass had relied on. [9] If ontological continuity should ever come back into fashion, the story will have begun with Robinson.

In the meantime our culture remains wedded to the discrete. We are still convinced that there is "space" between all the numbers, as we know there is between integers. Real numbers, we believe with Dedekind, can be isolated just like the counting numbers—and named by a cut in the continuous number line. Real things as well, if there are such, we have believed to be discontinuously different and separable from other real things just as one is different from two and two from three.

Trained in mathematics, Boltzmann applied this discontinuity principle to the constituent parts of a gas. Once "molecules" of a certain size were assumed, their number in a unit volume could be determined. Thereafter, their combinatorial collisions could account for heat, and even the direction of time could be explained as an effect of their enormous numbers. Success bred success; Planck derived the energy quantum from Boltzmann's probabilities, and some two generations later all the old continuous effects, even Maxwell's electromagnetic field, had been quantized and associated with a characteristic particle.

For artists, the independent particle idea led to seeing the subject of a painting as a set of independent dots of color—separable snags of perception in what William James, the last continuitarian, described as the "stream" of consciousness. As soon as this view prevailed, *sfumato,* the time-honored Renaissance technique, shading from one patch of color to another through all the intermediate tones, became unfashion-

able. Already in 1863 Manet had shown how to do without *sfumato* in *Dejeuner sur l'herbe*, and within a decade even an academic like Regnault could win a prize without using it.[10] Like the impressionists before him, Seurat found the technique both false and useless. In his studio Seurat rendered a myriad of discrete experiences of nature as tiny "dots" grouped so as to act on each other and reproduce the experience in consciousness. In the same decade, as the halftone screen was coming into use to divide newspaper pictures into pixels, Cézanne began to conclude that there were no color transitions in nature at all, because each little patch of color was an independent experience that had to be independently painted. Before the 1880s ended, Emile Bernard tried using much larger patches, the color compartments of cloisonné enamelware, to re-create a natural world while deliberately suggesting an ideal one. After Paul Gauguin picked it up, a critic called it "cloisonnism."

The most noticeable effect of discontinuity on poetry was to loosen all patterns of prosody and to make irony all but unavoidable. With Laforgue, transitions between tones of voice went the way of *sfumato* between colors. Transitions between metaphors vanished, since metaphors no longer called for preparation or explanation. With Rimbaud, poetry became an art of the juxtaposition of discrete fragments, or remembered details—indeed, of words themselves, shaken loose of their meanings. By 1913 Apollinaire was publishing *Alcools* with half its capital letters reduced and not even a comma to keep his tropes from colliding, while in Russia cubo-futurists had fragmented the words themselves into syllables.

Discontinuity applied to histology, the study of living tissue, resulted in 1888 in Cajal's resolution of the gray and white matter of the central nervous system into an astronomical number of discrete neurons or nerve cells. Nor did they communicate continuously, like waves through a network, but rather one or two at a time like molecules colliding in Boltzmann's ideal gas. Cajal's discovery is now viewed as the founding event of one of the century's most promising new sciences—cognitive neuroscience, the self-referential study of the biological bases of consciousness. The neuron was a painter's discovery, made by observation and draftsmanship, but Cajal was not a painter who cared for Modern painting. It was not an artist's technique that prepared him for his discovery, but the underlying idea of discontinuity. Similarly, it was the general idea of separating the hitherto inseparable that inspired Cajal's countryman, Weyler, to systematize and name the "reconcentracion" policy, putting the human "other" behind barbed wire where hitherto only animals and criminals had been, and dividing guerrillas from their families.

For Freud, the atomic unit was another of those separable snags of perception in the stream of consciousness: an unconscious image, an unbidden trope or joke, a piece of what Freud usually referred to as "material." This material of the unconscious might be a continuous fabric, and

that indeed was how Freud thought about it; but it was also unknowable. The most audacious and far-reaching division Freud found in the soul was between those two almost noncommunicating parts, conscious and unconscious. Like Husserl's *epoché,* which divided phenomena from the consciousness that experienced them, Freud's *Verdrängung* was a psychological Dedekind Cut that no Gestalt psychology could satisfactorily bridge.

The idea of discontinuity became unmistakably dominant in 1900, the last year of the old century, when the gene and the quantum appeared with dramatic abruptness to solve problems that were a century old. Then, as the solutions were being received with fascination, it turned out that they had not been really new. Even the scientists who were proposing them were not radical, and if it was a new twentieth-century metaphysic that had guided De Vries and Planck to their conclusions, it must clearly have taken them by surprise. Just as Hugo De Vries was preparing to propose the gene to account for the whole-number ratios he was finding in inheritance, he discovered that the credit would have to go to an Austrian monk and a thirty-five-year-old scientific paper that nobody at the time had been ready to read. Max Planck, who had been working for years to account for Kirchhoff's forty-year-old black-body radiation law, was all but forced into postulating the quantum because only with the micro-discontinuous quantum could he derive a continuous curve.

Within a year after the gene and the quantum had been announced, the definition of number and arithmetic began to engender the paradoxes of recursion and self-reference that threatened to undermine mathematics and even philosophy iself. It was Russell who first discovered how fundamental they were, struggled with them for months, and then told Frege. Both hoped for years that they would find a solution, and Russell cobbled together a *modus vivendi;* but as it became clear that the problem lay in the very concept of a mathematics that was both universal and consistent, the philosophers began to turn to other tasks. Edmund Husserl, whose first intellectual program was much like Frege's and Russell's—a philosophy of mathematics—quickly found his way to a new sort of subjective idealism in which arithmetic no less than proof was approached initially as a mental phenomenon. Indeed, everything knowable was a phenomenon, including the conscious self itself, a separable fragment of perception in a "stream" of consciousness Husserl called the *Erlebnisstrom.*

Meanwhile in America Edwin Porter, not a college man, knew very little about the fragmentations of the philosophical continuum, but he was in the throes of a new medium that functioned as a veritable tissue of discontinuities: moving pictures. On one level a film was made up of frames, a collection in series of still images; and on the next it was made up of moving images. Each moving image was next to another, even inside another, in a juxtaposition soon to be called "montage." It was

Porter who in 1903 began putting the effect he had learned to achieve with a change of films and a change of projectors onto the film itself. Since the ultimate goal was to bring in audiences by forging an illusion of a continuous "stream" of story, even filmmakers more educated than Porter did not quite grasp what they were doing. Nevertheless, though Porter was not the first to suspend an audience's disbelief, he was the first to pack them in with a story film.

The young Albert Einstein was open to discontinuity because of a philosophical preference for atomism of which all his earliest papers were a defense. When he proposed what became known as the photon in 1905, he called it "heuristic," meaning, almost playfully, let's try it and see if it works. It did work, and it earned him his Nobel Prize; but when the prize was awarded, Einstein was seventeen years older, already looking on in dismay as the quantum began to compromise the continuous fields with which his hero, Maxwell, had accounted for light. Einstein's other discovery of 1905, Special Relativity, was a field theory par excellence, and one that would lead him in a few years to a field theory of gravitation better than Newton's. Having digitized electromagnetic radiation in the same way that Planck had digitized heat, Einstein found himself with Planck among the doubters, defending the continuous field as the quantum infected physics with probability and paradox and began to dismantle causation itself.

The planar components of a painter's subject were isolated in 1907: more fragments of perception in the "stream" of consciousness. "Roped together," Picasso and Braque began to take their subjects apart and make cubism. Later it was collage and assemblage. Before they had finished, everything perceived in a subject could be treated as a movable part, and painting lurched toward a new, almost industrial goal, the reconstruction of the world. With Strindberg and Kokoschka, the same patchwork reconstruction reached the stage, and scenes, like metaphors, began to be juxtaposed across gaps instead of offering, like movies, the illusion of continuity. In all forms of music key came into question and phrases began to get shorter. Schoenberg innovated by transcending key-to-key modulations and developing from phrase to phrase without repetition, Stravinsky by stripping legato ties between phrases and notes, and the founders of jazz by doing similar things to American popular song.

Joyce brought the stream of consciousness to published literature, and at the same time found the fragments of perception in it, epiphanies or "moments of vision" as Virginia Woolf called them, not very different from Husserl's phenomena and Freud's fragments of unconscious material. Painters found still other snags in the stream of consciousness. Henri Matisse enlarged Emile Bernard's "cloisons," having begun earlier by enlarging Seurat's "dots." Later painters divorced the phenomena of color and form from objects until they too became objects. In 1911, Kandin-

sky's broad well-defined patches of saturated color would reflect nothing in the world but themselves.

One of the first comprehensive texts in twentieth-century philosophy was put together in 1955 and called *The Age of Analysis*.[11] There seems to be no better tag for Modernism even now. Modernists dissect routinely and obsessively, beginning with the functions of the calculus. The intellectual world of Modernism is principally a world of precise definition and separability. The unadorned hard edges we associate with Modernist design had already appeared in the architecture of Adolf Loos, Charles Rennie Mackintosh, and Louis Sullivan in the 1890s, and Loos wrote his manifesto, "Ornament as Crime," in 1908.[12]

All of this fragmentation and analysis has not been confined merely to intellectual culture. High on the list of the classic complaints of modernity is the one about the failure of integrity of modern life, and particularly of modern lives, fragmented and unharmonious, their activities asynchronous and divided against themselves. The complaint is old and was probably first heard in the 1820s when railway passengers were warned that speeds of twenty miles an hour might ruin their health. At the great World's Fairs of the turn of the century, and at the new "modern" amusement parks like Coney Island, visitors were warned about the dizzying effects of seeing and doing too much, deranging the senses and bringing on neurasthenia. We call it "museum fatigue" and do not think of it as being Modernist. In the "postmodern era," in fact, fragmentation of lives has been not only touted as inevitable, but even hailed as a new sort of virtue. Marxists meanwhile seemed to see it as an effect of the unequal commoditization of what had once been pricelessly human. Whatever value is placed on it, the fragmentation of lives is not only a perceived effect, but very possibly a long-term objective consequence of industrial modernity.

Does it make any difference to human beings who perceive this disintegration that on the scale of atoms or the scale of Planck, everything is digital? Yes, but the push probably comes from the way we think rather than the way things are. The question of scale is all-important, because continuity and discontinuity depend, with mathematical intimacy, on how closely you look. In the way historians gather and group events, explanation seems to hide randomness on the grand scale. That atoms are separate individuals on a periodic rather than a continuous table is a curious fact that has taken a very long time to explain. Yet this strange atomic uniqueness, the lack of intermediates between Hydrogen and Helium first seen in the chemistry of Mendele'ev's Periodic Table and then in the sharp-edged voids of Fraunhofer's absorption spectra, gives way once you go into the nucleus and focus on the transition state between atoms, isotopes, and radioactive decay. Discontinuity implies uncertainty in physics no less than it does in mathematics. It also implies both contra-

diction and causelessness, as Werner Heisenberg showed in 1927 with his famous measure of indeterminacy, and Niels Bohr in the same year with his principle of complementarity.[13] Multiply however much you don't know about the velocity of an electron by however much you don't know about its position, and, Heisenberg proved, you will never get a figure less than h, Planck's Constant. Know more about one, and you are guaranteed to know less about the other. Bohr, Heisenberg's mentor, endorsed the idea and extended it to everything. What we can't know in some area of subatomic physics is only the complement—the missing half—of what we can know. Measure for waves and get waves; measure for particles and get particles. The waves and particles contradict each other, but since they're never onstage together, physics can survive a little longer. In the fall of 1927, at the Solvay Conference, Einstein tried to argue Bohr out of the complementarity idea, asking him if he believed that God played dice. Bohr said he did, though in retelling the story later he silently replaced the word "God" with the phrase of a good atheist, "the providential authorities."[14]

In the 1930s, mathematics and logic again entered the spotlight. Kurt Gödel and Alan Turing proved once and for all that our mathematics, or any mathematics so conceived and so constructed, is always either inconsistent or incomplete. Gödel, Moravian born like Mendel, Freud, and Husserl, came to Vienna as a junior member of that remarkable platoon of neo-positivists, the Vienna Circle, whose godfather was Ludwig Wittgenstein. In 1931, Gödel confounded neo-positivism even more devastatingly than Wittgenstein had. He took *Principia Mathematica,* that *summa* by Whitehead and Russell of the logical foundations of mathematics, and proved with utmost rigor what Russell had only suspected— that the foundations could never be completed.[15] To do it, Gödel used the whole numbers, the integers that nineteenth-century mathematicians had once called "simple," and showed how one and only one of them, different from any other, could be assigned to each formula in the *Principia.* As Cantor would have said, he put the symbols, axioms, definitions, and theorems of Russell's arithmetic into one-to-one correspondence with the whole numbers, thus mirroring the numbers, recursively of course, back into the mathematical structure that produced them. He then showed how to give the number that corresponded to the proposition "this proposition is not provable," and to show that if "this proposition" were provable, then its contrary "this proposition is provable" would also have to be true. But if "this proposition is provable" and "this proposition is not provable" were both true, then the foundational axioms of arithmetic would have to be inconsistent. There was more. The number for "this proposition is not provable" reflected through the number-mirroring a proposition that was true. In other words, "this proposition is unprovable" was a proposition that could be proved. And

a third astounding consequence of Gödel's reasoning was that there were an unlimited number of these true but unprovable propositions in every consistent mathematical system that wasn't trivially simple. You might, in other words, weed each one out as you discovered it, add it to the list of unprovables and call it an axiom; but you could never stop new true but unprovable propositions from popping up.[16]

A deep breath is in order. Even the mathematicians took some time to understand and deal with this bombshell—a neat little infernal machine that cranked out mathematical proof that all of mathematics was either inconsistent or uncertain. Alan Turing, a mathematician nearly as brilliant as Gödel, took six years to digest it. Then, in 1937 he published a paper on the question Gödel had left open. It was an extension of the tenth of the twenty-three questions David Hilbert had proposed in Paris in 1900 as a game plan for twentieth-century mathematics; and the third of three that Hilbert had asked at another Mathematics Congress in 1928. Can we show, asked Hilbert, that mathematics is complete, can we show that it is consistent, and can we show that it is provable?[17] Gödel had already answered the first two questions by proving that mathematics was inconsistent if it was complete and incomplete if it was consistent. The only question left was provability—the "decision problem," as Hilbert called it. Was there any way to decide mathematically whether a mathematical proposition was one of those true but unprovable monsters Gödel had discovered? What could we know for sure about the solvability of mathematical problems or the provability of mathematical theorems before we actually solved or proved them? Turing's 1937 paper gave the answer, as discouraging for Hilbert as it was by then typical of mathematics and of twentieth-century thought in general.[18] The answer was that there not only existed problems whose solvability could not be predicted, but there were an infinite number of them. To prove this Turing first put things in one-to-one correspondence with the lowly integers—in other words, he counted them. What things did he count? The rules for computing other numbers. Turing defined a certain kind of number as "computable." A "computable number" was any of the real numbers, written as an endless decimal, that could be specified by an algorithm. The algorithm, unlike the number, came to an end. It was a finite recipe, or set of rules, for generating each succeeding digit in the decimal; and Hilbert would have recognized it as representing a decidable mathematical question. Turing then put these algorithms in order on a list and numbered them consecutively, counting (in theory, at least) a list of known and finite items. Was this list, in turn, an infinite one? Was there a finite recipe for adding to it? That would be the equivalent of Hilbert's question about whether there was a way to know that proofs existed or not. To find out, Turing applied the diagonal proof of the uncountability of the real numbers that Georg Cantor had come up with in 1874 and 1895, and in-

vented an algorithm of his own—the rules for mechanically applying the diagonal proof to his list of computable real numbers.

Turing's method was a lot like Gödel's. It had the same self-referential numbers. The difference was that while Gödel's neat little infernal machine had been implicit, Turing's was explicit. It computed an endless decimal digit by digit, by moving back and forth along a tape and writing and erasing ones. It was a mathematical brainchild, existing only in Turing's imagination and much too slow to try out in practice; but it is still known as the "Turing Machine." Nowadays we are more likely to call it a computer. Turing, who used the word "computer" in his paper to mean a person who did arithmetic, was in fact recruited by British intelligence in World War II to help build the first electronic "computer" in history and thereby read German military messages that had been encoded by machine.

Across the Atlantic from Turing's secret computer team, an engineer at the Bell Laboratories, Claude E. Shannon, discovered while wrestling with telephone switching systems that "information" itself behaved much like the entropy of Clausius and Boltzmann.[19] As the war reached its height, Shannon worked out a mathematics that reduced information from a vague concept to a Boltzmannesque sum of the logarithms of probabilities. "Information theory," he called it, demonstrating in two papers he was permitted to publish after the war had ended (and the code-breaking had died down) how all information was to be measured in binary digits—the one-or-zero code used in the Turing machine. For "binary digit" Shannon offered a short portmanteau word, *bit,* and the dawning computer age embraced it.[20] "Bit" is now not only a mathematically precise term, but perhaps the most ubiquitous metaphor for the digitization of the world at the end of the twentieth century.

If there is an exception to this digitization of ontology and aesthetics, it is the form of Western dance we have been calling "Modern" since Loïe Fuller taught Isadora Duncan and Ruth St. Denis how to turn skirt-dancing from vaudeville into art. The Modern Dance of Fuller, Duncan, and St. Denis, however, was not Modernist in the sense that word came to carry in the other arts and sciences. It was "modern" in the sense of not being "classical," like ballet, and it was "modern" in the older sense of the word as it had been applied to Ibsen, the sense of moral provocation. This sort of dance, however, was not "Modernist" in the sense of being disjunctive or jerky. On the contrary, it gloried in being continuous and fluid. Dance in general, and art dance in particular, was very late in adopting the rising discrete esthetic, and it was not until Merce Cunningham began to try out his "aperiodic" choreography in the early 1950s that modern dance began to be thought of as a montage of disparate movements juxtaposed by chance in staccato.[21]

As the century draws to a close, even history, the establisher par ex-

cellence of the continuities in our collective story, finds itself drawn in the direction of disjunction and discontinuity. In intellectual history, the discipline this book falls under, a major recent practitioner, Michel Foucault, has been responsible for the elaboration of a view of history that makes it inconceivable for people raised and acculturated in a particular era and a particular constellation of ideas to think in any other way than the one presented to them. The view is fashionable at the moment, depending for part of its force on the difficulty of asserting anything at all after a century of Nietzsches and Russells and Gödels has done its work. It helps the periodizers who wish to distinguish the mentality of the romantics, say, from that of the realists in ways that are clear and unambiguous, and it helps explain why culture sometimes seems a prison. Foucault called such an imprisoning mentality an episteme. Foucauldian epistemes might be extremely complex, but they began and ended abruptly, and in Foucault's view those inside an episteme could never step outside it. Foucault did not deny that we could know and understand romanticism and other past mentalities, and in fact he offered such understandings in several of his books; but the effect of his reasoning was to deny to both himself and his contemporaries any grasp of the mentality of our own era. This is a curious premise, coming toward the end of the Modernist century. If true, it suggests that anything Foucault wrote about contemporary affairs—and he wrote a great deal—could offer no perspective at all. It argues that the present book can be of no use because it proposes that the episteme of Modernism still abides and thus continues to deny us the necessary insight. It also implies that Modernism will always be with us since there is no longer any philosophically legitimate way to explain how epistemes can change. Finally, it implies that there is no such thing as self-consciousness for a culture or even for an individual. As we come to the end of a century of Modernism, with its radically self-referential methods, applied to undermine every conceivable categorical statement, it would be hard to imagine a more anti-epistemic notion than a categorical statement that we cannot see ourselves—or change as a result. Foucault and others have forgotten, or never learned, what happened to epistemology when Dedekind made his cut and Westerners began to precisely microtomize the world.

If the stories in this book make sense, then Modernism is still with us and postmodernism may not mean half as much as Continental criticism thinks it does. Such a view is on the level where the scholarly fur flies. It is large and invites controversy. Any controversy, however, must deal as best it can with stories, because the stories of Modernist creation and invention may in the end be the whole content and nothing but the content of the historical object called Modernism.

NOTES

1. For a summary of the theoretical assault on narrative, see Michael Roemer, *Telling Stories: Postmodernism and the Invalidation of Traditional Narrative* (Lanham, Md.: Rowman and Littlefield, 1995).

2. R. V. Jones, "Complementarity as a Way of Life," in *Niels Bohr: A Centenary Volume*, ed. A. P. French and P. J. Kennedy (Cambridge: Harvard University Press, 1985), 323–24.

3. "[Kafka] moved from a language marked by the discourses of his time to one that he and his contemporaries saw as 'modern,' and therefore, they hoped, universal, transnational, and infinitely interpretable in the ideological strife of their age." (Marshal Berman, review of *Franz Kafka: The Jewish Patient*, by Sander Gilman, *The Nation*, 20 November 1995, 606).

4. Robert Venturi, Denise S. Brown, and Steven Izenour, *Learning From Las Vegas* (Cambridge: MIT Press, 1972, 1977); Irving Howe, *The Idea of the Modern* (New York: Horizon, 1967); and Harry Levin, "What Was Modernism?" in *Refractions: Essays in Comparative Literature* (New York: Oxford University Press, 1966). The word is clearly much older. Charles Jencks finds it used by a British artist, John Watkins Chapman, in the 1870s and by Rudolf Pannwitz in 1917 (Jencks, quoted in Richard Appignanesi and Chris Garratt, *Introducing Postmodernism* [New York: Totem Books, 1995], 3). Werner Sollors points out that the American writer "Randolph Bourne used the term 'post-modernism' (in order to describe Japan) in his memorable essay 'Trans-National America' (1916), and Wolfgang Welsch, *Unsere postmoderne Moderne* (VCH, 1987) cites several instances from the 19th century." (Werner Sollors to H-IDEAS electronic bulletin board, 1 April 1995, and Randolph Bourne, *The Radical Will: Selected Writings, 1911–1918* [New York: Urizen Books, 1977], 250). Jon-Christian Suggs has found a note about chemistry sent to Walter F. White, sometime Executive Secretary of the NAACP, on 30 October 1928 with the letterhead:

POST-MODERN SCIENTIFIC THOUGHT
247 Palmyra Street
New Orleans, Louisiana

"There is a single primordial unit of matter;
there is a single primordial unit of ether-space."

and an undated manuscript by White, somewhat later than 1928, which reads: "Post-modernism slightly gone mad in its triangles, squares and angular contortions applied with ultra-vivid pigments made the machine impossible to ignore" (White Papers, Schomburg Center for Research in Black Culture, cited by Jon-Christian Suggs to H-IDEAS electronic bulletin board, 31 March 1995).

5. *New York Times,* 24 November 1985, Arts and Leisure section, p. 1.

6. Among these are *Amerikastudien* 22, no. 1 (1977), 9–46; John Barth, "The Literature of Replenishment: Postmodernist Fiction," *Atlantic Monthly* 245, no. 1 (January 1980), 65–71; Ihab Hassan, *The Dismemberment of Orpheus,* 2d ed. (Madison: University of Wisconsin Press, 1982); and the entire Fall 1984 issue of *New German Critique,* with articles by Hal Foster, Jürgen Habermas, Seyla Benhabib, Gerard Raulet, Peter Sloterdijk, David Bathrick, Andreas Huyssen, and Fred Jameson (to the latter two of which I am particularly indebted).

7. Charles Newman, *The Post-Modern Aura: The Act of Fiction in an Age of Inflation* (Evanston, Ill.: Northwestern University Press, 1985), and Stephen Toulmin, *The Return to Cosmology: Postmodern Science and the Theology of Nature* (Berkeley: University of California Press, 1984). Jim Diana spoke of "non-narrative techniques in postmodern dance" on NPR's "Morning Edition," 25 January 1988.

8. *Princeton Alumni Weekly,* 15 January 1986, 9; and Claude Rawson, review of *The History of Modern Criticism,* vols. 5 and 6, by René Wellek, *New York Times Book Review,* 30 March 1986, 8.

9. Ada Louise Huxtable, *The Tall Building Artistically Reconsidered* (New York: Pantheon, 1984).

10. *Newsweek,* 11 November 1985, 86–87.

11. Bruce Handy, "Postmodernism," *Spy,* April 1988, 100–108.

12. *Lingua Franca,* May 1992.

13. Margaret Atwood, *Cat's Eye* (New York: Bantam, 1989), 90.

14. Quoted in Phil Patton, "'High and Low': Modern Art Meets Popular Culture," *Smithsonian* 21, no. 8 (November 1990), 149.

15. *New York Times,* 24 November 1985, Arts and Leisure section, 1.

16. John Barth, "The Literature of Replenishment: Postmodernist Fiction," *Atlantic Monthly,* January 1980, 67; Maurice Beebe, "What Modernism Was," *Journal of Modern Literature* 3 (July 1974), 1065; in Astradur Eysteinsson, *The Concept of Modernism* (Ithaca, N.Y.: Cornell University Press, 1992), 3–4.

17. "Modernist experiment is no longer so young that it has nothing but freaks and abortions to show. In poetry, in the novel, in painting and music and architecture, a distinctively modern style has for some time now had its very considerable achievements, as the names of Rilke and Joyce and Picasso and Schoenberg and Gropius testify." Eric Bentley, *The Playwright as Thinker* (New York: Harcourt Brace Jovanovich, 1987), 21–22. A generation later, Ihab Hassan asked, "When will the Modern period end? Has ever a period waited so long? Renaissance? Baroque? Neo-Classical? Romantic? Victorian? When will Modernism cease and what comes thereafter? What will the twenty-first century call us? and

will its voice come from the same side of our graves?" Hassan, "POSTmodern-ISM: A Paracritical Bibliography," *New Literary History* 3 (Autumn 1971), 7.

18. "Modernists, for all their loud inveighing against Romanticism, longed for and adopted positions that are unmistakably, though sometimes covertly, Romantic." Albert Gelpi, quoted in Michael Saler, "The 'Medieval Modern' Underground: Terminus of the Avant-Garde," *Modernism/Modernity* 2, no. 1 (1995), 139 n. 10.

19. According to Clement Greenberg, "Manet started it all, not Cézanne. There was Flaubert in fiction, Baudelaire in poetry and Manet. It was that triumvirate in the 1850s that created what we call modernism" (*Newsweek,* 19 April 1993, 66). According to Irving Howe, "Modernism need never come to an end, or at least we do not really know, as yet, how it can or will reach its end." But that was in 1967. Irving Howe, ed., *The Idea of the Modern in Literature & the Arts* (New York: Horizon, 1967), 13.

20. Cyril E. Black, *The Dynamics of Modernization: A Study in Comparative History* (1966; New York: Harper Colophon paperback, 1975), 5–7, 186–92.

21. Canonically the first book of poems in Spanish Modernismo is Rubén Darío [Felix Rubén García Sarmiento], *Azul* (Azure) (Valparaiso, Chile: Excelsior, 1888). Critics listed the Cuban José Martí as a predecessor with *Ismaelillo* (My little Ishmael) (New York: Thompson and Moreau, 1882), and reckoned the "school" to include Julián del Casal, Salvador Díaz Mirón, José Asunción Silva, and Manuel Gutiérrez Nájera. A younger generation included Julio Herrea y Reissig and the prose writer José Enrique Rodó. English-speaking students of *Modernismo* are grateful for the bibliography by Robert Roland Anderson, *Spanish American Modernism: A Selected Bibliography* (Tucson: University of Arizona Press, 1970), and the more recent book by Gwen Kirkpatrick, *The Dissonant Legacy of* Modernismo: *Lugones, Herrera y Reissig, and the Voices of Modern Spanish-American Poetry* (Berkeley: University of California Press, 1989).

22. Robert Hughes connects "Modernisme" in a paragraph to "Huysmans, Verhaeren, D'Annunzio, Hauptmann, and Wilde, and of the currents—poorly understood as yet—of idealism and symbolism in Paris, especially the poetry of Stéphane Mallarmé . . . Maurice Maeterlinck . . . Henrik Ibsen. Nietzsche's vitalism . . . the American Transcendentalists, especially Ralph Waldo Emerson; [and] Walt Whitman. . . ." Robert Hughes, *Barcelona* (New York: Vintage, 1993), 392.

23. This story is told in chapter 17. Léon Hennique was the author of *Jacques Damour,* the play about a returned Communard that opened André Antoine's Free Theater in Paris in 1887. Its set, which brought down the house, was the backroom of a butcher shop with real meat hanging from the wall.

24. F. W. J. Hemmings, "The Origin of the Terms *Naturalisme, Naturaliste,*" *French Studies* 8, no. 111 (April 1954).

25. One lively multidisciplinary survey of the whole of twentieth-century thought begins where this book begins: O. B. Hardison, *Disappearing Through the Skylight: Culture and Technology in the Twentieth Century* (New York: Viking, 1989); but while it understands chronology, it avoids the term Modernism. There are, of course, some quite wonderful books on some of the arts and some of the sciences, notably William Aspray and Philip Kitcher, eds., *History and Philosophy of Modern Mathematics,* Minnesota Studies in the Philosophy of Science,

vol. 11 (Minneapolis: University of Minnesota Press, 1988); Houston A. Baker, Jr., *Modernism and the Harlem Renaissance* (Chicago: University of Chicago Press, 1987); Malcolm Bradbury and James McFarlane, eds., *Modernism 1840–1930* (New York: Penguin, 1976), on literature; Stephen G. Brush, *The History of Modern Science: A Guide to the Second Scientific Revolution, 1800–1950* (Ames: Iowa State University Press, 1988); Christopher Butler, *Early Modernism: Literature, Music, and Painting in Europe, 1900–1916* (New York: Oxford University Press, 1994); Norman F. Cantor, *Twentieth Century Culture: Modernism to Deconstruction* (New York: Peter Lang, 1988); Monique Chefdor, Ricardo Quinones, and Albert Wachtel, eds., *Modernism: Challenges and Perspectives* (Champaign: University of Illinois Press, 1986), on literature, painting and politics; Jean Clay, *De l'impressionisme à l'art moderne* (Paris: Hachette, 1975); Carl Dahlhaus, *Between Romanticism and Modernism: Four Studies in the Music of the Later Nineteenth Century* (Berkeley: University of California Press, 1991); Jean-Luc Daval, *Modern Art: The Decisive Years, 1884–1914* (New York: Rizzoli, 1979); Albert E. Elsen, *Origins of Modern Sculpture: Pioneers and Premises* (New York: Braziller, 1974); Astradur Eysteinsson, *The Concept of Modernism* (Ithaca, N.Y.: Cornell University Press, 1992), on literature; Kenneth Frampton, *A Critical History of Modern Architecture* (New York: Oxford University Press, 1983); Irving Howe, ed., *The Idea of the Modern in Literature & the Arts* (New York: Horizon, 1967); Frederick R. Karl, *Modern and Modernism: The Sovereignty of the Artist, 1885–1925* (New York: Atheneum, 1988), chiefly literature; Hugh Kenner, *The Pound Era* (1971; Berkeley: University of California Press, 1973); Stephen Kern, *The Culture of Time and Space* (Cambridge: Harvard University Press, 1983), on art and technology; Morris Kline, *Mathematics, The Loss of Certainty* (New York: Oxford University Press, 1983); David Lodge, *Modernism, Antimodernism, and Postmodernism* (Birmingham, England: University of Birmingham Press, 1977); Sven Lövgren, *The Genesis of Modernism: Seurat, Gauguin, Van Gogh & French Symbolism in the 1880s,* 2d ed. (Bloomington: Indiana University Press, 1971); Peter Nicholls, *Modernisms, A Literary Guide* (Berkeley: University of California Press, 1995); Robert B. Pippin, *Modernism as a Philosophical Problem* (Cambridge, Mass.: Blackwell, 1991); Dorothy Ross, ed., *Modernist Impulses in the Human Sciences, 1870–1930* (Baltimore, Md.: Johns Hopkins University Press, 1994); Roger Shattuck, *The Banquet Years* (New York: Knopf, 1968), on art and literature; Paul C. Vitz and Arnold B. Glimcher, *Modern Art and Modern Science: The Parallel Analysis of Vision* (New York: Praeger, 1984); and John Weiss, ed., *The Origins of Modern Consciousness* (Detroit, Mich.: Wayne State University Press, 1965), on physics, poetry, philosophy, psychology, and history. European literary High Modernism was the subject of an eccentric attempt at rigorous definition in Douwe Fokkema and Elrud Ibsch, *Modernist Conjectures: A Mainstream in European Literature, 1910–1940* (London: C. Hurst, 1987). Selected English High Modernist writers are linked to philosophy in two good studies: Louis Menand, *Discovering Modernism: T. S. Eliot and His Context* (New York: Oxford University Press, 1987) and Sanford Schwartz, *The Matrix of Modernism: Pound, Eliot, and Early Twentieth Century Thought* (Princeton: Princeton University Press, 1985).

26. Ninety-two such makers are listed by Louis Untermeyer in *Makers of the Modern World* (New York: Simon and Schuster, 1955). Good general references

are *Encyclopedia of the 20th Century* (New York: Facts on File, 1993); Alan Bullock and R. B. Woodings, eds., *20th-Century Culture: A Biographical Companion* (New York: Harper, 1983); and Asa Briggs, ed., *A Dictionary of Twentieth-Century Biography* (New York: Oxford University Press, 1992). Also useful is Alastair Davies, *An Annotated Critical Bibliography of Modernism* (Totowa, N.J.: Barnes and Noble, 1982).

27. In a review of the new *Columbia Literary History of the United States,* Robert M. Adams took contributor Quentin Anderson to task for discussing "the emergence of modernism" in Emerson, Henry Adams, and Henry James as if it meant industrialism and its consequences. "One had thought Cubism, harmonic discords, discontinuity, fractured surfaces, symbolic distances, and overt sexuality had something to do with modernism as a style—but they are nowhere to be seen" (*New York Times Book Review,* 24 January 1988, 6).

28. Charles Sanders Peirce, "The Nineteenth Century: Notes" (probably a manuscript for *A Review of Leading Ideas of the Nineteenth Century,* volume 1 of 12 advertised in *Publisher's Weekly,* 20 January 1894), in *Charles S. Peirce, Selected Writings,* ed. Philip P. Wiener (New York: Dover, 1966), 261.

29. This argument is made more briefly in my article, "The Problem of Continuity and the Origins of Modernism: 1870–1913," *History of European Ideas 9,* no. 5 (1988), 531–52.

30. According to nonacademic historian Nicholas Lemann, writing for an audience of historians, "Narrative when done with skill feels true in some strangely automatic way. It is very close to being the basic means by which the human mind organizes experience. Therefore, it has enormous power to mislead" (Lemann, "History Solo: Non-Academic Historians," *American Historical Review* 100, no. 3 [June 1995], 797). It is up to the reader to judge if it has done so here, for the reader is in a better position to know than the writer.

31. "Semblable aux atomes d'Epicure, les idées s'accrochent comme elles peuvent, au hasard des rencontres, des chocs et des accidents." Remy de Gourmont, "La Dissociation des idées" (November 1899), in *La Culture des idées* (Paris: 10/18, 1983), 114.

TWO

1. Franz I and II in Arthur J. May, *The Habsburg Monarchy, 1867–1914* (New York: Norton, 1968), 22.

2. Said by a biographer of Otto Wagner, who founded modern architecture in Vienna. Quoted in Peter Vergo, *Art in Vienna, 1898–1918* (Ithaca, N.Y.: Cornell University Press, 1981), 114. As Robert Musil put it: "Kakania was, after all, a country for geniuses; which is probably what brought it to its ruin" (Musil, *The Man without Qualities,* vol. 1, trans. Sophie Wilkins and Burton Pike [New York: Alfred A. Knopf, 1995], 31).

3. J. Sydney Jones, *Hitler in Vienna, 1907–1913: Clues to the Future* (New York: Stein and Day, 1983).

4. Jeremy Bernstein summarizes Mach's view of particulate ontologies in "Ernst Mach and the Quarks," in Mach, *Popular Scientific Lectures* (La Salle, Ill.: Open Court, 1986). Mach-like views can be found in France in pioneer historian of science Pierre Duhem's *The Aim and Structure of Physical Theory* (1904–5,

1906; Princeton: Princeton University Press, 1991), and in England in William Kingdon Clifford's *The Common Sense of the Exact Sciences* (1885; New York: Alfred A. Knopf, 1946) and in his disciple Karl Pearson's *The Grammar of Science* (1892; New York: Meridian, 1957).

5. Emil DuBois-Reymond, "The Limits of Natural Science," speech given at the German Scientific Congress, Leipzig, 14 August 1872, and thereafter famous as the "Ignorabimus" speech. Published as "Über die Grenzen der Naturerkennens," *Vers. Deutscher Naturforscher und Ärzte* (1872), 85; trans. in *Popular Science Monthly* 5, no. 17 (1874).

6. Stefan Zweig, *The World of Yesterday,* ed. H. Zohn (Lincoln: University of Nebraska Press, 1964), 87–88.

7. Quoted in Siegfried Bernfeld, "Freud's Earliest Theories and the School of Helmholtz," *Psychoanalytic Quarterly* 13, no. 3 (1944), 348. All three were students of Johannes Müller.

8. Ludwig Boltzmann, "In Memory of Josef Loschmidt," quoted in Engelbert Broda, *Ludwig Boltzmann: Man, Physicist, Philosopher* (Woodbridge, Conn.: Ox Bow Press, 1983), 27.

9. Hugo von Hofmannsthal, "Ein Brief (Chandosbrief)," in Gotthart Wunberg, ed., *Die Wiener Moderne* (Stuttgart: Reclam, 1981), 431–44.

10. Hermann Bahr, "Das unrettbare Ich" (on Mach's *Analyse der Empfindungen,* 1886, 1899), in Wunberg, ed., *Wiener Moderne,* 147.

11. Bahr to Bertha Zuckerkandl in Paul Hofmann, *The Viennese: Splendor, Twilight, and Exile* (New York: Doubleday Anchor, 1989), 120.

12. This is one of the big reasons why writers in the Central European tradition always think of Modernism as having some close relationship to industrialization, social criticism, and socialism. Those in the French tradition hardly see the relationship at all.

13. For more on the contribution of the Black Cat and other cabarets to Modernism, see chapter 6.

14. Zweig, *World of Yesterday,* 72–76.

15. Gustav Ratzenhofer, *Wesen und Zweck der Politik: Als Teil der Sociologie und Grundlage der Staatswissenschaft,* 3 vols. (Leipzig: Brockhaus, 1893).

16. Carl Schorske, *Fin-de-Siècle Vienna* (New York: Knopf, 1982), 167. It was this book by Schorske that almost singlehandedly returned Vienna to the center of the history of Modernism's beginnings.

17. Mark Twain, "Stirring Times in Austria" (December 1897), in *The Complete Essays of Mark Twain,* ed. Charles Neider (Garden City, N.Y.: Doubleday, 1963), 209.

18. Ibid., 234.

19. "Something impractical cannot be beautiful." Otto Wagner, *Modern Architecture: A Guidebook for His Students to this Field of Art,* trans. Harry Francis Mallgrave (Santa Monica, Calif.: Getty Center, 1988), 82.

20. Twain, "Stirring Times in Austria," 211.

THREE

1. G. H. Hardy, *A Mathematician's Apology* (New York: Cambridge University Press, 1967), 119.

2. A superb review of this long debate can be found in Norman Kretzmann, ed., *Infinity and Continuity in Ancient and Medieval Thought* (Ithaca, N.Y.: Cornell University Press, 1982) and Richard Sorabji, *Time, Creation, and the Continuum: Theories in Antiquity and the Early Middle Ages* (Ithaca, N.Y.: Cornell University Press, 1985). This chapter is also much indebted to Morris Kline, *Mathematics, The Loss of Certainty* (New York: Oxford University Press, 1983), a magisterial essay on the failure of mathematics to substitute for religion in the twentieth century.

3. Morton Gabriel White, ed., *The Age of Analysis: 20th Century Philosophers* (New York: Mentor, 1955).

4. The leading historians of mathematics all focus on Weierstrass's arithmetization of analysis, but are not always sure what this function was and when it was first exhibited. C. H. Edwards, Jr. and Carl B. Boyer both give the date as 1861—see Edwards, *The Historical Development of the Calculus* (New York: Springer, 1979), and Boyer, *A History of Mathematics* (Princeton: Princeton University Press, 1985), 604. Morris Kline gives what seems to be the correct sequence: recorded by one of Weierstrass's students in 1861, it was reported by Weierstrass himself to the Berlin Academy in 1872, and then in 1874 to Paul DuBois-Reymond in a letter DuBois-Reymond published in 1875—see Kline, *Mathematical Thought from Ancient to Modern Times* (New York: Oxford University Press, 1972), 956. The function itself appears in simplified form in James R. Newman, ed., *The World of Mathematics*, vol. 3 (New York: Simon and Schuster, 1956), 1962–63. P. Dugac, the specialist in this bit of history, summarizes his work in *Richard Dedekind et les fondements des mathématiques* (Paris: J. Vrin, 1976).

5. Modest to a fault, Dedekind later attributed the idea to the ancient Greek mathematician, Eudoxus—see Stuart Hollingdale, *Makers of Mathematics* (New York: Pelican, 1989), 358.

6. Aristotle *Physics* 5.226b21; in Kretzmann, ed., *Infinity and Continuity,* 310.

7. Richard Dedekind, "Continuity and Irrational Numbers," in *Essays on the Theory of Numbers,* trans. W. W. Beman (New York: Dover, 1963), 3.

8. Joseph Dauben, *Georg Cantor, His Mathematics and Philosophy of the Infinite* (Princeton: Princeton University Press, 1990), 130, 131. This is the definitive biography of Cantor.

9. H. Eduard Heine (1821–1881), "Die Elemente der Functionlehre," *Crelle's Journal* 74 (1872). See discussions in Kline, *Mathematical Thought,* 953, 983; Carl B. Boyer, *History of the Calculus and Its Conceptual Development* (New York: Dover, 1959), 288; and Gregory Moore, *Zermelo's Axiom of Choice* (New York: Springer-Verlag, 1983), 14.

10. "According to my own memorandum [diary?] I passed this day in perfect health and enjoyed a very stimulating conversation on 'system and theory' with my luncheon guest and honored friend Georg Cantor of Halle" (quoted in Hollingdale, *Makers of Mathematics, 355*).

11. Cantor, "Über die Ausdehnung eines Satzes der Lehre den trigonometrischen Reihen" (On the extension of a theorem in the theory of trigonometric series), *Mathematische Annalen* 5 (1872).

12. Cantor to Dedekind, 29 June 1877, *Briefwechsel Cantor/Dedekind*, ed. Emmy Noether and Jean Cavaillès (Paris: Hermann, 1937), 34.

13. Hermann Grassmann, *Lehrbuch der Arithmetik für höhere Lehranstalten*, pt. 1 (Berlin: Enslin, 1861); Julius Baumann, *Die Lehren von Zeit, Raum und Mathematik* (Berlin, 1868); Hermann Hankel, *Untersuchungen über die unendlich oft oszillierenden und unstetigen Funktionen* (Tübingen: Fues's Verlag, 1870); Eduard Heine, "Die Elemente der Functionenlehre," *Crelle's Journal* 74 (1872), 172–88; H. C. R. Méray, "Remarques sur la nature des quantités définies . . . ," *Revue des Sociétés Savantes* 2, no. 4 (1869), 280–89; Johannes Thomae, *Elementäre Theorie der analytischen Functionen* (Leipzig: Teubner, 1877); Schlömilch, *Handbuch der algebraischen Analysis* (Stuttgart: F. Frommann, 1889); Rudolf Lipschitz, *Lehrbuch der Analysis*, vol. 1 (Bonn: Cohen und Söhne, 1877); Ernst Schröder, *Lehrbuch der Arithmetik und Algebra* (Leipzig, 1873); Eugen Dühring, *Kritische Geschichte der allgemeinen Principien der Mechanik*, 3d ed. (Leipzig, 1878).

14. Helmholtz, "Zahlen und Messen, erkenntnistheoretisch betrachtet," and Kronecker, "Über den Begriff der Zahl," in *Philosophische Aufsätze, Eduard Zeller zu seinem fünfzigjährigen Doktorjubiläum gewidmet* (Leipzig: Fues's Verlag, 1887).

15. Freyer, *Studien zur Metaphysik der Differentialrechnung* (Berlin, 1883); Axel Harnack, *Die Elemente der Differenzial- und Integralrechnung* (Leipzig, 1881); Moritz Pasch, *Einleitung in die Differential- und Integralrechnung* (Leipzig: Teubner, 1882); Paul DuBois-Reymond, *Die allgemeine Functionentheorie* (1882), French trans. by G. Milhaud and A. Girot (Nice: Imp. Niçoise, 1887); Otto Stolz, *Vorlesungen über allgemeine Arithmetik* (Leipzig: Teubner, 1885–86); Rodolfo Bettazzi, "Su una corrispondenza fra un gruppo di punti de un continuo ambedue lineari," *Annali di Matematichi* 16 (1888), 49; Salvatore Pincherle, "Saggio di una introduzione alla teoria delle funzioni analitiche secondo i principii del Prof. C. Weierstrass," *Giornale di Matematichi* 18 (1880), 178, 317; Charles S. Peirce, *The New Elements of Mathematics*, ed. C. Eisele (The Hague: Mouton, 1976), and "On the Logic of Number," *American Journal of Mathematics* 4 (1881), 85–95; H. Cohen, *Das Princip der Infinitesimal-Methode und seine Geschichte* (Frankfurt: Suhrkamp, 1968); Jules Tannery, "De l'infini mathématique," *Revue générale des sciences pures et appliquées* 8 (1897), 129–40; Paul Tannery, "Le Concept scientifique du continu: Zénon d'Elée et G. Cantor," *Revue philosophique* 20 (1885), 385–410; Julius Baumann, "Dedekind und Bolzano," *Annalen der Naturphilosophie* 7 (1908); R. Reiff, *Geschichte der unendlichen Reihen* (Tübingen, 1889); Joseph Bertrand (1822–1900), *Traité d'arithmétique* (Paris, 1849).

16. Nietzsche, *Beyond Good and Evil: Prelude to a Philosophy of the Future*, ed. and trans. Walter Kaufmann (New York: Vintage, 1989), 12.

17. A good introduction to the history of this ancient problem is Christoph J. Scriba's article, "Number," in *Dictionary of the History of Ideas* (New York: Scribner's, 1973), 3:399–406, based on the same author's *The Concept of Number* (Mannheim/Zurich: Bibliographischer Institut, 1968). See also Tobias Dantzig, *Number, The Language of Science*, 4th ed. (New York: Free Press, 1953).

18. Richard Dedekind, "The Nature and Meaning of Numbers," trans. W. W. Beman, in *Essays on the Theory of Numbers* (New York: Dover, 1963).

19. Giuseppe Peano, *Arithmetices Principia Nova Methoda Exposita*, in *Selected Works of Giuseppe Peano*, ed. and trans. H. C. Kennedy (London: Allen and Unwin, 1973), 101–34. Peano's prefatory credits were to Charles Peirce's "On the Algebra of Logic I," *American Journal of Mathematics* 3 (September 1880), Schröder's *Der Operationskreis des Logikcalcüls* (Leipzig: Teubner, 1877), Jevons's *The Principles of Science* (London, 1874, 1879, 1883), Boole's *Laws of Thought* (London, 1854), and MacColl's "Calculus of Equivalent Statements," *I Proceedings of the London Mathematical Society* 9 (1877), 9–20. He also mentioned his late discovery of Dedekind's *Was sind und was sollen die Zahlen.*

20. Peano, "Sur une courbe, qui remplit toute une aire plane" (On a curve which completely fills a planar region), in *Selected Works of Giuseppe Peano*, 143–49.

21. Gottlob Frege, *The Foundations of Arithmetic*, trans. J. Austin (Evanston, Ill.: Northwestern University Press, 1980), 26. The indispensable text on Frege's achievement is Michael Dummett, *Frege: Philosophy of Mathematics* (Cambridge: Harvard University Press, 1991).

22. Frege, *Begriffschrift*, trans. S. Bauer-Mengelberg, in *From Frege to Gödel*, ed. J. van Heijenoort (Cambridge: Harvard University Press, 1967), 5.

23. Ibid., 7.

24. Frege, "Views of certain writers on the concept of number" and "Views on unity and one," sections 2 and 3 of *The Foundations of Arithmetic*, 24–67. The books criticized include John Stuart Mill's *System of Logic* (1843), Lipschitz's *Lehrbuch der Analysis*, vol. 1 (Bonn, 1877), Thomae's *Elementare Theorie der analytischen Funktionen* (1877), Hankel's *Vorlesungen über die complexen Zahlen und ihren Functionen*, vol. 1 (1867), Schröder's *Lehrbuch der Arithmetik und Algebra* (Leipzig, 1873), William Stanley Jevons's *The Principles of Science* (London, 1879), and Boole's *Mathematical Analysis of Logic* (1847).

25. Frege, *The Foundations of Arithmetic*, 79–80; Russell, *Introduction to Mathematical Philosophy* (1919; New York: Dover, 1993), 18.

26. Frege, review of *Zur Lehre vom Transfiniten*, by Georg Cantor, *Zeitschrift für Philosophie und philosophische Kritik* 100 (1892); in Dauben, *Cantor*, 225. In this review, Frege also claimed intellectual priority on the definitions of set and natural number, and coined the name "Dedekind-infinity" for what Dedekind had defined in *Was sind und was sollen die Zahlen*, sec. 5, prop. 64. Positivist epistemology, he agreed, was "incompatible" with the arithmetic infinite (in Dauben, 181).

27. Frege, *The Foundations of Arithmetic*, 98.

28. Frege, *The Basic Laws of Arithmetic*, trans. M. Furth (Berkeley: University of California Press, 1964).

29. Peano, "Sul concetto di numero" (On the concept of number) in G. Peano, ed., *Rivista di Mathematica I* (1891), 87–102, 256–67.

30. Edmund Husserl, *On the Concept of Number*, trans. D. Willard, in Husserl, *Shorter Works* (Notre Dame, Ind.: University of Notre Dame Press, 1981), and *Philosophie de l'arithmétique*, trans. J. English (Paris: Presses Universitaires, 1972). On the subject of Husserl's mathematics see J. Philip Miller, *Numbers in Presence and Absence: A Study of Husserl's Philosophy of Mathematics* (Boston: Nijhoff, 1982); J. N. Mohanty, *Husserl and Frege* (Bloomington: Indiana University Press, 1985); Giorgio Scrimieri, *La matematica nel pensiero giovanile di E.*

Husserl (Bari, 1965); Robert S. Tragesser, *Husserl and Realism in Logic and Mathematics* (Cambridge: Cambridge University Press, 1984); Richard Tieszen, "Mathematics," in Barry Smith and David Woodruff Smith, eds., *The Cambridge Companion to Husserl* (New York: Cambridge University Press, 1995); and especially Dallas Willard, *Logic and the Objectivity of Knowledge: Studies in Husserl's Early Philosophy* (Athens: Ohio University Press, 1984).

31. Husserl, *On the Concept of Number*, 98, 112.

32. Ibid., 97, 99, 113.

33. Frege to Husserl, 24 May 1891, in *Philosophical and Mathematical Correspondence*, ed. G. Gabriel et al., trans. H. Kaal (Chicago: University of Chicago Press, 1980), 61; and Frege, "Dr. E. G. Husserl: Philosophie der Arithmetik," *Zeitschrift für Philosophie und philosophische Kritik* 103 (1894), 22–41; trans. in Frege, *Collected Papers on Mathematics, Logic, and Philosophy*, ed. Brian McGuinness (Oxford: Basil Blackwell, 1984), 209.

FOUR

1. James Clerk Maxwell pointed the way a little earlier, but he remained the ultimate field theorist.

2. Ludwig Boltzmann, "Weitere Studien über die Wärmegleichgewicht unter Gasmolekülen," *Wiener Berichte* 2, no. 66 (1872), 275–370.

3. Boltzmann, *Gesamtausgabe*, ed. Roman U. Sexl, vol. 8 of *Internationale Tagung Anlässlich des 75. Jahrestages seines Todes 5.–8. September 1981 Ausgewählte Abhandlungen*, ed. Roman U. Sexl and John Blackmore (Brunswick: Vieweg, 1982), 2.

4. George Greenstein, "Ludwig Boltzmann," *American Scholar* (winter 1991), 99.

5. Boltzmann, "On a Thesis of Schopenhauer." Boltzmann writes that he wanted to call it "Proof that Schopenhauer Was a Degenerate, Unthinking, Unknowing, Nonsense-Scribbling Philosopher, Whose Understanding Consisted Solely of Empty Verbal Trash." It called Schopenhauer's writings an "unclear, thoughtless mass of words," and was not much kinder to Hegel's. Boltzmann, *Populäre Schriften* (Leipzig, 1905), #22; as translated in Engelbert Broda, *Ludwig Boltzmann: Man, Physicist, Philosopher* (Woodbridge, Conn.: Ox Bow Press, 1983), 29. Cf. Boltzmann, *Theoretical Physics and Philosophical Problems*, trans. Paul Foulkes, ed. Brian McGuinness (Dordrecht: D. Reidel, 1974), 184; Broda, *Ludwig Boltzmann*, 28.

6. Broda, *Ludwig Boltzmann*, 57; McGuinness, ed., *Theoretical Physics*, 79.

7. Boltzmann, "On the Methods of Theoretical Physics" (1892), in McGuinness, ed., *Theoretical Physics*, 6.

8. Boltzmann, "Studien über das Wärmegleichgewicht der lebendigen Kraft zwischen bewegten materiellen Punkten," *Wiener Berichte* 58 (1868), 517–60.

9. This is called "Avogadro's Number" after Amedeo Avogadro, who had shown it must be the same for a molar quantity of any gas at the same temperature, but had had no way of knowing what its value was. Loschmidt had given the actual figure as 0.5×10^{19} molecules for the slightly different quantity of a cubic centimeter in a paper titled "Zur Grösse der Luftmolecüle" (On the size of air molecules).

10. Boltzmann, "Analytischer Beweis des zweiten Hauptsatzes der mechanischen Wärmetheorie aus den Sätzen über das Gleichgewicht der lebendigen Kraft" (1871) and "Zusammenhang zwischen den Sätzen über das Verhalten mehratomiger Gasmoleküle mit Jacobis Princip des letzten Multiplicators" (The relationship between the laws of polyatomic gas molecules and Jacobi's principle of the last multiplier), *Sitzungsberichte der Wiener Akademie* 63, no. 2 (1871), 679. Gibbs singled this out in 1902 as the first paper using ensembles of systems, phase distributions of ensembles, and distribution change over time. Josiah Willard Gibbs, *Elementary Principles in Statistical Mechanics* (Woodbridge, Conn.: Ox Bow Press, 1981), vi.

11. The most comprehensive and reliable work on Boltzmann and the other pioneers of thermodynamics and statistical physics is Stephen G. Brush, *The Kind of Motion We Call Heat,* 2 vols. (New York: North-Holland, 1986). R. Dugas examined some of these questions in *La Théorie physique au sens de Boltzmann* (Neuchatel: Griffon, 1959).

12. Now called enthalpy. I owe this and other points to my physics colleagues, Michael McGarry and Paul Siegel.

13. "mein liebes dickes Schatzerl."

14. Boltzmann, "Bemerkungen über einige Probleme der mechanischen Wärmetheorie," *Wiener Berichte* 2, no. 75 (11 January 1877), 62–100; in Boltzmann, *Wissenschaftliche Abhandlungen,* vol. 2, ed. Fritz Hasenöhrl (Leipzig, 1909).

15. Stephen G. Brush, *The Temperature of History: Phases of Science and Culture in the Nineteenth Century* (New York: Burt Franklin, 1978), 67.

16. Quoted in Broda, *Ludwig Boltzmann,* 69.

17. Thomas S. Kuhn, *Black Body Theory and the Quantum Discontinuity, 1894–1912* (Chicago: University of Chicago Press, 1987), 38–41.

18. Maxwell wrote something similar about entropy that year, in his article for the *Encyclopedia Britannica* on "Diffusion." "Now, confusion, like the correlative term order, is not a property of material things in themselves, but only in relation to the mind that perceives them. . . . It is only to a being in the intermediate stage, who can lay hold of some forms of energy while others elude his grasp, that energy appears to be passing from the available to the dissipated state." James Clerk Maxwell, *Scientific Papers,* ed. W. D. Niven (Cambridge: Cambridge University Press, 1890), 2:646; in Theodore M. Porter, *The Rise of Statistical Thinking, 1820–1900* (Princeton: Princeton University Press, 1986), 201.

19. Boltzmann, "Über die Beziehung zwischen dem zweiten Hauptsatze der mechanischen Wärmetheorie und der Wahrscheinlichkeitsrechnung respektive den Sätzen über das Wärmegleichgewicht," *Wiener Berichte* 2, no. 76 (1877), 373–435.

20. Boltzmann, "Weitere Bemerkungen über einige Probleme der mechanischen Wärmetheorie," *Wiener Berichte* 2, no. 78 (6 June 1878), 7–46.

21. James Clerk Maxwell, "On Boltzmann's Theorem on the Average Distribution of Energy in a System of Material Points," *Transactions of the Cambridge Philosophical Society* 12 (1871–79), 547–70.

22. I am grateful to a tenth-grade student, Adam Stofsky, for asking me whether, if the universe were temporally infinite, it might not therefore contain every possible event several times over. The first person to point out the links between Boltzmann and Nietzsche was Stephen G. Brush (*The Temperature of*

History, 67, 73–76). Nietzsche's source in physics for his doctrine of eternal return appears to be Vogt's *Die Kraft* (Force), published in 1878, but see Paolo D'Iorio, "Cosmologie de l'éternel retour," *Nietzsche Studien* 24 (1995), 62–123.

23. Ernst Zermelo, "Über einen Satz der Dynamik und die mechanische Wärmetheorie," *Annalen der Physik (Wiedemanns Annalen)* 57 (1896), 485–94 (the Recurrence objection) and "Beweis, das jede Menge Wohlgeordnet werden kann" (Proof that every set can be well-ordered), *Mathematische Annalen* 59 (1904), 514–16, trans. Stefan Bauer-Mengelberg in Heijenoort, *From Frege to Gödel,* 139–41 (The Axiom of Choice). Henri Poincaré, "Sur le problème des trois corps et les équations de la dynamique," *Acta Mathematica* 13 (1890), 67. In 1899 Poincaré's third volume of *New Methods of Celestial Mechanics* followed up his paper by offering a proof that in the celebrated three-body problem of gravitation there existed no exact solution in functions of time, and that all series solutions were divergent. In other words, there was no way of telling exactly where Mars and Jupiter would end up (Poincaré, *Méthodes nouvelles de la mécanique céleste,* vol. 3 [1899; New York: Dover, 1957], 389). The best account of these discoveries appears in Ivar Ekeland, *Mathematics and the Unexpected* (Chicago: University of Chicago Press, 1988), 26–48.

24. Boltzmann, "On Certain Questions of the Theory of Gases," *Nature* 51, no. 413 (1895), and "Zu Herrn Zermelos Abhandlung 'Über die mechanische Erklärung irreversibler Vorgänge'" (On Mr. Zermelo's paper 'On the mechanical explanation of irreversible processes'"), *Annalen der Physik* 60 (1897).

25. Broda, *Ludwig Boltzmann,* 87.

26. Ibid., 46.

27. See L. Flamm's article in *Studies in History and Philosophy of Science* 14, no. 267 (1983) on Boltzmann's sewing, and Boltzmann's paper "On aeronautics."

28. Boltzmann, "Über die Unentbehrlichkeit [Indispensability] der Atomistik in der Naturwissenschaft," *Wiedemanns Annalen der Physik und Chemie* 60 (1897), 231; *Populäre Schriften* #10 in McGuinness, ed., *Theoretical Physics and Physical Problems,* 42–43.

29. Boltzmann, "More on Atomism," *Ann. der Phys. und Chemie* 61 (1897), 20; *Populäre Schriften* #11 in McGuinness, ed., *Theoretical Physics and Physical Problems,* 55.

30. Boltzmann, *Vorlesungen über die Principe der Mechanik* (Leipzig: Barth, 1897), 1:26; trans. in Broda, *Ludwig Boltzmann,* 48.

31. Arnold Sommerfeld described the scene in *Wiener Chemische Zeitung* 47 (1944), 25. The story is retold in Abraham Pais, *"Subtle is the Lord . . .": The Science and the Life of Albert Einstein* (New York: Oxford University Press, 1983), 83. Cf. Erwin N. Hiebert, "The Energetics Controversy and the New Thermodynamics," in Duane H. D. Roller, ed., *Perspectives in the History of Science and Technology* (Norman: University of Oklahoma Press, 1971).

32. Boltzmann, *Vorlesungen über Gastheorie II* (Leipzig: Barth, 1898), 85.

33. Boltzmann, "Über die Entwicklung der Methoden der theoretischen Physik in neuerer Zeit" (On the development of the methods of theoretical physics in recent times), in McGuinness, ed., *Theoretical Physics and Physical Problems,* 82.

34. Broda, *Ludwig Boltzmann,* 57.

35. Boltzmann, "On Some of My Less Known Papers on Gas Theory, etc.,"

lecture to Brunswick Naturalforscher conference, 1897; in Broda, *Ludwig Boltzmann,* 43.

36. Ibid., 79.

37. Muriel Rukeyser, *Willard Gibbs* (Woodbridge, Conn.: Ox Bow Press, 1988), 150–63.

38. Albert Einstein (Milan) to Mileva Maric, 13 September 1900, in *Albert Einstein, Collected Papers, Vol. 1, 1879–1902,* ed. John Stachel, trans. Anna Beck (Princeton: Princeton University Press, 1987), 149.

39. Einstein to Maric, 10 September 1900, in *Einstein, Collected Papers,* 1:133.

40. Einstein to Marcel Grossman, 6 September 1901, in *Einstein, Collected Papers,* 1:181.

41. Boltzmann, "Inaugural Lecture," Vienna, October 1902, in Broda, *Ludwig Boltzmann,* 14.

42. Boltzmann, lecture at the University of Vienna, 26 October 1903, in *Principien der Naturfilosofi/Lectures on Natural Philosophy, 1903–1906,* ed. Ilse M. Fasol (New York: Springer, 1990).

43. Boltzmann, *Principien der Naturfilosofi,* lecture #1, 78; trans. in Jeremy Bernstein, ed., *Mach, The Science of Mechanics* (Peru, Ill.: Open Court, 1989), xiv.

44. Boltzmann, "On a Thesis of Schopenhauer," *Populäre Schriften* #22, in McGuinness, ed., *Theoretical Physics,* 197.

45. Peter Coveney and Roger Highfield, *The Arrow of Time* (New York: Ballantine Books, 1991), 21.

FIVE

1. Seurat, *Angler* (Courtauld Collection).

2. Charles Angrand to Gustave Coquiot, in Norma Broude, ed., *Seurat in Perspective* (Englewood Cliffs, N.J.: Prentice-Hall, 1978), 34.

3. Edmond Aman-Jean to Gustave Coquiot, in Broude, ed., *Seurat in Perspective,* 34.

4. Charles Angrand to Gustave Coquiot, in Broude, ed., *Seurat in Perspective,* 35

5. Paul Signac, "D'Eugène Delacroix au Néo-impressionisme," *La Revue blanche* (May–July 1898).

6. Gustave Kahn, "Chronique de la littérature et de l'art: Exposition Puvis de Chavannes," *La Revue indépendante* 6 (6 January 1888), 142–46.

7. Seurat also found arguments for classic harmony and antimaterialism in the writings of a forgotten critic, David Sutter. Cf. Sutter, *Philosophie des beaux-arts appliquée à la peinture,* 2d ed. (n.p., 1870).

8. An early noticer of this structure was Guy Eglinton, whose article "The Theory of Seurat" (*International Studies* 81 [1925]) is credited by Daniel Catton Rich in his book, *Seurat and the Evolution of* La Grande Jatte (New York: Greenwood Press, 1969), 25.

9. The study is owned by the Metropolitan Museum of Art, which X-rayed it in 1990 and located the lines of division.

10. In 1935, critic Meyer Schapiro finally did notice. He seems to have been the first. Schapiro, "Seurat and *La Grande Jatte*," *The Columbia Review* 17 (November 1935), 9–16.

11. It is now called *Bar at the Folies-Bergère,* version 2 (Courtauld Institute), and was begun in 1879.

12. Though Cézanne seems to have made no still lifes at all in 1884.

13. Seurat, *Le peintre au travail* (Philadelphia Museum of Art)

14. Fénéon to Jeanès, 1944, in Joan Ungersma Halperin, *Félix Fénéon: Aesthete and Anarchist in Fin-de-Siècle Paris* (New Haven, Conn.: Yale University Press, 1988), 43.

15. Michel-Eugène Chevreul, *De la Loi du contraste simultané des couleurs* (Paris: Pitios-Levrault, 1839).

16. William Innes Homer, *Seurat and the Science of Painting* (Cambridge: MIT Press, 1964), 279–80.

17. Ogden N. Rood, *Modern Chromatics, with Applications to Art and Industry* (New York: Appleton, 1879), quoted in Homer, *Seurat and the Science of Painting,* 279–80.

18. Hermann von Helmholtz, *Handbuch der physiologischen Optik* (Leipzig: Voss, 1867), English trans. *Helmholtz's Treatise on Physiological Optics,* 2 vols. (Washington, D.C.: Optical Society of America, 1924); and Ernst Brücke, *Die Physiologie der Farben für die Zwecke der Kunstgewerbe* (Leipzig, 1866). In 1881 Brück also published a book on how movement was shown in the visual arts: *Die Darstellung der Bewegung durch die bildenden Künste.* This was the same Brücke who taught Freud neuroanatomy (see chapter 9).

19. As Charles Angrand remembered it, Seurat "never missed" a meeting, but that may have been later, after the Society had survived its rocky beginnings. Angrand to Coquiot, in Broude, ed., *Seurat in Perspective,* 35.

20. John Russell, *Seurat* (London: Thames and Hudson, 1985), 170.

21. Félix Fénéon, "VIIIe Exposition impressioniste," in Fénéon, *Oeuvres-plus-que-complètes,* ed. J. U. Halperin (Geneva: Droz, 1970), 1:35; trans. in Halperin, *Félix Fénéon,* 81. The article was reworked by Fénéon as "Les impressionistes en 1886," trans. Linda Nochlin in Broude, ed., *Seurat in Perspective,* 37.

22. Norma Broude, "New Light on Seurat's 'Dot': Its Relation to Photo-Mechanical Color Printing in France in the 1880's," in Broude, ed., *Seurat in Perspective,* 163–75.

23. Broude, ed., *Seurat in Perspective,* 38.

24. Ibid., 38.

25. Ibid., 37; and Russell, *Seurat,* 181.

26. J. Carson Webster, "The Technique of Impressionism: A Reappraisal," in Broude, ed., *Seurat in Perspective,* 99.

27. Fénéon, "Calendrier de septembre," in *Oeuvres-plus-que-complètes,* 1:116; trans. in Halperin, *Félix Fénéon,* 101.

28. Vincent van Gogh to Theo van Gogh, 3 June 1888, in Russell, *Seurat,* 408. John Rewald gives the date as 1887: "the leader of the Petit Boulevard is undoubtedly Seurat." Rewald, *Seurat* (New York: Abrams, 1990), 44.

29. Now in the Josefowitz Collection.

30. In the long controversy over the date of this manuscript, first published in

1910, I offer Goldwater's 1885 rather than Rewald's 1888. Cf. Robert Goldwater, *Symbolism* (New York: Harper, 1979) and Rewald, *Seurat*.

31. Gauguin to Emile Shuffenecker, 14 January 1885, in Herschel B. Chipp, ed., *Theories of Modern Art: A Source Book by Artists and Critics* (Berkeley: University of California Press, 1968), 59.

32. Paul Gauguin, "Notes synthétiques," in *The Writings of a Savage*, ed. Daniel Guérin (1974), trans. E. Levieux (New York: Paragon House, 1990), 9–10.

33. Van Gogh also had a part in this development. See Bogomila Welsh-Ovcharov, *Vincent van Gogh and the Birth of Cloisonism* (Toronto: Art Gallery of Ontario, 1981).

34. One of the first big exhibits of Japanese prints was at the Siegfried Bing gallery in Paris in June and July 1888. Reviewing it for the second *Revue indépendante* was the indispensable Félix Fénéon (*Oeuvres-plus-que-complètes*, 1:113–14). He reviewed the poster artists too, for *Le Chat noir* in April 1891, and appeared in several posters himself (*Oeuvres-plus-que-complètes*, 1:187–88).

35. "What role does nature play. . . . In decorative art, none or almost none. . . . In that art, color becomes essentially musical." Paul Gauguin, "On Decorative Art," in *The Writings of a Savage*, 12.

36. Fénéon picked this event up too, in his review of the Café des arts Volpini exhibition in 1889: "The methods of the spot-makers . . . were, toward 1886, abandoned. . . . Monsieur Gauguin was trying for an analogous goal, but with different methods. . . . He . . . questions the lines [of reality] and in each one of the spacious cantons that are formed by their interlakes, an opulent and heavy color swells mournfully without attacking the neighboring colors, without clouding itself." Fénéon, "Un autre groupe impressioniste," in *Oeuvres-plus-que-complètes*, 1:157–58, my translation.

37. Goldwater, *Symbolism*, 2.

38. Monet described his *Haystacks* series to Gustave Geoffroy in this way, probably in 1891.

39. Fénéon, *Oeuvres-plus-que-complètes*, 1:41–42. Monet's series paintings of the poplar trees along the Epte and of the haystacks (wheatstacks) were made in 1891, those of Rouen Cathedral in 1892.

40. Gustave Kahn, "Seurat," in Broude, ed., *Seurat in Perspective*, 21.

41. Seurat to Maurice Beaubourg, 20 August 1890, in Broude, ed., *Seurat in Perspective*, 18.

42. Conrad to Marguerite Poradowska, 2 July 1891, in *Lettres de Joseph Conrad à Marguerite Poradowska*, ed. René Rapin (Geneva: Droz, 1966), 87; quoted in Zdzisław Najder, *Joseph Conrad: A Chronicle* (New Brunswick, N.J.: Rutgers University Press, 1984), 147.

43. Pierre-Louis [Maurice Denis], "Défense (Définition) du néo-traditionnisme," *Art et critique*, 23 and 30 August 1890; trans. in Chipp, ed., *Theories of Modern Art*, 94.

SIX

1. Ezra Pound, *Poetry*, 1913. Spanish literary histories claim that *Modernismo* is a word first applied to literature by Spanish and Hispanic-American writers in the late 1890s; but this Modernismo essentially applies to a set of styles

learned from French Decadents and symbolists like Verlaine. For the Russians, the story is that Modernist poetry appeared in the same prewar decade as English Modernism, created by two brilliant women, Akhmatova and Tsvetaeva, and their friends Khlebnikov, Mayakovsky, Mandelstam, Blok, and Pasternak. They, too, however, had learned from Whitman and the French.

2. Seurat would be at the school the following academic year. It appears the two geniuses were never to meet, no matter how many times their paths would cross.

3. Jules Laforgue, *Mélanges posthumes,* ed. Philippe Bonnefis (Paris: Mercure de France, 1903), 7; trans. David Arkell, *Looking for Laforgue* (Manchester: Carcanet, 1979), 39.

4. Laforgue to Mme Mültzer (Sanda Mahali), March 1882, in Laforgue, *Oeuvres complètes, vol. 1, 1860–1883* (Lausanne: L'Age d'Homme, 1986), 763.

5. "'Ce bouffon de génie,' a dit Schopenhauer / Qui sanglote et sourit, mais d'un sourire amer." In Arkell, *Looking for Laforgue,* 38.

6. Ibid.

7. Paul Bourget, in *Le Siècle littéraire* 1 (April 1876).

8. Laforgue to Mme Mültzer, 12 or 19 September 1882, in *Oeuvres complètes,* 801.

9. "Kahn has sent me a beautiful play singular in its execution because of the *sans-gêne* of its rhymes." Laforgue to Henry, 13 October 1882, in *Oeuvres complètes,* 803.

10. Cros, "En Cour d'assises" (Court of sessions), first published in *Le Chat noir* 234 (3 July 1886); in Cros, *Oeuvres complètes* (Paris: J. S. Pauvert in association with Club français du livre, 1964), 50.

11. Herewith the complete text of the poem, which appeared in *La Renaissance littéraire et artistique* (25 May 1872); collected in Cros, *Le Coffret de santal* (Paris, 1873, 1879), *Saynètes et monologues,* 3d ser. (Paris: Tresse, 1878), and Cros, *Oeuvres complètes,* 107–8. George Moore describes the poem and gives its first English translation (reproduced here) in *Memoirs of My Dead Life* (New York: Boni and Liveright, 1920), 99, 103.

LE HARENG SAUR (THE KIPPERED HERRING)

Il était un grand mur blanc—nu, nu, nu,
Contre le mur une échelle—haute, haute, haute,
Et, par terre, un hareng saur—sec, sec, sec.

Il vient, tenant dans ses mains—sales, sales, sales,
Un marteau lourd, un grand clou—pointu, pointu, pointu,
Un peloton de ficelle—gros, gros, gros.

Alors il monte à l'échelle—haute, haute, haute,
Et plante le clou pointu—toc, toc, toc,
Tout en haut du grand mur blanc—nu, nu, nu.

Il laisse aller le marteau—qui tombe, qui tombe, qui tombe,
Attache au clou la ficelle—longue, longue, longue,
Et, au bout, le hareng saur—sec, sec, sec.

Il redescend de l'échelle—haute, haute, haute,
L'emporte avec le marteau—lourd, lourd, lourd:
Et puis, s'en va ailleurs—loin, loin, loin.

Et depuis, le hareng saur—sec, sec, sec,
Au bout de cette ficelle—longue, longue, longue,
Très lentement se balance—toujours, toujours, toujours.

J'ai composé cette histoire—simple, simple, simple,
Pour mettre en fureur les gens—graves, graves, graves,
Et amuser les enfants—petits, petits, petits.

There was a great white wall—bare, bare, bare,
Against the wall a ladder—high, high, high,
And below, a kippered herring—dry, dry, dry.

He comes, holding in hands—dirty, dirty, dirty,
A heavy hammer, a nail—pointed, pointed, pointed,
A ball of kitchen twine—fat, fat, fat.

And so he climbs the ladder—high, high, high,
And drives the pointed nail—toc, toc, toc,
Way up on the big white wall—bare, bare, bare.

He lets go of the hammer—which falls, which falls, which falls,
Hangs on the nail the twine—long, long, long,
And attaches the kippered herring—dry, dry, dry.

He comes down off the ladder—high, high, high,
Takes it away with the hammer—heavy, heavy, heavy,
And then goes off somewhere else—far, far, far.

And since then the kippered herring—dry, dry, dry,
At the end of the length of twine—long, long, long,
Slowly swings back and forth—still, still, still.

I composed this simple story—simple, simple, simple,
To infuriate serious people—solemn, solemn, solemn,
And entertain little children—small, small, small.

12. Ernest Coquelin, *Le Monologue moderne* (Paris: Ollendorff, 1881), 11, 14.

13. For more on the extraordinary centrality of the monologue in the birth of Modernism, see Randall Knoper, *Acting Naturally: Mark Twain in the Culture of Performance* (Berkeley: University of California Press, 1995), and my own "Monologues of the Mad: Paris Cabaret and Modernist Narrative from Twain to Eliot," *Studies in American Fiction* 20, no. 2 (December 1992).

14. Cros, "Autrefois," in *Oeuvres complètes*, 261, my translation. Cros's twenty-odd surviving monologues are all collected in this edition. It is worth remembering, with Joyce in the wings, that the French for stream-of-consciousness is *monologue intérieur.*

15. The Chat Noir, cradle of artistic Modernism, has recently been the subject of strong interest from scholars of every art. Three American exhibitions have

shown the cabaret off at its avant-garde best: Armond Fields, ed., *Le Chat Noir: A Montmartre Cabaret and Its Artists in Turn-of-the-Century Paris,* Exhibit catalog, Santa Barbara Museum of Art (Seattle: University of Washington Press, 1994); Phillip Dennis Cate and Mary Shaw, eds., *The Spirit of Montmartre: Cabarets, Humor and the Avant-Garde, 1875–1905,* Exhibit catalog (New Brunswick, N.J.: Jane Voorhees Zimmerli Museum, Rutgers University, 1996); and Phillip Dennis Cate and Patricia Eckert Boyer, eds., *The Circle of Toulouse-Lautrec: An Exhibition of the Work of the Artist and of His Close Associates,* Exhibit catalog (New Brunswick, N.J.: Jane Voorhees Zimmerli Museum, Rutgers University, 1986). See also Lisa Appignanesi, *The Cabaret* (New York, 1976); L. Richard, *Cabaret, cabarets. Origines et décadence* (Paris: Plon, 1991); Harold B. Segel, *Turn-of-the-Century Cabaret: Paris, Barcelona, Berlin, Munich, Vienna, Cracow, Moscow, St. Petersburg, Zurich* (New York: Columbia University Press, 1987); and my own "Monologues of the Mad: Paris Cabaret and Modernist Narrative from Twain to Eliot," *Studies in American Fiction* 20, no. 2 (December 1992).

16. *La Vie moderne* 36 (3 September 1881); in Laforgue, *Oeuvres complètes,* 245.

17. Laforgue to Sanda Mahali, 19 or 26 August 1882, in *Oeuvres complètes,* 798. On Modernism's Pierrot see Martin Green and John Swan, *The Triumph of Pierrot: Commedia dell'arte in the Imagination of Modernism* (New York: Macmillan, 1986).

18. Laforgue, "Complaint on the Oblivion of the Dead," trans. William Jay Smith, in *Selected Writings of Jules Laforgue* (New York: Grove Press, 1956), 36.

19. Laforgue to Ephrussi, 24 December 1882, in *Oeuvres complètes,* 813.

20. Verlaine, "L'Art poétique," *Paris-Moderne,* 10 November 1882.

21. Though perhaps not better, thirty years later, than Robert Frost, who wrote famously in 1913, "But if one is to be a poet he must learn to get cadences by skillfully breaking the sounds of sense with all their irregularity of accent across the regular beat of the metre." (Frost to John Bartlett, 4 July 1913, in Lawrance Thompson, *Robert Frost* [New York: Holt, Rinehart and Winston, 1982], 1:419). And Yeats, who wrote to his father that same summer, "I have tried to make my work convincing with a speech so natural and dramatic that the hearer would feel the presence of a man thinking and feeling" (David Perkins, *A History of Modern Poetry* [Cambridge: Harvard University Press, 1976], 577).

22. Laforgue, "Complaint of Lord Pierrot," trans. William Jay Smith, in *Selected Writings of Jules Laforgue,* 30–31.

23. Laforgue to Marie Laforgue, 14 May 1883, in *Oeuvres complètes,* 821, my translation.

24. Laforgue, "Agenda," 25 May 1883, in *Oeuvres complètes,* 880.

25. Arthur Rimbaud, "Voyelles," *Lutèce,* 5–12 October 1883.

26. Rimbaud, "Voyelles," trans. Paul Schmidt, in Arthur Rimbaud, *Complete Works* (New York: Harper Perennial, 1975), 123. The original French (from *Oeuvres complètes* [Paris: Pléiade, 1972], 53:

<div align="center">

VOYELLES

A noir, E blanc, I rouge, U vert, O bleu: voyelles,
Je dirai quelque jour vos naissances latentes:

</div>

A, noir corset velu des mouches éclatantes
Qui bombinent autour des puanteurs cruelles,

Golfes d'ombre; E, candeurs des vapeurs et des tentes,
Lances des glaciers fiers, rois blancs, frissons d'ombelles;
I, pourpres, sang craché, rire des lèvres belles
Dans la colère ou les ivresses pénitentes;

U, cycles, vibrements divins des mers virides,
Paix des pâtis semés d'animaux, paix des rides
Que l'alchimie imprime aux grands fronts studieux;

O, suprême Clairon plein des strideurs étranges,
Silences traversés des Mondes et des Anges:
—O l'Oméga, rayon violet de Ses Yeux!

27. "[N]o single work has had more influence in the history of modern litera-ture than the *Illuminations*. . . . Rimbaud discovered language in its autonomous (dis)functioning, freed from its obligations to express and to represent. . . ." Tzvetan Todorov, "Une Complication de texte: les *Illuminations*," *Poétique* 34 (April 1978); trans. in Marjorie Perloff, *The Poetics of Indeterminacy: Rimbaud to Cage* (Evanston, Ill.: Northwestern University Press, 1983), 3.

28. Rimbaud, "Promontoire," in *Oeuvres complètes*, 149.

29. Rimbaud, "Après le déluge," in *Oeuvres complètes*, 121–22.

30. Whitman, "Salut au Monde!" in *Poetry and Prose* (New York: Library of America, 1982), 307.

31. "On n'est pas sérieux, quand on a dix-sept ans." Rimbaud, "Roman," in *Oeuvres complètes*, 29.

32. Perloff, *Poetics of Indeterminacy*, 4. In a note, Perloff credits "undecid-ability" to Tzvetan Todorov, *Symbolisme et interprétation* (Paris: Seuil, 1978), 82; but the term in fact belongs to mathematics from David Hilbert (1900) to Kurt Gödel (1931). See chapters 3 and 22.

33. Rimbaud, "Mouvement," in *Oeuvres complètes*, 152; trans. Louise Varèse, in *Illuminations* (New York: New Directions, 1957), 116–19.

34. "Moi, je rêve de la poésie qui ne dise rien, mais soit des bouts de rêverie sans suite. Quand on veut dire, exposer, démontrer quelque chose, il y a la prose." Laforgue to Mme Mültzer (Sanda Mahali), 18 July 1882, in *Oeuvres complètes*, 792.

35. Laforgue, *Oeuvres* (Paris: Mercure de France, 1902), 2:129; my transla-tion, emphasis in original.

36. Indeed, back in June 1883 he had criticized Marie Krysinska's "Le Hi-bou" (The owl), an early free verse poem published in *La Vie moderne* (26 May 1883), for having unmatched syllable counts. Laforgue to Charles Henry, 7 or 8 June 1883, in *Oeuvres complètes*, 824.

37. Laforgue, "Dédicaces: Traduit de l'étonnant poète américain Walt Whit-man," *La Vogue* 1, no. 10 (1886), 325.

38. Whitman, *Poetry and Prose*, 175.

39. Kahn, "Intermède," *La Vogue* 1, no. 10 (1886), 335.

40. Whitman, "Europe, the 72d and 73d Years of These States" (1850), "France: The 18th Year of these States," and "O Star of France," in *Poetry and Prose*, 406, 377, 519.

41. "I have never had the common Puritan ideas about France," said Whitman to Traubel in 1888. Horace Traubel, *With Walt Whitman in Camden* (Boston, 1906), 1:461.

42. "Mme Blanc" [Thérèse Bentzon], "Les poètes américains," *Revue des deux mondes*, 1 June 1872.

43. Emile Blémont, "La Poésie en Angleterre et aux Etats-Unis," parts 1–3, *Renaissance artistique et littéraire* 7 (8 June 1872); 11 (1872); 12 (1872).

44. Rimbaud to Ernest Delahaye, June 1872, in *Oeuvres complètes*, 266.

45. Rimbaud, "Promontoire," in *Oeuvres complètes*, 149.

46. Whitman, *Poetry and Prose*, 203; Rimbaud, *Illuminations*, in *Oeuvres complètes*, 75.

47. Rimbaud to Paul Demeny, 17 April 1871, in *Oeuvres complètes*, 246–47; Whitman, *Poetry and Prose*, 49, 203, 210.

48. The free verse achieved by the Cuban poet José Martí in *Versos libres*, written in 1878–1882, was especially early; but it was not published until after Martí's death in 1895.

49. Laforgue, "Une femme m'attend," *La Vogue* 2, no. 3 (2 August 1886).

50. Whitman, *Poetry and Prose*, 258–59.

51. Laforgue, "L'Hiver qui vient," *La Vogue* 2, no. 5 (16 August 1886); reprinted in *Poésies complètes II* (Paris: Gallimard Poésie, 1979), 181–84; trans. William Jay Smith in *Selected Writings of Jules Laforgue* (New York: Grove Press, 1956), 90–91.

52. Arkell, *Looking for Laforgue*, 196–97.

53. *Walt Whitman Review*, 1957; Stuart Merrill, "Walt Whitman (à Léon Bazalgette)," *Le Masque* (Brussels), 2d ser., nos. 9 and 10 (1912); trans. in Henry S. Saunders, *An Introduction to Walt Whitman: with Two Scarce Whitman Portraits* (Toronto: Henry S. Saunders, 1934). Since it is very hard to find, I offer Merrill's anecdote in its original French:

> *Nous* [Stuart Merrill, Sturges, and MacIlvaine] *allions en un mot entendre le verbe qui plie à son rythme l'histoire de l'avenir, le Chant lyrique de la sainte démocratie. . . . Je venais de recevoir de Paris quelques numéros de La Vogue dont l'un contenant une traduction des Enfans d'Adam par Jules Laforgue. . . .*
>
> *—Ah! comme je suis heureux qu'on me traduise en français! s'écria-t-il.*
> *—Et quels poèmes de moi a-t-il traduits? demanda-t-il*
> *—Les Enfans d'Adam, répondis-je.*
> *—J'étais certain qu'un Français tomberait sur ce passage.*

Merrill, *Prose et vers* (Paris: A. Messin, 1925), 234–38.

54. Ezra Pound, "A Pact" ("Contemporanea"), *Poetry* (April 1913).

55. T. S. Eliot to Sholom Kahn, *Walt Whitman Review* 5, no. 3 (1959).

SEVEN

1. Santiago Ramón y Cajal, *Recollections of My Life* (Cambridge: MIT Press, 1989), 69–75.

2. Ibid., 36.

3. Ibid., 37.

4. Ibid., 36.

5. Ibid., 40–42, 44–46.

6. Ibid., 45, 53, 55, 58, 78, 82–83.

7. Ibid., 40–41, 92–93.

8. "Naming is an extremely important act in science." Steven Rose, *The Making of Memory: From Molecules to Mind* (New York: Anchor Books/Doubleday, 1992), 41.

9. "[T]axonomy . . . is a murky endeavor, for nothing in science raises so much controversy as attempts to classify and order the universe of observables. From the days of Linnaeus. . . . This disputatiousness is partly because the universe is a continuum, and our endeavors to identify discontinuities owe as much to our own human ingenuity and determination as they do to the material reality of what is being classified." Rose, *The Making of Memory*, 118.

10. Quoted in Siegfried Bernfeld, "Freud's Earliest Theories and the School of Helmholtz," *Psychoanalytic Quarterly* 13, no. 3 (1944), 348. The date is given as 1847 rather than 1842 in Gordon M. Shepherd, *Foundations of the Neuron Doctrine* (New York: Oxford University Press, 1991), 31.

11. Cajal had no anxiety on this score, but he understood the question. "And our much talked of psychological unity? What has become of thought and consciousness in this audacious transformation of man into a colony of polyps?" (Cajal, *Recollections*, 296). Modern neuroscience glories in addressing just this question.

12. Cajal, *Recollections*, 305.

13. Otto Deiters, *Untersuchungen über Gehirn und Rückenmark des Menschen und der Säugethiere* (Brunswick: Vieweg, 1865); in Shepherd, *Foundations*, 42–44, 47.

14. Gustav Mann, *Physiological Histology* (London: Oxford University Press, 1902); in Arthur Smith and John Bruton, *Color Atlas of Histological Staining Techniques* (Chicago: Year Book Medical, 1977), 9.

15. Camillo Golgi, "Sulla struttura della grigia del cervello," *Italian Medical Gazette*, 2 August 1873; trans. in Shepherd, *Foundations*, 84–88.

16. Rose, *The Making of Memory*, 259.

17. The ammoniacal silver nitrate occasionally exploded if left standing around in the lab.

18. In Shepherd, *Foundations*, 122. Cf. Cajal, *Histology*, trans. M. Fernán-Núñez (Baltimore: Williams and Wilkins, 1933), 413.

19. Cajal, *Recollections*, 303.

20. Ibid., 306; Cajal, *Histology*, 681; Dorothy F. Cannon, *Explorer of the Human Brain* (New York: Henry Schuman, 1949).

21. Cajal, *Recollections*, 321.

22. Ibid., 324.

23. Ibid., 336–38.

24. In *Freud, The Biologist of Mind* (New York: Harper, 1983), 16, Frank J. Sulloway cites without examination the assertions of R. Brun ("Sigmund Freuds Leistungen auf dem Gebiete der organische Neurologie," *Schweizerische Archiv für Neurologie und Psychiatrie* 37 [1936], 200–207), Smith Ely Jelliffe ("Sigmund Freud as a Neurologist," *Journal of Mental and Nervous Diseases* 85 [1937], 696–711), and Ernest Jones (*The Life and Work of Sigmund Freud,* vol. 1 [New York: Basic Books, 1953], chapter 14).

25. "If we assume," said Freud at the point in his lecture where the neuron idea would have been most likely to come up, "that the fibrils of the nerve have the significance of isolated paths of conduction, then we should have to say that the pathways which in the nerve are separate are confluent in the nerve cell: then the nerve cell becomes the 'beginning' of all those nerve fibers anatomically connected with it. . . ." Freud, "Die Struktur der Elemente des Nervensystems," *Jahrbücher für Psychiatrie* 5 (1884); in Shepherd, *Foundations,* 72–73. Freud is clearly talking about a network whose connections lie within cells rather than of independent neurons.

26. Cajal, *Recollections,* 357.

27. "Waldeyer, the illustrious biologist of Berlin . . . giving a resumé of Cajal's ideas and discoveries in a German weekly only baptized them with a new word, 'neurone'. . . ." Cajal, *Histology,* 287.

28. Cajal, "La fine structure des centres nerveux," Croonian Lecture at Royal Society, Burlington House, London, *Proceedings of the Royal Society, London,* Series B, 55 (1894), 444–67.

29. John C. Eccles, *The Physiology of Nerve Cells* (Baltimore: Johns Hopkins University Press, 1957), 10.

30. Cajal, "Leyes de la morfologia de las celulas nerviosas," *Revista trimestriel del micrografia* 1 (Madrid, 1897). Referenced in Cajal, *Histology,* 454. Arthur van Gehuchten helped Cajal pursue this hypothesis.

31. Cajal, "A Quelle époque apparaissent les expansions des cellules nerveuses de la moëlle épinière du poulet?" *Gaceta médical Catalana* 13 (1890), 737–39. Cf. Cajal, *Histology,* 461.

32. An article by Cajal in *Anales de la Sociedad Española de Historía Natural* (1892) describes neural pathways from the olfactory area (smell) to the hippocampus (memory), chemical "neurotropism" of growth cones, and a proposal for a "neurotropic" theory of nerve growth. Cf. Cajal, *Histology,* 482; also Cannon, *Explorer of the Human Brain,* 157.

33. Cajal, *Recollections,* 488.

34. Now in the Munch-Museet, Oslo.

35. Cajal, *Recollections,* 550.

36. Ibid., 546.

37. *Les Prix Nobel 1904–1906* (Stockholm: Norstedt, 1906).

38. Charles Scott Sherrington, *The Integrative Action of the Nervous System* (New Haven, Conn.: Yale University Press, 1977).

39. "Of broader interest is the potential significance of the neuron doctrine as one of the great ideas of modern thought. One thinks here for comparison of such great achievements of the human intellect as quantum theory." Shepherd, *Foundations,* 9.

EIGHT

1. "Hard" and "soft inheritance" are the terms used by Ernst Mayr in his comprehensive history, *The Growth of Biological Thought* (Cambridge: Harvard University Press, 1982), 677–79.

2. Emilio Roig de Leuchsenring, *Weyler en Cuba: Un precursor de la barbarie fascista* (Havana: Paginas, 1947), 93.

3. Byron Farwell, *The Great Anglo-Boer War* (New York: Norton, 1976), 393.

4. Richard E. Welch, *Response to Imperialism: The United States and the Philippine-American War, 1899–1902* (Chapel Hill: University of North Carolina Press, 1979, 1987), 36.

5. Daniel B. Schirmer, *Republic or Empire: American Resistance to the Philippine War* (Cambridge, Mass.: Schenkman, 1972), 225–26.

6. Thomas Pakenham, *The Boer War* (New York: Random House, 1979), 547; and map in A. Ruth Fry, ed., *Emily Hobhouse* (London: J. Cape, 1929).

7. Pakenham, *Boer War,* 523.

8. Philip Magnus, *Kitchener: Portrait of an Imperialist* (New York: Dutton, 1968), 186.

9. Pakenham, *Boer War,* 548.

10. Ibid., 538.

11. Ibid., 535.

12. Ibid., 539.

13. Schirmer, *Republic or Empire,* 227.

14. *Times* (Manila), 4 November 1901.

15. Farwell, *The Great Anglo-Boer War,* 397.

16. Nelson Miles, *Serving the Republic* (1911; Freeport, N.Y.: Books for Libraries Press, 1971).

17. John Adams, *Defence of the Constitutions of the United States,* in *Works,* ed. Charles F. Adams (Boston: Little, Brown, 1856), 4:401.

18. Jon M. Bridgman, *The Revolt of the Hereros* (Berkeley: University of California Press, 1981), 85–86, 184–91.

19. "The Putumayo Revelations," *The Illustrated London News,* 20 July 1912.

20. The authenticity of this telegram is in dispute. See Robert F. Melson, *Revolution and Genocide: On the Origins of the Armenian Genocide and the Holocaust* (Chicago: University of Chicago Press, 1992).

21. John S. Kirakossian, *The Armenian Genocide: The Young Turks before the Judgement of History,* trans. Shushan Altunian (Madison, Conn.: Sphinx Press, 1992).

22. Nicolas Werth, "Félix Dzerjinski et les origines du KGB," *L'Histoire* 158 (September 1992), 38.

23. Ibid., 38–40.

24. Ibid., 40–41.

25. Hitler seems to have asked, "Who talks nowadays of the extermination of the Armenians?" in August 1939. It was first printed by the *Times* (London) on 24 November 1945. Yves Ternon thinks Hitler was speaking of all the Poles, in-

cluding Jews. Ternon, "Il s'agit bien d'un génocide," *L'Histoire* 187 (April 1995), 42–43.

NINE

1. Freud to Wilhelm Fliess, 4 January 1899, in Freud and Fliess, *Correspondence,* ed. J. Masson (Cambridge: Harvard University Press, 1985), 338.
2. Freud, "Über Deckererinnerungen" (Screen memories), *Monatschrift für Psychiatrie und Neurologie* 6, no. 3 (September 1899), 215–30; in *The Standard Edition of the Complete Psychological Works of Sigmund Freud* [hereafter *StdEd,* with volume and page numbers], ed. J. Strachey (London: Hogarth, 1953–1974), vol. 3.
3. Freud, *The Interpretation of Dreams,* in *StdEd,* 4:136–37, 192–93, 216, 229, 230, 239, 337, 424–25.
4. Ibid., 4:249–50.
5. Ibid., 4:97, 152, 193, 196–98, 275, 398n; 5:440, 447–48, 475.
6. Freud, *New Introductory Lectures* (1932), in *StdEd,* 22:22.
7. Sigmund Freud to Wilhelm Fliess, 1 February 1900, in Freud and Fliess, *Correspondence,* 398.
8. *The Letters of Sigmund Freud and Arnold Zweig,* ed. Ernst Freud, trans. E. and W. Robson-Scott (New York: Harcourt, Brace and World, 1970), 23.
9. Freud, *The Interpretation of Dreams,* in *StdEd,* 5:481.
10. Ibid., 4:212.
11. The indispensable work on Freud's training in the materialist neuroscience of the nineteenth century and his work as a histologist and neuroanatomist is Frank J. Sulloway, *Freud, The Biologist of Mind* (New York: Harper Paperback, 1983).
12. Freud, *The Interpretation of Dreams,* in *StdEd,* 5:422.
13. Ibid., 4:206.
14. Ibid., 5:450.
15. Forel, in *Clark University 1889–1899 Decennial Celebration* (Worcester, Mass.: Clark University, 1899), 412–13. Forel called Breuer and Freud's a "doctrine of arrested emotions, which, unfortunately, was developed into a one-sided system."
16. Ramon y Cajal, in *Clark University 1889–1899 Decennial Celebration,* 320.
17. Forel, ibid., 410.
18. Freud, *The Interpretation of Dreams,* in *StdEd,* 4:111, 115, 117.
19. Ibid., 4:206. The cocaine episode is documented conveniently in *Cocaine Papers: Sigmund Freud,* ed. R. Byck (New York: Meridian, 1974).
20. Freud, *The Interpretation of Dreams,* in *StdEd,* 4:111.
21. Ibid., 4:170.
22. Ibid., 4:195.
23. Ibid., 4:195, 5:469.
24. Ibid., 5:437.
25. Ibid.
26. Ibid., 5:527, 531. "Act as though, for instance, you were a traveller sitting

next to the window of a railway carriage and describing to someone inside the carriage the changing views which you see outside." Freud, "On Beginning the Treatment," in *StdEd*, 12:135.

27. Report of Josef Breuer's discussion on 4 November 1895 of Sigmund Freud's papers, "Über Hysterie" (14, 21, 28 October), *Wiener Medizinische Presse* 36 (1895), 1717.

28. Freud, *The Interpretation of Dreams*, in *StdEd*, 5:483.

29. Ibid., 5:480.

30. Ibid., 5:525.

31. Ibid., 4:318.

32. Jeffrey M. Masson has been first and foremost in advancing this view of the crucial turn in Freud's thinking. See his edition of Sigmund Freud and Wilhelm Fliess, *Correspondence*, ed. J. Masson (Cambridge: Harvard University Press, 1985).

33. Freud, *The Interpretation of Dreams*, in *StdEd*, 4:260, 262, 263.

34. Freud to Fliess, 6 August 1899, in Freud and Fliess, *Correspondence*, ed. J. Masson, 365.

35. Freud, *Analysis, Terminable and Interminable*, in *StdEd*, 23:245.

36. Freud, *The Interpretation of Dreams*, in *StdEd*, 5:453.

37. An almost Freudian uncertainty about the possibility of agreement on Freud's legacy recently (December 1995) forced the U.S. Library of Congress to cancel an exhibit on Freud. For a current snapshot of the Freudian thicket see Frederick C. Crews, *The Memory Wars: Freud's Legacy in Dispute* (New York: New York Review, 1995).

TEN

1. Paula Becker to Otto Modersohn, 30 December 1899, in Paula Modersohn-Becker, *Letters and Journals* (Evanston, Ill.: Northwestern University Press, 1990), 144.

2. Paula Becker to her parents, 1 January 1900, ibid., 151.

3. Paula Becker, *Journal*, ibid., 152.

4. Paula Becker to her sister Milly Becker, 29 February 1900, ibid., 167; to her parents, 13 April 1900, ibid., 179.

5. Though Matisse would not have been from Becker's classes at the Académie Colarossi, described in letters to Milly Becker and to Otto and Helen Modersohn, ibid., 168, 170.

6. Clara Rilke-Westhoff, "A Recollection," ibid., 173.

7. Strindberg to Claes Looström, 15 October 1883, in *Strindberg's Letters*, ed. and trans. Michael Robinson (Chicago: University of Chicago Press, 1992), 1:117.

8. Eugen Weber, *France, Fin-de-Siècle* (Cambridge: Harvard University Press, 1986).

9. Paula Becker to Otto and Helen Modersohn, May 1900, in *Letters and Journals*, 186.

10. Paula Becker to her parents, 4 January 1900, ibid., 154.

11. Shari Benstock, *Women of the Left Bank: Paris, 1900–1940* (Austin: University of Texas Press, 1986), 82–83.

12. Henry Adams, *The Education of Henry Adams* (1907), in Adams, *Novels, Mont Saint Michel, The Education* (New York: Library of America, 1983), 1088.

13. Allan Massie, *Colette* (New York: Penguin, 1986), 43.

14. In March 1901, Derain would take Vlaminck to the van Gogh retrospective at the Bernheim jeune gallery and introduce him to Matisse.

15. Paula Becker, *Journal,* Worpswede, 2, 3, 5, and 26 July 1900, in *Letters and Journals,* 193–95.

16. Paula Becker, *Journal,* undated, ibid., 152.

17. Henri Poincaré, *New Methods of Celestial Mechanics* (Les méthodes nouvelles de la mécanique céleste, 1892–1899); ed. and trans. Daniel L. Goroff (Woodbury, N.Y.: American Institute of Physics, 1991).

18. Poincaré, "Sur les rapports de la Physique expérimentale et de la Physique mathématique," reprinted in *La Science et l'hypothèse* (Paris: Flammarion, 1902); trans. W. J. G., "Hypotheses in Physics" and "The Theories of Modern Physics," in *Science and Hypothesis* (New York: Dover, 1952).

19. Wilhelm Wien, "Les lois théoriques du rayonnement," in *Rapports du Congrès Internationale de Physique* (1900), 2:23–40; Otto Lummer, "Le rayonnement des corps noirs," ibid., 41–99.

20. Bertrand Russell, *Autobiography* (London: Unwin paperback, 1978), 147.

21. Felix Browder, *Mathematical Developments Arising from Hilbert Problems,* Proceedings of Symposia in Pure Mathematics, vol. 28 (Providence, R.I.: American Mathematical Society, 1974).

22. Remy de Gourmont, "La Morale de l'amour," in *La Culture des idées* (Paris: 10/18, 1983).

23. Carles Casagemas to Ramon Reventós, 25 October 1900, trans. in Marilyn McCully, ed., *A Picasso Anthology* (Princeton: Princeton University Press, 1982), 27–28.

24. Laforgue, "L'Hiver qui vient" (The coming of winter), in *Selected Writings of Jules Laforgue,* ed. and trans. William Jay Smith (New York: Grove Press, 1956), 90.

25. Paula Becker to Otto and Helen Modersohn, May 1900, in *Letters and Journals,* 187.

26. Paula Modersohn-Becker, *Journal,* 2 April 1902, ibid., 275. A year later, in Paris, Rilke wrote for her his great "Requiem for a Friend":

> but
> then you were in Time, and Time is long.
> And Time goes out, and Time fills up, and Time
> Is like a relapse in a prolonged illness.

> *aber*
> *nun warst du in der Zeit, und Zeit ist lang.*
> *Und Zeit geht hin, und Zeit nimmt zu, und Zeit*
> *ist wie ein Rückfall einer langen Krankheit.*

ELEVEN

1. "[A]s a rule hybrids do not represent the form exactly intermediate between the parental strains." Mendel, "Versuche über Pflanzenhybriden" (Experiments on plant hybrids), *Verhandlungen der naturforschenden Vereines in Brünn* 4 (1865); trans. E. R. Sherwood, in Curt Stern and Eva R. Sherwood, eds., *The Origin of Genetics: A Mendel Sourcebook* (San Francisco: W. H. Freeman, 1966), 9, and Alain F. Corcos and Floyd V. Monaghan, eds., *Gregor Mendel's Experiments on Plant Hybrids: A Guided Study* (New Brunswick, N.J.: Rutgers University Press, 1993), 77. Corcos and Monaghan translate Mendel's word *Spaltung* as "segregation" on p. 91. Cf. Stern and Sherwood, eds., *Origin of Genetics*, 15.

2. Mendel, "Versuche . . . ," in Stern and Sherwood, eds., *Origin of Genetics*, 11, and Corcos and Monaghan, eds., *Mendel's Experiments*, 82.

3. Mendel, "Versuche . . . ," in Stern and Sherwood, eds., *Origin of Genetics*, 13.

4. Ibid., 22; and Corcos and Monaghan, eds., *Mendel's Experiments*, 113. The italics are Mendel's own. Ronald Fisher ("Has Mendel's Work Been Rediscovered?" *Annals of Science* 1 [1936], 115–37) tried to show that Mendel's results were "too good" and might have been fudged, but in fact they weren't that good (Franz Weiling, "What about R. A. Fisher's Statement of the 'Too Good' Data of J. G. Mendel's Paper?" *Journal of Heredity* 77 [1986], 281–83).

5. Mendel, "Versuche . . . ," in Stern and Sherwood, eds., *Origin of Genetics*, 22.

6. Robert C. Olby, *Origins of Mendelism*, 2d ed. (Chicago: University of Chicago Press, 1985), 102. One offprint was sent to Anton Kerner von Marilaun, and two more ended up in the libraries of Martius Wilhelm Beijerinck and Theodor Boveri.

7. Karl Nägeli and A. Peter, *Die Hieracien Mittel-Europas* (Central European hawkweeds), 2 vols. (Munich, 1885–89).

8. Mendel's letters to Nägeli are available in Stern and Sherwood, eds., *Origin of Genetics*, 56–102.

9. Karl Nägeli, *Mechanisch-physiologische Theorie der Abstammungslehre* (A mechano-physiological theory of inheritance) (Leipzig: Oldenburg, 1884).

10. E. Posner and J. Skutil, "The Great Neglect: The Fate of Mendel's Paper between 1865 and 1900," in Olby, *Origins of Mendelism*, 216–19.

11. Hermann Hoffmann, *Untersuchungen zur Bestimmung des Werthes von Species und Varietät . . .*, 1869; Albert Blomberg, "Om hybridbildning hos de fanerogama vaxterna" (Ph.D. thesis, Uppsala, 1872); Schmalhausen, "On Plant Hybrids: Observations on the Petersburg Flora" (master's thesis, St. Petersburg, 1874), cited in Olby, *Origins of Mendelism*, 222–26, where it is shown that Darwin read Hoffmann but seems to have missed the reference to Mendel.

12. Wilhelm Olbers Focke, *Die Pflanzen-Mischlinge: ein Beitrag zur Biologie der Gewächse* (Giessen, 1881), 108; trans. Stern and Sherwood, in Stern and Sherwood, eds., *Origin of Genetics*, 103. Like Freud's *Traumdeutung*, Focke's book was available in the year before its printed date of publication. See Olby, *Origins of Mendelism*, 228–29.

13. Carl Correns to H. F. Roberts, 23 January 1925, in Stern and Sherwood, eds., *Origin of Genetics*, 135.

14. Mendel's half of his dispiriting correspondence with Nägeli was in fact found by Carl Correns in his father-in-law's papers.

15. Charles Darwin, *The Effects of Cross and Self Fertilisation in the Vegetable Kingdom* (New York: D. Appleton, 1877).

16. Erich Tschermak, "Ueber künstliche Kreuzung bei *Pisum sativum*" (On deliberate cross-fertilization in the garden pea), *Zeitschrift für das landwirtschaftliche Versuchswesen in Österreich* 3 (1900), 465–555; summarized in *Berichte der deutschen botanischen Gesellschaft* 18 (1900), 232–39.

17. Hugo de Vries, "Das Spaltungsgesetz der Bastarde" (The law of segregation of hybrids), *Berichte der deutschen botanischen Gesellschaft* 18 (25 April 1900); trans. E. Stern in Stern and Sherwood, eds., *Origin of Genetics*, 107.

18. A little after his "Das Spaltungsgesetz der Bastarde" was received by the *Berichte* on March 14, Hugo de Vries sent two more papers on the topic to French journals: "Sur la loi de disjonction des hybrides," *Comptes-rendus . . . de l'Académie des sciences* 130 (1900), 845–47, published four days before "Das Spaltungsgesetz" on April 21; and "Sur les unités des caractères spécifiques et leur application à l'étude des hybrides," *Revue générale de botanique* 12 (1900), 257–71. J. Krizenecky, *Fundamenta Genetica*, Folia Mendeliana vol. 6 (Prague: Czechoslovakian Academy of Science, 1965); cited by Ernst Mayr, *The Growth of Biological Thought: Diversity, Evolution, and Inheritance* (Cambridge: Harvard University Press, 1982), 728.

19. I follow here the view of Ernst Mayr (in *The Growth of Biological Thought*) and Robert Olby. De Vries himself claimed in 1924 that he had been getting segregated traits in his crossbreeding of *Oenothera* primroses since 1893. Cf. de Vries to H. F. Roberts, 18 December 1924, in Stern and Sherwood, eds., *Origin of Genetics*, 133–34.

20. C. Zirkle, "The Role of Liberty Hyde Bailey and Hugo de Vries in the Rediscovery of Mendelism," *Journal of the History of Biology* 1 (1968).

21. De Vries's own work on osmotic pressure and plasmolysis was not published until 1888 in *Botanische Zeitung* 46 (1888), 229–35, 245–53; *Zeitschrift für physikalische Chemie* 2 (1888), 415–32; *Comptes-rendus . . . de l'Académie des sciences* 106 (1888), 751–53.

22. De Vries, *Intracelluläre Pangenesis* (Jena: Gustav Fischer, 1889). The other works are Spencer, *The Principles of Biology*, vol. 1 (London, 1864); Weismann, *Die Kontinuität des Keimplasmas als Grundlage einer Theorie der Vererbung* (The continuity of the germ plasm) (Jena: Gustav Fischer, 1885); and Nägeli, *A Mechano-Physiological Theory of Inheritance* (1884).

23. Mayr, *Growth of Biological Thought*, 708–9.

24. The word "gene" seems to have been coined by Wilhelm L. Johannsen in his *Elemente der exakten Erblichkeitslehre* (Jena: Fischer, 1909).

25. De Vries, *Die Mutationstheorie: Versuche und Beobachtungen über die Entstehung von Arten im Pflanzenreich* (The mutation theory, experiments and observations on the origin of species in the vegetable kingdom), 2 vols. (Leipzig: Veit, 1901, 1903).

26. De Vries, *The Mutation Theory, Experiments and Observations on the Origin of Species in the Vegetable Kingdom* (Chicago: Open Court, 1910), 1:3. Everything about Mendel was edited out of this edition.

27. De Vries, "Ueber halbe Galtonkurven als Zeichen diskontinuierlicher

Variation," *Berichte der deutschen botanischen Gesellschaft* 12 (1894), 197–207; "Les demi-courbes galtoniennes comme indice de variation discontinue," *Archives Néerlandaises des sciences exactes naturelles* 28 (1895), 442ff; "Eine zweigipfliche Variationskurve," *Archiv für Entwicklungsmechanik der Organismen* 2 (1895), 52–64; "Over het omkeeren van halve Galtonkurven," *Botanisch Jaarboek* 10 (1898), 27–61.

28. Carl Correns, "G. Mendels Regel über das Verhalten der Nachkommenschaft der Rassenbastarde" (Law concerning the behavior of progeny of varietal hybrids), *Berichte der deutschen botanischen Gesellschaft* 18 (1900). Correns sent it on April 22. The journal received it on the 24th or 26th, and printed it in May. It is translated by L. K. Piternick in Stern and Sherwood, eds., *Origin of Genetics,* 119–32.

29. Correns, in Stern and Sherwood, eds., *Origin of Genetics,* 120.

30. De Vries had published a great deal in German, French, and Dutch by 1900, but only once in 1899 in English.

31. "Eine neue wissenschaftliche Wahrheit pflegt sich nicht in der Weise durchzusetzen, dass ihre Gegner überzeugt werden und sich als belehrt erklären, sondern vielmehr dadurch, dass die Gegner allmählich aussterben und dass die heranwachsende Generation von vornherein mit der Wahrheit vertraut gemacht ist." Max Planck, *Wissenschaftliche Selbstbiographie,* ed. Wieland Berg (Halle: Deutsche Akademie der Naturforscher Leopoldina, 1990), 15; trans. Frank Gaynor, in *Scientific Autobiography and Other Papers* (New York: Philosophical Library, 1949), 33–34. Planck repeated the idea from an earlier lecture, "Origine et évolution des idées scientifiques," in *Initiations à la physique,* trans. J. du Plessis de Grenédan (Paris: Flammarion, 1989), 267. Thousands of American students have read it, unattributed, in the opening chapter of Paul Samuelson's economics textbook.

32. Planck, *Scientific Autobiography,* 30.

33. Planck, *Planck's Original Papers in Quantum Physics,* ed. H. Kangro, trans. D. ter Haar and S. G. Brush (New York: Wiley, 1972), 46 n. 2. The essential historical work on Planck has been done by Martin J. Klein, "Max Planck and the Beginnings of Quantum Theory," *Archives of the History of Exact Sciences* 1, no. 459 (1962), and *History of Twentieth-Century Physics* (New York and London: Academic Press, 1977); H. Kangro, trans., *Early History of Planck's Radiation Law* (London: Taylor and Francis, 1972, 1976); Thomas S. Kuhn, *Black Body Theory and the Quantum Discontinuity, 1894–1912* (Chicago: University of Chicago Press, 1987).

34. J. L. Heilbron, *The Dilemmas of an Upright Man: Max Planck as a Spokesman for German Science* (Berkeley: University of California Press, 1986), 40.

35. Philipp von Jolly's flawed prediction was recalled by Planck in an address on December 1, 1924, and quoted in what is still the best narrative history of early twentieth-century physics: Barbara Lovett Cline, *Men Who Made a New Physics: Physicists and the Quantum Theory* (Chicago: University of Chicago Press, 1987), 34.

36. Planck, *Scientific Autobiography,* 46.

37. Ibid., 16.

38. "gelernt, trocken und eintönig." Ibid., 16.

39. *Annalen der Physik und Chemie* 109 (1860), 275; quoted in Abraham Pais, *"Subtle is the Lord . . .": The Science and the Life of Albert Einstein* (New York: Oxford University Press paperback, 1983), 364.

40. Gustav Kirchhoff, *Vorlesungen über die Theorie der Wärme,* vol. 4 of *Vorlesungen über mathematische Physik,* ed. Max Planck (Leipzig, 1877–1894). Thomas Kuhn, who has studied this material, counts Lecture 13 as the third of only four papers that applied probability concepts to gas theory before Boltzmann did. Kuhn, *Black Body Theory,* 61, 71.

41. Planck, "Gegen die neuere Energetik" (Against the new energism), *Annalen* 57 (1896), 72–78. The quotation is translated from the version in Planck, *Physikalische Abhandlungen und Vorträge* (Brunswick: Vieweg, 1958), 1:464–65, in Heilbron, *Dilemmas of an Upright Man,* 45–46.

42. Planck's 1891 address to the Deutsche Naturforscherversammlung on taking atomism or leaving it is in Planck, *Physikalische Abhandlungen,* 1:372–73.

43. Planck to Leo Graetz, 23 May 1897, in Kuhn, *Black Body Theory,* 27–28.

44. Planck, "Einheit des physikalischen Weltbildes," speech presented in Leyden in December 1908, trans. R. Jones and D. H. Williams, in Planck, *A Survey of Physics: A Collection of Lectures and Essays* (New York: Dover, 1960), and Planck, "Zur Machschen Theorie der physikalischen Erkenntnis. Eine Erwiderung" (On Mach's theory of physical knowledge: A reply), *Physikalische Zeitschrift* 11 (1910), 1186–90.

45. D. Flamm, "Boltzmann's Statistical Approach to Irreversibility," *University of Vienna Theoretical Physics Report* 4 (1989), 8.

46. Kuhn, *Black Body Theory,* 98.

47. According to Planck's biographer, Heilbron, "In those days Planck's sense of pitch was so perfect that he could scarcely enjoy a concert, much less the neighborhood children; but like his politics and his thermodynamics, his ear gradually lost its absolutism and allowed him greater satisfaction. . . . he preferred Schubert and Brahms to Bach, and he admired Schumann; of Bach he singled out the pathetic and emotional parts of the Saint Matthew Passion: all choices that reveal the deep romantic vein beneath his still exterior." Heilbron, *Dilemmas of an Upright Man,* 34–35.

48. Its inventor was Samuel Press Langley, the American scientist who had shown Henry Adams around the dynamos in Paris.

49. Planck, "The Origin and Development of the Quantum Theory," in *A Survey of Physics: A Collection of Lectures and Essays* (Physikalische Rundblicke, 1922), trans. R. Jones and D. H. Williams (New York: Dover, 1960), 105.

50. Emil Picard, "Sciences" (1903), quoted in Heilbron, *Dilemmas of an Upright Man,* 19.

51. Otto Lummer, "Le rayonnement des corps noirs," in *Rapports Congrès Internationale de Physique* (1900), 2:41–99. Cf. H. Kangro, *Early History of Planck's Radiation Law* (London: Taylor and Francis, 1972, 1976), 220; Planck, *Planck's Original Papers in Quantum Physics,* ed. H. Kangro, trans. D. ter Haar and S. G. Brush (New York: Wiley, 1972), 46 n. 1; Kuhn, *Black Body Theory,* 99.

52. *Physikalische Zeitschrift* 2 (1900), 111; in Christa Jungnickel and Russell McCormmach, *Intellectual Mastery of Nature: Theoretical Physics from Ohm to Einstein,* vol. 2, *The Now Mighty Theoretical Physics, 1870–1925* (Chicago: University of Chicago Press, 1986), 260.

53. Planck, "The Origin and Development of the Quantum Theory," in *A Survey of Physical Theory*, 106.

54. Planck, "On an Improvement of Wien's Equation of the Spectrum" (19 October 1900), in *Planck's Original Papers in Quantum Physics*, 35, 46–47 n. 2.

55. Planck, quoted in Armin Hermann, *Frühgeschichte der Quantentheorie, 1899–1913* (Baden: Mosbach, 1969), 32; in Pais, "*Subtle is the Lord . . .*," 370.

56. Planck, "The Origin and Development of the Quantum Theory," in *A Survey of Physical Theory*, 106.

57. Ibid.

58. Planck, "On the Theory of the Energy Distribution Law of the Normal Spectrum" (14 December 1900), in *Planck's Original Papers in Quantum Physics*, 42.

59. Planck to Wien, 13 November 1900, *Wien Papers*, Staatsbibliothek Preussische Kulturbesitz (Berlin, 1973), 110; in Jungnickel and McCormmach, *Intellectual Mastery of Nature*, 262.

60. This is the conclusion of Thomas Kuhn (*Black Body Theory*, 113), who also reviews the various versions of Erwin's reminiscence as reported by Arnold Sommerfeld in 1947 and R. W. Pohl in 1972 (*Black Body Theory*, 278 n. 30, 285 n. 44). Erwin, the last survivor of Planck's four children, was executed in 1945 for his role on the July 20 plot to kill Hitler. Planck survived him by only two years.

61. Planck, "New Paths of Physical Knowledge," in *A Survey of Physical Theory*, 49.

TWELVE

1. Bertrand Russell, *Autobiography* (London: Unwin paperback), 1978, 148. (Russell was one of those who understood that December 31, 1900 was the last day of the nineteenth century.)

2. Ibid., 148.

3. Ibid., 147–48.

4. Russell was enthusiastic about the finite arithmetization of calculus. "[A] German professor, who probably never dreamed of any connection between himself and Zeno. Weierstrass, by strictly banishing from mathematics the use of infinitesimals, has at last shown that we live in an unchanging world, and that the arrow in flight is truly at rest." Russell, "Recent Work on the Principles of Mathematics," *International Monthly* 4 (July 1901), 83–101; in *The Collected Papers of Bertrand Russell*, vol. 3, *Toward The Principles of Mathematics, 1900–02*, ed. Gregory H. Moore (London and New York: Routledge, 1994), 370. The paper was revised as "Mathematics and the Metaphysicians," and reprinted in Russell, *Mysticism and Logic* (1917; Garden City, N.Y.: Doubleday, 1957), cf. 80–81, and in James R. Newman, ed., *The World of Mathematics* (New York: Simon and Schuster, 1956), cf. 3:1580.

5. Russell, *Autobiography*, 148.

6. Russell to Alys Russell, 23 October 1900, in *The Selected Letters of Bertrand Russell*, vol. 1, *The Private Years, 1884–1914*, ed. N. Griffin (Boston: Houghton Mifflin, 1992), #89, 204–5.

7. Ibid., #91, 208.

8. The last-mentioned article was Russell, "Recent Work on the Principles of Mathematics," in *Collected Papers,* vol. 3. (See above, note 4.)

9. Russell remembered reading all of Cantor in 1896, but the contents of *Acta Mathematica* make 1898 more likely. Russell to Philip Jourdain, 15 April 1910, in Ivor Grattan-Guinness, ed., *Dear Russell—Dear Jourdain* (London: Duckworth, 1977), 132.

10. Russell, *Autobiography,* 150.

11. Russell to Couturat, 17 January 1901, in *Selected Letters,* #92, 210–11.

12. Russell, *Autobiography,* 150.

13. Ibid.

14. Ibid.

15. Ibid.

16. "Thus mathematics may be defined as the subject in which we never know what we are talking about, nor whether what we are saying is true. People who have been puzzled by the beginnings of mathematics will, I hope, find comfort in this definition, and will probably agree that it is accurate." Russell, "Recent Work on the Principles of Mathematics" (1901), in *Collected Papers,* 3:366. (See above, note 4.)

17. Russell, *Autobiography,* 149.

18. Ibid., 150.

19. Russell to Helen Thomas, 30 December 1901, in *Selected Letters,* #98, 224. Russell's opinion of the painter's art, by contrast, was nowhere near as high, and he seems to have been opaque to its Modernist masterpieces. Lecturing at the Barnes Foundation in 1941–42, he described Barnes's collection, which included Matisse's *Le Bonheur de vivre,* as "modern French paintings, mostly of nudes." Russell press interview quoted by Kenneth Blackwell, *Russell-L Digest* 307, 27 September 1995.

20. Russell to Couturat, 23 March 1902, in Russell, *Collected Papers,* 3:xxxiv.

21. Russell, *Autobiography,* 149.

22. Ibid., 152–54.

23. Russell to Lucy Donnelly, 23 May 1902, in *Collected Papers,* 3:xxxvi.

24. Russell to Alys Russell, May 1902, ibid.

25. Russell to Frege, 16 June 1902, in Jean van Heijenoort, ed., *From Frege to Gödel* (Cambridge: Harvard University Press, 1967), 125.

26. Frege to Russell, 22 June 1902, ibid., 127.

27. He would formulate, then abandon the theory of types, only to readopt it in 1908. Russell, "Mathematical Logic as Based on the Theory of Types," *American Journal of Mathematics* 30 (1908), 222–62; reprinted in Russell, *Logic and Knowledge* (New York: Macmillan, 1956) and in Heijenoort, ed., *From Frege to Gödel,* 150–82.

28. Russell to Goldsworthy Lowes Dickinson, 11 July 1902, in *Collected Papers,* 3:xxxviii.

29. Russell, *Diary,* July 1903, in *The Collected Papers of Bertrand Russell,* vol. 12, *Contemplation and Action, 1902–14,* ed. Richard A. Rempel, Andrew Brink, and Margaret Moran (London and Boston: George Allen and Unwin, 1985), 23.

30. Russell to Couturat, 29 September 1902, in *Collected Papers,* 3:xxxix.

31. Husserl to Albrecht, 22 August 1901, in Karl Schuhmann, *Husserl-Chronik: Denk- und Lebensweg Edmund Husserls* (The Hague: Martinus Nijhoff, 1977), 63.

32. Ernst Mach, *The Science of Mechanics* (Peru, Ill.: Open Court, 1989), 200.

33. Edmund Husserl, *Logische Untersuchungen I: Prolegomena zur reinen Logik*, ed. Elmar Holenstein, Husserliana vol. 18 (The Hague: Martinus Nijhoff, 1975), chapter 9, 196–213; trans. J. N. Findlay, in *Logical Investigations* (New York: Humanities Press, 1970), 1:197–210.

34. Husserl, "Psychologische Studien für Elementaren Logik" (Psychological studies for elementary logic), *Philosophia Mathematica* 30 (1894); trans. R. Hudson in Husserl, *Shorter Works*, ed. P. McCormick and F. Elliston (Notre Dame, Ind.: University of Notre Dame Press, 1981).

35. In his third draft of *The Principles of Mathematics*, written in 1899–1900, Russell said of Whole and Part that it was an indefinable relation "so important that almost all our philosophy depends upon the theory we adopt in regard to it" (*Collected Papers*, 3:119). By October he had abandoned the draft, writing in the margin "*Note*. I have been wrong in regarding the Logical Calculus as having especially to do with whole and part. *Whole* is distinct from *Class*, and occurs nowhere in the Logical Calculus, which depends on these notions: 1) implication, 2) . . . and 3) negation. Whole and part require the *Teoria della grandezza* (Bettazzi 1890), i.e. a special form of addition, not that of the Logical Calculus" (in *Collected Papers*, 3:xxviii).

36. Husserl, "Author's Abstracts (Selbstanzeigen)," trans. P. J. Bossert and C. H. Peters, in *Introduction to the Logical Investigations: A Draft of a Preface to the* Logical Investigations (The Hague: Martinus Nijhoff, 1975), 5. In a new introduction to the *Logical Investigations*, written in 1913, Husserl claimed to have worked from 1886 to 1895 along the path blazed by Leibniz, Bolzano, Stolz, Cantor, and Weierstrass (ibid., 37).

37. An unsympathetic, but careful analysis of Investigation Three can be found in David Bell, *Husserl* (New York: Routledge, 1990), 98–101.

38. Schuhmann, *Husserl-Chronik*, 65. K. D. Heller, *Ernst Mach: Wegbereiter der modernen Physik* (Vienna: Springer, 1964).

39. Husserl to Natorp, 7 September 1901, in Husserl, *Studien zur Arithmetik und Geometrie*, Husserliana vol. 21 (The Hague: Martinus Nijhoff, 1983), 396–400.

40. Russell to Couturat, 23 March 1902, in *Collected Papers*, 3:xxxiv. I have translated Russell's French.

41. Though Russell did follow the work of another Brentano student, Alexius Meinong, writing a devastating critique of it in a series of papers beginning with "On Denoting" in *Mind*, n. s., 14, no. 56 (October 1905).

42. Max Scheler, 1901, in John Raphael Staude, *Max Scheler: An Intellectual Portrait* (New York: Free Press, 1967), 22.

43. "Thus history encompasses phenomenology, and Husserl always knew it, from one end of his work to the other; but there is an intention, an a-historical pretention in phenomenology, which is why we begin phenomenology with its history and leave it on the topic of its debate with history." Jean-François Lyotard, *La Phénoménologie*, 9th ed., Que sais-je (Paris: PUF, 1982), 4; my translation.

44. Russell to Ottoline Morrell, 19 October 1911, in Ray Monk, *Ludwig Wittgenstein: The Duty of Genius* (New York: Free Press, 1990), 39. Russell to Ottoline Morrell, 2 November 1911, in Brian McGuinness, *Wittgenstein: A Life,* vol. 1, *Young Ludwig, 1889–1921* (Berkeley: University of California Press, 1988), 89.

THIRTEEN

1. Charles Musser's indispensable *Before the Nickelodeon: Edwin S. Porter and the Edison Manufacturing Company* (Berkeley: University of California Press, 1991) is the main source for this chapter, not only because it is the first serious Porter biography, but because it is a synthesis of the remarkable scholarship of the 1970s and 1980s that has revolutionized our view of early cinema.

2. "Mose," the Irish volunteer fireman or "B'hoy," first appeared in Benjamin Baker's play *A Glance at New York* in 1848. F. S. Chanfrau opened as Mose and played him for the next thirty-odd years (Myron Matlaw, ed., *The Black Crook and Other Nineteenth-Century American Plays* [New York: Dutton, 1967]). Edison's Chicago competitor, William Selig, had produced the 450-foot film *Life of a Fireman* just before 1901 began. Sigmund Lubin in Philadelphia made a 250-foot *Going to the Fire and Rescue* but, like James Williamson's *Fire!*, it was made just after Porter's, not before (Musser, *Before the Nickelodeon*, 218).

3. The Bioskop used two strips of Eastman roll film, alternately exposed, to achieve the required 16 frames per second.

4. It was in 1908 that actor D. W. Griffith, after starring in one of the last flops Porter made for Edison, walked into 11 East 14th Street and secured steady work in the Biograph ensemble. By 1909 he was directing the short masterpieces of continuity editing that put Biograph out front, as recounted in chapter 21 of this volume.

5. This was the first screen kiss in history. Adolph Zukor first began to think of moving out of furs and into film after he saw it in 1897.

6. *Los Angeles Herald,* quoted in Emmanuelle Toulet, *Birth of the Motion Picture*, trans. Susan Emanuel (New York: Abrams/Discoveries, 1992), 132.

7. Maxim Gorky, ["Leda Swan"], *Nizhegorodski listok,* 4 July 1896; in Emmanuelle Toulet, "Le Cinéma à l'Exposition Universelle, 1900," *Revue d'histoire moderne et contemporaine* 33 (April–June 1986), trans. Tom Gunning in *Persistence of Vision* 9 (1991), 31, and Toulet, *Birth of the Motion Picture,* 132

8. N. Karzhansky, "V kinematografe: Iz knigi 'Paris,'" *Rampa i zhizn* 32 (1915), 6; quoted in Yuri Tsivian, "Some Historical Footnotes to the Kuleshov Experiment," trans. Kathy Porter, in Elsaesser, ed., *Early Cinema,* 248.

9. Méliès's *Le Petit Chaperon Rouge* (Little Red Riding Hood) (1901) is also a long (525 feet) story film. The Edison Company duplicated and sold it as their own soon after its release, a tactic that was legal at the time. It is now lost.

10. R. W. Paul/Booth, *The Magic Sword, or A Medieval Mystery,* and *Scrooge, or Marley's Ghost.* Paul had made the first English two-shot fiction film in 1898, *Come Along, Do!.* That film and Méliès's contemporary *La Lune à un mètre!* seem to be the first films ever in which one shot was designed to be coherent with another.

11. This British Gaumont production was remade that same year by Biograph as *An Elopement a la Mode*.

12. André Gaudreault, "Detours in Film Narrative: The Development of Cross-Cutting," *Cinema Journal* 19, no. 1 (Fall 1979); reprinted in Elsaesser, ed., *Early Cinema*, 133–50.

13. C. Francis Jenkins, *Animated Pictures* (1898), quoted in Charles Musser, *The Emergence of Cinema: The American Screen to 1907* (New York: Scribner's, 1991; Berkeley: University of California Press, 1994), 15.

14. The measurement of 40-cycle-per-second firing rhythm and the hypothesis of a front-to-rear cortical "sweep" every 0.0125 second are by New York University neuroscientist Rodolfo Llinás (*New York Times*, 21 March 1995, C10).

15. *Scientific American*, 20 May 1893; in Musser, *Before the Nickelodeon*, 37–38. Edison's wife had shown off the kinetograph camera Dickson had perfected in May 1891, but no films were made or projected on that occasion.

16. This sort of division can perhaps best be seen through the analogous work of contemporary cartoonists like Winsor McCay, who had already begun to draw "strips" in which the subject seemed to change its appearance as it moved through a fixed point of view. Gerald Noxon, "Pictorial Origins of Cinema Narrative— The Birth of the Scene," *Journal of the Society of Cinematologists* 4 (1965).

17. André Gaudreault, "The Infringement of Copyright Laws and Its Effects (1900–1906)," *Framework* 29 (1985); reprinted in Elsaesser, ed., *Early Cinema*, 114–22.

18. Another candidate for the first close-up of a face is Georges Demeny mouthing "Je vous aime" before his Chronophotographe camera in 1891.

19. The word seems to have arisen around 1910. In 1916, producer Thomas Ince was said in the *Saturday Evening Post* 188 (13 May 1916) to have invented the "continuity script" to make film production more efficient, but much earlier such scripts exist, including the one Frank Woods wrote for Griffith's *After Many Years* in October 1908.

20. Roman Gubern, "David Wark Griffith et l'articulation cinématographique," *Cahiers de la Cinémathèque* 17 (Christmas 1975), 11; quoted by Gaudreault in Elsaesser, ed., *Early Cinema*, 141.

21. James's "stream of consciousness" ("The Association of Ideas," *Popular Science Monthly* 16 [March 1880], 577–93) precedes Edison's moving pictures, though not Muybridge's. Husserl's *Erlebnisstrom* (stream of experience) first appears clearly in *Logical Investigations* in 1901. Bergson seems to have been the first philosopher to compare the experience of cinema to the experience of consciousness, which he called "a cinematograph inside us" in the lectures of 1902–3 that were published as *Creative Evolution* (L'Evolution créatrice, 1911), 306, quoted in Robert Sklar, *Movie-Made America: A Cultural History of American Movie* (New York: Vintage, 1975), 48.

22. Robert C. Allen and Douglas Gomery, *Film History: Theory and Practice* (New York: McGraw-Hill, 1985) provides the best introduction to the exploding historiography of cinema. For the work that has recently revised the history of early cinema one might best begin with the articles edited by Elsaesser in *Early Cinema* and by John L. Fell in *Film Before Griffith* (Berkeley: University of California Press, 1983).

23. "Highly sensationalized headliner" is from Edison's advertising for *The*

Great Train Robbery in November 1903, before the movie was released, quoted in Musser, *Before the Nickelodeon,* 254. "Cinema of attractions" is Tom Gunning's much-cited characterization of the pre–1903 cinema in "The Cinema of Attractions: Early Film, Its Spectator and the Avant-Garde," *Wide Angle* 8, nos. 3/4 (Fall 1986), reprinted in Elsaesser, ed., *Early Cinema,* 56–62.

24. The name "Tin Pan Alley" was coined by a journalist named Monroe Rosenfeld in 1909 as the music business was in the process of moving uptown from Union Square to 28th Street.

FOURTEEN

1. This and subsequent excerpts from this song are from Jerry Vogel Music Co., New York; in Selwyn K. Troen and Glen E. Holt, eds., *St. Louis* (New York: Markus Wiener, 1993), 134.

2. Mark Twain, *Life on the Mississippi,* in *Mississippi Writings* (New York: Library of America, 1982), 365.

3. These and other details about St. Louis are from the standard history of the city, James Neal Primm, *Lion of the Valley: Saint Louis, Missouri* (Boulder, Colo.: Pruett, 1981).

4. T. S. Eliot, preface to *Huckleberry Finn,* by Mark Twain (London: Cresset Press, 1950); in Mark Twain, *The Adventures of Huckleberry Finn,* ed. Sculley Bradley et al. (New York: Norton, 1977), 328.

5. Twain, *Life on the Mississippi,* 239; T. S. Eliot, "The Dry Salvages," in *The Complete Poems and Plays, 1909–1950* (New York: Harcourt, Brace, 1959), 133.

6. Twain, *Life on the Mississippi,* 364; cf. 541.

7. Henry Adams, *The Education of Henry Adams,* in *Novels, Mont Saint Michel, The Education* (New York: Library of America, 1983), 1146.

8. Karl Pearson, *The Grammar of Science,* 3d ed. (London: Walter Scott, 1911; repr., New York: Meridian, 1957).

9. Pearson, *Grammar of Science,* 108; quoted in Adams, *Education of Henry Adams,* 1134.

10. Ernst Haeckel, *Die Welträtsel* (The riddle of the universe), trans. Joseph McCabe (Buffalo, N.Y.: Prometheus Books, 1992).

11. Adams, *Education of Henry Adams,* 1132.

12. Ibid., 1146.

13. W. C. Handy, *Father of the Blues: An Autobiography* (1941; repr., New York: Da Capo, 1969), 142. Handy's 1892 memories of St. Louis also included hearing a guitarist in a "white saloon" sing "Afterwards," a song in a blues mood that he knew and loved (p. 28), and a blues line "muttered" by a woman on the street (p. 119).

14. Luc Sante, "The Genius of Blues," *New York Review of Books* 41, no. 14 (11 August 1994), 46.

15. Sante, "The Genius of Blues," 46.

16. Barney and Seymore [Theron C. Bennett], "St. Louis Tickle" (Chicago: Victor Kremer, 1904). David A. Jasen and Trebor Jay Tichenor, *Rags and Ragtime: A Musical History* (1978; repr., New York: Dover, 1989), 47. Cf. Rudi Blesh

and Harriet Janis, *They All Played Ragtime* (New York: Oak Publishers, 1971), 77. According to Blesh and Janis, the American Modernist composer Virgil Thomson remembered hearing the tune when he was growing up in Kansas City, on the western side of Missouri.

17. John R. David, "Frankie and Johnnie: The Trial of Frankie Baker," *Missouri Folklore Society Journal* 6 (1984), 1–30.

18. New York City's police commissioner in 1895 was Teddy Roosevelt. His famous expression, "Bully," gets some of the strength of its connotation from "May Irwin's Bully Song." The song—which the 1990s would find stunningly racist—can still be heard on an 1895 recording, and another fragment of Irwin's performance survives as the first screen kiss, captured by Edison's cameras in the "Black Maria" and projected by Edwin Porter in Los Angeles in 1896.

19. Irwin's guitar-playing fellow passenger was a Chicago newsman named Charles Trevathan. W. C. Handy mentions "Looking for the Bully" as a song sung by St. Louis roustabouts about the East St. Louis police in 1892 (*Father of the Blues*, 27, 118–19). Mama Lou, who performed with a troupe of topless dancers, is also said to have premiered "There'll Be a Hot Time in the Old Town Tonight," published in 1896, and "Ta-Ra-Ra-Boom-De-Ay," published in 1891 (Jasen and Tichenor, *Rags and Ragtime*, 28).

20. W. C. Handy, who knew about ukeleles, heard this sort of guitar playing in a railroad station in Tutwiler, Mississippi in 1903, and called it "the weirdest music I had ever heard." Handy, *Father of the Blues*, 74; cf. 99, 123.

21. James Weldon Johnson, *Black Manhattan* (New York: Da Capo, 1991), 100.

22. Ida Wells and Frederick Douglass, "The Reason Why the Colored American Is Not in the World's Columbian Exposition" (Chicago, 1893) pointed out the lack of facilities, and called the famous "White City" of the Chicago World's Fair "a whited sepulchre."

23. Tom Turpin, "Harlem Rag" (1897) and "Bowery Buck" (Chicago: Will Rossiter, 1899). Turpin also published "A Rag-time Nightmare (March and Two-Step)" (Chicago: Rossiter, 1901), and one aptly named "The St. Louis Rag" (New York: Sol Bloom, 1903).

24. "Tin Pan Alley" was between Union Square and 28th Street and between Fifth and Broadway.

25. The ragtime pieces published the earliest as sheet music are all dated 1897: Tom Turpin, "Harlem Rag"; Kerry Mills, "At a Georgia Campmeeting," pub. by Kerry Mills; Jacob Henry Ellis, "Hannah's Promenade"; William Krell, "Mississippi Rag"; William Beebe, "Ragtime March"; R. J. Hamilton, "Ragtime Patrol"; Theodore H. Northrup, "Louisiana Rag"; and A. Shaw, "Rag-Ma-La."

26. Joplin, "The Favorite," published by A. W. Perry, Sedalia; "The Sycamore: A Concert Rag," published in Chicago; and "The Crysanthemum: An Afro-American Intermezzo."

27. The contest was held in New Douglass Hall, at Beaumont and Lawton Avenues, by Tom Turpin and his Rosebud Café. The review in *Palladium*, a St. Louis black newspaper, was found and reprinted by Jasen and Tichenor, *Rags and Ragtime*, 102–3.

28. Sitting Bull, who had played himself in Buffalo Bill's reenactments in the

1880s, had died fourteen years before, shot for resisting arrest by Indian police under U.S. orders on December 15, 1890. Buffalo Bill was still alive in 1904, but he was suing his wife for divorce and did not put on any shows.

29. It is now Washington University Fieldhouse, the site of the Clinton-Bush presidential debate on October 11, 1992.

30. The name of the hundred-yard-dash winner, for the record, was George Menz.

31. Legal segregation by race was just coming in in the southern United States, and such laws had been found constitutional by the Supreme Court in 1896 in the key case of *Plessy v. Ferguson*. See Charles A. Lofgren, *The Plessy Case: A Legal-Historical Interpretation* (New York: Oxford University Press, 1987).

32. Randy Sowell, Truman Library, personal communication.

33. "When I came out on the porch, a short man, wearing shorts, and in shirt-sleeves, and carrying oars over his shoulders, came across the yard. He had a fine intelligent face, a little nervous perhaps, but with beautiful eyes. . . . one of the finest descriptive psychologists of our age." Harald Høffding, *Erindringer*, trans. in Lewis S. Feuer, *Einstein and the Generations of Science* (1974; repr., New Brunswick, N.J.: Transaction Books, 1982), 119.

34. Hugh Kenner, *The Pound Era* (1971; repr., Berkeley: University of California Press, 1973), 17–22, 174.

35. C. S. Peirce, "Illustrations of the Logic of Science 2: How to Make Our Ideas Clear," *Popular Science* (January 1878); also in *Revue philosophique de la France et l'etranger.*

36. Peirce, "On Pragmatism and the Normative Sciences" was the first lecture, given on March 26, 1903. The third was "On Phenomenology, or the Categories." The seventh and probably the last lecture, "On Pragmatism and Abduction," was given on May 17, 1903. William James wrote that he did not understand it and avoided recommending its publication.

37. Hugo Münsterberg, "The Scientific Plan of the Congress," in *The International Congress of Arts and Sciences . . . Saint Louis, 1904* (Boston: Houghton Mifflin, 1905), 1:95.

38. Mach is said to have admitted that atoms might exist only after looking at a spinthariscope record of alpha particle impacts sometime after 1903: "Now I believe in the existence of atoms." Mach, *The Science of Mechanics,* ed. Jeremy Bernstein (Peru, Ill.: Open Court, 1989), xviii.

39. Ostwald, "Faraday Lecture," *Nature* 70 (1904); quoted in Florian Cajori, *A History of the Conceptions of Limits and Fluxions in Great Britain from Newton to Woodhouse* (Chicago: Open Court, 1919), 148.

40. Boltzmann, *Populäre Schriften* #2 (Leipzig, 1905), trans. Paul Foulkes, in *Theoretical Physics and Philosophical Problems,* ed. Brian McGuinness (Dordrecht: D. Reidel, 1974), 173.

41. Ostwald, "On the Theory of Science," in *International Congress of Arts and Sciences,* 4:349.

42. Ibid., 4:338.

43. Morton Prince, "Problems of Abnormal Psychology," in *International Congress of Arts and Sciences,* 5:754. The reference is probably to *Studies in Hysteria* of 1895.

44. James Bryce, *The American Commonwealth,* 2 vols. (1888); ed. and abr.

Louis M. Hacker (New York: Putnam, 1959); Werner Sombart, "Why Is There No Socialism in the United States?" *Archiv für Sozialwissenschaft und Sozialpolitik* (1907); later abbreviated in *International Socialist Review*. Sombart had published a multivolume history of capitalism in 1902. Bryce became the British Ambassador to the United States in 1907.

45. Harald Høffding, "The Present State of Psychology and its Relations to the Neighboring Sciences," in *International Congress of Arts and Sciences, 5*:627.

46. Paul Langevin, "The Relations of Physics of Electrons to Other Branches of Science," ibid., 4:124. The original was published as "La physique des électrons," *Revue générale des sciences pures et appliquées* 16 (1905), 257–76.

47. E. N. da C. Andrade, *Rutherford and the Nature of the Atom* (New York: Doubleday Anchor, 1964), 3, 70–78.

48. Ludwig Boltzmann, "On Statistical Mechanics (The Relations of Applied Mathematics)," in Boltzmann, *Populäre Schriften* #19, trans. in *International Congress of Arts and Sciences, 1*:593–603, and in *Theoretical Physics and Philosophical Problems,* ed. and trans. Brian McGuinness (Boston: D. Reidel, 1974), 159–72.

49. Boltzmann, *Theoretical Physics and Philosophical Problems,* ed. McGuinness, 159.

50. Ibid., 160, 162, 163, 169.

51. Ibid., 169; quoted in Engelbert Broda, *Ludwig Boltzmann: Man, Physicist, Philosopher* (Woodbridge, Conn.: Ox Bow Press, 1983), 84, 48.

52. Boltzmann, *Theoretical Physics and Philosophical Problems,* ed. McGuinness, 171.

53. Ibid., 172; quoted in Broda, *Ludwig Boltzmann,* 86.

54. Henri Poincaré, "The Principles of Mathematical Physics," in *International Congress of Arts and Sciences, 1*:608.

55. Ibid., 1:607.

56. Ibid., 1:609.

57. Ibid., 1:615.

58. Poincaré, *Les Méthodes nouvelles de la mécanique céleste,* vol. 3 (Paris, 1899), 389.

59. Poincaré, "Principles . . . ," in *International Congress of Arts and Sciences, 1*:616–17.

60. Ibid., 1:610.

61. Ibid., 1:611.

62. Poincaré, "La Mesure du temps," *Revue de métaphysique et de morale* 6 (1898).

63. Poincaré, "Principles . . . ," in *International Congress of Arts and Sciences, 1*:612.

64. Ibid., 1:621–22.

65. Boltzmann, *Principien der Naturfilosofi / Lectures on Natural Philosophy, 1903–1906,* ed. Ilse M. Fasol (New York: Springer, 1990).

66. Geronimo, quoted in Phillips Verner Bradford and Harvey Blume, *Ota Benga: The Pygmy in the Zoo* (New York: St. Martin's, 1992), 227.

67. "Au cours de nos conversations, pendant la semaine qu'il me donna la joie de passer seul avec lui en 1904, dans les vastes plaines de l'Amérique du Nord, au retour du Congrès de Saint-Louis, j'eus l'occasion de voir avec quel intérêt

passionné Henri Poincaré suivait toutes les phases de la révolution qui s'accomplissait ainsi dans nos conceptions les plus fondamentales." Paul Langevin, "L'Oeuvre d'Henri Poincaré: Le physicien," *Revue de métaphysique et de morale* 21 (1913), 702.

FIFTEEN

1. Albert Einstein, "On the Method of Theoretical Physics," in Einstein, *Ideas and Opinions* (1954; repr., New York: Dell/Laurel, 1973), 266; "Physics and Reality," ibid., 287; "On the Generalized Theory of Gravitation," ibid., 334.

2. If the *Annalen der Physik* of 1905 is another 1886 *La Vogue*, Drude is its Fénéon. He became editor early in 1905 and committed suicide in 1906.

3. Poincaré, *Science and Hypothesis,* trans. W. J. G. (1905; repr., New York: Dover, 1952), 141.

4. Albert Einstein (Milan) to Mileva Maric, 13 September 1900, in Einstein, *Collected Papers, Vol. 1, 1879–1902,* ed. John Stachel, trans. Anna Beck (Princeton: Princeton University Press, 1987), 149.

5. "I never met Willard Gibbs; perhaps, had I done so, I might have placed him beside Lorentz," Einstein said the year before he died, meaning Hendrik Lorentz, the only contemporary scientist Einstein unreservedly admired. When he finally read Gibbs's book in 1918, Einstein called it "a masterpiece, even though it is hard to read." Abraham Pais, *"Subtle is the Lord . . .": The Science and the Life of Albert Einstein* (New York: Oxford University Press paperback, 1983), 73. Poincaré had made exactly the same complaint in St. Louis.

6. Lenin, *Materialism and Empirio-Criticism* (St. Petersburg, 1908). Lenin's tract against the Machians and energeticists, written in Switzerland, was the first book he published.

7. Katya Adler, interview with Lewis S. Feuer, 31 March 1977, in Feuer, *Einstein and the Generations of Science* (1974; repr., New Brunswick, N.J.: Transaction Books, 1982), xxxvi. That year Adler had been offered the Zurich professorship but had turned it down, telling the hiring committee Einstein was the better physicist.

8. Einstein, "The Religious Spirit of Science," in *Ideas and Opinions,* 50.

9. Pais, *"Subtle is the Lord . . . ,"* 36.

10. Ibid., 37.

11. Ibid., 42.

12. Einstein, *Collected Papers, Vol. 2, 1900–1909,* ed. John Stachel, trans. Anna Beck (Princeton: Princeton University Press, 1989), 86. Another translation by Hermann is in Arthur Fine, *The Shaky Game: Einstein, Realism, and the Quantum Theory* (Chicago: University of Chicago Press, 1988), 14–15.

13. Einstein used a method much like this in his other paper of 1905, on the Brownian movement.

14. Einstein, *Collected Papers,* 2:94, 96, 97.

15. Einstein to Mileva Maric, 28 May 1902, in *Collected Papers,* 1:174.

16. Einstein, "How I Created the Relativity Theory," lecture in Kyoto, Japan, 14 December 1922; in Pais, *"Subtle is the Lord . . . ,"* 139.

17. Ibid., 131. Einstein mentions the "good idea [that] occurred to me in Aarau" in a letter to Mileva Maric, 10 September 1899, in *Collected Papers,* 1:133.

18. George Francis FitzGerald, "The Ether and the Earth's Atmosphere," *Science* (1889)—a one-paragraph note proposing the Contraction.

19. Hermann von Helmholtz, *Popular Lectures on Scientific Subjects,* trans. E. Atkinson, 2 vols. (London: Longmans, Green, 1884). The Academy would have read it in German.

20. "Together we read, after Pearson, Mach's *Analysis of Sensations* and *Mechanics* which Einstein had browsed through previously, Mill's *Logic,* Hume's *Treatise on Human Nature,* Spinoza's *Ethics,* some of Helmholtz's memoirs and lectures, some chapters from André-Marie Ampère's *Essay on Philosophy,* Riemann's *On the Hypotheses Which Serve as a Basis for Geometry,* some chapters from Avenarius' *Critique of Pure Experience,* [William Kingdon] Clifford's *On the Nature of Things in Themselves,* Dedekind's *What Are Numbers?,* Poincaré's *Science and Hypothesis,* which engrossed us and held us spellbound for weeks, and many other works." *Albert Einstein: Lettres à Maurice Solovine,* ed. M. Solovine (Paris: Gauthier-Villars, 1956); trans. Wade Baskin (New York: The Philosophical Library, 1987), 8–9.

21. Poincaré, *Science and Hypothesis,* 90.

22. Ibid., 163, 168, 176.

23. Einstein (Schaffhausen) to Maric, 17 December 1901, in *Collected Papers,* 1:187.

24. Einstein (Schaffhausen) to Maric, 28 December 1901, ibid., 1:189.

25. Einstein, "How I Created the Relativity Theory," lecture in Kyoto, Japan, 14 December 1922; in Pais, *"Subtle is the Lord . . . ,"* 139.

26. "[L]iegt erst im Konzept vor und ist eine Elektrodynamik bewegter Körper unter Benützung einer Modifikation der Lehre von Raum und Zeit." Einstein, *Collected Papers,* 5:27, 31. I quote an earlier translation by Gerald Holton which reads *legt* for *liegt erst.* Holton, *Thematic Origins of Scientific Thought: Kepler to Einstein* (Cambridge: Harvard University Press, 1988), 197.

27. The most complete discussion in print on the circumstances and immediate consequences of Special Relativity is Arthur I. Miller, *Albert Einstein's Special Theory of Relativity: Emergence (1905) and Early Interpretation (1905–1911)* (Reading, Mass.: Addison-Wesley, 1981).

28. "I stand at the window of a railway carriage which is traveling uniformly, and drop a stone on the embankment. . . . I see the stone descend in a straight line." Einstein, *Relativity: The Special and the General Theory,* 15th ed., trans. Robert W. Lawson (New York: Crown Publishers, 1961), 9 and passim.

29. Alfred North Whitehead, *Science and the Modern World,* Lowell Lectures, Harvard University, 1925 (New York: Free Press, 1967).

30. Paul Langevin, "L'évolution de l'espace et du temps," *Scientia* 10 (1911), 31–54. An abstract in *Revue de métaphysique et de morale* (1911), 455–66, reads "dans un projectile que la Terre lancerait avec une vitesse suffisamment voisine de celle de la lumière" (p. 466).

31. Fourth-dimension speculations in English include Johann Zollner's two papers endorsing Henry Slade in *Quarterly Journal of Science and Transcendental*

Physics (1877), cited in Michio Kaku, *Hyperspace: A Scientific Odyssey through Parallel Universes, Time Warps, and the 10th Dimension* (New York: Oxford University Press, 1994, 49–52); A. A. Robb, *A Geometry of Time and Space* (Cambridge: Cambridge University Press, 1936); Edwin Abbott Abbott, *Flatland: A Romance of Many Dimensions by a Square* (1884; repr., New York: Dover, n.d.); Howard Hinton, *What Is the Fourth Dimension? Ghosts Explained* (London: Swann Sonnenschein, 1884); A. T. Schofield, *Another World* (1888); N. A. Morosoff, "Letter to My Fellow-Prisoners in the Fortress of Schlüsselburg" (1891); Oscar Wilde, *The Canterville Ghost* (1891); and Hermann Schubert, "The Fourth Dimension," in *Mathematical Essays and Recreations* (Chicago: Open Court, 1898). H. G. Wells, *The Time Machine: An Invention* (London: Heinemann, 1895) is best-known among several stories he wrote on this theme; and in *The Inheritors* (1901), by Joseph Conrad and Ford Madox Ford, supermen from the fourth dimension take over our world. Many of these are discussed in Linda Dalrymple Henderson, *The Fourth Dimension and Non-Euclidean Geometries in Modern Art* (Princeton: Princeton University Press, 1986).

32. To give an idea of what was being published on the fourth dimension in the other languages Einstein knew, one might simply list those of the year 1903: E. Jouffret, *Traité élémentaire de géométrie à quatre dimensions* (Paris: Gauthier-Villars, 1903); Maurice Boucher, *Essai sur l'hyperespace: Le Temps, la matière et l'énergie* (Paris: Felix Alcan, 1903); Boucher, "La Relativité de l'espace euclidien," *Revue scientifique,* 4th ser., 20 (25 July 1903), 97–108; Poincaré, "L'Espace et ses trois dimensions," *Revue de métaphysique et de morale* 2 (1903), 281–301, 407–29, reprinted as chapters 3 and 4 in *La Valeur de la science* (1905; repr., Paris: Flammarion/Champs, 1970); and two articles by Einstein's fellow Olympian and former classmate, Marcel Grossman, "Die Konstruktion des geradelinien Dreiecks der nichteuklidischen Geometrie aus dem 3 Winkeln" and "Die fundamentalen Konstruktionen der nichteuklidischen Geometrie."

33. A colleague, Sam Keany, reminds me that one may take the time a clock-setting message takes to get from one clock to another and back, divide it by two, and add it to the time on each clock; but this, as Poincaré pointed out in "La Mesure du temps," is not quite the same thing as simultaneity.

34. Einstein, "Does the Inertia of a Body Depend on its Energy-Content?" *Annalen der Physik* 18 (26 November 1905), 639–41; in *Collected Papers,* 2:172–74. Einstein's notation used V instead of c, and L instead of E.

35. "The theory of relativity has justly excited a great amount of public attention. But, for all its importance, it has not been the topic which has chiefly absorbed the recent interest of physicists. Without question that position is held by the quantum theory." A. N. Whitehead, *Science and the Modern World,* Lowell Lectures, Harvard University, 1925 (New York: Free Press, 1967), 129. Biographer Pais agrees (Pais, *"Subtle is the Lord . . ."*).

36. Einstein described his moment of inspiration in the Kyoto lecture of 14 December 1922, quoted in Pais, *"Subtle is the Lord . . . ,"* 179. He began drawing the consequences of the idea in the fall of 1907 and mentioned it in a letter to Conrad Habicht on December 24 of that year (*Collected Papers,* 5:47). The description of it as "the happiest thought of my life" comes from Einstein's so-called Morgan MS and is quoted in Pais, *"Subtle is the Lord . . . ,"* 178.

SIXTEEN

1. The lore and scholarship that had been accumulating around this pivotal painting for nearly ninety years has now at last been collected and sifted by William Rubin, Hélène Seckel, and Judith Cousins in an indispensable book called *Les Demoiselles d'Avignon* (New York: Museum of Modern Art/Abrams, 1995). The book, which includes the English version of Rubin's article "The Genesis of *Les Demoiselles D'Avignon*" from the catalog of the big 1988 Paris exhibition edited by Seckel *(Les Demoiselles d'Avignon,* 2 vols. [Paris: Réunion des Musées Nationaux, 1988]), appeared after this chapter was written, as did the now standard biography by John Richardson *(A Life of Picasso, vol. 1, 1881–1906* [New York: Random House, 1991]) and a much-discussed 1995 profile by Norman Mailer.

2. See chapter 10, this volume. Max Jacob's memoir is "Souvenirs sur Picasso contés par Max Jacob," *Cahiers d'Art* 6 (1927), 202; trans. Marilyn McCully and Michael Raeburn in McCully, ed., *A Picasso Anthology* (Princeton: Princeton University Press, 1982), 54–55.

3. Fernande Olivier, *Picasso et ses amis* (1933), in Pierre Cabanne, *Le Siècle de Picasso,* vol. 1, *La Naissance du cubisme* (Paris Denoël/Gonthier, 1975), 195; trans. Jane Miller, *Picasso and his Friends* (London, 1964), 27.

4. Picasso to Roland Penrose in Penrose, *Picasso: His Life and Work* (London: Gollancz, 1958), 352; in Dore Ashton, ed., *Picasso on Art: A Selection of Views* (1972; repr., New York: Da Capo, n.d.), 30. At least 809 studies have been counted according to the new comprehensive work by Carsten-Peter Warncke, *Pablo Picasso, 1881–1973,* ed. Ingo F. Walther (Cologne: Benedikt Taschen, 1995), 1:146. Joseph Palau i Fabre, *Picasso: The Early Years, 1881–1907* (New York: Rizzoli, 1981) is also comprehensive for Picasso's early work, and not too many new details have been added since it was published.

5. André Salmon, "Histoire anecdotique du cubisme," in Salmon, *La Jeune peinture française* (Paris, 1913); "L'Anniversaire du cubisme," in Salmon, *L'Art vivant* (Paris: G. Crès, 1920). Translations are reprinted in Rubin et al., *Les Demoiselles d'Avignon,* 244–49.

6. "*Les Demoiselles d'Avignon,* how this title irritates me. Salmon invented it. You know very well that the original title from the beginning had been *The Brothel of Avignon.*" Picasso to Daniel-Henry Kahnweiler, in Kahnweiler, "Huit entretiens avec Picasso," *Le Point* 7, no. 42 (October 1952), 24; in Ashton, *Picasso on Art,* 153.

7. Rolf Laessøe, "A Source in El Greco for Picasso's *Les Demoiselles d'Avignon,*" *Gazette des Beaux-Arts* 110 (October 1987), 1425.

8. Louis de Vauxcelles's article on the "fauves" at the Salon d'Automne appeared in *Gil Blas,* 17 October 1905; reprinted in Jack Flam, ed., *Matisse: A Retrospective* (New York: Hugh Lauter Levin Associates, 1988), 47.

9. Herschel B. Chipp, ed., *Theories of Modern Art: A Source Book by Artists and Critics* (Berkeley: University of California Press, 1968), 203.

10. Picasso, quoted in Romuald Dor de la Souchère, *Picasso à Antibes* (Paris: Hazan, 1960), 14; in Ashton, *Picasso on Art,* 154. This quotation, by the way, suggests that Picasso went to the Musée de l'Homme before the warm days began

in May; but June is the date cubism's leading historian, John Golding, and most other experts prefer. Golding, *Cubism: A History and an Analysis, 1907–1914,* 3d ed. (Cambridge: Harvard University Press, Belknap Press, 1988), 45.

11. Christian Zervos, *Pablo Picasso* 2, no. 1 (1942), 10. Picasso to André Malraux, quoted in Golding, *Cubism,* 45. Malraux's account of Picasso's encounter with "primitive" art is in Malraux, *Picasso's Mask,* trans. June Guicharnaud (New York: Holt Rinehart and Winston, 1976).

12. This description of Picasso at work is quoted by Tom Prideaux, "The Terrible Ladies of Avignon," *Life* 65, no. 26 (27 December 1968), 51.

13. Malraux, *Picasso's Mask,* 18; quoted in William Rubin, "Picasso," in Rubin, ed., *"Primitivism" in 20th Century Art,* Exhibit Catalogue (New York: Museum of Modern Art, 1984), 1:255.

14. Michael Leja, "Le Vieux marcheur et 'les deux risques': Picasso, prostitution, venereal disease, and maternity, 1899–1907," *Art History* 8, no. 1 (March 1985).

15. These aspects of the *Demoiselles* were resurrected in a ground-breaking article by Leo Steinberg, "The Philosophical Brothel," parts 1 and 2, *Art News* 71, no. 5 (September 1972), 22–29; no. 6 (October 1972), 38–47.

16. Fénéon's visit is mentioned in Wilhelm Uhde, *Von Bismarck bis Picasso: Erinnerungen und Bekenntnisse* (Zürich: Oprecht, 1938), 142; and he is quoted by Picasso himself in Roland Penrose, *Picasso: His Life and Work* (New York: Harper and Row, 1973), 134.

17. Leo Stein, *Appreciation: Painting, Poetry and Prose* (1947; New York: Random House/Modern Library paperback, n.d.), 140.

18. Shchukin was quoted in Gertrude Stein, *Picasso* (1938; New York: Dover, 1984), 18.

19. Matisse is quoted in Penrose, *Picasso* (1973), 130.

20. Derain was first quoted in Kahnweiler, "Der Kubismus," *Die Weissen Blätter* (Zürich) 3, no. 9 (23 September 1916), 214; trans. in Rubin et al., *Les Demoiselles d'Avignon,* 234.

21. Uhde's "something Assyrian" is quoted by Kahnweiler in *My Galleries and Painters* (New York: Viking, 1971), 38. "Egyptian" is the adjective Uhde uses in Kahnweiler, "Naissance et développement du cubisme," in *Les Maîtres de la peinture française contemporaine,* ed. Maurice Jardot and Kurt Martin (Baden-Baden: Woldemar Klein, 1949), 14. Translations are in Rubin et al., *Les Demoiselles d'Avignon,* 255. Uhde's own memoir has the *Demoiselles* influenced by "negro art" but calls it neither "Egyptian" or "Assyrian."

22. "I have said that Cubism was born on the right half of *Les Demoiselles d'Avignon.* . . ." Daniel-Henry Kahnweiler, *Juan Gris: Sa vie, son oeuvre, ses écrits* (Paris: Gallimard, 1946); trans. Douglas Cooper, *Juan Gris: His Life and Work* (New York: Abrams, 1969), 108, 110.

23. Braque was first quoted by Kahnweiler, "Der Kubismus," 214, and later by others. The part about "tow" was added by André Salmon, *L'Art vivant,* 123. The dialogue about noses is first found in Maurice Raynal, "Panorame de l'oeuvre de Picasso," *Le Point* 7, no. 42 (October 1952), 13. Translations are in Rubin et al., *Les Demoiselles d'Avignon,* 229.

24. Matisse seems to have told Vauxcelles about Braque's "petits cubes" at the Salon d'Automne in Paris toward the end of September 1908. Vauxcelles's

article on Braque's "cubes" appeared in *Gil Blas* on November 14; the reference to Braque's "bizarreries cubiques" in his *Gil Blas* article on the Salon des Indépendants, 25 May 1909. Golding, *Cubism,* 3.

25. The fabled "Banquet Rousseau" is described in three not entirely compatible reports by Fernande Olivier (*Picasso and his Friends,* 68–70), Gertrude Stein (*The Autobiography of Alice B. Toklas* [New York and London, 1933], 106–7), and André Salmon ("Testimony against Gertrude Stein," *Transition* #23, pamphlet #1 Supplement [The Hague, February 1935], 14–15). Rousseau's ineffable judgment is found in Cabanne, *Le Siècle de Picasso,* 1:259.

SEVENTEEN

1. August Strindberg, *Samlade Skrifter,* vol. 50, 288; in Martin Lamm, *August Strindberg,* trans. Harry G. Carlson (New York: Benjamin Blom, 1971), 392.

2. Provincetown Players Program, 1924; in Eric Bentley, *The Playwright as Thinker* (1946; New York: Harcourt Brace Jovanovich, 1987), 195 n.

3. "The lords have sent an envoy with a challenge to the Earl Bothwell." Quoted in Michael Meyer, *Strindberg: A Biography* (1985; New York: Oxford University Press, 1987), 26. Meyer's is the standard for Strindberg biography in English.

4. Strindberg, "Om modernt drama och modern teater" (On Modern drama and the Modern theater), in *Ny Jord* (Copenhagen, 1889); quoted in Meyer, *Strindberg,* 211.

5. *Shaw's Dramatic Criticism,* ed. John F. Matthews (New York: Hill and Wang, 1959; Westport, Conn.: Greenwood Press, 1971), 75.

6. Ibsen, *A Doll's House,* Act III, in *The Oxford Ibsen,* vol. 5 (London: Oxford University Press, 1961), 63.

7. Strindberg, *Strindberg's Letters,* ed. and trans. Michael Robinson (Chicago: University of Chicago Press, 1992), 1:141.

8. Later in life Kokoschka described the subject of *Mörder, Hoffnung der Frauen:* "It was just what I had dreamed about women when I was younger. . . . I am the stronger! I wouldn't be swallowed by her." Oskar Kokoschka, *Dramen und Bilder,* trans. in Henry I. Schvey, *Oscar Kokoschka, The Painter as Playwright* (Detroit, Mich.: Wayne State University Press, 1982), 34.

9. Ibsen to Hans Osterling, 15 November 1887, in Meyer, *Strindberg,* 186.

10. Meyer, *Strindberg,* 266 n.

11. Ibsen, *Address,* 1887, in Bentley, *The Modern Theater,* 131.

12. Strindberg, *Letters,* 1:280.

13. Strindberg, *Miss Julie,* trans. Helen Cooper (London: Methuen, 1992), xiv–xv. Compare Strindberg's instructions to actors in about 1907 when *A Dream Play* was produced: "if the age is skeptical, insensitive, and democratic, as our age is . . . Tragedy itself adopts the tone of light conversation. . . . Verse gives way to prose; genres are mixed; kings don't dare to set themselves above the mob; everybody talks the same language and nobody is finicky about the words he uses." Strindberg, "Notes to Members of the Intimate Theater" (1907–9), in *The Chamber Plays,* trans. Evert Sprinchorn, S. Quinn Jr., and K. Peterson, 2d ed. (Minneapolis: University of Minnesota Press, 1981), 217.

14. "We have renewed our acquaintance with Pierrot, but a nineteenth-

century version who knows his Charcot." Strindberg, "On Modern Drama . . . ;" quoted in Meyer, *Strindberg*, 213.

15. Strindberg, *A Dream Play and Four Chamber Plays*, trans. Walter Johnson (New York: Norton, 1975), 19.

16. Falck, quoted in Meyer, *Strindberg*, 491.

EIGHTEEN

1. In 1918 Pressburg became Bratislava when that part of Hungary became Czechoslovakia.

2. Arnold Schoenberg, "How One Becomes Lonely" (1937), trans. Leo Black, in Edward Stein, ed., *Style and Idea: Selected Writings of Arnold Schoenberg* (Berkeley: University of California Press, 1975), 41.

3. Schoenberg, "National Music" (1931), in Stein, ed., *Style and Idea*, 173. Bruckner, it will be remembered, had tried (and failed) to teach Boltzmann to play the piano.

4. Malcolm MacDonald, *Schoenberg* (London: J. M. Dent, 1976), 90. There is no "definitive" biography of Schoenberg yet, but MacDonald's is both comprehensive and accessible.

5. Reviews cited in Barbara Tuchman, *The Proud Tower* (1966; New York: Bantam, 1967), 380. The performance was January 22. On January 23, the day reviews appeared, millionaire abusive husband Harry Thaw went on trial in lower Manhattan for the murder of his wife's lover. The new show drew similar reactions, and the State of New York closed it to the public; even so, the trial had an eleven-week run.

6. In Tuchman, *The Proud Tower*, 380.

7. Alex Ross has argued that the music is, on the contrary, at least partly Modernist. Ross, "'Salomé': A Party Run Amok?" *New York Times*, 15 October 1995, H35, 38.

8. Though Stravinsky would require an orchestra of 108 performers, including 24 woodwinds, for *Le Sacre du Printemps* in 1913. See chapter 21 of this volume.

9. The works are Strauss's tone poem, *Also Sprach Zarathustra*, and Mahler's *Symphony #3*, both composed in the summer of 1896.

10. Victor and Marina Ledin, liner notes to Scriabin, *Universe* [Mysterium: Prefatory Act], reconstructed and conducted by Alexander Nemtin, Russian Disc compact disc 11 004.

11. Chabrier's opera was *Le Roi malgré lui*, whose premiere in 1887 was judged by Ravel to have "changed the direction of harmony in France." Quoted in Alan M. Gillmor, *Erik Satie* (New York: Twayne, 1990), 20.

12. Fauré is perhaps best known to Americans for his much performed *Requiem*, a choral mass composed in 1877 and more in the Wagner-Franck manner than most of his work.

13. "Monsieur, I not only love, admire and venerate your music, I have been, still am in love with it. . . . The other evening I became intoxicated for the first time with *Le Parfum impérissable* [an 1897 setting of a poem by Leconte de Lisle], and this is a dangerous intoxication for since then I have returned to it

every day." Proust to Fauré, in J. Barrie Jones, trans. and ed., *Gabriel Fauré: A Life in Letters* (London: B. T. Batsford, 1989), 86.

14. It was the fourth time he had quoted this tune. The other three occur in Debussy, *La Belle au bois dormant* (1883), *Images #0* (1894) for piano, and *Estampes* (1903) for piano. The second line of this song, "les lauriers sont coupés," had supplied a title to Debussy's friend Dujardin, for his pioneering stream-of-consciousness novel in 1887.

15. Debussy to Ernest Chausson, 2 July 1893, in *Debussy Letters*, ed. François Lesure and Roger Nichols (Cambridge: Harvard University Press, 1987), 47.

16. From a dispatch by the Paris correspondent of the London *Era*, 21 December 1908; in Nicolas Slonimsky, *Music Since 1900*, 5th ed. (New York: Macmillan, Schirmer Books, 1994), 80.

17. Eric Salzman, *Twentieth-Century Music: An Introduction* (Englewood Cliffs, N.J.; Prentice-Hall, 1967), 16.

18. Dating Ives's work is always problematic, since several of his own dates are not reliable (Maynard Solomon, "Charles Ives: Some Questions of Veracity," *Journal of the American Musicological Society* 40, no. 3 [Fall 1987], 443–70). Geoffrey Block, Peter Burkholder, and Terry Milligan have published useful guides. The standard biography as of this writing was Frank R. Rossiter, *Charles Ives & His America* (New York: Liveright, 1975).

19. Vivian Perlis, ed., *Charles Ives Remembered: An Oral History* (1974; New York: Da Capo, 1994), 19.

20. "The 'Telephone' Song," a hit of 1899 ("Hello, my baby! Hello, my honey! Hello, my ragtime gal").

21. The safe was recalled by Ives's longtime partner, Julian Myrick, in Perlis, ed., *Charles Ives Remembered*, 34–38.

22. Jelly Roll Morton, *Anamule Dance*, vol. 2 of the Library of Congress Recordings (1938; Cambridge, Mass.: Rounder Records, 1993); Alan Lomax, *Mister Jelly Roll* (1950; New York: Pantheon, 1993), 157.

23. The earliest reference in the *Oxford English Dictionary* is to "the jazz" as a kind of dance in C. Stewart, *Uncle Josh in Society*, 1909.

24. "What is scurrilously called ragtime is an invention that is here to stay. Syncopations are no indication of light or trashy music, and to shy bricks at 'hateful ragtime' no longer passes for musical culture." Scott Joplin, *The School of Ragtime: Six Exercises for Piano* (1908), in *The Collected Works of Scott Joplin*, ed. Vera Brodsky Lawrence, 2 vols. (New York: New York Public Library in association with Belwin Mills Publishing, 1971), 1:284.

25. Ian Whitcomb, *Irving Berlin & Ragtime America* (1987; New York: Limelight Editions, 1988), 69.

26. He was. The opera became *Treemonisha* and was published at Joplin's own expense in 1911, the year of "Alexander's Ragtime Band."

27. Schoenberg's *Pelleas* had been undertaken before Debussy put his seal on the subject with an opera. In the end, Maeterlinck's play was set by no less than four of his contemporaries, all of them composers of genius, with the addition of incidental music by both Fauré and Sibelius.

28. Schoenberg, *Der biblische Weg* (1927), quoted in MacDonald, *Schoenberg*, 54.

29. Schoenberg, "How One Becomes Lonely" (1937), in Stein, ed., *Style and Idea*, 42.

30. Ibid., 49. The most careful account of what Schoenberg was composing in 1906–8 is Walter Frisch, *The Early Works of Arnold Schoenberg, 1893–1908* (Berkeley: University of California Press, 1993).

31. Schoenberg, "How One Becomes Lonely," in Stein, ed., *Style and Idea*, 49.

32. These were *Zwei Lieder*, Opus 14, *Das Buch der hängenden Gärten*, Opus 15, and *String Quartet #2*, Opus 10.

33. Schoenberg, "How One Becomes Lonely," in Stein, ed., *Style and Idea*, 49–50.

34. Schoenberg, "My Evolution" (1949), ibid., 86.

35. "I composed three-fourths of both the second and fourth movements of my Second String Quartet in one-and-a-half days each." Schoenberg, "Heart and Brain in Music" (1946), ibid., 55.

36. Herewith the complete text, in the original German, of Stefan George, "Entrückung" (Ecstatic transport), in *Der siebente Ring* (The seventh ring) (Berlin, 1907); the partial translation is in Joan Peyser, *20th Century Music: The Sense Behind the Sound* (New York: Macmillan, Schirmer paperback, 1980), 22—but I have retranslated several lines in the text.

> *Ich fühle Luft von anderem Planeten*
> *Mir blasen durch das Dunkel die Gesichter*
> *Die freundlich eben noch sich zu mir drehten*
>
> *Und Bäum' und Wege die ich liebte fahlen*
> *Dass ich sie kaum mehr kenne und du lichter*
> *Geliebter Schatten rufer meiner Qualen*
>
> *Bist nun erloschen ganz in tiefern Gluten*
> *Um nach dem Taumel streitenden Getobes*
> *Mit einem frommen Schauer anzumuten*
>
> *Ich löse mich in tönen kreisend, webend*
> *Ungründigen Danks und unbenamten Lobes*
> *Dem grossen Atem wunchlos mich ergebend*
>
> *Mich überfährt ein ungestümes Wehen*
> *Im Rausch der Weihewain brünstige Schreie*
> *In staubgeworfner Beterinnen flehen*
>
> *Denn seh' ich wie sich duftige Nebel lüpfen*
> *In einer sonnerfüllten klaren Freie*
> *Die nur umfängt auf fernsten Berges schlüpfen*
>
> *Der Boden schüttert weiss und weich wie Molke*
> *Ich steige über Schluchten ungeheuer*
> *Ich fühle wie ich über letzter Wolke*
>
> *In einem Meerkristallnen Glanzes schwimme*
>
> *Ich bin ein Funke nur von heiligen Feuer*
> *Ich bin ein Dröhnen nur der heiligen Stimme*

37. Schoenberg, "Heart and Brain in Music" (1946), in Stein, ed., *Style and Idea*, 57.

38. Schoenberg, "My Evolution" (1949), ibid., 86.

39. "my quartet is in F-sharp minor." Schoenberg, "A Legal Question" (MS, 16 January 1909), ibid., 187.

40. Gerstl's family salvaged fifteen paintings, including *Mathilde Schoenberg, The Schoenberg Family*, and two *Self-Portraits*, and stored them until 1931. They are reproduced by permission of Otto Breicha in Peyser, *20th Century Music*, 24–25.

41. Schoenberg, "How One Becomes Lonely," in Stein, ed., *Style and Idea*, 46–48.

42. *Wiener Tageszeitung*, 23 December 1908; quoted in Slonimsky, *Music Since 1900*, 86–87.

43. "I could have understood a kind of smile when . . . the song, *Ach du lieber Augustin*. But this provoked an eruption of laughter; instead of an understanding smile." Schoenberg, "How One Becomes Lonely," in Stein, ed., *Style and Idea*, 48.

44. Richard Batka, *Prager Zeitung*, 28 December 1908; in Slonimsky, *Music Since 1900*, 87.

45. *Neue Wiener Tageblatt*, 22 December 1908; quoted in MacDonald, *Schoenberg*, 1.

46. Batka, *Prager Zeitung*, in Slonimsky, *Music Since 1900*, 87.

47. Quoted in MacDonald, *Schoenberg*, 1.

48. Batka, *Prager Zeitung*, in Slonimsky, *Music Since 1900*, 87.

49. *Neue Wiener Tageblatt*, 22 December 1908; quoted in MacDonald, *Schoenberg*, 1.

50. *Neue Wiener Abendblatt*, 22 December 1908, in Ursula von Rauchhaupt, ed., *Schoenberg, Berg, Webern, the String Quartets: A Documentary Study* (Hamburg, 1971), 145; quoted in MacDonald, *Schoenberg*, 1–2.

51. Batka, *Prager Zeitung*, in Slonimsky, *Music Since 1900*, 87.

52. *Wiener Tageszeitung*, 23 December 1908; in Slonimsky, *Music Since 1900*, 86–87.

53. Schoenberg, "A Legal Question," in Stein, ed., *Style and Idea*, 188.

54. Schoenberg, "How One Becomes Lonely," ibid., 46.

55. Schoenberg, "A Legal Question" (MS, 16 January 1909), ibid., 185–89.

56. Schoenberg, "How One Becomes Lonely," ibid., 49–50.

57. Ibid., 30.

58. Among these musicologists is the eloquent Richard Taruskin. Cf. Taruskin, "A Myth of the Twentieth Century: *The Rite of Spring*, the Tradition of the New, and 'Music Itself,'" *Modernism/Modernity* 2, no. 1 (1995), 1.

59. And popular music as well, as a comparison of rap with minimalism may show.

60. Schoenberg, "A Self-Analysis" (1948), in Stein, ed., *Style and Idea*, 78.

61. Webern composed fifteen settings for Stefan George poems in 1908. His Opus 1, *Passacaglia for Orchestra*, a set of twenty-three short variations, premiered on November 4, 1908. Berg's Opus 1 was his *Piano Sonata #1*, finished in the same year.

62. The most careful introduction to Bartók in English is László Somfai, *Béla Bartók: Composition, Concepts, and Autograph Sources* (Berkeley: University of California Press, 1996).

63. The concert was Prokofiev's debut. In Russia, where the old Julian calendar was still used, the date was December 18.

NINETEEN

1. James Joyce, *A Portrait of the Artist as a Young Man,* ed. Chester G. Anderson (New York: Viking-Penguin, 1977), 1.

2. Richard Ellmann, *James Joyce* (New York: Oxford University Press paperback, 1965), 282. Ellmann's is not only the indispensable biography of Joyce; it is by common consent one of the greatest literary biographies ever written.

3. Joyce to Stanislaus Joyce, 12 July 1905, in *Selected Letters of James Joyce,* ed. Richard Ellmann (New York: Viking, 1975).

4. Joyce, *Stephen Hero* (New York: New Directions, 1963), 53.

5. Joyce, *Portrait,* 165.

6. Joyce, *Stephen Hero,* 211, 213.

7. Joyce, *Portrait,* 167.

8. Joyce, *Stephen Hero,* 84.

9. Ellmann, *James Joyce,* 69.

10. Ibid., 81.

11. Joyce, *Stephen Hero,* 40.

12. Ibid., 186, 204.

13. August Strindberg, *By the Open Sea,* trans. Mary Sandbach (New York: Penguin, 1987), cf. 85. Strindberg's first novel, *The Red Room* (1879), was in the discontinuous form of sketches, but Joyce did not know it either. Strindberg, *The Red Room,* trans. Elizabeth Sprigge (New York: Dutton, 1967).

14. Conrad's extraordinarily complicated way of telling a story has only recently been taken apart and assessed by literary critics. See Jakob Lothe, *Conrad's Narrative Method* (New York: Oxford University Press, 1989).

15. In Joyce, *Selected Letters,* 7.

16. Thomas Mann, *Buddenbrooks,* part 10, chapter 5, trans. H. T. Lowe-Porter (New York: Vintage, 1952), 504–16.

17. Schnitzler's priority was no fluke. Freud thought of him as a spiritual double, and learned some narrative technique from him. Moreover, two years before publishing *Gustl* he had read "a very one-of-a-kind story by Dujardin; Les lauriers sont coupés." Arthur Schnitzler to Marie Reinhard (Berlin), 3 October 1898, in Schnitzler, *Briefe,* ed. Therese Nickl and Heinrich Schnitzler, 2 vols. (Frankfurt am Main: Fischer, 1981).

18. Ellmann, *James Joyce,* 138. Lydia Ginzburg (*On Psychological Prose,* trans. J. Rosengrant [Princeton: Princeton University Press, 1994]) calls Tolstoy the first literary Modernist, noting in particular Anna Karenina's stream of consciousness as she prepares to go under the train.

19. Joyce to Stanislaus Joyce, 18 September 1905, in *Selected Letters,* 73.

20. There may be an oblique reference to "Sebastopol in May" in *Ulysses,* where Bloom keeps putting his father-in-law Tweedie at the battle of Plevna in the Russo-Turkish War of 1877, although no Englishmen had any reason to be

there. The Russian general at Plevna had also been in charge at Sebastopol in 1854, when the English were the enemy and gave Tolstoy's Praskukhin the fatal wound that provoked the earliest interior monologue in Russian literature. It is probably not significant that Garshin's story is set in the Russo-Turkish War.

21. Charles de Sivry, "L'Indécision," *Saynètes et Monologues*, 3d ser. (1878).

22. Edouard Dujardin, *Le Monologue intérieur: son apparition, ses origines, sa place dans l'oeuvre de James Joyce et dans le roman contemporain* (Paris: Albert Messein, 1931). Dujardin does not mention, presumably because he did not know, that he had himself passed the interior monologue on to Schnitzler. At least one critic, John Porter Houston, has claimed stream of consciousness for Dujardin's friend Jules Laforgue. "Laforgue's *Last Poems* can be seen as a kind of stream-of-consciousness novel in which we are situated so intimately in the main character's mind that we cannot easily distinguish fact from fantasy, past from present, real speech from imagined dialogue. . . . Dujardin's novel . . . [has] very little of the depth of memory or the play of daydream we find in Laforgue. The latter's elliptic technique and scrambling of planes of reference is actually much closer to a work like . . . *The Waves* . . . or . . . *The Sound and the Fury*." Houston, "Jules Laforgue," in J. Barzun and G. Stade, eds., *European Writers: The Romantic Century*, vol. 7 (New York: Scribner's, 1985), 1906.

23. Joyce, *Ulysses*, rev. ed. by Hans Walter Gabler (New York: Vintage, 1986), 868.

24. Joyce, *Portrait*, 215.

25. Joyce to Stanislaus Joyce, 15 December 1904, cited in Ellmann, *James Joyce*, 194 n. George Moore to Edmund Gosse, 1 March 1915, in Douglas A. Hughes, ed., *The Man of Wax: Critical Essays on George Moore* (New York: New York University Press, 1971), 224. Cf. Melvin Friedman, *Stream of Consciousness: A Study in Literary Method* (New Haven, Conn.: Yale University Press, 1955).

26. Moore to Dujardin, 22 July 1897, in *Letters from Geo. Moore to Edouard Dujardin, 1886–1922*, ed. John Eglinton (New York: Crosby Gaige, 1929), 40; Dujardin, *Le Monologue intérieur*, 18.

27. Joyce to Stanislaus, 19 January 1905, in *Selected Letters*, 51.

28. James R. Mellow, *Charmed Circle: Gertrude Stein and Company* (New York: Avon, 1975), 92.

29. Joyce to Stanislaus, c. 23 September 1905, in *Selected Letters*, 78.

30. Joyce to Mrs. William Murray ("Aunt Josephine"), 4 December 1905 (in *Selected Letters*, 81), asks for "a critique from a Dublin paper on Moore's novel [*The Lake*] in which Father O. Gogarty appears."

31. Joyce to Stanislaus, 31 August 1906, in *Selected Letters*, 100. 17 August 1905 is the date of the dedication to Dujardin in Moore, *The Lake*. Moore was with Dujardin at Fontainebleau at the time. George Moore, *Letters to Lady Cunard, 1895–1933*, ed. Rupert Hart-Davis (1957; Westport, Conn.: Greenwood Press, 1979), 44.

32. Joyce to Stanislaus, 6 September 1906, in *Selected Letters*, 101.

33. Joyce to Stanislaus, c. 18 September 1906, in *Selected Letters*, 106.

34. Moore, *The Lake* (1905, 1921), ed. Richard Allen Cave (Gerrards Cross, U.K.: Colin Smythe, 1980), 170–78.

35. Joyce, *Ulysses*, 158, lines 307–10.

36. Moore, *Confessions of a Young Man* (1888; New York: Putnam's, 1959); *Memoirs of My Dead Life* (1906; New York: Boni and Liveright, 1920); *Hail and Farewell*, 3 vols. (New York: Boni and Liveright, 1923); and *Conversations in Ebury Street* (1924; Dublin: Ebury Edition, 1936). Joyce seems not to have read the second, which was racy and thus privately printed, or the fourth.

37. Stein to Mabel Weekes, n.d., Yale Collection, quoted in Mellow, *Charmed Circle*, 101.

38. Ellmann, *James Joyce*, 261.

39. "PPS I have a new story for Dubliners in my head. It deals with Mr. Hunter." Joyce to Stanislaus Joyce, 30 September 1906, in *Selected Letters*, 112. "Jim told me he is going to expand his story 'Ulysses' into a short book and make a Dublin "Peer Gynt" of it." Stanislaus Joyce, *Diary*, 10 November 1907, in Ellmann, *James Joyce*, 274.

40. H. G. Wells's review is quoted in Robert H. Deming, ed., *James Joyce: The Critical Heritage*, Vol. 1: *1902–1927* (New York: Barnes and Noble, 1970), 87. Another reviewer, Edward Garnett, the publisher's reader for Heineman, thought *Portrait* "utterly fragmented." Hugh Kenner, *The Mechanic Muse* (New York: Oxford University Press, 1987), 72.

TWENTY

1. Franz Marc, *Papers*, 10 February 1911; in Susanna Partsch, *Franz Marc, 1880–1916* (Cologne: Benedikt Taschen, 1991), 30; cf. Hajo Düchting, *Kandinsky* (Cologne: Benedikt Taschen, 1991), 30.

2. Maria Makela, *The Munich Secession: Art and Artists in Turn-of-the-Century Munich* (Princeton: Princeton University Press, 1990), 6.

3. A critic in the English *Tait's Magazine* 17, no. 394/2 (1850) had referred to "the expressionist school of modern painters" (entry on "Expressionist" in *Oxford English Dictionary*). The French critic Louis Vauxcelles had used "expressioniste" earlier to describe work by Matisse; and in 1901 the painter Julien-Auguste Hervé had described the style of a group of his nature studies as "expressionisme" (Wolf-Dieter Dube, *Expressionism* [New York: Praeger, 1972], 18). These swallows seem to have failed to make a summer.

4. Kandinsky, *Über das Geistige in der Kunst* (On the spiritual in art) (1911), trans. in Kandinsky, *Complete Writings on Art*, ed. Kenneth Lindsay and Peter Vergo (New York: Da Capo, 1994), 218.

5. Kandinsky, *Rückblicke* (Reminiscences) (1913), trans. in *Complete Writings on Art*, 371–72.

6. Ibid., 363.

7. Ibid., 364.

8. Jelena Hahl-Koch, *Kandinsky* (New York: Rizzoli, 1993), 168–69. This is the indispensable biography of Kandinsky.

9. Kandinsky, "Three Pictures," appended to *Reminiscences* (1913), in *Complete Writings on Art*, 384.

10. Kandinsky, "Cologne Lecture" (1914), ibid., 397.

11. Ibid., 398.

12. Kandinsky, *Composition V* (oil on canvas), private collection, Switzerland.

13. Kandinsky, *Allerheiligen* (All saints) I (oil on card); *Allerheiligen* I (glass painting); *Allerheiligen* II (oil on canvas); *Engel des jüngsten Gerichtes* (Angel of the Last Judgment) (glass painting), all in Städtische Galerie im Lenbachhaus, Munich.

14. Kandinsky,*Apokalyptischer Reiter* (Rider of the Apocalypse) (tempera on glass); *St. Georg I, II,* and *III* (glass paintings and an oil); *Höllenhund und Paradiesvogel* (Hound of hell and bird of paradise) (glass painting). All are in the Städtische Galerie im Lenbachhaus, Munich.

15. Kandinsky, "Cologne Lecture," October 1914, in *Complete Writings on Art,* 399.

16. Kandinsky to Franz Marc, 2 October 1911, in Hahl-Koch, *Kandinsky,* 196.

17. Hideho Nishida, "Genèse de la première aquarelle abstraite de Kandinsky," *Art History* 1 (1978), 1–20.

18. Kandinsky to J. B. Neumann, 4 August 1935, in Hahl-Koch, *Kandinsky,* 181.

19. Ibid.

20. Kandinsky to J. B. Neumann, 28 December 1935, ibid., 184.

21. Kupka, *Girl with a Ball,* Musée national d'Art Moderne, Paris. The long genesis of *Amorpha* has been traced with great intelligence by Ludmila Vachtová in *Frank Kupka: Pioneer of Abstract Art* (New York: McGraw-Hill; London: Thames and Hudson, 1968).

22. Umberto Boccioni, Carlo Carrà, Luigi Russolo, Giacomo Balla, and Gino Severini, *Technical Manifesto of Futurist Painting,* Milan, 11 April 1910, and in *Comoedia* (Paris), 18 May 1910; trans. in Herschel B. Chipp, ed., *Theories of Modern Art: A Source Book by Artists and Critics* (Berkeley: University of California Press, 1968), 289–93.

23. Marcel Duchamp's *Nude Descending a Staircase II* (Philadelphia Museum of Art) was first exhibited in January 1912. Kupka's 1904 picture was *Ballad/Joys.*

24. Picasso, wrote Jean Metzinger, "defines a free, mobile perspective, from which that ingenious mathematician Maurice Princet has deduced a whole geometry." *Pan* (Paris), October–November 1910, 650; in Chipp, ed., *Theories of Modern Art,* 223. Princet's sources probably included: Charles Howard Hinton, *Scientific Romances* 1st and 2d ser. (London: Swan Sonnenschein, 1884–5, 1896); René de Saussure, "Les Phénomènes physiques et chimiques et l'hypothèse de la quatrième dimension," *Archives des sciences physiques et naturelles de Genève* (January–February 1891) and *Revue scientifique* (9 May 1891). For Poincaré and Pearson see chapter 15, this volume. Chapter 7 of Karl Pearson's *Grammar of Science* (London: Walter Scott, 1911) discusses motion with an extended example that may well have specifically inspired Marcel Duchamp's most celebrated painting: "Let us take . . . the case of a man ascending a staircase" (Pearson, *Grammar of Science,* 222 ff.). Lynda Dalrymple Henderson's wonderful book, *The Fourth Dimension and Non-Euclidean Geometries in Modern Art* (Princeton: Princeton University Press, 1986) collects most of the popular references to the fourth dimension with which the turn of the century was crowded. Michio Kaku's *Hyperspace: A Scientific Odyssey Through Parallel Universes, Time Warps, and the 10th Dimension* (New York: Oxford University Press, 1994) finds more. The plu-

rality of dimension was probably better understood and described for a broader public in 1900 than it is now. See chapter 15 in this volume, notes 32, 33.

25. Sonia Delaunay, *Nous irons jusqu'au soleil* (Paris: Laffont, 1978), 33. A biographical profile based primarily on these and other memoirs is Stanley Baron, with Jacques Damase, *Sonia Delaunay, the Life of an Artist: A Personal Biography Based on Unpublished Private Journals* (New York: Harry N. Abrams, 1995). The quilt, much faded, is now in the Musée national de l'Art Moderne in Paris.

26. Camilla Gray, *The Russian Experiment in Art, 1863–1922,* 2d ed. (New York: Thames and Hudson, 1986), 119. Short of a visit to the Čiurlionis Museum in Kaunas, Lithuania, one's best chance to see Čiurlionis's work is probably in a portfolio of reproductions: *M. K. Čiurlionis, 32 Reprodukcijos* (Vilnius: Grozines Literaturos Leidykla, 1961). For accounts of his career in English there is a special issue of the journal *Lituanus* 7, no. 2 (1961), with articles by George M. A. Hanfmann, Aleksis Rannit, Vyacheslav Ivanov, Raymond F. Piper, and Vladas Jakubenas; and notes by Romain Rolland, Bernard Berenson, Jacques Lipchitz, and Igor Stravinsky.

27. "This geometrical transparency seems to be an attempt to approach the possibilities of visual signalization of such conception that the three dimensions we have on disposal are insufficient." Vyacheslav Ivanov, "Čiurlionis and the Problem of the Synthesis of Arts," *Apollon* 3 (1914); in *Lituanus* 7, no. 2 (1961), 45.

28. *Composition no. 7* is in the Gemeentemuseum in The Hague. John Golding dates it to 1914 but puts it in the Guggenheim Museum in New York. John Golding, "Mysteries of Mondrian," *The New York Review of Books* 42, no. 11 (22 June 95), 59–65.

29. Frank Kupka, *Disks of Newton:* Study for *Amorpha: Fugue à deux couleurs,* 1911–12 (oil on canvas), Musée national d'Art Moderne, Paris; Robert Delaunay, *Disque, première peinture inobjective, ou disque simultané* (Disk, first nonobjective painting, or simultaneous disk), 1912–13 (oil on canvas), private collection. Sonia Delaunay's *Prisme électrique* (1913; oil on canvas, Musée national d'Art Moderne, Paris) is said to have been inspired by the newly installed electric streetlights on the boulevard Saint-Michel.

30. Delaunay, *Disque, première peinture inobjective, ou disque simultané* (Disk, first nonobjective painting, or simultaneous disk), 1912–13 (oil on canvas), private collection.

31. The American cartoonist Stuart Blackton, in fact, brought filmed animation to Paris in April 1907, a year before Kupka made his initial study of Andrée and her ball.

32. This suggestion was in fact made at the time about the crowded art world of Germany. A member of Strindberg's Black Pig Café circle in Berlin, the art critic Julius Meier-Graefe, wrote in 1904, "The art exhibition [is] an institution of a thoroughly bourgeois nature, due to the senseless immensity of the artistic output, and the consequent urgency of showing regularly what has been accomplished in the year." Meier-Graefe, *Modern Art* (1904), trans. Simmonds and Chrystal, in F. Frascina and C. Harrison, eds., *Modern Art and Modernism: A Critical Anthology* (London: Harper, Open University, 1982), 208.

33. Sixten Ringbom, "Transcending the Visible: The Generation of the Abstract Pioneers," in *The Spiritual in Art: Abstract Painting, 1890–1985* (New

York: Abbeville Press in association with Los Angeles County Museum of Art, 1986).

34. Peg Weiss (*Kandinsky in Munich,* Exhibition Catalogue [New York: Guggenheim Museum, 1982], plates 52–71) reproduces work by Obrist and Schmithals.

35. Peter Demianovich Ouspensky, *Chetvertoe Izmierenie* (The fourth dimension) (St. Petersburg, 1909). The book drew on earlier books by Hinton.

36. Malevich, *Black Square* (1913–15); *Black Circle; Black Cross; Black Square and Red Square,* Russian Museum, St. Petersburg).

37. Kandinsky to Schoenberg, 13 January 1911, in Arnold Schoenberg and Vassily Kandinsky, *Letters, Pictures, and Documents,* ed. Jelena Hahl-Koch, trans. J. C. Crawford (Boston: Faber and Faber, 1984).

38. Klee, *The Diaries of Paul Klee, 1898–1918,* ed. Felix Klee (Berkeley: University of California Press, 1968), 265.

39. Marc, *Die gelbe Kuh,* now in the Guggenheim Museum, New York.

40. Arthur Dove, *Leaf Forms,* private collection; *Movement No. 1,* Columbus Museum of Art, Columbus, Ohio. For more, see William Innes Homer, "Identifying Arthur Dove's 'The Ten Commandments,'" *American Art Journal* 12 (summer 1980), 21–32.

41. Mikhail Larionov, *Glass,* Guggenheim Museum, New York. See Gray, *The Russian Experiment in Art,* 145.

TWENTY-ONE

1. H. G. Wells, *A World Set Free* (1913; London: Hogarth Press, 1988), 160, 68, 133. Friedrich von Bernhardi, *Germany and the Next War* (1913; New York and London: Longman's, Green, 1914). Brailsford's statement, "My own belief is that there will be no more wars among the six Great Powers," is quoted in Peter Vansittart, ed., *Voices, 1870–1914* (New York: Avon, 1985), 218. Ludwig Meidner, *Apokalyptisches Landschaft* (Apocalyptic landscape), now in a private collection, and other Meidner visions from 1912 and 1913 appear in Carol Eliel, *The Apocalyptic Landscapes of Ludwig Meidner* (Los Angeles: Los Angeles County Museum of Art in association with Prestel, 1989).

2. Anna Akhmatova, "Poem without a Hero," lines 428–39, trans. D. M. Thomas, in Akhmatova, *Selected Poems* (New York: Penguin, 1988), 116.

3. "Greetings, friend. I am still sitting in Vienna and writing all sorts of rubbish." Stalin to Malinowsky, 2 February 1913 (Old Style), in Edward Ellis Smith, *The Young Stalin* (New York: Farrar, Straus & Giroux, 1967), 276. Stalin's book, *Nationalitätenfrage und Sozialdemokratie* (Marxism and the national question), was published later in 1913 in Berlin. For a précis of Bauer's *Die Nationalitätenfrage und die Sozialdemokratie* (Vienna, 1907; 2d ed. 1922), see Leszek Kolakowski, *Main Currents of Marxism* (New York: Oxford University Press, 1981), 2:285–90.

4. Stalin first tried out the new pseudonym to sign an article he wrote for a socialist journal on his way to Vienna in January 1913 (Smith, *Young Stalin,* 271). The story is retold with considerable verve in Frederic Morton, *Thunder at Twilight: Vienna, 1913–1914* (New York: Scribner's, 1989), 19–21.

5. Franz Kafka's novel chapter was published under the title "Der Heizer [The Stoker]—Fragment."

6. Stravinsky was also a St. Petersburger, from a family of some wealth and standing, but he had made his last visit to the city around Christmas 1910, and would, in fact, not see it again for fifty years.

7. Rosa Mayreder, "Geschlecht und Kultur," *Annalen der Natur- und Kulturphilosophie* 12 (1913).

8. "Atome nicht occult?" wrote Mach in the *Notizbuch*. In Rudolf Haller and Friedrich Stadler, eds., *Ernst Mach: Werk und Wirkung* (Vienna: Hölder-Pichler-Tempsky, 1988), 467.

9. Arthur M. Schoenflies, "Die Entwicklung der Lehre von den Punktmannigfaltigkeiten I," *Jahresbericht der DMV* 8, no. 2 (1900), and *Entwicklung der Mengenlehre und ihrer Anwendungen, erste Hälfte* (Leipzig: B. G. Teubner, 1913).

10. Waclaw Sierpinski, *Zarys Teoryi Mnogosci* (Set theory outline), Sierpinski, *Oeuvres choisies,* vol. 2: *Théorie des ensembles et ses applications: travaux des années 1908–1929,* ed. Stanislaw, Hartman, et al. (Warsaw: PWN—Editions scientifiques de Pologne, 1974–76).

11. Zygmunt Janiszewski, "Sur la géométrie des lignes cantoriennes," *Comptes-rendus* 151 (1910), 198–201. Jan Lukasiewicz, *O Zasadzie Sprzeczr'osci u Arystotelesa* (On the principle of contradiction in Aristotle) (Lwow, 1910). Polish mathematical logicians of later years include Stefan Banach, Alfred Tarski, and the young men who built the first mechanical computers and cracked the early versions of the German code machine in 1938. See Sr. Mary Grace Kuzawa, *Modern Mathematics: The Genesis of a School in Poland* (New Haven, Conn.: College and University Press, 1968), and Józef Garlinski, *The Enigma War: The Inside Story of the German Enigma Codes and How the Allies Broke Them* (New York: Scribner's, 1979).

12. L. E. J. Brouwer, "Over de grondslagen der Wiskunde" (On the foundations of mathematics, 1907), in *Collected Works* (Amsterdam: North-Holland, 1975). This was the first paper on what would eventually be called mathematical "Intuitionism."

13. John Quinn's speech is quoted in Milton W. Brown, *The Story of the Armory Show* (1963; repr., New York: Abbeville Press, Hirschhorn Editions, 1988), 36.

14. Arthur Davies, "Preface" to the Catalog for the International Exhibition of Modern Art (1913), in *1913 Armory Show 50th Anniversary Exhibition* (Utica, N.Y.: Munson-Williams-Proctor Institute, 1963), 157.

15. Randall Davey, in *1913 Armory Show 50th Anniversary Exhibition,* 97; William Zorach, ibid., 94.

16. Victor Salvatore, ibid., 97.

17. Theodore Roosevelt, "A Layman's Views of an Art Exhibition," *The Outlook,* 22 March 1913; in Roosevelt, *An American Mind: Selected Writings,* ed. Mario R. DiNunzio (New York: Penguin, 1995), 357.

18. Mabel Dodge to Gertrude Stein, 24 January 1913, in Robert A. Rosenstone, *Romantic Revolutionary: A Biography of John Reed* (New York: Alfred A. Knopf, 1975), 112; quoted in Martin Green, *New York 1913: The Armory Show and the Paterson Strike Pageant* (New York: Scribner's, 1988), 95.

19. Stuart Davis, in *1913 Armory Show 50th Anniversary Exhibition*, 95.

20. Milton Brown, "Introduction," in *1913 Armory Show 50th Anniversary Exhibition*, 36.

21. Charles Rearick, *Pleasures of the Belle Epoque: Entertainment and Festivity in Turn-of-the-Century France* (New Haven, Conn.: Yale University Press, 1985), 193. The receipts for the whole of France were sixteen million francs.

22. Guillaume Apollinaire, *Les Peintres cubistes* (Paris: Eugène Figuière, 1913); repr., ed. L. C. Breunig and J.-Cl. Chevalier (Paris: Hermann, 1965, 1980). It was published in May. Apollinaire's latest review of Picasso was published the same week (Apollinaire, "Pablo Picasso," *Montjoie!* 14 March 1913; in *Chroniques d'art, 1902–1918* [Paris: Gallimard/Idées, 1960], 367–70).

23. Guillaume Apollinaire, "A Travers le Salon des indépendants," *Montjoie!* 18 March 1913; in *Chroniques d'art, 1902–1918*, 378.

24. Guillaume Apollinaire, *Alcools, Poems 1898–1913*, trans. William Meredith (New York: Doubleday Anchor, 1965). Frederick Karl describes Apollinaire's subject as "'zones' or 'in-betweens,' which are the inner states of the artist attempting coherence of objects, things, places, space, and time. Narrative, in poetry as well as painting, had vanished. The viewer needed strategies for looking at a canvas, to see it as a whole or unity even when it seems segmented or fragmented." Karl, *Modern and Modernism: The Sovereignty of the Artist, 1885–1925* (New York: Atheneum, 1988), 271.

25. In October and November 1913, Sonia Delaunay also produced an accordion-folded abstract cubist "poster-poem," *La Prose du Transsibérien et de la Petite Jehanne de France*, with words by Blaise Cendrars, a Walt Whitman disciple. They called it the first "simultaneous book."

26. Ezra Pound, *Poetry*, 1913; Pound, "The Approach to Paris," parts 1–7, *The New Age* (4 September–16 October 1913).

27. Pound, *Selected Poems, 1908–1959* (London: Faber and Faber, 1975), 53.

28. "I have detested you long enough. . . . It was you that broke the new wood, / Now is a time for carving." Pound, *Selected Poems, 1908–1959*, 45. See also Pound, "What I Feel about Walt Whitman" (1909), in *Selected Prose, 1909–1965*, ed. William Cookson (New York: New Directions, 1973), 145–46. It is, of course, entirely incidental that in Walt Whitman's Brooklyn, the big news that April was a brand new baseball stadium at Ebbetts Field.

29. Bronislava Nijinska, *Early Memoirs*, trans. and ed. Irina Nijinska and Jean Rawlinson (1981; Durham, N.C.: Duke University Press, 1992), 470.

30. Quoted by G. de Pawlowski in *Comoedia* (Paris), 31 May 1913; in François Lesure, ed., *Le Sacre du printemps: Dossier de presse* (Geneva: Editions Minkoff, 1980), 18.

31. Another of Schoenberg's disasters. On March 31, 1913, Schoenberg conducted Berg's Opus 4, Webern's Opus 6, and his own *Chamber Symphony #1* in Vienna's most prestigious concert hall. It had to be stopped in the middle of Berg's *Five Orchestral Songs on Postcard-Texts by [Fünf Orchesterlieder nach Ansichtkarten-Texten von] Peter Altenberg*. Schoenberg did have a successful concert that year, his first; but the music was his *Gürrelieder*, written thirteen years before in late romantic style.

32. Igor Stravinsky, *An Autobiography* (New York: Norton, 1962), 47.

33. Nijinska, *Early Memoirs*, 470; Stravinsky, *Autobiography*, 47.

34. Igor Stravinsky and Robert Craft, *Conversations with Igor Stravinsky* (1959; London: Faber and Faber, 1979), 46.

35. Pawlowski, in Lesure, ed., *Le Sacre du printemps: Dossier de presse*, 20.

36. Henri Quittard, *Le Figaro*, 31 May 1913.

37. Even Stravinsky's newest and most irreverent biographer, Richard Taruskin, is reluctant to disagree with that judgment. Taruskin, "A Myth of the Twentieth Century: The *Rite of Spring*, the Tradition of the New, and 'Music Itself,'" *Modernism/Modernity* 2, no. 1 (1995), 1.

38. Besides the Schoenberg disaster in March, there was a concert on June 2 in Modena, Italy where the futurist composer Luigi Russolo premiered his *Intonarumori* (Music noises). Russolo's music, made out of street noise, was not a success, nor was the book he published explaining it—*L'Arte dei rumori* (The art of noises) (Milan: Direzione del Movimiento Futurista, 1913).

39. The efforts in the 1980s to reconstruct the ballet as originally choreographed by Nijinsky are chronicled in a series of articles by Millicent Hodson: "The Fascination Continues: Searching for Nijinsky's *Sacre*," *Dance Magazine* 54 (June 1980), 64–66, 71–75; "Nijinsky's Choreographic Method: Visual Sources from Roerich for *Le Sacre du printemps*," *Dance Research Journal* 18 (winter 1986–87), 7–15; and "*Sacre*: Searching for Nijinsky's Chosen One," *Ballet Review* 15 (Fall 1987), 53–66.

40. W[illiam] C[hristopher] Handy, *Father of the Blues, An Autobiography* (New York: Macmillan, 1941; repr., New York: Da Capo, 1969), 117.

41. "Its members have trained on ragtime and 'jazz.'" In *Oxford English Dictionary Supplement*, article on "Jazz."

42. Fritz Hasenöhrl, in Engelbert Broda, *Ludwig Boltzmann: Man, Physicist, Philosopher* (Woodbridge, Conn.: Ox Bow Press, 1983), 83.

43. Michel Plancherel's article disproving the ergodic hypothesis was in the *Archives des sciences physiques* 33 (1912). Reprinted in the *Annalen der Physik* 42 (1913), it appeared together with Artur Rosenthal's. Raymond J. Seeger, *Men of Physics: J. Willard Gibbs: American Mathematical Physicist Par Excellence* (New York: Pergamon Press, 1974).

44. Jean Perrin, *Atoms*, trans. D. Ll. Hammick (Woodbridge, Conn.: Ox Bow Press, 1990), 216–17.

45. Einstein, untitled article, *Naturwissenschaften* 1 (1913), 1077; in Abraham Pais, "*Subtle is the Lord . . .*": *The Science and the Life of Albert Einstein* (New York: Oxford University Press, 1983), 372.

46. Philipp Frank, *Einstein: His Life and Times*, trans. G. Rosen, ed. S. Kusaka (1947; New York: Da Capo, n.d.). Jeremy Bernstein dates this meeting to 1912 or 1913 in his "Ernst Mach and the Quarks," *American Scholar*, Winter 1983–84; reprinted in Mach, *Popular Scientific Lectures* (La Salle, Ill.: Open Court, 1986). Gerald Holton dates it to 1911 based on the address book in Haller and Stadler, eds., *Ernst Mach*.

47. Langevin's reminiscences of Poincaré, who had died on December 17, 1912, appeared in Langevin, "L'Oeuvre d'Henri Poincaré," *Revue de metaphysique et de morale* (1913).

48. Eve Curie, *Madame Curie*, trans. Vincent Sheehan (1937; New York: Da Capo, n.d.), 284.

49. Einstein to Mach, June 1913, in Pais, "*Subtle is the Lord . . .*," 285.

50. Einstein's lecture and mention of Mach's hypothesis is reported in *Physikalische aaitschrift* 14 (1913), 1249.

51. Einstein to Grossman, 29 October 1913, in Banesh Hoffmann, *Albert Einstein, Creator and Rebel* (New York: Viking Press, 1972), 116.

52. In Abraham Pais, *Niels Bohr's Times, In Physics, Philosophy, and Polity* (New York: Oxford University Press, Clarendon Press, 1991), 128.

53. Bohr's actual result was 3.1×10^{15}—well within experimental error.

54. Henry Gwyn Jeffreys Moseley, "The High-Frequency Spectrum of the Elements," *Philosophical Magazine,* 6th ser., 26 (1913), 257. To reach his conclusions Moseley measured the elements' X-ray frequencies.

55. Perrin, *Atoms,* 216–17.

56. Bohr interview, 7 November 1962, in Pais, *Niels Bohr's Times,* 139.

57. Husserl, *Ideas,* section 69, trans. W. Boyce Gibson (1931; New York: Collier Books, 1962), 180. There is a newer translation of *Ideas* by F. Kersten (Boston: Martinus Nijhoff, 1983). Eliot's definition of the poet's "objective correlative" would appear in his 1919 essay, "Hamlet and His Problems." Eliot, *Selected Essays* (London: Faber and Faber, 1951, 1986), 145.

58. Husserl, *Ideas,* section 33, trans. Gibson, 102.

59. "The perception itself is what it is within the steady flow of consciousness . . . is itself constantly in flux; the perceptual now is ever passing over into the adjacent consciousness of the just-past, a new now simultaneously gleams forth, and so on." Ibid., section 41, 118.

60. Both *Hearts Adrift* and *Tess of the Storm Country* were released in 1914.

61. In 1907 the world had quite suddenly begun to fill up with "nickelodeons" as film left the vaudeville programs and began to fill theaters on their own. The first low-priced, movies-only theater in the world seems to have been Pittsburgh's Nickelodeon, which opened in June 1905. The first one in Dublin, Ireland was the Volta, set up in 1909 by two Italians from Trieste and an expatriate friend of theirs named James Joyce.

62. Donald Elder, *Ring Lardner* (New York: Doubleday, 1956), 98.

63. J.-C. Marcadé, "Postface," in Kroutchonykh, Khlebnikov, Matiouchine, and Malévitch, *La Victoire sur le soleil,* trans. J.-C. and Valentine Marcadé (Lausanne: L'Age d'Homme, 1976), 68.

64. "Nero," tableau 1, in Kroutchonykh et al., *La Victoire sur le soleil,* 17. I have retranslated Marcadé's French into English.

65. "Young Man," tableau 6, ibid., 47.

66. Rush Rhees, ed., *Recollections of Wittgenstein* (New York: Oxford University Press, 1984), 2; in Ray Monk, *Ludwig Wittgenstein: The Duty of Genius* (New York: Free Press, 1990), 55.

67. Wittgenstein to Russell, 1913, in Monk, *Ludwig Wittgenstein,* 95.

68. Wittgenstein, *Tractatus Logico-Philosophicus,* trans. D. F. Pears and B. F. McGuiness (London: Routledge and Kegan Paul, 1961). The translation of the last proposition is mine.

TWENTY-TWO

1. For a lucid survey of how this century's philosophers have dealt with self-reference, see Hilary Lawson, *Reflexivity: The Post-Modern Predicament* (La Salle, Ill.: Open Court, 1986).

2. A superb account (with equations) of the discovery of quantum electrodynamics—one of the two or three most important discoveries in theoretical physics in this century—is found in Silvan Schweber, *QED and the Men Who Made It: Dyson, Feynman, Schwinger, and Tomonaga* (Princeton: Princeton University Press, 1994).

3. Henri Poincaré, "Sur le problème des trois corps et les équations de la dynamique," *Acta Mathematica* 13 (1890), 67. Poincaré also referred to the problem, without equations, in "Le mécanisme et l'expérience" (Experience and mechanism), *Revue de métaphysique et de morale* 1 (1893), 534–37. See chapter 4, note 19 in this volume.

4. Jacques Barzun's still readable *Romanticism and the Modern Ego* (Boston: Little, Brown, 1943) was among the first studies to argue that the central tendency of Modernism was the resurgence of the romantic self. The argument was no milder in the revised version, *Classic, Romantic, and Modern* (New York: Doubleday Anchor, 1962).

5. Barzun (*Classic, Romantic, and Modern*, 117) calls this quality of ironic self-consciousness "embarrassed shuffling."

6. Sherry Turkle writes in her new book, *Life on the Screen: Identity in the Age of the Internet* (New York: Simon and Schuster, 1995), that "the modernist view of reality is characterized by such terms as 'linear,' 'logical,' 'hierarchical,' and by having 'depths' that can be plumbed and understood," while postmodernism is "characterized by such terms as 'decentered,' 'fluid,' 'nonlinear,' and 'opaque.'" It may be that she has it backwards.

7. Michael J. White, *The Continuous and the Discrete: Ancient Physical Theories from a Contemporary Perspective* (Oxford: Oxford University Press, 1992).

8. Leopold Kronecker, "Über den Zahlbegriff," *Journal für die reine und angewandte Mathematik* (Crelle's) 101 (1887); quoted by Howard Stein, "*Logos, Logic,* and *Logistiké:* Some Philosophical Remarks in Nineteenth-Century Transformations of Mathematics," in William Aspray and Philip Kitcher, eds., *History and Philosophy of Modern Mathematics,* Minnesota Studies in the Philosophy of Science, vol. 11 (Minneapolis: University of Minnesota Press, 1988), 243.

9. Abraham Robinson, "Nonstandard Analysis," paper read before the joint meeting of the American Mathematical Society and the Mathematical Association of America, 1961. Cf. Joseph Dauben, "Abraham Robinson and Nonstandard Analysis," in Aspray and Kitcher, eds., *History and Philosophy of Modern Mathematics,* 178.

10. Edouard Manet, *Déjeuner sur l'herbe,* Musée d'Orsay, Paris. Alexandre Georges Henri Regnault, *Salomé* (1870), Metropolitan Museum of Art, New York.

11. Morton White, ed., *The Age of Analysis: 20th Century Philosophers* (New York: Mentor, 1955).

12. Adolf Loos, "Ornament als Verbrechung" (Ornament as crime), in *Sämtliche Schriften,* ed. F. Glück, vol. 1 (Vienna, 1962). Some other Loos essays are

translated in Loos, *Spoken Into the Void: Collected Essays, 1897–1900* (Cambridge: MIT Press, 1982).

13. Heisenberg first laid out the uncertainty principle in a letter to Wolfgang Pauli written at Bohr's Institute in Copenhagen on 23 February 1927, which ended by raising the possibility of *unkausalichheit* "causelessness." Heisenberg's paper was published by the *Zeitschrift für Physik* in May. Bohr proposed complementarity at a physicists' conference held in Como, Italy, in September, in an address reprinted in Bohr, *Atomic Theory and the Description of Nature* (1934; Woodbridge, Conn.: Ox Bow Press, 1987). Emil DuBois-Reymond's assertion, in 1872, of the limits of scientific certainty had been drowned in a brief controversy and was forgotten by 1927 (see above, chapter 2).

14. Bohr, in P. A. Schilpp, ed., *Albert Einstein, Philosopher-Scientist* (New York: Tudor, 1949), 218.

15. Kurt Gödel, "Ueber formal unentscheidbare Sätze der *Principia Mathematica* und verwandter Systeme" (On formally undecidable propositions of *Principia Mathematica* and similar systems), *Monatshefte für Mathematik und Physik* 38 (1931); trans. J. Heijenoort in Heijenoort, ed., *From Frege to Gödel* (Cambridge: Harvard University Press, 1967).

16. The best short explanation of Gödel's Proof is Ernest Nagel and James R. Newman, "Goedel's Proof," in Newman, ed., *The World of Mathematics* (New York: Simon and Schuster, 1956), 3:1668–95. There is a longer treatment by the same authors under the same title (*Gödel's Proof* [New York: New York University Press, 1958]), and a highly entertaining oblique analysis by Raymond Smullyan, appropriately titled *What Is the Name of This Book?* (Englewood Cliffs, N.J.: Prentice-Hall, 1978). Some readers will have been introduced not only to Gödel but to recursion in general in Douglas Hofstadter, *Gödel, Escher, Bach: An Eternal Golden Braid* (New York: Basic Books, 1979).

17. David Hilbert, "Probleme der Grundlegung der Mathematik," in *Atti del Congresso internazionale dei matematici, Bologna, 3–10 September 1928* (Bologna, 1929).

18. Alan Turing, "On Computable Numbers, with an Application to the *Entscheidungsproblem*," *Proceedings of the London Mathematical Society* 2, no. 42 (1937), 230–65.

19. Norbert Wiener, a student of Bertrand Russell, made a sharper identification in 1947, "Information is the negative of entropy," and repeated it in Wiener, "A New Concept of Communication Engineering," *Electronics* (January 1949), 74–76.

20. "If the base 2 is used the resulting units may be called binary digits, or more briefly bits, a word suggested by J. W. Tukey. A device with two stable positions, such as a relay or a flip-flop circuit, can store one bit of information." Claude E. Shannon, "A Mathematical Theory of Communication," *Bell System Technical Journal*, July and October 1948; in Shannon and Warren Weaver, *The Mathematical Theory of Communication*, 2d ed. (Urbana: University of Illinois Press, 1975), 32. Some of Shannon's other papers on cryptanalysis remain classified.

21. Merce Cunningham, *Sixteen Dances for Soloist and Company of Three,* was choreographed using random choices in 1951. His *Symphonie pour un homme seul* was choreographed in timed segments to an audiotape by Pierre

Henry and Pierre Schaeffer at Black Mountain College, North Carolina in 1952. Joseph Mazo writes of Cunningham, "His choreography makes use of pedestrian actions—walking, running, skipping—and of the awkward motions with which most humans propel their bodies. . . . His dances are based on the division of time into segments." Joseph H. Mazo, *Prime Movers* (1977; repr., Princeton: Princeton Book Co., n.d.), 201.

SELECT BIBLIOGRAPHY

The bibliography lists primary sources for the writers and thinkers whose stories I have told in *The First Moderns*. In addition I have listed secondary works I have used that are not cited in the footnotes, especially those that have attempted to cross fields and disciplines and those that raise or examine the question of ontological discontinuity in or before the period from 1872 to 1913.

Abstraction: Towards a New Art, Painting 1910–20. Exhibition catalogue. London: Tate Gallery, 1980.

Adams, Henry. *The Letters of Henry Adams.* Vols. 4–6 (1892–1918). Cambridge: Harvard University Press, 1988.

———. *Supplement to the Letters of Henry Adams.* 2 vols. Boston: Massachusetts Historical Society, 1989.

Adcock, Craig E. "Conventionalism in Henri Poincaré and Marcel Duchamp." *Art Journal* 44 (fall 1984), 249–58.

Adler, Irving. *The Elementary Mathematics of the Atom.* New York: John Day, 1965.

Aiken, Edward. "The Cinema and Italian Futurist Painting." *Art Journal* 41 (winter 1981), 353–57.

Akhmatova, Anna. *The Complete Poems.* 2 vols. Cambridge, Mass.: Zephyr Press, 1991. Updated and expanded edition published in 1 vol., 1993.

Alexander, Theodor, and Beatrice Alexander. "Schnitzler's *Leutnant Gustl* and Dujardin's *Les Lauriers sont coupés.*" *MAL* 2, no. 2 (1969), 7–15.

Allen, Garland E. *Thomas Hunt Morgan: The Man and His Science.* Princeton: Princeton University Press, 1978.

Antliff, Mark. *Inventing Bergson: Cultural Politics and the Parisian Avant-Garde.* Princeton: Princeton University Press, 1993.

Antoine, André. *Mes Souvenirs sur le Théâtre-Libre.* Paris: Fayard, 1921.

———. *Le Théâtre.* Paris: Les Editions de France, 1932.

Antokoletz, Elliot. *The Music of Béla Bartók: A Study of Tonality and Progression in Twentieth-Century Music.* Berkeley: University of California Press, 1984.

Anzieu, Didier. *Freud's Self-Analysis* [L'Auto-analyse, 1959]. Translated by Peter Graham. London: Hogarth, 1986.

Apollinaire, Guillaume. *Oeuvres poétiques*. Edited by M. Adéma and M. Decaudin. Paris: Gallimard, Pléiade, 1965.

Appleby, R. Scott. *"Church and Age Unite!" The Modernist Impulse in American Catholicism*. Notre Dame, Ind.: University of Notre Dame Press, 1992.

Aurier, Albert. *Oeuvres posthumes*. Paris: Mercure de France, 1893.

Austin, William W. *Music in the 20th Century, from Debussy through Stravinsky*. New York: Norton, 1966.

Baedeker, Karl. *Paris and its Environs*. 15th ed. Leipzig: Karl Baedeker; New York: Scribner's, 1904.

———. *Austria-Hungary*. 10th ed. Leipzig: Karl Baedeker; New York: Scribner's, 1905.

Bahr, Hermann. *Die Überwindung des Naturalismus* [The overcoming of naturalism: Sequel to *Critique of the moderns*]. Dresden: E. Pierson, 1891.

———. *Selbstbildnis*. Berlin: S. Fischer, 1923.

Bain, David Haward. *Sitting in Darkness: Americans in the Philippines*. New York: Penguin, 1986.

Banham, Reyner. *Theory and Design in the First Machine Age*. 1960. 2nd ed. New York: Praeger, 1967.

Banta, Martha. *Taylored Lives: Narrative Productions in the Age of Taylor, Veblen, and Ford*. Chicago: University of Chicago Press, 1993.

Bar-Hillel, Yehoshua, et al., eds. *Essays on the Foundations of Mathematics*. 2d ed. Jerusalem: Magnes Press, Hebrew University, 1966.

Barkan, Elazar, and Ronald Bush, eds. *Prehistories of the Future: The Primitivist Project and the Culture of Modernism*. Stanford: Stanford University Press, 1995.

Barker, Andrew W. *"Ein Lichtbringender und Leuchtender, ein Dichter und Prophet*: Responses to Peter Altenberg in Turn-of-the-Century Vienna." *Modern Austrian Literature: Journal of the International Arthur Schnitzler Research Association* 22, nos. 3–4 (1989), 1–14.

Bauman, Zygmunt. *Modernism and the Holocaust*. Ithaca, N.Y.: Cornell University Press, 1992.

Beller, Steven. *Vienna and the Jews, 1867–1938: A Cultural History*. New York: Cambridge University Press, 1989.

Belliver, André. *Henri Poincaré et Paul Valéry autour de 1895*. Chevreuse: n. p., 1958.

Bely, Andrey. *Petersburg*. 1913. Translated by R. A. Maguire and J. E. Malmstad. Bloomington: Indiana University Press, 1978.

———. *The First Encounter*. Translated by G. Janacek. Princeton: Princeton University Press, 1979.

———. *Selected Essays of Andrey Bely*. Edited and translated by Steven Cassedy. Berkeley: University of California Press, 1985.

———. *The Dramatic Symphony* and *The Forms of Art*. 1902. New York: Grove Press, 1987.

———. *André Bely: Spirit of Symbolism*. Edited by John E. Malmstad. Ithaca, N.Y.: Cornell University Press, 1987.

Bennitt, Mark. *Louisiana Purchase Exhibition.* St. Louis: Universal Exposition Publishing, 1905.

Bergson, Henri. *An Introduction to Metaphysics.* Translated by T. E. Hulme. New York and London: Putnam's, 1912.

———. *Durée et simultanéité: À propos de la théorie d'Einstein.* Paris: Alcan, 1922.

———. "Mouvement rétrograde du vrai." In *La Pensée et le mouvant.* Paris: n.p., 1934. On Proust.

———. *Time and Free Will* [Essai sur les données immédiates de la conscience, 1889, 1910]. Translated by F. L. Pogson. London: G. Allen, 1959.

———. *L'Evolution créatrice.* 1907. Paris: Presses Universitaires de France, 1983.

Blackmore, John T. *Ernst Mach.* Berkeley: University of California Press, 1972.

———, ed. *Ernst Mach—A Deeper Look.* Boston Studies in the Philosophy of Science. Boston: Kluwer Academic, 1992.

Block, Geoffrey. *Charles Ives: A Bio-Bibliography.* Westport, Conn.: Greenwood, 1988.

Bochner, Salomon. "Continuity and Discontinuity in Nature and Knowledge." In *Dictionary of the History of Ideas,* vol. 1, 492–504. New York: Scribner's, 1973.

Bohr, Niels. *Atomic Theory and the Description of Nature.* 1934. Woodbridge, Conn.: Ox Bow Press, 1987.

———. *Essays 1932–1957 on Atomic Physics and Human Knowledge.* Woodbridge, Conn.: Ox Bow Press, 1987.

Boltzmann, Ludwig. *Vorlesungen über die Principe der Mechanik.* 3 vols. Leipzig: Barth, 1897–1920.

———. *Wissenschaftliche Abhandlungen.* Edited by Fritz Hasenöhrl. 3 vols. Leipzig: Barth, 1909.

———. "Model." Entry in *Encyclopedia Britannica,* 11th ed. Vol. 18, 638. 1911.

———. *Reise eines deutschen Professors in Eldorado.* Leipzig: Barth, 1917.

———. *Lectures on Gas Theory* [Vorlesungen über Gastheorie, 1896–98]. Edited and translated by Stephen G. Brush. Berkeley: University of California Press, 1964.

———. "On the Fundamental Principles and Basic Equations of Mechanics." Clark University Lecture no. 1. Translated by J. J. Kockelmans. In *Philosophy of Science; the Historical Background.* New York: Free Press, 1968.

———. *Theoretical Physics and Philosophical Problems.* Translated by Paul Foulkes. Edited by Brian McGuinness. Dordrecht: D. Reidel, 1974. Includes *Populäre Schriften,* Leipzig, 1905.

———. *Gesamtausgabe.* Edited by Roman U. Sexl. Vol. 8. *Internationale Tagung Anlässlich des 75. Jahrestages seines Todes 5.–8. September 1981 Ausgewählte Abhandlungen.* Edited by R. Sexl and John Blackmore. Brunswick: Vieweg, 1982.

———. *Principien der Naturfilosofi / Lectures on Natural Philosophy, 1903–1906.* Edited by Ilse M. Fasol. New York: Springer, 1990.

Bolzano, Bernard. *Schriften.* 5 vols. Prague: Royal Bohemian Academy of Sciences, 1930–1948.

———. *Paradoxes of the Infinite.* 1851. Translated by D. A. Steele. New Haven, Conn.: Yale University Press, 1950.

————. *Theory of Science*. Translated by Rolf George. Berkeley: University of California Press, 1972.

————. *Philosophische Texte*. Edited by Ursula Neeman. Stuttgart: Reclam, 1984.

Boorse, Henry A., and Lloyd Motz, eds. *The World of the Atom*. New York: Basic Books, 1966.

Borsi, Franco, and Ezio Godoli. *Vienna 1900: Architecture and Design*. New York: Rizzoli, 1987.

Boyer, John W. *Political Radicalism in Late Imperial Vienna: Origins of the Christian Social Movement, 1848–1897*. Chicago: University of Chicago Press, 1981.

————. *Culture and Political Crisis in Vienna: Christian Socialism in Power, 1897–1918*. Chicago: University of Chicago Press, 1995.

Brakel, J. van. "The Possible Influence of the Discovery of Radio-active Decay on the Concept of Physical Probability." *Archive for History of Exact Sciences* 31 (1984–85), 369–85.

Braun, Marta. *Picturing Time: The Work of Etienne-Jules Marey (1830–1904)*. Chicago: University of Chicago Press, 1992, 1995.

Breitbart, Eric. *A World on Display: The St. Louis World's Fair of 1904*. VHS, 53 min. Corrales, N.M.: New Deal Films, 1994.

Brentano, Franz. "Von der Unmöglichkeit absoluten Zufalls." 1916. In *Versuch über die Erkenntnis*. Hamburg: n.p., 1970. See especially p. 141 on Boltzmann and continua.

————. *Psychology from an Empirical Standpoint*. Translated by A. C. Rancurello et al. Atlantic Highlands, N.J.: Humanities Press, 1973.

————. *Sensory and Noetic Consciousness* (1929). Edited by O. Kraus and L. McAlister. Translated by L. McAlister and M. Schattle. New York: Humanities Press, 1981.

Brion-Guerry, L., ed. *L'Année 1913; les formes esthétiques de l'oeuvre d'art à la veille de la Première Guerre mondiale*. 2 vols. Paris: Klincksieck, 1971–73.

Brody, Elaine. *Paris: The Musical Kaleidoscope, 1870–1925*. New York: George Braziller, 1987.

Brouwer, Luitzen Egbertus Jan. *Collected Works*. Edited by A. Heyting. Amsterdam: North-Holland, 1975.

————. "Intuitionism and Formalism." *American Mathematical Society Bulletin* 20 (1913–14), 81–96. Translation of inaugural address at University of Amsterdam.

Brush, Stephen G. *Kinetic Theory*. 3 vols. New York: Pergamon Press, 1965.

————. "Scientific Revolutionaries of 1905: Einstein, Rutherford, Chamberlin, Wilson, Stevens, Binet, Freud." In Mario Bunge and William R. Shea, *Rutherford and Physics*. New York: Dawson and Science History Publications, 1979.

————. *Statistical Physics and the Atomic Theory of Matter from Boyle and Newton to Landau and Onsager*. Princeton: Princeton University Press, 1981, 1983.

Buel, J. W., ed. *Louisiana and the Fair: An Exposition of the World, Its People and Their Achievements*. 10 vols. St. Louis: Progress Publishing, 1904.

Butts, Robert E., and J. J. Hintikka, eds. *Logic, Foundations of Mathematics and Computability Theory*. Dordrecht: D. Reidel, 1977.

Cajal, Santiago Ramon y. *Histology*. Translated by M. Fernán-Núñez. Baltimore: Williams and Wilkins, 1933.

———. *Studies on Vertebrate Neurogenesis*. Springfield, Ill.: Thomas, 1960.

———. *Studies on the Diencephalon*. Springfield, Ill.: Thomas, 1966.

———. *Las publicaciones valencianas de Cajal*. Edited by J. M. López Piñero and J. A. Micó Navarro. Valencia: Publicaciones Universidad de Valencia, 1983.

———. *The Neuron and the Glial Cell*. Edited by William C. De La Torre and Jack Gibson. Springfield, Ill.: Thomas, 1984.

———. *Neurocircuitry of the Retina*. New York: Elsevier, 1985.

———. *Cajal on the Cerebral Cortex: An Annotated Translation of the Complete Writings*. Edited by J. DeFelipe and Edward G. Jones. New York: Oxford University Press, 1988.

———. *Recollections of My Life*. Translated by E. H. Craigie, 1937. Cambridge: MIT Press, 1989.

———. *New Ideas on the Structure of the Nervous System in Man*. Translated by Neely Swanson and Larry W. Swanson. Cambridge: MIT Press, 1990.

———. *Cajal's Degeneration and Regeneration of the Nervous System*. New York: Oxford University Press, 1991.

Cantor, Georg. "Extension d'un theorème de la théorie des séries trigonométriques." *Acta Mathematica* 2 (1883), 336–48.

———. "Sur les ensembles infinis et linéaires de points 1–4." *Acta Mathematica* 2 (1883), 349–80.

———. Review of *Grundlagen* (1884), by Gottlob Frege. *Deutsche Literaturzeitung* 20 (1885).

———. *Contributions to the Founding of the Theory of Transfinite Numbers*. Edited by P. Jourdain. Chicago: Open Court, 1915. Reprint New York: Dover, n.d.

———. *Gesammelte Abhandlungen mathematischen und philosophischen Inhalts*. 1932. Edited by E. Zermelo. Hildesheim: Olms, 1966.

Cariou, Marie. *L'Atomisme: Gassendi, Leibniz, Bergson et Lucrèce*. Paris: Aubier Montaigne, 1978.

Carlson, Elof Axel. *The Gene: A Critical History*. Ames: Iowa State University Press, 1989.

Cate, Phillip Dennis. *The Graphic Arts and French Society, 1871–1914*. New Brunswick, N.J.: Rutgers University Press, 1988.

Cavafy, C. P. *Collected Poems*. Princeton: Princeton University Press, 1994.

Caveing, Maurice. *Zénon d'Elée: Prolégomènes aux doctrines du continu: étude historique et critique des fragments et témoignages*. Paris: J. Vrin, 1982.

Cézanne, Paul. *Cézanne: The Late Work*. Exhibition catalogue. Edited by William S. Rubin. New York: Museum of Modern Art, 1977.

———. *The Complete Paintings of Cézanne*. Catalogue raisonné by Sandra Orienti. New York: Penguin, 1985.

———. *Cézanne by Himself*. Edited by Richard Kendall. Boston: Little, Brown, 1988.

———. *Paul Cézanne Letters*. Edited by John Rewald. Translated by S. Hacker. Hacker Art Books, 1984; New York: Da Capo, 1995.

———. *Cézanne*. Exhibition catalogue. Edited by Françoise Cachin, Joseph J.

Rishel, et al. Paris: Réunion des Musées Nationaux, 1995; New York: Abrams, 1996.

Chekhov, Anton. *The Harmfulness of Tobacco*. In *Nine Plays of Chekhov*. Edited by Arthur Zeiger, 1946. New York: Grossett and Dunlap Universal Library, n.d.

———. *Letters of Anton Chekhov*. Edited by Avrahm Yarmolinsky. New York: Viking, 1973.

———. "An Attack of Nerves." 1888. In *The Portable Chekhov*. New York: Viking, 1947, 1978.

———. "A Boring Story" (1889) and "Lady with Lapdog" (1899). In *Lady with Lapdog and Other Stories*. Translated by David Magarshak, 1964. New York: Penguin, 1987.

Čiurlionis, Mikalojus-Konstantinas. *Čiurlionis und die litauische Malerei, 1900–1940*. Exhibition catalogue. Duisburg: Wilhelm-Lehmbruck-Museum, 1989.

Comte, Auguste. *Auguste Comte and Positivism: The Essential Writings*. Edited by Gertrud Lenzer. New York: Harper Torchbook, 1975.

(Congress, 1900). Paris. Exposition Universelle Internationale de 1900. Jury International. *Rapports*. Paris: Imprimerie nationale, 1903.

(Congress, Mathematics, 1900). *Compte rendu du deuxième congrès international des mathématiciens tenu à Paris du 6 au 12 août*. Paris: Gauthier-Villars, 1902. Includes Hilbert's 23 questions, of which see especially #10: Is math decidable?

(Congress, Philosophy, 1900). *Bibliothèque du congrès international de philosophie*. Paris: Armand Colin, 1901.

(Congress, Physics, 1900). *Rapports (Travaux) du congrès international de physique*. 4 vols. Paris: Gauthier-Villars, 1901.

(Congress, 1904). *The International Congress of Arts and Sciences. Saint Louis, 1904*. Boston: Houghton Mifflin, 1905–1907.

Cronin, Vincent. *Paris on the Eve: 1900–1914*. New York: St. Martin's, 1991.

Couturat, Louis. *De l'infini mathématique*. 1896. Reprint, Paris: Blanchard, 1973.

———. "La logique mathématique de M. Peano." *Revue de métaphysique et de morale* 7 (1899).

———. *La Logique de Leibniz d'après des documents inédits*. Paris: Alcan, 1901.

———. *Les Principes des mathématiques*. 1905. Reprint, Paris: A. Blanchard, 1980.

———. "Pour la logistique (réponse à M. Poincaré)." *Revue de métaphysique et de morale* 14 (1906), 208–250.

Cros, Charles. *Oeuvres complètes*. Paris: J. J. Pauvert, 1964.

De Bièvre, P., and H. S. Peiser. "'Atomic Weight'—The Name, its History, Definition, and Units." *Pure and Applied Chemistry* 64 (1992), 1535–43.

Debussy, Claude. *Debussy on Music*. Edited by Richard Langham Smith. Translated by François Lesure and R. L. Smith. Ithaca, N.Y.: Cornell University Press, 1988.

Dedekind, Richard. *Essays on the Theory of Numbers* [Stetigkeit und irrationale Zahlen, 1872, and Was sind und was sollen die Zahlen, 1888]. Translated by W. W. Beman, 1901. New York: Dover, 1963.

Delaunay, Robert. *Du Cubisme à l'art abstrait.* Edited by Pierre Francastel. Paris: S.E.V.P.E.N, 1957.

———. *Robert Delaunay.* Exhibition catalogue. Hamburg: Kunstverein in Hamburg, 1962.

———. *Notebooks.* In Jean Clay, *Modern Art, 1890–1918.* New York: Vendome Press, 1978.

———. *Robert Delaunay: Blick auf die Stadt, 1910–1914.* Exhibition catalogue. Mannheim: Städtische Kunsthalle Manneim/Mannheimer Morgen Grossdruckerei, 1981.

Delaunay, Robert, and Sonia Delaunay. *The New Art of Color: The Writings of Robert and Sonia Delaunay.* Edited by Arthur A. Cohen. Translated by David Shapiro and Arthur A. Cohen. New York: Viking Press, 1978.

———. *Delaunay und Deutschland.* Exhibition catalogue. Munich: Staatsgalerie moderner Kunst im Haus der Kunst, 1985.

———. Le Centenaire Delaunay. Exhibition catalogue. Paris: Musée d'art moderne de la ville de Paris, 1985.

Delaunay, Sonia. *Sonia Delaunay, 1885–1979: A Retrospective.* Buffalo, N.Y.: Albright-Knox, 1980.

Denis, Maurice. *Théories; 1890–1910.* 4th ed. Paris: Rouart et Watelin, 1920.

De Vries, Hugo. *Die Mutationstheorie.* 2 vols. Leipzig: Veit, 1901, 1903.

———. *The Mutation Theory, Experiments and Observations on the Origin of Species in the Vegetable Kingdom* [Die Mutationstheorie, Leipzig, 1910]. Translated by J. B. Farmer and A. D. Darbishire. 2 vols. Chicago: Open Court, 1909–10; New York: Kraus reprint, 1969. In the 1910 edition, discussion of Mendel-segregation was edited out.

———. *Intracellular Pangenesis* [Intracelluläre Pangenesis, 1889]. Translated by C. S. Gager. Chicago: Open Court, 1910.

Duchamp, Marcel. *Writings of Marcel Duchamp.* Edited by Michel Sanouillet and Elmer Peterson. New York: Oxford University Press, 1973; New York: Da Capo, n.d.

———. *The Complete Works of Marcel Duchamp.* Compiled by Arturo Schwarz. New York: H. N. Abrams, 1970–80.

———. *MARCEL DUCHAMP.* Exhibition catalogue. Edited by Anne d'Harnoncourt and Kynaston McShine. New York: Museum of Modern Art/Prestel, 1989.

Dujardin, Edouard. *Les Premiers poètes du vers libre.* Paris: Mercure de France, 1922.

———. *Le Monologue intérieur: son apparition, ses origines, sa place dans l'oeuvre de James Joyce et dans le roman contemporain,* Paris: Albert Messein, 1931.

———. *Les Lauriers sont coupés.* 1887. Paris: Le Chemin Vert, 1981.

Dupré, John. *The Disorder of Things: Metaphysical Foundations of the Disunity of Science.* Cambridge: Harvard University Press, 1993.

Duroselle, Jean-Baptiste. *La France de la "Belle époque."* 1972. Références. Paris: PFNSP, 1992.

Ehrenfest, Paul, and Tatiana Ehrenfest. *The Conceptual Foundations of the Statistical Approach in Mechanics.* 1912. Translated by J. Moravcik. New York: Dover, n.d.

————. *Collected Scientific Papers*. Edited by Martin J. Klein. Amsterdam: North Holland, 1959.

Einstein, Albert. "My Theory." *The Living Age* 304 (3 January 1920), 41–43. Reprinted from *The Times of London*.

————. "Autobiographisches." In *Albert Einstein, Philosopher-Scientist*. Edited by P. A. Schilpp. New York: Tudor, 1949.

————. *Albert Einstein: Lettres à Maurice Solovine*. Edited by M. Solovine. Paris: Gauthier-Villars, 1956. Translated by Wade Baskin. New York: The Philosophical Library, 1987.

————. *Relativity: The Special and the General Theory*. 15th ed. Translated by Robert W. Lawson. 1952. New York: Crown Publishers, 1961.

————. *The Correspondence between Albert Einstein and Max and Hedwig Born, 1916–1955* [Briefwechsel, 1969]. Translated by Irene Born. New York: Walker and Co., 1971.

————. *Albert Einstein—Michele Besso Correspondence, 1903–1955*. Edited and translated by P. Speziali. Paris: Hermann, 1972.

————. *Ideas and Opinions*. New York: Crown, 1954; New York Dell/Laurel, 1973.

————. *Collected Papers*. Vols. 1–6. Translated by Anna Beck. Princeton: Princeton University Press, 1987–1996.

Einstein, Albert, Hendrik Antoon Lorentz, Hermann Minkowski, and Hermann Weyl. *The Principle of Relativity*. London: Methuen, 1923; New York: Dover, 1952. Includes Einstein papers from 1905 (2), 1911, 1916 (2), 1917, 1919.

Eisenstein, Sergei. *Selected Works*. Edited by R. Taylor and M. Glenny. Vols. 1, 2, and 4. Bloomington: Indiana University Press, 1995.

Eliot, T. S. *The Complete Poems and Plays, 1909–1950*. New York: Harcourt, Brace, n.d.

————. *Selected Essays*. London: Faber and Faber, 1951, 1986.

————. *The Letters of T. S. Eliot: Vol. I, 1898–1922*. New York: Harcourt Brace Jovanovich, 1988.

————. *Knowledge and Experience in the Philosophy of F. H. Bradley*. 1916. New York: Columbia University Press, 1989. Includes 2 articles on Leibniz, monads, and Bradley from *Monist* 26 (October 1916).

Ellenberger, Henri F. *The Discovery of the Unconscious: The History and Evolution of Dynamic Psychiatry*. New York: Basic Books, 1970.

————. "The Story of Anna O.: A Critical Review with New Data." *History of the Behavioural Sciences* 8, no. 3 (July 1972).

Ellmann, Richard, and Charles Feidelson Jr., eds. *The Modern Tradition: Background of Modern Literature*. New York: Oxford University Press, 1973.

Elsaesser, Thomas, ed., with Adam Barker. *Early Cinema: Space—Frame—Narrative*. London: British Film Institute, 1990.

Erkkila, Betsy. "Walt Whitman and Jules Laforgue." *Walt Whitman Review* 24, no. 2 (1978).

————. *Walt Whitman Among the French: Poet and Myth*. Princeton: Princeton University Press, 1980.

Fauré, Gabriel. *Nocturnes and Barcarolles for Solo Piano*. New York: Dover, 1994.

Fechner, Gustav Theodor. *Ueber die physikalische und philosophische Atomen-*

lehre. Leipzig: Mendelssohn, 1855. 2nd ed. 1864. Reprinted Frankfurt am Main: Minerva, 1982.

Fell, John I., ed. *Film and the Narrative Tradition* (1974). Berkeley: University of California Press, 1986.

Ferguson, Robert. *Enigma: The Life of Knut Hamsun.* New York: Farrar, Straus and Giroux, 1987.

Fiori, Teresa, ed. *Archivi del Divisionismo.* 2 vols. Rome: Officina Edizioni, 1968.

Flam, Jack. *Matisse: The Man and His Art, 1869–1918.* Ithaca, N.Y.: Cornell University Press, 1986.

―――. "The Enigma of Seurat." *New York Review of Books,* 7 November 1991.

―――, ed. *The Documents of Twentieth-Century Art.* Berkeley: University of California Press, 1995ff.

Forel, Auguste. *Out of My Life and Work.* New York: Norton, 1937.

―――. *August Forel, Briefe/Correspondance, 1864–1927.* Edited by Hans H. Walser. Berne: Hans Huber, 1968.

Frege, Gottlob. *Translations from the Philosophical Writings of Gottlob Frege.* Edited by P. Geach and M. Black. Oxford: B. Blackwell, 1960.

―――. *The Basic Laws of Arithmetic* [Grundgesetze der Arithmetik, 1893–1903]. Translated by M. Furth. Berkeley: University of California Press, 1964.

―――. *Begriffschrift.* 1879. Translated by S. Bauer-Mengelberg. In J. van Heijenoort, ed., *From Frege to Gödel.* Cambridge: Harvard University Press, 1967.

―――. *Kleine Schriften.* Edited by I. Angelelli. Hildesheim: Olms, 1967.

―――. *On the Foundations of Geometry* (1903) and *Formal Theories of Arithmetic* (1885). Translated by E. H. W. Kluge. New Haven, Conn.: Yale University Press, 1971.

―――. *Conceptual Notation and Related Articles.* Edited by J. W. Bynum. Oxford: Clarendon Press, 1972.

―――. *Nachgelassene Schriften und Wissenschaftlicher Briefwechsel.* Edited by H. Hermes et al. Hamburg: F. Meiner, 1976.

―――. *Posthumous Writings* [Nachgelassene Schriften]. Edited by H. Hermes et al. Translated by P. Long and R. White. Chicago: University of Chicago Press, 1979.

―――. *Philosophical and Mathematical Correspondence* [Wissenschaftlicher Briefwechsel]. Edited by G. Gabriel et al. Abridged by B. McGuinness. Translated by H. Kaal. Chicago: University of Chicago Press, 1980.

―――. *The Foundations of Arithmetic* [Die Grundlagen der Arithmetik, 1884]. Translated by J. Austin, 1950. Evanston, Ill.: Northwestern University Press, 1980.

―――. *Collected Papers on Mathematics, Logic, and Philosophy.* Edited by Brian McGuinness. Oxford: B. Blackwell, 1984. Includes translations of most of *Kleine Schriften.*

French, A. P., and P. J. Kennedy, eds. *Bohr: A Centenary Volume.* Cambridge: Harvard University Press, 1985.

Freud, Sigmund. "An Unknown Autobiographical Fragment by Freud." *The American Imago* 4, no. 1 (August 1946).

―――. *The Standard Edition of the Complete Psychological Works of Sigmund Freud.* Edited by James Strachey. 23 vols. London: Hogarth, 1953–1974.

————. *Letters*. Edited by Ernst Freud. Translated by T. and J. Stern. New York: Basic Books, 1960. Dover reprint.

————. *Briefe, 1873–1939*. Frankfurt: S. Fischer Verlag, 1960, 1980.

————. *Cocaine Papers: Sigmund Freud*. Edited by R. Byck. New York: Meridian, 1974.

————. *The Origins of Psychoanalysis*. New York: Basic Books, 1977.

————. *A Phylogenetic Fantasy: Overview of the Transference Neuroses* (1914?). Edited by Ilse Grubrich-Simitis. Cambridge: Harvard University Press, 1987.

————, and Karl Abraham. *A Psychoanalytic Dialogue: Letters of Sigmund Freud and Karl Abraham*. Edited by Hilda Abraham and Ernst Freud. New York: Basic Books, 1965.

————, and Lou Andreas-Salomé. *Sigmund Freud and Lou Andreas-Salomé: Letters*. Edited by Ernst Pfeiffer. Translated by W. and E. Robson-Scott. London: Hogarth, 1972.

————, and Sandor Ferenczi. *The Correspondence of Sigmund Freud and Sandor Ferenczi*. Vol. 1, *1908–1914*. Translated by Peter T. Hoffer. Edited by E. Brabant, E. Falzeder, and P. Giampieri-Deutsch. Cambridge: Harvard University Press, Belknap Press, 1994.

————, and Wilhelm Fliess. *Correspondence*. Edited by J. Masson. Cambridge: Harvard University Press, 1985.

————, and Ernest Jones. *The Complete Correspondence of Sigmund Freud and Ernest Jones, 1908–1939*. Edited by R. A. Paskauskas. Cambridge: Harvard University Press, 1995.

————, and Carl G. Jung. *The Freud/Jung Letters*. Translated by R. Manheim and R. F. C. Hull. Edited by W. McGuire. Princeton: Princeton University Press, 1974, 1994.

————, and Arnold Zweig. *The Letters of Sigmund Freud and Arnold Zweig*. Edited by Ernst Freud. Translated by E. and W. Robson-Scott. New York: Harcourt, Brace and World, 1970.

Friedland, Roger and Deirdre Boden, eds. *NowHere: Space, Time and Modernity*. Berkeley: University of California Press, 1994.

Galison, Peter. "Aufbau/Bauhaus: Logical Positivism and Architectural Modernism." *Critical Inquiry* 16, no. 4 (Summer 1990).

Gardner, Howard. *Creating Minds: An Anatomy of Creativity Seen Through the Lives of Freud, Einstein, Picasso, Stravinsky, Eliot, Graham, and Gandhi*. New York: Basic Books, 1993.

Garshin, Vsevolod. *From the Reminiscences of Private Ivanov and Other Stories*. London: Angel Books, 1988.

Garton, Janet, ed. *Facets of European Modernism: Essays in Honour of James McFarlane*. Norwich, U.K.: Norvik Press, 1985.

Gauguin, Paul. *Gauguin and the Pont-Aven School*. Compiled by R. Field. London: Tate Gallery, 1966.

————. *Tout l'oeuvre peint de Gauguin*. Paris: Flammarion, 1981.

————. *Correspondance de Paul Gauguin, 1873–1888*. Edited by Victor Merlhès. Paris: Fondation Singer-Polignac, 1984.

————. *Noa-Noa: Gauguin's Tahiti*. Edited by N. Wadley. New York: Oxford University Press, 1985.

————. *Gauguin: A Retrospective*. Edited by Charles F. Stuckey. New York: Levin Associates/Macmillan, 1987.

————. *The Writings of a Savage*. Edited by Daniel Guérin (1974). Translated by E. Levieux. New York: Paragon House, 1990.

————. *Gauguin and the School of Pont-Aven*. Indianapolis Museum of Art, October 1994.

George, Stefan. *Stefan George: Selection from His Works Translated into English*. Translated by Cyril Meir Scott. London: Mathews, 1910.

————. *Gesamt-Ausgabe der Werke: Endgültige Fassung*. 18 vols., bound as 15. Berlin: Bondi, 1927–1934.

Gibbs, Josiah Willard. *Elementary Principles in Statistical Mechanics*. 1902. New York: Dover, 1960; Woodbridge, Conn.: Ox Bow Press, 1981.

————. *The Scientific Papers of J. Willard Gibbs*. 1906. 2 vols. Woodbridge, Conn.: Ox Bow Press, 1993.

Gide, André. *Journals*. Vol. 1. 1889–1927. Evanston, Ill.: Northwestern University Press, 1987.

Glockner, H. "Fechner, Lotze, und Planck." In *Die europäische Philosophie*. Stuttgart: Reclam, 1958.

Gluck, Mary. "Toward a Historical Definition of Modernism: George Lukács and the Avant-Garde." *Journal of Modern History* 58, no. 4 (1986).

Gödel, Kurt. *The Consistency of the Continuum Hypothesis*. Princeton: Princeton University Press, 1940.

————. *Collected Works*. Edited by Solomon Feferman et al. 3 vols. New York: Oxford University Press, 1986–1995.

Goehr, Alexander. "Schoenberg and Karl Kraus: The Idea behind the Music." *Music Analysis* 4 (1985).

Goetschel, Pascale, and Emmanuelle Loyer. *Histoire culturelle et intellectuelle de la France au XXe siècle*. Paris: Armand Colin, 1994.

Goldstein, Laurence. *The Flying Machine and Modern Literature*. Bloomington: Indiana University Press, 1986.

Gordon, Mel. "Meyerhold's Biomechanics." *The Drama Review* 18, no. 3 (1974), 73–88.

————, ed. *Expressionist Texts*. Baltimore, Md.: Johns Hopkins University Press, 1986.

Gorelik, Mordecai. *New Theatres for Old*. 1940. Revised edition. New York: Dutton, 1962.

Gourmont, Remy de. *Selected Writings*. Translated by Glenn S. Burne. Ann Arbor: University of Michigan Press, 1966.

Greenberg, Valerie. *Transgressive Readings: The Texts of Franz Kafka and Max Planck*. Ann Arbor: University of Michigan Press, 1991.

Greene, E. T. H. *T. S. Eliot et la France*. Paris: Boivin, 1951.

Gregory, Joshua Craven. *A Short History of Atomism from Democritus to Bohr*. London: A. & C. Black, 1931.

Grisolia, Santiago et al., eds. *Ramón y Cajal's Contribution to the Neurosciences*. New York: Elsevier, 1982.

Grünbaum, Adolf. *Modern Science and Zeno's Paradoxes*. London: Allen and Unwin, 1968.

———. *The Foundations of Psychoanalysis, A Philosophical Critique*. Berkeley: University of California Press, 1984.

Gunning, Thomas R. "The non-continuous style of early film." In Roger Holman, ed., *Cinema, 1900–1906*. Brussels: FIAF, 1982.

———. *D.W. Griffith and the Origins of American Narrative Film: The Early Years at Biograph*. Champaign: University of Illinois Press, 1991.

Hamsun, Knut. "Mark Twain." *Ny Illustreret Tidende*, 5 April 1885.

———. "August Strindberg." Chicago *American*, 29 January 1888, 20 December 1889.

———. *Hunger* [Sult]. Translated by Robert Bly. New York: Farrar, Straus and Giroux, 1967.

———. *The Cultural Life of Modern America*. Edited and translated by Barbara Gordon Morgridge. Cambridge: Harvard University Press, 1969.

———. *Mysteries* [Mysterier]. Translated by Gerry Bothmer. New York: Farrar, Straus and Giroux, 1971.

———. *Selected Letters*, vol. 1, *1879–98*. Edited by Harald Naess and James McFarlane. Norwich, U.K.: Norvik Press, University of East Anglia, 1990.

Hannequin, Arthur. *Essai critique sur l'hypothèse des atomes*. Paris: Masson, 1894.

Haskell, Francis. "Art and the Apocalypse." *New York Review of Books* 40, no. 13 (15 July 1993), 25.

Healy, Katherine S. "Edgar Degas and the Ballet Class at the Paris Opéra in the Early 1870s: An Analysis of Four Paintings." Bachelor's thesis, Princeton University, 1989.

Heijenoort, Jean van, ed. *From Frege to Gödel*. Cambridge: Harvard University Press, 1967. Includes papers by Burali-Forti, Frege, Gödel, Hilbert, König, von Neumann, Richard, Russell, and Zermelo.

Heisenberg, Werner. *Physics and Beyond: Encounters and Conversations*. Translated by A. J. Pomerans. New York: Harper, 1971.

Helmholtz, Hermann von. *Popular Lectures on Scientific Subjects*. 1870. Translated by E. Atkinson, 1880. 2 vols. London: Longmans, Green, 1884.

———. "On the Rate of Transmission of the Nerve Impulse." *Monatsberichte Preussischen Akademie der Wissenschaft* Berlin (1850), 14–15. Translated in W. Dennis, ed., *Readings in the History of Psychology*. New York: Appleton-Century-Crofts, 1948.

———. *Science and Culture: Popular and Philosophical Essays*. Edited by David Cahan. Chicago: University of Chicago Press, 1995.

Heller, Adele and Lois Rudnick, eds. *1915, The Cultural Moment: The New Politics, the New Woman, the New Psychology, the New Art, and the New Theater in America*. New Brunswick, N.J.: Rutgers University Press, 1991.

Henderson, Linda Dalrymple. *The Fourth Dimension and Non-Euclidean Geometries in Modern Art*. Princeton: Princeton University Press, 1986.

———. "X rays and the quest for invisible reality in the art of Kupka, Duchamp, and the Cubists." *Art Journal* 47 (winter 1988), 323–40.

Henel, Heinrich. "Kafka's *Der Bau*, or How to Escape from a Maze" in *The Discontinuous Tradition* (Stahl Festschrift). New York: Oxford University Press, 1971.

Henning, Edward B. *Creativity in Art and Science, 1860–1960*. Exhibition catalogue. Bloomington: Indiana University Press in association with the Cleveland Museum of Art, 1987.

Hilbert, David. "Über den Zahlbegriff." *Jahrbuch der deutscher Mathematiker-Vereinigung* 8, pt. 1 (1900), 180–84.

———. *Foundations of Geometry* [Grundlagen der Geometrie, 1899]. Translated by E. J. Townsend. Chicago: Open Court, 1902.

———. "Probleme der Grundlegung der Mathematik." In *Atti del Congresso internazionale dei matematici, Bologna, 3–10 settembre, 1928*. Bologna: n. p., 1929.

———. *Mathematische Probleme: Vortrag gehalten auf dem internationalem Mathematiker-Kongress zu Paris 1900*. Leipzig: Geest and Portig K. G., 1971.

Hintikka, Jaakko. "Virginia Woolf and Our Knowledge of the External World." *Journal of Aesthetics and Art Criticism* 38 (1979), 5–13.

———, ed. *The Philosophy of Mathematics*. London: Oxford University Press, 1969.

Hintikka, Jaakko, et al., eds. *Probabilistic Thinking: Thermodynamics and the Interaction of the History and Philosophy of Science*. Dordrecht: D. Reidel, 1981.

Hollander, Anne. *Moving Pictures*. New York: Knopf, 1989.

Hughes, Robert. *The Shock of the New*. New York: Knopf, 1981, 1991.

———. *Barcelona*. New York: Vintage, 1993.

Husserl, Edmund. *Ideas: A General Introduction to Pure Phenomenology* [Ideen zu einer reinen Phänomenologie, 1913]. Translated by W. R. Boyce Gibson. New York: Collier Books, 1962.

———. *The Idea of Phenomenology* [Die Idee der Phänomenologie, 1907, 1950]. Translated by W. Alston and G. Nakhnikian. The Hague: Martinus Nijhoff, 1964.

———. "Ein Brief Edmund Husserls an Ernst Mach" (18 June 1901). Edited by Joachim Thiele. *Zeitschrift für philosophische Forschung* 19 (1965), 134–38.

———. *Logical Investigations*. 1900–1901. Translated by J. N. Findlay. New York: Humanities Press, 1970.

———. *Philosophie de l'arithmétique* [Philosophie der Arithmetik, 1891]. Translated by J. English. Paris: Presses Universitaires, 1972.

———. *Introduction to the Logical Investigations: A Draft of a* Preface *to the* Logical Investigations. 1913. Edited by Eugen Fink. Translated by P. J. Bossert and C. H. Peters. The Hague: Martinus Nijhoff, 1975.

———. *Logische Untersuchungen* I: *Prolegomena zur reinen Logik*. Edited by Elmar Holenstein. Husserliana, vol. 18. The Hague: Martinus Nijhoff, 1975.

———. *Ideen zu einer reinen Phänomenologie und phänomenologischen Philosophie, I Buch, Allgemeine Einführung in die reine Phänomenologie*. 1913. Edited by Karl Schuhmann. Husserliana, vol. 3, books 1 and 2. The Hague: Martinus Nijhoff, 1976.

———. *Phantasie, Bildbewusstsein, Erinnerung: Zur Phänomenologie der anschaulichen Vergegenwärtigungen: Texte aus dem Nachlass (1898–1925)*. Edited by Eduard Marbach. Husserliana, vol. 23. The Hague: Martinus Nijhoff, 1980.

————. *Shorter Works*. Edited by P. McCormick and F. Elliston. Notre Dame, Ind.: University of Notre Dame Press, 1981. Includes *On the Concept of Number*.

————. *Contribution au calcul des variations* [Beitrag zur Variationsrechnung, 1882]. Translated by J. Vauthier. Queens Papers in Pure and Applied Mathematics, no. 65. Kingston, Ontario: Queens University Press, 1983.

————. *Studien zur Arithmetik und Geometrie: Texte aus dem Nachlass, 1886–1901*. Edited by Ingeborg Strohmeyer. Husserliana, vol. 21. The Hague: Martinus Nijhoff, 1983.

————. *Ideas Pertaining to a Pure Phenomenology and to a Phenomenological Philosophy: First Book* [Ideen zu einer reinen Phänomenologie, 1913]. Translated by F. Kersten. Boston: Martinus Nijhoff, 1983.

————. *Logische Untersuchungen* II: *Untersuchungen zur Phänomenologie und Theorie der Erkenntnis*. Parts 1 and 2. Edited by Ursula Panzer. Husserliana, vol. 19, parts 1 and 2. The Hague: Martinus Nijhoff, 1984.

Hutton, John G. *Neo-Impressionism and the Search for Solid Ground: Art, Science, and Anarchism in Fin-de-Siècle France*. Modernist Studies, vol. 1. Baton Rouge: Louisiana State University Press, 1994.

Huysmans, Joris-Karl. *L'art moderne* (1883) / *Certains* (1889). Paris: 10/18, 1975.

————. *A Rebours* (1884). Paris: 10/18, 1977.

Ibsen, Henrik. *The Oxford Ibsen*. Vol. 5. London: Oxford University Press, 1961.

International Symposium "100 Years Boltzmann Equation" in Vienna, 4–8 September 1972. In *Acta Physica Austriaca* Supplementum. New York: Springer Verlag, 1973. Includes contributions by D. Flamm, E. Broda, M. J. Klein, G. E. Uhlenbeck, and C. Cercignani.

Isaak, Jo Anna. *The Ruin of Representation in Modernist Art and Texts*. Ann Arbor, Mich.: UMI Research Press, c1986.

Ives, Charles. "Ragtime," "Beethoven and Strauss," and "Brahms's Orchestration." In Sam Morgenstern, ed. *Composers on Music: An Anthology of Composers' Writings from Palestrina to Copland*. New York: Pantheon, 1956.

————. *A Temporary Mimeographed Catalogue of the Music Manuscripts and Related Materials of Charles Edward Ives, 1874–1954*. Compiled by John Kirkpatrick. New Haven: n. p., 1960.

————. *Essays Before a Sonata, The Majority, and Other Writings*. Edited by H. Boatwright. New York: Norton, 1962.

————. *Memos*. Edited by John Kirkpatrick. New York: Norton, 1972.

————. *Universe Symphony*. Edited by Larry Austin. Performed by Cincinnati Philharmonia et al. Centaur CRC 2205 CD, 1994.

Jacob, Max. "Souvenirs sur Picasso contés par Max Jacob." *Cahiers d'Art* 6 (1927).

————. *Hesitant Fire: Selected Prose of Max Jacob*. Translated by M. Black and M. Green. Lincoln: University of Nebraska Press, 1991.

Jacobsen, Jens Peter. *Niels Lhyne* (1880, 1882). Translated by Tina Nunnally. Seattle, Wash.: Fjord Press, 1990.

Jahn, Wolfgang. "Kafka und die Anfänge des Kinos." *Jahrbuch der deutschen Schillergesellschaft* 6 (1962), 353–68.

James, Henry. *The Sacred Fount.* 1901. Edited by L. Edel. New York: Evergreen, 1979.

———. *The Correspondence of Henry James and Henry Adams, 1877–1914.* Baton Rouge: Louisiana State University Press, 1993.

James, William. *The Letters of William James.* Edited by Henry James. 2 vols. Boston: Atlantic Monthly Press, 1920.

———. *Selected Letters.* Edited by Elizabeth Hardwick. New York: Doubleday Anchor, 1961.

———. *Principles of Psychology.* 1890. Cambridge: Harvard University Press, 1983.

———. *Works.* 2 vols. New York: Library of America, 1988, 1992.

———. *Manuscript Essays and Notes.* 1872–1907. Cambridge: Harvard University Press, 1988.

———. *Manuscript Lectures.* 1872–1907. Cambridge: Harvard University Press, 1989.

———. *The Correspondence of William James.* Vol. 3, *William and Henry, 1897–1910.* Edited by Ignas K. Skrupskelis and Elizabeth M. Berkeley. Charlottesville: University Press of Virginia, 1994.

Janik, Allan, and Stephen Toulmin. *Wittgenstein's Vienna.* New York: Simon and Schuster paperback, 1973.

Jaques, Elliott, ed. *Levels of Abstraction in Logic and Human Action: A Theory of Discontinuity in the Structure of Mathematical Logic, Psychological Behavior and Social Organization.* London: Heinemann, 1978.

Jarry, Alfred. *Oeuvres complètes.* Edited by M. Arrivé. Paris: Gallimard, Pléiade, 1972.

Johnson, Ron. "Picasso's *Demoiselles d'Avignon* and the Theater of the Absurd." *Arts Magazine* 55, no. 2 (October 1980).

Johnston, William. *The Austrian Mind.* Berkeley: University of California Press, 1983.

Jones, J. Sydney. *Hitler in Vienna, 1907–1913: Clues to the Future.* New York: Stein and Day, 1983.

Joplin, Scott. *The Collected Works of Scott Joplin.* Edited by Vera Brodsky Lawrence. 2 vols. New York: New York Public Library/Belwin Mills Publishing, 1971.

———. *The Red Back Book* [*Fifteen Standard High Class Rags*]. Edited by Vera B. Lawrence. New York: Fanfare Press, 1973.

Jourdain, P. E. B. "The Development of the Theory of Transfinite Numbers (Part II): Weierstrass (1840–1880)." *Archiv der Mathematik und Physik* 14 (1909), 289–311.

———. "The Development of the Theories of Mathematical Logic and the Principles of Mathematics (Part I)." *Quarterly Journal of Pure and Applied Mathematics* 41 (1910), 324–52.

———. "Translator's Notes." In Ernst Mach, *History and Root of the Principle of the Conservation of Energy.* Chicago: Open Court, 1911.

———. "The Origins of Cauchy's Conception of the Definite Integral and of the Continuity of a Function." *Isis* 1 (1913), 661–703.

———. "Richard Dedekind." *The Monist* 26 (1916), 415–27.

————. *Dear Russell-Dear Jourdain*. Edited by I. Grattan-Guinness. London: Duckworth, 1977.

Joyce, James. *Ulysses*. New York: Modern Library, 1961.

————. *Stephen Hero*. New York: New Directions, 1963.

————. *Dubliners*. Edited by Robert Scholes and A. Walton Litz. New York: Viking-Penguin, 1969.

————. *Selected Letters of James Joyce*. Edited by Richard Ellmann. New York: Viking, 1975.

————. *Portrait of the Artist as a Young Man*. Edited by Chester G. Anderson. New York: Viking-Penguin, 1977.

————. *Ulysses*. Rev. ed. Edited by Hans Walter Gabler. New York: Random House, Vintage Books, 1986.

Jung, Carl Gustav. *Freud and Psychoanalysis: Collected Works*. Vol. 4. Edited by H. Read, M. Fordham, and G. Adler. Translated by R. F. C. Hull. New York: Pantheon, 1961.

————. *Synchronicity*. Princeton: Princeton University Press, 1973.

Kac, Mark, Gian-Carlo Rota, and Jacob T. Schwartz. *Discrete Thoughts: Essays on Mathematics, Science, and Philosophy*. Boston: Birkhäuser, 1992.

Kafka, Franz. *The Diaries of Franz Kafka*. Edited by Max Brod. New York: Schocken Books, 1949.

————. *The Complete Stories*. Edited by Nahum Glatzer. New York: Schocken Books, 1976.

Kahn, Douglas and Gregory Whitehead, eds. *Wireless Imagination: Sound, Radio, and the Avant-Garde*. Cambridge: MIT Press, 1994.

Kahn, Elizabeth Louise. *The Neglected Majority:* "*Les Camoufleurs*," *Art History, and World War I*. Lanham, Md.: University Press of America, 1984.

Kallir, Jane. *Arnold Schoenberg's Vienna*. Exhibition catalogue, Galerie St. Etienne. New York: Rizzoli, 1984.

————. *Paula Modersohn-Becker*. Exhibition catalogue. New York: Galerie St. Etienne, 1983.

————. *Viennese Design and the Wiener Werkstätte*. New York: Braziller, 1986.

Kandinsky, Vassily. *Kandinsky. Catalogue Raisonné of the Oil Paintings*. Vol. 1, *1910–1915*. Edited by Hans K. Roethel and Jean K. Benjamin. Hudson Hills, 1981; London, 1982.

————. *Sounds* (1912). Translated by E. Napier. New Haven, Conn.: Yale University Press, 1981.

————. *Complete Writings on Art*. Edited by K. Lindsay and P. Vergo. 2 vols. New York: G. K. Hall, 1982. Reprinted in 1 vol., 1994.

————. *Catalogue Raisonné of the Watercolors*. Vol. 1, *1900–1921*. Edited by Vivian Endicott Barnett. Ithaca, N.Y.: Cornell University Press, 1992.

————, and Franz Marc, eds. *Der Blaue Reiter*. 1912. Edited by Klaus Lankheit. Munich: R. Piper, 1965.

————, and Franz Marc, eds. *The Blaue Reiter Almanac*. 1912. Edited by Klaus Lankheit. London: Thames and Hudson, 1974.

————, and Franz Marc. *Wassily Kandinsky, Franz Marc, Briefwechsel: mit Briefen von und an Gabriele Münter und Maria Marc*. Edited by Klaus Lankheit. Munich: R. Piper, c1983.

————, and Arnold Schoenberg. *Letters, Pictures, and Documents.* Translated by J. Hahl-Koch. Edited by J. C. Crawford. Boston: Faber and Faber, 1984.

Kelvin, William Thomson, Lord. *Popular Lectures and Addresses.* 3 vols. London: Macmillan, 1889–1894.

————. *Kelvin's Baltimore Lectures and Modern Theoretical Physics* (1884). Edited by Robert Kargon and Peter Achinstein. Cambridge: MIT Press, 1987.

Kendall, Elizabeth. *Where She Danced.* Berkeley: University of California Press, 1984.

Kenner, Hugh. "Some Post-Symbolist Structures." In *Literary Theory and Structure.* Edited by Frank Brady, John Palmer, and Martin Price. New Haven, Conn.: Yale University Press, 1973.

Khlebnikov, Velimir (Victor). *Collected Works.* Edited by Ronald Vroon. Translated by Paul Schmidt. 2 vols. Cambridge: Harvard University Press, 1989.

Khlebnikov, Velimir and A. Kruchenykh. *Victoire sur le soleil* [Pobieda nad Solntsem. Victory Over the Sun]. Music by Mikhail Vasilievich Matyushin. Montage by Matyushin and Kasimir Malevich. Edited by J.-C. Marcadé. Lausanne: L'Age d'Homme, 1976.

Kirchhoff, Gustav R. *Abhandlungen über mechanische Wärmetheorie.* Edited by Max Planck. Leipzig: Engelmann, 1898.

————. *Abhandlungen über Emission und Absorption.* Edited by Max Planck. Leipzig: Engelmann, 1898.

Kirchner, Ernst Ludwig. *Chronik der Brücke.* 1913. In Buchheim, *Die Künstlergemeinschaft Brücke.* Feldafing: Buchheim-Verlag, 1956.

Kiss, Endre. *Der Tod der k.u.k. Weltordnung in Wien: Ideengeschichte Österreichs um die Jahrhundertwende.* Vienna: Böhlau, 1986.

Klee, Paul. *The Diaries of Paul Klee, 1898–1918.* Edited by Felix Klee. Berkeley: University of California Press, 1968.

Kokoschka, Oskar. *Das Schriftliche Werk.* Edited by Heinz Spielmann. 4 vols. Hamburg: Hans Christians Verlag, 1973–1976.

————. *My Life.* 1971. Translated by D. Britt. New York: Macmillan, 1974.

————. *Drawings and Watercolors of Oscar Kokoschka.* Edited by Serge Sabarsky. New York: Rizzoli, 1985.

————. *Oskar Kokoschka, 1886–1980.* New York: Guggenheim Museum, 1986.

————. *Oskar Kokoschka Letters, 1905–1976.* Translated by Mary Whittall. New York: Thames and Hudson, 1992.

————. *Oskar Kokoschka, Works on Paper: The Early Years, 1897–1917.* Edited by Alice Strobl and Alfred Weidinger. Exhibition catalogue. Vienna: Graphische Sammlung Albertina/Guggenheim Museum, 1994.

Kraus, Karl. *The Last Days of Mankind.* Translated by A. Gode and S. E. Wright. Abridged by F. Ungar. New York: Frederick Ungar, 1974.

————. *In These Great Times: A Karl Kraus Reader.* Edited by H. Zohn. New York: Carcanet, 1986.

————. *Half-Truths and One-and-a-Half Truths: Selected Aphorisms.* Edited by H. Zohn. New York: Carcanet, 1986.

Krauss, Rosalind E. *The Originality of the Avant-Garde and Other Modernist Myths.* Cambridge: MIT Press, 1985.

Krige, John. *Science, Revolution, and Discontinuity.* New York: Harvester Press, in association with Humanities Press, 1980.

Kronecker, Leopold. *Werke.* Edited by K. Hensel. Leipzig: Teubner, 1899.

———. *Vorlesungen über Zahlentheorie.* Edited by K. Hensel. Leipzig: Teubner, 1901.

Krüger, Lorenz, Lorraine Daston, and Michael Heidelberger, eds. *The Probabilistic Revolution.* 2 vols. Cambridge: MIT Press, 1987.

Kuleshov, Lev. *Kuleshov on Film: Writings of Lev Kuleshov.* Edited and translated by Ronald Levaco. Berkeley: University of California Press, 1974.

Kupka, Frantisek. *Frantisek Kupka: A Retrospective.* Exhibition catalogue. Compiled by M. Mladek and Margit Rowell. New York: Guggenheim Museum, 1975.

———. *Frank Kupka, 1871–1957.* Exhibition catalogue. Edited by Margit Rowell. Zürich: Kunsthaus Zürich, 1976.

———. *Frantisek Kupka, 1871–1957, Ou l'invention d'une Abstraction.* Exhibition catalogue. Edited by Suzanne Page, Jiri Kotalik, and Kirsztina Passuth. Paris: Musée de l'Art moderne de la Ville de Paris, 1989.

———. *La Création dans les arts plastiques.* Written in 1913, published in Czech, Prague, 1923. Edited and translated by Erika Abrams. Paris: Editions Cercle d'Art, c1989.

Kupper, Herbert I., and Hilda A. Rollman-Branch. "Freud and Schnitzler—(Doppelgänger)." *Journal of the American Psychoanalytic Association* 7, no. 1 (1959), 109–126.

Kuzmin, Mikhail. *Selected Prose and Poetry.* Edited and translated by Michael Green. Ann Arbor, Mich.: Ardis, 1980.

Laforgue, Jules. *Oeuvres complètes.* 3 vols. Paris: Mercure de France, 1902–1903.

———. *Les Complaintes.* Edited by Michael Collie. London: Athlone Press, 1977.

———. *Moralités légendaires.* Geneva: Droz, 1980.

———. *Oeuvres complètes.* Vol. 1, 1860–1883. Edited by J. L. Debauve, D. Grojnowski, P. Pia, and P.-O. Walzer. Lausanne: L'Age d'Homme, 1986.

———. *Moral Tales.* Translated by William Jay Smith. New York: New Directions, 1990.

Lamb, Trevor, and Janine Bouriau, eds. *Colour: Art and Science.* Cambridge: Cambridge University Press, 1995.

Langbaum, Robert. *The Poetry of Experience: The Dramatic Monologue in Modernist Literary Tradition.* New York: Norton, 1957.

Laporte, Paul. "The Space-Time Concept in the Work of Picasso." *Magazine of Art* 40 (1947), 26.

Lardner, Ring. *You Know Me Al.* Champaign: University of Illinois Press, 1992.

———. *The Annotated Baseball Stories of Ring W. Lardner, 1914–1919.* Edited by George W. Hilton. Stanford, Calif.: Stanford University Press, 1995.

Lasswitz, Kurd. *Atomistik und Kriticismus: Ein Beitrag zur erkenntnistheoretischen Grundlegung der Physik.* Brunswick: Vieweg, 1878.

———. *Geschichte der Atomistik vom Mittelalter bis Newton.* 2 vols. Hamburg and Leipzig: L. Voss, 1890, 1892.

Latour, Bruno. *We Have Never Been Modern.* Cambridge: Harvard University Press, 1995.

Lautréamont [Isidore Ducasse]. *Oeuvres complètes.* Paris: Hachette, Poche, 1963.

Law, Alma, and Mel Gordon. *Meyerhold, Eisenstein and Biomechanics: Actor Training in Revolutionary Russia.* London: McFarland, 1996.

Lears, Jackson. *No Place of Grace: Antimodernism and the Transformation of American Culture, 1880–1920.* New York: Pantheon, 1981.

Le Corbusier (Charles-Edouard Jeanneret-Gris). *Early Works.* With contributions by Geoffrey Baker and Jacques Gubler. New York: St. Martin's, 1987.

———. *Journey to the East.* 1911. Edited and translated by Ivan Zaknič. Cambridge: MIT Press, 1987.

———. *Towards a New Architecture.* 1923. Translated by Frederick Etchells. New York: Dover, 1987.

———. *The Decorative Art of Today.* 1925. Translated by James I. Dunnett. Cambridge: MIT Press, 1987.

———. *Le Corbusier: Une Encyclopédie.* Exhibition catalogue of "L'Aventure Le Corbusier: 1887–1965" at Centre Georges Pompidou. Paris, 1987–88.

Leff, Harvey S., and Andrew F. Rex, eds. *Maxwell's Demon: Entropy, Information and Computing.* Princeton: Princeton University Press, 1991.

Lehmann, A. G. *The Symbolist Aesthetic in France, 1885–1895.* 2d ed. New York: Oxford University Press, 1968.

Leitner, Bernhard. *The Architecture of Ludwig Wittgenstein.* New York: New York University Press, 1976.

Lewis, Tom. *Empire of the Air: The Creation of Radio.* New York: HarperCollins, 1991.

Lipsitz, George. *The Sidewalks of Saint Louis: Places, People, and Politics in an American City.* Columbia: University of Missouri Press, 1991.

Lista, G. *Futurisme: Manifestes, Documents, Proclamations.* Lausanne: L'Age d'Homme, 1973.

Loizeaux, Elizabeth Bergmann. *Yeats and the Visual Arts.* New Brunswick, N.J.: Rutgers University Press, 1986.

London, Jack. *Works.* 2 vols. New York: Library of America, 1982.

———. *The Letters of Jack London.* Edited by E. Labor, R. C. Leitz III, and I. M. Shepard. 3 vols. Stanford, Calif.: Stanford University Press, 1988.

Long, Rose-Carol Washton. *Kandinsky: The Development of an Abstract Style.* New York: Oxford University Press, 1980.

———, ed. *German Expressionism: Documents from the End of the Wilhelmine Empire to the Rise of National Socialism.* Berkeley: University of California Press, 1996.

Loos, Adolf. *Sämtliche Schriften.* Edited by F. Glück. Vol. 1. Vienna: Herold, 1962.

———. *Spoken Into the Void: Collected Essays, 1897–1900.* Cambridge: MIT Press, 1982.

Loran, Erle. *Cézanne's Composition.* 1943, 1963. Berkeley: University of California Press, 1985.

Lorentz, Hendrik Antoon. "Michelson's Interference Experiment" and "Electromagnetic Phenomena in a System Moving with Any Velocity Less than That of Light." In Einstein et al., *The Principle of Relativity.* London: Methuen, 1923; New York: Dover, 1952.

————. *The Theory of Electrons.* New York: Dover, 1952.

Loring, F. H. *Atomic Theories.* London: Methuen, 1921.

Loschmidt, Johann Josef. *Chemische Studien. A: Constitutions-Formeln der organischen Chemie in geographischer Darstellung. B: Das Mariotte'sche Gesetz.* Vienna, 1861. Milwaukee, Wis.: Aldrich Chemical Company, 1989.

Loss, Archie. *Joyce's Visible Art: The Work of Joyce and the Visual Arts, 1904–1922.* Ann Arbor, Mich.: UMI Research Press, 1984.

Lugné-Poë, Aurélien-François. *La Parade: souvenirs et impressions du théâtre.* 2 vols. Paris: Gallimard, 1930–1931.

Lutz, Tom. *American Nervousness, 1903: An Anecdotal History.* Ithaca, N.Y.: Cornell University Press, 1991.

MacGowan, Christopher J. *William Carlos Williams's Early Poetry: The Visual Arts Background.* Ann Arbor, Mich.: UMI Research Press, c1984.

Mach, Ernst. *Grundlinien der Lehre von den Bewegungsempfindung.* Leipzig: Engelmann, 1875.

————. *Analysis of the Sensations* [Beiträge zur Analyse der Empfindungen, 1886]. Translated by C. Williams and S. Waterloo, 1897. La Salle, Ill.: Open Court reprint, n.d.

————. *Space and Geometry.* 1901–1903. La Salle, Ill.: Open Court, 1906.

————. *Erkenntnis und Irrtum: Skizzen zur Psychologie der Forschung.* Leipzig: Barth, 1905. 2nd ed. 1906.

————. *History and Root of the Principle of the Conservation of Energy.* Chicago: Open Court, 1911.

————. *Principles of Physical Optics.* London: Methuen, 1926.

————. Mach Symposium. *Synthese* 18 (1968).

————. Ernst Mach, Physicist and Philosopher. *Boston Studies in the Philosophy of Science* 6 (1970).

————. *[Popular] Scientific Lectures* (1894). Chicago: Open Court, 1985.

————. *Über Ernst Machs "Erkenntnis und Irrtum": mit zwei Anhängen, Kleine Schriften über Ernst Mach, Der Brentano-Mach-Briefwechsel.* Edited by Roderick M. Chisholm and Johann C. Marek. Amsterdam: Rodopi, 1988.

————. *The Science of Mechanics.* Peru, Ill.: Open Court, 1989.

MacLeod, Glen. *Wallace Stevens and Modern Art: From the Armory Show to Abstract Expressionism.* New Haven, Conn.: Yale University Press, 1993.

Maeterlinck, Maurice. *On Emerson and Other Essays.* Translated by Alfred Sutro. New York: Dodd, Mead, 1912.

————. *The Treasure of the Humble.* 1896. Translated by Montrose J. Moses. New York: Dodd, Mead, n.d.

————. *La Vie de l'espace.* Paris: Fasquelle, 1928.

Mahler, Gustav, and Richard Strauss. *Correspondence, 1888–1911.* Edited by H. Blaukopf. Translated by E. Jephcott. Chicago: University of Chicago Press, 1984.

Malevich, Kasimir. *Ecrits.* 2 vols. Lausanne: L'Age d'Homme, 1976.

————. *Kasimir Malevich, 1878–1935.* Exhibition catalogue. Edited by Jeanne D'Andrea. Los Angeles: Armand Hammer Museum, 1990.

Mallarmé, Stéphane. *Oeuvres.* Vol. 1, *Poésies.* Edited by Carl Paul Barbier and Charles Gordon Millan. Paris: Flammarion, 1983.

————. *Selected Letters of Mallarmé*. Edited by Rosemary Lloyd. Chicago: University of Chicago Press, 1988.

————. *Oeuvres*. Edited by Henri Mondor and Gérard Jean-Aubry. Paris: Gallimard, Pléiade, 1989.

Mansfield, Katherine. *The Short Stories of Katherine Mansfield*. New York: Alfred A. Knopf, 1937.

————. *Journal of Katherine Mansfield*. Edited by John Middleton Murry. London: Constable, 1954.

————. "The Unpublished Manuscripts of Katherine Mansfield." Edited by Margaret Scott. *The Turnbull Library Record*, n.s, 3 (1970). Includes "Juliet," "London," and "Summer Idylle, 1906."

————. "Fifteen Letters from Katherine Mansfield to Virginia Woolf." *Adam International Review* 370–375 (1972–1973).

————. *The Urawara Notebook*. Edited by Ian A. Gordon. New York: Oxford University Press, 1978.

————. *The Critical Writings of Katherine Mansfield*. Edited by Clare Hanson. New York: St. Martin's, 1987.

————. *The Collected Letters of Katherine Mansfield*. Vol. 1, 1903–1917. Edited by V. O'Sullivan with M. Scott. New York: Oxford University Press, 1990.

Marey, Etienne-Jules. "Des Allures de cheval. Etudiées par la méthode graphique." *Compte-rendus des séances de l'Académie des Sciences* 75 (1872).

————. *Animal Mechanism: A Treatise on Terrestrial and Aerial Locomotion* [La Machine Animale: Locomotion Terrestre et Aérienne, 1873]. New York: Appleton, 1874.

————. *La Méthode graphique dans les sciences expérimentales et principalement en physiologie et en médicine*. Paris: G. Masson, 1878.

————. *Movement*. Translated by Eric Pritchard. London: Heinemann, 1895.

————. "The History of Chronophotography." *Smithsonian Institution Annual Report* (1901), 317–41.

————. *E. J. Marey, 1830–1904*. Exhibition catalogue. Paris: Centre Georges-Pompidou, in association with Musée nationale d'Art moderne, 1977 (film).

Marquis, Donald M. *In Search of Buddy Bolden: First Man of Jazz*. Baton Rouge: Louisiana State University Press, 1993.

Martí, José. *Major Poems: A Bilingual Edition*. Translated by Elinor Randall. Edited by Philip S. Foner. New York: Holmes and Meier, 1982.

————. *Critical Writings: A Bilingual Edition*. Translated by Elinor Randall. Edited by Philip S. Foner. New York: Holmes and Meier, 1982.

Martin, Steve. *Picasso at the Lapin Agile*. 1993–94 (play).

Mason, Stephen S. "From Pasteur to Parity Violation: Cosmic Dissymmetry and the Origins of Biomolecular Handedness." *Ambix* 38 (1991), 85–98.

Masur, Gerhard. *Prophets of Yesterday*. New York: Harper paperback, 1966.

Matisse, Henri. *Matisse on Art*. Edited by J. Flam. New York: Dutton, 1978; Berkeley: University of California Press, 1994. New ed. 1995.

————. *Matisse, a Retrospective*. Edited by J. Flam. New York: Levin Associates, 1988.

Maxwell, James Clerk. "Does the Progress of Physical Science Tend to Give Any Advantage to the Opinion of Necessity (or Determinism) over That of the Con-

tingency of Events and the Freedom of the Will?" In Campbell and Garnett, *The Life of James Clerk Maxwell*. London: Macmillan, 1882; reprinted New York: Johnson, 1969.

———. *A Treatise on Electricity and Magnetism*. New York: Dover, n.d.

———. *Maxwell on Saturn's Rings*. Edited by Stephen G. Brush et al. Cambridge: MIT Press, 1983.

———. *Maxwell on Molecules and Gases*. Edited by Elizabeth Garber, Stephen G. Brush, and C. W. F. Everett. Cambridge: MIT Press, 1986.

———. *The Scientific Letters and Papers of James Clerk Maxwell*. Edited by P. M. Harman. 2 vols. 1862–1873. New York: Cambridge University Press, 1995.

May, Arthur J. *Vienna in the Age of Franz Joseph*. Norman: University of Oklahoma Press, 1966.

McCay, Winsor. *Little Nemo in Slumberland*. 6 vols. Northampton, Mass.: Kitchen Sink Press, 1994.

McClatchy, J. D. *Poets on Painters: Essays on the Art of Painting by Twentieth-Century Poets*. Berkeley: University of California Press, 1991.

McCue, George, and Frank Peters. *A Guide to the Architecture of St. Louis*. Maps and drawings by Pat Hays Baer. Columbia: University of Missouri Press, 1989.

McCully, Marilyn, ed. *A Picasso Anthology*. Princeton: Princeton University Press, 1982.

McDonnell, John J. *The Concept of an Atom from Democritus to John Dalton*. Queenston, Ontario: Edwin Mellen Press, 1991.

McEvoy, John G. "Continuity and Discontinuity in the Chemical Revolution." *Osiris* 4 (1988).

McGann, Jerome. *Black Riders: The Visible Language of Modernism*. Princeton: Princeton University Press, 1993. On typefaces.

McGrath, William J. *Dionysian Art and Populist Politics in Austria*. New Haven, Conn.: Yale University Press, 1974.

———. *Freud's Discovery of Psychoanalysis: The Politics of Hysteria*. Ithaca, N.Y.: Cornell University Press, 1985.

McKay, Claude. *Home to Harlem* (1928). Boston: Northeastern University Press, 1987.

———. *The Dialect Poetry of Claude McKay*. Edited by Walter Jekyll. 1912. North Stratford, N.H.: Ayer, 1995.

Méliès, Georges. *158 Scénarios de films disparus de Georges Méliès*. Paris: Association "Les Amis de Georges Méliès," 1986.

Mellow, James R. *Charmed Circle: Gertrude Stein and Company*. New York: Avon, 1975.

Millet, Jean. *Bergson et le calcul infinitésimal*. Paris: Presses Universitaires de France, 1974.

Modersohn-Becker, Paula. *The Letters and Journals of Paula Modersohn-Becker*. Edited by Gunter Bush and Liselotte Von Reinken. Evanston, Ill.: Northwestern University Press, 1990.

Mondrian, Piet. *The New Art, the New Life: The Collected Writings of Piet Mondrian*. Edited by H. Holtzman and M. S. James. New York: G. K. Hall, 1986.

———. *Mondrian*. Exhibition catalogue. New York: Sidney Janis Gallery, 1988.

———. *Piet Mondrian, 1872–1944*. Exhibition catalogue. Compiled by Yves-

Alain Bois, Joop Joosten, Angelica Zander Rudenstine, and Hans Janssen. Haags Gemeentemuseum/National Gallery of Art, Leonardo Arte, 1995.

Monk, Ray. *Ludwig Wittgenstein: The Duty of Genius*. New York: Free Press, 1990.

———. *Bertrand Russell: The Spirit of Solitude*. London: Cape, 1996.

Moore, George. *Impressions and Opinions*. 2d printing. New York: Brentano's, 1891.

———. *Modern Painting*. New enlarged ed. London: W. Scott, 1898.

———. *Reminiscences of the Impressionist Painters*. Dublin: Maunsel, 1906.

———. *Celibates*. 1895. New York: Brentano's, 1919.

———. *Memoirs of My Dead Life*. 1906. New York: Boni and Liveright, 1920.

———. *Hail and Farewell* (*Ave*, 1911; *Atque*, 1912; *Vale*, 1914). New York: Boni and Liveright, 1923.

———. *Avowals*. London: Heinemann; New York: Brentano's, 1924.

———. *Letters from George Moore to Edouard Dujardin, 1886–1922*. Edited by John Eglinton. New York: Crosby Gaige, 1929.

———. *Conversations in Ebury Street* (1924). Dublin: Ebury Edition, 1936.

———. *Letters to Lady Cunard, 1895–1933*. Edited by Rupert Hart-Davis. London: Rupert Hart-Davis, 1957.

———. *Confessions of a Young Man*. 1888. New York: Putnam's, Capricorn, 1959.

———. *George Moore in Transition: Letters to T. Fisher Unwin and Lena Milman, 1894–1910*. Edited by H. E. Gerber. Detroit, 1968.

———. *The Untilled Field* [An T-ür-Gort, Sgéalt, 1902]. 1903. Gerrards Cross, U.K.: Colin Smythe, 1976.

———. *The Lake* (1905, 1921). Edited by Richard Allen Cave. Gerrards Cross, U.K.: Colin Smythe, 1980.

Moore, G. E. (George Edward). "The Nature of Judgment." *Mind* (April 1899).

———. "The Refutation of Idealism." *Mind*, n. s., 48 (October 1903).

———. *Principia Ethica*. Cambridge: Cambridge University Press, 1903.

Morgan, Ann Lee. *Arthur Dove: Life and Work, with a Catalogue Raisonné*. Newark: University of Delaware Press, 1984.

Morton, Frederic. *A Nervous Splendor: Vienna, 1888/1889*. New York: Penguin Books, 1980.

———. *Thunder at Twilight: Vienna, 1913–1914*. New York: Scribner's, 1989.

Morton, "Jelly Roll" [Ferdinand LaMothe], and Allan Lomax. *Mister Jelly Roll*. 1950. New York: Pantheon, 1993.

Munch, Edvard. *The Frieze of Life*. National Gallery Publications. New York: Abrams, 1993.

———. *Edvard Munch*. Exhibition catalogue. Museum Folkwang Essen, 1987; Kunsthaus Zürich, 1988.

———. *Edvard Munch and Harald Sohlberg: Landscapes of the Mind*. Exhibition catalogue. National Academy of Design, New York, 1995. Hanover, N.H.: University Press of New England, 1995.

Münch, Richard. *Die Kultur der Moderne*. 2 vols. Frankfurt am Main: Suhrkamp, 1993.

Murata, T. "A Few Remarks on the Atomistic Way of Thinking in Mathematics." *Japanese Studies in the History of Science* 6 (1967), 47–59.

Music From the New York Stage, 1890–1920. 4 vols., 12 CDs. London: Pearl Recordings (Koch International), 1994.

Musil, Robert. *On Mach's Theories* [Beitrag zur Beurteilung der Lehren Machs, 1908]. Translated by Kevin Mulligan. Washington, D.C.: Catholic University of America Press, 1982.

———. *Five Women* [Drei Frauen; Vereinigung, 1911, 1924]. Boston: Godine, 1987.

———. *Young Törless* [Die Verwirrungen des Zöglings Törless, 1906]. New York: Alfred A. Knopf, 1990.

———. *Precision and Soul: Essays and Addresses*. Chicago: University of Chicago Press, 1990.

———. *The Man without Qualities* [Der Mann ohne Eigenschaften, 1930, 1932, 1942]. Translated by Sophie Wilkins and Burton Pike. 2 vols. New York: Alfred A. Knopf, 1995.

Musser, Charles, with Carol Nelson. *High-Class Moving Pictures: Lyman H. Howe and the Forgotten Era of Travelling Exhibition, 1880–1920*. Princeton: Princeton University Press, 1991.

———. *Thomas A. Edison and His Kinetoscopic Motion Pictures*. New Brunswick, N.J.: Rutgers University Press, 1995.

———, ed. *The Movies Begin*. 3 videotapes (films by Edison, Acres, Pathé, etc.). New York: Kino on Video, 1994.

Muybridge, Eadweard. *Eadweard Muybridge: The Stanford Years 1872–1882*. Exhibition catalogue. Palo Alto, Calif.: Stanford Museum of Art, 1972.

———. *The Male and Female Figure in Motion*. 1887. New York: Dover, 1984.

Neumann, John von. *Mathematical Foundations of Quantum Mechanics*. Princeton: Princeton University Press, 1996.

Nietzsche, Friedrich. *Philosophy in the Tragic Age of the Greeks* [Die Philosophie im tragischen Zeitalter der Griechen, c1870]. Translated by Marianne Cowan. Washington, D.C.: Regnery Gateway, 1962.

———. *On the Genealogy of Morals* [Zur Genealogie der Moral, 1887]; *Ecce Homo* [1888, 1908]. Edited and translated by Walter Kaufmann. New York: Vintage-Random House, 1967.

———. *The Will to Power*. Edited by Walter Kaufmann. New York: Vintage-Random House, 1967.

———. *The Gay Science* [Die fröhliche Wissenschaft, 1882, 1887]. Edited and translated by Walter Kaufmann. New York: Vintage-Random House, 1974.

———. "On Truth and Lies in a Nonmoral Sense" [Über Wahrheit und Lüge im aussermoralischen Sinne, 1873]. In *Philosophy and Truth: Selections from Nietzsche's Notebooks of the Early 1870's*. Edited by Daniel Breazeale. Atlantic Highlands, N.J.: Humanities Press, 1979, 1990.

———. *Sämtliche Werke, Kritische Studienausgabe*. Edited by G. Colli and M. Montinari, and continued by W. Müller-Lauter and K. Pestalozzi. Berlin: De Gruyter, 1967–1995.

———. *Daybreak: Thoughts on the Prejudices of Morality* [Morgenröte, 1881]. Translated by R. J. Hollingdale. New York: Cambridge University Press, 1982.

Nijinska, Bronislava. *Early Memoirs*. Edited and translated by Irina Nijinska and Jean Rawlinson (1981). Durham, N.C.: Duke University Press, 1992.

Nijinsky, Vaslav. *The Diary of Vaslav Nijinsky*. 1936, 1953. Edited by R. Nijinsky. Berkeley: University of California Press, 1995.

———. *Cahiers*. Paris: Editions Actes-Sud, 1995. Unexpurgated.

Nochlin, Linda. *The Body in Pieces: The Fragment As a Metaphor of Modernity*. New York: Thames and Hudson, 1994.

Noxon, Gerald. "Cinema and Cubism." *Journal of the Society of Cinematologists* 2 (1962).

———. "Pictorial Origins of Cinema Narrative." *Journal of the Society of Cinematologists* 3 (1963), 4 (1965), 7 (1968).

Nye, Mary Jo. *Molecular Reality: A Perspective on the Scientific Work of Jean Perrin*. New York: Elsevier, 1972.

———, ed. *The Question of the Atom*. San Francisco: Tomash, 1984.

Okrent, Daniel, Walter Bernard, Milton Glaser, and Lorraine Glennon, eds. *Our Times: The Illustrated History of the 20th Century*. Atlanta: Turner Publishing, 1995.

Olivier, Fernande. *Picasso and his Friends* [Picasso et ses amis, 1933]. Translated by Jane Miller. London, 1964; New York: Appleton Century, 1965.

———. *Souvenirs intimes: Ecrits pour Picasso*. Paris: Calmann-Lévy, 1988.

Olsen, Donald J. *The City as a Work of Art: London, Paris, Vienna*. New Haven, Conn.: Yale University Press, 1986.

O'Malley, Michael. *Keeping Watch: A History of American Time*. New York: Viking, 1990.

O'Neill, Eugene. *Selected Letters*. Edited by T. Bogard and J. R. Bryer. New Haven, Conn.: Yale University Press, 1988.

———. *Complete Plays*. 3 vols. New York: Library of America, 1988.

———. *The Unknown O'Neill: Unpublished or Unfamiliar Writings of Eugene O'Neill*. Edited by Travis Bogard. New Haven, Conn.: Yale University Press, 1988.

Osler, Margaret J. *Atoms, Pneuma, and Tranquillity: Epicurean and Stoic Themes in European Thought*. Cambridge: Cambridge University Press, 1991.

Ostwald, Wilhelm. "Die Ueberwindung des wissentschaftlichen Materialismus." *Verhandlungen Gesellschaft deutscher Naturforscher und Ärzte* 67, pt. 2, 1st half (1895), 155–68.

———. *Aus dem Wissentschaftlichen Briefwechsel Wilhelm Ostwalds*. Vol. 1, *Briefwechsel mit Ludwig Boltzmann, Max Planck, Georg Helm und Josiah Willard Gibbs*. Edited by Hans-Günther Körber. Berlin: Akademie-Verlag, 1961.

———. *Electrochemistry* [Elektrochemie: Ihre Geschichte und Lehre, 1896]. Translated by N. P. Dale. Washington, D.C.: Smithsonian Institution, 1980.

Ottenheimer, Harriet. "The Blues Tradition in St. Louis." *Black Music Research Journal* 9, no. 2 (1989), 135–51.

Ouvrard, Nicole, gen. ed. *Vienne 1880–1938: L'Apocalypse joyeuse*. Exhibition catalogue. Paris: Musée Nationale de l'Art Moderne, 1986.

Pakenham, Thomas. *The Boer War*. New York: Random House, 1979.

Palau i Fabre, Joseph. *Picasso: The Early Years, 1881–1907*. New York: Rizzoli, 1981.

———. *Picasso: Cubism, 1907–1917*. New York: Rizzoli, 1990.

Peano, Giuseppe. *Arithmetices Principia Nova Methoda Exposita.* Turin: Bocca, 1889.

——. Review of *Vorlesungen über die Algebra der Logik (exakte Logik),* vol. 1, by F. W. K. Ernst Schröder. *Rivista di Matematica* 1 (1891).

——. Review of *Grundgesetze der Arithmetik,* by Gottlob Frege. *Rivista di Matematica* 5 (1895), 122–28.

——. *Selected Works of Giuseppe Peano.* Edited and translated by H. C. Kennedy. London: Allen and Unwin, 1973.

Peirce, Charles Sanders. *Collected Papers of Charles Sanders Peirce.* Vols. 1–6. Edited by C. Hartshorne and P. Weiss. Cambridge: Harvard University Press, 1931–1935.

——. *Collected Papers of Charles Sanders Peirce.* Vols. 7–8. Edited by A. W. Burks. Cambridge: Harvard University Press, 1958.

——. *The New Elements of Mathematics by Charles S. Peirce.* Edited by Carolyn Eisele. 4 vols. The Hague: Mouton, 1976.

——. *Writings of Charles S. Peirce: A Chronological Edition.* 5 vols. to date (1857–1893). Bloomington: Indiana University Press, 1982.

——. "The Schröder-Peirce Correspondence." Edited by Nathan Houser. *Modern Logic* 1 (Winter 1990–91), 206–36.

Perloff, Marjorie. *The Poetics of Indeterminacy: Rimbaud to Cage.* 1981. Evanston, Ill.: Northwestern University Press, 1983.

——. *The Futurist Moment: Avant-Garde, Avant Guerre, and the Language of Rupture.* Chicago: University of Chicago Press, 1986.

Pessoa, Fernando. *Selected Poems.* Translated by E. Honig. Athens: Ohio University Press, 1971.

Peter, Laszlo, and Robert B. Pynsent, eds. *Intellectuals and the Future in the Habsburg Monarchy, 1890–1914.* New York: St. Martin's Press, 1988.

Peterson, Ronald E. *A History of Russian Symbolism.* Philadelphia: John Benjamins, 1990.

Picasso, Pablo. *Pablo Picasso: A Retrospective.* Exhibition catalogue. New York: Museum of Modern Art, 1980.

——. *Je Suis le Cahier: The Sketchbooks of Picasso.* Edited by A. Glimcher and M. Glimcher. Boston: Atlantic Monthly Press, 1986.

——. *Picasso on Art: A Selection of Views.* Edited by Dore Ashton. New York: Da Capo Press, 1988.

——. *Les Demoiselles d'Avignon.* Exhibition catalogue. 2 vols. Musée Picasso. Paris: Editions des musées nationaux; Seattle, Wash.: University of Washington Press, 1988.

——. *Collected Writings.* New York: Abbeville, 1989.

——. *Les Demoiselles d'Avignon.* Edited by William Rubin, Hélène Seckel, and Judith Cousins. New York: Museum of Modern Art, in association with Abrams, 1995.

——. *The Sketchbooks.* Vol. 1 (1899–1924). Exhibition catalogue of Musée Picasso. Edited by Brigitte Réal. Paris: Musées Nationaux, 1996.

Pierrot, Jean. *The Decadent Imagination, 1880–1900.* Translated by D. Coltman. Chicago: University of Chicago Press, 1981.

Pillon, M. "L'Evolution historique de l'atomisme." *Année philosophique* (1891), 106–8, 197–200, 204–7.

Planck, Max. *Das Princip der Erhaltung der Energie.* Leipzig: Teubner, 1887.

———. *Vorlesungen über Thermodynamik.* 1897. Leipzig: Veit, 1905.

———. *The Universe in the Light of Modern Physics.* Translated by Walter Henry Johnson. New York: Norton, 1931.

———. *Physikalische Abhandlungen und Vorträge.* 3 vols. Braunschweig: Vieweg, 1958.

———. *Theory of Heat Radiation* [Vorlesungen über die Theorie der Wärmestrahlung, 1913]. Translated by M. Masius. New York: Dover, 1959.

———. *A Survey of Physics: A Collection of Lectures and Essays* [Physikalische Rundblicke, 1922]. Translated by R. Jones and D. H. Williams. London, 1925. Reprint New York: Dover, 1960.

———. *Planck's Original Papers in Quantum Physics.* Edited by H. Kangro. Translated by D. ter Haar and S. G. Brush. New York: Wiley, 1972.

———. *Vorträge und Erinnerungen.* 8th ed. Stuttgart, 1970. Enlarged 5th ed. of *Physikalische Rundblicke, 1922.*

Poincaré, J. Henri. "Le Continu mathématique." *Revue de métaphysique et de morale* (January 1893).

———. "L'Oeuvre mathématique de Weierstrass." *Acta Mathematica* 22 (1898–1899), 1–18.

———. "Les Mathématiques et la logique." *Revue de métaphysique et de morale* 13 (1905), 815–835; 14 (1905), 17–34; and 15 (1906), 294–317.

———. "A propos de la logistique." *Revue de métaphysique et de morale* 14 (1906), 866–68.

———. *Science and Method* [Science et méthode, 1908]. Translated by F. Maitland. London, 1914.

———. *Science and Hypothesis* [La science et l'hypothèse, 1902]. Translated by W. J. G., 1905. New York: Dover, 1952.

———. *Oeuvres.* Vol. 11. Paris: Gauthier-Villars, 1956.

———. *Mathematics and Science: Last Essays* [Dernières pensées, 1913]. Translated by J. Bolduc. New York: Dover, 1963.

———. *La Valeur de la science.* 1905. Paris: Flammarion, Champs, 1970. Includes "L'état actuel et l'avenir de la Physique mathématique," Poincaré's 1904 St. Louis Address, translated in *Congress, 1904* listed above.

———. *New Methods of Celestial Mechanics* [Les Méthodes nouvelles de la mécanique céleste, 1892–1899]. Edited by Daniel L. Goroff. New York: American Institute of Physics, 1991.

Porter, Theodore M. *The Rise of Statistical Thinking, 1820–1900.* Princeton: Princeton University Press, 1986.

Poulet, Georges. *Studies in Human Time.* 1950. Translated by E. Coleman. New York: Harper Torchbooks, 1959.

Pound, Ezra. "This Hulme Business." *Townsman* 2 (January 1939). Reprinted in *The Poetry of Ezra Pound.* Edited by Hugh Kenner. Norfolk, Conn.: New Directions, 1951.

———. *Literary Essays of Ezra Pound.* Edited by T. S. Eliot. New York: New Directions, 1968.

———. *The Selected Letters of Ezra Pound, 1907–1941.* Edited by D. D. Paige. New York: New Directions, 1971.

————. *Selected Prose, 1909–1965*. Edited by William Cookson. New York: New Directions, 1973.

————. *Collected Early Poems of Ezra Pound*. Edited by M. J. King. New York: New Directions, 1976.

Proust, Marcel. *Contre Sainte-Beuve*. Paris: Gallimard, Folio, 1954.

————. *Essais et articles*. Paris: Gallimard, 1971.

————. *A la Recherche du temps perdu*. 3 vols. Paris: Gallimard, Pléiade, 1980.

————. *On Reading Ruskin* [La Bible d'Amiens, Sésame et les Lys]. Edited and translated by J. Autret, W. Burford, and P. J. Wolfe. New Haven, Conn.: Yale University Press, 1987.

Psarros, Nikos. "The tiniest part of . . .—The concept of molecule in chemistry, physics and biology." 3rd Erlenmeyer-Colloquy for the Philosophy of Chemistry at the University of Marburg, 16 September 1996.

Raabe, Paul, ed. *The Era of German Expressionism*. 1972. Woodstock, N.Y.: Overlook Press, 1985.

Rabinbach, Anson. *The Human Motor: Energy, Fatigue, and the Origins of Modernity*. New York: Basic Books, 1992.

Ramsey, F. P. *Philosophical Papers*. Edited by D. H. Mellor. Cambridge: Cambridge University Press, 1990.

Rayleigh, J. W. Strutt, Lord. *Scientific Papers*. 4 vols. New York: Dover, 1964.

Read, Oliver and Walter L. Welch. *From Tin Foil to Stereo*. Indianapolis: W. H. Sams, 1959.

Rey, Abel. *La Théorie de la physique chez les physiciens contemporains*. 1907. Paris: Alcan, 1923.

Richardson, J. A. *Modern Art and Scientific Thought*. Urbana, Ill.: University of Illinois Press, 1971.

Riley, Charles. *Color Codes: Modern Theories of Color in Philosophy, Painting and Architecture, Literature, Music, and Psychology*. Hanover, N.H.: University Press of New England, 1995.

Rilke, Rainer Maria. *Where Silence Reigns*. Translated by G. C. Houston. New York: New Directions, 1978. Includes "Worpswede" (1903) and "The Rodin-Book (I and II)" (1903–7).

————. *Letters on Cézanne*. Translated by J. Agee. Edited by C. Rilke. New York: Fromm International, 1985.

————. *Gedichte*. Frankfurt am Main: Insel, 1986.

Rimbaud, Arthur. *Oeuvres complètes*. Paris: Gallimard, Pléiade, 1972.

Rioux, Jean-Pierre. *Chronique d'une fin de siècle: France, 1889–1900*. Paris: Seuil, 1991.

Robinson, Abraham. *Non-Standard Analysis*. Amsterdam: North-Holland, 1966; Princeton: Princeton University Press, 1996.

————. "Some Thoughts on the History of Mathematics." *Compositio Mathematica* 20 (1968), 188–93.

Rocke, Alan J. *Chemical Atomism in the Nineteenth Century: From Dalton to Cannizzaro*. Columbus: Ohio State University Press, 1984.

Romein, Jan. *The Watershed of Two Eras: Europe in 1900*. 1967. Translated by Arnold J. Pomerans. Middletown, Conn.: Wesleyan University Press, 1978.

Romer, Alfred. *The Restless Atom: The Awakening of Nuclear Physics*. 1960. New York: Dover, 1982.

————, ed. *The Discovery of Radioactivity and Transmutation*. New York: Dover, 1964.

————, ed. *Radiochemistry and the Discovery of Isotopes*. New York: Dover, 1970.

Roosevelt, Theodore. *An American Mind: Selected Writings*. Edited by Mario DiNunzio. New York: Penguin, 1995.

Rosenbaum, S. P. *Victorian Bloomsbury: The Early Literary History of the Bloomsbury Group*. Vol. 1. New York: St. Martin's Press, 1987.

————, ed. *The Bloomsbury Group: A Collection of Memoirs and Commentary*. Toronto: University of Toronto Press, 1995.

Rota, G. C. "Mathematics and Philosophy: The Story of a Misunderstanding." *Review of Metaphysics* 44 (December 1990), 259–71.

Rothstein, Edward. *Emblems of Mind: The Inner Life of Music and Mathematics*. New York: Times Books, 1995.

Henri Rousseau. With essays by Roger Shattuck, Henri Béhar, Michel Hoog, Carolyn Lancher, and William Rubin. New York: Museum of Modern Art, 1985.

Rucker, Rudy. *Infinity and the Mind*. New York: Bantam, 1983.

————. *The Fourth Dimension: A Guided Tour of Higher Universes*. Boston: Houghton Mifflin, 1984.

Ruhla, Charles. *The Physics of Chance from Blaise Pascal to Niels Bohr*. New York: Oxford University Press, 1992.

Russell, Bertrand. *An Essay on the Foundations of Geometry*. Cambridge: Cambridge University Press, 1897; New York: Dover, 1952.

————. "My Mental Development." In *The Philosophy of Bertrand Russell*. Edited by Paul A. Schilpp. Evanston, Ill.: Library of Living Philosophers, 1944.

————. *Logic and Knowledge, Essays, 1901–1950*. Edited by R. C. Marsh. London: Allen and Unwin, 1956.

————. *Mysticism and Logic*. 1917. Garden City, N.Y.: Doubleday, 1957.

————. *Principles of Mathematics*. 1903. New York, Norton, n.d.

————. *My Philosophical Development*. 1959. London: Unwin paperback, 1975.

————. *Autobiography*. 1967–1969. London: Unwin paperback, 1978.

————. *Philosophical Essays*. 1910, 1965. New York: Simon and Schuster paperback, 1984.

————. *The Collected Papers of Bertrand Russell*. Vol. 7, *Theory of Knowledge: The 1913 Manuscript*. Edited by Elizabeth Ramsden Eames. London and Boston: George Allen and Unwin, 1984. Paperbound, 1992.

————. *The Collected Papers of Bertrand Russell*, Vol 12: *Contemplation and Action, 1902–14*. Edited by Richard A. Rempel, Andrew Brink, and Margaret Moran. London and Boston: George Allen and Unwin, 1985.

————. *The Philosophy of Logical Atomism*. 1918. Peru, Ill.: Open Court, 1985.

————. *The Collected Papers of Bertrand Russell*, Vols. 1–4 (1888–1905). London and New York: Routledge, 1990–1994.

————. *The Collected Papers of Bertrand Russell*. Vol. 6, *Logical and Philosophical Papers, 1909–1913*. Edited by John Slater. London and New York: Routledge, 1992.

————. *The Selected Letters of Bertrand Russell*. Vol. 1, *The Private Years, 1884–1914*. Edited by N. Griffin. Boston: Houghton Mifflin, 1992.

————. *Introduction to Mathematical Philosophy.* 1919, 1920. New York: Dover, 1993.

Russell, Bertrand, and Alfred North Whitehead. *Principia Mathematica.* 2d ed. Vol. 1. Cambridge: Cambridge University Press, 1925.

Rydell, Robert W. *All The World's A Fair: Visions of Empire at American International Expositions, 1876–1919.* Chicago: University of Chicago Press, 1985.

————. *World of Fairs: The Century-of-Progress Exhibitions.* Chicago: University of Chicago Press, 1993.

Sanchez, A. *Barcelone, 1888–1929: Modernistes, anarchistes, noucentistes ou la création fiévreuse d'une nation catalane.* Paris: Autrement, 1992.

Sandler, Iris, and Laurence Sandler. "A Conceptual Ambiguity that Contributed to the Neglect of Mendel's Paper." *History and Philosophy of the Life Sciences* 7 (1985), 3–70.

Satie, Erik. *Ecrits.* Edited by Ornella Volta. Paris: Champ Libre, 1977.

Schaberg, William H. *The Nietzsche Canon: A Publication History and Bibliography.* Chicago: University of Chicago Press, 1996.

Schenck, Celeste M. "Exiled by Genre: Modernism, Canonicity, and the Politics of Exclusion." In Mary Lynn Broe and Angela Ingram, *Women's Writing in Exile.* Chapel Hill: University of North Carolina Press, 1989.

Schivelbusch, Wolfgang. *The Railway Journey: The Industrialization and Perception of Time and Space.* Berkeley: University of California Press, 1986.

Schnitzler, Arthur. *Leutnant Gustl.* Berlin: S. Fischer, 1906.

————. "The Truth about *Lieutenant Gustl.*" *Die Presse* (Vienna), 25 December 1959.

————. *My Youth in Vienna.* 1918. Edited by Frederic Morton. Translated by Catherine Hutter. New York: Holt, Rinehart and Winston, 1970.

————. *Briefe.* Edited by Therese Nickl and Heinrich Schnitzler. 2 vols. Frankfurt am Main: Fischer, 1981.

————. *Illusion and Reality: Plays and Stories of Arthur Schnitzler.* Edited by Paul F. Dvorak. New York: Peter Lang, 1986.

————. *The Road to the Open* [Der Weg ins Freie, 1908]. Translated by Horace Samuel. Evanston, Ill.: Northwestern University Press, 1991.

————. *Lieutenant Gustl.* 1900. Los Angeles: Sun and Moon Press, 1993.

Schoenberg, Arnold. *Works.* Complete edition. Vienna: Universal-Edition; Mainz: B. Schotts Söhne, 1960ff.

————. "The Composition with Twelve Tones," "Gershwin," "Charles Ives." In *Composers on Music: An Anthology of Composers' Writings from Palestrina to Copland.* Edited by Sam Morgenstern. New York: Pantheon, 1956.

————. *Style and Idea: Selected Writings of Arnold Schoenberg.* Translated by L. Black. Edited by L. Stein. Berkeley: University of California Press, 1975.

————. *Theory of Harmony* [Harmonielehre, 1911]. Translated by R. E. Carter. Berkeley: University of California Press, 1983.

————. *The Letters of Arnold Schoenberg.* Edited by Erwin Stein. Translated by E. Wilkins and E. Kaiser. Berkeley: University of California Press, 1988.

————. Letters, etc. In *Schoenberg, Berg, Webern, the String Quartets: A Documentary Study.* Edited by Ursula von Rauchhaupt. Hamburg, 1971.

————. Letters to Kandinsky. In *Letters, Pictures, and Documents.* Edited by J. Hahl-Koch. Translated by J. C. Crawford. Boston: Faber and Faber, 1984.

Schröder, F. W. K. Ernst. *Der Operationskreis des Logikkalkuls.* Leipzig: Teubner, 1877.

———. *Vorlesungen über die Algebra der Logik (exakte Logik).* Vol. 1 (1890) through Vol. 3, Pt. 1 (1895). New York: Chelsea reprint, 1966.

Schuhmann, Karl. *Husserl-Chronik: Denk- und Lebensweg Edmund Husserls.* The Hague: Martinus Nijhoff, 1977.

Schvey, Henry I. *Oscar Kokoschka, The Painter as Playwright.* Detroit, Mich.: Wayne State University Press, 1982.

Schwartz, Hillel. *Century's End: A Cultural History of the Fin de Siècle from the 990s through the 1990s.* New York: Doubleday, 1990.

Scott, Bonnie Kime, ed. *The Gender of Modernism.* Bloomington: Indiana University Press, 1990.

Seaman, Francis. "Mach's Rejection of Atomism." *Journal of the History of Ideas* 29 (1968).

Senelick, Laurence. *Cabaret Performance: Sketches, Songs, Monologues, Memoirs.* Vol. I, *Europe, 1890–1920.* Baltimore, Md.: Johns Hopkins University Press, 1989.

Seurat, Georges. *Seurat: L'oeuvre peint, biographie et catalogue critique.* Compiled by Henri Dorra and John Rewald. Paris: Les Beaux-Arts, 1959. Includes Fénéon on Seurat.

———. Papers translated in *Seurat in Perspective.* Edited by Norma Broude. Englewood Cliffs, N.J.: Prentice-Hall, 1978.

———. *Seurat: Correspondances, témoignages, notes inédites, critiques.* Paris: Acropole, 1991.

———. *Seurat.* Exhibition catalogue. Compiled by Robert L. Herbert, with Françoise Cachin, Anne Distel, Susan Alyson Stein, and Gary Tinterow. Metropolitan Museum of Art. New York: Abrams, 1991.

Shannon, Claude E., and Warren Weaver. *The Mathematical Theory of Communication.* Urbana, Ill.: University of Illinois Press, 1949, 1975.

Sharpey-Schafer, Edward. *The Essentials of Histology.* 1885. New York: Lea and Febiger, 1920.

Shaw, George Bernard. *Shaw on Music.* Edited by Eric Bentley. New York: Doubleday Anchor, 1955.

———. *Shaw on Theatre.* Edited by E. J. West. New York: Hill and Wang, 1958.

———. *Complete Prefaces.* Vol. 1, 1889–1913. London: Allen Lane, in association with Penguin Press, 1993.

———. *The Quintessence of Ibsenism.* 1891. New York: Dover, 1994.

Shattuck, Roger. *The Innocent Eye: On Modern Literature and the Arts.* New York: Washington Square Press, 1986.

Shaw, Donald L. "*Modernismo,* Idealism and the Intellectual Crisis in Spain, 1895–1910." *Renaissance and Modern Studies* 25 (1981), 24–39.

Shlain, Leonard. *Art and Physics: Parallel Visions in Space, Time and Light.* New York: William Morrow, 1991.

Shorter, Edward. *From Paralysis to Fatigue: A History of Psychosomatic Illness in the Modern Era.* New York: Free Press, 1992.

Signac, Paul. *Signac.* Exhibition catalogue. Paris: Louvre, December 1963–February 1964.

————. *D'Eugène Delacroix au néo-impressionisme.* Paris: Hermann, 1964, 1987.

————. "Extraits du journal inédit." Edited by John Rewald. *Gazette des Beaux-Arts,* series 6, 36 (July-December 1949), 112–13.

Silliman, Robert H. "Smoke Rings and Nineteenth-Century Atomism." *Isis* 54 (1963), 461–74.

Silverman, Debora L. *Art Nouveau in Fin-de-Siècle France: Politics, Psychology, and Style.* Berkeley: University of California Press, 1988.

Silvestre, Armand. *Guide Armand Silvestre de Paris et de ses environs et de l'Exposition de 1900.* Paris: Didier and Méricans, 1900.

Simmon, Scott. *The Films of D. W. Griffith.* New York: Cambridge University Press, 1993.

Simon, Linda, ed. *Gertrude Stein Remembered.* Lincoln: University of Nebraska Press, 1994.

————, ed. *William James Remembered.* Lincoln: University of Nebraska Press, 1996.

Smith, Joan Allen. *Schoenberg and His Circle: A Viennese Portrait.* New York: Macmillan Publishers, Schirmer Books, 1986.

Sokel, Walter H., ed. *Anthology of German Expressionist Drama.* Ithaca, N.Y.: Cornell University Press, 1986. Includes material on Kaiser, Kokoschka, Sorge, and Sternheim.

Stein, Gertrude. *Harvard Essays.* In Rosalind S. Miller, *Gertrude Stein: Form and Intelligibility.* New York: Exposition Press, 1949.

————. *The Autobiography of Alice B. Toklas.* 1933. New York: Random House, 1961.

————. *Selected Writings of Gertrude Stein.* Edited by C. Van Vechten. New York: Random House, 1962.

————. *The Making of Americans.* New York: Something Else Press, 1966.

————. *Fernhurst, Q.E.D., and Other Early Writings.* New York: Liveright, 1971.

————. *Everybody's Autobiography.* New York: Vintage, 1973.

————. *The Yale Gertrude Stein: Selections.* New Haven, Conn.: Yale University Press, 1980.

————. *Picasso.* 1938. New York: Dover, 1984.

————. *Lectures in America.* Edited by Wendy Steiner. Boston: Beacon Press, 1985.

————. *Three Lives.* 1909. New York: Dover, 1996.

Steinman, Lisa M. *Made in America: Science, Technology, and American Modernist Poets.* New Haven, Conn.: Yale University Press, 1987, 1989.

Stella, Joseph. *Joseph Stella.* Exhibition catalogue, 22 April–9 October, 1994. Compiled by Barbara Haskell. New York: Abrams, in association with Whitney Museum of American Art, 1994. Includes Stella, "I Knew Him When" (1924); "The Brooklyn Bridge (A Page of My Life)" (1929); and "Autobiographical Notes" (1946, 1960).

Stern, Fritz. *The Politics of Cultural Despair: A Study in the Rise of the Germanic Ideology.* 1961. New York: Doubleday Anchor, 1965.

Stoppard, Tom. *Jumpers* (play, 1972). New York: Grove Press, 1973.

————. *Travesties* (play, 1975). New York: Grove Press, 1975.

———. *Arcadia* (play, 1995). Boston and London: Faber and Faber, 1995.

Strauss, Richard, and Gustav Mahler. *Correspondence, 1888–1911.* Edited by H. Blaukopf. Translated by E. Jephcott. Chicago: University of Chicago Press, 1984.

Strauss, Richard, and Hugo von Hofmannsthal. *Correspondence, 1907–1918.* 1926. Translated by Paul England. New York: Knopf, 1927; London: Collins, 1961.

Stravinsky, Igor. *Chronicle of My Life.* New York: Simon and Schuster, 1936.

———. *Poetics of Music in the Form of Six Lessons.* Translated by Arthur Knodel and Ingolf Dahl. Cambridge: Harvard University Press, 1947, 1970.

———. "Dissonance and Atonality," "Cacophony," and "Modernism and Academicism." In *Composers on Music: An Anthology of Composers' Writings from Palestrina to Copland.* Edited by Sam Morgenstern. New York: Pantheon, 1956.

———. *Chroniques de ma vie.* 1935–36. 2 vols. Paris: Denoël/Gonthier, 1962.

———. *Igor Stravinsky; An Autobiography.* New York: Norton, 1962.

———. *Vesna sviashchennia* [Le sacre du printemps; The Rite of Spring]. Musical score. New York: Dover, 1989.

———. *Stravinsky, Selected Correspondence.* Edited and translated by Robert Craft. Vol. 1. New York: Alfred A. Knopf, 1982.

Stravinsky, Igor, and Robert Craft. *Conversations with Igor Stravinsky.* London: Faber and Faber, 1959.

———. *Memories and Commentaries.* New York: Doubleday, 1960.

———. *Expositions and Developments.* Garden City, N.Y.: Doubleday, 1962.

———. *Themes and Conclusions.* London: Faber, 1972. Combining *Themes and Episodes* (1966) and *Retrospectives and Conclusions* (1969).

———. *Dialogues.* 1963. Berkeley: University of California Press, 1982.

Stravinsky, Vera. *The Salon Album of Vera Sudeikin-Stravinsky.* Edited and translated by John E. Bowlt. Princeton: Princeton University Press, 1995.

Strindberg, August. *The Son of a Servant.* Translated by Evert Sprinchorn. Garden City, N.Y.: Doubleday Anchor, 1966.

———. *The Red Room: Scenes of Artistic and Literary Life.* 1879. Translated by Elizabeth Sprigge. New York: Dutton, 1967.

———. "Des arts nouveaux! ou Le hasard dans la production artistique." Translated by Albert Bermel. In Strindberg, *Inferno, Alone and Other Writings,* 96–103. Garden City, N.Y.: Doubleday, 1968.

———. *A Madman's Manifesto.* Translated by Anthony Swerling. University: University of Alabama Press, 1971.

———. *Getting Married.* 1884, 1886. Translated by Mary Sandbach. New York: Viking, 1973.

———. *A Dream Play and Four Chamber Plays: Stormy Weather; The House That Burned; The Ghost Sonata; The Pelican.* Translated by Walter Johnson. New York: Norton, 1975.

———. *Sleepwalking* [Somnambulist] *Nights.* Translated by Arvid Paulson. New York: Law-Arts Publishers, 1978.

———. *Inferno; From an Occult Diary.* Translated by Mary Sandbach. New York: Penguin, 1979.

————. *Plays of Confession and Therapy: To Damascus I, To Damascus II, and To Damascus III.* Seattle: University of Washington Press, 1979.

————. "Notes to Members of the Intimate Theatre." 1907–1909. In *The Chamber Plays.* Translated by Evert Sprinchorn, S. Quinn Jr., and K. Petersen. 2d ed., 204–223. Minneapolis: University of Minnesota Press, 1981.

————. *I Havsbandet.* 1890. Stockholm: Almqvist and Wiksell, 1982.

————. "Fröken Julie." 1888. Edited by Gunnar Ollén. In *Samlade Verk,* vol. 27. Stockholm: Almqvist and Wiksell, 1984.

————. *By The Open Sea.* 1890. Translated by Mary Sandbach. Athens: University of Georgia Press, 1986.

————. *The Roofing Ceremony* and *The Silver Lake.* Translated by David Mel Paul and Margareta Paul. Lincoln: University of Nebraska Press, 1987.

————. *Plays: Two: The Dance of Death, A Dream Play,* and *The Stronger.* Translated by Michael Meyer. London: Methuen, 1991.

————. *The Chamber Plays: Thunder in the Air; After the Fire; The Ghost Sonata; The Pelican; The Black Glove.* Translated by Eivor Martinus. Bath, U.K.: Absolute Classics, 1991.

————. *Miss Julie.* 1888. Translated by Helen Cooper. London: Methuen, 1992.

————. *Strindberg's Letters.* Edited and translated by Michael Robinson. 2 vols. Chicago: University of Chicago Press, 1992.

Sullivan, Louis. *The Autobiography of an Idea.* 1924. New York: Dover, 1956.

————. *The Function of Ornament.* Edited by Wim de Wit. New York: W. W. Norton, in association with St. Louis Art Museum, 1986.

Symons, Arthur. *Collected Works.* 9 vols. London: Martin Secker, 1924.

Sypher, Wylie. *Rococo to Cubism in Art and Literature.* New York: Random House, 1960.

Tannery, Paul. "Le Concept scientifique du continu: Zénon d'Elée et G. Cantor." *Revue philosophique* 20 (1885), 385–410.

Taupin, René. *L'Influence du symbolisme français sur la poésie américaine (De 1910 à 1920).* Paris: Honoré Champion, 1929.

Taylor, Christiana J. *Futurism: Politics, Painting, and Performance.* Ann Arbor, Mich.: UMI Research Press, 1985.

Taylor, F. W. *The Principles of Scientific Management.* New York: Harper, 1947.

Taylor, Joshua C., ed. *Nineteenth-Century Theories of Art.* Berkeley: University of California Press, 1989.

Taylor, Richard, ed. and trans. *The Film Factory: Russian and Soviet Cinema in Documents, 1896–1939.* Cambridge: Harvard University Press, 1988.

Teich, Mikuláš, and Roy Porter. *Fin de Siècle and its Legacy.* Cambridge: Cambridge University Press, 1990.

Teitelbaum, Matthew, ed. *Montage and Modern Life, 1919–1942.* Cambridge: MIT Press, 1994.

Timms, Edward, and Ritchie Robertson, eds. *Vienna 1900: From Altenberg to Wittgenstein.* Edinburgh: Edinburgh University Press, 1990.

Toller, Ernst. *I Was a German: An Autobiography.* Translated by Edward Crankshaw, 1934. New York: Paragon House, 1991.

Toulmin, Stephen. *Cosmopolis: The Hidden Agenda of Modernity.* New York: Free Press, 1990.

Toulmin, Stephen, and June Goodfield. *The Discovery of Time.* Chicago: University of Chicago Press, 1965.

Toulouse-Lautrec, Henri de. *The Complete Prints.* Compiled by Wolfgang Wittrock. Edited and translated by Catherine E. Kuehn. 2 vols. New York: Harper and Row, 1985.

———. *Complete Lithographs and Drypoints.* Edited by Jean Adhémar. Chartwell, 1987.

———. *Letters of Henri de Toulouse-Lautrec.* Edited by Herbert D. Schimmel. New York: Oxford University Press, 1991.

———. *Henri de Toulouse-Lautrec.* Exhibition catalogue. New York: Museum of Modern Art, 1988. With contributions by Arnold, Cate, Frey, and Castleman.

Trilling, Lionel. "The Modern Element in Literature." 1961. In *Beyond Culture.* New York: Harcourt Brace Jovanovich, 1965, 1978.

Tsvetaeva, Marina. *Selected Poems.* New York: Viking-Penguin, 1993.

Tucker, Paul Hayes. *Monet in the '90s: The Series Paintings.* New Haven, Conn.: Yale University Press, 1989.

Turing, Alan M. "Computing Machinery and Intelligence." In *Minds and Machines.* Edited by A. R. Anderson. Englewood Cliffs, N.J.: Prentice-Hall, 1964.

———. "On Computable Numbers, with an Application to the *Entscheidungsproblem.*" *Proceedings of the London Mathematical Society* 2, no. 42 (1937), 230–65. Reprinted in *The Undecidable.* Edited by M. Davis. Hewlett, N.Y.: The Raven Press, 1969.

Twain, Mark. *Les Adventures de Huck Finn.* Translated by William L. Hughes. Paris: A. Hennuyer, 1886.

———. *Autobiography.* Edited by Charles Neider. New York: Harper, 1959.

———. *Huckleberry Finn.* Edited by Sculley Bradley, Richard Croom Beatty, E. Hudson Long, and Thomas Cooley. New York: Norton Critical Editions, 1961, 1977.

———. "Stirring Times in Austria." In *The Complete Essays of Mark Twain.* Edited by Charles Neider. Garden City, N.Y.: Doubleday, 1963.

———. *The Works of Mark Twain: Early Tales and Sketches, 1851–1885.* Edited by Edgar M. Branch and Robert H. Hirst. 2 vols. Berkeley: University of California Press, 1979–81.

———. *Mississippi Writings.* New York: Library of America, 1982.

———. *Huckleberry Finn.* Edited by Walter Blair. Berkeley: University of California Press, 1988.

———. *Mark Twain's Letters.* Vol. 1, 1853–1866. Berkeley: University of California Press, 1988.

———. *Tales, Sketches, Speeches, Essays.* 2 vols. New York: Library of America, 1993.

———. *Adventures of Huckleberry Finn: The Only Comprehensive Edition.* New York: Random House, 1996.

Valéry, Paul. *Oeuvres.* Edited by J. Hytier. 2 vols. Paris: Gallimard, Pléiade, 1957.

———. *Collected Works.* Edited by J. Mathews. Princeton: Princeton University Press, 1957ff.

Van Gogh, Vincent. *The Complete Letters of Vincent Van Gogh.* 3 vols. London, 1958.

————. *Van Gogh's "Diary"; the Artist's Life in His Own Words and Art*. Edited by Jan Hulsker. New York: Morrow, 1971.

————. *The Complete Van Gogh: Paintings, Drawings, Sketches*. Compiled by Jan Hulsker. New York: H. N. Abrams, 1980.

————. *Van Gogh in Arles*. Exhibition catalogue. Edited by R. Pickvance. New York: Metropolitan Museum of Art, 1985.

————. *Van Gogh in Saint-Rémy and Auvers*. Exhibition catalogue. Edited by R. Pickvance. New York: Metropolitan Museum of Art, 1986.

————. *Vincent Van Gogh: The Complete Paintings*. Compiled by Ingo F. Walther and Rainer Metzger. Cologne: Taschen, 1990.

van Heijenoort. *See* Heijenoort.

Van Melsen, Andrew G. *From Atomos to Atom: The History of the Concept ATOM*. 1952. New York: Harper, 1960.

Vardac, A. Nicholas. *Stage to Screen: Theatrical Method from Garrick to Griffith*. Cambridge: Harvard University Press, 1949.

Varnedoe, Kirk. *Northern Light*. Exhibition catalogue. Brooklyn, N.Y.: Brooklyn Museum, 1982.

————. *Turn-of-the-Century Vienna*. Exhibition catalogue. New York: Museum of Modern Art, 1987.

Varnedoe, Kirk, and Adam Copnick. *High and Low: Modern Art and Popular Culture*. New York: Museum of Modern Art, 1990.

————. *Modern Art and Popular Culture: Readings in High and Low Art*. New York: Museum of Modern Art, 1990.

Venturi, Lionello. *Cézanne*. New York: Rizzoli, 1978.

Vergo, Peter. *Art in Vienna, 1898–1918*. Ithaca, N.Y.: Cornell University Press, 1975, 1981.

Vettard, Camille. "Proust et Einstein." *Nouvelle Revue Française* (August 1922). By a mathematician.

Vienna, 1850–1930: Architecture. New York: Rizzoli, 1993.

Vienna Psychoanalytic Society. *Minutes*. Edited by Herman Nunberg and Ernst Federn. Vols. 1–4. New York: International Universities Press, 1962, 1967, 1974, 1975.

Villiers de l'Isle-Adam, Auguste-Mathias. *Axël*. Translated by June Guicharnaud. Englewood Cliffs, N.J.: Prentice Hall, 1970.

————. *Tomorrow's Eve* [L'Eve future, 1886]. Translated by Robert Martin Adams. Urbana: University of Illinois Press, 1982.

————. *Oeuvres complètes*. Edited by Alan Raitt and Pierre-Georges Castex, with Jean-Marie Bellefroid. 2 vols. Paris: Gallimard (Pléiade), c1986.

————. *La Révolte; La Machine à gloire*. Paris: Le Passeur, cecofop, 1989.

Virtanen, Reino. *L'imagerie scientifique de Paul Valéry*. Paris: J. Vrin, 1975.

Vivanti, G. "Bibliografia . . ." (of set theory). *Rivista di Matematica* 3 (1893).

Vlaminck, Maurice. *Tournant dangereux*. Paris: Stock, 1929.

Volkov, Solomon. *St. Petersburg—A Cultural History*. Translated by A. W. Bouis. New York: Free Press, 1995.

Waelti-Walters, Jennifer, and Steven C. Hause. *Feminisms of the Belle Époque: A Historical and Literary Anthology*. Lincoln: University of Nebraska Press, 1994.

Wagner, Richard. *"The Art Work of the Future" and Other Works.* Translated by W. Ashton Ellis. Lincoln: University of Nebraska Press, 1993.

Waldekranz, Rune. "Strindberg and the Silent Cinema." In *Essays on Strindberg.* Edited by Carl Reinhold Smedmark. Stockholm: Strindberg Society, 1966.

Waldman, Diane. *Collage, Assemblage, and the Found Object.* New York: Abrams, 1992.

Walser, Robert. *Jakob von Gunten.* 1909. Translated by Christopher Middleton. New York: Vintage, 1983.

Watson, Steven. *Strange Bedfellows: The First American Avant-Garde.* New York: Abbeville, 1991.

Webb, Karl Eugene. *Rainer Maria Rilke and Jugendstil.* Chapel Hill: University of North Carolina Press, 1978.

Weber, Eugen. *France, Fin de Siècle.* Cambridge: Harvard University Press, 1986.

Wegener, Alfred. *The Origin of Continents and Oceans.* New York: Dover reprint, n.d.

Weierstrass, Karl. *Mathematische Werke.* 7 vols. 1894–1915. Hildesheim: Olms, 1967.

Weil-Bergougnoux, Michele. "Robert Challe postmoderne? ou La méconnaissance de l'ante-moderne." *Oeuvres et critiques* 19, no. 1 (1994), 31–38.

Werkner, Patrick. *Austrian Expressionism: The Formative Years.* Translated by N. T. Parsons. Seattle: University of Washington Press, 1994.

Wertheim, Arthur F. *The New York Little Renaissance: Iconoclasm, Modernism, and Nationalism in American Culture, 1908–1917.* New York: New York University Press, 1976.

West, Rebecca. *1900.* New York: Viking, 1982.

Weyl, C. H. Hermann. "Über die Definitionen der mathematischen Grundbegriffe." 1910. In *Gesammelte Abhandlungen.* Edited by K. Chandrasekharan. Vol. 1, 298–304. Berlin: Springer, 1968.

Weyler, Valeriano. *Mi mando in Cuba.* 5 vols. Madrid: F. G. Rojas, 1910–1911.

White, Michael J. *The Continuous and the Discrete: Ancient Physical Theories from a Contemporary Perspective.* Oxford: Oxford University Press, 1992.

Whiteside, Andrew G. *The Socialism of Fools: Georg Ritter von Schönerer and Austrian Pan-Germanism.* Berkeley: University of California Press, 1975.

Whitman, Walt. *Oeuvres choisies.* Translated by Jules Laforgue, Louis Fabulet, André Gide, Valery Larbaud, Jean Schlumberger, and François Vielé-Griffin. Paris: NRF, 1918, 1930.

———. *Complete Poetry and Collected Prose.* New York: Library of America, 1982.

———. *Selected Letters of Walt Whitman.* Edited by Edwin Haviland Miller. Iowa City: University of Iowa Press, 1995.

Wiener, Norbert. *Ex-Prodigy: My Childhood and Youth.* 1953. Cambridge: MIT Press, 1964.

———. *Collected Works.* Edited by P. Massani. Cambridge: MIT Press, 1987.

Wilde, Alan. *Horizons of Assent: Modernism, Postmodernism, and the Ironic Imagination.* Philadelphia: University of Pennsylvania Press, 1987.

Willard, Frances. *A Wheel within a Wheel* [How I Learned to Ride the Bicycle, 1895]. Sunnyvale, Calif.: Fair Oaks Publishing, 1991.

Willette, Adolphe. *Feu Pierrot 1857–19—*. Paris: H. Floury, 1919.

Wilson, Edmund. *Axel's Castle: A Study in the Imaginative Literature of 1870 to 1930*. 1931. New York: Scribner's, n.d.

Winn, James Anderson. *Unsuspected Eloquence: A History of the Relations between Poetry and Music*. New Haven, Conn.: Yale University Press, 1981.

Winter, Robert. *Igor Stravinsky, The Rite of Spring*. CD-ROM with score, performance, and documents. New York: Voyager, n.d. [1994?].

———. *Crazy for Ragtime*. CD-ROM with scores, performances, and documents. New York: Calliope Media, n.d. [1996].

Wittgenstein, Ludwig. *Tractatus Logico-Philosophicus*. Translated by D. Pears and B. McGuinness. London: Routledge and Kegan Paul, 1961.

———. *Philosophical Investigations*. 1945 and MS 1949. Translated by G. E. M. Anscombe, 1953. 3d ed. New York: Macmillan, n.d.

———. *Remarks on the Foundations of Mathematics*. Translated by G. E. M. Anscombe. Edited by Anscombe, G. von Wright, and R. Rhees, 1956. Cambridge: MIT Press, 1983.

———. *A Wittgenstein Reader*. Edited by Anthony Kenny. Oxford and Cambridge, Mass.: Basil Blackwell, 1994.

Wittlich, Petr. *Prague fin de siècle*. Paris: Flammarion, 1992.

Wohl, Robert. *The Generation of 1914*. Cambridge: Harvard University Press, 1979.

Wood, Joanne. "Lighthouse Bodies: The Neutral Monism of Virginia Woolf and Bertrand Russell." *Journal of the History of Ideas* 55, no. 3 (July 1994), 483–502.

Woolf, Virginia. "Mr. Bennett and Mrs. Brown." 1924. In *The Captain's Death Bed and Other Essays*. New York: Harcourt, Brace, 1950.

———. "Modern Fiction." 1919. In *The Common Reader, First Series*. 1925. Edited by A. McNellie. New York: HBJ/Harvest, 1984.

———. *The Essays of Virginia Woolf*. Edited by Andrew McNellie. 3 vols. New York, 1989.

———. *The Voyage Out*. 1915. New York: Oxford University Press, 1996.

Worbs, Michael. *Nervenkunst: Literatur und Psychoanalyse im Wien der Jahrhundertswende*. Frankfurt am Main: Europäische Verlagsanstalt, 1983.

Wright, Frank Lloyd. *Collected Writings*. Edited by Bruce Brooks Pfeiffer. Vols. 1 and 2: 1894–1932. New York: Rizzoli, 1992.

———. *Frank Lloyd Wright: Presentation and Conceptual Drawings*. 4 CD-ROMs. New York: Luna Imaging, in association with Oxford University Press, 1995.

Wurtz, Adolphe Charles. *La Théorie atomique*. Paris: G. Baillère, 1879.

Yates, W. E. *Schnitzler, Hofmannsthal and the Austrian Theater*. New Haven, Conn.: Yale University Press, 1992.

Yeats, William Butler. *Essays and Introductions*. New York: Macmillan, 1961.

———. *The Autobiography of William Butler Yeats*. New York: Macmillan, 1965.

———. *Letters to W. B. Yeats*. Edited by Richard J. Finneran et al. 2 vols. New York: Columbia University Press, 1977.

———. *The Collected Poems*. Edited by Richard J. Finneran. New York: Macmillan Publishers, Collier Books, 1989.

———. *Mythologies.* London: Macmillan Papermac, 1989.

———. *The Collected Letters of W. B. Yeats.* 3 vols. (to 1904). New York: Oxford University Press, 1986.

Yevtushenko, Yevgeny, Albert C. Todd, and Max Hayward. *Twentieth-Century Russian Poetry: Silver and Steel: An Anthology.* New York: Doubleday Anchor, 1994.

Zermelo, Ernst. "Über einen Satz der Dynamik und die mechanische Wärmetheorie." *Annalen der Physik (Wied. Ann.)* 57 (1896), 485–94. Against Boltzmann's ergodic hypothesis.

———. "Über die Addition transfiniter Kardinalzahlen." In *Nachrichten Königliche Gesellschaft der Wissenschaft* (Göttingen), 1901, 34–38.

———. "Beweis, das jede Menge Wohlgeordnet werden kann" [Proof that every set can be well-ordered). *Mathematische Annalen* 59 (1904), 514–16. Translated by Stefan Bauer-Mengelberg in *From Frege to Gödel.* Edited by J. van Heijenoort. Cambridge: Harvard University Press, 1967.

———. "Investigations into the Foundations of Set Theory I" (1908). Translated by S. Bauer-Mengelberg. In *From Frege to Gödel.* Edited by J. van Heijenoort. Cambridge: Harvard University Press, 1967.

Zervos, Christian. *Pablo Picasso.* 33 vols. Paris: Cahiers d'Art, 1932–1973.

Zola, Emile. *Le Bon combat: de Courbet aux impressionistes: Anthologie d'écrits sur l'art.* Edited by Gaetan Picon. Paris: Hermann, 1974.

———. *Le Roman expérimental.* 1880. Edited by Aimé Guedj. Paris: Garnier Flammarion, 1971. Includes *Le Naturalisme au théâtre* (1881).

Zweig, Stefan. *The World of Yesterday* [Die Welt von Gestern: Erinnerungen eines Europäers, 1942]. Edited by H. Zohn. Lincoln: University of Nebraska Press, 1964.

INDEX